AMERICAN PICTURESQUE

JOHN CONRON

American
Picturesque

THE PENNSYLVANIA STATE UNIVERSITY PRESS

UNIVERSITY PARK, PENNSYLVANIA

Early drafts of parts of Chapters 7 and 8 appeared in *Revue Française d'Etudes Américaines* and *Canadian Review of American Studies.*

LIBRARY OF CONGRESS CATALOGING-IN-PUBLICATION DATA

Conron, John.
American picturesque / John Conron.
 p. cm.
Includes bibliographical references and index.
ISBN 0-271-01920-4 (alk. paper)
1. Arts, American. 2. Arts, Modern—19th century—United States.
3. Picturesque, The. I. Title.
NX503.7.C66 2000
700'.973'09034—dc21 98-51056
 CIP

THIS BOOK IS FOR

Cheryl
comrade, mavourneen, txai,
who gives without stint or calculation.

FOR

Maura and Ted
John Michael

IN RETURN.

AND FOR

Eunice McCormick Conron
October 7, 1908 – April 4, 1999
"The voice," she often said, a refrain in the music of her life,
"the voice is the greatest gift of God."

CONTENTS

7. Lilly Martin Spencer, *Shake Hands?* 1854. Oil on canvas, 25⅛ × 30⅛ inches. Ohio Historical Society, Columbus.

8. Lilly Martin Spencer, *This Little Pig Went to Market,* 1857. Oil on canvas. Ohio Historical Society, Columbus.

9. William Rimmer, *Expression,* from *Elements of Design* (Boston, 1864), plate 36. Courtesy American Antiquarian Society, Worcester, Massachusetts.

10. John Neagle, *Pat Lyon at the Forge* (detail), 1829. Oil on canvas, 68½ × 94½ inches. Courtesy of the Pennsylvania Academy of the Fine Arts, Philadelphia. Gift of the Lyon family.

11. George Catlin, *Two Crows, a Chief,* 1832. Oil on canvas, 24 × 29 inches. National Museum of American Art, Smithsonian Institution, Washington, D.C. Gift of Mrs. Joseph Harrison Jr.

12. William Sidney Mount, *Farmer Whetting His Scythe,* 1848. Oil on canvas, 20 × 24 inches. The Museums at Stony Brook, Stony Brook, Long Island, New York. Gift of Mr. and Mrs. Ward Melville, 1955.

13. Charles Caleb Ward, *Force and Skill,* 1869. Oil on canvas, 10 × 12 inches. The Currier Gallery of Art, Manchester, New Hampshire. Gift of Henry Melville Fuller.

14. Seymour Joseph Guy, *Making a Train,* 1867. Oil on canvas, 18⅛ × 24⅜ inches. Philadelphia Museum of Art. George W. Elkins Collection.

15. George Caleb Bingham, *The County Election,* 1851–52. Oil on canvas, 35⁷⁄₁₆ × 48½ inches. The Saint Louis Art Museum. Museum Purchase.

16. Thomas Cole, *Sunset in the Catskills,* 1841. Oil on canvas, 22½ × 30 inches. Museum of Fine Arts, Boston. Bequest of Mary Fuller Wilson.

17. Fielding Lucas, *Twilight: Passage of the Blue Juniata Through the Warrior Mountains. Progressive Drawing Book* (Baltimore, 1826),

color plate XII. Courtesy American Antiquarian Society, Worcester, Massachusetts.

18. John T. Bowen, "Cottage with nearer part in strong light, and distant part in quiet, even tint of shadow, which makes it recede well." *The United States Drawing-Book* (Philadelphia, 1838), from fig. 9, color plate 18. Courtesy American Antiquarian Society, Worcester, Massachusetts.

19. Fielding Lucas, Monumentalized figure. *Progressive Drawing Book,* fig. 9. Courtesy American Antiquarian Society, Worcester, Massachusetts.

20. John G. Chapman, Marine panorama from three viewpoints. *American Drawing Book* (New York, 1864), p. 132. Courtesy American Antiquarian Society, Worcester, Massachusetts.

21. Martin Heade, *Approaching Storm: Beach Near Newport,* 1860s. Oil on canvas, 28 × 58⅜ inches. Museum of Fine Arts, Boston. Gift of Mrs. Maxim Karolik for the M. and M. Karolik Collection of American Paintings, 1815–1865.

22. William Trost Richards, *On the Coast of New Jersey,* 1883. Oil on canvas, 40½ × 72½ inches. In the Collection of The Corcoran Gallery of Art, Washington, D.C.

23. William Trost Richards, *The League Long Breakers Thundering on the Reef,* 1887. Oil on canvas, 28³⁄₁₆ × 44⅛ inches. Brooklyn Museum of Art. Bequest of Alice C. Crowell.

24. Asher B. Durand, *Study of a Wood Interior,* c. 1850. Oil on canvas mounted on panel, 16½ × 24 inches. Addison Gallery of American Art, Phillips Academy, Andover, Massachusetts. Gift of Mrs. Frederic F. Durand.

25. Thomas Cole, *Voyage of Life: Childhood,* 1839–40. Oil on canvas, 52 × 78 inches. Munson-Williams-Proctor Institute Museum of Art, Utica, New York.

Collection of The Newark Museum, Newark, New Jersey. Gift of William F. Laport, 1925 (Alinari/Art Resource, New York)

49. Thomas Cole, *Sunset in the Catskills,* 1841. Detail of tree at left. Oil on canvas, 22½ × 30 inches. Museum of Fine Arts, Boston. Bequest of Mary Fuller Wilson.

50. William Harvey, *Epitome of the Historic Progression of the United States.* From the title page of *Connected Series of Forty Views of American Scenery* (1841). Courtesy American Antiquarian Society, Worcester, Massachusetts.

51. Fanny Frances Palmer, *Across the Continent, "Westward the Course of Empire Takes Its Way,"* 1868. Published by Currier & Ives. Museum of the City of New York. The Harry T. Peters Collection.

52. George Inness, *The Lackawanna Valley,* c. 1856. Oil on canvas, 33⅞ × 50¼ inches. © Board of Trustees, National Gallery of Art, Washington, D.C. Gift of Mrs. Huttleston Rogers, 1945.

53. Frederic Church, *The Heart of the Andes,* 1859. Oil on canvas, 66⅛ × 119½ inches. The Metropolitan Museum of Art, New York. Bequest of Mrs. David Dows, 1909.

54. Frederic Church, *The Icebergs,* 1861. Oil on canvas, 64⅜ × 112½ inches. Dallas Museum of Fine Arts. Anonymous Gift.

55. C. S. Reinhart, *Their Bridal Tour—at Niagara Falls. Harper's Weekly,* September 29, 1888.

56. Asher B. Durand, *Progress,* 1853. Oil on canvas, 7¹⁵⁄₁₆ × 48 inches. The Warner Collection of Gulf States Paper Corporation, Tuscaloosa, Alabama.

57. Anonymous, *Amoskeag Millyards,* c. 1850. Oil on canvas. Courtesy of the Manchester (New Hampshire) Historic Association.

58. William Hart, *Albany, New York, from the East Side,* 1846. Collection of the Albany Institute of History & Art. Gift of the Vosburgh Estate.

59. John Bachmann, *New York City Hall, Park and Environs,* c. 1849. Tinted lithograph (Stokes 1849 E117). I. N. Phelps Stokes Collection, Miriam and Ira D. Wallach Division of Art, Prints and Photographs, The New York Public Library. Astor, Lenox and Tilden Foundations.

60. Philip Harry, *Tremont Street, Boston,* c. 1843. Oil on panel, 13½ × 16⅛ inches. Museum of Fine Arts, Boston. Gift of Maxim Karolik for the M. and M. Karolik Collection of American Paintings, 1815–1865.

61. P. Giradet (after H. V. Sebron), *Broadway and Spring Street, New York,* 1855. Engraving and aquatint (Eno 344). Eno Collection, Miriam and Ira D. Wallach Division of Art, Prints and Photographs, The New York Public Library. Astor, Lenox and Tilden Foundations.

62. Charles Bird King, *Rip Van Winkle Returning from a Morning Lounge,* c. 1825. Oil on canvas, 44 × 56½ inches. Museum of Fine Arts, Boston. Bequest of Maxim Karolik.

63. Eastman Johnson, *Not at Home,* c. 1870–80. Oil on board, 22½ × 26½ inches. Brooklyn Museum of Art. Gift of Miss Gwendolyn O. L. Conkling.

64. Frank W. Benson, *Girl Playing Solitaire,* 1909. Oil on canvas, 102.9 × 128.3 cm. Worcester Art Museum, Worcester, Massachusetts.

65. Charles Loring Elliott, *Asher B. Durand,* 1860. Oil on canvas, 55.6 × 68.8 cm. Walters Art Gallery, Baltimore.

66. Henry Inman, *Mrs. James Donaldson,* c. 1830. Oil on canvas, 27 × 34 inches. The New-York Historical Society.

67. William Harnett, *The Faithful Colt,* 1890. Oil on canvas, 18½ × 22½ inches. Wadsworth Atheneum, Hartford, Connecticut. The Ella

I make no claims to exclusivity in my use of the term "American picturesque." I mean the picturesque in the United States, not the picturesque as a national posses-sion. The aesthetic was not owned by nations; it led an international life we need to know much more about.

Yet it is fair to say that the picturesque was the first American aesthetic. Its influence is everywhere evident in nineteenth-century Euro-American culture. It converts both the world and the human body into readable texts. It alters the built environment with designs for spaces both public and private. It alters the structure and semiotics (the means of meaning) of painting, architecture, and landscape ar-chitecture, of poetry and prose narrative. Reading space in picturesque terms comes to constitute another literacy to be achieved by the citizens of the new republic.

For all of its impact and centrality, however, the picturesque is a notoriously elu-sive idea. It both eludes and invites reconstruction. Its constituent ideas are not only manifold, plastic, intricate, and inherently interdisciplinary, but also interlocking: they interpenetrate and transform one another, so that one cannot be rightly under-stood without the others. Nevertheless, they are both accessible and self-consciously democratic.

The intellectual behavior of the aesthetic, too, is curious, even anomalous. It is formed by a poetics of intensity but is also remarkably durable: flourishing from the late eighteenth century to the early twentieth, it is now undergoing a postmodernist revival. It begins as a fad, little understood but much bandied—and parodied—and then comes to its full maturity between 1830 and 1870—a reversal of the usual progress of ideas. It inspires a vast theoretical literature, where it is explained, taught, and ad-vocated; but artists use it without comment, as if it were (as it is) a *lingua franca,* so that frequently one must reconstruct their understanding from their use of it.

It is also ubiquitous—almost. Imported (from England) to the Northeast and the Middle Atlantic states, it adapts itself readily to the regions of the Midwest and the Far West, but not (except in cities) to the South. It passes across social as well as spatial boundaries, entering the houses of working-class Irish and the written narra-tives of African Americans as well as the culture of an emergent middle class, though it seems not to have affected oral cultures.

The task of reconstruction is further complicated by our own debased idea of the aesthetic, the product of its senility and of modernist revision, which reduces the term to a synonym for quaint, exotic, or charming. An appropriately multileveled definition of the aesthetic is the work of Chapters 1 to 7, and the rest of the book is an application of it.

These chapters attempt to define an appropriately historicized version of the pic-turesque as well, for it leads a nineteenth-century life very much distinguishable from

its eighteenth-century predecessors. To reconstruct that life requires a revision of current thinking about it, for Christopher Hussey's characterization (in 1926) of the English picturesque as an "interregnum between classic and Romantic art," a "prelude" to Romanticism, still carries inordinate weight among contemporary scholars. The substantial body of picturesque art and theory introduced in this book constitutes proof of the idea's vitality throughout the nineteenth century, and English and French picturesque art offers similar proof. The question is not "Does the picturesque exist in the nineteenth century?" but "How is it accommodated to nineteenth-century values?"

American versions of the aesthetic, I believe, are radically changed by at least three developments in nineteenth-century intellectual history. One of these is the emergence of an eclecticism that blurs where it does not erase boundaries between the picturesque, the sublime, and the beautiful, changing and multiplying the meanings of all three terms. During the 1830s, "beauty" comes to mean "picturesque beauty" and "sublimity," "picturesque sublimity." Like its baroque model, picturesque beauty is a beauty astir with energies, vibrant with color and light. Similarly, picturesque sublimity is more various, but also less terrific, than its Burkean predecessor. Eclecticism compounds the varieties and contrasts—the discontinuities—inherent in the lines, textures, and colors of picturesque forms. This is the subject of Chapter 2.

A second change is semiotic. Until the 1830s, Americans follow the eighteenth-century English practice of defining effect associationally—the perception of a form triggering feelings and trains of thought "analogous to the character or expression of the . . . object." Associationism allows well-read travelers, for example, to play out, in their mind's eyes, "poetical" and "historical" events—Ovid's stories of naiads and dryads, Saint Paul landing at Pozzuoli, the battles of Napoleon, the American Revolution, and other such "gigantic associations of the storied past"—in the landscapes in which they took place. It allows "the cold page" of poetry or history, as the American George Hillard puts it, to be translated into "living forms" acting out, in the mind's eye, dramas that "before, we had only read."

After 1830, as Chapters 3 and 4 are designed to show, an idealism informed by the New Thought from England and Germany locates meaning in the forms themselves. Associationism, where not abandoned altogether (as it is, say, in Ralph Waldo Emerson, Henry David Thoreau, Harriet Beecher Stowe, and Frederick Law Olmsted), is consigned (as in James Fenimore Cooper, Thomas Cole, and other members of the generation of the 1820s) to a distinctly subordinate role. In the new paradigm of picturesque effect, observers do not see and remember; they read picturesque phenomena as they would read any other text; and as in any other text the phenomena express moods, symbolic meanings, and even—details becoming "incidents"—narrative meanings. Idealism does for symbolic and narrative meaning what eclecticism does for mood: makes it complex, manifold, dynamic. Aesthetically eclectic forms are capable by definition of producing mixed and even dramatically conflicting feelings and meanings.

A fusion of nature with art constitutes the third distinctive characteristic of nineteenth-century American versions of the picturesque. The boundaries between

art and nature, blurred by eighteenth-century picturesque theory, now virtually disappear. In a culture in which canonical art is not popularly accessible until after mid-century, the natural environment, both rural and wild, becomes the model and standard—the authoritative text—of aesthetic values. "We would supply a place in reading," writes the Reverend Warren Burton in 1852, self-elected Professor of Landscape Scenery, "that has hitherto been vacant": a place in which natural "scenery" can be read like pictures (that is, like paintings and therefore "picturesque"). Read "steadily and repeatedly," natural scenery becomes, in American versions of the picturesque, the chief means of aesthetic education. The country ramble performs the same offices as a Grand Tour. Emerson makes a similar argument in *Nature* (1836).

Boundaries between the picturesque arts, meanwhile, also become blurred. Aesthetic discourse comes to be characterized by a kind of synesthesia. Paintings, prose narratives, and landscape architecture are said to enact a "poetry of scene" or a "poetry of light." Literature and landscape architecture are both understood to "paint" scenes—the one with words, the other with terrain, foliage, water forms, and architectural forms; and pictures are understood to narrate. Landscape "scenery" is a metaphor (very consciously) drawn from drama; the human body, too, is imbued with dramatic expression—the visible languages of posture, gesture, and countenance. Verbal discourse may also be picturesque. "Picturesque speech," as Emerson argues, is an art of intensifying powerful images with powerful feeling. Vocal tone charges images in language with feeling just as visual tone does in paint. That idea redefines not only drama but also oratory, and (as Poe, for one, demonstrates) lyric and narrative discourse. Language becomes painterly not only in its imagery but also in its sounds, as sounds intensify the visual tonalities inherent in images. Discordant tones of voice are the correlatives of chiaroscuro, and conversely, Emerson adds, "the law of harmonic sounds reappears in the harmonic colors." Painting is, like architecture, a "frozen music."

Chapters 4 through 7 consider the application of notions about picturesque effect to nineteenth-century American painting: to both the representation of images and the composition of the pictures that contextuate them in scenes. Chapters 8 through 12 trace the extension of these ideas to nineteenth-century American architecture, landscape architecture, and literature.

The chief purpose of this book is to reconstruct a synoptic definition of the picturesque aesthetic as it was understood in the nineteenth century—synoptic in the sense that it weaves together ideas and practices that have since been segregated from each other or ignored altogether. It is this segregation, I believe, that has made the aesthetic so elusive to its twentieth-century students.

My methods are an amalgam of aesthetic theory, cultural history, and comparative arts. My principal sources come from the nineteenth-century literature designed to explain, to teach, and in the process to popularize the picturesque aesthetic and to situate the continent and its people in the picturesque universe. The pervasiveness of this body of theoretical literature is most easily suggested by a short list of the picturesque manifestoes addressed in this book: Ralph Waldo Emerson's *Nature* (1836); Thomas Cole's "Essay on American Scenery" (1836), and Asher Durand's "Letters

on Landscape Painting" (1855); Andrew Jackson Downing's *The Architecture of Country Houses* (1850) and Catherine Beecher and Harriet Beecher Stowe's *The American Woman's Home* (1869); Downing's *Treatise on the Theory and Practice of Landscape Gardening, Adapted to North America* (1841) and Frederick Law Olmsted's reports on Central Park (1852–c. 1870); Samuel Morse's *Lectures on the Affinity of Painting with the Other Fine Arts* (1826) and Edgar Allan Poe's critical reviews of prose fiction over the 1830s and 1840s. The bibliography includes a more extensive representation of theoretical texts.

The theory situates picturesque art, as Jean Clay argues in another context, "squarely within the bounds of modernism." It incorporates a dialogue between structuralist and semiotic tendencies. Theorists define the art in terms of its "material and formal constituents"; but they insist that the art is also and always expressive—that form and structure mean. Accordingly, I too alternate between structuralist and semiotic approaches to the aesthetic, though giving pride of place to the semiotic as the more inclusive. In the process, I have taken some pains to give my analysis coherent, if usually tacit, relation to Rudolf Arnheim's *Art and Visual Perception,* Seymour Chatman's *Story and Discourse,* E. H. Gombrich's *The Image and the Eye,* David Bordwell's and Kristin Thompson's *Film Art,* Gerard Gennette's *Narrative Discourse* and *Figures of Literary Discourse,* and Mikhail Bakhtin's *The Dialogic Imagination.* These relations illuminate, for me, the often startling contemporaneity of the picturesque idea.

From the even more massive body of picturesque art, I analyze in some detail (and in light of the theory) landscape, topographical, and genre painting; rural cottages and villas in styles ranging from Gothic and Italian Revival to Queen Anne; a landscape garden (Montgomery Place); a rural cemetery (Mount Auburn); a picturesque suburb (Llewellyn Park); Central Park and urban architecture; and prose narratives by James Fenimore Cooper, Henry David Thoreau, Nathaniel Hawthorne, Frederick Douglass, Harriet Wilson, Harriet Beecher Stowe, Elizabeth Stuart Phelps, and others. In Chapters 1 through 4, such artistic texts serve chiefly as examples of the theory, and my analysis is therefore limited to the theoretical points being defined in a given chapter. With the introduction of scenic and narrative aspects of the aesthetic—the picturesque as a compositional theory—in Chapters 5 through 9, I am able to analyze artistic texts more elaborately, and Chapters 9 through 12 take the shape of detailed case studies of three such texts. People who have seen for themselves the elusiveness of the picturesque aesthetic will understand the necessity of such a careful approach.

After Chapter 7, as I follow extensions of picturesque theory to the arts of architecture, landscape architecture, and literature, the analysis also becomes synoptic. The book's comparativism emerges only here because it must, I believe, be grounded in an understanding of the picturesque as a principle of effect governing both forms or images (Chapters 2–4) and the scenic structures that contextuate them (Chapters 6–7)—and grounded as well (as the term "picturesque" itself implies) in an understanding of painting.

Systematic attention to some of the cultural contexts of the aesthetic also emerges gradually, because this too is contingent upon a grounded knowledge of the

aesthetic. What I wish to show, so far as this context is concerned, is the aesthetic's remarkable adaptability to nineteenth-century American culture's clangor and jangle of contrary tendencies. While it comes to serve the status quo, the picturesque is also appropriated by Transcendentalists to articulate a mystical view of the world and by urbanists and feminists to serve the causes of reform.

It serves both (or, more accurately, many) sides of the cultural dialogue on gender. Separate sphere ideology devolves around a narrative of domesticity in which home is declared the primary setting for a "feminine" characterology—a metonym of woman's mind—and keeping order there, a defining plot of women's lives; while "the world" becomes the setting for masculine identities and fates. This ideology is a recurrent one in picturesque art. In practice, however, the separation is not so simple. The picturesque house is a sphere dialogically defined by both genders: a mental map, often as surreal as apartheid, of spaces, functions, powers, and responsibilities both divided (often hierarchically, it is clear) and shared by gender. What Andrew Jackson Downing wants of the picturesque house, for example, is a place out of history where the American male can be reformed in several senses of the term. What the Beecher sisters want is that the American woman and her house be brought into history and enfranchised. As Chapter 10 argues, that dialogic tension explains, for one thing, why picturesque beauty is the first and chief criterion for Downing, while for the Beechers it must follow from and elaborate ideas about justice, efficiency, and health.

As with the art of houses, so with the art of the city. What I am calling the picturesque city (c. 1840–70) displays with particular force the ambiguities underlying nineteenth-century reform impulses: the push-pull, for example, between moral reform of individuals and social reform of oppressive human environments, between espousals of laissez-faire individualism and espousals of the social contract. For moral reformers, the responsibility for disorder and its resolution rests ultimately upon the individual; for social reformers, upon people in power. Chapter 11 considers how urbanist reform ideology informs picturesque values in the architecture of New York City and especially in Central Park, whose chief designer, Frederick Law Olmsted, is also (in his various reports to the park commissioners and other civic authorities) a still-compelling reader of its picturesque design.

Paradoxically, the impact of Transcendentalism on the picturesque is related, in literature and painting, to an emergent art of the local. In such an art, as Warren Burton argues, the importance of picturesque landscape devolves around "less striking phenomena" than that of the tour and the exploration, with their "search of the distant" and their aggressive extensions of the sphere of national influence. Like many women writers and like the luminist painter Fitz Hugh Lane, Henry David Thoreau is acutely aware that little in his own "lake country" matches the drama of the English and Italian lake districts. Walden "cannot much concern one who has not long frequented it or lived by its shores." The tourist's search for picturesque variety in traveling through dramatic landscapes is displaced by the native's emergent sense of variety in a single environment (or bio-region, as postmodernists call it) as subtler and more elusive changes become apparent over time. The logic of local art is that of the area-study, not the travelogue.

But the local is by no means parochial. Transcendental versions of the picturesque situate it both in the macrocosm and in the great span of Judeo-Christian time, between Genesis and Apocalypse. I have approached this subject, too, by means of leitmotif. For Ralph Waldo Emerson, whose chapter "Beauty" in his essay *Nature* (treated in Chapter 3) is the summa on the subject, the minds of studious observers both alter and are altered by their native environment. Picturesque effect is a ladder of awarenesses that leads into the spiritual reaches of beauty to anagogical insight. From such a perspective, as the paintings of Fitz Hugh Lane quietly declare (Chapter 7), familiar forms become masks of the profundities that lie behind or beneath them: surfaces reveal, on long looking, both the beginning and the end of time and the attributes of their Creator. That is a profession made by Thoreau as well (Chapter 12). *Walden* seeks in its local environment the prospect of a unity informing all of the complexities of the picturesque universe, including what Emerson calls the "occult relations" between the "I" of consciousness and the "it" of the world's body. The earth and all of its constituent forms are fellow creatures; the human body, conversely, a little earth: and both are plants growing on "the bosom of God." That is of no little interest to postmodernist students of the environment.

My strategy of exposition is thus the declaration of a hope that this book serve as a reconnaissance for more concerted explorations of the American picturesque. I even confess the hope that it may suggest directions for the kinds of detailed work still needed for a more rounded appraisal of its place in the history of what Robert Venturi calls "complexity and contradiction in art."

For what it is worth, nothing in this book came quickly or easily. I began it in 1978 as a way of exploring representations of the visible world in general and in particular the influence of the ideas of William Gilpin on American painting and literature. I set out to teach myself American art history, which, as it turns out, was entering a golden age. Sometime in the mid-1980s, I was confronted with the growingly evident fact that if landscape constitutes one pole in nineteenth-century Euro-American sacred space, architecture and its constellation of ideas about home constitutes the other, and that neither can be well understood without the other. I set out to learn enough about picturesque architecture to be able to write about it. In the late 1980s, it became clear that I needed to include landscape architecture and, by extension, the city. Most of the last twenty years, therefore, I have spent in study of disciplines new to me. To my mind, this is a story about the allure but also the difficulty of interdisciplinary study (now I know why this book has no predecessor) and about the freedom still possible in the academy.

I could not have kept to this project without guides and teachers. The first of these were my comrades and friends, John Sherman and Mike Carley. Marines in need called on them. They responded without stint and without calculation of the costs and would still if they could. John was killed several times over in Quang Nam in June 1965, and his bones did not come home until 1997. Mike was killed at Duc Pho in February 1967. All around that, things get ambiguous and dark.

Given the nature of this book, there were not many I felt I could tax as readers. The task of spotlighting the anomalies, the contradictions, the blurrinesses, the

repetitions, without devastating their author fell to friends. Virginia and Alden Vaughan gave from an inexhaustible (and always credible) fund of encouragement, and Virginia got me material support at times when I was most in need of it. Sun-Hee Gertz entered a dusky nightmare of a house and threw open curtains and windows to the light and the air. The task of spotting the blather and harumphing fell to Michael Kelly Spingler, who with SunHee got me to hear the music of the subject. Jeannette Hopkins asked (it seems to me) all the difficult questions about the focus and architecture of the book; in the process, she pulled me to a critical distance away from a manuscript that was by then wrapped around and through me like bindings, and got me to hear and see again what was and was not on the page. Steve DiRado gave me not only his perfectionism as an artist in some of the images, but conversation about pictures as inexhaustible as the pictures he makes. The conversations of Winston Napier and Heather Roberts have added both heft and spirit to my thinking. Philip Gura would not give up or let me give up in the long search to find this expensive book a place. And Philip Winsor committed The Pennsylvania State University Press to lay it out beautifully, in a way that I had almost given up hoping for. Cherene Holland and Jennifer Norton have since taken up the task. What moves me most in retrospect is how all gave unstintingly and without calculation of the costs.

Funding for several stages of research and the gathering of illustrations came at critical times from Clark University Faculty Grants and especially from grants from the Alice C. Higgins School of the Humanities. Thank you, Alice Higgins.

It is impossible to imagine writing without reading. One day at the American Antiquarian Society, I read in a nineteenth-century art-instruction book a reference to a pamphlet titled *Picturesque Anatomy* by John Rubens Smith. Unthinkingly, I did what readers do when they assume the absence of a great library: took a note, daydreamed for a bit on where and whether I might find it someday. Fifteen minutes after an elaborate double-take, I was reading it. The richnesses of the society's holdings matches the grace of its librarians—and I am especially thankful to Georgia Barnhill, Joanne Chaison, and Marie Lamoureux.

I live better for what Harvey Slarskey, Rosemary Kiritsy, Rory O'Connor, and Father Paul O'Connor give to life and to the people around them, and it lifts my heart to see them.

My family is my rock and my ship. Leslie and Bob Carola, who live, breathe, and eat books, taught me where the shoals are. No one on this earth has more of my respect as well as my love than Maura Leslie and John Michael Conron: how beautiful upon the mountains are their feet. More than any, Cheryl completes me.

Deo gratias.

Sight is the noblest of senses. Any thing that helps to perfect it really enlarges the world for us; for what passes unnoticed, might . . . as well not exist.

—Quotation from J. E. Cabot in William Rimmer, *Elements of Design* (1854)

We would supply a place in reading which has hitherto been vacant.

—Warren Burton, *Scenery-Showing* (1862)

∾

The Picturesque Aesthetic

AN INTRODUCTION

TWO PICTURESQUE LANDSCAPES

On June 13, 1806, Meriwether Lewis notes in his journal his "discovery" of the Great Falls of the Missouri River. He tries to wrestle what he sees into the form of a verbal sketch designed to end the falls' concealments from the view of the citizens of the new republic. The activities of discovery are familiar to us; his means, less so. First he locates himself (and therefore the viewer) precisely; the very shape of his subject depends upon this. He stands on a promontory jutting into the river, with a frontal view of the falls from about a hundred and fifty yards downstream. Then he tries to evoke—literally, to give voice to—the turbulent complexity of rock and moving water outside and a related complexity, inside, of exhilaration and collected concentration. One notes the frequent measurements of size and distance. Eighty feet high and two hundred yards wide, the main fall, Lewis notes, takes the form of a foamy "sheet" (of paper?) engraved with a calligraphy of motions and countermotions "which assumes a thousand forms in a moment, sometimes lying up in jets of sparkling foam to the height of fifteen or twenty feet, which are scarcely formed before large rolling bodies of the same beaten and foaming water are thrown over and conceal them." Below, still writhing with "impetuous" energies, the fallen water strikes against the abutment on which he stands and "seems to reverberate"—energy translated into sound—then "roll[s] and swell[s] into half-formed billows of great height which rise and again disappear in an instant."[1]

Three decades later, on July 6, 1836, Thomas Cole composes in *his* journal a verbal sketch of South Lake in the Catskill

Mountains of New York State, a subject he had first painted in the summer of 1826. Like Lewis's Missouri Falls, this too is—or at least appears to be—wilderness water. Since Cole's point of view shifts (he is at one point in a boat), the subject takes shape in a kinematic sequence of perspectives, though the principal one is (like Lewis's) from a promontory: the low, wooded neck separating North and South Lake. Like Lewis's Missouri, Cole's lake has the look of "virgin waters." (We may take this, however, as an artistic conceit, since the lake lies just under the elegant Mountain House hotel.) Cole's is a purely *aesthetic* discovery. The lake is "virgin" because "the prow of the sketcher['s boat] had never yet curled" its waters, and because it is "enfolded by the green woods whose venerable masses had never yet figured in annuals, and overlooked by stern mountain peaks never beheld by Claude or Salvator, nor subjected to the canvas by the innumerable dabblers in paint of all past time. . . . No Tivolis, Ternis, Mont Blancs, Plinlimmons; but primeval forests, virgin lakes, waterfalls."[2] Yet Cole's viewpoint, like Lewis's, is calculated to frame a field of vision in which (space become plastic to the eye of the perceiver) some forms are foregrounded and others are emphatically distanced. In a phrase used by Cole's contemporaries, it "sends back" to the background the mountain summits of High Peak and Round Top.

This water, however, is inscribed with a very different array of effects than the falls. Cole's sketch from the shore contrasts effects of brilliance and repose, fecundity and ghostly decay. It frames its subject, quite self-consciously, as a vista: a view into distances, with what William Gilpin had called "sidescreens" (here dead trees on the foregrounded promontory) forming a frame to limit lateral vision. The description accepts the invitation of the vista, the focus moving from its foreground (dead trees, brilliant forest) to its background (Round Top) to its center—a water surface so still that its reflections take on the appearance of material reality, forming a surreal collage of inverted mountaintop and floating, or flying, boat. The surreal effect is intensified by yet another visual mirage: the figures of ghosts, or of ghostly *genii loci*, which Cole superimposes as a metaphor upon the forms of dead trees. The trees are an "exceedingly picturesque" feature of "the scenery of this lake."

> Their pale forms rise from the margin of the lake, stretching out their contoured branches, and looking like so many genii set to protect their sacred waters. On the left was another reach of forest of various hues, and in the center of the picture rose the distant Round Top, blue and well defined, and cast its reflection on the lake, out to a point where our boat swung like a thing in air. The headland was picturesque in the extreme. Apart from the dense wood, a few birches and pines were grouped together in a rich mass, and one giant pine rose far above the rest. On the extreme cape a few bushes of light green grew directly from the water. In the midst of their sparkling foliage stood two of the bare spectral trees, with limbs decorated with moss of silvery hue, and waving like gray locks in the wind.

The differences between the two sketches are patent. Lewis's is situated in Montana prairie country; Cole's in the deciduous forest and glacially sculpted mountains

of the American Northeast. Lewis's is organized around an idea of energy; Cole's around an idea of subtly animated repose. Lewis's is the work of an amateur carrying a knowledge of pictorial art as a small parcel in the baggage of the explorer and field scientist; Cole's is the work of a professional artist and an amateur writer.

Yet it is their kinships that are most significant. Both sketches reveal a massive transformation of the aesthetic intelligence in Western thought. From Homer to Donne, nature had been apprehended, in Hugh Kenner's fine words, "according to the forms of personal analogies, as a field of wills and forces to be kenned—the world of moonlight sleeping upon banks, winds cracking their cheeks, and the stars keeping their course"—and as a concertation of voices to be heard. In the eighteenth century, however, nature lost both her body and her voice and became, in one heuristic metaphor, a furnished house; in another, dialogically opposite one, a mysterious and multifarious otherness, complex, changeful, and yet as signifying as the scenery on a stage.[3] That is the vision of nature defined by the picturesque aesthetic.

And that is the vision of nature evident in the two sketches. Both define the picturesque in terms of the four distinguishable but interrelated behaviors that typify nineteenth-century American theory and practice of the aesthetic.

A Grammar of Complexity

The sketches define natural landscapes grammatically as gatherings of complex forms with varying and contrasting visual effects. Outlines, surface deformations, and groupings—irregular, uneven, or broken—are intense expressions of energy, motion, or change, whether active or kinetic, present or past, converging on them or arising from within. The lines and surfaces that Lewis images convey a sense of violent turbulence. The "sheet" of falling water keeps getting broken. The perpendicular cliff above it has been "broken" by a ravine and a road running through it and the ravine "beaten" by the hooves of buffalo seeking water. Below, buffalo bones float in a pool. By contrast, the bottom downstream is habitable and filled with the exuberant energies of foliage.

Cole's dead trees are also defined by broken lines. Some limbs have dropped off; some are broken visually by hairlike moss or "bushes of light green" growing out into the water; and the grotesqueries of the dead trees contrast with the vibrancy of living foliage. Cole gets equivalent effects from textural contrasts between foliage and water and from contrasts of color and light between the pale grays and silvers of the dead trees, the blue mountain, and the sparkle of light on leaves. That sparkle and Lewis's rainbow demonstrate the complexities of light (and shadow) that occur when it passes across irregular surfaces. Picturesque light effects are as complex, various, and contrastive as picturesque lines and forms.

Picturesque Effect: Form as Mood, Form as Sign

In both sketches, the visual grammar of line, form, and light is invested semiotically with feelings and ideas, that is, with picturesque effect. The modal effects of both Lewis's and Cole's sketches, to begin with, are manifold. Both are constructed to visualize impressions as various and changeful as the world and the consciousness they represent. The impressions are neither simply beautiful nor simply sublime, but

meldings of beauty *and* sublimity that alter the very meanings of both. Lewis's attention to the beautiful forms of falling water mediates the sublimity of the Great Falls, just as their sublimity makes these formal beauties both more vigorous and more dangerous than neoclassical ideas of beauty allow. Cole's landscape combines elements of beauty (the glassy lake, the brilliant forest) with elements of a less dangerous sublimity (the mountain, the distances, the silence, the spectral stirrings). His interest is too visual to be purely sublime: the sublimity of depth (distance) is merely implicit, for example, in his arresting image of a blue mountain.

These effects are even more evident in the painting Cole had already done of the lake. *Lake with Dead Trees* (Fig. 1) combines with great subtlety elements of both beauty and sublimity. The dead trees, the frightened deer, the massed height of the mountains and the storm clouds (presented as dissipating) are touches of sublimity, as is the pervasive sense of stillness and silence concentrated in the middle ground. Yet all of the forms are delineated by the irregular curve, the line of picturesque beauty; the surface of the lake, principal subject of the picture as the title suggests, is beautifully smooth and reflects the emergence of blue sky and sun; and the mountains are transfigured by light and moisture into soft, beautiful piles, almost as insubstantial as clouds. We call this landscape beautiful because elements of beauty are made to predominate, but it is a beauty that is a bit disheveled, scarred even, and thus (from a classical perspective) imperfect. The modal effects of the picture, like the verbal sketches, are both soothing and disturbing, disturbing and soothing.

Both verbal sketches, moreover, symbolize their moving images. Lines and surfaces become hieroglyphs of profundities; they are seen both to mask and to reveal. Movements become gestural, as if forms—as if the body of the earth itself—were prescient. Lewis's watery sheet behaves like a gorgon. It takes the form alternately of jets, bodies, billows; it swallows buffalo (as the bones indicate) and beats against Lewis's promontory "with great fury." Creatures of a more benign world, Cole's ancient, sepulchral, vatic trees, wearing the dress of wizards, their foliate crowns "waving like gray locks" in a gentle breeze, "[stretch] out their contoured branches" in gestures of benediction.

An Art of the Scene

The third behavior of these sketches (and by extension, of picturesque art) is syntactic. Both evoke scenes by using conventions of mise-en-scène. Spectator-positioning, framing, lighting, and the treatment of forms as "props" all give the imagery a context and a cumulative and intensified coherence. "Sketch" and "scene" are virtually synonymous.

In Lewis's sketch, the positioning of the viewer accentuates the sublime turbulence of the falls, which are monumentalized (apparently enlarged) by the view from below. The power of the water is magnified by its downward plunge at the viewer. The power of the main fall, however, is mediated by its relation to a second fall, "a smooth even sheet of water" with a delicate rainbow rising from it. The frame, a sweeping prospect view (forerunner to Cole's vista), also mediates by delimiting the violence and by including, downstream from the falls, a stretch of calm water and "a

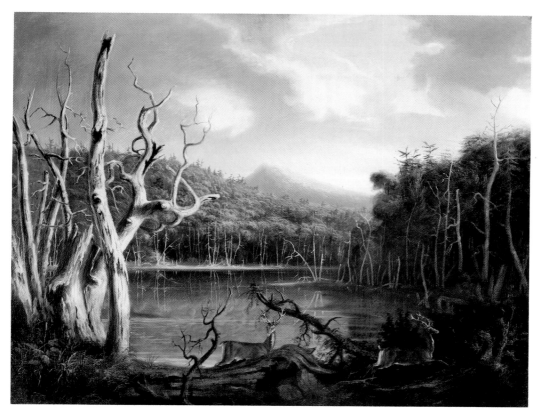

Fig. 1 Thomas Cole, *Lake with Dead Trees*, 1825. Oil on canvas, 27 × 34 inches. Allen Memorial Art Museum, Oberlin College.

handsome little bottom," thick with cedars, cottonwood trees and a grouping of Indian lodges. The sketch thus defines a scene in which aqueous "fury" is also tempered by fertility, in which dangerous space is contained by habitable space.

Cole's sketch is similar, if subtler, in its use of mise-en-scène, as one would expect of a painter. Here, too, the effect is multiple and eclectic, based on a contrast between the sublimity of the dead trees and the mountains and the beautiful repose of the light, the lake, and the living forest. And here, too, the principal frame (a vista) elaborates the meanings of the effects. Variations in the density and specificity of the descriptive discourse serve to situate the imagery in the organizing frame of the vista. Foregrounded forms such as the dead trees are represented in populous and minute detail (the kind of detail noticeable only in forms proximate to the viewer) and made symbolic with the help of metaphoric images. Minimal and general in detail—forms more named than described—the mountains are made to seem distant to the viewer. Cole's description both defines and enacts the visual experience of the vista, and in the process it expresses concertedly the effects of its images. The beauty seems to spread like a ripple, to radiate from the break in the distant clouds to the forest and the lake water.

In both sketches, moreover, literary discourse also serves effect. Lewis's discourse reinforces the effects of the water it evokes. The very syntax, a paratactically constructed montage of short, verb-dominated sentences spliced by commas, reproduces

rhythmically the hectic motion of the water, as alliterated plosives ("break," "bodies," "beaten," "billows") reproduce its violent sounds. Cole's syntax, also paratactic, is slower in its rhythms and filled with more detail; congruently, it orchestrates slow rather than hectic movement.

Form, Scene, Narration

The fourth and most inclusive picturesque behavior is narrative. Both sketches transform landscape into dramatic "incident." Lewis's does so by giving the scene the form of a "moving picture," as William Gilpin had called it, in which movement in the landscape assumes the character of a natural event. Cole's gives the scene the incidental character of a processional whose motion (save for the wind-stirred branches) is visual rather than material. The eye is led from foreground to background and back again, and with it, light and repose flow toward the viewer like a wave.

One of the most insistent impulses of such picturesque art is the multiplication of narrative strands, and the sketches are representative in this as well. Both characterize themselves reflexively as narratives of discovery, presenting pictures of things their writers have never seen before to Euro-American citizens of the republic, who have not seen them either. In this, they are examples of the narrative convention of the picturesque excursion—"in pursuit of the picturesque"—with which an emergent Euro-American culture set out to survey the aesthetic resources of the nation and its peoples.

Paradoxically, Lewis's falls and Cole's lake also take their places in a context of New World landscapes perceived to be unchanged, "untouched," "from the beginning." Their very existence is situated in a narrative of divine revelation: they are texts from the book of creation, the reading of which is also narratized. Cole's sketch enacts an epiphanic moment in which immaterial, transcendent realities are seen to declare themselves. Branches that are both dead and animate reach out in benediction, and in this magically reflective *trompe l'oeil* world still water becomes (as Thoreau would later evoke it) a lower heaven; matter gets stood on its head; and everything—mountain, boat, and viewer—begins to fly! The scene verges on being a natural equivalent of the Assumption.

The picturesque book of creation is a sacred, if unsettling, mix of benedictive insight and catastrophic violence. A pre-Darwinian version of the struggle for survival surfaces in the very verbs of Lewis's sketch and in the details of the track beaten by buffalo hooves above the falls and the buffalo bones at the bottom; an intimation of evolution (the cycle of life and death) appears at the center of Cole's scene. In the lodges "formed of sticks," Lewis's sketch also hints at a narrative of human inhabitation, another version of which is an absent presence in Cole's sketch, for what he omits from his vista is as significant as what he includes. The trees died, we know, because the dam of a lumber mill on the outlet (Catskill Creek) flooded them. Cole's own presence on the lake, his journal makes clear, was made possible by the presence of a tourist hotel, the Catskill Mountain House, an elegant and massive construction of Greek Revival architecture (no house of sticks!), which broke the skyline perhaps three hundred yards from where he positions himself to sketch the lake and which offered, besides its world-famous access to American mountain scenery, beds with

linen, elegant meals, and an impressive cellar of French wines. The hotel was the likely owner of the boat he appropriated for his row on the lake.

As we begin to watch the watchers more closely, subtler and more dramatic narrative strands appear. Both sketches enact a struggle to mediate between reality (however it may be defined) and artistic convention. Both are in some sense about themselves—reflexive representations of an artist's (and by extension a culture's) struggle to give order to the resistant materials of natural form without draining them of their invigorating energies. Picturesque art, as Martin Price observes, is "a drama more than a composition"—which is to say that it enacts a drama of composition—"and our response is to the presentation of character rather than to the internal coherence of the object."

> The picturesque in general recommends the rough or rugged, the crumbling form, the complex or difficult harmony. It seeks a tension between the disorderly or irrelevant and the perfected form. Its favorite scenes are those in which form emerges only with study or is at the point of dissolution. It turns to the sketch, which precedes formal perfection, and the ruin, which succeeds it. Where it concentrates upon a particular object, the aesthetic interest lies in the emergence of formal interest from an unlikely source [a broken sheet of water, a flying boat, for example] . . . or in the internal conflict between the centrifugal forces of dissolution and the centripetal pull of form [dead trees].[4]

This, too, is a dramatic emphasis. The work of art itself—and particularly the art of the sketch, which is by definition unfinished—takes on the character of a drama of "the energies of art wrestling with resistant materials or the alternative form of the genius of nature or time overcoming the upstart achievements of a fragile but self-assertive art."

> The drama of the picturesque achieves neither the full tragedy of the sublime, nor the serene comedy of the beautiful. [Uvedale] Price likens its effect to that of the mixed genre, such as tragicomedy: "by its variety, its intricacy, its partial concealments, it excites that active curiosity which gives play to the mind, loosening those iron bonds, with which astonishment chains up its faculties." So, when Reynolds rejects the tyranny of the "rigid forms" of tragedy in his defense of tragicomedy, he argues: "Man is both a consistent and an inconsistent being, a lover of art when it imitates nature and of nature when it imitates art, of uniformity and of variety, a creature of habit that loves novelty."

"The principles of art," moreover, "must conform to this capricious being." Just so, Lewis's sketch takes the dramatic form of a frustrated attempt to do artistic justice to the falls. After describing the falls, Lewis confesses vexation and disgust at not being able to do them justice. His knowledge of the picturesque canon—the exemplary picturesque texts (in literature, architecture, and landscape architecture as

well as painting) from the seventeenth to the nineteenth centuries—allows him to measure his performance against exemplary representations of waterfalls. "I wished," he writes, "for the pencil [the genius for linear sketching] of Salvator Rosa, a Titian, or the pen [the genius for verbal sketching] of [James] Thompson that I might give . . . some just idea of this truly magnificent and sublime object." Cole defers to some of the canon's exemplary landscapes (Tivoli, Terni, Mont Blanc, Plinlimmon) and painters (Claude Lorrain, Salvator Rosa). His sketch celebrates the freshness of a landscape that has not, yet, been painted by a Claude or Salvator or "subjected" to scribblings and dabblings. Artistically, it is a blank page waiting to be filled.

Both sketches speak loudly, if indirectly, of a burgeoning nationalism; Cole's, of urbanization, including an urban locus for publishing and advertising such sketches; a readership literate visually as well as verbally; a religious belief in the manifold "ministries" (Emerson's term) of nature; and an obsession with the matrix of relationships between nature and culture.

In this, too, the sketches are wholly representative versions of the aesthetic that dominates nineteenth-century American culture. Like them, the American picturesque transforms nature—and art—into a grammar of forms or images (depending upon which art we refer to) inscribed with the values of complexity, variety, and contrast and encoded, by means of picturesque effect, with modal, symbolic, and narrative significations. Lines, surfaces, and colors visualize what is within forms or impinging upon them. (Everything, says Lavater in a statement much repeated by Americans, has a physiognomy; everything speaks the language of gesture, in which its depths of being and meaning become accessible to the sympathetic eye.) "The poetry of forms," as nineteenth-century Americans call it, is just this transformation of things by "effect," or "expression." This is also true of the poetry of light. Picturesque effects are by definition manifold and confer manifold identities on forms and scenes: signifiers of mental states, polysemous symbols, narrative "incidents."

The American picturesque is, at the same time, an art of pictorial composition. As its very name suggests, it arranges forms and atmospheres into "pictures," which picturesque theory defines both structurally and semiotically. Structurally, the picture incorporates a tension between variations (or contrasts) that complicate and energize a "unity of effect" that imparts coherence in several ways by identifying a principal form and subject to which all else is subordinate, by gradating (and thus relating) contrasts, and by constructing leitmotifs of line, texture, and color. The picture both harmonizes divergences in form and, conversely, complicates unities with multiplicities and oppositions.

Semiotically, the picture is a plotted arrangement of space, form, and discourse that elaborates a "general [thematic] effect." It is both scenery (a landscape, an interior) and the events that "take place" there: a dramatically significant arrangement of human figures; an arrangement of forms in some historical or dramatic relation to each other; a representation of natural or psychological events—waterfalls, storms, epiphanies. Narrative signification is the product of mise-en-scène. Like its theatrical counterpart and predecessor, the picturesque scene arranges its constituent forms in groupings and sequences, situates the spectator in relation to these arrangements and

lights, and frames them in signifying ways. Arrangements of forms (as Chapters 6 and 7 will show) can signify temporal and causal as well as spatial relationships.

ENLARGING THE VISIBLE WORLD: A CULTURAL PROJECT IN VISUAL LITERACY

Nineteenth-century versions of the picturesque like Lewis's and Cole's are the products of a Euro-American cultural project in visual literacy as long-lived as it is inclusive. The project begins in the 1790s and unfolds throughout the nineteenth century, reaching an apogee between 1830 and 1870. Its massiveness and the massive influence of the picturesque aesthetic upon it are suggested by the sheer heterogeneity and number of its cultural productions.

The Pictorialization of American Art

For nineteenth-century Americans as for their English progenitors, paintings (and, by extension, prints and engravings) are the paradigms of picturesque art: the term "picturesque" ("like a picture") itself valorizes visual arrangements that look like paintings. In American painting, picturesque theory provides the imagery, the varied spectrum of effects, and the scenic strategies for the representation of landscape in the Hudson River School and the luminists; of buildings, townscapes, and cityscapes in topographical painting; and of the human figure in genre painting.

On grounds that painting has, in Samuel Morse's terms, "an affinity with the other fine arts"—particularly with literature, architecture, and landscape architecture—these arts are also redefined in pictorial terms. The transformation imbues with subtle synchronies works as various as Central Park and *Moby-Dick.* Each of the arts is invested with a grammar of picturesque forms (or images). As in painting, strategies of "lineation" and "coloration" define images that mediate between picturesquely sublime and beautiful "conceptions or sentiments."[5] Sublime subjects are defined by lines typically broken, crazed, jagged (like upraised hackles), and by sharp contrasts of light and dark that cause "irritation . . . animation, spirit and variety"; beautiful subjects by the calligraphy of the irregular curve, smooth textures, soft colors, and warm or cool (but not dazzling) light. Picturesque beauty, moreover, has a "reiterated attraction": beauties of line are intensified by "beauties of color, contrasts, variety &c."[6]

As Lewis's and Cole's sketches demonstrate, style in picturesque literature—a product partly of descriptive imagery and partly of lyric discourse (pace, rhythm, alliteration, and so on)—is seen to have its antipodes of sublimity and beauty as well. Likewise the limits of style and effect in antebellum picturesque architecture are set by Gothic Revival (with its muted sublimities) and the polished beauties of the Italianate Revival styles; and the limits in picturesque landscape architecture—a product of terrain, water forms, foliage, and architectural furnishings—by the symmetrical geometries of the classical and the wild irregularities of the "modern" (picturesque) styles.

The picturesque arts are all understood to be scenic as well. The terms "painting" and "scene" are as interchangeable as, in literature, the terms "sketch" (Irving's

Sketch-Book, Hawthorne's "Sketches from Memory" and "Night Sketches" and "Mrs. Hutchinson," Poe's "Oval Portrait" and "Landor's Cottage") and "scene." The picturesque house is conceived both as a part of the scenery around it and as an arrangement of rooms each composed like sets in a theater, with its own distinctive effect, its own palette and "props," its own mise-en-scène. Picturesque parks and gardens, too, are conceived as sequences of scenes, with foliage both creating the frames and converting sunlight into dramatic lighting—thickly planted spaces producing dark shadow; open lawns, meadows, clearings or lakes, brilliant light; and openly grouped plantations, chiaroscuro.

And in each of the arts, scenes are always at least potentially narrative. Literary "painting," as Poe calls it, is designed to focus, like painting itself, on physical or psychological events. In literature and painting, human figures are imbued with motion and energy; the human face, the most sensitive surface in the picturesque universe, is made capable of visualizing the most subtle and expressive movements and deformations caused by emotion rising from within or by the energies of the environment from without; and figures become signifiers of a dramatic form of narration. Narration also occurs not only with the sequencing of forms in scenes but also with the sequencing of the scenes themselves. In the arts as in nature, paths (including visual paths) become plots expressing the cumulative coherence of an unfolding story.

The American Scene as a "Pursuit of the Picturesque"

Imparting that narrative coherence to American landscapes and their inhabitants is the avowed function of the nineteenth-century travel narrative, the experimental laboratory for a picturesque literature. With its painterly analogue the "home scene," the travel narrative transforms the emergent nation into an *omnium gatherum* of readable scenes and figures.

At first, this "pursuit of the picturesque" is decidedly local. In the 1820s, following William Gilpin's advice, American travelers make river valleys and adjacent mountains "the great directing lines of picturesque excursions," such as Thomas Cole's to the Catskills. The defining forms of the landscape are more often monumental and exemplary than typical: the Catskills, for example, become an *axis mundi* of the American picturesque—a gigantic closet of models for American art. Above the escarpment, High Peak, Round Top, South and North Mountains heave, Cole observes, "like the subsiding billows of the ocean after a storm"; and not coincidentally, their summits combine a "pyramidal shape" with the "easy flow" of an irregular curve defined by Gilpin as exemplary in its picturesqueness. On closer views, as Henry Tuckerman observes, the mountains resolve into "an inexhaustible series of pictures, unsurpassed in freshness, scope, and variety":

> . . . wooded gorges and glittering cascades, wild masses of rock, noble groups of trees, umbrageous ledges clad in brilliant autumnal, emerald spring, or ermine winter garniture. . . . Here we look down a precipice, along whose sides cling majestic trees, and at whose base frets a crystal stream with moss-grown rocks around; there is a solemn pine forest; now a sunny glade tapestried with wild-flowers; groups of elms, oaks with white lichens, the dark hemlock . . .

chestnuts, beds of laminated gray stone—the towering summit, the green lapsing "Clove," the glistening cascade . . . the sweep of the gale over leagues of forest . . . silence broken only by the chirp of the squirrel or the tap of the woodpecker, and the roar of the tempests, whose prolonged echoes shake the hills.[7]

What makes this scenery surpass its canonical models, American observers declare, is the "variety and magnificence" of its lighting and atmospheric effects. American skies, Thomas Cole contends, combine all the best effects of Old World skies—"the blue unsearchable depths of . . . northern [Europe]," "the silver haze of England," "the golden atmosphere of Italy"—with such New World effects as "the unheaped thunder-clouds of the Torrid Zone, fraught with gorgeousness and sublimity." These effects are intensified, in landscapes, by the purity and transparency of the water, "for the reflections of surrounding objects, trees, mountains, sky, are the most perfect in the clearest water; and the most perfect is the most beautiful."[8]

As the century unfolds, local and regional landscapes are brought together into a stupendous scenic montage of the nation and, by extension, the American continents. The aesthetic geography of Cole's "Essay on American Scenery" (1836), limited to the New England and New York interiors, stops at the Palisades and Niagara Falls. During the 1840s and 1850s, the exploration ranges northward to Arctic landscapes (Noble's *After Icebergs with a Painter*); southward into the tropical jungles, savannahs, and mountain ranges of Central and South America (Church's journals); and, most emphatically, westward across the prairie region and the "Great American Desert" into the High Sierras. In the process (this is a subject in need of more research), picturesque conventions and regional realities modify each other, the aesthetic proving more adaptable than other cultural baggage in the representation of diverse bio-regions.

The massive and profusely illustrated two-volume *Picturesque America* (1874), a sign of this realization westward, is a scenic inventory of transcontinental scope. Its design, its editor declares (the authorship is multiple, each author a specialist), is to present "full descriptions and elaborate pictorial delineations of the scenery characteristic of *all* the different parts of our country." This includes not only natural landscapes "characteristic" of the country's various regions but also spaces and figures on which civilization has impressed its "various aspects": "views of our cities and towns, characteristic scenes of human activity on our rivers and lakes," and even genre scenes of "American life and habits" that "possess the picturesque element." Like so many newspapers, magazines, and travel books, the book promulgates the idea of "picturesque excursions" into landscapes from Maine to New Orleans, from Cape Cod to Los Angeles.[9]

This has become a fairly familiar part of the story.[10] So has the encoding of the American landscape with the contrary tendencies of a burgeoning and increasingly urban civilization and a disinterested openness to what Emerson calls the manifold "ministries" of nature. One layer of symbolic effect, as recent scholarship has so forcefully demonstrated, runs recurrently to the political.[11] Landscapes express the national mission of Euro-American settlement and cultivation. They take shape as a

mosaic of "innumerable spots to which the heart of patriotism would fasten; yea, into which it would grow . . . as into a warm, loving bosom." Then (ideally) the bosom begins to glow "with . . . aspirations to improve, and bless, and glorify the land of nativity, and the heritage of freedom." [12]

The other most recurrent layer of symbolic effect is epistemological and ultimately mystical. As Emerson so generatively defines it, landscapes produce in their readers a ladder of awarenesses. The "tonic" of beauty transforms not only feelings, but all of the faculties of the mind. Landscapes reveal the scientific laws that permeate them. They invigorate language, which is "rooted" in natural forms and processes. They discipline the will and preach to the conscience. They teach the imagination "the unspeakable but intelligible and practicable meaning of the world" as transcendental idea. And having taught "the lesson of worship," they reveal the face of "him who made them."

As Lawrence Buell has recently argued, this hermeneutical tradition, not wholly annexed by the politics of American empire, defines a desire to understand ("stand under," as to a teacher or holy one) rather than to own and use nature—an ethic much in need of resuscitation in the waning days and landscapes of the twentieth century. Emerson's is the most sophisticated and inclusive version, but by no means is it the only one. [13] "[L]et the idea of the holy, parental Creator be ever connected as the all-pervading and upholding spirit" of the natural landscape, declares the Reverend Warren Burton, self-appointed "professor of landscape," "and how would religion be radiant from each tint of loveliness; how would it envelop the forms of beauty, and the masses of grandeur, and overlay the mysterious expanses of the Sublime! How would Religion, going forth from the inner temple of the soul, fill with its holy, enhancing presence, the great outward temple of God, from the verdure and flowers around the altar of prayer, to the azure and stars of the dome." Landscapes are "the surpassing, perfected picturings of God." [14]

The pictorialization of travel narratives makes possible, in turn, the pictorialization of prose fiction, shaping, for male writers, its recurrent plot of the quest as a kind of picturesque excursion into the higher ministries of nature. Washington Irving's tales, James Fenimore Cooper's *The Deerslayer* (and the other Leather-stocking Tales), the short narratives of Nathaniel Hawthorne, Edgar Allan Poe's *The Narrative of Arthur Gordon Pym,* Thoreau's *Walden,* and Melville's *Moby-Dick*—virtually all of the canonical fiction adapts a discourse, a (typically wilderness) scenography and even a strategy of scenic sequencing derived from the aesthetic. Fictions by women adapt these strategies to the antipodes of the home, the city, and the mill and the very different stories taking place there. Fictions by African Americans lay bare the conventions.

Picturesque Reconstruction

The picturesque oversees the Euro-American reconstruction as well as the representation of nineteenth-century space. Like landscape, the picturesque house is defined as a struggle to complicate the straight line and the smooth surface. Peaks and salients—wings of varying heights; chimneys, towers, and dormers—turn the roof into a kind of geometricized ridge. Asymmetrical ells, wings, and other such projections break up the boxy form of the house's body. Bay and bow windows and other

visually penetrable spaces break up the walls, carrying the landscape (visually) into the house as porches, parterres, statuary, and outbuildings carry architectural space into the landscape. Ornamentation adds its sculptural movement to the house's most significant lines: doors, windows, rooflines. To theorists like Downing, such "variously marked features" express the variety of tastes, interests, energies, and attachments that characterizes the consciousness of the inhabitants.

Picturesque architecture shades into landscape architecture. Leitmotifs of line (the inverted V's of eaves and evergreens, for example) and color (a palette of earth colors) are designed to link the house to landscapes either found or constructed, and plantings are designed to link the landscape to the house. The idea works microcosmically as well, allowing whole towns to be related to their environing landscapes.

1. *Rural Improvements.* For Andrew Jackson Downing, the most popular of many theorists and proponents of picturesque architecture and landscape architecture, visual literacy and the reform of the rural landscape are aspects of the same project. Like the essays of Emerson and Poe, Downing's writings are emphatic expressions of the Second Great Awakening, that ubiquitous trope of social and cultural as well as moral reform. The voice of his *Rural Essays* is jeremaic, repeatedly denouncing the "sins" of American culture and pointing the way toward millennium to be achieved by picturesque art. "I wish," he declares in his first book, "to awaken a quicker sense of the grace, the elegance, or the picturesqueness of fine forms that are capable of being produced . . . by Rural Architecture and Landscape Gardening—a sense which will not only refine and elevate the mind, but open to it new and infinite sources of delight." [15]

2. *Urban Reformations.* Urban versions of the American picturesque offer means of both visualizing symptoms of disorder and making the built environment of the city more efficient and healthy, more just, and more beautiful. Literature and the visual arts (painting, print-making, and eventually photography) are enlisted into the service of changing hearts and minds about the way things are. Landscape architecture generates designs for parks, cemeteries, asylums, campuses, streets, yards, whole suburbs as well as central business districts. Architecture generates designs for civic buildings (cathedrals, city halls, schools, and asylums), commercial buildings (department stores, hotels, early skyscrapers), and residences (town houses, apartments, tenements, three-deckers). Inside these residences, the picturesque is both a principle of decoration and an iconography of images reiterated in etchings, lithographs, and other mass-produced images; in needlework, on fans, china, clocks, mirrors, wallpaper, window shades. In the picturesque city, spaces as apparently diverse as, say, Fifth Avenue, the interior of A. T. Stewart's department store, the brownstones of Samuel Sloan, the urban parlors of Cornelia Randolph, and the urban parks of Frederick Law Olmsted become linked profoundly to each other, semiotically as well as structurally.

Essays in Visual Literacy: The Literature of Picturesque Theory

An oceanic literature of theory variously philosophical, critical, explanatory, and evangelical guides the diffusion of the American picturesque. From 1790 on, copies of formative English treatises on the picturesque—William Gilpin's *Three Essays,*

Observations on Cumberland and Westmorland, Remarks on Forest Scenery; Uvedale Price's *Essays on the Picturesque;* Humphry Repton's *Sketches and Hints on Landscape Gardening* and *Theory and Practice of Landscape Gardening;* J. C. Loudon's encyclopedias of picturesque architecture and landscape architecture—are republished, excerpted, or summarized.[16] Lectures such as Samuel Morse's on the affinities between painting and the other fine arts; verbal sketches such as Downing's "Montgomery Place"; essays such as Thomas Cole's on American scenery or Margaret Fuller's on art are published in newspapers or magazines and then again in book form. Whole magazines are devoted, in increasing numbers, to the picturesque arts: *The Ladies' Magazine of Literature, Fashion and the Fine Arts; Graham's American Monthly Magazine of Literature and Art; Union Magazine of Literature and Art; The Crayon; The Horticulturist,* which concentrates (especially during Downing's tenure as editor) on picturesque architecture and landscape architecture.

Between 1820 and 1860, one hundred and forty-five drawing instruction books appear, including John Hill's *Art of Drawing Landscapes,* Fessenden Nott Otis's *Easy Lessons in Landscape,* Maria Turner's *Young Ladies' Assistant in Drawing,* Fielding Lucas's *Progressive Drawing Book,* John Gadsby Chapman's *American Drawing-Book,* and the anonymously written *Picturesque Drawing Book.*[17] Critical readings of canonical and contemporary paintings appear in reviews like James Fenimore Cooper's of Cole's *Course of Empire* sequence; exhibition catalogues like Thomas Cole's for his *Voyage of Life* sequence; histories of the arts like Henry Tuckerman's *American Artist Life* and James Jackson Jarves's *Art Studies;* and dictionaries like Shearjashub Spooner's *Biographical and Critical Dictionary of Painters.* An equally voluminous literature of picturesque figuration includes instructions on representation of the human figure like John Rubens Smith's *Picturesque Anatomy;* studies of physiognomy and facial expression like Lavater's *Essays on Physiognomy,* Spurzheim's *Phrenology in Connexion with the Study of Physiognomy,* and LeBrun's *Heads Representing the Various Passions of the Soul* (all translations); essays about acting (*The Art of Acting*); essays about picturesque fashion (Horace Bushnell's "Aesthetics of Dress")[18] and picturesque costuming.[19] In etiquette manuals, the picturesque presides over the century's massive changes in dress, facial expression, and other aspects of the art of self-presentation.[20]

Architectural pattern books like Alexander Jackson Davis's *Rural Residences,* Andrew Jackson Downing's *Architecture of Country Houses,* Calvert Vaux's *Villas and Cottages,* Gervaise Wheeler's *Rural Homes,* and Samuel Sloan's *City and Suburban Architecture;* architectural histories like Louisa Tuthill's *History of Architecture* and Jacob Bigelow's *History of Mount Auburn;* and books on picturesque interior decoration like Cornelia Randolph's *Parlor Gardener,* Clarence Cook's *The House Beautiful,* and Charles Eastlake's *Hints on Household Taste* guide the application of picturesque values to a succession of nineteenth-century architectural styles; and equivalent offices are performed for landscape architecture by essays and books like André Parmentier's "Landscapes and Picturesque Gardens," Andrew Jackson Downing's *Treatise on the Theory and Practice of Landscape Gardening,* Henry W. Cleaveland and Samuel D. Backus's *Villages and Farm Cottages,* and Frank Scott's *Suburban Gardens.*

As interest in "picturesque excursions" rises, there appear in mounting numbers instructions in reading landscapes and cityscapes such as Thomas Cole's "Essay on American Scenery," Warren Burton's *Scenery-Showing*, guidebooks such as Clarence Cook's *Description of Central Park*, the anonymously written *Picturesque Pocket Companion and Visitor's Guide Through Mount Auburn* and the *Picturesque Itinerary of the Hudson River*, and M. G. van Rensselaer's "Picturesque New York." Essays and reviews of poetry and prose narrative attend routinely (if less systematically than Edgar Allan Poe) to literary "scene-painting" and "portraiture." Diaries and journals like those of Cole and Thoreau allow artists to explain picturesque values to themselves—or, in letters, to friends, patrons, editors—and then to experiment with them.

With urban institutions created for the display of art (museums and galleries, magazines) and a printing technology that evolves from woodcuts to engravings, chromolithographs, and graphic illustrations designed for mass production, the dissemination of visual images is equally massive. In a single three-month visit to Philadelphia in 1838, Maurice Bloch estimates, George Caleb Bingham had access to art instruction books, available from booksellers like Carey and Hart; to newspapers and journals full of writings on the picturesque; and to conversations with picture dealers, artists in their studios, and collectors. Landscapes and genre paintings attributed to Salvator Rosa, Ostade, and Teniers (all in the picturesque canon), along with recent paintings by Washington Allston, Benjamin West, Henry Inman, Charles Willson Peale, Charles Bird King, and Thomas Doughty, hung at The Pennsylvania Academy Annual of 1838. A sale Bingham might have attended featured paintings "said to be by Ostade, Teniers, Van Dyke, and Rubens; drawings attributed to Michelangelo, Rembrandt, Dürer; and prints after Claude, Teniers, Poussin." And paintings by John Gadsby Chapman (author of *American Drawing-Book*) hung at an exhibition by the Artist's Fund Society of Philadelphia.[21] If all of this was available in Philadelphia, consider what must have been available in a New York which by the 1830s was asserting its ascendancy as the preeminent American culture capital.

Who was the audience for this great wave of words and images? Clearly, it is meant to educate fledgling artists like Bingham, but it is also directed to the reading public at large. Its entrepreneurial and self-advertising functions notwithstanding, it has its idealistic side as well. Visual literacy (so goes the consensus) promises to increase the quality of private and of public life, to waken Americans to values beyond those of mere commodity and to the necessity, and the possibility, of inscribing these values into the built environments of house, street, town, and city. It is therefore a concomitant of citizenship in the new republic and a necessary condition of republican civilization.

Visual literacy becomes part of the scenario of self-fulfillment—a necessary condition of "the upbuilding of the single man" (in Emerson's phrase)—for like verbal literacy it both stimulates and satisfies "a healthful thirst for knowledge." It is a crucial means of affecting Euro-America's progress toward high civilization. Aesthetic knowledge and judgment (or taste), the principal signs of this progress, are made manifest both in "pictures and statues, stately domes and high achievements" (that is, in *belles lettres*) and in a populace educated to "that fine amalgam of perception,

feeling and intelligence called taste." At its most democratic, as one writer of an art-instruction book argues, taste is literacy: a means of apprehending the "expression" in things—their hidden "aspects and combinations" of meaning; things "as they really are"—"irrespective of use, association, or other secondary imparted value."[22]

The most beguiling vision of the project in visual literacy is that all work and all products of work can become works of art. Visual literacy would lead farmers to produce "straighter furrow[s]" and "a neater and better fence"; rural improvers to complete the reformation of the rural landscape; mechanics to produce more artfully designed craftwares and machines; and writers to produce a literature both better and more powerfully constructed for its visual coherences. Visually literate women, as feminists such as Catherine Beecher and Harriet Beecher Stowe foresee, would lead the vanguard in the struggle toward equality by reseeing and reconfiguring the American home.[23]

The picturesque offers a vision of cities, too, as works of art. Americans have the duty, James Jackson Jarves argues, to struggle unceasingly against "whatever deforms and debases" American life; to make it "as lovely as possible in manners, dress, and buildings; to adorn our homes, streets, and public places; in short, to infuse beauty by the aid of art into all objects."[24]

"Much beauty is beyond the reach of art; that within it, is the picturesque—visible beauty addressed to the eye."

—Thomas Lander quoting Guizot, *The Crayon* (June 1856)

[The sublime and the beautiful] often approach each other so as to lose their distinctive character.

—Samuel Morse, *Lectures on the Affinity of Painting with the Other Fine Arts* (1826)

The liberal, sympathetic, and discerning lover of truth in art, both in practice and criticism, will cherish and recognize an eclectic ideal.

—Henry Tuckerman, *Book of the Artists* (1867)

∞

THE SUBLIME, THE BEAUTIFUL, AND THE PICTURESQUE DISTINGUISHED

In eighteenth-century English theory, the boundaries between aesthetic categories are relatively clear and stable. For the most part, the beautiful, the sublime, and the picturesque are all distinguishable from one another.[1]

Neoclassically beautiful forms tend to be small (therefore endearing); smooth (like leaves, pond water, the polished surfaces of ornamental furniture or thoroughbred horses), but also subtly varied, their surfaces "continually changing" though without "protuberances"; delicate (like myrtle or jasmine or silk); and "clean and fair" rather than muddy of color, preferably "mild" in tint (light blue, light green) or, if "vivid," then also varied, like flowers or facial complexions. A dove, for example, is beautiful in all of these ways: it is small, "smooth and downy" in texture; a soft, variegated pearly gray in color; and its curves "melt into one another" continuously—no bumps, no breaks: "The head increases insensibly to the middle, from whence it lessens gradually until it mixes with the neck; the neck loses itself in a larger swell, which continues to the middle of the body, when the whole decreases again to the tail; the tail takes a new direction; but it soon varies its new course: it blends again with the other parts; and the line is perpetually changing, above,

Eclecticism and the Multiplication of Feelings in Forms

below, upon every side." Sculpted pools are beautiful; mountain lakes with their irregular shorelines are not. The faces of the young (and especially of young women) may be beautiful; the faces of the old are not.[2]

Neoclassical beauty is also definable by its effects on the perceiver. Beautiful forms are the source of the mildest, most pleasurable, most benevolent feelings: "delightful . . . repose," affection—a "mild and equal sunshine of the soul" that "makes the heart so dilate with happiness" that the viewer is "disposed to every act of kindness . . . to love and cherish all around him."[3]

Sublime forms, by contrast, are the source of the most powerful feelings, from horror and terror ("an apprehension of pain or death") to the more muted intensities of awe and admiration. The chief visible characteristic of sublimity—its "source" and "root"—is a *power* capable of destruction, such as that of storms, waterfalls, "a man or [an] . . . animal of prodigious strength," "kings or commanders." These provoke ideas of "strength, violence, pain and terror" in the mind of the viewer. *Obscurity* (as of night or mist) is sublime because it blurs or masks manifestations of power or vastness, intensifying their impact by withholding from sight "the full extent" of the danger they represent. *Definitionlessness*—as when the outlines of large forms or extensive spaces are obscured by shadow, or as in circles (rotundas, for example), whose curve has no end, or linear sequences "continued so long and in such a direction, as by their frequent impulse on the sense to impress the imagination with an idea of progress beyond their actual limits"—is sublime because it suggests infinity. *Vastness* (height or depth) produces an impression of superhuman scale and a similar impression emerges from contemplations of "the wonders of minuteness"—the particles composing matter, for example. *Privation* of the senses ("vacuity, darkness . . . silence") is sublime because it suggests a void and heightens the feeling of being alone in an empty universe; rudeness of aspect (as in Stonehenge) because it suggests obstacles overcome by strength. *Magnificence* is sublime because it is beauty too vast or too "rich" and "profuse" to be merely beautiful; like constellations or fireworks, it produces, in its "splendid confusion," "an appearance of infinity." For Burke, the Godhead is the exemplar of all of these sublime traits: almighty, omnipresent but obscure, infinite, magnificent. In its presence, "we shrink into the minuteness of our own nature, and are, in a manner, annihilated."[4]

Eighteenth-century versions of the picturesque, by contrast, typically place it in a middle ground between the sublime and the beautiful, for its visible qualities are by definition complex and eccentric. Picturesque lines are bent into varied and irregular curves—or, more violently, lopped physically or fragmented visually by intervening forms. Vibrating with energy, pushing and pulling with varying intensities at the surfaces they define, pushing out into the forms and spaces around them or pulling them in, like gravitational fields, picturesque lines seem constantly in motion. Picturesque textures are varied and forceful: undulant and otherwise slightly irregular surface textures, bordering on the beautiful, make the eye pleasurably "eager and hurrying" in its journey across them; broken textures "harass and distract" the eye and complicate the passage of light, creating effects of "rich" brilliancies alternating with the mysteriously opaque shadow.

For Uvedale Price, the "degree of difficulty" that picturesque lines and surfaces

present induces thought as well as feeling. A "certain irritation or stimulus" provokes the viewer's intellectual curiosity and evokes elusive ideas of "animation, spirit and variety." Hiding as much as they reveal, these lines and surfaces are indeterminately hieroglyphic. Regularly curved lines and soft textures—a down of turf, say, with "gentle swelling knolls and hillocks"—can be taken in at once by the eye and the mind. But "let those swelling knolls . . . be broken into abrupt rocky projections, with deep hollows and coves beneath the overhanging stones; instead of the smooth turf, let there be furze, heath, or fern, with open patches between, and fragments of the rock and large stones lying in irregular masses," then, Price argues, each cove, hollow, and break produces an opposition between "brilliant light" and "sudden shadow" that both invites and eludes the viewer's gaze. In such a field of energies, moreover, each step the viewer takes "changes the composition" of the scene.[5]

NINETEENTH-CENTURY FUSIONS: PICTURESQUE BEAUTY, PICTURESQUE SUBLIMITY

The spirit of eclecticism, one of the three defining features of nineteenth-century versions of the picturesque, blurs these aesthetic distinctions in American versions of the picturesque. The English theorist William Gilpin initiates the process by telescoping the picturesque and the beautiful. For him, the picturesque is a kind of beauty with its surfaces roughed up, its effects invigorated. "Complex forms" mix picturesque with classical beauty, either simultaneously or sequentially, over time. At rest, the human body, for example, is beautifully balanced and proportioned in its parts, but its lines are "infinitely varied," and so its lights and shadows are "exquisitely tender in some parts, and yet . . . round, and bold in others." When the body is "agitated by passion, its muscles swoln by strong exertion," however, it loses its classical symmetries. Its limbs become picturesquely asymmetrical and its *smooth surface ruffled.*"[6]

"Indissoluble Chain[s]" of Picturesque Effect in Nature

Following Gilpin, nineteenth-century American students of the picturesque renegotiate, bend, traverse, and eventually erase the boundaries between picturesque beauty and sublimity. In the process, they extend and complicate exponentially the notion of picturesque effect. Both nature and art become picturesque, in part, by virtue of their eclecticism.

Few natural forms, Samuel Morse argues in his *Lectures on the Affinity of Painting with the Other Fine Arts* (1826), produce an "unmixed emotion," and in many, the sublime and the beautiful "approach each other so as to lose their distinctive character." Simultaneously or over time, these forms inspire a variety of mixed feelings, ranging from cheerfulness to melancholy, and even to terror. The feelings produced by water, Morse quotes the English gardener Thomas Whately, are, for example, " 'so various . . . that there is scarcely an [emotional] impression which it cannot enforce.' " "A deep stagnated pool dank and dark with shades [that] it dimly reflects"; a dull, torpid river sunk between its banks like a hollow eye: these are the very "seat[s]" of melancholy, gathering a gloom that neither art nor sunlight can dissipate. Moving water, however, quickens effect. "A gently murmuring rill, clear and

shallow . . . just dimpling," induces not melancholy but a silence that "suits with solitude and leads to meditation." A current that "wantons in little eddies, over a bright sandy bottom, or babbles among pebbles, spreads cheerfulness all around." Faster motions mix picturesque and sublime effects. Moderate agitation "animate[s]"; high velocity and turbulence—"the roar and rage of the torrent, its force, its violence, its impetuosity"—terrify.[7]

Like water, Americans begin to argue in the 1830s, virtually all natural forms are in some degree eclectic and thus picturesquely complex and various in shape and effect. For Edgar Allan Poe, beauty and sublimity typically exist in a "compound." "'[T]here is no exquisite beauty,'" the narrator of "Ligeia" declares (quoting Francis Bacon), "'without some strangeness in its proportion'"—or without some sublime "monstrosity" of color or light, such as the red light that colors so many of Poe's interiors or the orange and purple sunset and its green reflections in "Landor's Cottage." All beauty has its deformations and, conversely, nothing is ugly or unrelievedly grotesque: "Even the corpse," Emerson declares, "has its own beauty." Things are beautiful or sublime only because beauty or sublimity dominate, but the domination is by no means absolute: forms change character over time and in varying circumstances. The fine foliage and simple form of the young oak, Andrew Jackson Downing observes, are beautiful, its bark picturesquely textured. The mature oak takes on a sublime grandeur and majesty in its size, strength, and longevity; its trunk is furrowed and patched, in places, with moss; its outline has a "singular freedom and boldness," and the lights and shadows "reflected and embosomed in its foliage" have a complex "breadth" of effect. Its limbs are massive, buttresslike, and also intricate; and its leaves are beautifully lobed, smooth, a pale green on top with glaucous undersides.[8]

Sublime nature is likewise an eclectic mixture of effects. In the "tempestuous yet sternly beautiful night" in Poe's "House of Usher," elements of beauty make sublimity not only more interesting but also more expressive of the complexities of the world. To the same end, the scale and power of icebergs, as of Frederic Church's iceberg paintings (see Fig. 54), Henry Tuckerman argues, are complicated by textures the color and consistency (variously) of "alabaster, rock-crystal, emerald, topaz, amethyst, and every gem on earth"; and by shapes evoking "cathedral, obelisk, shrine, domes, pilasters, arches," as well as "crags and cliffs. . . ." If the force and immensity of an iceberg terrify, these "picturesque agencies" delight. In the mountains of the American Northeast, Cole declares in his "Essay on American Scenery" (1835), beauty and sublimity are also picturesquely bound together in ways that make them distinctively American. Unlike the Alps, the Catskills have "varied, undulating, and exceedingly beautiful outlines—they heave from the valley of the Hudson like the subsiding billows of the ocean after a storm," and in the fall their forest-crowned summits turn beautifully "riant" with color. The White Mountains are "the sublime melting into the beautiful, the savage tempered by the magnificent." "[T]he bare peaks of granite, broken and desolate, cradle the clouds; while the vallies [*sic*] and broad bases of the mountains rest under the shadow of noble and varied forests; . . . nature has . . . no where so completely married together grandeur and loveliness." Niagara Falls binds the sublime and the beautiful into "an indissoluble chain."[9] "In

its volume we conceive immensity; in its course, everlasting duration; in its impetuosity, uncontrollable power. There are the elements of its sublimity. Its beauty is garlanded around in the varied hues of the water, in the spray that ascends the sky, and in that unrivalled bow which forms a complete cincture round the unresting floods."

The natural world, Americans agree, is as multifarious in time as it is in space. Subject to flux and change, forms and landscapes subject the viewer, in turn, to the anxieties and intellectual provocations of complexity. Every form has to be sounded, every landscape examined in light of their changeful multiplicities of aspect and the multiplicities of feeling they inspire, form and consciousness interpenetrating.

"A Flexible Resourcefulness": The Picturesque Canon

If nature is picturesque, so too, by definition, are the paintings referred to by the very term "picturesque." Although it grows, changes, and is regularly reinterpreted between 1720 and 1890, the picturesque canon includes the paintings of Italian, Dutch, British, and French masters from the sixteenth to the nineteenth centuries; the poetry of Horace, Virgil, James Thomson, William Wordsworth, and dozens of lesser late classical, Augustan, and Romantic poets committed to principles of *ut pictura poesis;* the pictorialized prose narratives of Walter Scott and the Gothic novelists; houses from post-Reformation through nineteenth-century England; eighteenth- and early nineteenth-century English landscape architecture, including the work of Thomas Whately, William Chambers, Humphry Repton, and J. C. Loudon; and such actual landscapes as the Campagna and the Apennines, the Bay of Naples, and the Italian and English Lake Districts.[10] The combined technologies of print and visual reproduction make the canon accessible even to nontravelers like Poe, Thoreau, and Rebecca Harding Davis.[11]

The canonical painters, Americans agree, exemplify the eclectic spirit of the picturesque. They complicate effect at every level. Salvator Rosa's baroque pictures of the Apennines, so goes the consensus until about 1850, virtually define the repertoire of sublime images, representing "all that is lonely and fearful" in mountains: cliffs and splintered rock; dark, wind-bent forests; the lightning-scorched hulks of oak and chestnut trees; water in all of its most tumultuous forms (boiling creeks, the hurtle of falls); chiaroscuros of brilliant light and black darkness (Color Plate XI). Nevertheless, Salvator's sublimity is (picturesquely) mediated by an exhilaration typical of the more vigorous kinds of beauty. Filled with that exhilaration, his mountain bandits dance. Even the sublimely "giant-limbed" figures of Michelangelo's *The Last Judgment*—"one of the most extraordinary blendings of the grand and monstrous in art," as Cooper declared—are imbued as well with a "stony, unmoved calmness."[12]

Raphael's figures, exemplars of the beautiful in form and spirit alike, are nevertheless endowed, James Jackson Jarves argues, with a "matchless variety" of effects. Raphael gives the body of his *Madonna del Sisto,* for example, a powerful physical beauty ("brilliant" olive-colored eyes, black eyebrows), a complexion "fair as wheat."[13] Her dress and gestures, Jarves argues, bespeak the spare, beautiful simplicity of her speech. In her face, Raphael overlays an expression of gentleness and purity with the sublime "intellect, power, and fortitude" of a poet and prophet. "'[T]here she stands—the transfigured woman, at once completely human and

completely divine, an abstraction of power, purity, and love . . . looking out, with . . . her slightly dilated, sibylline eyes, quite through the universe, to the end and consummation of all things." She looks "as if she beheld afar off the visionary sword that was to reach her heart through HIM, now resting enthroned in that heart, yet already exalted through the homage of the redeemed generations who were to salute her Blessed.' " [14]

The beauty of Claude Lorrain's landscapes is likewise complicated by elements of sublimity. The Claudian vista, which William Gilpin defines as the *sine qua non* of the picturesque landscape, typically recedes from the richly picturesque deformations of the foreground through the idyllic beauty of the middle ground to the muted sublimities of distant mountain and sky (Color Plate x). Claude's light is varied as well: now taking on a brilliance that, approaching sublimity, makes forms vibrate with local highlights; now softening into *sfumato,* the golden haze (evident in Italian nature as in Italian painting) that wraps everything in its idealizing repose—*il riposo di Claudio*—makes distances "gradually [melt] into infinity." Claude's (and Italy's) magical light, Jarves notes, also varies with the time of day: "golden and purple" at sunrise and sunset; a silvery, "quivering stillness" at noon. Contrasts like that of a dark mass of trees set against a bright sky, Morse adds, constitute "the passage of *discord* which gives vivacity to the whole." [15]

Between such picturesque complications of sublimity or beauty lie painters like Titian, who create neither "an impression of power as with [Angelo], nor of beauty as with [Raphael], but . . . power and beauty equipoised" in a balance of contrasts—for every curve a jagged slash, for every darkness a brightness. In his most picturesquely beautiful landscapes and figures, he juxtaposes his most radiant colors—"white linen, skies, sunny architecture, flesh, rosy [or] salmon-colored draperies"—against "intense darks": "black and brown hair, armor, purple and black dresses." Titian's beauty is irradiated with an anxious repose, a dark exhilaration. [16]

As in nature, art expresses a sense of play—play of form and structure, play of light, play of meaning—requiring of the viewer's gaze "a flexible resourcefulness" that makes it "[a]lert to novel possibilities and constantly alive." [17]

Picturesque Beauty

Given warrant by nature and the canon, Americans after 1830 redefine the very taxonomies of beauty and sublimity in picturesque terms. Like its baroque predecessor, "picturesque beauty" is a beauty with its surfaces roughed up and its effects intensified. It is by definition various, Morse argues, both in its sources (it may arise "from a particular arrangement which accords with our ideas of order, from utility, from variety, from a certain proportion, from association, or from all these sources together") and in its manifestations ("there is a beauty of form, of color, of contrast, of variety, etc., all which may exist separately or combined"). [18] There are various cultural and regional constructions of the beautiful as well. Gothic, Italianate, Rhinish, Near Eastern, and Japanese styles of architecture are all picturesquely beautiful, as are the landscapes, natural and constructed, of Greece, Rome, China, the Alps, the Rockies, the tropics. [19]

Picturesque beauty both suggests and eludes coherence, its forms made mysteri-

ous and unfamiliar by subtle amalgams of feeling and meaning. Elements of comic incongruity (as in Poe's "Morella") make it grotesque; elements of sublimity (as in a sunset), exhilarating; elements of pathos (as in the climactic scenes of *The Pearl of Orr's Island*), sentimental. Mixed with neoclassical beauty (as in the Central Park Mall), it acquires an elegant "polish" and "finish." Mixed with the strangeness of the tropics, as in the valley of Louisiana in Poe's "Morning on the Wissahiccon," it becomes voluptuously disturbing. The "gentle undulations" of this landscape and the surreal clarity of the valley's "crystallic streams" are imbued with an "interwreathed" multiplicity of effects by "flowery slopes" and a "gigantic, glossy, multi-colored" jungle foliage that is "sparkling with gay birds and burthened with perfume." The effect is strangely otherworldly and at the same time erotic.[20] To complicate matters, it turns out to be something other than it seems.

Two strategies of construction, American students of the picturesque agree, give such intricate effects their order and coherence. Conceiving of the picturesque as a unity-in-variety, one strategy establishes a hierarchy among the effects. It identifies a dominant affect (the one most often repeated) and subordinates the others. For Samuel Morse, beauty, for example, is intensified by repetition: "the more the qualities are multiplied, the greater will be the sum of beauty, and the more its lasting effects."[21]

The other strategy emphasizes differences, and representation gravitates toward the discontinuities of the *assemblage*. The face of Poe's Ligeia, for example, is a powerful concatenation of "antique" effects, each beautiful in a powerfully distinctive way. Her raven-black hair is Homerically "hyacinthine"; her chin has "the gentleness of breadth, the softness and the majesty, the fullness and the spirituality, of the Greek"; but her nose is "Hebrew" in its aquiline shape, its "luxurious smoothness of surface," and its "harmoniously curved nostrils" that "[speak] the free spirit." Her distinctive eyes are "fuller than the fullest of the gazelle eyes of the tribe of the valley of Nourjahad." Unity here becomes a more elusive and implicit affair than that defined by reiteration. Every detail is complicated by discord. Like the apartment in Poe's "The Assignation," the beauty of Ligeia "dazzle[s] and astound[s]" by its disregard for proprieties. Synthesis is possible only conceptually.[22]

Picturesque Sublimity

Infused with picturesque values, the sublime, too, turns polymorphic and polymodal. Between the Revolution and the 1830s, it had been pronouncedly Burkean and Gothic—the visible demonstration of supernatural being or (as in Cooper's *Last of the Mohicans*) of secular forces with equivalent effects. Set in a dark, tumultuous environment of waterfalls, caves, forests, and mountain cliffs, whose sublimities are intensified by an atmosphere of deception and surprise, the novel's harrowing episodes evoke a forest world for which warfare becomes a heuristic metaphor.

Burkean and Gothic sublimity do not disappear after 1840—witness Melville's *Moby-Dick* and Clarence King's *Mountaineering in the High Sierras*. But incorporating the picturesque ideology of multiplicity and change, it is complicated, like Church's *Icebergs* (see Fig. 54), by "picturesque agencies." Its terrors are mixed with delight.

That limits the range of terror, of course. But if eclecticism limits, it also paradoxically restores, a measure of power to a sublimity weakened by banality and overuse. The anonymous poem "Lines Written at Niagara" (1807) typifies the sentimentality to which the sublime had been reduced by the first quarter of the nineteenth century:

> Whate'er I've been told of thy wonders is true!
> All nature at once seems to rush on my view.
> And, lost in the trance you occasion, I cry,
> How stupendous the scene! what an atom am I!

This poem's true subject is not Niagara Falls (the "you") but the trance produced by its sublimity. The poem reduces it to what nineteenth-century Americans called a gush of "touzy-mouzy" (rapturous dizziness) without evident cause and therefore without motivation.[23]

Touzy-mouzy is one reason for the decline of the sublime in the early nineteenth century. The "monotony"—the character of monotonality—of the sublime, as Cooper suggests, is another. When the brief rush of astonishment recedes, Alpine sublimities become boring for their sameness.

Reification, as Margaret Fuller suggests, is yet a third reason. In her representation of Niagara Falls in *Summer on the Lakes* (1844), the touristic literature of the falls has eclipsed the experience of the falls themselves. For their "magnificence" and "sublimity," she reports, she was too well prepared "by descriptions and by paintings." Expecting to be overwhelmed by "unlimited wonder and awe," she finds herself reduced to comparing her experience, even as she experiences it, "with what I had read and heard." After her reading, the reality is an anticlimax.[24]

Like the painters of the period,[25] she searches for a new perspective, a new light, worrying all the while that she will be "most moved in the wrong place." Yet in this, too, she discovers, she has been anticipated. Ironically, her experience of Niagaran sublimity occurs only after she stops looking for one—only when she starts to see in picturesque terms. The views from the bridge and from Terrapin Tower under a full moon, she observes in a carefully visualized sketch, are "grand, and . . . also gorgeous." In the moonlight, everything visible tends "to harmonize with the natural grandeur" of the scene. Shadow gives to most of the falls a "poetised indefiniteness" and reduces the river below to a blackness relieved only by reflecting the color of "blue steel." "Moonlight picks out a bow of silvery white" atop the column of mist and a part of the falls in the foreground—images of delicacy and power juxtaposed. No distractions undercut these effects: no guidebook descriptions, no "gaping tourists . . . eyeing with their glasses, or sketching on cards the hoary locks of the ancient river god." She is able to experience here in its full force the falls' complex union of "mutability and unchangeableness."

1. *Wilderness Sublimities.* Fuller's sketch is typical of what happens to natural sublimity in American literature after 1830. An infusion of the picturesque restores to it a pictorial syntax absent from "Lines Written at Niagara" and at the same time com-

plicates its effects. Even where Burkean sublimity is given full rein in a particular sketch, other effects prevail in sketches that precede or follow it.

This is a behavior particularly evident in the literature of wilderness excursions. In *Mountaineering in the Sierra Nevada* (1871), for example, Clarence King sketches Mount Tyndall as a sublime assemblage of "broken sky-line, battlemented and adorned with innumerable rough-hewn spires and pinnacles"; "overhanging precipices that sank two thousand feet into the Kings Can[y]on"; the sound of waterfalls; a "cold ghastly shade" in the foreground and a "deep impenetrable gloom" rising in the gorge "with vapor-like stealth." Light and color, however, imbue the mountain with "strange but brilliant" effects that soften its "stern grandeur of granite and ice." Under a violet sky, the skyline glows an intense orange, and the mountain walls, their tops "dyed fiery orange," swim in a "warm purple haze." [26]

King's sketch of it, moreover, is followed by a scene of magical beauty and intimacy in which fields of alpine grass in view of the mountain become, from close up, soft and "fragrantly jewelled with flowers of fairy delicacy": "chalices of turquoise and amethyst, white stars, and fiery little globes of red." A glacial lake becomes a beryl-colored sheet of "lovely transparency" with a necklace of grass and flowers so charming—a pastoral bower in a picturesquely sublime mountainscape—that King pictures himself nestling into it. The deciduous forests of the Northeast, the prairie, the Rocky Mountains, and the Pacific slope; tropical and arctic landscapes; the canonized Old World landscapes of the Alps, the Apennines, the deserts of Egypt and the Holy Land—all come, like Mount Tyndall, to be rendered eclectically in American travel narratives after 1830, with varying visual configurations and varying effects, from the sublime to the ridiculous. [27]

In this literature, changing effects serve narrative ends as well. King's sketch sequence of Mount Tyndall reiterates national history as the era iconizes it: a history of male wanderings and trials among sublime circumstances (wilderness or war) in search of the virginal beauties and maternal fecundities of a hospitable landscape. [28] That is a narrative plotted in works as diverse as Asher Durand's painting *Progress* (see Fig. 56), Nathaniel Willis's *American Scenery,* and Francis Parkman's *France and England in North America.* In these picturesque narratives, the ideology of gender evident in the Burkean sublime (even, indeed, in Burke's formulation of it) becomes overt. The rigors and dangers of wilderness travel, the presence of unfriendly Indian tribes and of wild beasts, and the absence of acceptable accommodations make most of the Western wilderness a place "to which *ladies* can have [no] access." [29] Both the landscapes and the plots they orchestrate are held out as "a gentleman's preserve." [30]

The construct of picturesque sublimity, fortunately, is not so exclusive. As Miriam Davis Colt's *Went to Kansas* and Caroline Kirkland's *New Home, or Life in the Clearings* powerfully demonstrate, American women writers are able to construct, with picturesque conventions, an opposing and equally powerful wilderness narrative that begins with the disruption of a home, unfolds as a movement (with family) into wilderness, and ends with attempts to reconstruct the home in a new land. [31]

Picturesque sublimity, moreover, is as various in its meanings as in its visual effects and its moods. The religious vision inherent in Burkean sublimity persists, but gets

mixed with nationalist ideology—revelation eliding into manifest destiny. As Henry Tuckerman's *Book of the Artists* (1866) illustrates, the pursuit of the picturesque is in part a rhetorical screen for the imperial extension of American space. That has been demonstrated with notable clarity in recent monographs on Frederic Church and Albert Bierstadt.[32] That can also be argued of travel narratives, the novels of Cooper and Melville, and the monumental historical narratives of the Boston Brahmins.

2. *Urban Sublimities.* Picturesque sublimity appears, with its attendant visual syntax and semiotics, in representations of the American commercial city as well—an extension anticipated by Burke's interest in sublime architecture. The urban sublime is a manifestation of the energies, the scale, and the mysteries of modern social organization. The imagery of H. V. Sebron's *Broadway and Spring Street, New York* (see Fig. 61) is typical of urban topographical painting before the advent of the skyscraper—which is also viewed as sublime. It gravitates toward the central business district as the locus of sublimity, the perspective monumental commercial buildings accentuating their height as diagonal lines accentuate their power.[33] Situated between the uninhabitable whitenesses of a snowy street and a stormy sky, they are at once an expression of and a bulwark against the sublimities of nature. Wind unfurls the corporate flags, and the buildings seem to ride like ships through the darkening light and the snow. Purposeful human energies—a crowded omnibus, sleighs, a firetruck responding (it appears) to a billow of dark smoke rising from a roof—oppose and at the same time harmonize with natural energies: that is how the social environment of the city is defined here.

Here, too, urban sublimities are complicated by eclecticism. The architecture, most of it Italianate, is patently, and picturesquely, beautiful.[34] Snow and spots of metallic-catching light dramatize the eclectically varied ornaments on the building facades. Bustling workmen, businessmen, and *flâneurs* are dressed as if for a theatrical performance, in costumes that, like the set of the street, are more colorful than the theater of nature.[35] American versions of urban sublimity are by no means limited ideologically to Sebron's boosterism, but all are, like his, subject to picturesque complexity.

THE EXHALTATION OF BEAUTY, THE SUBORDINATION OF SUBLIMITY

Eclecticism makes art bold, elusive, capable of surprise, and supremely expressive of the dynamics of energy and change. Yet it also leaves conventional aesthetic categories, as it leaves traditional values, in disarray. With it, aesthetics becomes, almost, a homemade world. Invented to interpose some coherence, cumbersome taxonomies—the "historical sublime," the "architectural sublime," the "terrific sublime," the "pathetic sublime," the "transcendental sublime"[36]—become subject to slippage almost as soon as they are invented. Paradigms of beauty and sublimity multiply and oppose each other. Small wonder that the labyrinths of nineteenth-century eclecticism have as yet been so little explored![37]

By way of reconnaissance, it is useful, I think, to consider some of the most

influential permutations of picturesque beauty and sublimity between 1830 and about 1880, including the notions of "softened sublimity" and "the moral picturesque," in which aesthetic multiplicity gives way to hierarchies dominated by the beautiful. Sublimity is increasingly reduced to a subordinate role: that of adumbrating or even in limited ways opposing (like discords in music), but at the same time harmonizing with, picturesque beauty. In the paradigm of the moral picturesque, the energies of the sublime become more potential than kinetic: more evident in silence and stillness than in turmoil. Its mysteries turn quietistic.[38] The longer beauty remains dominant, the more bodiless and spiritualized it becomes—as if the articulation of a desire to withdraw from the shocks and uncertainties of the sensory world. In the second half of the century, in short, aesthetics turns genteel.

"A Softness That Lessens Harsh Features"

The idea of a "softened" sublimity—exemplified, for James Fenimore Cooper, in the Italian landscape—is an early expression of the impulse to subordinate sublimity. Where the idea of picturesque sublimity allows for the eruption of Burkean sublimities, that of softened sublimity requires the sublime to be congruent with the beautiful. Reduced to qualities that complement rather than oppose the beautiful, it becomes by definition muted and, like revelation, brief: evident mostly in flickers, fragments, hints. Its effects run from "magnificence" (as of sunsets) to "dignity" (as of old oaks) but do not include cataclysmic energies. It manifests itself in a monumental but not an apparently infinite scale (hills but not mountains, villas but not palaces); in the luminous obscurities of haze, but not the terrifying obscurities of thunderstorms or blizzards; in energies more often past or potential than kinetic, energies made evident in the deformations of surfaces by scars, cracks, stains. Awe, admiration, anxiety, sorrow (as Friedrich von Schiller argued[39]): that is the range of feelings it produces. Horror and terror appear infrequently at best and are veiled when they do appear.

Softened sublimity thus defines a world more benevolent, and more inhabitable, than Burke's. Cooper devises the term to describe the view, from the castle of St. Elmo, of Naples, the bay, and the cliffs rising up from it. Although the view has all the requisites of "a terrific bird's eye view," it is not terrifying. Time, the delicacies of Italian sunlight and *sfumato,* and architectural accessories ("palaces, villas, gardens, towers, castles, cities, villages, churches, convents, and hamlets" that "leave no point fit for the eye unoccupied, no picturesque site unimproved") all cast a "softness . . . around every natural object here" that "lessens all the harsher features" of Naples' sublime, volcanic landscape.[40]

This softened sublimity, Cooper observes, "reigns throughout the region." Light and atmosphere cast a "bewitching and almost indescribable softness" on the lines and clusters of fishing boats in a "picturesque sea," on the "union of sublime land and glorious water," and on architecture over which "history, from remote antiquity, had thrown its recollections and charms." These effects mellow every detail of form and color and blend "all the parts into one harmonious whole" in which there is a "total absence of anything unseemly or out of keeping."[41] Nowhere is this

eclectic ideal more strikingly evident than in Cooper's verbal sketch of Ischia from the water:

> Here a scene presented itself which more resembled a fairy picture than one of the realities of this everyday world of ours. . . . We had the black volcanic peaks of the island for a background, with the ravine-like valleys and mountain-faces, covered with country-houses, in front. . . . [A]fter passing a sort of bridge or terrace, which I took to be a public promenade, the rocks rose suddenly, and terminated in two or three lofty, fantastic, broken, fragment-like crags. . . . On these . . . were perched some old castles, so beautifully wild and picturesque, that they seemed there for no other purpose than to adorn the landscape.[42]

Closer to the foreground, strolling figures lend "a movement of life" to the scene. The light and the "refinements" of the architecture "give rise to a sublimity . . . which, though it does not awe, leaves behind it a tender sensation allied to that of love."

In no sense an idiosyncratic judgment, nor one to be dismissed as wishful bourgeois thinking (though eventually, perhaps, the notion degenerates into that), softened sublimity is a formulation reached deliberately and independently, it seems, by American artists as diverse as Emerson; Thoreau, with his well-known retreats from Burkean sublimity on Cape Cod and Mount Katchdin; Downing, for whom sublimity cannot be accommodated in a landscape garden; Poe after 1840;[43] the Fuller of *Summer on the Lakes;* Harriet Beecher Stowe; and Rebecca Harding Davis. It is a judgment reached in painting as well. In Cole's *Sunset in the Catskills* (see Fig. 16), typical of his landscapes from the late 1830s on, all forms are defined by the line of picturesque beauty: the irregular curve. The space is sublimely deep, but mostly because of the sunlit sky; the massed height of the mountains is mediated by distance, softened by late sunlight, autumn color, and *sfumato* into piles almost as insubstantial as clouds. The light is itself a softened sublimity, and so is the pervasive sense of stillness and silence. This is a description that applies equally well to luminist landscapes.[44]

As if in confirmation of this aesthetic change, students of the picturesque canon begin to argue by 1850 that the extremes of Burkean sublimity cannot be visualized and are therefore irrelevant to painting.[45] The sublimities that *can* be painted are the ones most readily harmonized with the beautiful or the ones that may even be called beautiful in themselves. Since the picturesque now "denotes any kind and every variety of beauty," Thomas Lander declares (quoting Guizot), it "may be applied with equal propriety to the subjects of Hobbema or Salvator Rosa." Even Michelangelo becomes, at his best, a painter of the beautiful. His explorations of sublime *terribilitas* and *horribilitas* are now seen to be strained, mannered, unnatural, even bizarre. The "sublimely appalling" and transcendently beautiful *Last Judgment,* Jarves argues, is a failed attempt to represent a spectacle of "mortality finished and immortality begun."

The effete earth, its expired civilization, gaping graves, and wild drift of human souls [rise] in continuous vast clouds . . . [;] above, the rainbow hues, [the "flood of light"], sparkling gems, and golden gates . . . tell of Paradise, its sealed multitudes in their bright garments of redemption[; below,] . . . the lurid glow . . . from the quenchless flames of the bottomless pit . . . quivers on the agonized looks of those whose eternal day and night it is about to be; gloating, impatient Satan count[s] his prey, and his loathsome crew anticipate their spoils; . . . mountains falling, oceans drying up, sin-laden nature disappearing forever in the abyss.

The attempt fails because these events cannot be visualized persuasively. Michelangelo's reputation is assured not by *The Last Judgment*, Jarves concludes, but by the pictures on the ceiling of the Sistine Chapel. Those are imbued with "a significant sublimity" that is subordinated to a beautiful "purity and freshness of idea and expression." The aesthetic hierarchy produces a "broad unity . . . as perfect as its solemn repose."[46]

Maimed Virtue: "The Moral Picturesque"

In the paradigm of the moral picturesque, the values of beauty and sublimity are extended to the immaterial phenomena—moral and intellectual character—that work behind and express themselves through the visible mask of the body. Moral picturesqueness is "the mark God sets on virtue": a state of virtuous (or vicious) feeling made manifest in facial expressions and body language, even in tones of voice. Its presence elicits love or sympathy or respect from viewers even before they understand what they are seeing.[47]

What makes this picturesque, Nathaniel Hawthorne suggests, is that beauties of virtuous feeling are typically complicated, even made grotesque (human nature being flawed), by physical or moral deformations. It is a beauty therefore incomplete and complicated but not yet overcome by imperfection. A man of "a depressed, neglected air, a soft simple-looking fellow with an anxious expression," Hawthorne observes in a tavern in the Berkshires, asks the people there about his missing wife, a prostitute. The crowd ridicules him. His moral picturesqueness emerges in the tones of his voice as he responds, vulnerably, feelingly, if also a little self-righteously, "A man generally places some little dependence on his wife, . . . whether she's good or bad." It is a beautiful gesture complicated by his "depressed, neglected air"—an expression (the sketch suggests) of his sense of the hopelessness of his love—and the gesture is made the more intensely picturesque by the contrasts between his feeling and the crowd's emotional hardness. He is a man, Hawthorne concludes, "moved as deeply as his nature would admit, in the midst of [the] hardened [hearts of the] gibing spectators."[48] In another case, that of the crippled Lawyer Giles (model for a character in "Ethan Brand"), liquor has erased the signs of his having been a gentleman and has made him an "elderly ragamuffin" in "soiled shirt sleeves and tow-cloth trousers"; a "filthy and disgusting" figure of a man. He has also been grotesquely "used up" by his physical labors. An ax has chopped off part of a foot and a steam

engine torn off a hand. But if he is (in several ways) ruined, he has not succumbed to ruin. If there is "something wild, and ruined, and desperate in his talk," there are also intermittent signs of an acute intellect, "something of elevation in his expression . . . and a sort of courtesy in his manner." In "Ethan Brand," the omniscient narrator detects in him "the courage and spirit" of a maimed warrior still fighting "a stern battle against want and hostile circumstances," who wants no charity. That, too, is the moral picturesque.[49]

Nonhuman forms are also given a moral character that asserts itself, picturesquely, as a kind of "nevertheless" against the imperfections, the scars, the eventual ruin of material existence. In John Ruskin's formulation of the idea, enormously influential in the United States, such forms become "nobly" picturesque by virtue of some "pathos of character," some beauty that appears in signs of suffering "nobly endured" and complicates the expressions of "*suffering*, of *poverty*, or *decay*." In human figures, this might be a conscious will to endure, but it need not be so. "[T]he picturesqueness," Ruskin argues, "is in the unconscious suffering,—the unconscious confession of the facts of distress and decay . . . ; the world's hard work being gone through all the while, and no pity asked for, nor contempt feared."[50]

Silent Energy and a Spirit of Repose: The Metaphysical Picturesque

As sublimity enters the picture, moral shades into metaphysical picturesque. Typically, this version of the picturesque includes what Barbara Novak calls a quietist sublimity—by definition softened, "subdued," "tender," even "exquisite," but filled with intimations of divine presence.[51] The metaphysical picturesque endows the viewer with an ultimately mystical power of insight. Attached to visible qualities (its signifiers), invisible except in its effects, it requires of viewer (and reader) at once an emotional openness and a mind capable of bringing to bear all of its own manifold faculties—of being, as Emerson puts it, where and what it sees. Moods of awe, wonder or pathos (the emotional signifiers of sublimity), are also its signifiers, and these too are conditions of epiphanic insight.

Serenely beautiful landscapes are the most typical manifestations of the metaphysical picturesque. In Lakes Ammonoosuc and Pemigewasset in Franconia Notch, Cole thus observes (Novak observing him), the water has the beautiful "purity and transparency" typical of the American wilderness, and so does the air. Yet its sublimely mountainous circumstances, superimposed (literally reflected) on its tranquil surface, imbue it with sublimity as well. Sublimity is cocooned in beauty; and beauty is made resonant, even "stirring," by an absent presence, voiceless, invisible, but felt.[52]

> Shut in by stupendous mountains which rest on crags that tower more than a thousand feet above the water, whose rugged brows and shadowy breaks are clothed by dark and tangled woods, they have such an aspect of deep seclusion, of utter and unbroken solitude, that, when standing on their brink a lonely traveller, I was overwhelmed with an emotion of the sublime, such as I have rarely felt. It was not that the jagged precipices were lofty, that the encircling woods were of the dimmest shade, or that the waters were pro-

foundly deep; but that, over all, rocks, woods, and water, brooded the spirit of repose, and the silent energy of nature stirred the soul to its inmost depths.

The metaphysical picturesque lends itself with particular force to the artistic visions of nineteenth-century women's narratives. In *The Minister's Wooing* (1869), Harriet Beecher Stowe, re-visioning New England history from a feminist perspective,[53] focuses on a moment of crucial theological and social change: the beginning of the liberalization of Calvinist New England around 1800. This she visualizes in an allegory in which the sublime imagination of Calvinism is gradually tempered by the metaphysical picturesqueness of the liberal Protestant imagination. The allegory begins with yet another critique of the limits of "pure" sublimity. Calvinism, Stowe suggests, is the theological equivalent of Burkean sublimity: an "energetic, original" map of the infinite. Its views of human life are, like natural sublimities, "gloomy enough to oppress any heart" and disturbing enough to create in its followers a "vast sea" of thought and feeling that surges "from depths to heights." Puritan discourse is the expression of this worldview. The "dread words" of Puritan sermons evoke the "terrible power" of Calvinist doctrine. Doctrine and discourse together engender "paroxysms of opposition to God and fierce rebellion . . . followed, at length, by mysterious elevations of faith and reactions of confiding love."[54]

Energy, force of conviction, acuteness and sympathy of vision: these are the fruits of Calvinism, but from Stowe's perspective they are exclusionary and therefore not wholly just—a "slow poison" that stunts and sickens minds that are not robust. "[W]hile strong spirits walked, palm-crowned, with victorious hymns, along these sublime paths, feebler and more sensitive ones lay along the track, bleeding away in life-long despair. Fearful to them were the shadows that lay over the cradle and the grave. The mother clasped her babe to her bosom, and looked with shuddering to the awful coming trial of free agency, with its terrible responsibilities and risks." This "awful dread" and gloom victimized Calvinist women with particularly cruel intensity, freezing their minds with "glacial reasonings in regions . . . where spiritual intuitions are as necessary as wings to birds." Stowe reiterates this Alpine trope when she has Madame de Frontignac (a character with the French gift of "appreciation, which seizes at once the picturesque side of every condition of life") call the Puritan mind "sublime, but a little *glaciale*—like the Alps."[55]

In the novel, the sublimities of Calvinism are mediated on manifold levels and in manifold ways. For one thing, Stowe visualizes the more Christ-centered and enthusiastic theology displacing Calvinism in terms of its psychological consequences. The heart of Mary Scudder, prophet and galvanizer of the change, begins to color the doctrine-chilled spaces of her mind with its "warm life-tint," and her Calvinist "map of the Infinite" is displaced by a gallery of sacred (Raphaelesque) pictures in which theology "[falls] away." "The sublimity of disinterested benevolence,—the harmony and order of a system tending in its final results to infinite happiness,—the goodness of God,—the love of a self-sacrificing Redeemer,—were all so many glorious pictures, which she revolved in her mind with small care for their logical relations." This is a transformation whose effects could not be imaged without the discourse of the moral and the metaphysical picturesque.

At its best, eclecticism in all of these nineteenth-century manifestations tempers the theatrical extremes of sublimity with the perceived multiplicity and complexity of forms, human figures, and scenes, as the sublime, in turn, charges even common objects with a sense of mystery. Beauty is discovered in "the near, the low, the common"; in forms not yet completed, in forms dissolved by age or deformed by violence; in the elusive harmonies between forms apparently unlike. For American versions of the picturesque, eclecticism defines a world in which nothing is purely beautiful or purely sublime, but also a world in which nothing is without a measure of beauty and sublimity, however impure or incomplete or transient.

Among the works of creation [man] observes . . . contrast in its varied applications pervading every thing.

—Samuel F. B. Morse, *Lectures on the Affinity of Painting with the Other Fine Arts* (1826)

The ancients probably felt no wrong in esteeming the mountain a purple picture whereon Oreads might appear as rightly as moss; because they believed the gods built it & were not far off, & so every tree & flower & chip of stone had a religious lustre, & might mean anything.

—Emerson, *Journals and Miscellaneous Notebooks*

෨

Reading Forms

SYMBOLISM IN
PICTURESQUE EFFECT

When their effects are only felt, Emerson declares, picturesque forms become mere "show"—spectacle, "tinsel." They must be imbued with symbolic effect, with "expression" that engages the intelligence as well.[1] Idealism, the second defining feature of nineteenth-century versions of the picturesque, does for symbolic effect what eclecticism does for mood. It imparts an invigorating complexity of meaning.

With this complication of effect, polymodal becomes polysemous. Meanings, multiplying, elaborate or contend with one another. Designed, like the forms they modify, to flow and not to freeze, meanings unfold, shift, and flow into one another, change as time passes, as light and visual perspective change, as ideological perspectives change. Forms and images of forms convey their meanings implicitly: by hints, whispers, glimmers. It becomes as difficult, and as necessary, to establish persuasive readings of them as it is of scripture, whose exegetical tradition constitutes one model of interpretation.[2] But even persuasive readings cannot be definitive.[3]

SIGNIFYING OPPOSITIONS

It is even difficult to see *how* forms (and images) mean. American versions of the picturesque include any of several distinct but related semiotic models. In what I would call the model of signifying oppositions, the simplest of the three, meaning

emerges from the breaks created in picturesque forms by variations or contrasts, as, for example, where a smooth surface begins to fold or fracture or light gradates into shadow. Breaks are dialogical "evidences of nature struggling with opposing forces."[4]

Beauty and Sublimity

In the model of signifying oppositions, eclectic amalgams of beauty and sublimity become signs of tensions between harmony and an energy that may be spirited, discordant, disturbed, even violent. The ruined Temple of Jupiter Olympus, Downing argues, is a model of classical beauty reduced by "the violence of time" and weather to "only a few columns and broken architraves" stripped of their "exquisite mouldings," but still bearing traces of its beauty. The clothes of Murillo's beggar boys are also ruined, but the boys' demeanor suggests "a certain irregular struggling of a better feeling" against the violence of poverty.[5]

Signifying oppositions between beauty and sublimity are evident, on a grander scale, in Nathaniel Willis's popular sketch of the Niagara River, where the smoothly flowing river suddenly becomes "infuriated" as it approaches the Falls: "The rocks, whose soaring points show above the surface, seem tormented with some supernatural agony, and fling off the wild and hurried waters, as if with the force of a giant's arm. Nearer the plunge of the Fall, the Rapids become still more agitated; and it is almost impossible for the spectator to rid himself of the idea that they are conscious of the abyss to which they are hurrying, and struggle back in the very extremity of horror."[6] As eclecticism spreads, so do the meanings ascribable to the tensions and complexities of picturesque forms.

Naturalism and Classicism

Breaks also produce tensions between geometry and organicism. Organicism without geometry is disorderly, even illegible; geometry without organicism is "naked" and cold. The geometries may be concealed, but their presence is crucial, for the eye, argues John Gadsby Chapman, can calibrate picturesque irregularities only by their "variation . . . from a right line." The ideal picturesque form balances the geometries of the triangle or the circle against the organicism of the irregular curve. Thus the oak's crown is a globe full of openings and hollows. Sprays jut out from it or retreat into its interior, and there are deep shadows and brilliant highlights—but it is a globe nonetheless. That balance is the aim of picturesque composition as well. Triangular groupings of figures are typical even in the wildest of genre paintings, as roughly triangular groupings of trees are in the wildest of garden scenery. Wildness, too, is defined by the character of its resistance to an inherent geometry.[7]

American observers frequently define this relationship as an opposition between classical and naturalistic values. In the picturesque house, for example, the classical ideals of proportion and symmetry (the "balance of opposite parts") are complicated by variously shaped "parts, projections, recesses, towers" that make the symmetries more interesting.[8]

The same principle applies to architectural interiors as well. In Harriet Beecher Stowe's *The Pearl of Orr's Island,* Mara Lincoln decorates the geometries of her

eighteenth-century neoclassical bedroom with seashells and forest greenery and with arts also given to organic curves. A chaste white bedspread is embroidered with a "knotted tracery." Over the bed hangs a still life representing, in crimson and white, the living traceries of trillium. A book-table is similarly draped with "a long strip of curious and delicate embroidery," and over *it* hangs a looking glass embroidered with "long, drooping festoons of that gray moss which hangs in . . . graceful wreaths from the boughs of pines in the deep forest shadows of Orr's Island." On a third altar to the picturesque, that of the fireplace mantel, stand Indian vases filled with crowfoot, anemone, liverwort, and other spring wildflowers, and over them hangs a painting of the Bay of Genoa, a canonical picturesque landscape, whose "curiously wrought" frame Mara has decorated with moss and seashells. Mara's mind as well as her room show the effects of what Stowe calls elsewhere Romantic "raid[s]" on the "frigid simplicity" of New England Calvinism. The picturesque does not displace these values; it worries them as a jazz musician might worry a line.[9]

Form and Deformation

Analogous tensions exist between perfection and disorder in picturesque forms: between form and deformation, ripeness and decay, order and dissolution. Ruins, a particularly powerful embodiment of these tensions, are a violation of the surfaces holding a form together and, at the same time, a riveting multiplication of surfaces—an *assemblage* of outside and inside, public and private. In late eighteenth-century English versions of the picturesque, ruins assume the status of icons.[10] For Uvedale Price, the ruin evident in old houses (like that, for example, in seventeenth-century Dutch painting) is a kind of death-in-life: a strangely beautiful congruence between natural forms, architectural forms warped by weathering, and the deformations and "eccentricities" of their elderly inhabitants. Weathering and aging, Price observes, "[sober] down" colors. Human figures, roofs, and timber, all turning gray, merge with the gray-green tones of vegetation. Warping makes geometric forms organic—a process that is literalized as pavement and mortar are broken by weeds, and roofs sprout mossy growths the color of rust. The aging inhabitants of such a house turn "homely," sharing with house and landscape a "unity of appearance" that is the sign of their approaching death.[11]

William Gilpin, on the other hand, is fascinated with the grotesquely beautiful ruins produced by human mayhem. The picturesqueness of his family home Scaleby is, he notices with playful wit, an unexpected by-blow of Cromwell's campaign of deconstruction, which decimated parts of England, as of Ireland, to save them. Two sides of the house's tower have been sheared off, the edges of the other two broken, and the remaining walls are punctured where not collapsed. Scaleby's "whole plan" has been laid bare, like a ruin by Piranesi, and is mixed disturbingly with natural forms. Foliage blooms in shattered arches and vaults—the very bulwarks of the house. Weeds and "spiry grass" befur the exposed floor. Under remnants of ceiling swoop daws, swallows, martins. Invisible people stir behind a tattered curtain that walls off a makeshift room from the unroofed hall. For Gilpin, Scaleby becomes a "perfect," if too literal, model of picturesque architecture. The question is how to reproduce these effects without actually rupturing roof and walls.[12]

In nineteenth-century Euro-America, some of the most telling ruins are survivors of eighteenth-century struggles for dominion: the French and Indian War, the Revolution. Situated (in pictures) between a sublimely forested landscape and a stormy sky, Fort Putnam on the Hudson, for example, rehearses in its deformed walls the combat that took place there. The walls expose an interior of "two or three arched casements" that look like ribs. But ribs and casements alike, Nathaniel Willis observes, are now "overgrown with vines and shrubbery," as if nature itself would help to erase from the sunny, pacific, agricultural American present reminders of the sublime darknesses and the bloody struggles of the northeastern frontier.[13]

The form and order of a civilization at peace emerges from the old violences of the nation's birth. That is a recurrent visual plot in narratives as diverse as James Fenimore Cooper's *Last of the Mohicans* and Nathaniel Willis's *American Scenery.* "The hand of the husbandman has already begun to clear these grounds," writes a minister about Lake George, scene of fierce fighting during the Revolution, and will "at no great distance of time" replace the battleground with "all the smiling scenes of agriculture. It does not demand the gift of prophecy to foresee, that the villas of opulence and refinement will, within half a century, add here all the elegances of art to the beauty and majesty of nature."[14] The Revolution is reduced to memory alone; this is no longer a place in which it can be seen to have taken place, left its marks.

Even for progressive Americans, the meanings of ruin are many and various. To the nostalgic Cooper of *The Pioneers,* Natty Bumppo's abandoned cabin becomes the elegiac reminder of a vanishing way of life in a society addicted to relentless change. To Downing, old rural structures are eyesores to be redeemed by reconstruction. Abolitionist readings of slave quarters and even of slaves' bodies oscillate restlessly and without definitive resolution between social and moral interpretations: ruin as the consequence of a corrupt social system, as the outward sign of moral degeneracy, or both. By the contrasts between a plantation house and slave-quarters with a warped roof, broken beams, and rotten, moss-grown shingles, Eastman Johnson transforms his *Old Kentucky Home* (Fig. 2) into a "prophetical" sign of the decay of the slave-holding South. "How fitly do the dilapidated and decaying negro quarters typify the approaching destruction of the 'system' . . . they serve to illustrate!" (The contrasts between the ruined house and its smiling inhabitants, the critic adds with a gratuitous expression of racism, suggests that image of the happy-go-lucky African American is a "reality"—unfortunately so, because this irresponsibility allows slavery's corruptions to spread "unheeded and unchecked.")

Urban slums are another instance of New World ruin. Visible cause of social and psychological degradations of their inhabitants, they are also, for reformers like Jane Addams and Jacob Riis, visible products of landlords' greed and indifference. To Temperancers, they are metonyms of alcoholic excess.[15]

Although the most powerful images of cleared forests are situated in progressive scenarios of an agricultural order emerging from the forest culture, a few American observers such as George Perkins Marsh see, prophetically, that wilderness forests also become ruinous when clear-cut for Euro-American occupation. "[M]an is everywhere a disturbing agent," Marsh declares.

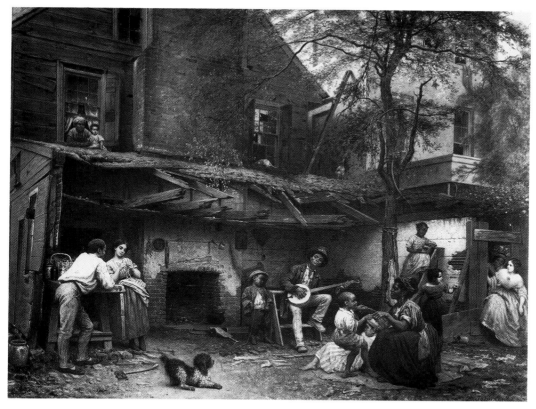

Fig. 2 Eastman Johnson, *Old Kentucky Home (Life in the South)*, 1859. Oil on canvas, 36 × 45 inches. The New-York Historical Society.

He has felled the forests whose network of fibrous roots bound the mould to the rocky skeleton of the earth. . . . He has broken up the mountain reservoirs, the percolation of whose waters through unseen channels supplied the fountains that refreshed his cattle and fertilized his fields. . . . [H]e has torn the thin glebe which confined the light earth of extensive plains, and has destroyed the fringe of semi-aquatic plants which skirted the coast and checked the drifting of sea sand. . . . He has ruthlessly warred on all the tribes of animated nature whose spoil he could convert to his own uses, and he has not protected the birds which prey on the insects most destructive of his own harvests.

As the process becomes "more energetic and unsparing," nature "avenges herself upon the intruder" with eroding rains. In parts of Asia Minor, North Africa, and Greece, Marsh seeks to show, the earth has been reduced to an assemblage of bald mountains, of barren, turfless hills, and of swampy and malarious plains—"a desolation almost as complete as that of the moon." That is the fate of the American landscape as well, Marsh believes, unless clear-cutting can be stopped.[16]

Downing's scenario of civilization concentrates on the configurations and meanings of picturesque houses, but his houses too are defined by signifying oppositions between form and deformation. The surfaces of Andrew Jackson Davis's exemplary

Rotch House (see Fig. 74) in New Bedford, Massachusetts, are broken (unlike Gilpin's Scaleby) only in a visual sense, from subject to playful and animating deformation. The roof is hipped, surmounted with chimney stacks, and rises and falls over a sequence of dormers. The walls push outward into a porch, a veranda, and other such projections, then recede into gables, hollows, and recesses. They are pierced with glassed-in apertures (bay, bow, oriel windows) where inside is opened (but only visually, without ruptures in the skin of the house) to outside, outside to in. Further confusions of the boundaries between outside and inside occur where domestic furniture is allowed to spill out across a veranda or terrace and natural forms are brought into the house. The architectural form that constitutes the pinnacle of nineteenth-century rural civilization has the same characteristics as the ruin, but the story it symbolizes is very different. This house, Downing declares, makes a "reasonable" connection to surrounding nature.[17]

Exposure and Concealment

The oppositions of inside and outside are closely related, in turn, to those between revelation (or exposure) and concealment. An irregular globe that juxtaposes the organic and the geometric, the crown of a tree in bloom also juxtaposes (like Gilpin's ruined house) exterior and interior, form and void, near and far. Its "nearer surface," partly "open and permeable, and in a measure transparent," reveals fragments of "its central [interior] portions," its "opposite limit," and even the space that stretches away from its far side. "[T]he hue of the background on which it is relieved," Asher Durand observes, "must be seen through its apertures in some parts, in others the retiring color and texture of its centre and opposite branches, together with gleams of reflection from the enlightened portions of its interior (for the light strikes through it as well as on it). . . . In addition . . . reflections from the sky [are] visible on the upper portions of the shaded [leaf clusters]."

An even more transparent medium, still water juxtaposes not only surface, interior, and environment, Durand observes (like Thoreau and Fitz Hugh Lane), but also matter and its dematerialized reflections. "We see its surface: through that, the bottom, when shallow, and at the same time surrounding objects and the sky above all distinctly imaged upon this surface."[18]

Picturesque atmospheres can also mask or veil what lies behind them, revealing fragments and glimpses of what they mask, like screes on a stage, like blooming trees, like the walls of houses. Clouds, haze, and twilight are atmospheric veils; distance is (or draws) a veil. Deep shadow is a mask; night is a mask.

To the American religious imagination, natural forms may be read as natural types of revelation: the appearance of a presence interior (like character, spirit, sentience) or posterior (like destiny) or anterior to them (the godhead). Surfaces are seen to vibrate with this presence like tympani or to be marked with its signifying impressions, as entablatures are marked with hieroglyphs or temple walls with emblematic pictures. By an act of imaginative vision, surfaces may be turned, as in Emerson's version, to glass—form revealed as the material effect of an ideal cause. Surfaces can at any time be rent, suddenly, violently, or dissolved, or lifted off like masks, or parted like veils, to reveal a terrifying and unutterable power: that is Poe's

Color Plate 1 Martin Johnson Heade, *Newburyport Meadows*, c. 1872–78. Oil on canvas, 10½ x 22 inches. The Metropolitan Museum of Art, New York. Purchase, The Charles Engelhard Foundation.

Color Plate 11 Martin Johnson Heade, *Thunderstorm over Narragansett Bay*, 1868. Oil on canvas, 32⅛ x 54½ inches. Amon Carter Museum, Fort Worth, Texas.

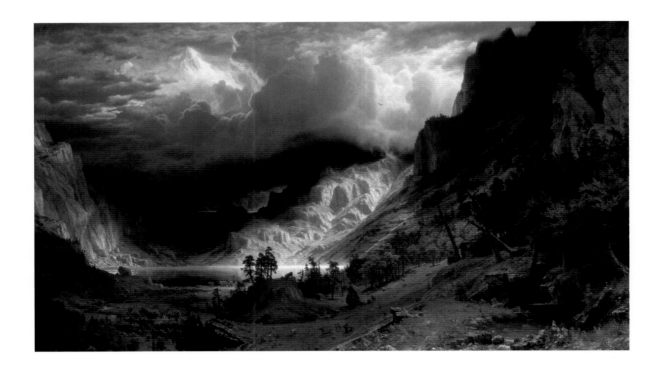

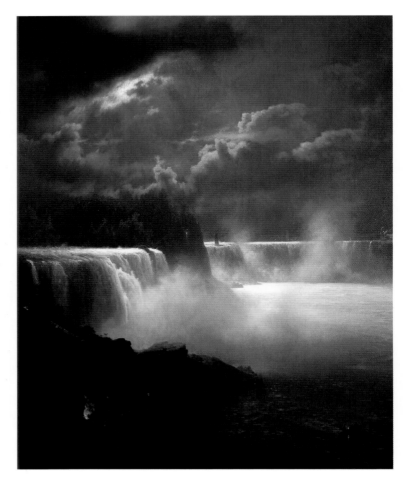

Color Plate III (ABOVE)
Bierstadt, *A Storm in the Rocky
Mountains—Mount Rosalie*
(1866). Oil on canvas, 83 x 142½
inches. Brooklyn Museum of Art.

Color Plate IV (RIGHT)
Herman Herzog, *View of Niagara
Falls in Moonlight*, 1872. Oil on
canvas. Museum of Fine Arts,
Springfield, Massachusetts.

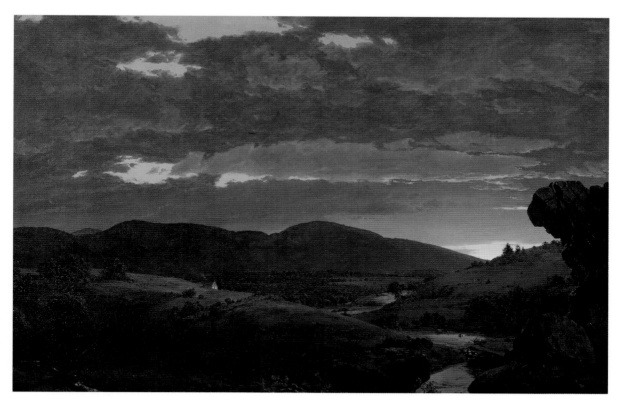

Color Plate V Frederic Church, *Twilight, "Short Arbiter 'Twixt Day and Night,"* 1850. Oil on canvas, 32½ x 48 inches. Collection of The Newark Museum, Newark, New Jersey.

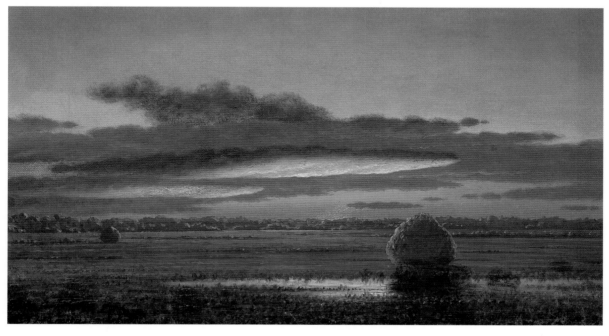

Color Plate VI Martin Johnson Heade, *Sunset over the Marshes,* c. 1863. Oil on canvas, 10½ x 18½ inches. Museum of Fine Arts, Boston. M. and M. Karolik Collection.

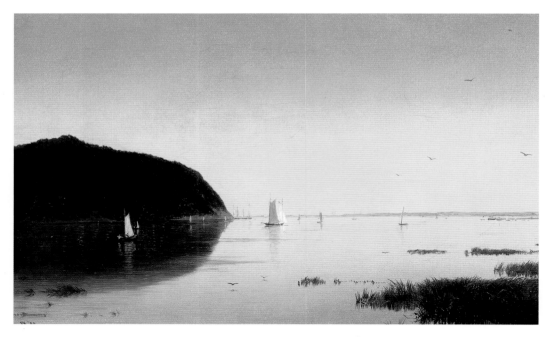

Color Plate VII John Kensett, *Shrewsbury River, New Jersey,* 1859. Oil on canvas, 18½ x 30½ inches. The New-York Historical Society.

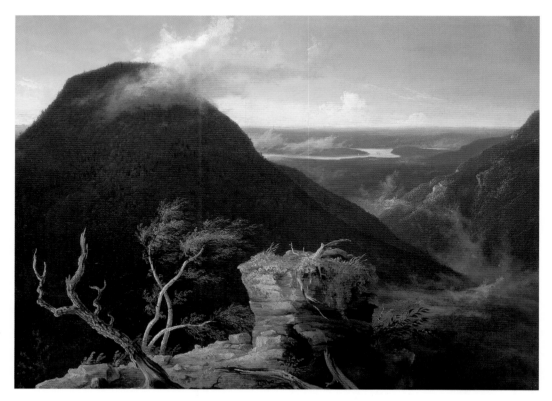

Color Plate VIII Thomas Cole, *Sunny Morning on the Hudson,* 1827. Oil on panel, 18½ x 25½ inches. Museum of Fine Arts, Boston. Gift of Mrs. Maxim Karolik for the M. and M. Karolik Collection of American Paintings.

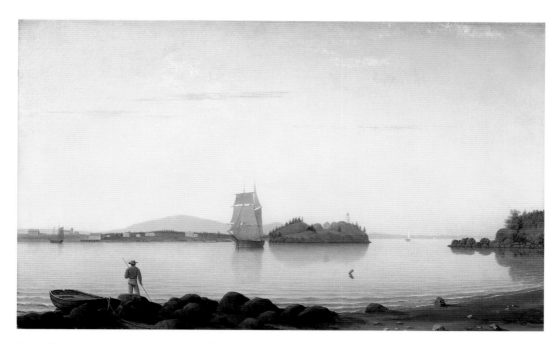

Color Plate IX Fitz Hugh Lane, *Owl's Head, Penobscot Bay* (1862). Oil on canvas, 16 x 26 inches. Museum of Fine Arts, Boston. M. and M. Karolik Collection of American Paintings.

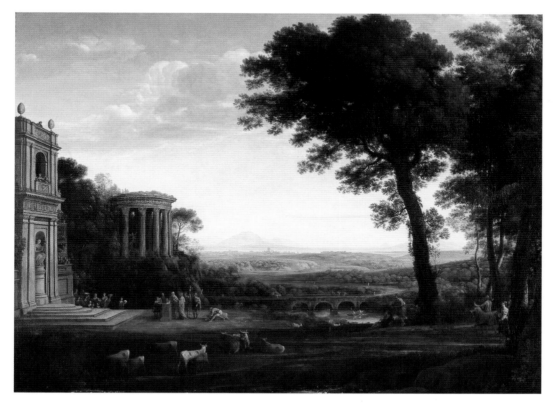

Color Plate X Claude Lorrain, *Landscape with the Father of Psyche Sacrificing at the Milesian Temple of Apollo*, 1663. Oil on canvas, 174 x 200 cm. Anglesey Abbey, National Trust, England.

Color Plate XI Salvator Rosa, *Landscape with a Lake, Mountain, and Five Soldiers in the Foreground.*
Oil on canvas, 48⅞ x 80½ inches. Bequest of John Ringling, Collection of the John and Mable Ringling
Museum of Art, Sarasota, Florida.

Color Plate XII Thomas Cole, *View Near Catskill*, 1827. Oil on canvas, 24½ x 35 inches. Fine Arts Museum
of San Francisco. Gift of Mr. and Mrs. John D. Rockefeller 3rd.

Color Plate XIII Thomas Cole, *View on the Catskill, Early Autumn*, 1837. Oil on canvas, 39 x 63 inches. The Metropolitan Museum of Art, New York.

Color Plate XIV Thomas Cole, *River in the Catskills*, 1843. Oil on canvas, 28½ x 41½ inches. Museum of Fine Arts, Boston.

Color Plate xv James Hope, *Bird Mountain, Castleton, Vermont*, 1855. Oil on canvas, 35 x 54½ inches. Museum of Fine Arts, Boston. Gift of Maxim Karolik of the M. and M. Karolik Collection of American Paintings, 1815–1865.

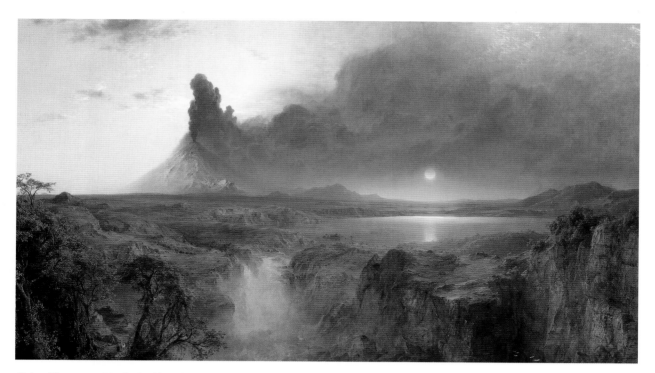

Color Plate XVI Frederic Church, *Cotopaxi*, 1862. Oil on canvas. 121.9 x 215.9 cm. The Detroit Institute of Arts.

Color Plate XVII Sanford Gifford, *Twilight on Hunter Mountain*, 1866. Oil on canvas, 30½ x 54 inches. Terra Museum of American Art, Chicago.

Color Plate XVIII Fitz Hugh Lane, *Christmas Cove*, c. 1863. Oil on canvas, 15 ½ x 24 inches. Private collection.

Color Plate XIX Fitz Hugh Lane, *Stage Rocks and Western Shore of Gloucester Outer Harbor*, 1857. Oil on canvas, 23 x 38 inches. Cape Ann Historical Association, Gloucester, Massachusetts.

Color Plate XX Fitz Hugh Lane, The *Western Shore with Norman's Woe*, 1862. Oil on canvas, 21$\frac{1}{2}$ x 35$\frac{1}{2}$ inches. Cape Ann Historical Association, Gloucester, Massachusetts.

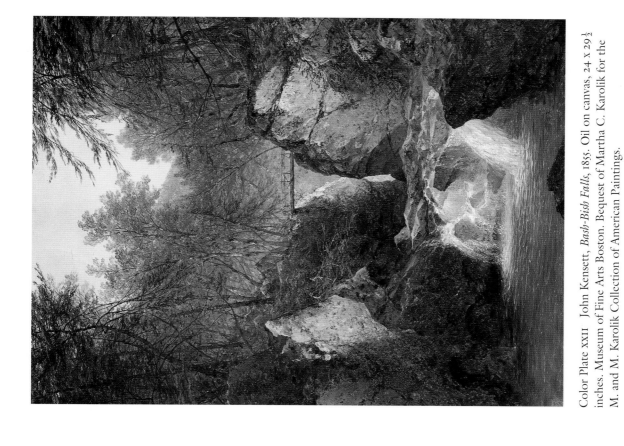

Color Plate XXII John Kensett, *Bash-Bish Falls*, 1855. Oil on canvas, 24 x 29 ½ inches. Museum of Fine Arts Boston. Bequest of Martha C. Karolik for the M. and M. Karolik Collection of American Paintings.

Color Plate XXI Worthington Whittredge, *The Old Hunting Grounds*, c. 1864. Oil on canvas, 27 x 36 inches. Reynolda House, Museum of American Art, Winston-Salem, North Carolina.

Color Plate XXIII Thomas Cole, *Home in the Woods*, 1847. Oil on canvas, 44 x 66 inches. Reynolda House, Museum of American Art, Winston-Salem, North Carolina.

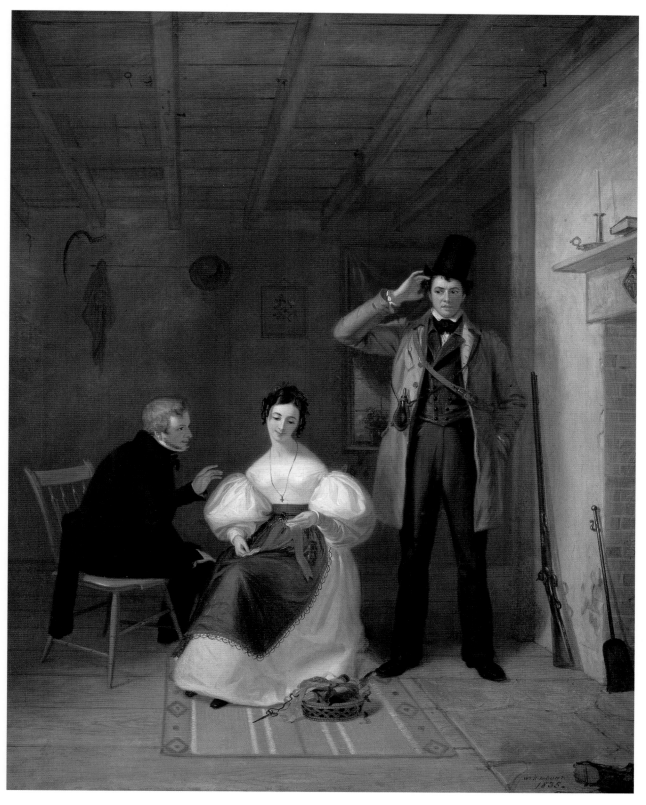

Color Plate XXIV William Sidney Mount, *The Sportsman's Last Visit*, 1835. Oil on canvas, 17½ x 21½ inches. The Museums at Stony Brook, Stony Brook, New York. Gift of Mr. and Mrs. Ward Melville, 1958.

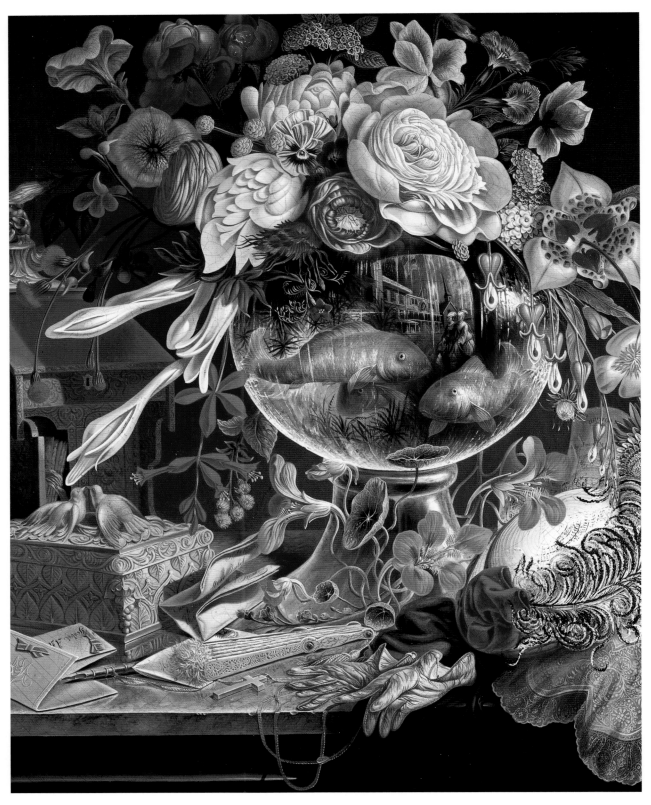

Color Plate XXV Edward Ashton Goodes, *Fishbowl Fantasy*, 1867. Oil on canvas, 25$\frac{1}{8}$ x 30 inches. Collection of Mr. and Mrs. Stuart P. Feld.

view. We live in a house whose moral and intellectual darkness is only momentarily relieved by gleams and glimmers: that is Hawthorne's.

Conversely, surfaces that conceal may signify a retreat of the spirit: a natural type of the Fall. In Emerson's version, degeneration is the immuring of the spirit behind increasingly opaque surfaces, so that the world seems to shrink to a mere material existence, and "the contrast between us and our house is more evident."[19] Opaque and expressionless surfaces obdurately stymie insight into the powers that move them and move in them. We are reduced to a world of impenetrable pasteboard illusions—victims, like theater audiences, of a confidence trick: that is Melville's view.

Tensions between exposure and concealment captivate the nineteenth-century American social imagination, especially in readings of cities and their inhabitants. It is the paradoxical purpose of urban (as of rural) homes, Samuel Sloan declares, to conceal familial intimacies from public view and at the same time to proclaim publicly the family's commitment to the values of the private life. The windowless walls, airless rooms, and "promiscuity" (closeness, density) of slum tenements, argues Jacob Riis, are outward signs, or possibly causes, of the moral and social darknesses corroding the lives of the inhabitants in the forms of depression and disease that remain largely invisible until revealing themselves in public in acts of criminality.

Faces in city streets (as I wish to show in Chapter 4) are masked. The anonymous subject of Poe's "Man of the Crowd" wears a mask of guilt, his anonymity concealing the cause. In Victorian America, bodies as well as faces must be revealingly concealed. Although warranted by classical principles, nudes are an embarrassing subject even when veiled as allegory. Better to cloak personified virtues in outmoded togas. Victorian American dress accentuates gender but seldom sexuality. It is designed to reveal only the body's most expressive and most public portals of feeling and idea: the hands and the face. All else is to be swaddled in a drapery itself designed to express character and stature rather than, say, hips.[20]

THE TRANSCENDENTALIZATION OF PICTURESQUE EFFECT: EMERSON'S *NATURE*

In the spiritualized versions of picturesque effect defined by Transcendentalists, natural as well as human forms are signs of evident invisibilities. Meaning is not produced by surfaces but rises to them, *im*pressing itself upon them, from within—an *ex*pression of their character. Read concentratedly, forms can even reveal the "causes and spirits" that created them. Such a reading of the visible world becomes both a typological experience and an enactment of the Transfiguration. It initiates "a delicious [awakening] of the higher powers" and an awareness of the presence of kindred powers in material nature, and it reaches its apogee in an experience of "the reverential withdrawing of nature before its God."[21]

Pictures in the Eye

No nineteenth-century version of the transcendental picturesque is more luminous and influential than Emerson's *Nature*.[22] Fruit of the marriage between picturesque theory and the New Thought from Germany and England, the essay re-imagines the very terms of the transaction between forms and consciousness that constitutes

picturesque effect. For Emerson, nature, by definition picturesque, is at once a material design; an inexhaustible picture, textual, polysemous; and "an apparition" of its divine fabricator. Even the most common objects harbor a "double meaning," "a quadruple or . . . centuple or much more manifold meaning." Human consciousness, as manifold and polymorphic as the world it beholds, is wholly capable of experiencing and representing such a world. Each of its several (Kantian) faculties—the understanding, the conscience, Reason, or the imagination—discovers distinctive layers of signification in picturesque effect.[23]

Rejecting what Ruskin calls the "lower picturesque," with its "dogma" of a world deformed and ruined, Emerson defines in his chapter on "Beauty" a version of the aesthetic similar in many ways to Ruskin's "noble picturesque." The small forms he catalogues at the outset—the acorn, the grape, the pinecone, the wheat ear, and so on—are all picturesquely beautiful by virtue of their irregular curves and their intensities of color. The large "primary forms"—hills, bodies of water—can be picturesque in their groupings and movements as well. All of these forms are also subject to picturesque variations over time. Living forms grow and die; all forms change, circumstantially, with changes of light and perspective.

As he evokes it in short descriptive sketches, the Concord landscape takes shape as a succession of beautifully curved forms emerging and withdrawing, wavelike, in fields of light and bright color (crimsons, pinks, yellows, blues, greens). At every moment of their duration, they present beauties "never seen before" and never to be seen again. Each has its concordantly medicinal effects, which lift the viewer's spirits. In January, thus, "the leafless trees become spires of flame in the sunset, with the blue east for their background, and the stars of the dead calices of flowers, and every withered stem and stubble rimed with frost, contribute to the mute music." In July, by the river, pickerel-weed blooms "in large beds . . . and swarms with yellow butterflies in continual motion"—a "pomp of purple and gold."[24]

Yet a sixth kind of beauty comes into play as natural phenomena form pictures in the viewer's eye. Emerson gives to the eye itself the "plastic power" of the artist to construct pictures by framing and positioning (but not lighting) them. Like "the best of artists," it frames what it sees in its beautifully round and symmetrical circle of vision, locating some forms (by virtue of their relative size and detail) as "near" and others (shrunk, generalized, light-softened) as "distant." Unlike the painter's frame, however, the eye is not fixed but kinematic: a gaze or step in any direction changes not only the perspective but the very shapes of forms, their scenic contexts, their meanings. In the eye, therefore, the whole world becomes scenic. For Emerson, the connotation of *picturesque* is not the body of paintings in the picturesque canon but the kinematic pictures formed effortlessly by the eye and then, "instinct" with effect, read by the consciousness. A good memory constitutes the mind's own picturesque canon.[25]

Light is a seventh source of beauty. Local effects of lighting add to the circumstantial beauties of things. "There is no object so foul," even a corpse, "that intense light will not make beautiful." At the same time, light is the precipitator (as it is in painting) of the eye's pictures' general effects. Its values unify forms and their multiplicities of meaning. Different conditions of light and darkness imbue the forms they environ with different meanings, situating them in the space of a sublimely large

and mysterious universe. Like revelation, light can transfigure things into luminous signs of idea and spirit. In moonlight, drained of color and substance, Emerson observes, the eye's pictures turn phantasmagoric. At midnight, wholly dematerialized, they begin to float in the dematerialized worlds of "mystic philosophy" and Gothic "dreams." At their most sensational in noon light, they enter the world of materialism: texts to be fathomed by the understanding, which "adds, divides, combines, measures" and otherwise breaks nature down into its parts and processes: space, "time, . . . climate, locomotion, the animals, the mechanical forces." But in the alchemies of a rising or setting sun, matter and idea reach balance with each other. Sunrise gives forms the aspect of an "Assyria"—robust, but also gilded, iconic; sunset, the erotic look of a "Paphos," city of Aphrodite.[26]

Emerson's beauty being eclectic, it is manifold in its emotional effects. Nature produces, variously repose, joy, buoyancy, or exultation (how often these words recur in *Nature*!). It lifts the heart and is a tonic to the mind. But these effects are typically mixed with awe and even fear at the softened sublimities—the vastnesses, silences, and mysteries—of a universe through which light flows like an emissary. That is the amalgam evident in the much-bruited sketch of an experience of transparency on Concord Common. "Crossing a bare common, in snow puddles, at twilight, under a clouded sky, without having in my thoughts any occurrence of special good fortune, I have enjoyed myself to perfect exhilaration." The exhilaration seems to arise from a *trompe l'oeil* effect: the congruence of a clouded twilight sky and a bare landscape filled with reflective puddles of melting snow—sky above, sky below. In this imagistic marvel, a thing outward and subjective (as Pound would later say) becomes a thing inward and subjective. Emerson reenacts the instinct toward transcendence with which matter and mind, in his Transcendentalist view, are both endowed. His imagination, becoming where and what it sees, turns reflective. His head "bathed by the blithe air," he reports the sensation of being "uplifted into infinite space," bodiless, egoless, angel-like, a transparent eyeball. The experience ends only at the point where exhilaration gives in to "fear," presumably at the threat of complete disorientation or of imminent annihilation. The vastness of the universe lies hidden and mysterious even in quotidian places, and the soul willingly gravitates toward it—up to a point.

A similarly eclectic effect occurs in the sketch of a beautiful "spectacle of morning" unfolding along the ridge above his Concord Manse. As "long slender bars of cloud" (favorites of the luminist painters) "float like fishes in the sea of crimson light," they radiate feelings that "an angel might share," presumably because the viewer again finds himself aswim in the sky's "silent sea." As his focus shifts from the radiance to the oceanic quietude of space, his mood shifts (here, too) from joy to exhilaration. His breathing in harmony with the breathing, almost sentient air, he experiences, again, the sensation of apotheosis: "I seem to partake of [the air's] rapid transformations: the active enchantment reaches my dust, and I dilate and conspire with the morning wind."[27]

The Ministries of Nature

Emerson's model of effect is both epiphanic and transfigurative. As these two sketches suggest, the "tonic" of natural beauty stirs the mind as well as the feelings, and the stirred mind endows what it sees with, or sees in them (for Emerson, it does

not seem to matter which),[28] manifold and cumulative symbolic effects. In his recurrent trope of symbolization, forms and scenes imaged by the eye "minister" to each of the mind's several faculties. In the process, each faculty "transfigure[s]" matter into its constitutive significances. Symbolization is an "upstreaming" both of consciousness and of meaning; an ascent through sensory and emotional into moral, imaginative, and spiritual ways of knowing. Emerson defines this ladder of awarenesses with particular clarity in his distinction between the "animal eye" (his trope for "the senses and the unrenewed understanding") and the "eye of Reason" (his Kantian term for the imagination). The animal eye sees things with an "instinctive belief in the absolute existence of nature," and what it sees informs the understanding. From its inherently materialist perspective, "man and nature are indissolubly joined. Things are ultimates." The eye of Reason, however, "shows us nature . . . afloat" (as in a sea of crimson light or a floating eye). "[T]he animal eye sees, with wonderful accuracy, sharp outlines and colored surfaces. When the eye of Reason opens, to outline and surface are at once added grace and affection, and abate somewhat of the angular distinctness of objects. If the Reason be stimulated to more earnest visions, outlines and surfaces become transparent, and are no longer seen; causes and spirits are seen through them. The best moments of life are these delicious awakenings of the higher powers, and the reverential withdrawing of nature before its God."[29] Ultimately, seeing both produces and experiences a conversion. Taught the highest level of seeing, that of worship, the imagination sees picturesque nature anagogically, as the sign of an always potential, and supernatural, millennium. In this, what Barbara Packer has called the paradox of Emerson's "tenderness for natural appearances" and his "fierce refusal to accept natural limitations" is made emphatically manifest.[30]

1. *Mute Gospels: Form as Allegory.* No things but in ideas. To this dynamic of transformed and transformative vision, the faculty of conscience contributes an apprehension of the moral significances inherent in things; it turns them into allegorical texts imbued with "ethical character."[31] "Therefore is nature glorious with form, color, and motion, that every globe in the remotest heaven; every chemical change from the rudest crystal up to the laws of life; every change of vegetation from the first principle of growth in the eye of a leaf, to the tropical forest and antediluvian coalmine; every animal function from the sponge up to Hercules, shall hint or thunder to man the laws of right and wrong, and echo the Ten Commandments." The "sea-beaten rock," materially firm, teaches conscience the virtues of ethical firmness: steadfastness and endurance in the face of adversity. The farm, as Christ's parables demonstrate, is a "mute gospel" rich with "sacred emblem[s]" of right conduct: "the chaff and the wheat, weeds and plants, blight, rain, insects, sun."

The "mark God sets upon virtue" is most beautifully evident, in Emerson's view, in the human body: "that singular form which predominates" over all other natural forms. The most powerful representations of moral beauty, a sequence of brief sketches (verbal equivalents of genre paintings) demonstrates, are people whose virtues are "in unison" with their native landscapes—presumably because the landscapes have done their ministries on them. Since heroic action (including "original" thought and vision) rhymes with the character of the place in which it takes place,

the environing landscape adds "the beauty of the scene" to "the beauty of the deed." Mise-en-scène assists the process of visualizing this. The positioning of heroic figures at the center of "the visible sphere" (that is, the eye's frame) signifies the centrality of the virtues they represent. "When the bark of Columbus nears the shore of America;—before it, the beach lined with savages, fleeing out of all their huts of cane; the sea behind; and the purple mountains of the Indian Archipelago around . . . [d]oes not the New World clothe his form with her palm-groves and savannahs as fit drapery?" The higher the virtue, moreover, the more expansive the environment in which it takes its place in the memory: "Homer, Pindar, Socrates, Phocion, associate themselves . . . in our memory with the geography and climate of Greece"; but the "visible heavens and earth sympathize with Jesus."

In Emerson's democratic pantheon, more representative types of human character bear, like Hawthorne's Lawyer Giles, morally picturesque "marks as of some injury," are "marred and superficially defective." Nevertheless, they too have a sublimely mysterious and powerful spiritual beauty, if only imperfectly or intermittently or potentially, for they too are afloat on "the unfathomed seas of thought and virtue whereto they alone of all organizations, are entrances." Through them, as through "fountain-pipes," these seas may surge up at any moment.[32]

2. Natural Types: Form as Symbol. As conscience allegorizes the world's pictures, imagination (or "Reason") reads their "intellectual" meanings; that is, it symbolizes visual pictures, reading their constituent forms as signifiers of the universe's unity (chapter III). The ministries of things as symbols include the gifts of language (chapter IV), idealism (chapter VI), and ultimately worship (chapter VII). Cosmic in its pan-historical and panoramic scope, Emerson's enlightened imagination, like Poe's "angelic imagination," by definition idealizes nature. It "beholds the whole circle of persons and things, of actions and events, of country and religion"—including even reflective puddles and cirrocumulus in a twilight sky—"not as painfully accumulated, atom after atom, act after act, in an aged creeping Past, but as one vast picture, which God paints on the instant eternity, for the contemplation of the soul."[33]

The enlightened imagination is also by definition reflexive. Picturing forms, it perceives its own "occult relations" with them. Joy and exaltation (a joy edged with fear)—the intense feelings produced by a poetic vision of things—"inflame" and "exalt" the mind's pictures of things. At the same time, the imagination charges them with significance. The images become both representations of the world and tropes—"types," allegories, "symbols," metaphors—of ideas: no things but in ideas. Picturesque discourse, in Emerson's definition of it, evokes ideas by presenting natural appearances as their picture; simultaneously, it evokes states of mind "by presenting the natural appearance as [their] picture" as well. Flowers are thus symbolic types of "the delicate affections"; the blue sky, eternally calm and full of "everlasting orbs," a type of Reason. And thus, as in dream-life, "Light and darkness are our familiar expressions for knowledge and ignorance; and heat for love. Visible distance behind and before us, is respectively our image of memory and hope."[34]

As he constructs this argument, Emerson pursues collaterally an answer to the question of how the "fearful extent and multitude" of natural forms and the ideas they signify produce "an integrity of impression," a "tranquil sense" of the unity in

variety in which "all thought of multitude is lost." His answer requires a definition of the picturesque not only as a language but also as a principle of composition. A picture in the eye, however much detail it includes, takes on a complex and elusive unity (*e pluribus unum*) because its constituent forms, all beautiful, originate in the harmonious unity of the universe, as the word *universe* (going toward a oneness) itself signifies. To the fully awakened imagination, the nature that forms its populous, changeful, and polysemous pictures in the eye is rightly perceived as "a sea of forms radically alike, and even unique." "Therefore the standard of beauty is the entire circuit of natural forms,—the totality of nature; which the Italians expressed by defining beauty [as] '*il piu nell' uno*' [that is, the many in one]. Nothing is quite beautiful alone: nothing but is beautiful in the whole." In Emerson's transcendental version of picturesque, "a single object is only so far beautiful as it suggests this universal grace."[35]

3. *First and Last Things: Form as Anagogy.* Paradoxically, the ultimate ministry (or effect) of nature for Emerson is to "emancipate" human consciousness not just from delight in the world's materiality, but even, if only intermittently, from "belief in its substantial existence." In this, Emerson leaves even idealism behind and embraces the kind of seeing that only spirit can achieve. Idealism denies "the existence of matter," but it "does not satisfy the demands of the spirit" for intimations of matter's divine cause. Idealism "leaves God out of me. It leaves me in the splendid labyrinth of my perceptions, to wander without end." Emerson's idealism, as Packer shows, therefore becomes a passage in a larger dialectic. "It diminishes and degrades matter in order to receive a new view of it, namely this, that the world is the new fruit of Spirit evermore." Where matter comes from and where it is going—questions of first and last things—are questions to be answered by the spirit alone.[36]

As in biblical exegesis, Emerson's multivalent reading of picturesque effects in nature therefore culminates in anagogy: forms become signifiers of an imminent millennium as perceived by a transfigured consciousness that is itself a type of the millennium. "As when the summer comes from the south the snow-banks melt and the face of the earth becomes green before it, so shall the advancing spirit create its ornaments along its path, and carry with it the beauty it visits and the song which enchants it; it shall draw beautiful faces, warm hearts, wise discourse, and heroic acts, around its way, until evil is no more seen." In that eventuality, we will be emancipated from art and nature as well as evil.[37] The ultimate ministry of picturesque nature is to lead the ecstatic mind beyond it and beyond itself.

In the meantime, however, *Nature* is both a decisive codification of the transcendental picturesque and a prophetic gloss of some of the finest art and literature produced in America over the next three decades or more, including the luminist paintings of Fitz Hugh Lane; the poetry of Dickinson and Whitman as well as Emerson himself; the prose narratives of Hawthorne, Melville, Poe, and Thoreau. Their versions of the picturesque are various and even contradictory, of course. But all are in accord with Emerson's idea that picturesque nature is a gathering of forms marked, like faces, with "the discontinuous splendors of [their] inner life,"[38] and, like temple walls, with "emblems, pictures, and commandments of the Deity."

The whole history of the passions, as told in the physiognomy, the [face], the attitudes and bearing of the characters portrayed, is aimed at in painting. . . . Not only the painter, but every master of fiction and poetry finds an illimitable subject there.

—James Henry, "The Incentives and Aims of Art,"
The Crayon (January 24, 1855)

∞

Reading the Human Body

The most popular of the three ideas of picturesque effect, that of dramatic expression, is based on the assumption that human character, an inward state of being, is projected onto the body's surfaces by means of "the silent languages of deportment, of countenance, and . . . the light of the eye." The effects of the inward life express themselves in visible "agitations" of the body, as William Gilpin called them: appearing, for example, in stains of color on the face (blushes, apoplectic crimsons); marking the mouth and eyes with lines or tremors (moving ripples); propelling the body into calligraphies of posture and gesture.[1] Such deformations bespeak not only feelings but also activities of conscience, intellectuality, and even that history of consciousness called moral character.[2] They too can therefore be read at the levels of symbolic and narrative as well as modal effect.[3]

THE BODY AS URBAN TEXT

Readings

In genre painting and portraiture, and in city streets as well as in the theater, the paradigm of dramatic expression seems ubiquitous. The emergent discipline of psychology, for example, assumes that "the face and character harmonize, just as do all the parts of a good picture."[4] The head and face, argues Emil Spurzheim, are maps and pictures of the mind's "affective and intellectual faculties." Physiognomy reads the head's "skeletal and organic constitution"; phrenology, its irregular landscape of knobs, peaks, and valleys (thirty to fifty of them). It is the discipline of pathognomy—a reading of human "gestures and motions" designed to distinguish "the benevolent, candid, and

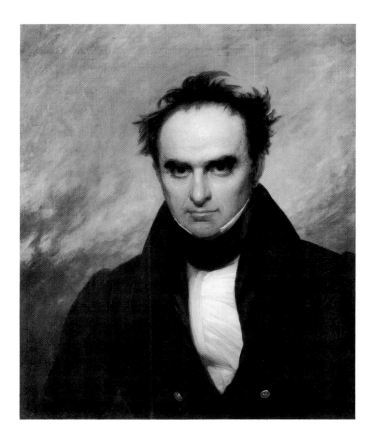

Fig. 3
Francis Alexander, *Daniel Webster* (*Black Dan*), 1835. Oil on canvas, 25 × 30 inches. Hood Museum of Art, Dartmouth College, Hanover, New Hampshire.

modest individual from another who is cruel, artful, and haughty"—that makes dramatic expression a science. Each of these psychological readings of the body, including pathognomy, exerts its influence on nineteenth-century figural art. Strong but benevolent feelings blaze from the eye, the forward thrust of the head, and even the electric hair of Francis Alexander's *Daniel Webster* (Fig. 3), for example. The viewer is able to see the emotional and intellectual energies that galvanized Webster's speech.

Etiquette manuals, too, use the paradigm of dramatic expression to teach urban Americans ways of reading the bodies of strangers, and of presenting their own, in public places. Before 1850, they assume a moral transparency: an unmediated translation of character into the visible languages of facial expression, gesture, and dress (which can also be read dramatically as costume). "The . . . expression of the face," observes one manual writer, "is . . . the story . . . [it] tells about the feelings of the heart."[5] Deportment, another insists, tells the story "as readily as . . . the features of the face." The subject's gaze, yet others advise, is especially expressive: "There is the timid glance of modesty, the bold stare of insolence, the warm glow of passion, the glassy look of stupidity, the calm serenity of innocence, the open frankness of candor, the furtive look of hypocrisy." The walk, too, is a signifying "index" of feeling and character: "There is the thoughtful walk and the thoughtless walk, the responsible walk and the careless walk, the worker's walk and the idler's walk, and so on." Even tones of voice (like words) give "incidental expression" to thoughts and feelings; because they are "involuntary," they are more candid than words and deeds.[6]

Self-Presentations

That identity can be presented dramatically by means of artistic decoration is yet another premise of urban versions of the picturesque. Clothing, Horatio Greenough declares, may be "as much an emanation from, and an expression of [the wearer's] . . . spirit, as his words or his actions—it tells the state his soul keeps in its clay tenement." As architectural ornament accentuates the most expressive parts of the picturesque house (doors, windows, chimney), so dress as a picturesque art accentuates the most expressive parts of the body, especially the face, that "great subject of artistic study[,] . . . seat of the distinguishing human powers" and "medium of expression for the spiritual nature." Lines, textures, and colors are clothing's most variously expressive elements. Simple draping and long, unbroken lines (as in a judge's robe) express dignity; short and complicated lines, vivacity; curves, particularly if long and sweeping, grace; straight lines and angles, "power and strength." Somber colors express gravity, "light and clear colors serenity, variations vivacity," contrasts brilliancy, and so on.

> [L]et us suppose a lady of a tall figure, dignified mien and tranquil temperament, inclining to joyousness, wishing to array herself so as to heighten the impression her character would give. She would select stuffs of quiet, light tints, probably greys of one character mainly [like the undertint in a landscape painting], and have them made up in the simplest form possible, coming high in the neck and flowing down to the ground. . . . She would have no flounces to disturb the simplicity of the lines (unless she should be short-waisted, when flounces would hide it by dividing the length of the skirt). She would display little or no jewelry, or any other ornament, except perhaps a pale flower on her bosom, or a ribbon at the throat. If she used ornament to any extent, it would probably be around her head.[7]

Until mid-century, urban readers are taught to dress themselves, like figures in paintings or actors on stage, in clothing that expresses "the essential nature of the wearer." But dress so conceived, as Greenough himself suggests, does not so much individuate as idealize character, and even idealizations constitute a socially constructed self. After 1836, for example, as Karen Haltunnen demonstrates, women's dress is designed to express the sentimental ideal of "demure self-effacement" that is visualized, for example, in William Sidney Mount's *The Sportsman's Last Visit* (Color Plate XXIV). This requires a long and willowy look, with narrow, sloping shoulders, a slender waist, and an attitude of "drooping restraint." To accentuate the shoulders, evening décolletage becomes "extremely low." On dresses, the sleeves and bodice tighten; the cloth is made to descend in a straight line to a "low, slim, pointed waist" and a "full and bell-like" skirt; and the palette runs to delicate "grayed tones, such as lavender and lilac, tan, silver gray, gray green, and silver blue." Congruently, the hair is designed to frame the face with drooping curls that fall from a sleekly combed-back crown.[8] With dress such as this, individuals abstract themselves into social and psychological types.

Targetings

By not later than mid-century, however, the naiveté of this assumption about moral transparency becomes evident; urban predators learn to read the characters of strangers as a means of potential profit and, at the same time, to conceal their own characters behind deceptive masks. The "inexperienced youth . . . on the sidewalk of the city," one manual writer warns, "is marked and watched by eyes . . . he never dreamed of." Playing the roles of ladies and gentlemen, confidence men, prostitutes, and other aggressive entrepreneurs begin acting out performances designed to trick the young out of their money or to "[make] war upon [their] virtue." Selected for their "beauty, grace and accomplishments," prostitutes, for example,

> dress in great elegance, and quite as decorously as females generally do at balls, parties, or at concerts. Meet them in the streets, or at picture galleries, or at a fashionable soiree, and there is nothing about them to attract attention. No person who knows them or their character can in any way recognize them in public. . . . Some are girls of superior mind. Some have had fortunes lavished on their education. Some can sing and play exquisitely. . . . Many support their parents in fine style. Some have children . . . [born] to them when they were happy wives.⁹

The masks and performances of salesmen, the manuals declare, are equally deceptive, for they too assume the persona but not the character of the gentleman. Where the gentleman is moved by an ethos of benevolent civility, the salesman is moved only by a "passion" for profit. For the salesman, the appearance of gentility is a kind of capitol: "He renders contradiction smooth, listens to it patiently; intends [like the gentleman] to flatter . . . ; complies with any request"—but only if "his interest be not compromised." Nevertheless, as the manuals also declare, deceptions like these reveal themselves to the informed gaze. The salesman's eye, attitudes, and "slightest actions" all betray his desire for gain: he flatters "awkwardly"; he bows too frequently and too obsequiously.¹⁰

Maskings and Performances

Increasingly after 1850, middle-class readers of the etiquette manuals, therefore, are advised to conceal their private selves, too, from the eyes of strangers—to fashion their own masks to meet the masks they meet. One paradox of "genteel performance," as Karen Haltunnen observes, is that it is designed to preserve virtue by obscuring congruencies between character and demeanor, so that virtue cannot be detected and manipulated.¹¹

Women's dress itself becomes a kind of mask, "ample, brilliant, and decidedly opaque." The advent of the sewing machine initiates "an orgy of braiding, pleating, puffing and tucking" that hides women's bodies from head to foot. Legs are hidden under long skirts, often twelve to fifteen feet in circumference. To draw the eye to their opaque surfaces, they are covered with "ruffled and pinked flounces, narrow and

wide flounces, fringed and flower-bedecked and beribboned flounces—and by richly patterned borders." Bodices, too, blossom with ribbons, lace, and artificial flowers. Arms disappear under ballooning sleeves in "bell, bishop, Gabrielle, and pagoda styles." To mask their inward lives as well as to discharge sexual predators, respectable women learn to adapt "a modest and measured gait," to control their gazes, and to eschew any gesture that might attract attention to them. "The true lady," one manual writer declares, now walks the street "wrapped in a mantle of proper reserve, so impenetrable that insult and coarse familiarity shrink from her."[12]

At the same time, genteel clothing is designed to encode "the impression [the wearer wishes] . . . to make" on a more exclusive audience. "Society has its grammar as language has," Clara Moore observes. The respectable gentleman, therefore, begins to wear the costume and demeanor of "the aspect of solid, substantial, inexpressive businessman," dressed in black, topcoated, top-hatted, begloved—an expression of the "purely *sedentary* power . . . of the administrator and conference table."[13]

PERFORMING SELVES: FIGURATION ON THE STAGE

Meanwhile, manuals of acting (and of oratory) also teach that states of mind have multiple and simultaneous expression in the body and in the process offer the heuristic metaphor for urban identity as socially constructed "roles"—performing selves. As *The Art of Acting* defines it, "deportment, gesticulation, grimace, look," and costume are all visual expressions (as dialogue and its attendant tones of voice are oral expressions) of thought and feeling, which also simultaneously impart to the voice distinctive intonations, as well as their distinctive verbal discourse, and "paint" the body with their distinctively sublime or beautiful effects. Working in synchrony, these languages are capable of expressing states of mind—even complex and ambiguous states of mind—with extraordinary intensity.[14] Acting is construed as the mastery of these expressive masks, and some of the masks, at least, are presented as appropriate in the public spaces of the street as well as on stage. In the picturesque city, every space becomes a potential set for actorly performances.

On stage, the performances run to the melodramatic. Fear, for example, can be pictured by a look of sublime "wildness." The mouth and eyes gape. The hands lift palm forward, shield-like, toward "the dreadful object," and one foot draws back behind the other: the body "shrinking from danger." By contrast, love is enscripted by a beautiful calligraphy of curves, arching eyebrows and arching wrinkles on the skin of the forehead, a bended knee. Hope bends the torso forward, spreading the arms and opening the hands "as if to receive the object of its longings," while desire thrusts the bent arms more insistently forward in a crescent of need, "as to grasp" the lover.

The most dramatically interesting expressions involve mixtures of mood and require, therefore, a complex and varied demeanor. Wonder, a mixture of love and fear, raises the eyes as love does, but fills them with fear. As fear does, it opens the mouth and makes the body shrink; but as love does, it makes the hands go slack. Pity, "a

mixed passion of love and grief," contracts the facial features (where love expands them), lowers the gaze to "the object of compassion" (pitiers are assumed to be elevated above the pitied), and lifts the hands as in benediction. The pitier "might even to his honor weep."

In mimes of mixed and even opposed feelings, the body is able to act out pictorial narrations in complex sequences of varying and contrasting body languages. Grief is typically (and sublimely) "violent, frantic and sudden" in its appearance. As its agitations take their course, the griever, perhaps still "remarkably reasonable and sagacious in some parts of his behavior," gradually succumbs to a "frenzy" in which the body rocks crablike, backwards and forwards, without purpose, the gaze lifts heavenward (as with joy), and the hands begin "beating the head or forehead, tearing the hair." "As if choking," the griever has trouble catching a breath but may, nevertheless, be overtaken by fits of "screaming, weeping, stamping."

In the spontaneous dramas of the city's public spaces as well as on the stage of the American theater, such expressions of feeling are governed, as strictly as dress, by ideologies of class, gender, and ethnicity. *The Art of Acting* reinforces a social hierarchy of emotional behaviors defined in the etiquette manuals by the "true gentlemen" and the "fine [lady]." Indeed, class and gender are both defined by these behaviors. The gentleman wears a public mask of "imperious passions"—giving orders, teaching, making judgments—that gives him an appropriately "authoritative gravity." He holds his eyes steady, the eyebrows "a little drawn over, but not so much as to look surly or dogmatical," and speaks slowly, distinctly, peremptorily. Only in private spaces, in the company of women, is he allowed to display more "suppliant passions": "a smiling, prepossessing yet anxious face," a demeanor distinguished by "beauty of form, elegance of manners, sweetness of voice, passionate eyes, and susceptibility of heart." Like the gentleman in William Sidney Mount's *The Sportsman's Last Visit* (Color Plate XXIV), he displays "perfect ease of deportment, even under the most embarrassing circumstances; manners that conciliate, and gain universal esteem; good breeding so disciplined as never to be thrown from its guard, or, except on the most extraordinary occasions, betrayed to the discovery of passions; a smooth and flowing enunciation; a bland gaiety of heart that no trifles can disturb; a flattering, yet not officious, attention to every person present; and all those charms of address and demeanor which cannot fail to win our affections." As the situation demands, he can shield his vulnerability either with his imperiousness or with a mask of "exterior charms which can steal upon and enslave the female heart."

Constructed as the sentimental paragon of True Womanhood, by contrast, the fine lady presents herself as a picture of the "suppliant passions."[15] Her life takes shape as a sequence of gestures. Displays of love, hope, joy, desire, all add to her beauty by intensifying her body's (and her clothing's) concertation of curves. To make herself more captivating in courtship, she might don (in private only) the mask of a coquette—an "ample mixture of delightful caprice," apparently spontaneous though in fact "perfectly at her command." Marriage, however, requires (like appearances on the street) masks of abnegation: a love tempered by piety, purity (the suppression of sexual feelings), submissiveness, and a complex mask of patient long-

suffering (grief ameliorated by love). The object of this visible syntax of sainthood is in part God, in part a man. For both, modesty, the outward form of purity, requires that the gaze be lowered "to the breast, if not to the feet of the superior character"; gratitude, the visible manifestation of submissiveness, propels the right hand to the breast and requires a look of "sincere and hearty sensibility of obligation." Piety manifesting itself in displays of solicitation, the believer "kneel[s] and speak[s] with ardor." Culture mirroring art as art mirrors culture, the demeanor of the True Woman thus makes her a sister of the slave, who must also assume, in encounters with whites, a mask of submissiveness in "look, word, [and] motion."[16]

Types of "the lower life"—country people and immigrants, for example—distinguish themselves from ladies and gentlemen by visible expressions of ignorance. After 1850, vacant eyes, "great slowness of mind" and movement, and an "apparent stupidity of . . . manner" make the rural husbandman, Jefferson's pillar of democracy, a comic figure, a rube. Uncensored expressions of violent feeling, like misuses of "proper" English, reduce such types to a place even farther down the social hierarchy. Only the low, for example, give public vent to displays of anger, in which, as in Richard Caton Woodville's *Politics in an Oyster House* (see Fig. 46), the head begins "nodding and shaking in a menacing manner," the teeth are bared like a dog's, and fisted hands flail the air. Pride is another graceless emotion: it "assumes a lofty look" comically subverted by a "pouting" mouth and (as with Stephen Crane's Pete, in *Maggie*) a strut shot through with a "slow, stiff, bombastic affectation of importance."[17]

At the very bottom of the emerging social scale, where moral corruption displaces social pathology, figural masks are reduced to the status of grotesque ruins. Drunkenness, murdering all fine feeling, makes the body the picture of a "human nature sunk below the brutal." Slack and torpid, apelike, the drunkard's body lolls. Like some of the figures in George Caleb Bingham's *The County Election* (see Fig. 15), life is drained from the face. The eyes go blank and half shut, the mouth spreads in an idiot smile, which might be punctuated, as moods suddenly swing, by "ridiculous" anger or "affected" displays of pride. These are mannerisms that nineteenth-century WASPs ascribe indiscriminately—and not necessarily as the product of alcohol—to African Americans in minstrel shows,[18] to the Irish and Germans in burlesques,[19] and to these and other ethnic minorities (Jews, Asians) in newspaper cartoons and genre paintings.[20]

PRESENTING SELVES: FIGURATION IN GENRE PAINTING

From portraiture to cartoon caricature, from improvised street theater to dramas performed on a proscenium stage and, by extension, from journalistic through travel writing and political discourse to belletristic narrative, nineteenth-century American figural art, too, participates in these layered and increasingly complicated dramas of self-presentation, and it, too, assumes—at least until the 1850s—a moral transparency that allows readers of figures to believe that the agitations they see signify actually felt emotions.

But it is figural painting, together with the mythopoetic characterizations of Herman Melville and Harriet Beecher Stowe and the lyric portraits of Walt Whitman, that gives dramatic expression, on a purely ideal plane, its fullest range and complexity of meaning. From about 1820 on, art-instruction books typically include at least a chapter on drawing the human figure; and some, like John Rubens Smith's *Picturesque Anatomy,* concentrate at great length on facial expressions and on the forms of muscles that give "picturesque expression" to the body by the way they "[contract] in length and [increase] in bulk" as the body moves. Contemporary viewers of painting, moreover, define the picturesque canon of painting as first and chief a figural art, in which representations of the body give moods their "hue" and "abstract intellectual qualities . . . their significant livery." American genre painting is also popular enough by the 1860s to warrant a long, thoughtful chapter in Henry Tuckerman's *American Artist-Lives.*[21]

Emphatic Similes: Disproportion and Caricature

In genre painting, many kinds and degrees of picturesque deformation can be pictured and imbued with layers of meaning, or effect. Comic genre painters in the United States are fascinated with physically disproportionate or irregular figures, especially the grotesquely thin, whose flesh both (barely) covers and reveals their bones; who, like Washington Irving's Ichabod Crane, a popular subject, display, on a "loosely hung" frame shovel-sized feet, "a spindle neck," a disproportionately small flat head with "huge ears," and "a long snipe nose" that looks like "a weather cock." Fat also fascinates for its fleshscapes of undulant ridge and ravine and its expressive tensions between strain and dilation. Irving's Van Tassel, his face "dilated" with contentment, "good humor," and fat, is a type also depicted, to less comic effect, in the genial beefy rustics of William Sidney Mount and George Caleb Bingham. Like Hawthorne, Poe, and Melville, comic and sentimental painters take a pronounced interest in amputated limbs and in bodies in other ways "used up."

Disproportions can be intensified by caricature. Some of the most violent deformations of the body in nineteenth-century American painting, David Gilmour Blythe's painted caricatures such as those in *Boy Playing Marbles,* in James Flexner's memorable summation, depict most of humanity as "squat and slug-like, wrapped in unlovely flesh, stupefied, like bloated leeches, with unhealthy blood" (Fig. 4). Blythe gives men of power aggressively jutting, grinning skulls and makes their bodies "semiskeletons possessed by demonic energy." For him, deformities are produced, even in children, by the ruined intelligences that are in truth produced by social oppression or by a universe inclined to make humanity the butt of cruel jokes. That dark vision makes him atypical of his contemporaries, who prefer the gentler, if still astringent, moral correctives of Augustan and LeBrunian satire. F. O. Darley's caricatures, Tuckerman observes, take the "natural language" written into their subjects' physiognomies as outward signs of moral deformities, the "funny image and the real person . . . indissolubly mingled to the fancy." An overbloated subject is thus reduced to "a galvanized dumpling bouncing on an imaginary steed"; a complacent one, to an "emphatic smirk."[22]

Fig. 4
David Gilmour Blythe,
Boy Playing Marbles,
c. 1858. Oil on canvas,
22 × 26½ inches.
National Museum
of American Art,
Smithsonian Institution,
Washington, D.C.

"Dishevelment"

Before mid-century, dishevelment is a deformation caused chiefly by physical labor or by environment and is a signifier of vitality. Portraits of women by Virgil, Milton, and Sir Joshua Reynolds, William Gilpin argues, are picturesque not the least by virtue of the animation that wind imparts to their hair.[23] Antebellum American genre painters (and writers) celebrate the dishevelments produced by physical labor and by exposure to the weather. Like foliage or lake water, clothes become sensitive registers of the effects of sun and rain. These and the frictions, abrasions, and erosions of physical labor turn them into beautiful corrugations of ridge and valley, in keeping with the landscapes in which they work. In the paintings of William Sidney Mount and George Caleb Bingham, boots, trouser cuffs and knees, and the elbows and necks of shirts calibrate the rhythmic stresses of stoop labor; waistlines and trouser pockets sag from these stresses as well.

Dishevelments thus function as signs of the relationship between environment and labor, but they can be, at the same time, dramatic expressions of human character. In Bingham's riverboatmen (see Fig. 40), shirts strain over thickly muscled arms and work-bent backs, as well as over waists thickened, no doubt, by the notorious overabundance of the nineteenth-century American table. And like their clothes, their bodies and faces are rough, open, unbound by decorums, genial, democratic. Shirts are assertively open-collared; sleeves, and sometimes trousers, uprolled. Senses of order and pride assert themselves in mended rips and patchwork. As with Salvator Rosa's red-shirted banditti and Whitman's roughs, splashes of brilliant color in shirts, vests, kerchiefs, hats are the visual equivalents of extravagant yawps. An unselfconsciously baroque sense of style gives hats a rakish tilt and skews cravats. Their clothes ripple like their bodies with joyful music.

After mid-century, with Victorian decorums emerging in American cities, the representation of dishevelment becomes more critical. Enoch Perry's *The True*

Fig. 5 Enoch Perry, *The True American,* 1876. Oil on canvas, 11⅞ × 16⅛ inches. The Metropolitan Museum of Art, New York.

American (Fig. 5), for example, demotes laborers to loungers and dozers. The picture summarizes satirically almost half a century of observations that it is Americans' notoriously bad posture that produces grotesque dishevelments of dress. The single upright figure is not at all upright, but draped like a sack over a windowsill. Two figures sit on their spines, a third on his hip, and yet another rides a chair backward, head and arms draped over the chairback. Feet rest on chair rungs, porch railing—anyplace but the floor. Scuffmarks and tobacco stains appear in improbable places, and the porch columns show signs of hackmarks from indolent knife blades. Every head in the picture, even that of the horse on the poster, has been lopped off by intervening objects. The children of Jefferson and Whitman, Mount and Bingham, have become mindless yokels.

In the clothing of slaves (and, after the war, of urban street children), meanwhile, dishevelment becomes an increasingly powerful sign of social oppression. In LeClear's *Buffalo Newsboy* (see Fig. 68), dishevelment is a kind of ruin. Straight lines and smooth textures have virtually disintegrated; inside and outside are intermixed, confused. Knees and elbows are visible through split seams and holes. Incongruously, soft surfaces have stiffened and hard surfaces softened, and every edge is warped and tattered. The obviously cast-off boots, absurdly long, have the look of tree roots or wrinkled cloth, toes bent permanently up, gaps exposing a rootlike toe. As on Charlie Chaplin's tramp, though not to comic effect, clothes so ruined as these disfigure the body and constrict its movements. The boots—though not the feet—are enor-

Fig. 6
Seymour Joseph Guy,
The Little Sweeper, 1870.
Oil on canvas, 8⅛ × 12⅛
inches. The Metropolitan
Museum of Art, New
York.

mous. The shoulders, pinched by a shrunken coat, seem tiny, skewed, rigid. As in Seymour Joseph Guy's *The Little Sweeper* (Fig. 6), the clothes are hand-me-downs. The contrasts between former elegance (dressy hand-me-downs) and present ruin, between past and present fit (too loose or long for the current wearer), symbolize the physical and emotional effects of disaccommodation and mirror with shocking harmony the disorders visualized in the environing spaces. Like the sweeper's dress, for example, the elegant stone post is covered with scars and smears.

Dishevelment in the portraiture of middle-class women is defined in yet another way by separate-sphere ideology as a sign of True Womanhood's labors with unruly children and unremitting housework. As Lilly Martin Spencer's *Shake Hands?* attests (Fig. 7), this ideology governs the work of female as well as male artists.[24] In postwar paintings of middle-class women, who are imagined to be liberated from physical labor, the disheveled look becomes, paradoxically, a fashion statement: picturesque art representing a picturesque art inspired by picturesque art. Even though she

Fig. 7 Lilly Martin Spencer, *Shake Hands?* 1854. Oil on canvas, 25⅛ × 30⅛ inches. Ohio Historical
Society, Columbus.

is in repose, the mother's dress in Spencer's *This Little Pig Went to Market* (Fig. 8),
for example, has the kind of animated vitality that characterizes Bingham's step
dancers. Folds take on the rhythmic energies of wrinkles, fringe the animation of
tatters, and colors add a darkly sumptuous vitality. Complex drapery and multiple
layers of fabric transfigure the mother's body into a screen or mask that reveals very
little of the body it hides.

Fig. 8 Lilly Martin Spencer, *This Little Pig Went to Market*, 1857. Oil on canvas. Ohio Historical Society, Columbus.

"Agitation"

More even than disproportion and dishevelment, it is agitation—which denotes not just discord but a broad spectrum of emotional effects—that characterizes picturesque figures in nineteenth-century American art.

The writing of American males (Irving, James Fenimore Cooper, Edgar Allan Poe, and Herman Melville) gravitates toward the sublime intensities of agitation, sharing with William Gilpin an attraction to late classical sculpture ("the Laocoön, the fighting gladiator, and the boxer") and to baroque painting and Gothic narrative, in which figures act out dramas of heroic struggle, martyrdom, religious ecstasy, and other grand *affetti,* their bodies caught in "strong, momentary action," their muscles "swoln by strong exertion," and their faces transfigured by such "tragic passions" as horror, terror, or grief.[25]

With some exceptions, however, American genre painting gravitates, like the writing of American females, toward the muted pleasures and discords—the "suppliant" and "imperious" rather than the "tragic" moods—of daily life. "Pleasure, mirth, laughter," writes William Rimmer in his drawing instruction book (addressing to painters the counsel *The Art of Acting* addresses to actors) are visualized by lines "elevated at the outer corner" of the mouth, nose, and eye. The discordant emotions of "[d]islike, anger, hate, malignity, rage, fury," by contrast, are expressed "eyebrows depressed at the inner corner, eyes horizontal . . . beneath them, nostrils elevated at outer corner, mouth depressed at outer corner" (Fig. 9). That is the expressive range he teaches, and, exceptions duly noted, it virtually defines the range represented in American genre painting. In genre painting, too, the suppliant emotions come to be associated with the lady, the imperious with the gentleman, and the discordant with the lower classes.[26]

Another emergent hierarchy in genre painting, less class-bound, is based on the complexities of the inner life. At their most elemental, as in Blythe's *Boy Playing Marbles* (see Fig. 4), figures are raw tissues of nerves responding to stimuli: unreflective, unaware of these effects, and therefore essentially pathetic. The bodies of figures more responsive to experience demonstrate benevolent feeling—if only, like Hawthorne's and Stowe's moral picturesques, incompletely and elusively. Higher states of consciousness produce effects at once more subtle and intense. Consider the fiddle player in Figure 40. His wrinkled clothing tells a history of weathering and manual labor (look at the boots!), but the wrinkles around his mouth signify a sweet geniality—a counterassertion of character and a visible cause or effect (or both) of the otherwise invisible music coming from the bow on his fiddle. What makes his life significant is a principle of goodness neither active (accomplished by good works) nor notional (known and believed) so much as emotional. The power of music over physical hardship is dramatized in the fiddler's tender embrace of the fiddle, in the delicate rhythms of the fingers as well as in the smile. In this as in other art of the sentimental tradition, character is exemplary precisely to the extent that the body is agitated, subtly, by benevolent feeling.

In still more complex characters like George Yewell's bootblack (see Fig. 70), agitation defines a consciousness characterized by "a direct sensuous apprehension of

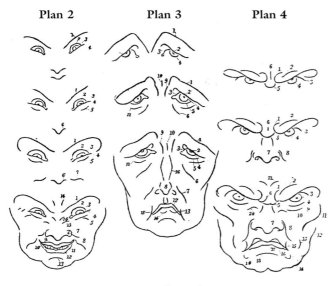

Plan 2 Plan 3 Plan 4

Fig. 9
William Rimmer,
Expression, from *Elements
of Design* (Boston, 1864),
plate 36. Courtesy Ameri-
can Antiquarian Society,
Worcester, Massachusetts.

Expression

Plan 2 Pleasure, mirth, laughter, all lines elevated at the outer corner.
Plan 3 Sorrow, suffering, pain, agony, all lines depressed at the outer corner.
Plan 4 Dislike, anger, hate, malignity, rage, fury—eyebrows depressed at the
inner corner, eyes horizontal from beneath them, nostrils elevated at outer
corner, mouth depressed at outer corner.

thought, or a recreation of thought into feeling." Habits of reflection as well as feel-
ing write themselves into the face.[27]

Contrasts of Status and Demeanor

Contrasts of color and texture create yet other kinds of expressive deformation in the
figure. At its simplest, the picturesque engenders an interest in physical marrings of
the flesh—in stains, blotches, scars that may be read either in moral terms or as a his-
tory of the impact of environment. The brow of John Neagle's *Pat Lyon at the Forge*
(Fig. 10) is reddened almost to a char, his cheek reddened and blistered, his jaw
streaked with black dirt. Interest in African-American faces, circumscribed by racial
stereotypes, focuses on the vibrant energy produced by contrasts between dark skin
tones, white eyes and teeth, and jets of bright color in the clothing. Interest in Indi-
ans recurrently centers on contrasts between the "classic beauty" of their bodies and
the "wildness" of their painted designs, which give skin the mixed character of nat-
ural pigmentation, decorated mask, and pictographic text, as in George Catlin's *Two
Crows, a Chief* (Fig. 11).[28]

As the semiotic layers multiply in painted figures, contrasts between body lan-
guages become capable of dramatizing conflicts, ambiguities, and counterassertions
of consciousness against environmental circumstance, imparting to figures some-
thing of the roundedness of literary characterization—as when some facet of beauty
(a curve, a smooth texture, a delicacy of form or color) or sublimity (dignity of bear-
ing, passion, a sense of mystery) reveals itself among the deformations of agitation
and dishevelment.

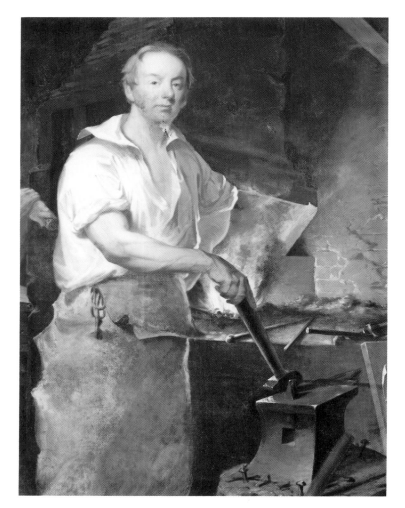

Fig. 10
John Neagle, *Pat Lyon
at the Forge* (detail),
1829. Oil on canvas,
68½ × 94½ inches.
Courtesy of the Pennsyl-
vania Academy of the
Fine Arts, Philadelphia.

Contrasts between dress (status) and gesture (bearing), for example, come to express differences between psychological and social typologies. The social status of William Sidney Mount's *Farmer Whetting His Scythe* (Fig. 12) is figured in his disheveled work clothes, including a collarless white shirt with its sleeves uprolled over red underwear. But the act of whetting the scythe calls forth from this beefy, rumpled figure an extraordinary grace. His hands are poised along the blade, his head bent to them in concentration, his face softened by a smile more visible than his sweat. As Mount presents him, he is not taxed but fulfilled by his work—the nearly effortless work of harvesting the prodigious bounties of the New World that his girth reflects. Wholly absorbed, he seems to be playing an ancient music (the posture rhymes with the figures of lyre-playing cupids in the picturesque canon). And if the position of his arms makes him a musician, the expression of his face makes him a listener as well. The "beautiful aerial warmth" of the sky and the distance makes his shirt and his face glow.[29]

Until mid-century, the figures of women in genre portraits, too, are ruddy and solid; their clothes disheveled, as in Spencer's paintings (see Figs. 7 and 8), by the physical exertions of domestic work. But these dishevelments, too, stand in sharp

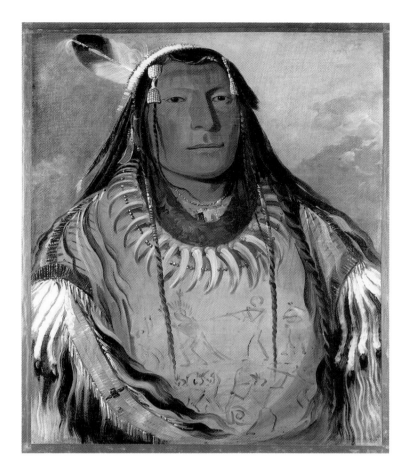

Fig. 11
George Catlin, *Two Crows, a Chief*, 1832. Oil on canvas, 24 × 29 inches. National Museum of American Art, Smithsonian Institution.

contrast to facial expressions. The idealized face of the woman in *This Little Pig Went to Market* has the sensitive, patient, and reflective loving-kindness of a Madonna. That of the woman in *Shake Hands?* is as awake, focused, reflective, mobile, and good-humored as the faces of Bingham's riverboatmen. These women, too, are presented as being spiritually elevated by their work.

As the second half of the century unfolds, painted figures take on an evident intellectuality. That is the case, for example, with the dreamers and fantasts who appear with increasing frequency. Children, as Patricia Hills observes, are pictured as dreamers of future adulthood by the superimposition of adult gestures. For boys, the dreams are of manly work. In Charles Caleb Ward's *Force and Skill* (Fig. 13), two barefoot boys enact the ritual of sharpening a knife at the wheel of a grindstone. Lacking manly force and skill, they have divided the task. Legs outspread, one supplies the force to turn the wheel; the other the skill of holding the blade against it. For girls, the fantasies gravitate toward womanly charm—rehearsals for a life defined by the male gaze. Seymour Joseph Guy's *Making a Train* (Fig. 14), as Hills observes, represents "a young girl stepping out of her dress in such a way as to create a train of drapery falling behind her." Guy lights her body and positions it so that her chemise has slipped over her shoulders, making "none too subtle" the picture's covert eroticism.[30]

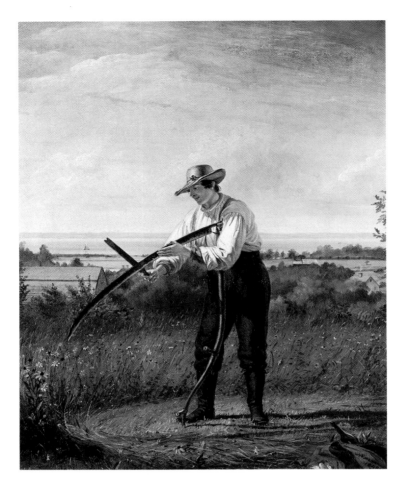

Fig. 12
William Sidney Mount,
*Farmer Whetting His
Scythe,* 1848. Oil on
canvas, 20 × 24 inches.
The Museums at Stony
Brook, Stony Brook,
Long Island, New York.

Characters in Groups

Pictorial characterization is further complicated by contrasts between figure and figure or, as I wish to show in Chapter 5, figure and environment (that is, setting). Situating figures in groups emphasizes their sociality. Situating them in crowded scenes defines them in terms of a social milieu. Like Whitman's New York scenes, Bingham's *The County Election* (Fig. 15) is so populous (almost sixty figures) that no single incident, figure, or small grouping dominates. Figures are defined principally by their participation in the democratic ritual of voting day.

Variety is the dominant effect in *The County Election,* but contrast plays a crucial role as well. The principal contrast is between the courthouse porch at one end of the crowd and the cake and cider stand at the other: the gravity of the vote juxtaposed against the levity of drink. Situated between these two synecdoches of American society, the figures participate in a multiplicity of incidents and effects, ranging from earnest political discourse and reflection to genial goodwill to drunken stupor.

The grouping is unified, socially as well as visually, by leitmotifs, among them white shirts, battered hats—working men in their Sunday best—though the candidates and their helpers sport top hats and cravats as well. And how many backs are bent, for different reasons! The dramatic coherence of the scene turns on a reiteration of the themes of deliberation (about the election) and the distractions of public spectacle: the cumulative effects of the love of games, alcohol, and various

Fig. 13
Charles Caleb Ward,
Force and Skill, 1869. Oil
on canvas, 10 × 12 inches
(30.5 × 25.4 cm). The
Currier Gallery of Art,
Manchester,
New Hampshire.

Fig. 14 Seymour Joseph Guy, *Making a Train,* 1867. Oil on canvas, 18⅛ × 24⅜ inches. Philadelphia
Museum of Art.

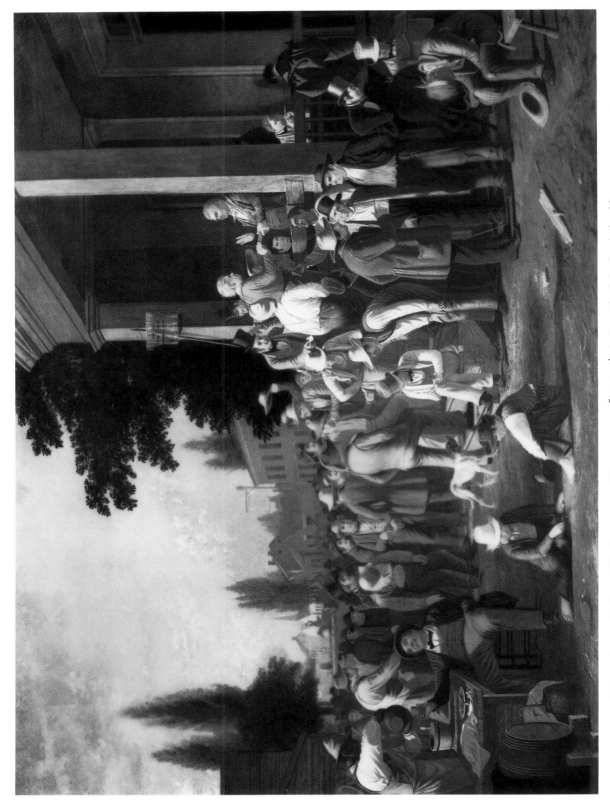

Fig. 15 George Caleb Bingham, *The County Election*, 1851–52. Oil on canvas, 35⁷⁄₁₆ × 48½ inches. The Saint Louis Art Museum.

forms of political discourse upon American political consciousness. The sequence begins with the stoned figure of the cider drinker, then gradually gains energy and momentum, surging finally up the steps of the courthouse to the oath-taker and the clerk, then "crashing down on the slumping back of a dazed and dejected drunken citizen."[31]

In this sequence, three smaller groupings act out particularly significant events. The principal grouping, which Bingham centers and lights with a catching light, gathers around the courthouse stairs, where voters, as Barbara Groseclose observes, are "collared by gabbling candidates or their agents at the penultimate moment of decision." On the porch at the top of the grouping (a hierarchy-within-the-hierarchy) are assembled clerks and judges. The top-hatted judge reading a roll draws the attention of a rank of spectators stretching across the picture to the man in a vest at the left. Nearer the foreground, lit by the catching light, is a political striker—"a distributor of tickets," as a nineteenth-century reader observes, "*very* politely tendering his services in that regard to an approaching voter." And at the apex of this grouping stands "a voter, a well-set Irishman in a red flannel shirt," hat doffed to the judge, the "thick pussy looking citizen who is swearing him in."[32]

In a third group of figures gathered around the cider stand occurs the painterly equivalent of auctorial commentary on the ritual of the vote. The stand exerts a less august power than the porch. Its three best customers, grouped in an open triangle across the foreground, embody the anarchic and self-destructive potentialities of this society of Missouri country people. The cider-drinker to the left visualizes the benign effects of drink: his face glows with good feeling and is split with a beatific smile. He has tipped his chair so far back that it threatens to topple. Positioning this figure near the beginning of the narrative sequence, Groseclose argues, Bingham purposely complicates his picture: democratic converse is fueled, but also sabotaged, by drink. One of the cider-drinker's mates, positioned at the other end of the triangle and at the end of the narrative sequence, has a bandaged head (from a debate turned brawl?). He sags forward, sick or enervated. Behind the cider-drinker, the third of this trinity of topers, unconscious, lolls sacklike in the arms of a man dragging him into the crowd.

Sequencing is a means of complicating themes. So, too, is foregrounding. As the grouping recedes from the middle ground, it dissolves into fragments and shadows. As it approaches the picture-plane, however, its constituent groupings and incidents increase in size, detail, and importance. Foregrounding gives added weight to Bingham's theme of alcoholic excess and to gambling and gamesmanship as well. Seated in the near foreground, on the street to the right of the cider drinker, two small boys remind the viewer of "the heightened challenges in a political contest as the game nears its finish. The game they play, mumble-the-peg, grows more dangerous and requires more skill at the end." These comic and critical vignettes are intensified by their contrast to the setting of the scene, which is dominated by "a majestically rising classic portico built of plain boards by Missouri carpenters." The architecture "proclaims the stability, vitality and expansion, the simple plebeian grandeur of the raw and powerful republic." Too many of the figures behave with less majesty.[33]

Bingham also makes his Whiggish criticism of the democratic process (or at least

of the Jacksonian Democratic process) with other details that elaborate and intensify the discords between social ideal and social actuality. "A man placed directly below the balloting," for example, seems to be flipping a coin. Echoing this voter's indecisiveness, "a mangy dog peers uncertainly at the crowd on the steps." A banner on the steps adds yet another signifier of the breach Bingham sees between political ideal and political reality. It reads: "The Will of the People the Supreme Law."

The least change in our point of view gives the whole world a pictorial air.

—Emerson, *Nature*

While its parts are copies of natural objects, the whole [picture] is an artificial arrangement similar to a poem.

—Samuel F. B. Morse, *Lectures on the Affinity of Painting with the Other Fine Arts*

[T]he composition of a [picture] . . . involves . . . its *general outline—grouping, effect of light and shadow—expression, color,* etc., all harmoniously agreeing together, all directly bearing upon its motive [theme] or subject.

—John Gadsby Chapman, *American Drawing-Book*

∞

An Art of the Scene

WELL-IMAGINED DISCORDS: THE PICTURESQUE AS A COMPOSITIONAL PRINCIPLE

As Chapters 2 to 4 have demonstrated, the picturesque is a grammar of images with layered effects. Chiefy, however, it is a strategy of composing pictures—scenes—in which the images are given definitive shapes and contexts. Picturesque composition counterbalances the values of complexity, variety, and contrast with a general unity of effect. "The true exercise of art," as Fielding Lucas states the case (quoting the English artist John Varley)

> consists in contrasting the round with the square, the light with the dark, the hard with the soft, the far with the near, the local and distinct with the general and indefinite, the distant actions of the vacant many with the composure of the near and contemplative few . . . in recumbent and reposing objects, opposed to rapid and gliding ones . . . ; and in . . . the judicious and skilful application of well imagined discords and incidents.

The precise strategy of picturesque composition depends on the effects desired: sublime pictures require the power of sublime images; beautiful pictures, the complex harmonies of beautiful images. Picturesque composition, John Gadsby Chapman declares, is the "proper admixture" and "skilful union" of these constituent images.[1]

In the structural terms that dominate nineteenth-century picturesque theory, the picture's unity of effect is achieved by four principles. The first, *balance,* requires that any mass on the left-hand side be set off against an apparently equivalent mass on the right; any mass in the foreground, set off against an equivalent mass in the background; and that the massed volume of light be set off against a roughly equal volume of shadow. Paradoxically, however, the second principle, *hierarchization,* assumes a kind of imbalance, for it marks—both structurally and semiotically— a principal effect and a "principal subject," to both of which all other images and effects are subordinated and related.[2]

Gradation—an "imperceptible" transition from "one form or figure to another, one local effect to another"—softens the contrasts between them. As yellow evening light melts into deep azure by "evanescent degrees," so gradations of color create easy transitions between light and shadow, and equivalent gradations are possible between, say, horizontal and vertical lines. This softening of differences, Chapman argues, produces harmonies between even disparate forms. So does the fourth principle, *repetition,* which relates forms by leitmotifs of line or color. In the well-composed picture, "every tint . . . put upon the background," Lucas writes, should recur in the foreground, with the middle ground constituting a gradation between the two.[3] Backgrounded mountains are thus rhymed with earth and rock in the foreground; blue sky with blue water; green forest with green tree. Even local color (autumnal foliage, a red shirt, a white house) added here, for the force of contrast, is to be answered there (a red sunset, white clouds).[4]

Some nineteenth-century American painters, we know, were influenced directly by these arguments;[5] many more compose in ways consistent with them. *Sunset in the Catskills* (Fig. 16) by Thomas Cole, a known reader of art-instruction books like Lucas's, is based precisely on a range of contrasts between hard and soft, between "the local and distinct" and "the general and the indefinite." No two forms, even trees, are exactly alike. The foreground is an orchestration of linear and textural contrasts between foliage, tree trunks, roots, flowers, the streambank, and the glassy water whose reflections double and vary them; the greens of the foliage vary and are intermixed with autumnal colors; and the play of light and shadow add to the complexity of the arrangement: some trees glow with the brilliances of a slanting backlight that silhouettes their branches; others are immersed in shadows. Distancing, too, varies the look of forms.

In its multiplicity, the picture achieves its unity by typically picturesque means. Dark shadow ringing the edges of the picture balances the two ovals of light in the middle. Curves gradate and soften the contrasts between verticals (the tree trunks, the mountains) and horizontals (the creek surface, the ridgeline). Curves also constitute a leitmotif that joins into an undulant serpentine the shaggy trees receding into the middle ground; joins the bend in the creek, its rippled surface, the curved boat, the trees and their reflections; joins to all this the wavy loom of ridges with their domed trees, the summits of Kaaterskill High Peak and Round Top that cut the still sky like shark fins, the aureoles of light, the clouds; as leitmotifs of blue join bright blue water to bright blue sky, golds join leaf to sunlight and so on. Curve and gold together orchestrate the picture's general effect of a beautiful repose.

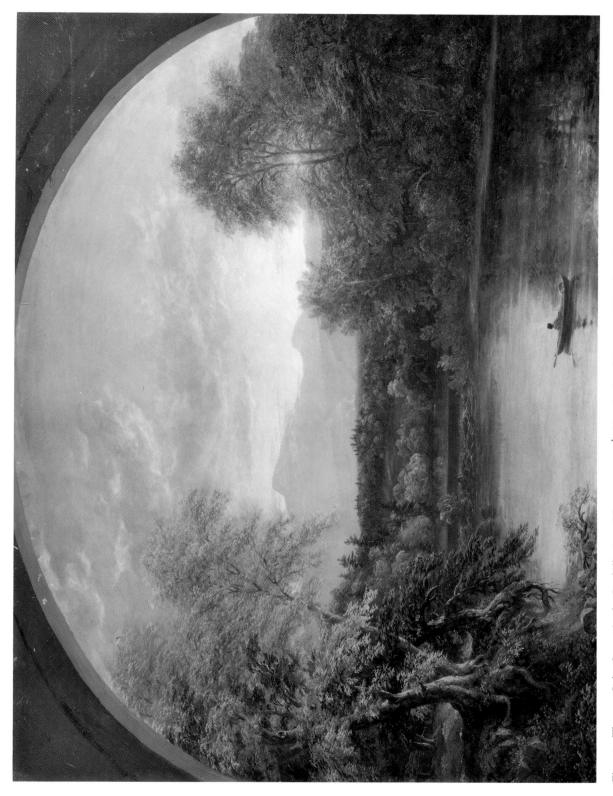

Fig. 16 Thomas Cole, *Sunset in the Catskills*, 1841. Oil on canvas, 22½ × 30 inches. Museum of Fine Arts, Boston.

In nineteenth-century theory, "structure" and "expression" are coterminous with each other and employ the same conventions. Thus repetition, a structural principle, also becomes the painter's equivalent to metaphor: a "visible analogy . . . to the acknowledged means by which things are held together"; and visual hierarchies (as I wish to show in Chapter 6) are the painter's means of plotting narrative meaning.

The most inclusive way of composing scenes picturesquely, however, is what I will call picturesque mise-en-scène: the art of transforming them into "a little spectacle framed off from everything else"—the art, that is, of *putting things into scenic form*. Mise-en-scène articulates both a picture's principal theme and its modal effects by means of perspective (point of view or spectator-positioning), framing, and lighting.[6] It is mise-en-scène that harmonizes the expressive meanings of images and adds force to the picture's general effects.

Two people, Nathaniel Whittock argues in *The Oxford Drawing Book* (in terms very similar to Poe's),[7] may represent the same subject—Stonehenge, say—with equal truth to appearances, but the knowledge of mise-en-scène makes one representation more legible and more powerful than the other. Mr. A's sketch of Stonehenge is the nineteenth-century equivalent of a snapshot. To get in "the whole of the stones, and likewise a great part of the surrounding country," he climbed a slope and positioned himself at "a great distance." Although he sketched and colored his picture with "great truth," his Stonehenge is shrunken not only by distance but also by the perspective. Swallowed up by the earth around it, the top of its largest stone makes only a small bump on the horizon line. And because Mr. A placed it, as he saw it, under a cloudless sky, the sketch has no animation. Flat light flattens the textures of the stones, draining them of the animation and the mystery of shadow. His Stonehenge is a minor incident in a monochromatic field of earth and sky. It is mimetically accurate but "tame" and "spiritless."[8]

Mr. C composed his Stonehenge more dramatically. He came so close to the stones that they become "gigantic," dominating the skyline and looming over the viewer. To accentuate textural contrasts, he threw a strong light on the central mass, subduing the rest with a middle tint and made a dark gray cloud rise as it rolls behind the stones, so that its looming darkness intensifies the light. The masses of shadow it casts around the stones are, like the stones themselves, "grand and imposing." Near one stone, he places an old shepherd, his "venerable form and white smock frock" giving him the grand "spirit of one of the Druid priests, who [has] come to visit the ruins of former grandeur."

That is Whittock's—and by extension the nineteenth century's—inductive definition of picturesque mise-en-scène: a perspective that groups the scene's forms and figures in ways that accentuate their effects; a frame that formalizes the perspective by defining the limits, and by extension the subject, of the scene; and a transformation of natural light into lighting that elaborates and intensifies the picture's general effect.

Each of these elements of mise-en-scène adds semiotic coherence and force to

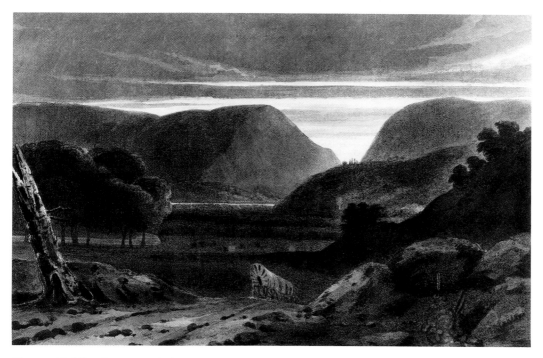

Fig. 17 Fielding Lucas, *Twilight: Passage of the Blue Juniata Through the Warrior Mountains. Progressive Drawing Book,* Baltimore (1826), color plate XII. Courtesy American Antiquarian Society, Worcester, Massachusetts.

the constituent images of the picture, as each contributes its characteristically picturesque tensions to the compositional dynamic of unity and contrast or variety. Mr. C's picture, though a product of Whittock's verbal imagination, might be said to use mise-en-scène to elaborate and intensify themes of power, duration, and change. Both his foregrounding and his monumentalization of Stonehenge by means of "a very low horizon" magnify its power by magnifying its bulk and height. His frame links Stonehenge to a broad sweep of turbulent sky; his lighting links sun, altar, and (by contrast) dark cloud, investing them with an aura of power and mystery. Lighting and framing articulate, almost as if by conjure, the Druidic view of nature that the architecture and the figure conceptualize. The old shepherd is a trope of Druidic culture, and his age (like the presence of Mr. C) implies the post-pastoral, as well as post-Druidic, culture that produces the picture itself. The picture is as much about time as it is about space.

If thematic congruities require congruent effects of mise-en-scène, thematic contrasts require contrasting effects. The point of view in Fielding Lucas's *Twilight: Passage of the Blue Juniata [River] Through the Warrior Mountains* (Fig. 17), as Lucas himself reads it, for example, intensifies a tension between the sublimity of mountains and the repose of an agricultural landscape. "The huge solemn mountains in the distance appearing more giant even, when contrasted with the narrow stream which following some convulsion of nature, has forced its passage through their midst—the broad low bottom and its quiet fields, the distant village and its curling and silent smoke, the scathed tree, the rocky foreground and the solitary mullen, all

join to create the sensation of perfect rest, the more perhaps, when contrasted with the wagon rumbling down into the valley: the only moving thing on the wide landscape." The lighting—the hazy, drizzling gloom of twilight in late fall, Lucas argues—is "admirably adapted" to intensify this juxtaposition of the convulsive and the quiet. So, too, are the atmospheric effects. A thick gloom erases distances, locking the eye and the mind claustrophobically into a space that "exhibits no prospect of comfort or cheerfulness"—except, mutedly, the smoking chimneys in the distance. Such correspondences between states of light and states of mind confirm Emerson's dictum that "every hour and change corresponds to and authorizes a different state of mind, from breathless noon to grimmest midnight."[9]

Lighting the Scene

As Mr. C's picture suggests, lighting is a particularly forceful way of setting mood in painting, and it is equally powerful in literature as well. The permutations of specifically picturesque effects of lighting may seem endless, but in fact they revolve around four atmospheric variations, each producing different impressions, "making us feel sad, or glad, or awed." The obscurities of midnight make sublime scenes more sublime. "Broad and vivid" passages of sunlight, particularly the rosy golds of sunrise and sunset, imbue what they touch with a radiant warmth; the silvery lights of mist and moon imbue it with a cool abstractness. The effects of other lights and shadows vary with their mass and intensity.

1. *Light and Shade Contending.* Moderately dark shadow, like that in Mr. C's Stonehenge or in Figure 18, "dignifies" what it tinges; but deep darknesses obscure and mystify; and chiaroscuro—the flashes of light-in-darkness produced, for example, by storms—agitates and even terrifies. As in Alfred Bierstadt's *A Storm in the Rocky Mountains—Mount Rosalie* (Color Plate III) the approaching darknesses and energies of scud or rain-cloud turn scenery "wild, stormy," and, at sunset, eclectically "grand," as one layer of clouds is often "entirely shut off from the light of the sun," and another "in its full blaze." Sometimes huge masses of cumulus "boil up from the horizon edged with gold." Under such conditions, forms like the house in Church's *Twilight* (Color Plate V)—whether engulfed in shadow and silhouetted by light or engulfed in light so that they stand out against the darkness, "light and shade in extreme contention, yet fully harmonized"—take on a heroic grandeur.[10]

2. *Ruddy to Raging Lights.* Ruddy light—as from hearth fires, stained glass (Poe), bonfires, or industrial mills (Rebecca Harding Davis)—is also variable in intensity according to the effects desired of it. Distant campfires produce local effects of warm repose, touching with umber the forms and figures around them, "as in Shakespeare's description of the camp-fires of the French and English." A small fire in the foreground (Color Plate IV) produces a well-lit "near scene," concentratedly intense, "variously broken" and the warmer and more intimate for the surrounding darkness, to which its edges are connected by "the beauty of gradation." Flames intensifying to a hot red rhyme with more violent agitations in human figures: "the hat waved," the body contorted, the lips of a "bawling mouth."[11]

Not surprisingly for a culture of wood, conflagrations—fire at its most massive and intense—produce some of the most sublime effects in nineteenth-century American art.[12] Raging fire creates hellish images, its furious movements imparting a monstrous life to things as its color turns them lurid. As flames take on form and solidity, bodies dematerialize into mirages, wraiths, grotesque demons. Hawthorne depicts a bonfire on Lake Erie where deep night extinguishes all signs of the world around it, except for the figures of Irish stevedores, so that it "waste[s] itself in the immense void . . . , as if it quivered from the expiring embers of the world." The men appear and disappear in its glow as they work:

> Sometimes a whole figure would be made visible, by the shirtsleeves and light-colored dress; others were but half seen, like imperfect creatures; many flitted, shadow-like, along the skirts of darkness . . . ; and often, a face alone was reddened by the fire, and stared strangely distinct, with no traces of a body. . . . [T]hese wild Irish, distorted and exaggerated by the blaze, now lost in deep shadow, now bursting into sudden splendor, and now struggling between light and darkness, formed a picture which might have been transferred, almost unaltered, to a tale of the supernatural.

When the stevedores throw sticks on the fire, they seem like "devils condemned to keep alive the flames of their own torments."[13]

Grand, too, though dreadful, are houses afire at night, especially as their "dignity of form" is devoured by the flames. "The bursts of fire from windows and doors, the illumination of the internal parts of a structure, and the varied force of the fire on . . . different materials" (form asserting itself, form dissolving) are all intensely picturesque, Poe observes, as are the reflections on still, dark water of burning ships: a mingling of "magnificence, grandeur and terror." He quotes approvingly the verbal sketch of a steamboat afire in Colonel Stone's *Ups and Downs in the Life of a Distressed Gentleman*, in which a furious fire is "stimulated to madness" by pitch and tar on dried timbers. Stone intensifies this effect with recollections of the "fierce conflicts in this spot—sieges and battles and massacres," when, with a horrible rhyming of the firelight, bloody water turns "red as the crimson flowers that blossom upon its margin."[14]

3. *Cool Lights: Cloud, Mist, Moon.* In contrast to these sublime effects, cloudy light, as in Martin Johnson Heade's *Newburyport Meadows* (Plate I) or John Frederick Kensett's *Bash-Bish Falls* (Color Plate XXII), cools the colors of the forms it touches. "[M]any a form, and many a hue, which in the full glare of sun-shine would be harsh, and discordant," Gilpin observes, "are softened, and melted together in harmony" by this silvery light. Mist, too, softens or turns forms into "a general mass of softened harmony . . . and sober colouring."[15]

The ultimate silvery light, that of the moon, imparts an "airiness" to forms, abstracting them into "bright obscurities on a darker ground" or, more subtly, into shapes outlined with silver threads; and in winter landscapes, snow, too, has a lunar effect, brightening the ground and darkening the sky. Even in familiar domestic

scenery, Hawthorne observes, the moon's abstracting light makes unfamiliar what it touches, giving forms, as meditation does, a cool insubstantiality. Familiar details— "the chairs, with each its separate individuality; the centre-table, sustaining a work-basket, a volume or two, and an extinguished lamp; the sofa; the book-case; the picture on the wall"—all seem to "lose their actual substance, and become things of intellect." For Emerson, moonlit spaces are the visible expression of Transcendentalism and the German fairy tales. For Hawthorne, they are "neutral territory . . . somewhere between the real world and fairy-land," where "the actual and the imaginary may . . . each imbue itself with the nature of the other."[16]

4. *Warm Lights: Sunrise and Sunset.* By contrast, warm lights, "offspring of the sun," invigorate what they touch. The "crystal-like" air at dawn invests the emergent world with great splendor and with an air of serenity, purity, and freshness particularly appropriate to the wilderness of the New World. In Cole's description of a sunrise viewed from the vicinity of South Mountain, a view he also represents in his painting *Sunny Morning on the Hudson* (Color Plate VIII), mist covers the Hudson Valley like a "drifted snow" through which jut the distant summits of the Berkshire mountains, as soft as "things of another world." Rising through its "bars of pearly hue," the sun kindles its lower layers and streaks its upper surface with tree shadows. The fields that appear where the mist breaks up are "exquisitely fresh and green," the dark mountains "sparkling," and the Hudson still asleep "in deep shadow."[17]

The slanting light of the rising sun, Gilpin observes, stains the tops of objects red or gold, while their lower parts remain "lost in a dark mass of varied confusion," as if they were natural types of the creation.[18] Like Hawthorne's coalfire, sunrise radiates a genial, benevolent light, sculpting forms into three-dimensionality, imbuing them (as Thoreau and Fitz Hugh Lane both observe) with the ruddy glow of living flesh.

Sunsets imbue scenes with splendor and mystery. Their "liquid gold" turns things iconic, as if sacralizing them; night shades, running at first like rills through sky and earth, intensify by contrast the splendor of the sinking light. For mid-century painters, sunsets, particularly tropical sunsets, are the opulent equivalents of baroque oratory or opera. Each of three kinds of sunsets colors the earth, as William Sylvester observes, with its "marvellous . . . transition of color." One is complicated by stormlight (Color Plate V). A second, attended by cirrus clouds, expresses a beautiful "repose, purity, . . . delicacy of color, and serenity of light" (Color Plate VI). The barlike clouds turn orange, then "the purest, faintest, golden yellow, with shadowed sides of pale amber." As the sunlight fades they are metamorphosed into amber threads, "without light or shadow—an infinitude of filaments . . . deepening in their amber towards the horizon." As night flows in, they recede into the gray repose of the atmosphere—a tint more or less evident in every sunset and "no less remarkable than the brilliant color." The nearly cloudless sunset typical of the Indian summers of the New World (Color Plate VII), as it is of Claude's Italy, is "the most poetical" of the three, for its "tenderest gradation of gold into grey blue, deep, penetrable . . . ether," leads "the rapt eye into depths *immeasurable as eternity*."[19]

5. *"The Poetry of Light."* Picturesque lighting has symbolic as well as modal effects. *Catching light,* for example, the natural counterpart of a theatrical spotlight, is a kind of pictorial synecdoche. Throwing parts of forms into brilliant relief, it expresses at the same time their "appropriate character" (Color Plate V). *Richness,* the interplay of highlights and shadows produced when slanting light spatters across rough surfaces in the foreground (Color Plate XI), is to "the outline of a form what the muscular structure is to the skeleton." More extensive masses of light and shadow add animation and mystery to scenes. Light explodes from rough surfaces in bursts of brilliancy or stipples and streaks what it touches. Shadows pool in folds and pockets. Brilliant light and deep shadow, hiding as much as they reveal, stimulate but also stymy curiosity, keeping it "alive and unsatisfied." In Salvator Rosa's *Rescue of the Infant Oedipus* (see Fig. 34), "the wild flashing of the lights and darks and the sudden contrast of the limbs and foliage of . . . trees" accentuate the sublime violence of the picture's dominant theme: "the exposure of the infant Oedipus upon a desolate mountain."[20]

Positioning the Viewer

Spectator-positioning (perspective, point of view) offers a similar range of possibilities, for scenes can be viewed, as later in film, from "any position or at any distance from the observer" and their constituent forms at any distance "from one another." Detaching pictorial from material form, spectator-positioning makes both space and images of forms as malleable as clay. It has the plastic power to shrink or magnify them by foregrounding or by sending them back into the illusory depths of the picture-space; to compress (foreshorten) or expand them; to destabilize and even to fracture them—unexpected aspects, behaviors, meanings.[21]

Every perspective, moreover, like every effect of lighting, engenders its distinctive effects. To position spectators at the corner of a house in the Federalist style, for example, is to transform into an unstable arrangement of verticals and diagonals—fragmented, say, by the intervening limbs of an old oak, and glowing, say, with the rosy gold light of a rising sun—complicating its classical beauties with picturesque ones. To position viewers below the house (so that it towers above them); to fragment it with a skeletal oak; and to obscure it with a midnight darkness, so that, say, only its flame-lit windows seem to have any substance, is to invest it with sublimity.

To the viewer in motion, the Reverend Warren Burton observes, space itself becomes plastic—a sequence of scenes "in continuous and mingled arrangement." Driving down a "well-wrought . . . courtly avenue" through a landscape garden, for example, has the same effect as reading "the ever novel passages of a romance" such as *Don Quixote,* where "new objects burst continually on the view, and the eye must be busy to catch them," while the mind wonders "what will come next, and where you shall come out." When "you at length emerge, the brighter light and the broad, clear lands seem like the happy conclusion of an uncertain story." At rest or in motion, point of view complicates "the *meaning* of forms" and scenes. Masking forms with other forms, centering or marginalizing things in the field, allows the omission of "every line in which no meaning is seen" and the inclusion of every line that resonates with meaning. No things but in ideas.[22]

Positioning imposes on the "natural picture" the matrix of orienting lines and points that give the "artistic picture" (the representation) its semiotic coherence and intensity. The best perspective is that which complements most powerfully the principal effect of a scene. For picturesquely beautiful effects, it is that point from which the principal forms are seen to compose themselves symmetrically, carrying the eye to the center of the picture—the repose of the forms reiterated in that of their arrangement. For more energized effects, the best perspective is off-center, the forms arranged asymmetrically, with, perhaps, a strong diagonal separating foreground from background (see Fig. 22).[23]

The choice of perspective, in turn, defines the scene's "proportion" (extensive or intimate), its limits, its principal subjects and effects, and thus its dominant themes. Visual perspective here elides into the subtleties of conceptual and ideological positioning implied in literary constructions of point of view.[24]

1. *Obliquity: Looking from an Angle.* In picturesque theory, spectator-positioning defines a three-dimensional relationship between viewer and subject. Laterally, it privileges oblique views, from the right or left of the subject, over frontal views and profiles. Obliquity presents forms in their three-dimensionality, revealing depth as well as height and width, but in so doing, destabilizes them. Viewed obliquely, even symmetrical subjects—ships, houses, faces—become asymmetrical: regularities become picturesquely irregular. Vertical lines remain vertical, but horizontal lines, subject to the laws of perspective, become diagonals, the most unstable lines in nature (Fig. 18). Parallel lines appear to converge. Details of similar size become dissimilar as the distant ones shrink and the proximate are magnified. Windows become lopped, tipped-over triangles, unequal in scale because they diminish as they recede. Discrepancies in size, by contrast, appear to vanish: that door back there is smaller than this window; this tree stump next to us, bigger than that house.[25]

2. *Tilt: Looking Up, Looking Down.* In vertical orientation (a range of relationships film critics call "tilt"), picturesque art privileges the view from above or below instead of that from eye-level—and this, too, for the energies it imparts to things. Forms seen from below—an arrangement produced by lowering the horizon line behind them—achieve the appearance of "a most gigantic size" (Fig. 19). Their lower extremities enlarged and their upper extremities foreshortened, they become, like Mr. C's Stonehenge, monumentalized: a Niagara Falls from Table Rock, a heroic sculpture on a pedestal, a Captain Ahab on his quarter-deck standing over an Ishmael.[26]

Forms lowered by raising the horizon line (as in Mr. A's Stonehenge), however, are diminished in both scale and power. They shrink, flatten out, and merge into the ground around them.[27]

Because of what it can mask and accentuate in a scene, tilt is also a means of visual plotting. Slightly depressed perspectives tilt the landscape downward, monumentalizing "the nearest objects" and lowering the most distant, "till they come almost level with the line of the horizon." Claude Lorrain's paintings (Color Plate x) thus monumentalize the trees and the figural narratives in his foregrounds and allow

Fig. 18
John T. Bowen, "Cottage with nearer part in strong light, and distant part in quiet, even tint of shadow, which makes it recede well." *The United States Drawing-Book* (Philadelphia, 1838), from fig. 9, color plate 18. Courtesy American Antiquarian Society, Worcester, Massachusetts.

Fig. 19
Fielding Lucas, Monumentalized figure. *Progressive Drawing Book,* fig. 9. Courtesy American Antiquarian Society, Worcester, Massachusetts.

A very low horizontal line increases the height
of any upright object, as in [this image], where the figure
is rendered of a most gigantic size, by representing the
horizontal line not much higher than the ankle.

the sky to dominate the background—a perspective wholly congruent with the importance he attaches to light. From more elevated perspectives, landscapes begin to take on the maplike features of the "bird's eye view" and to endow viewers with the psychological power that comes from being able to look down on things, as if they were spread at one's feet.[28]

The panorama offers a similar, if less dramatic, choice of vertical orientations. Low vantage-points from the beach, for example, as Chapman demonstrates in his *American Drawing Book* (Fig. 20), compact seascapes to narrow bands across the

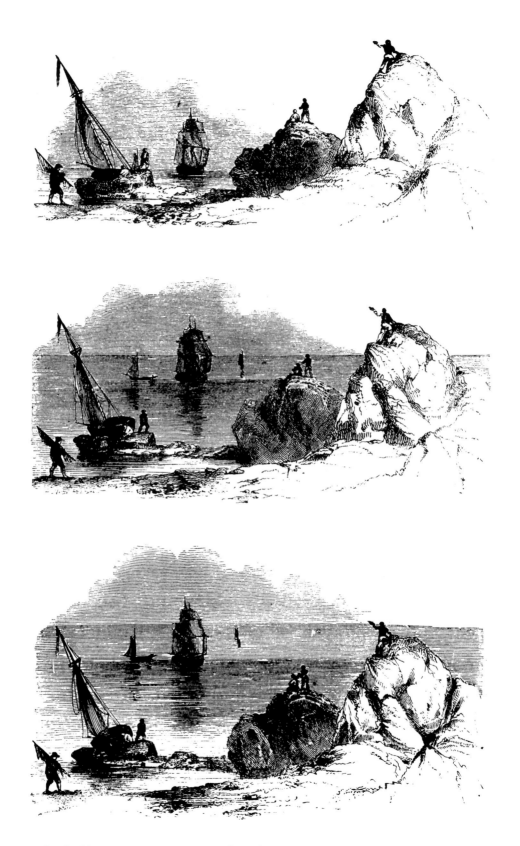

Fig. 20 John G. Chapman, Marine panorama from three viewpoints. *American Drawing Book* (New York, 1864), p. 132. Courtesy American Antiquarian Society, Worcester, Massachusetts.

bottom of the picture, masking the decks of ships while they monumentalize the hulls. Elevated perspective, as from a rocky outcrop rising above the sand (on the level of the figure standing in shadow), bring decks, revealing the actions of the figures on it. From the top of the outcrop, "the line of the horizon ascending with us," the sea (now expanded into "a vast perspective plain") becomes the picture's principal subject.[29]

3. *Foregrounding and Distancing.* Foregrounding, too, enlarges forms, as distancing shrinks them. "Sent back" into the distance as the viewer moves away from them, forms lose volume, then details, then richness of color, then even their outlines, so that, particularly in hazy or misty atmospheres, they seem to melt into one another. "Brought forward" as the viewer approaches them, forms first differentiate themselves from their environs, take on outline, color, volume, texture, detail, and finally—as they loom into the foreground—size. Detailed and richly lighted forms are by definition foregrounded.[30] Forms generalized and indistinct (characterized by a calligraphic scribble, say, or in literature by a noun alone) are by definition distanced.[31]

Foregrounding presents forms in all of their inherent intricacies of line, texture, color, light, and shadow. Radical foregrounding defamiliarizes them. Close up, a bird's plumage, for example, becomes a forest of feathers whose tufts and ridges break light into rainbows of colors and semi-tints. Foregrounding defines forms in all of their eclectic multiplicity of being and feeling, their signifying oppositions, their body languages. Its most radical expression, the portrait, tends to isolate forms from their contexts and even, metonymically, from themselves (as in facial portraits) and is thus a forceful expression of individualism. Distancing, by contrast, tends to socialize forms, defining them by their relationships to other forms and to their environing spaces. Radically distanced forms merge into more inclusive entities: trees and rocks become a ridge, houses a town. Distancing subdues, where foregrounding accentuates, energies; and accentuates, where foregrounding subdues, mystery. It softens the materiality of things, transfiguring the stony solidities of mountains, as Gilpin observes, for example, into "yellow streams of light and purplish tints" as tender and evanescent as lake water: "a sort of floating colour—always in motion—always in harmony—and playing with a thousand changeable varieties into each other" (Color Plates XII and XIII). From a distance, the slant of evening light dissolves mountain walls into pools of shadow interspersed with planes of light and color and, later, as the mountains are dematerialized by darkness, with glints of catching light among "grand masses" of shadow. Distant summits are the first things touched by sunrise, and as the light travels downward, it gives the whole mountain shape and fire.[32]

Distance may trick the eye in less benevolent ways as well. From a distance, Melville's Ishmael sees Queequeg, then Ahab, then the whale, incompletely and therefore indistinctly, and is able, therefore, to keep his prejudices and predispositions intact. Queequeg is, to him, a barbaric welter of dark tattoos on a dark skin that masks a dark intent; Ahab, a martyr; the whale, signifier of a murderous rage. Only with intimate proximity is Ishmael's vision altered, clarified, complicated.

Something similar happens to virtually every foregrounded form in a scene, because it is foregrounding, typically, that defines a picture's principal subject by endowing it with a "prominent place," scale, and complexity; and, by extension, distancing the other parts of the view makes them "accessory to, and dependent upon" the principal subject.[33] It is in these discriminations, as Chapter 6 will show, that the narrative plotting of the scene is grounded.

4. *Centering and Marginalization.* A foregrounded subject dominates the picture and commands the viewer's eye. A centered one is central to the meaning as well, just as marginalized (like distanced) forms are by definition subordinated. Like foregrounding, centering is a means of signifying a picture's principal subject. When one form is foregrounded and another centered, the subject may well be based on a contrast or variation between them. In *View on the Catskill, Early Autumn* (Color Plate XIII), for example, Thomas Cole centers a house, masking it with shadow and foliage so that it only gradually impinges itself on our sight, and foregrounds the figures of a woman and child. Centering makes the house—and the domestication of the environing landscape—one subject of the picture. Foregrounding makes the woman and child yet another subject, linked to the house by both symbolic and narrative syntaxes. The house demonstrates that the figures have come to stay, that they are inhabitants of the landscape. It also redefines the landscape: the natural wilderness that first appears to dominate the scene is both marginalized and sent back into the distance. Marginalization is a visual signifier of social as well as spatial status. Marginalization of the figures of women and African Americans, particularly in public spaces, for example, is a seme of their marginalization in American society. So, too, as the century progresses, is the marginalization of working-class figures when they are not being singled out for caricature.[34]

Defining the Scene: The Picturesque Repertoire of Frames

Painting offers to artists by the 1850s a nearly cinematic array of possibilities for making visual frames—including the vista, the panorama, and what I am calling the close-up—"consistent with the subject." Each wraps its forms and figures in a different "quantity" of space and therefore in a distinctive context, including (as I will argue in Chapter 7) a distinctive narrative context.[35]

1. *Deep Space: The Vista.* A window into deep space, the vista is the most well known and widely used of the frames in the picturesque repertoire. Its relation to the art of theatrical scenery is reasonably well established.[36] So is its nineteenth-century American history, since art historians have viewed it for some time now as virtually synonymous with Hudson River School painting.[37]

The appropriation of the vista by picturesque theory is also well established. The vista, William Gilpin observes, is most easily recognized by the way *sidescreens* of valley slope or trees or some other frame-within-the-frame limit the vista's lateral sweep and, like the screens on the wings of a stage set, lead the eye into its illusory depths. That journey is designed to navigate a sequence of three spaces definable ei-

ther as elements of a single scene or as scenes in themselves. The *foreground,* as Gilpin suggests, presents a close scenery of picturesquely broken ground—a round knoll, a slope, a rugged stretch of road or "some other part of nature equally grand or picturesque"—mottled with light and shadow and furnished with irregular groupings of trees and rocks, small, nervous, brilliant passages of water, and even, perhaps, human presences—figures and architectural forms, or fragments of them—all designed to give it "spirit, and agitation." [38]

The central feature of the *middle ground,* and therefore of the picture as a whole, is a lake or lakelike reach of river, with its curving alternations of point and cove, bay and promontory, its vertical rise and fall of bluff and beach, and the juxtapositions on its surface of reflected light and landscape with actual forms from islands and boats, to lake bottom. Clear water, along with the human eye, is the most sensitive, and thus variable, surface in the picturesque universe.

Finally, a mountainous *background* acts as terminus to this exploration of deep space. Both an amphitheatrical wall and a climax of sorts, the mountain (and indeed, the "background") is yet another signifier (with the very term "background") of the vista's inherently dramatic character.

Landscape scenery takes place within the boundaries of these theatrically defined spaces. Scenically, as Cole's *Sunset in the Catskills* demonstrates (see Fig. 16), the vista is a studied progression from the turmoil of the proximate to the luminous mysteries of the distant, from form to light and atmosphere, the visible microcosm to the visible macrocosm, the earthly to the heavenly, and it is therefore a perfect expression of romantic idealism. It is also a variable depiction of variable subjects. In sublime vistas, modeled after Salvator Rosa, forms get wild, brilliances lead into obscure darknesses, and the progression from near to distant is filled with visual surprises. In picturesquely beautiful vistas, modeled after those of Claude Lorrain, local color and light with electric and even "violent opposition[s] of colour, light, and shade" give the foreground an anxious effect that typically shades by degrees into a middle ground of tender and luminous tonalities: the radiant gold lights of sunrise or sunset softened, say, by a haze or mist that melts the edges of things and reconciles the anxieties of difference. The backgrounded mountains are transformed by the hazy brilliancies of sun and cloud into ranges of light that are doubled in the reflective water of the middle ground as their textures are doubled in the foreground.

2. Wide, Deep Space: The Panorama. By contrast, the panorama expresses with particular subtlety the sheer sweep of landscapes too "uninteresting," because too horizontal, to be privileged by vistas. Panoramas stretch laterally with great momentum so that their subjects seem to continue beyond the limits of the frame; at the same time, they recede into deep backgrounds terminated by a horizon itself typically flat, though it may be broken here and there, perhaps, by intervening forms—as it is, say, in Frederic Church's panoramic portraits of Labrador icebergs (see Fig. 54). Derived from Dutch painting, American versions of the panorama reach their apogee in the luminist painting of the 1850s through the 1870s. The luminist panorama is an exploration of the edges of the nineteenth-century landscape. In it, prairies are

reimagined and redefined as seas of grass; swamps, as magically and troublingly amphibian; the Hudson and other rivers as tranquil reaches, lakelike, reflective, rather than (as in vistas) cliff-walled rapids or falls. But the luminist sanctum sanctorum is the coastal landscape of the Northeast: William Sidney Mount's gold-green Long Island Sound; the alternations of concave sands and convex fingers of puddingstone in John Frederick Kensett's Newport and Nahant; the floating haystacks of Martin Johnson Heade's Newport and Newburyport salt marshes; Fitz Hugh Lane's pastoral and maritime Gloucester Harbor and his forested Penobscot Bay.

These panoramas constitute, to my mind, not a rejection but a maturation of picturesque values. They do not emphasize sublime effects. Even in the brewing panoramic storms of Lane's and Heade's late work (Fig. 21; Color Plate 11), the very horizontality of the panorama, framing the storms, adds a measure of repose as light adds a measure of grace. The storms remain more potential than kinetic; they loom ominously but do not strike. They are distanced, both physically and psychologically, across foregrounds of permanently luminous, permanently reflective space: the subjects of contemplation more than fear.

Panoramas are constructed, as Lucas and other writers of art-instruction books teach, out of the tensions produced by variety and a unity of effect derived, in picturesque fashion, from balance, gradation, repetition, and the hierarchization of subject matter.[39] Their very multiplicity of feeling and meaning points toward picturesque expression. Divorced for the most part from the Gothic dramaturgies and Burkean sublimities of the vista, the luminist panorama marries the proximate and the commonplace to the mysteries of deep space, light and silence—a world of softened sublimities and manifoldly beautiful effects that bespeaks the presence of picturesque eclecticism. In Fitz Hugh Lane's *Western Shore with Norman's Woe* (Color Plate XX), for example, the hard, dark, broken, mineral landscape, the deepening shadow, the autumnal coloring, the darkening of the sky, and the absent sun all contribute to an effect of elegiac sadness. Typically, however, this gradates into the radiant serenity of a warm sky and the only slightly creased smoothness of slack water in late afternoon. The placid air, its tranquillity accentuated by long bars of cirrocumulus cloud and by ochres, yellows, and pinks all doubled in the placid sea: the isolated boat with its arrested crew; Norman's Woe itself, cast off from the continent like a boat adrift; the boulders singly adrift along the shoreline; the canopies of foliage on the skyline: all complicate the serenity with congruent effects of preternatural solitude, stillness, buoyancy. In this picture, too, multiplicity requires, for coherence, the hierarchies provided by mise-en-scène. Only toward the margins, and mutedly, can the mood be called elegiac. The scene's repose is given center stage.

The (limited) variety of effects in this frame, too, derives, in large part, from picturesque conventions of mise-en-scène—particularly of lighting and spectator-positioning. The most reposeful effects of coastal landscapes, for example, as Lisa Andrus shows, are produced by a frontal view of the shore (see Fig. 71), which emphasizes horizontality, regularity, stability. Oblique positioning produces more powerful mixtures of animation and repose: viewed obliquely, shorelines are imbued with a movement to which surf adds fugal countermovements (Fig. 22). Shorelines that curve toward the picture-plane, however, tend to mute that effect. Shorelines erupting

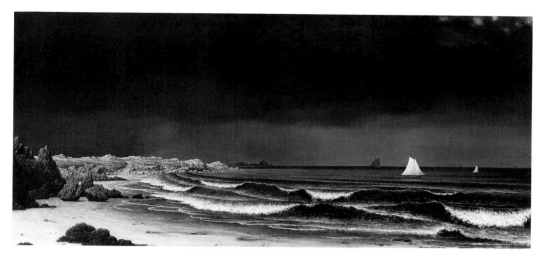

Fig. 21 Martin Heade, *Approaching Storm: Beach Near Newport,* 1860s. Oil on canvas, 28 × 58⅜ inches. Courtesy, Museum of Fine Arts, Boston.

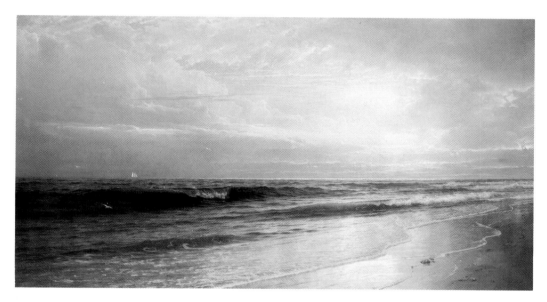

Fig. 22 William Trost Richards, *On the Coast of New Jersey,* 1883. Oil on canvas, 40½ × 72½ inches. The Corcoran Gallery of Art, Washington, D.C.

into headlands that weight them to one end intensify the effects of coastal scenery characterized, as in Maine and Newfoundland, by its eruptions of wind and water (Fig. 23).[40]

3. *Intimate Space: Interiors and Portraits.* If the study of light leads toward the panorama, the study of forms and figures leads toward the close-up, itself a repertoire in the picturesque repertoire of frames. Close-ups define their subjects as a "scenery of the foreground," giving them detailed definition as complex forms or figures. What nineteenth-century theorists of the picturesque called the "close scene" encloses its subjects in the narrower but often more intense context of a space no larger, roughly, than a proscenium stage. More radically even than the close scene, the por-

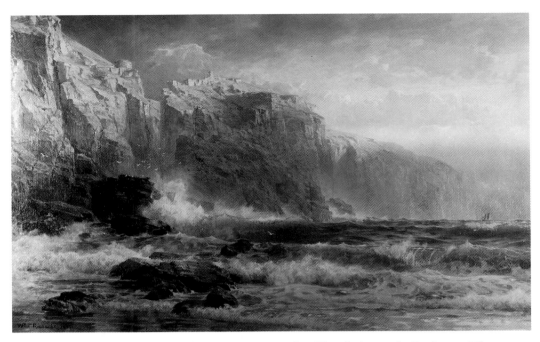

Fig. 23 William Trost Richards, *The League Long Breakers Thundering on the Reef,* 1887. Oil on canvas, 28³⁄₁₆ × 44⅛ inches. Brooklyn Museum of Art.

trait gives rise to fresh and prophetically modern strategies of design. Space contracts as the background approaches the picture surface. Muting interest in the picture's edge and the subject's environs, the portrait is a foray into microcosms. It confronts its viewers with enlarged forms—a house, a canopy of foliage, a pickerelweed—that loom into the foreground.

Approaching the picture surface, subject and composition become coterminous: the form *becomes* the composition—a "harmonious unity" of parts, as one instruction book puts it, with its inherent "adjustments of [the] . . . balances, reliefs, and effects" of its details, its congruent "disposition of light and shadow," and its "regulation of . . . masses of color." Lines in portraits take on the liberated character of drawing, and surfaces are capable of becoming as intricate as landscapes, as expressive (almost) as the human body.[41] The portrait can so radically foreground its subjects that they fill or even spread beyond its limits and are reduced metonymically to parts: forests become groves or screelike walls of foliage, for example, as humans become heads.

More needs to be learned about these variations of the close-up, the least-studied of the frames in the picturesque repertoire. Figural painting seems the most hospitable to the close scene and the portrait; topographical painting is drawn, clearly, to architectural portraiture.[42] But Gilpin demonstrates that the close-up is also an integral part of landscape painting as well. It occurs in nature: in rock- or tree-walled forest clearings, in grottoes, in streambeds; in foregrounds walled off by cloud or mist; at the turning of roads walled with earthen banks or foliage. Seventeenth-century Dutch painters, Gilpin claims, first defined such spaces as picturesque, devising compositions in which, for example, intricate patterns of light and shadow play

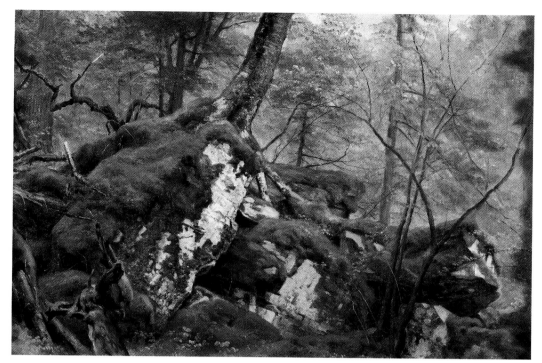

Fig. 24 Asher B. Durand, *Study of a Wood Interior,* c. 1850. Oil on canvas mounted on panel, 16½ × 24 inches. Addison Gallery of American Art, Phillips Academy, Andover, Massachusetts.

over such shapes as "the bold protuberances of an old trunk" tufted with foliage of different shapes, densities, and colors: a unity-in-multiplicity.[43]

And what is the career of the close-up in the other picturesque arts? The interior of a picturesque villa is a sequence of close scenes punctuated by vistas; so, too, is the Ramble in Central Park. *The Pioneers,* "Ligeia," *Walden, Moby-Dick,* "Life in the Iron Mills" are all composed as sequences of portraits and close scenes punctuated by vistas or panoramas. By 1840, feminine consciousness is characterized, in part, by its gravitation toward "little scenes and things," toward "the overlooked but indispensable detail"—a tendency evident in writers as different as Emily Dickinson, the Margaret Fuller of *Summer on the Lakes,* and the Miriam Davis Colt of *Went to Kansas.* Reduced to toting water for her fever-stricken family from several miles away, fever-stricken herself, Davis evokes repeatedly and at length the consolations of light on prairie grass, which blooms as her family dies.

> Sunday, August 17th . . . up this morning as soon as yonder sun sent his bright rays aslant the broad fields of grass, peering in between the logs of our cabin, tinging the pale cheek, for the moment, with the flush of health. . . . The yellow sensitive plant is all in bloom . . . with bright yellow flowers growing all along . . . the under side of the stalk. . . . The hop-vines, supported by saplings, are loaded with full-grown hops; and clustering all in among the green leaves of the grape-vine, is its rich fruit yet green. The prairies are still decked with flowers that come peeping up above the tall grass, as if asking for homage.[44]

By 1850, as panoramas also begin to make their appearance in luminist landscapes, Asher Durand's series of forest interiors becomes the first concerted experiment of the close-up in American landscape painting. In *Study of a Wood Interior* (Fig. 24), Durand treats foliage as permeable, three-dimensional arrangements of space and mass "in a measure transparent," so that simultaneously the viewer both sees it and sees into and through it. Like ruins, trees become signifying *assemblages* of solid and void, closed and open, inside and outside. After Durand's experiments, close-ups appear in Church's oils of rocks, trees, clouds; in the streambed interiors of John Frederick Kensett, David Johnson, William Trost Richards, and Aaron Draper Shattuck; and in Pre-Raphaelite portraits of ferns, pickerelweed, thrushes' eggs and other small natural forms by Fidelia Bridges, John Henry and John William Hill, and Thomas Farrer.[45]

Close-ups offer topographical and genre painters an equally intimate relation to domestic scenery. American topographical painters begin the portraiture of country houses by 1800, and not much later, genre painters begin experimenting with domestic scenes. As on the proscenium stage, genre painters erase the wall between inhabitants and viewers and, drawing from Dutch traditions, convert the remaining walls into *assemblages* of inside and (through doors and windows) outside, "idealized" spaces (as in hung paintings) against "actual" spaces; as mirrors and hallways or stairways juxtapose the rooms against other interior spaces. Within these expansive limits, figures play out scenes in a theater of domesticity ranging in its effects from ruinous disorder (see Fig. 62) to rural simplicity (Color Plate XXIV) to a nervous Victorian repose (see Figs. 63 and 64). At their most complex, these interiors become both metonymic projections of the inhabitants' consciousnesses (their states of mind, their status in life, even their histories of feeling) and synecdoches of the nation.[46]

COLE'S *VOYAGE OF LIFE* AND THE ART OF PICTURESQUE MISE-EN-SCÈNE

Picturesque strategies of mise-en-scène allow enormous conceptual and ideological freedom in the choice of subject and effect.[47] The possibilities are amply demonstrated in Cole's sequence of four paintings, *The Voyage of Life* (Figs. 25–28), for which he also acted (by means of letters and exhibition notes) as reader. The "poetical" theme of the series, Cole declares, is that of a life defined by four "antithetical" stages of consciousness, each defined by its congruent framing, positioning, lighting, and grouping.[48] Spaces alternate between the intimacies of the close scene and the depth of the vista; lights change from a placid morning glow to the chiaroscuros of storm light; and perspective is complicated by discontinuities between the focus of the spectator's gaze and that of the subject. All of these devices articulate, like the landscapes they give shape to, the history of a human mind.

The frame of the first picture, *Childhood* (Fig. 25), Cole explains, is that of a close scene designed to represent the "views and capabilities" of a child's mind. Both are limited to "a very small circle," because the child "neither looks back in the past, nor forward into the future." The focus of the child's gaze, locked as it is upon the rosy morning light and "the luxuriant flowers and plants" close by on the riverbank,

signifies, moreover, "the narrow experience of Childhood, and the nature of its pleasures and desires." And the flowers are both cause and "emblem," influence and subject of the influence, of "joyousness and wonder"—"the characteristic emotions of childhood" (Noble 287).

But the scene is not limited to the child's perspective. Cole allows the viewer to see things in this picture that his subject does not: the stream, sign of the child's destiny; the boat with its decorative "Figures of the Hours," sign of "the thought . . . that we are borne on the hours down the Stream of Life"; the guardian angel, sign of divine guidance; even the foregrounded Egyptian Lotus, yet another image "symbolical of human life." (Other flowers, perennials, give the shore the character of an Edenic garden.)

With this multiplication of perspectives, the narrative becomes ironic. Seeing what the child does not know as well as what he does, viewers are made aware of their own limits of knowledge as well. Immersed, with the painter, in a current flowing "directly towards" us, so that we are looking back at what is already past, viewers are positioned to resist the passage of time. The meanings of childhood become retrospective and narrative. A stream flowing "from a deep cavern, in the side of a craggy and precipitous mountain," Cole explains, is "emblematic of our earthly origin, and . . . mysterious," prenatal past. Strikingly like the space of the last picture in the sequence, it bespeaks an order neither beautiful nor temporary like Eden, but powerful and permanent, if void of organic life, like the walls of the New Jerusalem. Visible to the viewer but not to the child, the juxtaposition of cave and garden suggests an ironic discontinuity between the pleasures of the present and the mysteries of what precedes them, just as the positioning of the spectator suggests the brevity of the pleasures: we are being pushed away from Eden even as we look, into a deciduous, postlapsarian landscape, along the right-hand margin, in which things bloom and then die. Visible gaps between experience and intellection (here, memory) recur throughout the sequence.

In *Youth* (Fig. 26), the close scene gives way to the expansive frame of the vista. The subject's forward-looking gaze suggests a consciousness now defined by hope, and the character of the landscape—that "wide paradise" visible on first glimpse—projects this dreamy idealism. "The scenery of the picture—its clear stream, its lofty trees, its towering mountains, its unbounded distance, and transparent atmosphere—figures forth," Cole declares, "the romantic beauty of youthful imaginings when the mind elevates the Mean and Common into the Magnificent, before experience teaches what is the Real." Mise-en-scène and imagery both define the natural world as an objective correlative of hope: a picturesquely beautiful meld of repose and exuberant animation (the voluptuousness of the leafy surfaces; the warmth, even the occasional heat, of the colors; the expansiveness of the vista). In the "cloudy pile of Architecture" upon which the youth's gaze is locked, moreover, Cole depicts a young mind's "aspirations after glory and fame." This landscape is also the apparent cause of the changes in the figural grouping: the angel has left the boat, and the youth, "now alone[,] . . . takes the helm himself . . . in an attitude of confidence and eager expectation."

Fig. 25 Thomas Cole, *Voyage of Life: Childhood,* 1839–40. Oil on canvas, 52 × 78 inches. Munson-Williams-Proctor Institute Museum of Art, Utica, New York.

Fig. 26 Thomas Cole, *Voyage of Life: Youth,* 1840. Oil on canvas, 52½ × 78½ inches. Munson-Williams-Proctor Institute Museum of Art, Utica, New York.

Fig. 27 Thomas Cole, *Voyage of Life: Manhood,* 1840. Oil on canvas, 52 × 78 inches. Munson-Williams-Proctor Institute Museum of Art, Utica, New York.

Fig. 28 Thomas Cole, *Voyage of Life: Old Age,* 1839–40. Oil on canvas, 51½ × 78½ inches. Munson-Williams-Proctor Institute Museum of Art, Utica, New York.

Positioned behind the youth, the viewer sees this, of course. But positioned obliquely to one side, the viewer is also given to see what the youth does not: changes in the vegetation near him; a note of discord in the figure of the angel; a glimpse, through the woods, of an actual future that the youth has not yet seen or imagined. Only a touch of Eden remains as the landscape at left changes into deciduous forest. Its green leafiness, no longer perennial, is subject to not-yet-evident deformations of time, death, and winter. The guardian angel's face, moreover, expresses an anxiety whose cause is revealed beyond her outstretched arm. In "glimpses beneath the trees," the river, bending, enters a gauntlet of rock and roiling water.

That gauntlet is the setting of *Manhood* (Fig. 27). Here the frame contracts again, this time to represent an embattled and fearful mind as it responds to a hard, sharp-edged, hazardous, relentless, and apparently indifferent world: that of middle age. The "gloomy eclipse-like tone, the conflicting elements, the trees riven by tempest": these, Cole suggests, also represent the *agon* of mature consciousness, so that the landscape is both a synecdoche of human circumstances and the metonym of a state of mind. "Storm and cloud enshroud a rugged and dreary landscape. Bare, impending precipices rise in the lurid light. The swollen stream rushes furiously down a dark ravine, whirling and foaming in its wild career." The illusion of human control has also been wrenched away: the helm of the boat is gone, the voyager's shoulders are bent in defeat. Relieved only by splashes of silver light, the darkness of the scene gives it its "deep and abiding sorrow." The figure's mouth and brows magnify sorrow to the point of despair; the "[d]emon forms . . . hovering" in the darkness, Cole says, are designed to figure "Suicide, Intemperance and Murder; . . . the temptations that beset men in their direst trouble."

But the figure's face and body express a more divided state of mind. Despite terror and depression, the subject's uplifted eyes are filled with an "upward and imploring look" that figures a "dependence on a Superior Power." That "*faith saves him from* the destruction . . . seems inevitable." The viewer is positioned to see this salvation, as the voyager does not, figured in the placid water at the bottom of the fall.

Old Age (Fig. 28), like *Youth*, is a vista that both influences and figures a complex consciousness—battered, world-weary, but now hopeful and even composed. For the first time in the sequence, the subject and the viewer are looking at the same prospect. Artist, viewer, and subject converge in the recognition of a reality transcending matter. The world is now a saline wasteland, with "no longer any green thing upon it" and no succor in green things; "[p]ortentous clouds . . . [brood] over a vast and midnight ocean"; and "barren rocks," seen through the gloom, figure "the last shores of the world." Yet the "deep waters" in the distance are transfigured by a shaft of light. A line of angels leads the old man's, and our own, eyes up the unearthly "steps" in the shaft to a scene "such as the eye of mortal man has never beheld": the figure of an apotheosized Christ emerging from the center of a brilliant aureole, a beacon, a welcoming.

Cole's sequence of paintings is a representative sample of the semiotic possibilities that mise-en-scène imparts to natural or imagined images alike as it converts them into pictures.

The first requisite . . . of a composition is, that it should tell its story.

—John Gadsby Chapman, *The American Drawing-Book*, 1845

It is the quality of the incidents in the story which is to be told on canvas—the humor and the pathos—the grandeur or the beauty of the ideal . . .—that we should consider . . . as much as the mere *language* of the narration, the tones and tints, the glazing and the scumbling.

—William J. Hoppin, *Transactions of the American Art-Union*, 1847

∾

The Body as Narrative in American Genre Painting

TOWARD A "DRAMATIC PICTORIAL ART"

Painterly narration is limited by the literal stillness of its medium. Since painters cannot make their forms and figures actually move, narration is necessarily anachronic: the action is always impending or completed. The intention to act may be pictured, but not the act intended: "the threatening gesture, but not the descending blow." The consequences of action may also be pictured, but not their causes: "a fallen stone . . . but not a *falling* stone."[1]

Accepting these limits, Renaissance and Baroque Italian painters in the picturesque canon invented the Western conventions of pictorial narration. As settings for their narratives, they invented the picturesque landscape, with its hugely various array of possible effects, its impressionist style (no "incongruous ornamentation," no "jarring accessories") designed to concentrate effect, and its capacity to suggest motion by means of linear signifiers: running water by ripples; wind by "the direction given [by lines] to all flexible objects on which it operates"; and motion in animals and humans by "the natural position which hints at coming or completed action." Devising the conventions of mise-en-scène, they learned to construct landscapes that function, like stage sets, as spatial reinforcements of the picture's story. To enact the story itself, they discovered the conventions of dramatic expression—figures inscribed with facial expressions, gestures, postures, and costumes all acting as signifiers of the motives and the psychological consequences of

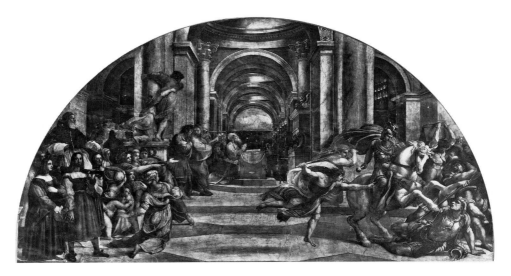

Fig. 29 Raphael, *Chastisement of Heliodorus in His Attempt to Plunder the Sacred Treasures of the Temple at Jerusalem*. Detail. Stanza di Raffaello, Vatican Palace, Vatican State.

action. By way of plot, they devised figural groupings in which one figure's expression could be read as the cause or effect of another's. Raphael uses the upraised arm of the archangel Michael, for example, to signify dramatically the impending *Chastisement of Heliodorus in His Attempt to Plunder the Sacred Treasures of the Temple at Jerusalem* (Fig. 29). Michael's whole body tilts with that arm. Hair streaming behind him, he is frozen in the act of charging at Heliodorus with an "unearthly . . . fire" and velocity, and Heliodorus's and his comrades' "cowering" postures bespeak their expectation of his "annihilating blow."[2]

This is James Jackson Jarves's reconstruction of the canonical art of pictorial narration. Samuel Morse's *On the Affinity of Painting with the Other Fine Arts* (1826) is an early version of this discovery; Jarves's *Art-Hints* (1855), *Art Studies: The Old Masters of Italy* (1861), and other books are a later and more detailed version of it; and together they both inform and anticipate narrative practice in nineteenth-century American genre painting.

Marking the Visual Path

In Morse's view, identifying the "principal subject" and the principal event of the picture is the first concern of narrative painters. These are typically given the privileged positions of the foreground and the center of the frame, and they may also be identified by lighting. Rembrandt's *Presentation in the Temple* (Fig. 30), for example, mutes the minor figures with shadow, singling out the foregrounded figures of the Holy Family and the rabbi with "an overpowering mass" of catching light—the painter's equivalent of the spotlight.[3]

Narrative coherence, Morse observes, also requires the inclusion of a visual path that leads the viewer's eye "from part to part . . . according to their . . . importance" in the narrative. Figural groupings are the chief means of defining the path; lighting may also be used both to draw the viewer's gaze along it and to control the speed of the gaze (and thus the pace of the plot), as well as to accentuate particularly sig-

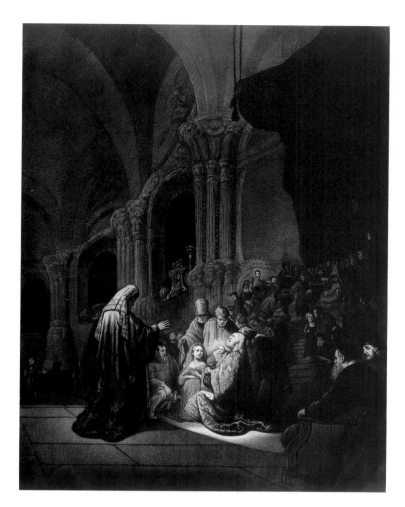

Fig. 30
Engraving after Rembrandt, *Presentation in the Temple*. The British Museum, London.

nificant images. This path is the painting's visual plot. In Rubens's *Mary Magdelene Washing the Feet of Our Savior in the House of the Pharisee* (Fig. 31), a strong light accentuates the figures of Mary Magdalene and Christ, slowing the viewer's gaze momentarily to allow an examination of their "expression." Then smaller pools of light draw the gaze, less slowly, past the other important figures in the picture. Near the middle of the group, above Mary Magdalene and the table, a shadowy track branching off from the main path ascends into the sky, where the gaze momentarily "los[es] itself" in the religious "mystery" that Raphael confers upon the central event. The illuminated forehead of the Pharisee at left center draws the gaze back to the last four heads in the sequence. In their varied expressions, Raphael figures a musical multiplicity of human responses to Mary Magdalene's act of homage.

Focalizing the Narrative

The visual path makes narrative intelligible; the principle of congruity makes it all-inclusive, relating every element to the scene and its anachronic narrative and, in the process, endowing it with a poetics of intensity. For Morse, congruity (or keeping) is a thematic, structural, and stylistic "consistency," established by leitmotifs, between images and the dominant effect. Jarves agrees: congruity is a semiotic "unity

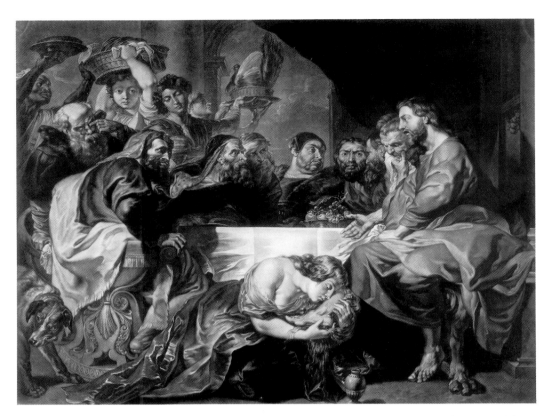

Fig. 31 Engraving after Rubens, *Mary Magdelene Washing the Feet of Our Savior in the House of the Pharisee*. The British Museum, London.

of feeling, thought and material" created by repetition. Repetition also serves "to raise the passion strongly which the mere narration would but faintly have excited."[4]

In turn, congruity becomes the means of expressing the dramatic unities of time and place. In Morse's view, the baroque propensity for crowding pictures with too many narrative incidents threatens coherence because it does not adhere to these unities. Jacob Matham's grisaille *Calvary* (Fig. 32)[5] is absurdly incongruous because it tries to represent "no less than five distinct *actions, five* different *times*" and has to picture the same place in three different places. Worse yet, its visual path (from bottom to top) violates chronology, offering no other logic in its place. First, mocked by soldiers, Christ sits naked on the cross; then He is "disrobed, buffeted, and scourged." After being bound to the cross and crucified, He is then seen, not yet crucified, staggering toward Golgotha, "with the multitude bearing his cross."[6]

Congruity, however, does not preclude multiple narratives in a picture. It only requires that all be related—if only as discordances—to the principal effect.[7] In *Landscape with Pyramus and Thisbe* (see Fig. 33), Poussin presents four separate incidents from Ovid's story in Book IV of *Metamorphoses,* Morse demonstrates, but each is not only linked in a chronological—indeed causal—path, but also is "related by Congruity to the [effect] of terror which he wishes to excite."[8] The unfolding consequences of the lovers' actions take on the logic of a processional coming toward the viewer. The war between the lovers' parents that caused Pyramus and Thisbe to flee their homes and their city is figured in the burning castle in the background. The

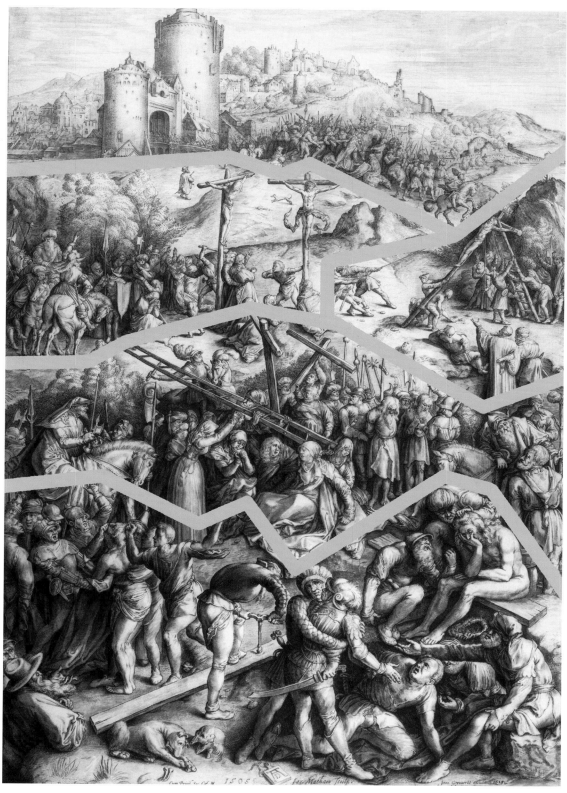

Fig. 32 Engraving after Albrecht Dürer (wrongly attributed), *Calvary*. The British Museum, London. By Jacob Matham. Lines have been added to distinguish the five incidents in Maltham's narration.

Fig. 33 Nicolas Poussin, *Landscape with Pyramus and Thisbe*. Das Städelsches Kunstinstitut, Frankfurt, Germany.

trials that follow on their exile are figured in the lion's attack on the horse in the middle ground (in Ovid, the signs of an attack make Thisbe kill herself, thinking Pyramus dead). And the foreground plays out (anachronically) the story's climax—the dead Thisbe and a Pyramus about to kill himself for grief.

Everything else in the picture is subordinate, and everything is linked to these events. "Related by congruity to the passion [the artist] wishes to raise," even the three settings are designed to "cluster round the deed." The lovers are everywhere displaced: their city is breaking apart; the wilderness they traverse is by nature assaultive (note the group of cattle fighting in the distance); and even the suicides are enveloped by a storm.[9] The picture reminds Morse of the setting of Duncan's horrible murder in *Macbeth*, which is likewise congruent with the action. The murder takes place at midnight, "the fittest [time] to conjure up every species of horror" the play conjures: the earth shaken by quakes as by a fever; chimneys blown down by wind; prophecies of fire; the apparition of "the air-drawn dagger"; witchcraft, wolf howls, owl screams, lamentations, "strange screams of death."

In painted narratives, Morse argues that style, too, must be congruent with "the thing expressed." That means not only an imagery but also a pace appropriate to the principal effect. Two kinds of visual syntaxes govern narrative pace—which is to say, the pace of the viewer's gaze as it moves along the visual path.[10] Fast, fragmented, minimal, suggestive, the pace of *Pyramus and Thisbe* choreographs the horror, terror, and obscurity of the sublime scenes it enacts. So, too, does Salvator Rosa's *Rescue of the Infant Oedipus* (Fig. 34). In both, juxtaposed contrasts—light against dark,

Fig. 34
Salvator Rosa, *The Rescue
of the Infant Oedipus*,
1663. Etching with dry
point, second state,
472 × 724 mm. Museum
of Fine Arts, Boston.

beauty against violence or deformity—make the gaze "jump" nervously "from one
place to the next," unable to anticipate what it will encounter next.[11]

The other syntax links incidents by easy transitions and gradual changes of color,
line, or light—that is, by gradations. Replicating a lover's gaze by the way it leads
the viewer's eye slowly and "gently . . . through every part," it leads the viewer to
anticipate the beautiful concordances between things. With this syntax, Claude
Lorrain's *Landscape with the Father of Psyche Sacrificing at the Milesian Temple of
Apollo* (Color Plate x) gives the light a fluid, tidal movement in keeping with its
mood and theme. A divine gift, the rising light enacts a genesis in its stately progress
toward the foreground. Distant mountains coalesce in the morning sky; mist marks
a distant bay and the course of a hidden river; glints on the water and the foliage mark
the light's progress toward the bridge in the middle ground. Pushing back night as
it approaches the foreground, it islands the dark trees on the right and then recedes
into deep shadows "to which morning has not yet come." But over the figures at the

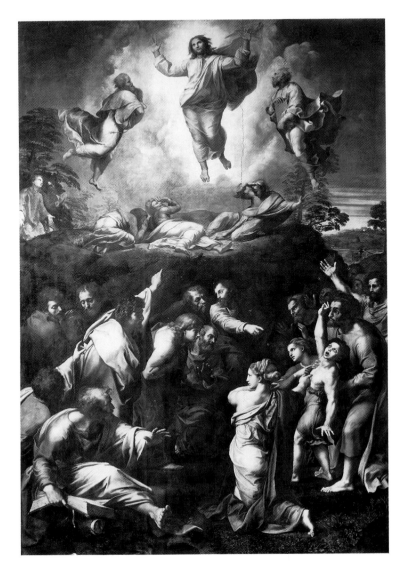

Fig. 35
Raphael, *The Transfiguration*. Pinacoteca, Vatican Museums, Vatican State.

left—the "devotees . . . preparing the sacrifice to Apollo, the god of morning"—it settles like an answered prayer.[12]

Complicating the Narrative

1. *The Multiplication of Events.* Congruity requires the dominance of a single effect in the painted narrative, but narration proceeds by variations and contrasts of effect—the visual equivalents of change and conflict. Americans embrace canonical paintings that evoke, as in *Pyramus and Thisbe,* a multiplicity of events—even apparently discordant events. In *The Transfiguration* (Fig. 35), Raphael yokes two apparently unrelated events from the Gospel of Mark—the Transfiguration itself and the spectacle of a boy stricken, the next day, by insanity—with radically contrasting effects. Yet they are not incongruous, Thomas Cole argues, because each incident is composed to illuminate the other. What would the Transfiguration mean, Christ "lifted from the earth like a bright exhalation," if it were not a consoling sign, to

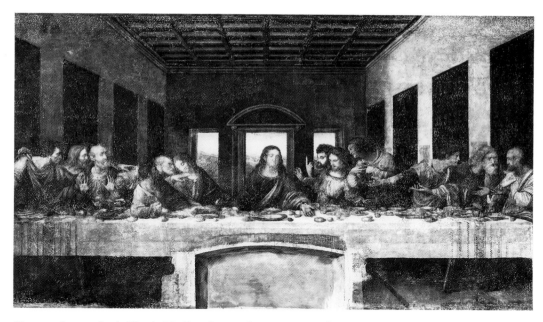

Fig. 36 Leonardo da Vinci, *The Last Supper*. Santa Maria Della Grazie, Milan.

people in grief, of Christ's divinity? And what would the lower part of the picture mean "if broken from the upper, so that if there were no source of hope?" The discordances of feeling that ripple through the crowd around the wild boy—"the distressed parent," "the unbelieving Sadducee"—are resolved in the figure of "the confident believer" who points up toward a radiant "Healer."[13]

2. *The Multiplication of Effects*. Jarves, too, is fascinated with multiple narration in the picturesque canon. The Italian masters frequently produce it, he observes, by including an audience of viewers-in-the-text such as those witnessing Raphael's transfigured Christ or Rubens's Mary Magdalene's act of praise. Their varying or conflicting body languages confer manifold meanings upon the events enacted.

Even speech-events can be complicated by this form of perspectivism. For Jarves, the exemplary drama of multiple effects is Leonardo da Vinci's *Last Supper* (Fig. 36). Leonardo focuses his story on the moment just following Christ's revelation that "One of you shall betray me" and just preceding Judas's unmasking as the betrayer: an action just completed and an action yet to happen. Leonardo pictures Christ's words in terms of their manifold visible effects—"horror, doubt, suspicion, . . . astonishment," acceptance—on the bodies of the apostles and of the speaker, Christ himself. "Some are stunned by the enormity of the charge; others are vociferous, indulging in violent gestures and powerful emotions." Some turn to Christ, some to each other, all "eagerly questioning as to whom [the statement] applies." Even the still-life expresses the shock of the news: the dishes on the table are scattered, cups upended.[14]

What gives these ripples of effect "a feeling and power such as no other artist has ever rivaled," Jarves argues, is Leonardo's treatment of the principal figures. Christ shows himself "meekly obedient" to the "foreordained Destiny" denoted in His

words. John's face reveals his fidelity both to Christ and to Christ's teachings, but it also defines a more divided, a more human, response. On it a painful anguish at impending loss erodes a look of serene joy at Christ's presence. The expressions of the other apostles, for all their variousness, are linked to John's and sounded by it, as John's expression is sounded by Christ's.

The exception in this plotted cacophony is the "hypocritical" face of Judas, isolated, alone, leveling on Christ with a "sinister gaze . . . for further indications of discovery." He has already masked himself—but not completely. The betrayer betrays himself. Near one hand lies "the ill-omened salt," overturned by his "convulsive start" at Christ's announcement. Now the other hand "involuntarily" approaches the dish to which Christ will shortly refer when He makes the second revelation: "'It is one that dippeth with me in the dish.'"

3. *The Visualization of Conflict.* Varying perspectives multiply the meanings of events. Contrasting responses, like those among Raphael's witnesses to the boy's

seizure, make the meanings of events ambiguous, paradoxical, even contentious. Titian's *Death of Saint Peter Martyr* (Fig. 37), Jarves observes, defines its titular event, as a paradox. Peter's death is, first of all, an act of assassination—sudden, terrifying, horrific. To intensify these effects, Titian focuses on the second victim, the wounded monk at the left, who rushes forward, "the speed of his movement made graphic by the streaming of his heavy clothes." "Confused and not knowing where to go," his eyes gape with terror. The setting elaborates and intensifies that terror. Convulsing as if in sympathy with the panicked monk, it is filled with fearsome energies and discords. The leaves of the forest, Jarves notes, have turned "spectral" and are jostled by a night wind that "moans" through them. In the far distance, just perceptible among the troubled leaves—and a nightmarish personification of them—"an affrighted horse and rider fly . . . the crime." Such details as these allow Titian to define the violence subtly, without reducing his narrative to pornographies of "ghastliness and . . . gore."[15]

In the figure and vicinity of Peter, the whole event assumes a very different character. Peter himself is invested with the signs of a double consciousness—the visual trope of martyrdom. Even while his hands are raised to ward off the assassin's knife, his eyes have lifted up, along a second visual path, toward a "mysterious opalescent light" that descends from the top of the picture. In this celestial light, haloed angels materialize, "waiting to welcome the spirit of the martyr with crowns of everlasting joy." The assassination is transformed into an apotheosis.

PICTORIAL PLOTTING IN AMERICAN GENRE PAINTING

Anachronicity

Like its Italian exemplars (and like more recent influences from the Netherlands, England, and France), American genre painting clearly aspires to the status of a dramatic pictorial art. Accepting the limits of anachronic plotting, it, too, concentrates on the "momentary transitions" between actions passed and actions to come. It, too, intensifies these moments with congruencies of setting, mise-en-scène, and style.[16] And it, too, gravitates toward psychological narrative: backgrounding causes; foregrounding their effects upon "the action and expression" of the principal actors; and complicating these effects by a multiplication of perspectives.[17]

But like its Dutch models, mainstream American genre painting applies these conventions to a subject matter decidedly secular and democratic. It turns away, for the most part, from the religious and mythical subjects and elaborately intense *affetti* of Italian figure painting and even from the monumental (and aggressively masculine) battles and quests of history painting. Some literary genre painters, to be sure, gravitate toward these sublimities. In John Quidor's renderings of scenes from Washington Irving's prose narratives—stories in which comic characters suddenly encounter the ineffable—the agitations of terror produced by the encounter take on an expressionist intensity. "Through spidery evergreens, blasted tree hulks, and knuckled roots," James Flexner writes of *Ichabod Crane Pursued by the Headless Horseman* (Fig. 38), an Ichabod dressed like a scarecrow "gallops towards [a] ghastly

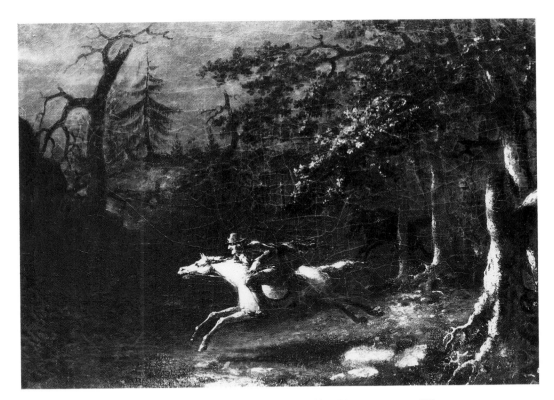

Fig. 38 John Quidor, *Ichabod Crane Pursued by the Headless Horseman*, 1832. Oil on canvas, 22⅝ × 30¹⁄₁₆ inches. Yale University Art Gallery, New Haven.

incandescence." The glare splashes over the rider's face, "a hatchet-mask of terror." "But whatever waits unseen ahead can be no more terrible than what rides behind: a topless human trunk"—the headless horseman, his head in the crook of his arm, its "oversized booby face staring with idiotic amusement" at Ichabod's terror.[18]

Mainstream American painters, however, are drawn more to the small harmonies and discords of daily life than to night-terrors; more to moods of quiet pleasure or gentle comedy than to awe, terror, or rapture. They value events more as signs of social arrangements than as revelations of the ineffable.

A Poetic of Intensity: The Concentration of "Idea and Effect"

"The story must be well told," Mount tells himself in his journal; and that means maximum "[c]oncentration of . . . idea and effect." The figures must be grouped along a coherent visual path and nuances of character and incident inscribed concertedly into "the striking and expressive parts" of the body: "the stamp of the foot, the head, the elevation of the hand." Lighting, spectator-positioning, and framing must all serve the dominant theme and its effects. "Thought and color" also "travel together"—costume rhyming with countenance. Where faces are "lively and cheerful," let the dress be "gay and rich in colour"; and where they are "pale and sad" (in mourning, say), give it "a subdued splendor or a somber cast."[19]

For Mount, style too must serve effect. In his *Dance of the Haymakers* (Fig. 39),

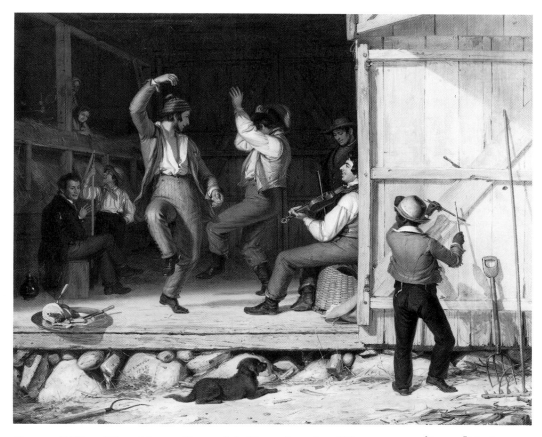

Fig. 39 William Sidney Mount, *Dance of the Haymakers,* 1845. Oil on canvas, 24½ × 29⅞ inches. The Museums at Stony Brook, Stony Brook, Long Island, New York.

the violin radiates a joyful air—a visual correlative of sounds that can be heard as well in colors, in the very lines. Every body and every thing is a response to its music. Everything *is* music—even the young man excluded for his color, even his shadow on the barn door; and everything is dance, even the tines of a rake and a pitchfork. Even the slicemarks on the ham on the barn floor "spiral and pirouette."[20] Dozens of paintings of the 1830s and 1840s—most memorably by Mount and George Caleb Bingham—seek to picture music in similar ways. In Bingham's *Jolly Flatboatmen* (Fig. 40), the formalized exhilaration of the step-dance, the well-fed, work-bulked bodies of farmers and rivermen become the music. Broad backs arch; arms rise and bend, fingers up-pointing; knees rise and bend, toes pointed nicely down. Smiles, out-streaming hair, rippling shirts and kerchiefs all form curves as flowing and tremulous as fiddle sounds. The pleasure of it all curves mouths into smiles.

A Poetic of Complexity

Mount's *pirouetting* ham also demonstrates the commitment to a congruity complicated—"worried," as musicians say—by variety and contrast. By their very discordance, an anonymous critic argues (as Poe does of picturesque narrative), comic touches intensify "the motive" (that is, the motif or theme) of the picture. Even

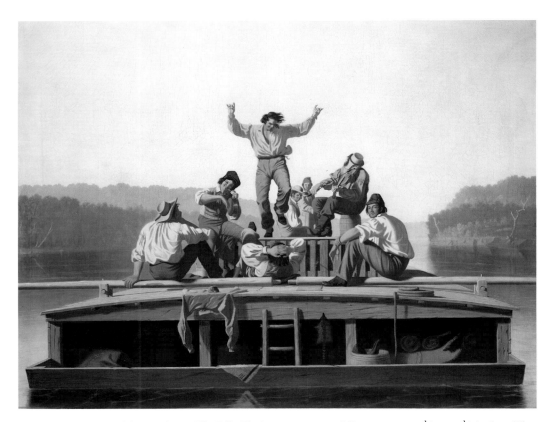

Fig. 40 George Caleb Bingham, *The Jolly Flatboatmen*, 1846. Oil on canvas, 38⅛ × 48½ inches. The Manoogian Foundation, Taylor, Michigan.

when the subject is serious, "and the feeling it naturally awakens is of a thoughtful character," touches of "grave, quaint humor" can be made to harmonize with the effect—though "grotesquely it may be."[21]

1. *Reflexivity.* Until the Civil War at least, American humor, including visual humor, is a powerfully subversive force. American genre painting, as Elizabeth Johns has demonstrated,[22] is filled with sight gags, puns, and *trompe l'oeil* illusions designed to undercut the artificialities and banalities of decorum, including decorums of language. That is the effect of John Carlin's *Salts Ashore (After a Long Cruise)* (Fig. 41), a bedlam of visual puns. One drunken sailor is upsetting an apple cart; another's eyes are fixed upon a sail-like sign reading "SALT-PROVISIONS," under which civilian clothes are displayed. Taking an immigrant's perspective, the Irish Carlin stands American nativist ideology and behavior on its head. By means of an iconography derived from cartoon caricatures but here toned down, the woman stroller is represented as black, the clothes merchant as Jewish, and the apple vendor as Irish. These ethnic immigrants, however, play the roles of citizen-victims. It is Yankees, sailors off a ship called "NEW YORK," who play the roles popularly ascribed to immigrant hooligans.

In paintings about painting, humor becomes a way of making narration reflexive (about itself) as well as subversive when it visualizes the instabilities of meaning on which the authority of art is based. David Claypoole Johnston's *Wide Awake—*

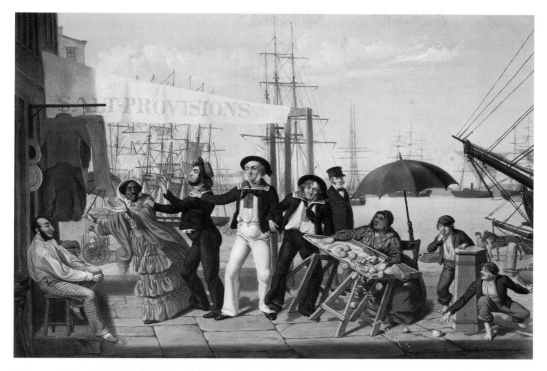

Fig. 41 John Carlin, *Salts Ashore (After a Long Cruise)*, 1857. Oil on canvas, 20 × 30 inches. The Metropolitan Museum of Art, New York.

Sound Asleep (see Fig. 42) paints an artist-jokester painting a face on the bald head of a sleeping man. Just enough of the victim's "real" face appears to expose reality as itself an artifice. The sleeping subject's head—the work of two artists: the one represented and the one (Johnston) representing him—is a mirror image in which back becomes front, and everything except an ear is endowed with a doubleness. A fringe of hair on the one face becomes a beard on the other. A mouth down-turned in sleep (the mask of tragedy) becomes upturned in a smile (the mask of comedy). As closed eyes open, "sound asleep" becomes "wide awake." Even the setting comments on this elaborate joke: the name of the company on whose dock the joke takes place is "Marker and Sleeper." In yet another comic turn, the art of graffiti upstages the art of painting. The comic whimsy of the graffitto is able to cover a "baldness" (that flat, unornamented surface abhorrent to students of the picturesque) that Johnston's mimetic art can do nothing about.

In *The Painter's Triumph* (Fig. 43), Mount defines democratic art as an oxymoron. Positioning the viewer so that the painting on the artist's easel is masked, along with four other canvases turned to the wall (a fifth, facing us, is partly obscured), he defines painting as, not a product, but a communication that is part teaching, part sales pitch. The painter discourses excitedly, his inaudible language explaining his invisible images. It is his body that speaks. Poised like a fencer or a dancing master, he is an exemplar of the new urban decorums. His "triumph," it appears, is the transformation in his viewer-auditor. Hands on knees, whip across one thigh, the stolid farmer has been sold. His face is a mask of slightly excessive and awkward benevolence, as if charmed, though not used to being charmed, by an infant or a foal.

Fig. 42 David Claypoole Johnston, *Wide Awake—Sound Asleep,* c. 1845. Oil on canvas, 17⅝ × 21½ inches. Collection of Mrs. H. John Heinz III.

Art has power to infuse even the stolid husbandman with feeling. Yet this ambiguous and momentary triumph of democratic art comes at a cost. The face in the single visible picture-within-the-picture, an Apollo, exemplar of classical ideals and witness to the transaction, is turned away as if in disgust.

2. *Multiple Perspectives.* As with canonical painting (and as with Hawthorne's scarlet letter and Melville's whale), the figural subjects of American genre painting are imbued with effects multiplied by their dramatic contexts, their visible histories, and their reception by viewers-in-the-text. The open trunk in the parlor in Richard Caton Woodville's *The Sailor's Wedding* (see Fig. 44) clearly signifies the approaching departure of the justice of the peace, whose belongings are packed into it: he is leaving his digs. Yet the smile of the bride as she gazes at the trunk suggests something about her forthcoming move and the change of status that goes with it. She seems to have appropriated it as a prop in her own fantasy.

Similarly if more complexly, the varied responses of thirteen spectators and participants in the picture worry the very idea of a sailor's wedding, defining it neither as sacramental nor solemn and celebratory, but as a spectacle at once comic and pathetic. Clearly the wedding party has appeared suddenly, unannounced—hastily set into motion, presumably, by the sailor-groom at the end or beginning of a long cruise. The picture plots a moment of transition between the arrival of the wedding party and the anticipated marriage. The would-be groom waits at awkward pause,

Fig. 43 William Sidney Mount, *The Painter's Triumph*, 1838. Oil on wood, 19½ × 23½ inches. Courtesy of the Pennsylvania Academy of the Fine Arts, Philadelphia.

his impulse arrested, as the best man negotiates with an obdurate justice of the peace, who seems disinclined to legalize the impulse.

The group of four smirking, elbowing onlookers crowded into the doorway gives this moment the character of comic theater. The household's responses define it, by contrast, as an intrusion to be ignored or resisted or a diversion from domestic duties to be welcomed. Having put down a jar of pickles on the broad windowsill, the "little daughter" of a maid, as Henry Tuckerman reads the scene, now "stands with it in her hands forgetful, absorbed in delighted wonder at the smart appearance of the bride," as the bride is absorbed, dreamily, in the trunk. Knife and fork in arrested motion and truculence knotting his forehead, the justice is decidedly less enchanted. "[B]y no means pleased at the interruption," he is "hesitant as to whether he will splice them and be done with it, or make them wait until he has finished his luncheon."[23]

The responses of the wedding party, foregrounded and centered, dramatize the principal discords of this scene. The embarrassment of becoming a public spectacle and of interrupting an old man's lunch, a dawning sense of the solemnity of the moment, and the fragility and haste of the impulse impelling them are all made manifest in their expressions. The best man's gaze is fixed, pleadingly, on the justice's scowling face. Shaken by emotional and perhaps by alcoholic excess, hands stuffed

Fig. 44 Richard Caton Woodville, *The Sailor's Wedding*, 1852. Oil on canvas, 18⅛ × 22 inches. Walters Art Gallery, Baltimore.

into his pockets and top hat teetering drunkenly, the bride's father seems near collapse—he is propped up by his wife as she and the maid of honor stare mortified into empty space. The sailor bridegroom, principal figure of this group as the judge is of his, carries himself with a jaunty self-confidence he no longer seems to feel: his hands seem to be fiddling, and his eyes have closed. With him, the spirit of the party threatens to deflate as we look.

The very multiplicity of these defining perspectives raises questions asked routinely of prose and film narrations. What exactly is the point of view? It has to be omniscient, for no character seems aware, as the artist makes us aware, of the moment's multiplicity of meanings and perspectives. Only some members of the wedding seem to sense (if belatedly) its gravity; only the witnesses at the door respond to the comedy of it; no character registers the evident pathos of the event. The perspectives of the sailor and the justice, privileged by mise-en-scène, are given such equal weight that it is hard to say, despite the title, whose story dominates the scene; but neither is privileged in any definitive way, and no perspective is dismissed. The omniscient narrator variously signals his assent to each perspective. Like *The Scarlet Letter, The Sailor's Wedding* is designed to picture "different sides of the same . . . idea."[24]

It is the style that reveals something of the narrator's attitudes toward his characters. Sympathetic, he gives the figures their dignities as well as their comic flaws, keeping the most explosive comic perceptions marginal, muted (by shadow), and therefore subordinate. Outrage like that so evident in, say, political cartoons of the period is not evident here, nor are its ideological correlatives. The lines, the colors, the lighting are subdued, gentle; they do not expose as fiercely as caricature does. Woodville invests the scene, in short, with the ideology of the sentimental tradition, though this perspective distances him from his subjects. In his world, suffering is merely discomfiture, the morally intelligible consequence of impulsiveness, and impulsiveness is a threat to the emergent decorums of urban life. The embarrassment will pass—but not without demonstrating to the viewer of the painting, if not to the participants and their witnesses, the necessity of these decorums. Viewers *of* the painting, like the viewers *in* the painting, are all being instructed in the nation's emergent Victorian decorums. In this, *Sailor's Wedding* is typical of American genre painting after 1850.

"Conversation Pieces" Before and After 1850

Before 1850, American genre painters seem particularly drawn to the rituals of rural life with their opposing loci of house and field, their slow rounds of work and leisure, their feelings and rituals associated with the events of birth, marriage, and aging. Attracted (after the Dutch) to what William Sidney Mount calls "conversation pieces"— visualizations of the effects of spoken words on speakers and listeners—antebellum artists seek to become almost literally vernacular. Visual tones act as the analogues of spoken tones, and settings become objective correlatives of the emotional atmospheres produced by speech. In fall, country men and women gather the fruits of the fields and, not at all coincidentally, court each other: ripeness is all. In the formal parlors of the farmhouse, ministers perform the genial formalities of country weddings. In kitchens, women and old men teach as if their words were, like the implements

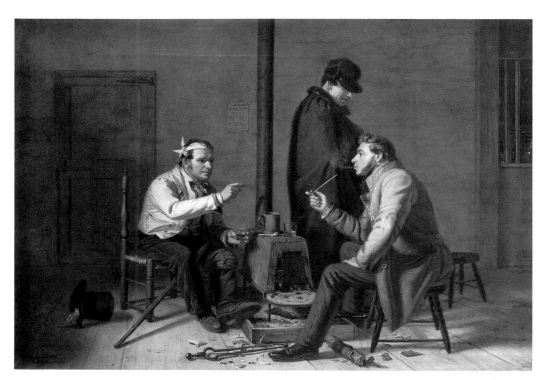

Fig. 45 William Sidney Mount, *The Long Story*, 1837. Oil on panel, 17 × 22 inches. In the Collection of The Corcoran Gallery of Art, Washington, D.C.

and the foods around them, designed as sustenance for the young: plain, republican speech from plainly clothed nurturers in plain, republican interiors.[25] In saloons and other such enclaves of Anglo-Saxon male discourse, men lounge, drink, gamble, tell long stories, or watch, from porches, public spectacles ranging from shooting matches to political campaigns. The man "puffing out his smoke," as Mount himself reads his *Long Story* (Fig. 45), is a tavern- and storekeeper, a "Citizen," and a some-time "General, or Judge, or Postmaster, or what you may please as regards standing in society." The listener in the cloak is a stranger "in no way connected with the rest, only waiting the arrival of the stage." The principal interest is "centered in the old invalid who certainly talks with much zeal": "[a] kind of Barroom Oracle, chief um-pire during all seasons of warm debate, whether religious, moral or political, and first taster of every new barrel of cider rolled in the cellar; a glass of which he now holds in his hand while he is entertaining his young landlord with the longest story he is ever supposed to tell."[26]

After 1850, with cities burgeoning even on the Mississippi, genre painting dra-matizes the massive changes of nineteenth-century urban life. The changes trans-form rural spaces, the looks and demeanors of the figures situated in them, and even the events enacted in them. The public space of the local saloon gives way to spaces designed for transients: hotels, restaurants, railroad stations. Linsey-woolsey gives way to tailored cloth and to such ornaments as ties, dress hats, dresses in the senti-mental style. Fiddles become violins to be listened, not danced, to: music becoming a performance to be heard politely, quietly. Public discourse also changes. As the war

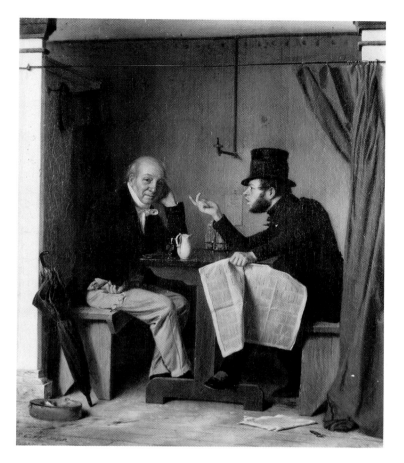

Fig. 46
Richard Caton
Woodville, *Politics in an
Oyster House,* 1848. Oil
on canvas, 13 × 16 inches.
Walters Art Gallery,
Baltimore.

looms, talk becomes increasingly agitated; oral stories give way to newspaper stories, reading gives way to debate, debate to remonstration. In Woodville's *Politics in an Oyster House* (Fig. 46), the political passions of the speaker and perhaps the amused detachment of his auditor (who winks conspiratorially at us) have brought him to the brink of violent rage. His foot is cocked upon the crosspiece of the table, his top hat tipped belligerently forward, the brim masking his eyes. A newspaper, the evident cause of his feelings, hangs from one fist, while two fingers poke out from the other to enumerate the points he is trying to make. He is all out-thrust chin—the very picture of anger as manuals like *The Art of Acting* delineate it. His lips erupt with his words.

By the 1850s, debate, too, becomes formalized by the public oratory of the political campaign and the courtroom. Country trial lawyers begin to gesticulate at trials held in makeshift theaters of the law. In what must be the most crowded canvases of the period, Bingham's campaigning politicians hold forth to crowds of voters. In his *Stump Speaking* (Fig. 47), the agitations of formal discourse reach their height. Although his smile is laconic, the speaker's whole body bends forward behind outstretched, pleading hands. "In my orator," Bingham explains, "I have endeavored to personify a wily politician, grown gray in the pursuit of office and the service of his party. His influence upon the crowd is manifest." Behind him, however, sits "a shrewd clear-headed opponent, who is busy taking notes and who will, when his turn

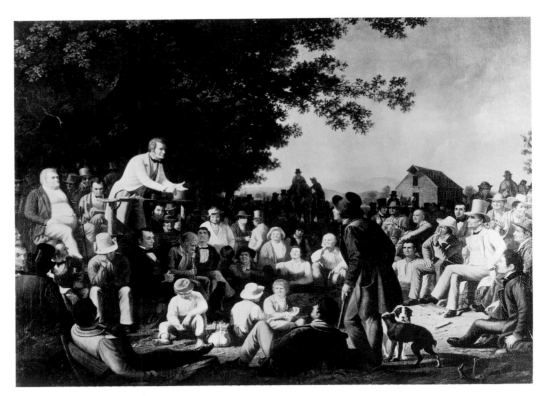

Fig. 47 George Caleb Bingham, *Stump Speaking*, 1864. Oil on canvas, 42½ × 58 inches. Collection of Nationsbank.

comes, make sophisms fly like cobwebs before the housekeeper's broom." To hint at the possibility of bunkum, Bingham has a child lazily mimic his gestures, and two dogs parody the moment in even more reductive terms: each sniffs the other suspiciously, as if getting ready for a dogfight.[27]

Genre painting dramatizes the social transformations of private life as well. Even the interiors of farmhouses are defined as settings of change brought about by the appearance of visitors. Some dramatize the inroads of the federal government and the emergent sense of nationhood, in the form of civil servants, census takers, tax men, and (after the war) pension claim agents. Itinerant artists and "image peddlers" dramatize the growing awareness of the house (and the family) as a work and a subject of art. But the traveling peddler is the chief avatar of the new commercial ethos, spinning his pitches with the gestural art of an orator to rapt rural householders. To calibrate the effects of such encounters, painters attend to the varied responses of the listeners as they become citizens, patrons, consumers. "Look at the two girls examining a piece of stuff," writes Henry Tuckerman of John Ehninger's *Yankee Peddler* (Fig. 48), "how characteristic the faces and attitudes! See the baby stretch over its mother's shoulder (while she bargains for the coffee-mill held temptingly up by the peddler), and strive to reach the trumpet the little brother holds to his lips."[28]

The most dramatic representation of domestic change, however, is the transformation of the rural householders themselves into ladies and gentlemen. In William Sidney Mount's *The Sportsman's Last Visit* (Color Plate XXIV), for example, the di-

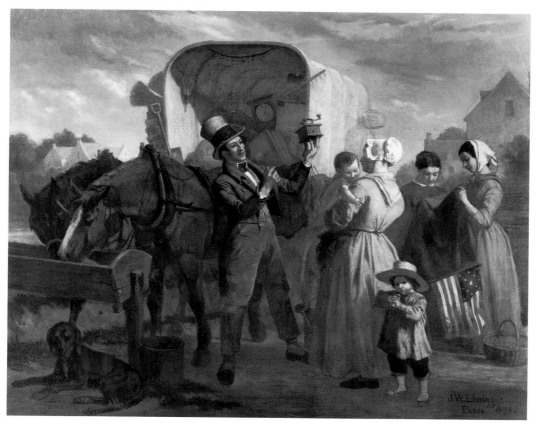

Fig. 48 John Ehninger, *Yankee Peddler*, 1853. Oil on canvas, 25½ × 32½ inches. Collection of The Newark Museum, Newark, New Jersey.

sheveled but robust simplicity of a rural ethos is in the process of being displaced by the genteel Victorianism of an urban one. The young woman's body is becoming, like her parlor, a work of picturesque art. A paragon of the sentimental ideal, she expresses her sensibility "by graceful attitudes rather than by movement." The fringe of ringletted curls framing her face is repeated in the fringe around the apron, and a rose-red rose accentuates her hair as a red band does her waist. Like the hair, the full skirt and belled sleeves are a concert of demure curves. The dress's low neckline emphasizes not her sexuality but the delicate and vulnerable slope of her shoulders; her inclined head bespeaks a delicacy of manner as well; and the white simplicity of the dress, like the crucifix on the translucent bodice, emphasizes the chasteness of these effects. Like the Lady defined in *The Art of Acting,* this ideal of True Womanhood is the embodiment of the "suppliant passions": piety, purity (the suppression of sexual feelings), and submissiveness.[29]

The young gentleman is equally alert to the new ideals of self-representation. His suit, a muted black, elegantly tailored and equally contemporary, bespeaks serious purpose, dignity, means, status—and acquiescence to the new decorums. Given the propriety of the situation, he cloaks his "imperious passions" and his authority, like the Gentleman of *The Art of Acting,* in "a smiling, prepossessing yet anxious face." He displays "beauty of form, . . . passionate eyes, and susceptibility of heart." His

demeanor is marked by a "perfect ease of deportment"; "manners that conciliate"; "a flattering, yet not officious, attention to the lady, whose heart he is bent on steal[ing] . . . and enslav[ing]."[30]

The sportsman's dress, by contrast, matches the woman's for color but not for harmony or subtlety. His touches of fashion—a large cravat, a stovepipe of a top hat—are loud and exaggerated as well as out of date in this place. The weathered and disheveled coat, more suitable for hunting than for courting, the bulging knees of his trousers, and the crossed shoulder straps (one of them still sporting a powder flask) all bespeak a commitment to utility over decorum, activity over the sedentary niceties of the genteel life.

The most telling contrast between the refined and the republican, however, is gestural. The seated couple has formed a kind of loveseat of their chairs. Their bodies perform a static dance: both sit side-saddle, she nearly facing the viewer, he with his head and torso turned toward her, and both heads are delicately inclined. The sportsman stands splay-footed on the hem of her skirt, his spread legs and his hand in pocket bespeaking the careless indecorum of the lounger. One of the many situational ironies is that, guileless, unstudied, this citizen of the new republic has suddenly become a comic spectacle. The gestures that both link and oppose his and the gentleman's right hands say everything. The gentleman's hand is raised as if in tender salute, fingers forming a graceful curve that repeats the curve of the woman's sleeve, so that he seems to be caressing her at a short remove. The sportsman's hand is also raised, the fingers also curved, but they are closing on the lid of his own hat, which he is about to doff. It is a gesture of bemusement—the instinctive recognition, not yet fully comprehended, of a *fait accompli:* a displacement. As the picture's title suggests, it is of no consequence to the others.

The days and seasons . . . influence you[,] awaken emotions, convey teachings. If you can relate this influence, you tell their story.
—G. W. Sheldon quoting Jervis McIntee, *American Painters* (1879)

[T]he character of the subject may . . . well regulate the form of the picture.
—John Gadsby Chapman, *American Drawing-Book*

∿

Space as a Verb

Narration is possible in picturesque forms and spaces, as well as in figures. The poetry of living forms begins where scars, weathering, and even what may be read as gestures begin to signify histories of assaults and resistances. The turbulent history of the tree that Thomas Cole situates in the left foreground of *Sunset in the Catskills* (Fig. 49), for example, is expressed in a contrast between the turmoil at the bottom and the beautifully delicate ramifications at the top. Erosion has washed half the ground from under the tree, nearly toppling it into the streambed. Half of its roots have been exposed, and some are dying. Lichens coat the bark; lopped branches bear marks of lightning strikes or heavy winds. Even humans seem to have left their mark: as its multiple trunks demonstrate, the tree is undergoing a second growth.

Other marks, ascending the trunk, suggest the tree's counterassertions against this and subsequent assaults. Fisted roots clench the eroding bank. Cutting a long curve out over the creek and then upward again, toward the sun, the curve in its main trunk is a graphic sign of its struggle to balance itself, like a wrestler or dancer, against the pull of gravity. Near the bottom of the curve, a second trunk splits off—a counterweight, lighter, thinner, more regular than its parent—so that the tree as a whole takes the shape of a bowed, asymmetrical but still balanced vee. As if to celebrate its struggle to survive, Cole highlights the point where the bowed trunk has restored itself to verticality. And out over the top of the tree, the ultimate outcome of its struggle and a kind of "nevertheless," floats a canopy of incongruously delicate green leaves, rhythmic as music, soft as

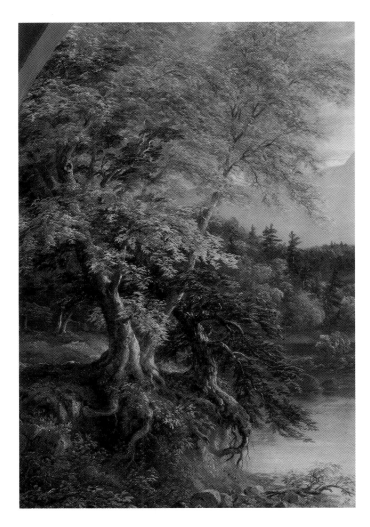

Fig. 49
Thomas Cole, *Sunset in the Catskills*, 1841. Detail of tree at left. Oil on canvas. 22½ × 30 inches. Museum of Fine Arts, Boston.

the clouds. Yet the leaves are also tinged and wrinkled: intimations of autumn. Yet they also glow with soft, warm light in a present filled with peace, however brief—and yet the landscape is filling with night shadows and the onset of winter.

Cole's tree, in short, exists in time *and* space. It even seems to harbor an element of moral character: a will to live, a grace evident in its eventual flowering. It is portrayed by a typically picturesque multiplication of contending shapes and meanings that spur meditation and freshen repeated readings of it. Narrative signification lies in the breaks and transitions—the contrasts and variations—that both divide and link sequences of details.

Narration in space—specifically, the two poles of nineteenth-century American sacred space, landscapes and domestic interiors—depends on the sequencing *between* as well as *in* forms. In these sequences, as in those of human figures in genre painting, "next to" can signify "before" or "after" or even "because of," as it does, for example, in the ubiquitous sequence of tree, stump, and cabin in nineteenth-century American culture. The sequence is typically anachronic—the viewer sees not action but its results—and yet it is possible to read the cabin, with its horizontal tree

trunks, as both the cause and the product of the felled tree. Variations in the forms (tree and tree stump, for example) signify change; contrasts (tree against house) signify discontinuity or discord; and repetition (a living tree set next to our hypothetical tree, say, and still there next to the stump) signifies duration.

Narratized sequences of forms in landscape painting produce, in the words of one anonymous nineteenth-century critic, "a direct road or air line of attraction"—a visual path—along which "the eye shall naturally fall" on each form in its time, allowing the mind to "expatiate" on each, as I have on Cole's tree. All of the landscape's "poetic power," this critic declares, depends upon the coherence of that path; "all its beauty or . . . grandeur must surround and depend upon" it. So, too, does its narrative coherence: the path is "as a grand plot, to which all the incidents, hills, trees, clouds, cattle, [figural] groups, etc., . . . relate," one after another in their intended order, as the eye encounters them.[1]

These narratized paths have several possible configurations in the space of the picture. Recessional sequences lead the eye from the foreground to the background, traversing the temporal and conceptual territories between now and then, matter and idea, earth and heaven. As in dreams, "the luminous distance" becomes "the future," and "the clear but shaded foreground . . . our present." Dialogically, the one keeps pulling the eye from the other:

> . . . the far future fascinating the eye with its glorious indefiniteness; the nearer future beckoning it away from the grosser and more tangible objects nearest at hand, and the present, while rewarding the closest and most careful notice, yet forbidding the vision to dwell otherwise than cursorily upon its large but shaded objects.[2]

Processional paths, reversing this sequence, lead from the depths of the picture toward the foreground and the viewer, a past unfolding toward a foregrounded present, a cause leading to its (pictorially emphasized) effects. Lateral paths unfold across the picture plane, usually in the foreground. And vertical paths ascend from earth to sky or vice versa.

Narration is a feature of every frame in the picturesque repertoire,[3] and each of these frames uses narration to its own distinctive ends. As arrangements of scenes change, their meanings also change. The spaces of the vista and the panorama accommodate extensive narration, in which the plot is more important than the individual actors, who are characterized by their relationships to it. And since these frames accommodate more than a single path, they make possible the multiple narration that is virtually ubiquitous in American landscape painting. There may be so many "underplots," indeed, that they threaten to "overpower the main story"— though coherence requires that there *be* a main story: that is, a principal plot that subsumes the underplots, as it does in the pictorial narratives of Edgar Allan Poe.[4]

Windows into the proximate, close-ups, by contrast, present their subjects *intensively*, imbuing them (like Cole's tree) with the complexities of character, an inner spirit, even a history. Plot becomes an element of characterization.

SPACE AS A VERB:
FRAME AND
NARRATOR IN
LANDSCAPES
AND INTERIORS

117

The painters of the Hudson River School are clearly drawn to the vista in part as a means of representing the manifold effects of the Anglo-American civilization (or domestication or refinement) of the natural landscape. That culturally ubiquitous narrative, its early stages given perhaps their fullest gloss in Timothy Dwight's *Travels in New England* (1821–22), comes to constitute the master plot of the Hudson River vista.

Dwight's version of the narrative unfolds in a succession of landscapes, house types, and types of human character.[5] In the first stage, "foresters or *Pioneers . . .* prepare the way for those who come after them" in the prodigiously violent process of "clearing" the forest culture. Trees are axed or girdled, killed, and burned; a harrow with "very stout iron teeth" rips open the topsoil. The violence of the pioneers and a related spirit of restlessness are visible not only in their work but also in the character of their crude log cabins in their stump-dotted fields: raw, makeshift—architecture as temporary bivouac in a war zone. For Dwight, the cabin is a metonym of the moral, social, aesthetic, and even biological imperfections of its inhabitants. But it is also a signifier of the desire for domesticity that the maturing civilization will perfect. It initiates but does not conclude the transformation of the landscape and the civilization inhabiting it.

In the second stage of Dwight's scenario, the fields become more regular and extensive, and the cabin is transformed into a vernacular farmhouse, efficient in its functions as an agricultural workplace and healthful enough to infuse the minds of its inhabitants with "the energy which results from health, as well as that which results from activity." The vernacular house is a signifier of this transformation. Its clean, spare geometries are the signs of a commitment to an orderly life of "regular society" and a stable economy, as its fields' geometries are signs of "good farming"—architecture as worksite.

In the third and final stage of the scenario, agricultural landscapes form the periphery of a town. Farmers are joined— and elevated (Dwight being a Federalist)— by a "superior" elite of town-dwellers, including governors, ministers, teachers, and manufacturers. The presence of each is signaled by monumental civic architecture: a town hall, a school, a church, a commercial business district; and, along streambeds, "mill-seats filled with every kind of machinery." The townscape declares the binding and exalting pull of civil society. Its outlying farmhouses, therefore, are now made "handsome," "beautiful"—architecture as a work of art. So Andrew Jackson Downing also describes it, in more detail.

Painters devise similar visual symbols and use multiple visual paths for this extensive narrative. The untitled frontispiece of William Harvey's *Connected Series of Forty Views of American Scenery* (Fig. 50), for example, is a variation on Dwight's scenario. As Harvey himself reads his vista, a sequence arranged laterally across the foreground narrates "the first step" toward Anglo-American civilization, a particularly violent and extensive "subjugation of the wilderness," with images of pioneers "hewing down, cutting, and burning . . . timber" to construct a log hut and a maze of fields littered with felled trees and stumps. A second, recessional, sequence plots a

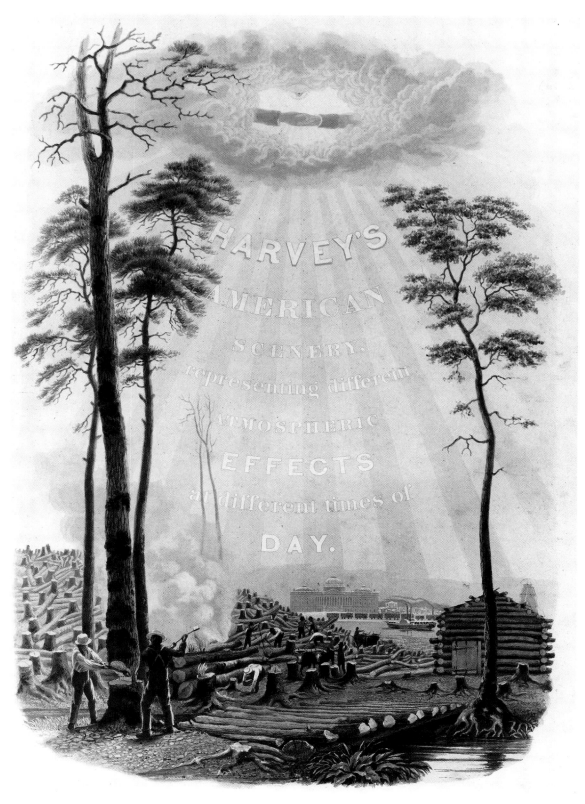

Fig. 50 William Harvey, *Epitome of the Historic Progression of the United States*. From the title page of *Connected Series of Forty Views of American Scenery* (1841). Courtesy American Antiquarian Society, Worcester, Massachusetts.

narrative of nationhood that spans from the hut to the Capitol building in the distant background: the house as bivouac to the house as seat of national law. On the path between, underplots define the manifold elements of social and economic transformation. As steamboats and then railroads succeed horse riders, transformations of the landscape image the evolution from a pioneer to an agricultural and industrial economy.

> The ripe wheat-field [as Harvey instructs his readers] . . . indicates an advanced state of improvement. Another and distinct class of social life is now called into action.
>
> The steam boat comes next, increasing the facilities of communication; and finally the rail-road strengthens the social compact. Beyond, [in] . . . the Capitol . . . the national legislature is in session, known by the two flags flying . . . between the domes. Here . . . is assembled the chosen intelligence of the land, through whose wisdom the nation flourishes or decays.

Meanwhile a vertical sequence of images—itself a multiple narrative—descends from the heavens to the changing landscape. One strand represents divine approval of the progress toward nationhood: "The watchful eye of Providence . . . [sheds] down rays of glory" that kindle the cleared landscape beyond its dark, wild foreground. Harvey makes "prismatic" another, reflexive, strand of light shed on the book title, "to intimate" that the work of the painting and the book also contribute to the work of civilizing the new nation and is also providentially graced. Just beneath the title, a revelation "seen through thick dispersing clouds," the picture's principal iconic images appear: two joined hands symbolizing "union and industry"—the cause of the changes in the landscape and the art that represents them and the political result of the work of civilization.[6]

The amazing continuity of the vista in nineteenth-century landscape painting is assured, in part, by its extraordinary capacity to represent in imaginative ways, as Harvey's does, a manifold variety of responses, including ambiguous and conflicted responses, to the Euro-American transformation of the landscape. The ambiguities are expressed, among other ways, by contending narratives. The indigenous forest, for example, is also narratized by what I will call ecological narrative, a secular vision of natural order laid out in the late essays of Thoreau and in George Perkins Marsh's *Man and Nature*. Ecological narration defines the landscape—and most pertinently the forested landscape—as a multiplicity of processes, and cycles joining even the most disparate natural forms into a community. Evolution is one cord in this narrative strand: the struggles for survival waged by individual forms against other forms of their species, against other species, and, like Cole's tree, against such natural catastrophes as storms, fires, floods, age. But nineteenth-century versions of the process of succession, which fulfills the community's tendency to a state of diversity, stability, and harmony, constitute another cord. "The organic and inorganic world," Marsh declares, are bound together by "such mutual relations and adaptations as secure, if not the absolute permanence and equilibrium of both, a long continuance of

the established conditions of each at any given time and place, a very slow and grad-ual succession of changes in those conditions."[7] To this end, the forest is nourished by cycles of heat and rain, for example, and in turn contributes to the regulation of these cycles.

Yet a third, and more familiar, strand in the Hudson River vista (and in the panorama also) is that of typological narrative: the inscription of American water, hills, trees, sky, with the eschatological stories of Genesis and Apocalypse. Landscape, as Emerson both argues and demonstrates in *Nature,* is the many-layered revelation of God's mind. In painting, the path of sunlight recurrently substantiates the world at sunrise and dematerializes it at sunset. In Cole's *Sunny Morning on the Hudson* (Color Plate VIII), for example, gold light gradually (Lyellianly) quickens an amor-phous stony darkness, separating mountain from mist, foliage from rock. Light kin-dling or suffusing the world as a natural type of the Transfiguration or of the millen-nium or of the epiphanic descent of grace: these are recurrent luminist narratives. In Fitz Hugh Lane's *Owl's Head, Penobscot Bay [Maine]* (Color Plate IX), a cool dawn quietly gives things their substance, and the man in the foreground, an image of its contemplative effect, looks transfixed, buoyantly afloat, as if the world were miracu-lously materializing around him, flowing in on a tide of mystical light.

As the century unfolds, however, eschatology in typological narrative is all but displaced by the story of the Chosen People, with emphasis on the Abrahamic cove-nant. The American landscape is a type of the Promised Land. Natural typology not-withstanding, "there is no perfect[a]bility in this world," as Cole declares, and that includes the wilderness. To Cole, Frederic Church, and other Hudson River School exemplars of what one critic called "the [Calvinist] New England mind pictorially developed," the salvation of the new Chosen People depends upon the agricultura-tion of a wilderness held to be both incomplete (because it does not have the "finish") of the rural landscape) and unfruitful (because it does not provide the Euro-American diet). *Human* nature, as Harvey's narrative suggests, is also civilized and redeemed by both the labor of transformation and the art that celebrates it. Need-ing "improvement," "finishing," to elevate it to the ideal standards of picturesque beauty, the wilderness must be twice civilized: not only by the imagination but also by the ax.[8] Natural and human processes are therefore pitted in an apparently un-resolvable *agon,* powerfully represented by the complications of form and effect in picturesque art.

Domesticated Vistas

Ambivalences about the mind of God and the place of religion, nature, aesthetics, work, technology, gender, and society in the American landscape all come into play in such a vista as Cole's *View on the Catskill* (Color Plate XIII). The low sun, the gra-dations of deepening darkness in the foreground and the upper left corner, the ris-ing cumulus on the left, and the red and yellow accents on the trees are all examples of "softened sublimity" and all markers of natural events and ecological processes in this landscape. But all are subordinated to a domestic narrative related both topo-graphically and figurally. Cole hides in this picture, so that they and their implications

SPACE AS A VERB:
FRAME AND
NARRATOR IN
LANDSCAPES
AND INTERIORS

121

emerge only on long looking, a stunning number of human artifacts and figures. In the middle ground at the center of the picture, the position of privilege, a farmhouse partly concealed by foliage appears and, like Wallace Stevens's jar, becomes the matrix that changes the wilderness indelibly. Muted by shadow and masked by foliage, stumps and rail fencing, gradually evident, reconfigure the clearing in the foreground as a pasture. Masked by foliage, a whole system of fields and pastures appears along the creek and recedes across the ridgeline behind the house. The forest is in fact a farm.

A prosperous farm. In the background, where ridge succeeds to mountain wall, barely perceptible plumes of smoke signify the presence of a town, Palenville, New York, with its tannery and lumber mill. That is the nearly hidden cause of this half-concealed, half-revealed narrative of domestication. The smoke is the beginning of a grand plot arranged processionally. It explains the finished look of the vernacular farmhouse, which Cole relates to it by the leitmotif of a smoke plume from its chimney. And that in turn explains (along with the season and the time of day) both the dress and the activities of a running man in a clearing to the left, a man with a top hat to the right, a man in a boat in the middle ground at center, and the woman and child in the foreground: figures all enjoying (except for the running man) a moment of late afternoon leisure. Nothing but those distant smokestacks indicates work in the picture's present.

The running man pursues two horses, large and powerful, who appear to be running wild through a clearing until we see the fence that makes that clearing, too, a pasture and the horses farm horses. We also see the head and shoulders of the man shouldering a weapon as he climbs the forested hill along the half-concealed rail fence at right. Is the weapon a rifle? A scattergun for birds? It does not matter which. His top hat signifies that the hunt is now for sport and not survival. The man in the boat on Catskill Creek represents an even more advanced state of civilization, characterized by the cultivation not of earth but of mind and feeling. Reflective as the water, he drifts like Emerson's transparent eyeball, egoless, and perhaps even, like Emerson on the Concord Green, apparently bodiless from the illusion of flight, in the space between glowing sky and glowing sky-water, his head "bathed by the blithe air, and uplifted into infinite space."

But it is the woman and child in the foreground that represent the climax and culmination of Cole's narrative of civilization. In Romantic iconography, flowers express "the delicate affections." The woman offers a bouquet of them to her infant, benevolent natural influence and maternal nurture conjoining in an act of education—the kind of scenario that defines, in separate-spheres ideology, the highest offices of married womanhood.[9] The landscape has become an extension of the home.

Like Harvey, Cole also characterizes the whole arrangement as a destiny made manifest by a descent of light, bestowing the special grace of a shaft of catching light for the vignette of maternal education in the foreground. The sky is the "soul of scenery," Cole writes in his "Essay on American Scenery."[10] Here the soul's "expression of tranquillity and peace" becomes the theme of the picture's most signifi-

cant subordinate narrative. Except, perhaps, for the running man and the frisky horses, the rich gold benediction of late afternoon light makes each object it touches—but none more than the figures of the woman and child—a gilded icon. It is possible to see the peace of this painting as the promised fruit of the work of bringing Abrahamic order to a promised land.

But Cole is clearly troubled by the fact that the work does not stop there. That is evident in his sequel, called *River in the Catskills* (Color Plate XIV), the same landscape at a later stage of transformation. Here the ax and the red-shirted ax-man are foregrounded as a principal grouping in a narration of the violence of landscape domestication. This ax—like so many others in American landscape painting, as Barbara Novak argues—is both shaper and destroyer, destroyer and shaper; a "double edged symbol of progress" by which national identity is both "constructed and threatened." Picturesque syntax also expresses a troubling disparity between what the ax destroys (forest "monarchs") and what it produces (naked clearings, makeshift cabins, and joyless farmhouses).

In landscape painting, images of the railroad constitute an even more disturbing, because more extensive, destroyer of natural order and signifier as well of new forms of social organization and of knowledge too abstract to be visualized. Tracks with their "shockingly regular geometry" telescope distance and accelerate time, and bridges become metaphors for "identifying access with understanding." The popular medium of the print openly celebrates the locomotive (Fig. 51). Foregrounded and monumentalized, it becomes the avatar of a sublimity now engendered by human organization—streamlined, trailing smoke, in motion even at rest, and pulling cars that, juxtaposed against the cabins they pass, seem like utopian prophecies of modernist architecture and of life on the road.[11] But painted vistas like George Inness's *Lackawanna Valley* (Fig. 52) plot more wistful scenarios. Although the locomotive steams toward the foreground—implicating if not actually threatening the viewer and in any case threatening, like cities, to burst the limits and coherences of the frame—its aggressive power is diminished for the moment by distance and its preemptive otherness harmonized, like the locomotive in Cole's painting, with the rural landscape by means of gradation and repetition. Steam and smoke are blended with cloud; metal camouflaged by shadow or foliage—technology made continuous with the natural order and with the emergent vision of the domesticated landscape. Along with a virtually denuded landscape, Cole accepts the train in his *River in the Cat-skills*, but ambiguously, as a condition of the prosperity, ease, and comfort of the rural home.

In *Bird Mountain, Castleton, Vermont* (Color Plate XV), a virtual reprise of Dwight's narrative even to its setting in Vermont's Champlain Valley, James Hope arranges his narrative of civilization to very different effect than Cole's. A narrative of forest destruction extends laterally across a foreground that has the look of a combat zone. The tree at the right has been killed by fire, as the scorched earth suggests; the upturned roots of the stump at the center foreshadow its future. The forest becomes a field of ashes even as we look.

The land in the deep foreground at left seems to have been harrowed. Although

SPACE AS A VERB:
FRAME AND
NARRATOR IN
LANDSCAPES
AND INTERIORS

123

Fig. 51 Fanny Frances Palmer, *Across the Continent, "Westward the Course of Empire Takes Its Way,"* 1868. Published by Currier & Ives. Museum of the City of New York.

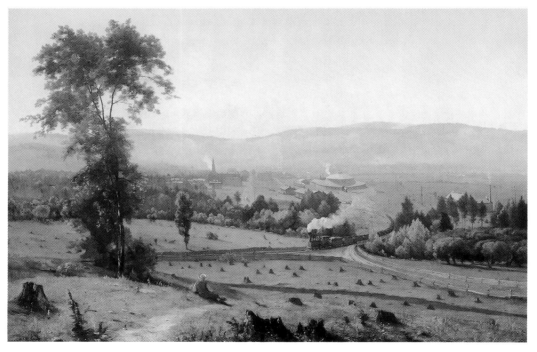

Fig. 52 George Inness, *The Lackawanna Valley,* c. 1856. Oil on canvas, 33⅞ × 50¼ inches. Copyright © Board of Trustees, National Gallery of Art, Washington, D.C.

the red glow of the sunlight on it recapitulates the violence of the fire that has deforested it, grass grows around the tree stumps—the beginning of a pasture. More well-defined pastures populate the middle ground, and these are succeeded by fenced fields, roads, houses, a railroad line. The town of Castleton, Vermont, at once epicenter and climax of landscape transformation, occupies the high ground at the center, just below Bird Mountain. It is graced and made iconic by the rising sun.

In Hope's painting, the artist as reader of natural scripture becomes the artist as social historian and (typically ambivalent—even, like Cole, reluctant) celebrant of landscape change.[12] Dramatizing the conditions of its own making, the domestic vista becomes a mirror of its subject—a landscape aesthetically reformed (visually contained, made scenic and signifying)—even as its subject is reformed by the ax, the plow, and the railroad. In both, the effects become congruent with "domestic affections" and domestic narratives,[13] even as Andrew Jackson Downing and other builders of American country houses reconstruct the rural landscape, privileging it by framing from the porch and the front windows (where possible) vistas that also recapitulate the civilization of the wilderness (see Figs. 76 and 77).

Salvatoran Vistas

Nineteenth-century American vistas, of course, are not only and always about civilization. Ecological narratives enter painting not later than the mid-1820s, in Cole's vistas of the Catskill wilderness. In these, he uses the Salvatoran vista (see Color Plate XI), a variant that reverses the Claudian recession from populated foreground to mountain terminus, and focuses the foreground on a sublime scenery of exposed rock, continuous winds, and flowing water.

The light in Cole's *Sunny Morning on the Hudson River* (Color Plate VIII) defines the processional path of a typological narrative that makes the landscape's foreground a natural type of genesis. A blanket of dissolving mist covers the Hudson Valley "like drifted snow," Cole writes in his reading of this landscape, from which the peaks of the Berkshires rise like "things of another world."[14] In the background, the light turns the mist into "bars of pearly hue." Trees rising through the mist in the middle ground manifest themselves in "innumerable streaks" across its upper surface. But as the light reaches the foreground, it falls on wholly materialized forms.

The foreground is filled by an ecological narrative. Where mountain rock has been fractured and dissolved and small pockets of soil collect in its crevices, a succession of grasses, plants, and dwarfed pines asserts itself against the mountain environment's buffeting wind. Ironically, the sun's nurture for the struggling plants (Cole attends to each streak of light from a rising sun on the wind-bent leaves and stalks and branches) also emphasizes, as by a spotlight, the community's hard struggle for survival. The pines, there in part because of the offices of the grass in the preparation of the soil, in turn provide some scant protection for their benefactors. The wind has written itself into their dwarfed and twisted shapes; the smaller plants are bent but not twisted. This small ecological scenario is both expanded and generalized in the recession to the forested crest and flanks of South Mountain at left— the "after" to the foreground's "before."

SPACE AS A VERB:
FRAME AND
NARRATOR IN
LANDSCAPES
AND INTERIORS

125

Even in this painting, however, the grand plot of domestication is an undeniable, if muted, presence. As a "very beautiful" line of light streaks the eastern horizon and the mist begins to dissolve, Cole writes, the middle ground at the right takes shape, in nineteenth-century parlance, as an "emerging picture" of fields "exquisitely fresh and green," aglow in the morning light. The Hudson River beyond is already filled with glowing sails. We find ourselves looking from the scene of a genesis to that of a green, glowing Promised Land. During the 1830s, as *View on the Catskill* demonstrates, Cole himself traveled the path laid out recessionally in *Sunny Morning on the Hudson,* leaving behind the sublimities of the Salvatoran perspective for the complex, elusive, and anxious beauties of the domesticated vista and its backward glance at the distant beauties of forest and mountain.

Composite Vistas

If not in the East, then westward, northward, southward. Like mid-century travel narratives, the densely detailed natural landscapes of Church and Albert Bierstadt are fruits of "pursuits of the picturesque" into wildernesses still largely intact by mid-century: the Rockies, the tropics, and the Arctic.

In his vistas, Church stretches space three-dimensionally, vista fusing with panorama, to accentuate the sheer extent of virgin wildernesses. Mountains elongate into ranges. Elevated perspectives and clear atmospheres likewise expand the sense of spatial depth, tilting the terrain toward the viewer. These enlargements of space accommodate a strikingly complex and extensive ecological vision. The "singular formation and quality of the hills" in *Heart of the Andes* (Fig. 53), for example, constitutes a Humboldtian narrative of geological process: "the far-away and soaring snowy peaks," a volcanic range; "the central plain with its . . . watercourses"; and "the lapsing valley," dug by the river in the foreground. *Cotopaxi* (Color Plate XVI) concentrates on a volcanic scenario of landscape formation and, in the foreground, a narrative of ecological succession.

Bierstadt is particularly interested in the geographies of geological and biological process. *Cotopaxi,* as Tuckerman notes, narrates an ecological succession: "the gradually increasing vigor and freshness of the vegetation as it recedes and descends from the volcano, until, in the foreground, a group of fine old trees refreshes the eye." *Heart of the Andes* presents a sequence that proceeds from a mass of "luxuriant" jungle on the central plain and a river valley to a sequence of "epitome[s] and typical portrait[s]" in the foreground: fern palms, "mimosas in rich festoons, a scarlet paroquet, a gorgeous insect," and innumerable other flora and fauna typical of the place; the skies, too, some of the incidents and grand effects typical of tropical light and atmosphere. Collagelike, each of these paintings condenses a bio-region into a composite vista.[15]

But these wilderness vistas, too, incorporate narratives of human (Latin-American) domestication. Under the trees in the foreground of *Cotopaxi,* Church places the figures of pioneers with pack-laden llamas looking for a place to settle. What Tuckerman calls the "heroism and the martyrdom, the . . . knowledge, and the wonderful adventure" associated with aesthetic explorations such as Church's complicates the implication of the vignette territorial reconnaissance. Like its subject, the

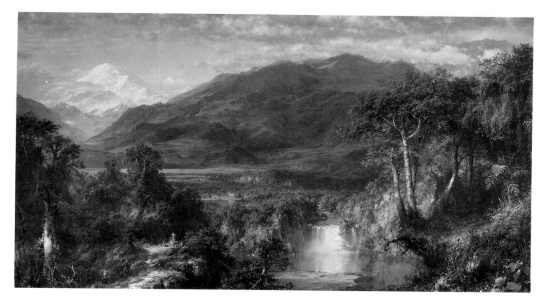

Fig. 53 Frederic Church, *The Heart of the Andes,* 1859. Oil on canvas, 66⅛ × 119½ inches. The Metropolitan Museum of Art, New York.

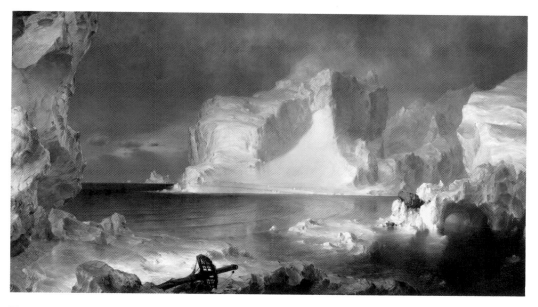

Fig. 54 Frederic Church, *The Icebergs,* 1861. Oil on canvas, 64⅜ × 112½ inches. Dallas Museum of Fine Arts.

SPACE AS A VERB:
FRAME AND
NARRATOR IN
LANDSCAPES
AND INTERIORS

127

painting is itself a "sublime symbol of [human] daring and achievement, and a solemn memorial of human sorrow and faith," in the process of territorial expansion.[16] To a similar end, the path leading into the distances of *Heart of the Andes* is literalized, on the left, in a footpath that a dramatically situated crucifix turns into a *via crucis.* Leading up to the central plain above the jungle, it ends in a townscape— a church with a red-tiled roof, a checkerboard of roads, farms, fields, and pastures— that is the culmination of a long climb upward.

Aerial Vistas

By the 1850s, meanwhile, the pursuit of ecological narrative also leads painters to elevate their lines of sight, producing a type of vista called the "aerial study." Here the narrative element is focalized upon the behaviors of light and the changes of weather as these emanate from the obscurities of deep space and then move across the landscape to the foreground. Beginning in the 1940s, Asher Durand's principal subject becomes the "veil or medium" of misty atmosphere that interposes itself "between the eye and all visible objects." Strangely, it materializes as it recedes: it is "*felt* in the foreground," Durand observes, "*seen* beyond that, and palpable in the distance." Increasingly paler tones articulate this sequence. "The most evident of the phenomena and laws" observable in "the widespread horizon," Jasper Cropsey adds after taking up his own aerial studies, is that "the canopy of blue is not opaque, hard, and flat, as many artists conceive it, . . . but a luminous, palpitating air, in[to] which the eye can penetrate infinitely deep, and yet find depth." Changes of atmosphere make it "constantly varied" as they travel "by the most imperceptible gradations from the zenith to the horizon" and then manifest themselves in the water and temperature cycles that affect the vegetation. Light, too, is in part a function of water and temperature cycles. The northeastern sky, Kensett observes, is "clear and blue through the clouds after rain—soft and hazy when the air is filled with heat, dust and gaseous exhalations—golden, rosy, or green when the twilight gathers over the landscape." By the 1850s, luminists, using the panoramic frame, begin exploring spectrums of lights and atmospheres, from the cool, silvery lights of cloudy atmospheres (Color Plate XXII) to the radiant brilliancies of dawn, sunset, and twilight (Color Plates V to IX).[17]

Aerial studies concentrate on atmospheric events and processes, but not to the exclusion of landscapes and landscape transformation. Sanford Gifford's *Twilight on Hunter Mountain* (Color Plate XVII) is, as Barbara Novak observes, primarily "a picture of a day." Its principal event, the onset of night, is defined by an atmospheric contrast: the air is lemon-colored, gradating into orange; the up-ended bowl of mountain and the bowl-like hollow below have darkened into a red laced with black shadow. The light in the sky is a benediction; that on the earth fades into a growing darkness. "What an idea of silence and endurance is expressed by that mountain!" declares one nineteenth-century viewer of the painting. Its "large flowing outlines [smite] abruptly against the fading light, . . . while night creeps into every cleft of its mighty sides, and the last clouds linger and flush and deepen in tint as the sun goes from the lucid air."

Nevertheless, this picture of a twilight is also the picture of a place at a distinct moment in its history of domestication. The forest in the foreground has been displaced by stump-dotted fields and a home in the woods.[18]

In the Northeast, aerial studies even participate in the domestication of sublime landmarks. Mid-century painters try to cope with the mind-numbing proliferation of sublime images of Niagara Falls, for example, by finding ways to defamiliarize them. Like Margaret Fuller, they experiment with new (and usually softer) lights and atmospheres: the falls frozen in midwinter or under a moon that dematerializes them

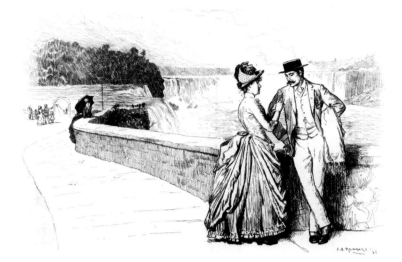

Fig. 55
C. S. Reinhart, *Their
Bridal Tour—at
Niagara Falls.
Harper's Weekly,*
September 29, 1888.

into a "[vale] of winding light" (Color Plate IV). They experiment with new subjects—the river upstream, the whirlpool downstream—and with novel points of view—the falls from midstream, from well downstream—that distance, diminish, or exclude the sublimity of falling water or (like the prose of John Muir) fragment and telescope it into a "scenery of the foreground" that mediates sublimities of power and motion with beauties of line and texture.[19]

Eventually Niagara Falls is also physically transformed into a touristic habitat, replete with walks, towers, ornamented lawns, and banner-hung viewing platforms. In C. S. Reinhart's *Their Bridal Tour—at Niagara Falls* (Fig. 55), the title itself evokes the main plot. The picture's principal subject, foregrounded and centered, is a pair of honeymooners. Readers-in-the-text, they have eyes only for each other and not for the falls they have supposedly come to see (their backs are turned to them). The same can be said for a single female in the middle ground: her head, too, is turned to the more compelling spectacle of the handsome newlyweds. Congruently, the falls are pushed to the background, sharing it with a piece of elaborate and extensive lawn scenery replete with well-dressed families, an arched gate, a paved walk, and a stone wall that frames the falls behind it. As Cole's *View on the Catskills* helps transform the Hudson Valley, Reinhart's etching helps transform Niagara into what George William Curtis calls, in another context, a "picture in the gallery of love": a decorously indirect correlative of the contained passions of married love. Even the wild becomes a suburb of the domestic.[20]

Divided Vistas

The domesticated vista represents change as harmonious, if complicated, in its effects on natural landscapes. The divided vista, with its juxtapositions of contrasting scenes, presents a more dissonant view. Durand's *Progress* (Fig. 56), for example, opposes civilization against the wilderness. The wild scene at left is paradoxically ruinous: a stony mountain, a riven and dying tree, a storm, darkness, a column of aging Indians proceeding toward the foreground. The civilized scene at right, receding familiarly from

SPACE AS A VERB:
FRAME AND
NARRATOR IN
LANDSCAPES
AND INTERIORS

129

Fig. 56 Asher B. Durand, *Progress*, 1853. Oil on canvas, 48 × 7^{15}⁄$_{16}$ inches. The Warner Collection of the Gulf States Paper Corporation, Tuscaloosa, Alabama.

an agricultural foreground to a thriving river port and railroad stop, is brilliant and astir with energies. Familiarly, it recedes from an agricultural foreground to a thriving river port, hub of railroad and steamboat traffic. The two scenes connect contrapuntally. Distance and atmosphere shrink and mute the buildings, the telegraph poles, and the smoke from the steamboats and the locomotive, so that they seem to be energies less threatening and more durable than those of the storm on the left. The Hudson is both river and shining road. Marginalized, muted by shadow, the wilderness remnants constitute a tattered "before" to the townscape's "after." Yet they haunt this scene of Anglo-American triumph like a ghost that will not be chased away: a dark side to the townscape's noonday brightness.

A similarly discontinuous counterpoint characterizes the anonymous *Amoskeag Millyards* (Fig. 57). One scene, laid out maplike in the bird's-eye view, is a millyard so abstractly arranged and so extensive that it seems cubist. The mill's forbidding geometry (squares and triangles, chiefly, with a few curves imposed by the organic form of the island) and its brick-red color, literally limitless, break through the frame at the top of the painting and continue indefinitely, out of sight. By contrast, the pastoral landscape to the right is shrunken and hazy. The river there remains tree-lined and reflective, as it should be in the Claudian vista, but the stretch adjacent to the mill is a square-diked, bridge-laced drainage canal, troubled and stained by effluents, and dirty smoke stains the sky.

The mill is as incomprehensible as it is intrusive. No path lets a viewer imagine strolling contemplatively through it as we do in traditional vistas. Physical access is blocked by gates and bridges; visual access, by an impenetrable maze of railroad

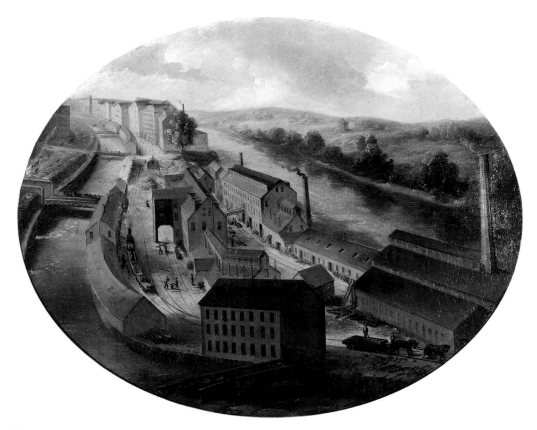

Fig. 57 Anonymous, *Amoskeag Millyards,* c. 1850. Oil on canvas. Courtesy of the Manchester (New Hampshire) Historic Association.

SPACE AS A VERB:

FRAME AND

NARRATOR IN

LANDSCAPES

AND INTERIORS

131

tracks and loading docks. Adjusting our eyes to follow the tracks, we are already adjusting our minds to a human order unanticipated in Dwight's version of civilization.

Urbanized Vistas

The question of where that process will end is an anxious and recurrent one for vista painters after 1850. Jefferson's answer, still strong in the first half of the nineteenth century, is a nation of rural freeholdings. Frederick Law Olmsted's answer, more accurate, is a "strong drift cityward." Farmscapes are self-fulfilling prophecies of cityscapes. Cole anticipates that eventuality in 1836. The "flourishing towns, and neat villas" constructed in the Hudson Valley by "the hand of taste" may eventuate, hopefully, in a model city defined, like that of Wordsworth's London from Westminster Bridge, by "temple, and tower, and dome, in every variety of picturesqueness and magnificence."[21] American commercial cities, as Cole knew from his residence in New York, were turning out much rawer than that.

The same collision between ideal and reality is evident in the evolution of the popular topographical vistas of towns and cities. Through the 1830s, the cities are viewed across a harbor, river, field, or some other natural space—and thus still situated in Dwight's Federalist script of civilization, still environed by rural nature. In William Hart's *Albany, New York, from the East Side* (Fig. 58), for example, the city

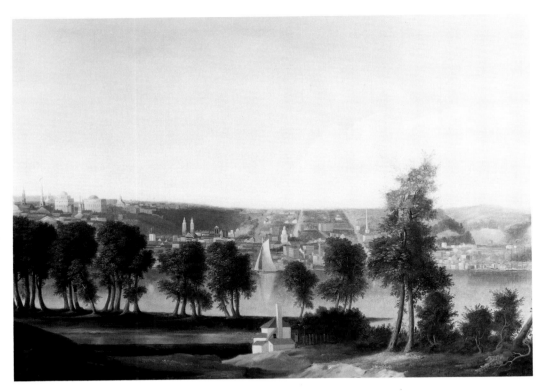

Fig. 58 William Hart, *Albany, New York, from the East Side*, 1846. Collection of the Albany Institute of History & Art.

rises from the western bank of the Hudson in irregular terraces to a ridge "crowned with the capital" that remains "embowered amid the foliage of old trees." The far riverbank has become a working port, with "coaling stations and foundries to the south, and, to the north, long ranges of cattleyards. Above . . . rise . . . fine old houses, and towering churches, and massive legislative halls, and huge caravansaries of hotels." [22] The foreground, suburbanized down to the sail of a sporting boat in the river, remains a green landscape.

By the 1850s, however, cities had grown too extensive to be contained within the limits of the vista, and artists had to resort to bird's-eye views or, alternatively, to the radical synecdoche of the street vista. In residential zones at least, vistas of middle-class urban or suburban enclaves retain the look of rural landscapes but have in fact been cultivated to look natural. Paintings of them are thus picturesque representations of picturesquely reconstructed landscapes. The confusion is evident in the anonymously painted *Home of Captain George P. Burnham as it appeared at 94 Cottage Street, North Malden, Mass., in 1845* (illustration not included), whose principal subject is the house's ornamental garden. Young bushes and irregularly planted copses of trees, picturesquely rough and various in texture, create a too-new and therefore not-yet-convincing simulacrum of the natural. An urn overflowing with flowers in the middle of the garden and a conservatory attached to the house connect garden to house. A witty incident in the foreground is tellingly ironic. The animal loose in Cottage Street is a sheep being chased off, not chased back, by a dog. In this garden, it is an unwelcome interloper. Nothing is to be consumed save by the eye alone. [23]

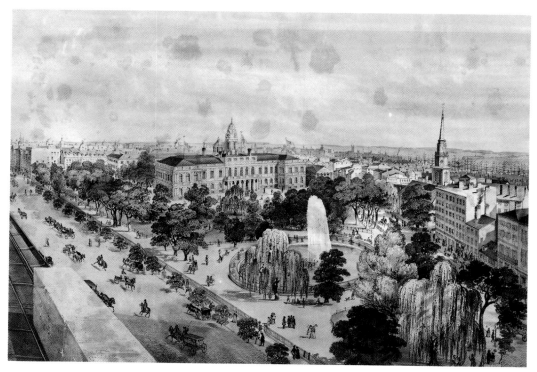

Fig. 59 John Bachmann, *New York City Hall, Park and Environs*, c. 1849. Tinted lithograph (Stokes 1849 E117). I. N. Phelps Stokes Collection, Miriam and Ira D. Wallach Division of Art, Prints and Photographs, The New York Public Library. Astor, Lenox and Tilden Foundations.

A second urban zone delineated in topographical painting is that of the civic center, with its churches, city halls, courthouses, and other public architecture. Here, too, picturesque design replicates itself as architects apply picturesque design principles to urban architecture, but the narrative remains connected, tenuously, to Dwight's scenario: the foundation of American communal life on principles symbolized by the buildings' functions: law, education, freedom of worship (and hence a multiplicity of various churches).[24] As in John Bachmann's vista of New York's City Hall (Fig. 59), the buildings are presented obliquely and monumentally, for maximum picturesque effect, and lighting effects are designed to intensify the animation of sculpted facades.

The third zone represented in urban vistas after 1850—that of the central business district, hub and showcase of a new commercial architecture, including hotels, department stores, theaters, and other places of consumption and amusement—is unprecedented and unanticipated by Dwight.[25] Nevertheless, the central business district manifests a kind of improvisational picturesqueness as it juxtaposes an eclectic and clamorous heterogeneity of styles and scales. Quite early, painters and printmakers learn to accentuate this energy with picturesque strategies of mise-en-scène and to inscribe on it a narrative of urban growth. In Philip Harry's *Tremont Street, Boston* (Fig. 60), two-story wood structures are overshadowed by the multistory stone structures of a growing city, Georgian simplicity by the picturesque complexities of Italianate Revival. Even the buildings not designedly picturesque are made

SPACE AS A VERB:
FRAME AND
NARRATOR IN
LANDSCAPES
AND INTERIORS

133

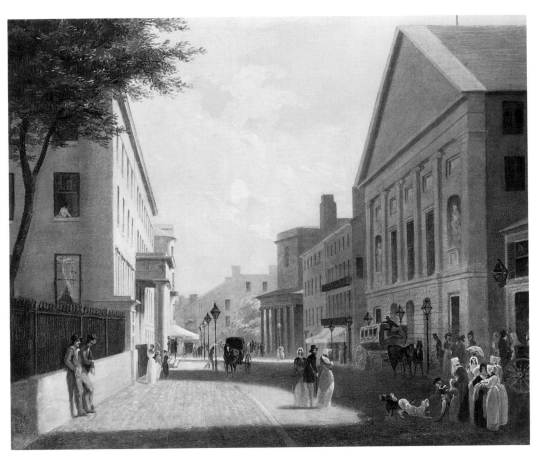

Fig. 60 Philip Harry, *Tremont Street, Boston*, c. 1843. Oil on panel, 13½ × 16⅛ inches. Museum of Fine Arts, Boston.

picturesquely interesting by foreshortening, monumentalization, and a low sidelight that casts long shadows. Space and form are joined in nearly cubistic planes. Symmetrical windows and a portico with Roman columns decorating the rectangular facade of the Tremont Hotel at left are juxtaposed against a collage of iron fence, tree (one of the picture's few organic shapes), and a dark cube of empty space. On the other side of the Tremont, the Italianate curve of a bow window juts out from the Albion Hotel.

The wall of buildings on the right is an even more complex arrangement of planes: a white-painted, two-story shop with shuttered window and suspended lantern; then the elaborately sculpted stone facade of the Tremont Temple, another Italianate affair, with rusticated stone on the ground floor, Ionic columns and sculpture in niches on the second, and a massive, inexplicably bare pediment on the third story; then two four-story brownstones; then the imposing arcade of Ionic columns of the publishing house of *Gleason's Pictorial Magazine;* and finally an attenuated fragment of Georgian brownstone. Windows—curtained, pedimented, shuttered, plain—provide a visual unity-in-variety, suggesting, in the process, the specular character of this architecture. Harry's oblique perspective accentuates the contrast between the ornamented facades and the unornamented sides of the buildings on the

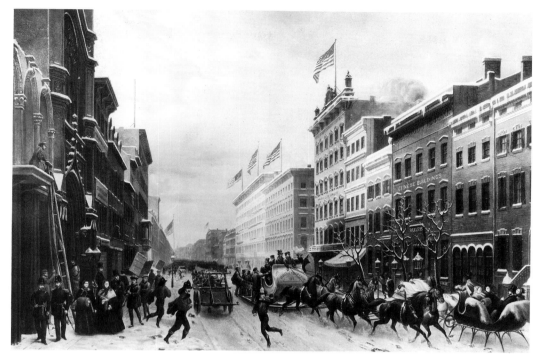

Fig. 61 P. Giradet (after H. V. Sebron), *Broadway and Spring Street, New York,* 1855. Engraving and aquatint (Eno 344). Eno Collection, Miriam and Ira D. Wallach Division of Art, Prints and Photographs, The New York Public Library. Astor, Lenox and Tilden Foundations.

SPACE AS A VERB:
FRAME AND
NARRATOR IN
LANDSCAPES
AND INTERIORS

135

right side of the street. It also accentuates the importance of the ground floors of the facades, for each is designed—with paint schemes, porticoes, arches, awnings, an arcade—to draw the eyes and the strollers into doorways. Even nature is geometric: a rectangle of blue sky, rectangular pools of light on the street, and two visually fragmented trees—street furniture.

By the second half of the century, commercial streets are also transformed, like the twentieth-century highway strip, into collages of signs and advertisements, shop windows, elaborate doorways, and ornamented facades in a variety of competing styles, including Gothic, Second Empire, and Queen Anne as well as Italianate.[26] In an engraving of H. V. Sebron's *Broadway and Spring Street, New York* (Fig. 61), the architecture, most of it still Italianate, as one would expect in 1855, is patently and picturesquely beautiful. Its monumentality makes it a little sublime, and so does its situation between the uninhabitable whitenesses of a snowy street and a stormy sky. This street and its buildings are at once an expression of and a bulwark against the sublimities of nature, which charge it with their energies. Wind unfurling their flags, the buildings seem to ride like ships through the darkening light and the snow. Snow and spots of metallic-catching light accentuate the ornaments on the facades.

Purposeful human energies—a crowded omnibus, sleighs, a fire truck responding (it appears) to a billow of dark smoke rising from a roof—oppose and at the same time harmonize with these natural energies. The figures in the street define the social environment of the city, which is wholly in harmony with the physical environment. Before middle-class decorum begins to govern the street, the American city,

this picture suggests, is a social environment made as Whitmanesquely animated and vigorous by its contrasts as by its commercialized architecture of desire. The human figures represent a colorful and heterogeneous mix of working people (the firemen, the bus driver, the men with placards) and *flâneurs* (the well-dressed women on the sidewalk and in the carriage, the men in uniform). It is at once a workplace and an elaborate sequence of sets designed for very diverse dramas of self-representation. Even the firemen answering an alarm are part of the spectacle!

A backward look at the succession of landscapes leading to these cityscapes requires several revisions in traditional notions about landscape painting. The first of these is an evolution in effects. In Church's *Icebergs,* the "stern sublimity" of wilderness is relieved by "picturesque agencies"; in Sebron's *Broadway,* sublimity has been urbanized. Virtually all of the other vistas after 1835 demonstrate the domination of picturesque beauty traced in Chapter 2.

The second is a telescoping of art-historical taxonomies. As the American landscape become settled and increasingly urbanized, landscape painting increasingly appropriates elements of genre and topographical painting (landscapes with human figures and human artifacts) until the distinctions between them are virtually erased. In urban vistas like Harry's and Sebron's, buildings take on the interest (and, as "sidescreens" and termini, the design functions) of valley and mountain walls in Claudian vistas, as streets take on the functions of lake or river. The painting of the rural landscape persists, of course, but after the Civil War it becomes formulaic and increasingly tinged with nostalgia—the expression of a wish that things stay as they were—until the realism of Winslow Homer and the abstract imagery of Georgia O'Keeffe, John Marin, and others revitalize the tradition. In this, too, Cole is prophetic. The river valleys of the American Northeast, he writes in his "Essay," have already been extensively deforested, and some are already seats of the industrial revolution.[27] His new subject after 1835, before he turns in the 1840s to such "allegorized landscapes" as *Voyage of Life,*[28] is therefore the spectacle of man in his social capacity cultivating a landscape that now "encompasses our homes." In this he anticipates the evolution of the vista for the next fifty years.

Analogous blurrings of boundaries occur in the picturesque repertoire of frames. The spirit of eclecticism complicates this taxonomy, too. As Church's landscapes demonstrate, the panorama can accommodate the depth of the vista and vice versa, and, as Cole's tree demonstrates, portraiture is also possible in the foregrounds of vistas and panoramas. A quite popular combination of close-up and vista or panorama both foregrounds its subjects and environs them in deep space, giving them both individuated and contextual definition.

THE CLOSE-UP AS DOMESTIC NARRATIVE

House Portraits

Close-ups, too, incorporate plots of the domestication and refinement of Anglo-American civilization. Their dominant locus, however, is the house rather than the landscape, and in this they conjoin topographical and genre painting. Where vistas

narratize landscapes as synecdoches of public change, close-ups narrate changes in domestic arrangements as metonyms of change in private life—changes also evident in human figures, when these are included.[29] A house portrait on one side of the picture, a vista into deep space on the other, Thomas Cole's *Home in the Woods* (Color Plate XXIII) does both, making a pioneer's cabin the subject of several interconnected narratives of personal as well as public transformation.

The plot of pioneering begins in the left foreground with the two stumps, one axed and the other downed by wind: humanity joining nature in a process too selective to be called destruction. (Indeed, the picture expresses Cole's ideal view of settlement as a harmonic interrelation of nature and culture.) Proximity allows a detailed representation of forest transformation. In a sequence that unfolds across the foreground and recedes into the middle ground, fallen trunks are transformed into logs both for firewood (note the ax and the chimney smoke) and for house-building.

Variations and contrasts in the sequence of architectural artifacts, moreover, narrativize the cabin's past and future as well as its present. The lean-to in the foreground, the crudest structure, is an emblem of its beginning. The one attached to the cabin is larger and more finished. The lighting concentrates the viewer's eye on the tensions between the cabin's present unfinishedness and its future grace: rough logs are juxtaposed against the refinements of chimney, gabled eave, framed windows, and porchlike roof above the door—signs of its eventual transformation into a work of art. Like Natty Bumppo's cabin in *The Pioneers,* this one is both harbinger and blueprint of the picturesque cottage. With a touch of wit typical of the picturesque, Cole makes the hen coop the most finished architectural structure after the house itself—but that too thickens the theme of refinement. Like privileged guests, the hens are sheltered in a model of what the cabin will become. A related evolution is evident in the forest at left center. From under its canopy emerges, on long looking, a stumpy pasture already fenced for the several cows that materialize from the shadows.

With the human figures, Cole defines his house as a social environment as well as a material one, and it, too, is seen to be undergoing refinement. It is the figures that transform the cabin into the "home" of the title. Emerging from the vista at left with fish for his family, the husband-father plays the role of hunter-gatherer. Yet this role is a temporary one. His clothes indicate that changes in economics and in status have already begun. With his brimmed hat and his vest, he is a homespun aspirant to respectability. Meanwhile, the affectionate gestures of the woman, who appears at the edge of her (virtually invisible) domestic sphere, suggests that she carries on there "the moral work of society . . . —raising children [and] . . . providing a harmonious retreat for husbands." In this idealized painting of domesticity, the work that binds and elevates the nation also binds and elevates the family.[30]

House portraiture also defines, in particularly telling detail, an early stage of the century's changing relations between nature and domestic culture. Between 1820 and 1850 or so (and intermittently thereafter), as the domestic vista documents the Euro-American acculturation of the forest wilderness, portraits like Cole's envision the ideal of mutual adaptation between nature and culture that Downing also espouses. Cole's house does so, in ways typical of picturesque architecture, by confusing the boundaries between inside and outside. Like Thoreau's house at Walden, its

SPACE AS A VERB:
FRAME AND
NARRATOR IN
LANDSCAPES
AND INTERIORS

137

space extends beyond its walls. A pot and dishes along the bench to the right of the door suggest a kind of *plein-air* dining room—a patio! The lean-to at the end of the cabin has been converted into a storeroom and that in the foreground, with its wash-tub and line of clothes, into a laundry—a work space segregated from the interior, as if the family were already beginning to consider the latter as a space of leisure.

As architectural forms extend the house into the landscape, natural forms extend the landscape into the house. A vine spreads across its outer walls—the beginning of a picturesque embowerment, and architectural shapes reiterate natural shapes, in recognition of their kinship. The pines behind the house form a wall repeated in its walls, which are made of the same wood. Their triangular tips are repeated in the inverted vee of the gable. The pitch of the roof rhymes with the shape of the ridge in the middle distance. House and landscape are congruent with each other.

Separations of the Spheres in Domestic Interiors

Making transparent, as a proscenium stage does, the wall between inside and outside, private and public, inhabitants and viewers, domestic interiors in genre painting typically accommodate a theater of domesticity.

The figures performing in them dramatize the century's changes in the idea of domesticity and in the qualities of feeling, behavior, and identity attending it. Early in the period, republican interiors frame, like stage sets, the discords that complicate but also reinforce scenarios of maturation from childhood through courtship, marriage, child-rearing, and aging. This gravitation toward biological and emotional plotting, as Ann Douglas has shown, constitutes a feminization of American narrative. But *feminized* does not mean played out from a female perspective. With the most evident exception of Lilly Martin Spencer (see Figs. 7 and 8), interiors play out an emphatically masculine view of the home. As Elizabeth Johns observes, they depict women neither in control of their sphere, nor in community, in sisterhood. Women are exclusively wives and mothers—the mothers chiefly of sons. Repeatedly, they dramatize the unruly energies and rebellions of male adolescence in republican interiors; the leave-takings of young men as they enter the world; the returns of men, young and old, from the world. And repeatedly they exonerate men as causes of the discords they dramatize. In Charles Bird King's *Rip Van Winkle Returning from a Morning Lounge* (Fig. 62), for example, both the set and the domestic drama taking place in it are designed to enlist the sympathies of the viewer for the recalcitrant Rip, instead of his "shrewish" wife (as King and Washington Irving both characterize her), who is seen to be abusing her power and neglecting her sphere. Like landscapes, republican interiors are thus "essentially about men."[31]

The interiors themselves are designed like stage sets to elaborate these personal narratives, and in the process their narrative themes of domestication and refinement become in many ways analogous to those situated in land- and cityscapes. The refinement of the republican interior (and its inhabitants) takes place concurrently with the refinement of the public self. As the ideal of the house as place of leisure comes to prevail over that of the house as a place of work, kitchens and other domestic worksites gradually disappear, and parlor scenes multiply. Women are transformed from co-laborers into ladies of leisure or into people doing the elevated work of mothers, nurturers, educators. As an emblem of this, the parlor becomes, as in

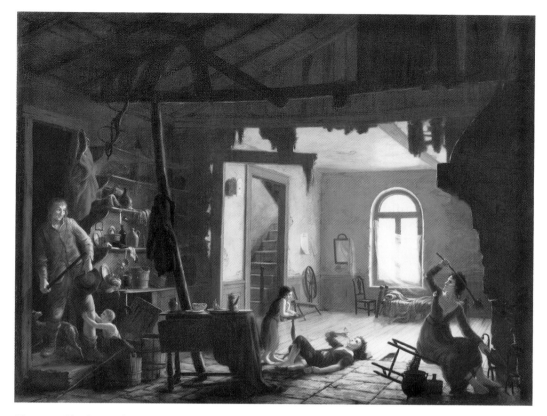

Fig. 62 Charles Bird King, *Rip Van Winkle Returning from a Morning Lounge*, c. 1825. Oil on canvas, 44 × 56½ inches. Museum of Fine Arts, Boston.

SPACE AS A VERB:
FRAME AND
NARRATOR IN
LANDSCAPES
AND INTERIORS

139

Dutch painting, a Christian arcadia not subject to worldly deformations. Cloth is "spotless, unrumpled and without stain or suspicion"; metal, polished to "a state of brilliance." An atmosphere of domestic tranquillity prevails. Rooms are immersed in a twilight of cool repose.[32]

That is the transformation emerging, for example, in William Sidney Mount's *The Sportsman's Last Visit* (Color Plate XXIV). Like the sportsman, the room presents a republican decor—rural, vernacular, designed for use and comfort. It is severe, even ascetic, in its functionalism. The floorboards are bare, the beams exposed, the walls earth-toned and ornamented only by functional still-lifes: a sickle on a hook, a kerchief and hat on a peg. The sportsman's rifle, leaning familiarly against the wall by the fireplace, at the same angle as the coal shovel, indicates how much at home he has been here.

But like the figure of the young lady (and like the house of Mara Lincoln in Stowe's *The Pearl of Orr's Island*), the room is beginning to change. The rug under the woman's chair is a small island of color and ornament on the hard, plain floor, and as one looks the island becomes an archipelago. Thread spills from a sewing basket in curls that are repeated in the ornamental leaves and blossoms on the potholder under the mantel; in the picture on the rear wall; in the plant on the windowsill; in the wedge of living foliage visible through the window.

The refinement of American life is attended by such a refinement of nature as Mount subtly suggests. One of the remarkable convergences in close-ups after 1850

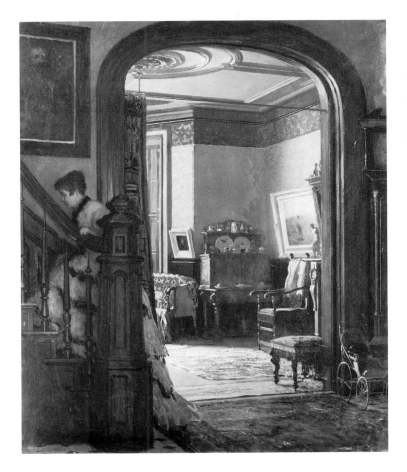

Fig. 63
Eastman Johnson, *Not at Home,* c. 1870–80. Oil on board, 22½ × 26½ inches. Brooklyn Museum of Art.

is that between domestic and forest interiors (roomlike clearings). Both contemplative spaces are set apart from the world's bustle. Each assumes the characteristics of the other, and each becomes poised between inhabitability and a disquietingly mysterious insubstantiality. Where exactly we are when we are in them is by no means a foregone conclusion. In the American painting, the edges of forest clearings and streambeds, "in a measure transparent," like Durand's trees, become *assemblages* of inside and outside, near and far: we see them, see into them, see through them. Open doors and windows have the same effects in domestic interiors, actual and painted alike, and these are typically complicated by juxtapositions of actual and idealized space (hung paintings, for example) or by juxtapositions of several interior spaces by means of mirrors and hallways or stairways.

Brought inside, nature is then sealed off from the outside world by walls and heavy curtains and made a trope of art.[33] Victorian parlors take on the look of bowers filled, as in Eastman Johnson's interior (Fig. 63), with the vaguely organic shapes of plush furniture, art objects, potted flowers, ornamented screens, and drapery. Chiaroscuro accentuates these effects as it becomes more palpable than the planes of walls and ceilings. Darkness erases walls and corners, and gleams of light impart to the interior "an impression of all-pervading movement." The light in Nicolas Maes's *The Listener,* an American critic observes, in a description that is also a gloss of Johnson's interior, is "a moving presence of slow and changing life" that an-

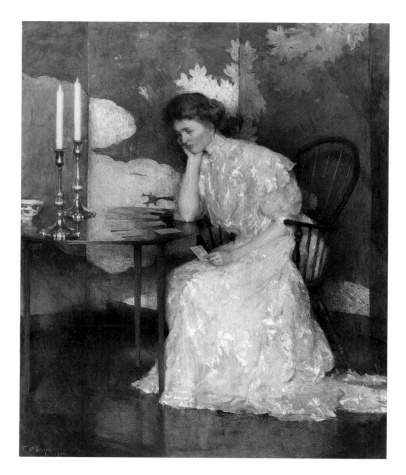

Fig. 64
Frank W. Benson, *Girl Playing Solitaire*, 1909. Oil on canvas, 102.9 × 128.3 cm. Worcester Art Museum, Worcester, Massachusetts.

SPACE AS A VERB:
FRAME AND
NARRATOR IN
LANDSCAPES
AND INTERIORS

141

imates even inanimate things. Catching light flares from the yellowing white apron and tippet of a girl descending "the stairs that just hides her, in her silent and arrested moment." Islands of light illuminate, fitfully, the troubling mysteries and obscurities of private life: "it is difficult to say," the reader concludes, "whether the light begins to be shadow, or shadow begins to be light, and so, amid half-glooms, to isolated points of brightness; the baluster head catching at just one rounded bit the stray glimmer; the glimmer breaking out again, yellow and brassy, on the farther nails of the straight . . . chair that peers from background space and wall, in cozy and gathered dimness."[34] When the darkness finally dissipates in the interiors of the Boston School, the American withdrawal from nature culminates in sealed, airless brilliancies populated by solitary, dreaming women in white (Fig. 64).

Objectifications of the Self in Portraiture

An analogous development characterizes nineteenth-century portraiture. During the 1830s and 1840s, portraiture in painting, as in literature, gravitates toward the dramatic expression of an interior self. In his portrait of Asher Durand (Fig. 65), for example, Charles Loring Elliott, a leading antebellum portraitist, systematically omits all details that would distract from an emphasis on the subject's consciousness. There is no outward action, no complex relation to an environment, no (or little) sign of social or economic status. Such incidents as can be said to occur are psychological:

Fig. 65
Charles Loring Elliott,
Asher B. Durand, 1860.
Oil on canvas, 55.6 ×
68.8 cm. Walters Art
Gallery, Baltimore.

Elliott's Durand, as James Flexner observes, is a face filled with the expression of "an energetic moment."

By mid-century, however, dramatic expression is complicated, and often vitiated, by expressions of status. Henry Inman and other postwar (and postdaguerreotype) portraitists seek to catch in their subject's faces "the movement of features that exemplifies a salient trait"; they seem most interested in defining their subject's performing selves. "Mrs. James Donaldson" (Fig. 66), for example: her body-language, dress, and even the props that dominate the picture-space around her are objectifications of her, or her husband's, desire for status.[35] They mask her interior life.

The ultimate objectification is the use of still-life as a kind of portraiture. The deformations in William Harnett's portrait of a Colt Army Revolver (Fig. 67), for example, bespeak a hard history and a change of status that expresses, indirectly, those of its owner as well. "The dull glint of the rust-pocked steel barrel and the cracked ivory handle of the Colt," Carol Troyen observes, "bespeak its long and faithful service" (at Gettysburg); but it hangs now from a nail on a wall—a memento, a work of found art. A bullet hole in the wall (the wall of a porch or country house, perhaps, with its sun-crazed paint, but in no sense the wall of a parlor) and an enigmatic *trompe l'oeil* newspaper clipping positioned like a caption add elements of latent power and mystery.[36]

Fig. 66
Henry Inman, *Mrs. James Donaldson*, c. 1830. Oil on canvas, 27 × 34 inches. The New-York Historical Society.

SPACE AS A VERB:

FRAME AND

NARRATOR IN

LANDSCAPES

AND INTERIORS

143

Assemblages of still life also serve more explicitly as objectified human portraiture, as if people were becoming the objects they collect. Edward Ashton Goodes's *Fishbowl Fantasy* (Color Plate XXV), for example, tells the story of a woman's life in arrangements of forms that include a bouquet of summer flowers; three goldfish looming in the shadows of the fishbowl (centered); a (reflected) view—picture-within-the-picture—of two women standing before a church, a civic building, and a flag; and an array of memorabilia scattered across the lower edge of the picture. Each is related to the whole by means of leitmotifs: the reflected picture, for example, is connected to the framing picture by the leitmotif of a woman's hat, and, along the lower edge of the picture, other feminine accouterments are also grouped (and thus identified) with the hat. The color pink is another leitmotif.[37]

It is the name "Isabel" and contiguous icons that imbue this assemblage with the coherence of a psychological portrait. Two doves with their beaks touching; a writing cabinet surmounted by a *putto;* a letter inscribed "Dear Isabel" and signed "Frank"; an invitation: these impart the narrative coherence of a love story. Yet the juxtaposition of flowers and fish in the picture's center carries the disturbing suggestion of a disjunction between Isabel's expectations and the reality awaiting her. The flowers, as Trevor Fairbrother observes, are symbols of passion (the bleeding heart to

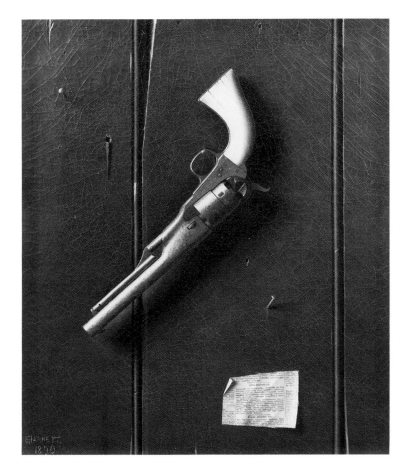

Fig. 67
William Harnett, *The Faithful Colt*, 1890. Oil on canvas, 18½ × 22½ inches. Wadsworth Atheneum.

the right), happiness, fertility, and material prosperity. Under them, however, looms the shadowy domestic reality of the fish: plump, torpid, dreamy, and imprisoned as in a bell jar. The theme reverberates ironically in a song title on a sheet of music: "Oh! Woo Me Not from My Cottage Home." [38]

Transactions Between Self and Environment: The Portraiture of Urban Street Children

In *Mrs. James Donaldson, The Faithful Colt,* and *Fishbowl Fantasy,* portraiture variously defines the domestication of the self. In the representations of urban street children, increasingly popular in the second half of the century, portraiture also defines the converse process: the ravages of homelessness. In genre portraits like those of Thomas Le Clear's *Buffalo Newsboy* (Fig. 68), William Page's *The Young Merchants* (Fig. 69), and George Yewell's *The Bootblack* (Fig. 70), the conventions of dishevelment and agitation are at their most complex. The figures are battlegrounds of opposing forces. Environment is seen to imprint one story on the bodies of their subjects and the counterassertions of character yet another. Victims of this environment, the figures have not yet succumbed to it, and, indeed, like Cole's tree, they assert themselves against it. Bingham's riverboatmen are what they are by virtue of their environment; these street children are what they are in spite of it. Nevertheless, they have also internalized the city's promise.

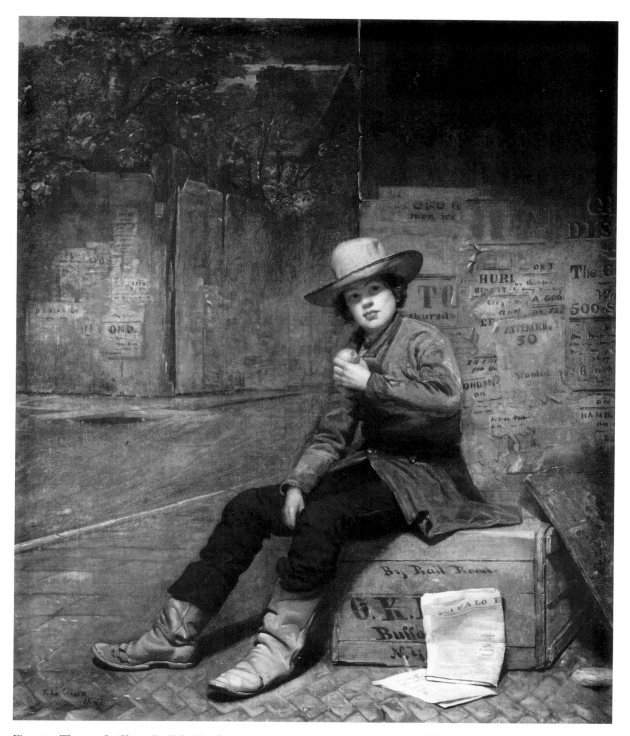

Fig. 68 Thomas LeClear, *Buffalo Newsboy,* 1853. Oil on canvas, 20 × 24 inches. Albright-Knox Art Gallery, Buffalo, New York.

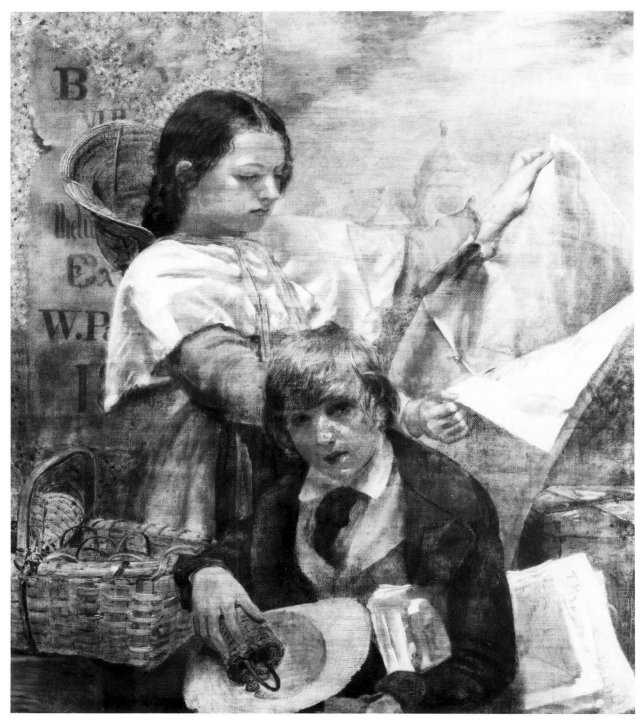

Fig. 69 William Page, *The Young Merchants*, 1842. Oil on canvas, 36½ × 42⅛ inches. Courtesy of the Pennsylvania Academy of the Fine Arts, Philadelphia.

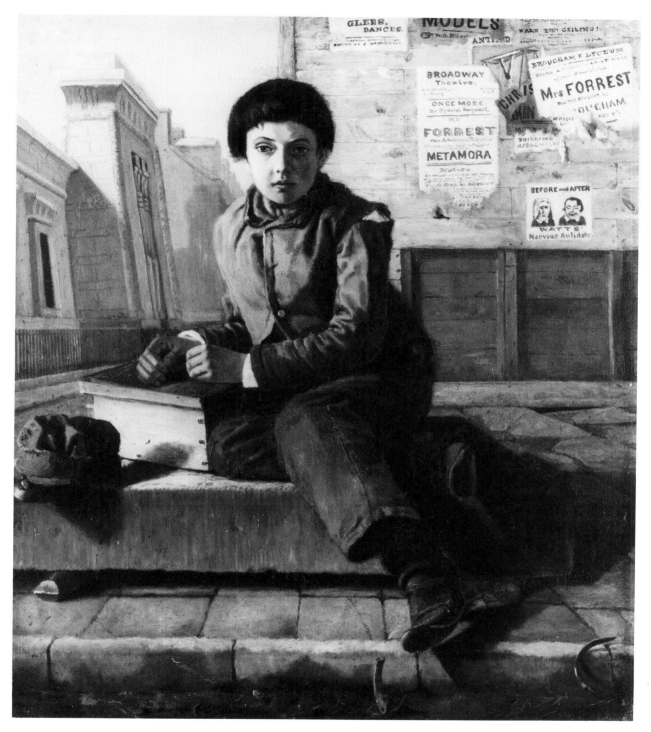

Fig. 70 George Yewell, *The Bootblack,* 1862. Oil on canvas, 12 × 14 inches. The New-York Historical Society.

Leitmotifs that link the bodies to their urban environment as effect to cause define the city as a social and psychological influence, and contrasts signify counterassertions of the will or conflicts between dreams and social realities. Each composition is divided. Half the space is occupied by a stony, claustrophobic cul-de-sac on the margins of a business district: a back alley, typically, whose blank, graffitied walls define their isolation and oppression, but also their desires. The other half is a cramped vista whose forms signify the city's promises. In *Young Merchants,* the dome rising over the open newspaper is New York's City Hall. In *The Bootblack,* the prospect is more ominous: the facade toward which the boy leans and to which he is linked by diagonal lines is New York City's prison, the Tombs. In *Buffalo Newsboy,* a fruit tree walled off from the narrow back street by a high fence at the left defines the city's relentlessly exclusionary geometries.

Yet other promises appear in the posters festooning the alley walls. Collages of words and images—eye-catching, clamorous, variously scripted, and sometimes unintelligible (the appeals of commerce withheld from the figure and the viewer)—intensify the subjects' marginality. In *Young Merchants,* weather has erased from the top of a poster all but a B and the faded fragments of what might be a W, and the figure of one of the merchants fragments the rest (the sequence W. Pa suggests a witty self-advertisement by the artist). In *Buffalo Newsboy,* similar fragments—TO, HURL, thursda, 50, 50, Wonder, ondon, By Rail Road, Buffalo E—cover the walls, the box on which the newsboy sits, and the papers he is selling. In *The Bootblack,* the layered fragments evoke a history of changing urban desires. At the center, the oldest layer of posters, appears a torn and darkened CHRIS[T]. Surrounding that, old theater posters: Mr. FORREST// METAMORA; Mrs. FORREST// ougham. Above these, in a frieze superimposed across the top, a new dispensation for new desires: NEW SONGS, GLEES, DANCES: MODELS: walk the ceiling! And at the bottom, the newest (least weathered) addition: a frowning face (like the bootblack's) and a smiling face—advertisements for a cure-all named Watts Nervous Antidote.

The cubistic wedges of sidewalk closed off by their graffitied walls define the city as harsh and ruinous, grimy, dark, airless, unforgivingly hard—qualities cited by social reformers from Catherine Beecher to Jacob Riis as the conditions of disease, depression, and deviant behavior. The gutter visible in *The Bootblack* is choked with litter and, like all the other surfaces, chipped, pock-marked, stained. Signs of unremitting violence reappear, with shocking harmony, in the figures. The clothes of the unaccommodated children in *The Young Merchants,* indicating a kind of genteel poverty, show signs of mere dishevelment in frayed cuffs and gouged hat brims; and so does their hair, tousled and stiff. The ruined clothes of LeClear's Buffalo newsboy are near disintegration. These clothes disfigure the body: the boots make the feet seem enormous. The shoulders, pinched by a shrunken coat, are compacted, skewed, rigid.

These are victims of a world characterized by everything that Bingham's river world is not; a world in which dirt, darkness, constriction, weather, age, civilization, and class all contribute, simultaneously and relentlessly, to physical misery. The bodies are painfully thin, stiffened and twisted by cold or pain. The bootblack holds thin, red fingers pinched together, like wooden paws. His eyes and those of the young

merchant boy are bruised and pouched, and the latter is hunched over like an old man. The figures are wary and exhausted, as if the targets of abuse.

Street children are a subject of major interest in nineteenth-century America because they demonstrate the most pressing problems of urban disorder and urban identity. In these innocent victims, reformers and artists alike see the physical and emotional effects of slum life written large. Some also fear the prospect of moral and social degeneration: the slide, greased by "low fellowship and bad habits," into alcoholism and pauperism, criminality, and social unrest. "The perception of this awesome and darkening cloud of immoral potential, poised so as to threaten the nation's most fragile blossoms," writes Bruce Chambers, "sent a shudder through the heart of every virile male and watchful mother." Fears about moral degeneration are exceeded only by fears that street children, angry and organized, might threaten the social fabric by criminal activity or even, eventually, by revolt.[39]

The most significant feature of the three genre portraits, however, is the discontinuities between environment and character, body and expression. Body language and possessions visualize an inner life dominated by ambitious dreams. Their settings are lit theatrically, with catching light illuminating both the products they sell and the masks of civility they have put on to sell them. And so their location on the fringes of the commercial business district takes on special meaning as a theater of (constricted) ambition, down to the emblandishments of the poster fragments behind them. In this light, it is possible to see that they have even tried to dress the part, with cravats, coats, hats, white shirts (for some), and even (for the young merchant) a vest. As with Benjamin Franklin, character is their hope of redemption, their destiny, and the *appearance* of character their capitol.

Surely the most powerful image of this drama of the struggle for success is the face of the bootblack. It is divided almost cubistically, by chiaroscuro, into two contrasting masks. From the dark mask looks the eye of the victim and the potential victimizer: wary, slightly glazed, on the edge of bitterness. From the lit mask, however, looks an eye whose expression is reassuringly familiar. Like Ragged Dick's, it is observant, reflective, open to experience but still innocent and apparently benign. Posture extends and accentuates the effect. The lordly sprawl of the body, propped (like that of the boy in Bingham's *Fur Traders*) on an elbow, reiterates the expression of the face. Essentially alone, the bootblack has attained the calm poise of equanimity and the self-reliance of the individualist. Yet he cannot redeem himself alone, and therefore he waits patiently, like Horatio Alger's characters, for a sympathetic viewer who will be his customer, his deliverer.

These close-ups are typical of the impulse in genre painting, after the 1850s, to depict worlds defined not so much by specific outward events as by an inner life made visible on the surfaces of the body. Like the characters in Henry James or Mark Twain, the figures compensate for their oppressive and anonymous urban environments by acts of memory or of faith. Children fantasizing a powerful or glamorous adulthood (see Figs. 13 and 14); women in brilliant, splendidly polished rooms pensively contemplating children or open windows or books (see Fig. 64); combat soldiers remembering their homes or returned veterans their battles; immigrants lost between past and future; the old absorbed in biblically inspired visions of the future

SPACE AS A VERB:

FRAME AND

NARRATOR IN

LANDSCAPES

AND INTERIORS

149

or looking back, with the aid of a fire on the hearth, to youth: these recurrent subjects of late nineteenth-century portraiture signaling the advent of realism dramatize a qualified acceptance of the way things are, mixed with a conviction of the saving necessity of dreams and ideals, as if dislocation between the two had become an inevitable fact—as if the conflicts and ambiguities of urban life had to remain, like other sources of the blues, open-ended and outwardly unresolved.

FITZ HUGH LANE'S GLOUCESTER HARBOR: THE PANORAMA AS ECOLOGICAL NARRATIVE

Panoramas are also adapted to narratives of Euro-American civilization, even to representations of urban ports (Boston, New York), where commercial ships form temporary "roads" across the water. But luminist panoramas situate landscape and cityscape alike in seas of space and light that have distinctive qualities and relate distinctive incidents of their own. Cool, "hard," "palpable," Barbara Novak observes, luminist light "radiates, gleams, and suffuses on a different frequency than atmospheric light. With atmospheric light, which is essentially painterly and optical, air circulates between particles of strokes. Air cannot circulate between the particles of matter that comprise luminist light."[40]

This poetry of light makes Fitz Hugh Lane's panoramas—including his two *Stage Rocks* paintings (Color Plate XIX and Fig. 71) and his *Norman's Woe* (Color Plate XX), both set in Gloucester Harbor—the supreme pictorial expression of Transcendentalist narrative. They situate the harbor in a universe whose patterned energies, manifold, incessant, and (like Emerson's) picturesquely beautiful, allow only partial and momentary stillnesses. Ripples in the water signify a turn of the tide, a rising breeze; triangles of darkness in the southwestern sky, night; oranges and browns in foliage, autumn; columns of cumulus rising from cloud banks, the return of the weather that has left visible marks of its violence on the shoreline. These narratives of natural change, however, are muted and marginalized. So, too, after 1850, are the narratives of human activity. It is not clear whether the barely visible figures in *Stage Rocks* (Fig. 71), for example, are raising or lowering the sail, embarking or debarking. The mood suggests a debarkation, but the full sails of the schooner at the left suggest embarkation, the rhythm of human movement tuned to the rhythms of wind and tide.

In the deformations of the shore world, the energies of Lane's cosmos become evolutionary. The scarred land rises from the water's edge, changing as it rises. A history of weathering links the shoreline's sequences of bedrock, boulders, pebbles, and sand; a history of storms, the bones of wrecked ships, and the dead vegetation on the beach. A more insistent narrative strand plots the emergence of beauty from this violence.[41] Boulders and bedrock together summarize the geological history of this ecotone: its facets still carry the marks of its having been torn by glaciers from its bed and scored, then stained, chipped, and eroded. Pebbles sculpted into ovate perfection and fine sand foretell a boulder's future in *Norman's Woe* (Color Plate XX), and in the other pictures the bedrock undulates like the waves of ice and water that sculpted it. On the beach, the effects of oceanic transformation are more grotesque,

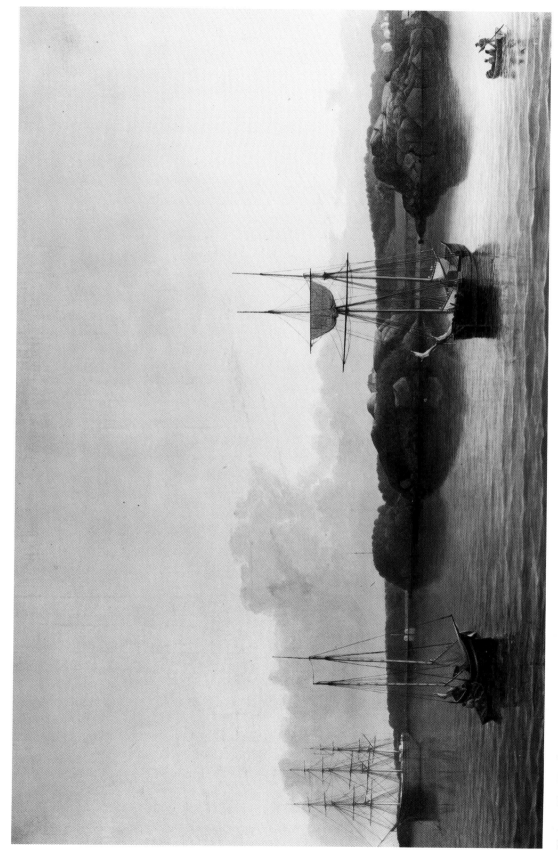

Fig. 71 Fitz Hugh Lane, *Stage Rocks and Western Shore of Gloucester Harbor*, 1857. Oil on canvas, 23 × 38 inches. Private collection.

mixing organic and inorganic, life and death, in a subaqueous stew. The splitting boulder in the foreground is shaped like a house, and the house-sized boulder behind like a giant clam, with a dark fissure between its two shells. A log half-buried in a tide-line is festooned with leaflike clumps of seaweed.

Above the beach, naked rock is furnished by weeds and grasses; then, upslope, by waves of trees, the climax of this ecological succession. The settlement narrative emerges from this in seamless sequence: the trees give way to intermittent fields, the fields to houses. One of his deepest subtleties is the way Lane links even apparently contrasting forms conceptually. In *Stage Rocks,* gray shadow links the white symmetries of Federalist houses, suggesting the classical divorce from nature, to the gray rocks (thus: a civilization in complex harmony with nature), and color and form link houses to ships (thus: a maritime civilization).

Lane's version of settlement is thus the emergence of a human ecology patterned after its natural homologue. Thick, broad-beamed, even ungainly working craft, Lane's ships are nevertheless linked by leitmotif to rocks, trees, waves, and clouds— a declaration of the profound unity between nature and Lane's Yankee culture, for all of its aggressive commercialism. Their hulls are as massive and durable as granite rock; their bows curved like waves and pointed for slicing the water; their masts and spars rise like abstractions of the trees in the background (Color Plate XVIII). Creatures of fire and air as well, their sails catch, like the water, the faintest stirrings of wind and, like the clouds they resemble, the least flickers of light. Furled into medallions (a favorite configuration of Lane's), the up-curved tips of the sails look like the wings of gulls.

It is in the seaward views like *Norman's Woe* that Lane's Transcendentalist narrative merges with the most dramatic effect. Its recessional path moves the viewer's gaze from the abrasive darkness of *terra firma,* scarred and old, to the numinous immensities and synchronies of ocean and sky—and to a state of mind in which, as in *Moby-Dick,* "water and meditation are wedded forever." The luminist brushstroke intensifies the effect by disappearing, taking with it signs of the artist's presence. Like Emerson's transparent eyeball, the smooth luminist surface is beyond ego; its glassy surface, Novak observes, "transforms paint into a substance that shines and emanates," like light; and like light, it "heightens the textural properties of [forms] . . . beyond the compass of normal vision: the hard, taut ripples in a lake, the crystallinity of rocks, the minute identities of pebbles." The medium disappears into "the illusively hyper-real image." Phenomenal and at the same time immaterial, mystical, light both releases and creates meaning.[42]

The grand plot of Transcendentalist narrative in Lane's panoramas is circular. Drawing the eye into distances, the painting then follows the path of the brilliant, mystical light proceeding, in a sequence of spiritualizing effects, toward the foreground from the sky. Stilled by the atmosphere, the water becomes (as at Thoreau's Walden) "sky-water," a "lower heaven" radiant with reflected light. In sky-water, reflections transfigure material forms. The cloud bank gets inverted—cast free of gravity and of its earthly orientation (up and down); magnified, so that it nearly fills the frame of the cove; intensified tonally; diffused, its form (nearly) indistinguishable, such is the subtlety of the gradation, from the light. Things become palpably ideal-

ized. To a reflective viewer, the reflected forms seem to ascend into existences be-yond time and matter: the scene as a natural type of the millennium. The water itself takes on allegorical meaning. We are made "a crystal well," Thoreau writes in his journal in yet another unintentional elucidation of Lane's work, "clear," capable (like artists) of lucid reflection because profoundly calm: not (by nature) "turbid" or "sour" from our contact with the world nor turbulently "jarred by chagrins in deal-ing with [it]."[43]

The reflection in *Norman's Woe*—a reflection on a reflection—also becomes a trope of luminist painting itself. "The reflection," writes Thoreau in his journal (and *Norman's Woe* rhymes its agreement), "is never a true copy or repetition of its sub-stance, but a new composition." Just as Thoreau's Walden pellucidly intensifies color and magnifies images like a Michelangelo, so Lane's Atlantic receives and transfigures its images of the New World. Like the luminist artist, the ocean is itself dematerial-ized and (almost) disappears, mirrorlike, into its reflected surface.[44]

Lane's light, like Emerson's and Thoreau's, is at the same time a type of grace. It heals, animates, and completes as well as spiritualizes the forms it touches—and it does so (as in *Walden*) paradoxically, by truths made evident through visual illusions. Light suffuses the broken shelf of granite called Norman's Woe. Its warmth gives the rock the ruddiness of flesh, which seems to palpitate in the still air. Joined by its reflection, it is rounded into an oval, its beauty made complete. It is transfigured not only by, but also into, light. Loosed from earth, loosed even from matter, the glow-ing shape of rock and light floats in a sea of light. Vertical curves push it upward: form containing, and obeying, the impulse to ascend. In the offshore views, the earth it-self is set afloat, revealing its buoyancy, its inherent impulse to rise. It hovers between sky and sky-water like the apotheosized saints of baroque painting.

And everything that rises must converge: must take its place, as Emerson de-clares, in "the entire circuit of forms" that is "the standard of beauty . . . *il più nell' uno*," that invests forms with "universal grace." The earth household has its roots in a universe in which all things are a going toward oneness. Lane's way of showing this is to link everything by means of the picturesque line of beauty: sign of a divinely mandated, pervasive harmony, gradually emerging in the world's flux. The most in-clusive ministry of light in *Norman's Woe* is its accentuation of the domelike curva-ture of the sea-battered rock of the title. Ripplelike, that curve connects it to shore-line, vegetation, wave, human art, cloud, even the arcs of light and darkness. In the "undiluted air of evening," everything seems to have been copied from the ripple, Thoreau declares at an epiphanic moment in *A Week on the Concord and Merrimack* (332–33). "Trees were but rivers of sap and woody fibre, flowing from the atmo-sphere, and emptying into the earth by their trunks, as their roots flowed upward to the surface." In the sky, "there were rivers of stars. . . . There were rivers of rock on the surface of the air, and rivers of ore in its bowels, and our thoughts flowed and cir-culated, and this portion of time was but the current [!] hour." In *Norman's Woe,* water has rounded and polished the granite into forms as various as coves and peb-bles; it sustains the rippling vegetation above the tide-line as the vegetation sustains human beings. Even the scalloped form of the sloop is wavelike.[45]

But water is also a result of the ripple, like the clouds (water transfigured by heat)

SPACE AS A VERB:

FRAME AND

NARRATOR IN

LANDSCAPES

AND INTERIORS

153

and the arcs of light and darkness, and so here, too, as in Emerson's nature, "[t]he granite is differenced in its laws only by the more or less of heat, from the river [or ocean] that wears it away," and both resemble the air that flows over them, as "the air resembles the heat which rides with it through Space." Heat, like light, is in turn a type of love—a manifestation of those "endless circulations of divine charity" that give form and order to creation, endowing all forms in it with the capacity to become one (a universe). That is how *Norman's Woe,* like all of Lane's luminist paintings, becomes "an abstract or epitome" of the Transcendentalist's world. "[T]he works of nature are innumerable and all different," Lane might be said to declare with Emerson, but "the result or expression of them all is similar and single. Nature is a sea of forms radically alike and even unique. . . . What is common to them all is [picturesque] beauty. . . . Nothing is quite beautiful alone: nothing but is beautiful in the whole."[46]

[A] country residence . . . [should make] such a composition as a landscape painter would choose for his pencil.

Landscape Gardening is just as much a picture, though a living one, made by trees, as a painted landscape . . . made by the pencil or brush.

—Andrew Jackson Downing, *Treatise on the Theory and Practice of Landscape Gardening*

Comparing the Picturesque Arts

ARCHITECTURE AND
LANDSCAPE ARCHITECTURE
AS PAINTING

For eighteenth-century English theorists, painting was the source and template of picturesque values. For nineteenth-century American theorists, and artists, the matter is more complicated. Nature is the source of picturesque values; painting appropriates natural scenery, in the process refining and conceptualizing it in more finished and more congruent landscapes. This symbiotic relationship between nature and painting informs "the laws and precepts" of all picturesque arts, including architecture, landscape architecture, and literature. To each of these arts, picturesque composition imparts, as it does in painting, a structural balance of tensions between variety or contrast and a unity derived from repetition, gradation, and the hierarchization of effects. Meaning gets expressed in a concatenation of effects that unifies both scenes (all picturesque art is by definition scenic) and their constituent images or forms; it is always potentially narrative as well as modal and symbolic.

This is Samuel Morse's case, in *Lectures on the Affinity of Painting with the Other Fine Arts* (1826), for a comparativist conception of picturesque art, and it states an American consensus. Writes William Sidney Mount of painting: "Con[c]entration of an idea and effect makes a picture—subject, color, light and shadow." The picturesque park, Frederick Law Olmsted declares, in capital letters, "IS A SINGLE WORK OF ART, . . . SUBJECT TO THE PRIMARY LAW OF EVERY WORK OF ART, NAMELY THAT IT SHALL BE FRAMED UPON A SINGLE, NOBLE MOTIVE, TO WHICH THE DESIGN OF ALL ITS PARTS, IN SOME MORE OR LESS SUBTLE WAY, SHALL BE CONFLUENT AND HELPFUL." And prose narrative, echoes Edgar Allan Poe, depends

largely upon "the nice adaptation of its constituent parts" to a "*unity or totality*" of interest"; that makes it literary "painting."[1]

ARCHITECTURE AS PICTURESQUE FORM

Just so for picturesque architecture as well. The sheer variousness of the picturesque house—the bent or interrupted lines and (visually) broken surfaces, the walls' and the roof's wavelike sequences of bay and cove, the varying but congruent "arrangement, sizes, or forms of the different parts"—makes it adaptable to any habitable landscape, and the play of brilliant North American light, its "broad and deep shadows" accentuating both the "real form" of the house and the ornaments that catch the light, completes its integration into the landscape. The unity of the picturesque house is the product of "an agreement made in the midst of the variety of forms . . . by some one feeling which pervades the whole," and that brings all of its parts into an "agreeable relation with each other"—just as in painting a "pervading tone" (and in actual landscapes a soft atmosphere) harmonizes variations and contrasts of color and form.[2]

In the composition of the picturesque house, the shifting relationship between scale and complexity—a problem that Poe also recognizes in his distinctions between the novel and the short story and Fitz Hugh Lane in his tiny paintings of minimalized immensities—is denoted in distinctions between the cottage and the villa.[3] In the small form of the cottage as in the short story, complexities are to be kept few and relatively simple. In the more ample form of the villa, as in the novel, complexities can be multiplied to the point of risking "confusion or disagreement." Yet regardless of scale and complexity, picturesque principles of composition prevail. For Downing as for his antebellum contemporaries, Gothic and Italianate Revival styles serve these principles particularly well by offering manifold means of complicating lines and surfaces and equally manifold means of harmonizing them.[4]

1. *The Rural Gothic Cottage*. Simplicity notwithstanding, the picturesqueness of the rural Gothic cottage, Downing argues, derives from its variety of effect. Like Thoreau's cabin, it has the classical beauties of the rectangle: regularity, uniformity, proportion, symmetry. But structural additions—small wings, a bay window, a gabled entrance—add an animated, even an aggressive, energy. Its walls and roof expand and contract as if the force of its life were pushing outward as the environment pushes in.[5]

The simplicity of Gothic ornaments is also relative, for these are designed to add their own complications to the cottage's already complicated surfaces.[6] "[L]umpish and unmeaning" chimneys, transformed into cylindrical columns with caps and pediments, can be sculpted with organic tracery. The lines of roof eaves reaching out boldly past the walls (an effect provided by Hudson River bracketing) can be sculpted into Gothic arches by molded gables, verge boards, and finials. The same treatment can be accorded to windows. Doors, too, may be treated in this fashion and further complicated with hoods, small roofs, or even porches (Fig. 72).

To Downing, the chief function of this ornament is semiotic: it sacralizes the

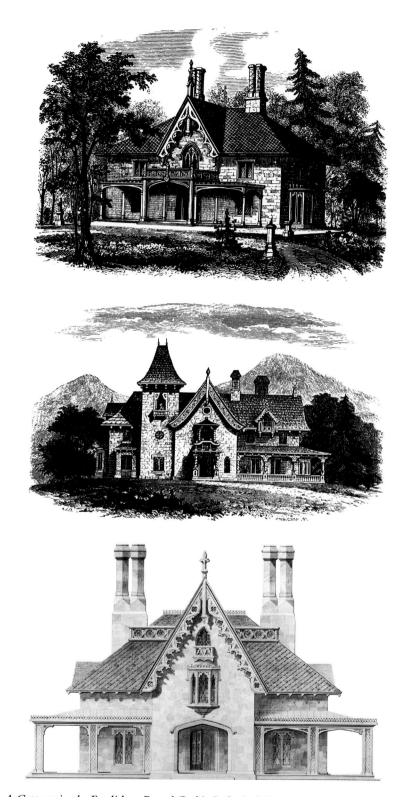

Fig. 72 (top) *A Cottage in the English or Rural Gothic Style.* A. J. Downing, *Cottage Residences.* Design II.
Fig. 73 (middle) *A Lake or River Villa.* A. J. Downing, *Architecture of Country Houses.* Design XXXII.
Fig. 74 (bottom) A. J. Davis, *The Rotch House,* New Bedford, Massachusetts. Front elevation. The Metropolitan Museum of Art, New York.

meanings of the cottage's most distinctively domestic elements. Ornamented chimneys thus celebrate the power and nurture, the warmth of the hearth; ornamented eaves, the ideas of familial shelter and protection; ornamented windows (large or small), the inhabitants' outlook on the world; ornamented entrances, their congress with it. Simultaneously, ornament contributes to the cottage's unity of effect. Gothic arches make doors, windows, and gables rhyme. The arabesques of living foliage planted around this construction fracture and fuse architectural columns with branches, roof with crown—an effect repeated in Gothic tracery—and become assertions of the cottagers' kinship with environing nature.

2. *The Tudor Gothic Villa.* The forms and meanings that compose American forms of the villa, typically a moderately large house, are yet more manifold, increasingly and then excessively so as the century unfolds. To Downing and his contemporaries, the scale of the villa is desirable not only for large families, but also because it liberates that spirit of emotional and intellectual play that define the most subtle aspects of picturesque effect. Ideally speaking, it is, he argues, an environment whose variety and complexity both shape and are shaped by the variety and complexity of modern consciousness. That makes it a work of art as exacting and expressive in its way as Central Park or *The Scarlet Letter.* After 1850, however, this textuality deteriorates.

Like Thomas Cole's *Sunset in the Catskills* (see Fig. 16) and other vistas of the Hudson River painters, the Gothic villa's "bold projections, deep shadows, and irregular outlines" give it both the powerful drama and the layered meanings of picturesque effect. One of its most distinctive structural features is the signifying tension between vertical and horizontal masses. Chimneys, gables, doors, and columns pull up against the horizontality that must dominate the house, asserting itself in the shape of the central mass, in groundline, roofline, and skyline. The impulse to soar inspirits and animates the impulse to nestle.

Like Hudson River School vistas, moreover, the Gothic style, with its several substyles, is capable of expressing a wide range of effects. In Elizabethan and collegiate versions of the style, its roof tilts steeply and erupts into pointed gables and finials. The castellated version bristles with parapets and battlements. The more subdued Tudor version (Downing's favorite) rises rhythmically into dormers and treelike chimney clusters, like a series of low ridges. Villa walls are similarly plastic, even discontinuous. In one of Downing's favorite designs, a lake or river villa (Fig. 73), a gabled entranceway, a tower, a wing, and a veranda (with assorted bays, oriels, dormers, and chimney clusters) all pull against a central mass that is itself severed (visually) into two fragments. The house keeps assembling and dissassembling itself as we look.[7]

Complexities like these tax all the means of achieving unity of effect. Since the composition of the Gothic villa requires at least the appearance of symmetry (the equivalent of balance in painting), projections from one side of the central mass need to be rhymed with projections from the other side; projections from the front, with projections from the back. Balance, however, need only be visually apparent. Like the oak tree, whose unequal branches form a head that *looks* "symmetrical with respect to the trunk," appendages to the central mass of the house can be made to look sym-

metrical in the composition as a whole. Shadows cast by projections; the visual fragmentation caused when architectural parts are masked by other parts or by foliage; the juxtaposition of a large wing off the rear of the central mass against a smaller wing off the front (the architectural equivalent of foreshortening), so that distance diminishes the one and proximity enlarges the other: these are all means of bringing actually varied masses into apparent balance with one another.[8]

If the picturesque villa is to exude the unanxious energy, the concerted vitality, appropriate to domestic architecture, Downing argues, its verticals, too, need to be subordinated to a dominantly horizontal orientation. Energy must be subordinated to the spirit of repose, as lesser motifs are subordinated to the general effect. In Davis's Rotch House in New Bedford, Massachusetts, a long veranda anchors the "aspiring" lines of the roof and the vertical accents of the central gable, and the roof walk, verge board, and second-story balcony anchor the rise of the massed chimneys (Fig. 74). Tensions between vertical and horizontal can also be mediated by the "softer and more humanized" effects of the curve, such as that in the hipped roof of the Rotch House or the Rhinish roof of the river villa (see Fig. 73), because the curve is the linear equivalent of gradation in painting. Incorporating both vertical and horizontal elements, it harmonizes them, as gradation harmonizes contrasting colors.[9]

Repetition, however, is the chief means of unifying effect, especially in designs that push contrast and variety to their limits. Although there is "hardly a single continuous, unbroken line" or surface in Russell West's villa in the Norman Style (Fig. 75), curves and triangles bring it together. Curved arches ("every opening," in fact, "is arched") harmonize its round tower with its central mass, and the tower's broken shape is repeated in the porch roof, the octagonal roof, the columns flanking the doorway, even the window moldings. Above the window arches, triangular chevrons repeat, and integrate, the shape of the roofs.[10]

3. *The Italian Revival Villa.* Italian Revival villas (with their Roman, Tuscan, and Venetian substyles) also give full expression to the picturesque spirit of play, though their effects differ profoundly from the Gothic. Its energies tend to be subordinated to the effects of a polished, rather than a rough, beauty. The Italianate style, Downing argues, quoting Loudon's *Encyclopedia of Architecture,* declares itself in

> scattered irregular masses, great contrasts of light and shade, broken and plain surfaces and great variety of outline against the sky. The blank wall on which the eye sometimes reposes; the towering campanile, boldly contrasted with the horizontal line of roof . . . ; the row of equal-sized, closely placed windows, contrasting with the plain space and single window of the projecting balcony; the prominent portico, the continued arcade, the terraces, and the variously formed and disposed out-buildings, all combine to form that picturesque whole, which distinguish the modern Italian villa from every other.[11]

Where the Gothic villa rhymes with the Claudian vista and with broken upland landscapes, the Italianate villa rhymes with the luminist panorama and the low,

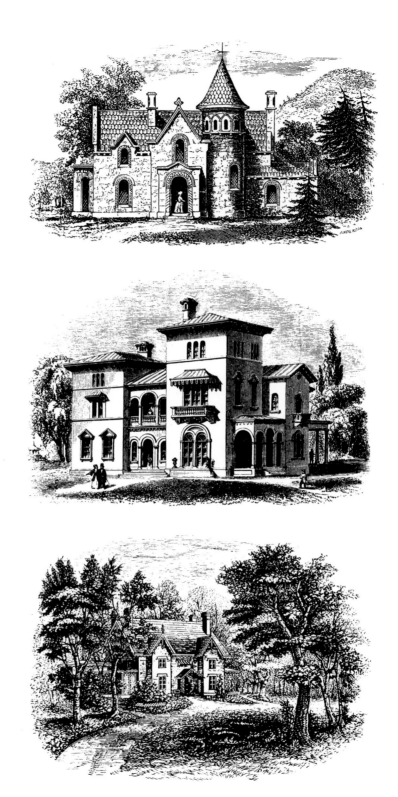

Fig. 75 (top) *Villa in the Norman Style*. A. J. Downing, *Architecture of Country Houses*. Design XXI.

Fig. 76 (middle) *Villa in the Italian Style* (King Villa, Newport, Rhode Island). A. J. Downing, *Architecture of Country Houses*. Design XXVIII.

Fig. 77 (bottom) *Mrs. Camac's Residence, near Philadelphia*. A. J. Downing, *Treatise on Landscape Gardening*, fig. 11.

undulant, panoramic landscapes of coasts and coastal plains—a natural scenery to which both gravitate.[12] Like, say, Fitz Hugh Lane's *Stage Rocks and Western Shore* (Color Plate XIX), the Italianate facade is an exercise in planar recession—radically telescoped, of course. Richard Upjohn's design for the King Villa, in Newport, Rhode Island, for example, recedes from two "foregrounded" campaniles to a plane formed by the arcade and the porch; then to the facade of the central mass, two stories tall (Fig. 76). Organized by these planes, its elements give the house a bold irregularity, a strong contrast of light and shadow, and thus "a peculiarly striking and painter-like effect," not the least for its emphasis on "a few strong lines and well-marked features."[13] As in *Stage Rocks*, vertical assertions (campanile, chimneys, arcaded columns, tall windows) add local effects of "power and elevation" without subjugating the house's emphatic horizontality. Reiterated curves impart to the most disparate shapes—doors and windows, arcades, verandas, balconies, even roof tiles—the effects of rhythmic ripples.[14]

ARCHITECTURAL MISE-EN-SCÈNE

The Art of Interiors

Picturesque architecture is also scenographic. Mise-en-scène governs in mutually reinforcing ways both the decoration of the interior and the relation of the house to its environing landscape. Responsive to the needs and characters of the inhabitants, interiors can be designed for a variety of rooms, from the intimate spaces of nooks (architectural equivalents of the close scene) to the expansive vistas of large rooms arranged en suite. Enlarged sheets of glass, enabling such extravagant gestures as the Crystal Palace and the department store window, also enable the enlargement of bay and oriel windows, which bring the outside more expansively in. Meanwhile, screens are used increasingly to contract room space. Interior walls become increasingly less definitive and more responsive to a scenography of light and color.

Color becomes a means of visually shrinking or expanding space. To increase the feeling of expansiveness, the house's principal rooms are given the tonalities of the Claudian vista: the ceiling painted, skylike, in the lightest tone; the side walls darkened, like foliage, with the woodwork "a shade darker" than that; and the carpet, like the earth, "darkest of all." Colors are also used expressively to create effects congruent with the human activities for which rooms are designed.[15] Halls and stairways, Downing urges, should be painted "a cool and sober tone—gray, stone color, or drab"—and simply decorated, so that they complement the "richer and livelier hues" of the rooms leading off from them. "Masculine" studies should be appointed in colors "comparatively grave," to reflect and to help induce the *gravitas* of reading, writing, and meditation. Walls painted "some shade of fawn or neutral tint" complement a furniture (Gothic in a Gothic, Italianate in an Italianate house[16]) constructed, like the bookcases, of dark oak and covered with dark leather or morocco. Even the carpet is selected for its "severe and quiet tone." "Feminine" sewing rooms (for ornamental work) or morning rooms (for entertainment) or "closets" (for

study) are to be designed "with any variation of coloring that [the woman's] fancy may dictate," though their effects, too, must be congruent with the functions carried out in them. In these scenarized sets for reflection, even the folds of curtain, as Poe demonstrates in his "Philosophy of Furniture," contribute to the rituals of the brown study.

By contrast, the principal rooms of the ground floor, the house's social spaces, are more brightly colored. The dining room, Downing advises, should be "rich and warm in its coloring, and more of contrast and stronger colors may be introduced here" than in the parlor, and the furniture should be "substantial, without being clumsy," and simply decorated, in keeping with the informality of American dining. For the desired effects of geniality and good cheer, the parlor walls should be painted in such shades as pearl-gray, pale apple-green, ashes of rose, and "relieved by darker shades, for contrast." To sustain this brilliance in the evenings, parlor furniture needs to be rich in color and texture, delicate in form. A hearth with a small circle of chairs drawn up around it makes the room "cozy and homelike." The parlor functions and effects multiply, appropriately, when sliding doors form one interior wall. Closed, the doors fill the need for "disconnection and privacy." Open, they create an elegantly expansive "sociability": an interior vista expansive and dramatic enough to set off social gatherings. The bay window has a similar plasticity on a smaller scale: with curtains closed, it becomes a nook for reading or dreaming; with curtains open, it foregrounds vistas into both the landscape and the room.[17]

Lighting also plays an increasingly dramatic role in interior scenographies. Bay windows, attached greenhouses, and other such expanses of glass allow rooms to be filled with the radiances of morning or afternoon sunlight, which may be pooled and doubled in mirrors or muted by drapes or even (as Poe suggests in "Philosophy of Furniture") stained by colored glass. Progress in lamp construction extends the repertoire of lighting effects. The effects of a "tempered and uniform moonlight," mild, cool, and casting warm shadows, Poe observes, for example, can be achieved by means of an Argand lamp with a crimson-tinted ground-glass shade.[18]

Rooms and niches variously scaled and colored may also be variously lit—an effect not at all unlike those alternations of tenebrous nook and bright vista in Cole's *Voyage of Life* or in passages of Frederick Law Olmsted's Central Park. Spaces leading off from the pathlike hallway may suddenly darken or brighten, contract or expand into vistas down the long axis of a room or suite of rooms, or even, through a bay window, lead out into a framed vista of fields, rivers, and distant mountains.

Late in the century, the illusion of interior landscapes is further elaborated by the introduction of painted—and in cities, of natural—foliage. The English designer William Morris, an influential force in American interiors after mid-century, advocates the painting of ceilings as cloudless blue skies animated, perhaps, with swallows and a sun breaking through clouds. "[S]trange trees, boughs and tendrils" on wallpapers and fabrics transform rooms into simulated gardens or fields, and patterned carpets turns floors into "green meadow[s] studded with flowers" to similar effect. Other rooms in a cottage or villa may represent, variously, "the close vine-trellis that keeps out the sun by the Nile side; or . . . the wild woods and their streams, with the dogs panting beside them; . . . or . . . many-flowered summer meadows."[19]

The House in a Landscape

It is such arrangements as these—various in their modalities, manifold in the activities they accommodate, and thus complex in identity—that make the picturesque villa a metonym of modern consciousness as well as a form in a landscape with landscapes within. For Downing, the villa's exteriors are (ideally) public projections of the mature mind's multiplicities, as various as the interior within it. As in literature, "the dramatic, the serious, the narrative, and the didactic" discourses are "each peculiarly adapted to the expression of certain modes of thought and life," he argues, so architectural styles in the picturesque repertoire are "each peculiarly capable of manifesting certain mental temperaments, . . . or of harmonizing with certain tastes in the life of the individual." Classical villas are the expression of a "rational, logical, sensible" mind: a mind impressed with the belief that "nothing occurs without reason" and therefore uncomplicated by caprice, whim, ambiguity. Gothic Revival villas, by contrast, are projections of temperaments more "poetic, aspiring, imaginative," imbued with the "fanciful complexity" that comes with the belief that there is "no peace within the mere bounds of rationality." Italian Revival villas are expressions of more fully socialized temperaments. Their "spacious and elegant" arcades and balconies inviting leisurely conversation, these styles are more genial, civil, urbane than Gothic Revival. Like that "elegant culture" of Renaissance and Baroque Italy, they express an "enjoyment of the present moment." For more complicated temperaments, however, picturesque touches add their expressions of "originality, boldness, energy, and variety of character."[20]

Like so much else in picturesque art, architectural exteriors have a simultaneous multiplicity of effects. Ideally considered, they are designed to project the private lives and minds of the inhabitants; but they are also designed to adapt the rural house (cottage or villa) to the landscape. Adaptation, too, requires a scenographic eye. As in "the best landscape engravings and pictures" of Claude, Poussin, and other canonical artists from which it draws its strategies, adaptation makes the house a harmonious part of the "general scene." In Downing's typically antebellum view, adaptation is a reciprocal affair. The landscape may be adapted to effect a transition between nature and architecture: trees near the house, for example, may be induced to grow into columnar shapes, their roots "a little elevated above the level of the ground" like natural pedestals surmounted by shaftlike trunks and foliate caps. But more important, the picturesque house must be composed in congruence with "the other parts of the landscape." As in painting, the congruence is best achieved by repetition.[21]

1. *Gothic Landscapes*. Gothic cottages are ideally set in broken landscapes such as those of the Hudson Highlands (Downing's native ground) because their own irregularities of line and surface rhyme with this "spirited rural scenery." As in Thomas Cole's *Home in the Woods* (Color Plate XXIII), Gothic eaves and window arches repeat the triangular shapes of "spiry-topped" evergreens; roofs, the slopes and crests of steep ridges; walls, the undulant shapes of riverbanks or treelines (see Figs. 73 and 74). To the same end, house colors are keyed to an earthy palette: fawn, drab, warm grays, sage, straw, cream, chocolate.[22]

Strategies of "embowerment" complete the adaptation of house to landscape. Trees are planted, singly, to screen the cottage (Fig. 77), and a drapery of "bower, vine, and creeper" (grape vines harmonizing especially well) can add to them the shapes and textures of a forest copse. A cottage so treated, Downing observes, seems (from a distance) "to grow out of the ground" like the tree environing it: a production of nature as much as art.[23]

The Gothic villa, likewise, must have, outwardly as well as inwardly, "secluded shadowy corners . . . nooks . . . where one would love to linger" and other such effects to which "the heart can . . . become attached to, as naturally as the ivy attaches itself to the antique wall, preserving its memories from decay." Like Cooper, Downing sees the inherent kinships between Gothic villa and forest grove, with its columnar trunks, its arched ceilings (of foliage), its traceries of leaf spray and vine, and even its "somber" or "mellow" ("churchly") hues. Viny walls make the porch the architectural equivalent of a cave or bower, in which, as in other such shadowy nooks, the inhabitants can linger, as the house itself nestles in the landscape.[24]

Downing's lake or river villa on the Hudson (see Fig. 73) is also designed to mirror the effects of "repose and action[,] . . . beauty and power" that are produced by the assertions of vertical riverbank and mountains (as well as the woodlines) against the horizontal river. The vertical elements of Gothic architecture harmonize also with craggy hills—architectural answering geological form. The concave curve of the roof, a borrowing from Rhinish architecture, rhymes with pine boughs and also with "the grand hollow or mountain curve . . . rising from the water's edge." Viewed frontally (as Downing's architectural sketch positions the viewer to do), the house's broken surfaces and bold projections seem to pulse in harmony, as well, with the wind, the clouds, the cloud-dappled light.[25]

2. *Italianate Landscapes.* The undulant horizontality and the elegance of Italianate villas link them to the increasingly suburbanized landscapes of the coast and coastal plain. Hillhouse Avenue in New Haven, Downing notes, "abounds with tasteful . . . Tuscan or Italian Suburban Villas[,] . . . models for this kind of dwelling"; so, too, do summer resorts like Newport, Rhode Island.[26] Toward these landscapes, Italian Revival paradoxically requires a much more aggressive relationship. Gothic houses are adapted *to* "[u]nsymmetric nature." The landscapes of Italianate houses are gardens in which nature must be made to "agree in elegance with the style of art evinced in the mansion itself." To establish "avowed connections" with the house, the garden is designed like a sequence of rooms furnished with statues and architectural forms (balustrades, gazebos, and so on). Garden foliage is best potted in "handsome urns" or vases, or shaped into wall-like hedges, in designs also "in keeping with the house." Even water, if present in the garden foreground, is to be sculpted by fountains. This is an early but emphatic sign of the urbanization of picturesque architecture.[27]

TOWARD A HISTORY OF PICTURESQUE ARCHITECTURE, 1860–1890

After 1850, the semiotically coherent vision of antebellum picturesque architecture is, at the very least, blurred by architectural practices. The history of this second stage

of picturesque architecture also includes its appropriation across the American landscape and its elaboration of an increasingly large repertoire of styles.

Diffusion

The architectural ideas spread from the urban epicenters of the picturesque aesthetic, New York, Boston, and Philadelphia, to their rural suburbs (where ideal and praxis are most interrelated) and thence to New England and the Middle Atlantic States, the Middle West and Canada, and (by the end of the century) the West Coast. In the process, the praxis subjects ideas such as Downing's to several modifications. For one thing, the relationship of picturesque to existing architecture makes it even more eclectic than Downing envisioned. Georgian, Federal, and vernacular styles continue to dominate the domestic architecture of old and relatively conservative eastern towns, often until well after the Civil War. That limits picturesque influence largely to such touches as ornamented eaves, chimneys, porches, and bay windows.[28] Even in the newer parts of town, the older styles demonstrate their tenacity. Here, Gothic and Italian Revival houses are routinely modified by Federalist, Georgian, and vernacular details.

Class, too, affects praxis. The houses built for prosperous citizens typically act as local exemplars, but the houses patterned after them are routinely modified to fit not only smaller budgets and differently scaled house lots but also different ideas about form and effect. Although it dictates the limits of scale, money exercises no absolute rule over ideas about style and effect.

By contrast, new towns in the West, less conservative, construct whole neighborhoods of new houses. Their particular styles, picturesque *in toto*, nevertheless depend on the timing of the economic booms that finance them. The boom in Kalamazoo, Michigan, for example, occurs in the 1840s, at the advent of the Italianate era. The houses of Kalamazoo, therefore, leap directly from the Greek Revival popular in the 1820s to the Italianate style. Here, moreover, it is the middle class that introduces Italianate design. The wealthy enlarge and complicate these exemplars as they situate their villas upslope (a literalization of vertical mobility). Downslope and in the hollows, members of the lower middle class reduce and simplify the design.[29] As diffusion proceeds and demands increase, there is also a pronounced democratization of design. Local architects and clients freely combine their own ideas and improvisations with those of plan-books; so, too, increasingly, do carpenters and house-owners, to whom the architectural design books are addressed. After 1850, the houses of Kalamazoo quite frequently sport an eclectic mixture of Greek, Italianate, and Gothic touches. When Charles Bates, a grocer and dry-goods merchant, builds a house in the 1860s, he models it after a recent predecessor in Kalamazoo, adding details from Samuel Sloan's *Homestead Architecture*.[30]

Everywhere across the landscape, the sheer scope of the diffusion makes industrialization inevitable. To accommodate amateurs like Bates, lumberyards turn even carpenters into consumers by mass-producing ornamental moldings, brackets, window sashes, newel posts, and shingles in various styles and substyles. The Drain House, built in Oregon in 1892 and still standing (see Fig. 110), is entirely prefabricated, from the carved panels, beveled and leaded glass transoms, tower finials that

adorn the interior to the peak and gable ornaments, dentils, horizontal bands, fish-scale shingles, portico balustrades of the exterior—more than three hundred shipping crates' worth of machine-tooled ornament. As industrialization makes the picturesque house more affordable to larger numbers of Americans, however, it also destroys the semiotic effects of picturesque design. Motivated by conspicuous consumption, the Drain House and its like cannot bespeak the lives and character of its inhabitants in the ways that Downing and Thoreau envision.[31]

Stylistic Succession

For another thing, Downing's plan-books are succeeded by a multitude of others, including Gervaise Wheeler's *Rural Homes* (1851) and *Homes for the People in Suburb and Country* (1855), Calvert Vaux's *Villages and Cottages* (1857), and Samuel Sloan's *The Model Architect: . . . Designs for Cottages, Villas, Suburban Residences, Etc.* (1852) and *City and Suburban Architecture* (1859). As their very titles suggest, these books are, like the houses they present, increasingly urbanized; indeed, Sloan's books, particularly, define the residential heart of the picturesque city. As picturesque revivals continue, moreover, the plan-books become by necessity increasingly eclectic. After 1850, the repertoire of styles swells to the size of a costume parade: Gothic, Italianate, and assorted minor revivals (Swiss, Persian, Rhinish, with its curving roof)[32] are joined by Second Empire, Egyptian, Queen Anne, and Romanesque, as well as by such "exotica" as Persian and Japanese styles.

In the process, the intelligibility of rural architecture further deteriorates. It is most intelligible structurally, Vincent Scully observes, as a celebration of space, light, and the organicism of wood. But at its worst, it serves divided purposes. Inside, particularly, it is a nostalgic retreat into simulacra of simpler, premodern pasts; outside, it tends to become the kind of hectic, outsized, bravura performance characteristic of commercial cities. Toward the end of the century, the very meanings of *cottage* and *villa* are corrupted (as in Newport, Rhode Island) by opulent excess. By then, the locus of picturesque architecture has long since shifted to the city.

The Second Empire style, appropriated from Haussmann's Paris after 1860, is emphatically urban: a rejection of the easy sprawl and play of the rural villa for the studied formalities of the mansion and the townhouse. At its most formal, the style compresses form into the shape of an attenuated cube, accentuating the effect of density with its materials: chiefly stone, brick, and stucco. Tall windows and the up-sweeping top-hat shape of the mansard roof—what Scully calls a "single plastic hammerblow"—give it a monumentality designed, like the black suit of the American businessman, to be imposing, although rural and small town versions of the style soften these effects. The classical proportions of the central mass are complicated by asymmetrically positioned wings, verandas, bays, and other such projections that impart something of the informality of rural living. Pushed to extremes (perhaps by urban influences), however, picturesque ornament is capable of producing shock. Richly decorated surfaces and details so disturbed the dense mass of J. Frederick Kernochan's Edgewater (built in Newport, Rhode Island, in the mid-1860s and since destroyed), that the building took on, in Scully's words, "the power of a surreal image or a primitive sculpture" (Fig. 78). A long row of dormers broke up its mansard roof.

Fig. 78
"Edgewater," the
J. Frederick Kernochan
House, 1864. Demol-
ished. From George Ma-
son, *Newport and Its Cot-
tages*. Courtesy of the
Preservation Society of
Newport County, New-
port, Rhode Island.

Polychromed shingles imposed an anxious, superanimated energy, like that of the new super-rich who would soon be drawn to Newport.[33]

The Queen Anne style of the 1870s and 1880s restores the prewar ideals of comfort and informality. The complex projections of the exterior and their shadows declare the variety of room shapes and sizes within, where double doors and other perforations of the walls create interior vistas, inglenooks and alcoves offer more intimate spaces, and a chiaroscuro of light and darkness even more dramatic than the Gothic presents itself.[34] An eclectic mélange of eighteenth- and nineteenth-century furniture styles—Chippendale, Rococo, eighteenth-century Dutch, and contemporary, for example, in the home of the English originator of the style—completes the effect of informality. These are the effects achieved in many of the houses designed by Stanford White and his partners. One enters his Skinner House in Newport (Fig. 79) through the darkness of a long, deep porch to a rectangular hallway half in darkness, half lit by a wall of small-paned windows on the stairway landing to the left. The principal rooms radiate from here. The den to the right, at the front of the house, is small, dark, and (shades of Poe's Dupin) dominated by its fireplace. In the living room around the corner from the study, space suddenly expands and brightens. Light streams in from a circular bay in a round tower attached to the front end of the house. From here, an interior vista sweeps back across the room's long axis to the dining room en suite, terminating in a dining room fireplace and mantel, this too flanked by a small study. French windows kindle the dining room with light and frame a vista that recedes, at right angles to the interior vista, past a small hedged garden to trees and a dark hedge at the end of a green, sunlit lawn.

The vibrant spatial contrasts between den and living room, study and dining room, are reiterated on the house's exterior as well. Here, too, the dark voids of porches, the bold projections of a wing and a witch-cap tower, and a variety of window shapes, as Scully observes, compose "a small essay in the picturesque."[35]

What Scully terms the "stick" style, a variation of Queen Anne, incorporates quotations from medieval English and American colonial architecture, including the gambrel roof. As in the Jacob Cram House in Middletown, Rhode Island (Fig. 80),

Fig. 79
McKim, Mead, and White,
Skinner House, 1882. Cour-
tesy of the Preservation
Society of Newport County,
Newport, Rhode Island.

Fig. 80
Jacob Cram House,
1871–72. Courtesy of the
Preservation Society of
Newport County, New-
port, Rhode Island.

gabled trusses and chevroned strips of wood on the outside walls articulate the struc-
ture of the inside.[36] Shadow again turns deep porches into dark voids, and sunlight
intensifies the patterned musics of chevrons, buttressed triangles in the eaves, and
cylindrical and conic towers. Vestiges of Queen Anne "filtered through an American
sensibility" and dedicated to informality and comfort characterize the interior.[37]

But where is meaning in this? To graceful fragments of Italy—Renaissance arches
and arcades, Palladian windows—the stick style adds the studied informalities of
early eighteenth-century versions of medieval and early Renaissance rural architec-

ture—a revival of a revival. Plain materials (wood and stucco, mostly, for American variants); a proliferation of white-painted windows, small-paned, shuttered, and of markedly varied size and shape; deep porches; witch-cap towers; boxed stairs with ramped rails and twisted balusters: these add the charms and exoticisms of rural life at an early stage of the British Empire.[38]

The power of Anglo-American nostalgia for the age of Queen Anne is emphasized by its ambiguous relation to the modern. In an age increasingly dominated by science and big business, the Queen Anne style opposes (in Witold Rybczynski's fine phrase) physics with fashion, incorporation with paeans to the stability and longevity of family life. The "mainly visual approach of interior decorators," Rybczynski observes, clashes with "the mechanical approach of the engineers." In an age producing canned and then frozen foods (and the refrigerators to hold them), Georgian wainscoting still decorates dining rooms. French windows and glazed doors share with gas mantels and then (after 1890) electric lights the function of illumination. At a time when central heating and ventilation have become domestic fixtures—as they are, for example, in the Beecher sisters' American woman's home—capacious Queen Anne fireplaces with high mantels and inglenooks present themselves as attempts to reassert the centrality of the hearth. In their defense, Edith Wharton and Ogden Codman argue in *The Decoration of Houses* that "the good taste and *savoir faire* of the inmates of a house may be guessed from the means used for heating it."[39] With the Queen Anne Revival, the rural villa becomes a dreamy retreat from the machine as well as the madding crowd.

PICTURESQUE LANDSCAPE ARCHITECTURE AS AN ART OF THE SCENE

The Beautiful and the Picturesque in Landscape Scenery

Picturesque landscape architecture is another mimetic and painterly art. This, as Downing demonstrates in his *Theory and Practice of Landscape Gardening*, is chiefly an art of plantation. Nature demonstrates the eclectic beauties of foliage: the billowy surge and retreat of leaf sprays, like the alternations of cove and point on a coastline or a Gothic villa; the intricate and varied beauties of individual trees (to whose picturesqueness Downing devotes a long chapter in his *Treatise on Landscape Architecture*); and the more inclusive effects of trees and shrubs planted in various groupings—small islands, peninsular screens, deep forest, and so on—of varying densities, from the "close" plantings in forests to the "open" plantings in meadows. The picturesque canon of painters—particularly Raphael, Claude, Salvator Rosa, and Poussin—demonstrates the possibilities of picturesque plantation as a scenic art. That begins with the representation of subtle harmonies in foliate groupings not necessarily found in nature: the repetition, for example, of the willow's drooping spray in the larger and darker spray of an oak; the willow's pendant branches in those of a weeping birch; the airy lightness of the willow's leaves in a common birch's; and the willow's delicacy, light, and color, in the horizontal branches of a three-thorned acacia.[40]

The influence of painting adds the more inclusive harmonies of a composition in which foliage, terrain, water, and architectural forms—the major elements of the art of landscape architecture—all function congruently as elaborations of a general

effect. That the principle of congruence applies to landscape architecture Samuel Morse (quoting Thomas Whately) makes very clear in a description of the landscape garden at Stowe in Buckinghamshire, England. In one scene in the garden, an effect of penumbral gloom is produced by a thick, dark tangle of horse chestnuts and alders, "mis-shaped elms and ragged firs," and an understory of "uncouth" sumac thickened with ivy that "not only twines up the trees, but creeps also over the falls of the ground, which are steep and abrupt." The note for grotesqueness recurs both in the trunks of dead trees left standing in the tangle and in the chestnuts and alders, which, rising in clusters from the same root, "bear one another down and slant over the water." These trees produce the darkest greens in the foliate spectrum and cast the darkest shadows.

The darkness and grotesqueness of the scene are also made manifest in a filmy pool whose cloudy water doubles the dark tangle by reflection and seems at the same time to be "eating into" the bank on which it stands. Faced with broken flints and pebbles, a grotto, too, preserves in its textures, its dusky color, and its atmosphere "all the character of its situation." So does a mossy path scattered with gravel. Foliage thus establishes the effect that terrain, water, and architecture all intensify by their congruity. The general effect is a scene in which, as in painting, "more circumstances of gloom concur than were ever perhaps collected together" in nature.[41]

Plantation in the picturesque landscape garden also furnishes appropriate frames for the scenes composing it. The close grouping of the chestnuts and alders at Stowe closes around viewers claustrophobically, but close plantations can also be used to very different effect—as, for example, in a scenery walled, roomlike, by hedges, carpeted with lawn or flowery parterres, and furnished with benches, fountains, sculpture. For vistas, treelines serve as sidescreens defining the scene's lateral limits; in the absence of mountains, planted on a ridge-line to emphasize their height, treelines may also serve as termini. In the flat terrain of coasts and coastal plains, low shrubs and flowerbeds, more horizontal than vertical, may punctuate the horizontal sweep and planar recession of panoramas. A knowledge of "aerial perspective" (the effects of distance on color), also drawn from painting, allows the architect to create both "artificial distance" and artificial scale. When near grounds are planted with dark foliage and far grounds with light foliage, distance apparently expands. Conversely, light foliage in the near ground and dark in the depths, telescoping distances, frame close scenes.[42]

Foliage also transforms sunlight into picturesque lighting. As with Stowe's forest scenery, thick foliage produces the garden's principal shadows (its twilights), as open surfaces of lawn, meadow, or water produce its "principal light" (its noons). These local effects of light and shadow—extended, massed, balanced, and even gradated throughout the garden as they are in painted vistas—accentuate the garden's unity of effect. As in the Claudian vista, the spaces around the house, kept shady, are connected with the forest's "distant shadows"; the lawn or lake in the middle ground is bright, though it may be splashed (by open groupings of trees) with shadows.[43]

In theory, garden scenery is as variable as picturesque eclecticism allows. In American practice, Downing argues (and Olmsted concurs), its range of effects is more limited. Since democratic values require that even large landscape gardens

(more than two hundred acres) be of "comparatively limited scale," sublime effects remain "wholly beyond the powers" of American landscape gardeners; they are open, late in the century, only to the designers of national parks or of such monuments as Niagara Falls. Fusions of beauty and picturesqueness, with touches perhaps of a "softened" sublimity added by vistas that lead the eye beyond their limits, are the chief effects of the private garden and the public park.[44]

The smallest gardens (not more than a few acres) are limited, like cottages and short stories, to a single dominant effect: beautiful *or* picturesque, but not both.[45] Since the chief source of beauty is a harmony among house, garden, and terrain, compositional strategies tend toward the classical, without reproducing the "geometrical style" (Fig. 81). In the picturesquely beautiful garden, lines are chiefly "flowing and gradual" curves; textures, smooth, rich, luxuriant—the organic equivalent of the Italian Revival villa. The terrain likewise unfolds in "easy undulations melting gradually into each other," and its most appropriate plantation is a grass lawn mown to "a softness like velvet" and ornamented with open groupings of beautiful trees (the elm, the ash): smooth-stemmed, round-headed, and symmetrically curved.[46] Water forms (a pondbank, a brook) and walks and roads are also curved.

Small picturesque gardens ("modern" in Downing's terminology) are best situated, by contrast, in more rugged landscapes such as the Hudson Highlands (Fig. 81). Homologues of Gothic architecture, their lines tend, ideally, to heave up into steep hills, and their surfaces, "comparatively abrupt and broken," are fractured by dingles, rock forms, and riverbank. The ideal tree forms in picturesque gardens are roughly textured (pine, larch, oak), some pointed like Gothic arches, some old and therefore ruffled, like stream-water, the most congruent water form for this landscape. And walks and roads, like streams, like the terrain, should jog abruptly in three dimensions.[47]

Scenic Zones

In large gardens, as in novels, the distinctions between beautiful and picturesque become more complicated. Large gardens tend to be divided into three irregular, interpenetrable, and roughly concentric zones, each characterized by different "modes" of scenic arrangement and different effects. In the inmost of these, the architectural zone around the house, art everywhere proclaims its presence. In the middle (park or pastoral) zone, there is a balance, as in pastoral poetry, between art and nature, between classical and picturesque beauty. In the outer, the wilderness zone, art disappears, as in realism, into an illusion of naturalness.[48]

1. *Architectural Zone.* As in the classical garden and the Italianate villa, the effects of the architectural zone run to polish and elegance. A smooth lawn flows wavelike over undulating terrain, its textures barbered and soft. The scenery of the terrace and formal garden—"episodes to the great lawn," as Humphry Repton called them[49]—becomes more extensive and pronounced after 1850 as a way of making the garden "agree in elegance with the style of art evinced in the mansion itself"[50]—and particularly with the elegances of Italian Revival, Second Empire, and Queen Anne styles.[51] Water is sculpted by fountains; and exotic plants by urns or vases designed,

Fig. 81 Three Styles Incorporated into Picturesque Landscape Architecture: 1. The Geometric; 2. The Beautiful; 3. The Picturesque. A. J. Downing, *Treatise on the Theory and Practice of Landscape Gardening*, figs. 12, 13, and 14.

like the terrace, balustrades, and stairways, benches and gazebos, in the style of the house. When the private landscape garden evolves into the public park, and the house disappears, garden and terrace scenery become architectural synecdoches: villa landscapes without the villa.[52]

Flowers laid carpetlike in beds and parterres add a particularly dramatic element of color to garden scenery. Downing lists more than three hundred species of flowers, the landscape architect's equivalent of a painter's palette that can be applied in dabs, patches, and even fields of color. Verbenas and roses, for example, add a spectrum of yellows, from buff through canary and sulphur yellow, and of reds ranging from pale flesh tints through blushes, pinks, salmon, rose, scarlet, crimson, ruby, carmine, amaranth, and purple. A brilliant contrast (in its season) to the greens, blues, and earth tones of house and landscape, color at these intensities creates pools that glow like the catching light of a cloud-mottled sky; and " 'when diffused, as in a fine evening over a . . . landscape' " (Downing quoting Uvedale Price), it has the effect of *sfumato,* "that rich union and harmony" of glowing mist "so enchanting in nature and in Claude."[53]

2. *The Park Zone.* After the elegant formalities of architectural scenery, the park zone is an informal blend of the beautiful and the picturesque. Here the terrain begins to pitch and roll, and architectural elements become pronouncedly rural. The grass grows longer—pasture rather than lawn. Trees turn indigenous (maple, elm, oak, pine) and their groupings more complex and variable, ranging from open copses to irregular screens along lakeshore or meadow edge. Less neatly trimmed than in the garden, paths take on the look of rural lanes, turning unexpectedly, but in concert with the roughening terrain.[54]

The lake is the paradigm of picturesque expression in the park.[55] Viewed from a distance, its very form is defined by "bays and projections, sinuosities . . . sometimes bold . . . [sometimes] smaller and more varied in shape and connexion." Viewed from the paths meandering along it, the shoreline now telescopes to a close-scene (an inlet, say), now opens into vistas across the water, like rooms from the hallway of a picturesque villa. "The soft and trembling shadows of the surrounding trees and hills, as they fall upon a placid sheet of water—the brilliant light which the crystal surface reflects in pure sunshine, mirroring too, at times . . . the cerulean depth and snowy whiteness of the overhanging sky," Downing observes, give the lake "an almost magical effect in a beautiful landscape."[56]

Foliage adds a third dimension to lake scenes. The upcurving lower bank that rises from the water's edge can be furnished with a rough carpet of ferns and trailing plants (the periwinkle, the moneywort). An upper bank of underwood (hazel, hawthorne, winter berries, azaleas, spirea, the buttonbush so favored by Thoreau), planted for their contrasts of form and color, can be added to this, a wave superimposed upon a wave, itself capped by an undulant screen of aquatic trees (willows, elms). Then comes the towering crest of an oak and pine forest. All of these "thick overhanging groups and masses . . . cast . . . deep cool shadows" on the lake-water, in which sunbeams "quiver and play . . . and are reflected back in dancing light." From a distance, the "cooler and softer tints" of the reflected foliage relieves and harmonizes the glow of sunlight on water.[57]

3. *Wilderness Zone.* At the margins of the picturesque garden, the scenery turns wild. Here the terrain buckles dramatically into ridges and the ridges into rocky valleys and outcroppings. Water takes the congruently broken forms of fast-moving streams and cataracts. Plantings create the artful illusion of a forest with footpaths. Trees grow loosely grouped and scattered here and are more tightly grouped, "even two or three in the same hole" (to suggest a second growth), producing "wilder and more striking forms." The bark of forest trees is "deeply furrowed and rough, the limbs twisted and irregular, and the forms and outlines distinctly varied." Shrubby understories of hazel, hawthorne, and the like form with the trees of the upper canopy "such picturesque and striking groups, as painters love to study and introduce into their pictures," and bright vines, "themselves picturesque in their festoons and hangings," may be draped "negligently," here and there, over tree limbs.[58]

In this profligate exuberance, found or built, architecture turns "sylvan." Bridges and prospect towers ("whence a charming *coup d'oeil* or bird's eye view is obtained") are fashioned from logs; crude benches, from oak or elm branches bound with vines;[59] arbors, from living branches bent together and roofed, perhaps, with straw thatch; and grottoes, fashioned with ferns and vines so as not to seem fashioned at all. At the center appears, perhaps, Downing's version of the natural house—picturesque architecture in its pioneer mode: a cabin built around a living tree, its walls alive with parti-colored mosses "not unlike . . . a thick Brussels carpet."[60]

Paths

The varied scenery of the picturesque garden is further varied by viewers' unfolding experience of it as they traverse its paths. Paths of three kinds lead not only *through* scenes, as visual paths do in painting, they also link scenes into sequences, like plotted episodes in a picturesque narrative.

1. *The Claudian Vista.* As in painting, it is a visual path that determines the orientation of the house at the center of the garden and the concentric logic of its zones. The vista is framed by windows in the house's principal rooms and, outside, by the terrace or veranda (Figs. 82 and 83). Like Claude's Neapolitan landscapes, its foreground consists of the garden's architectural scenery.

> The various play of light afforded by . . . sculptured forms on the terrace; the . . . fine colors and deep foliage of the flowers, heightened by contrast to their vases; the projections and recesses of the parapet, with here and there some climbing plants luxuriantly enwreathing it, . . . connecting [it] . . . pleasantly with the verdure of the turf beneath; the still further rambling off of vases, etc., into the brilliant flower-garden, which . . . maintains [a] . . . connection with the architecture of the house, all this . . . unites agreeably the forms of surrounding nature with the more regular and uniform outlines of the building.

The chief feature of the middle ground is, of course, the sun-brilliant lake or lawn. The amphitheatral terminus to the vista may be constructed from an irregular

Fig. 82 (left) *Distant View at Tarrytown* (from the veranda of a cottage at Irving Park). Benson J. Lossing, *The Hudson.* Fig. 83 (right) *Bracketed Veranda from the Inside.* A. J. Downing, *Architecture of Country Houses,* fig. 45.

wall of trees, planted (ideally) on a hilltop, although the truly Claudian solution is mountains. The most exemplary picturesque gardens in America are able to appropriate neighboring mountains, as those in Dutchess County, New York, for example, appropriate (like Thomas Cole's painting) the Catskills.

2. *The Entrance Drive.* The two paths designed for the physical movement of viewers are for the landscape architect what plotting is for the novelist and editing is for the film director. Like cameras tracking, viewers moving along them experience space as a succession of scenes that "constantly change." The scenery takes on the elusive character of a montage, which connects even apparently discontinuous (varying, contrastive) elements by means of repetition. Like the "judicious author," the landscape gardener "seems not to be guiding, but exploring with [the stroller] some new region." Like the reader of a narrative, the viewer is carried "from one [striking scene] to another in such a manner, as to be totally unconscious of the consummate skill with which [the] . . . route has been prepared."[61]

One of these paths, the driveway from the road to the house, introduces the major architectural and natural motifs to come, like a prologue in a poem or a symphony. Gate and gatehouse anticipate the style of the house; and scenic "incidents" arranged along the drive, an avenue of three-dimensional serpentine curves, climbing, descending, skirting ridge and hill, typically anticipate the garden's wilderness scenery. The drive itself ends in a visual climax. At the most dramatic moment possible, the forest dissolves and the scenery of the lawn emerges with a suddenness that gives it the force of a *coup d'oeil.* The house rises from the lawn's brilliant interplay of light and shadow "in the same manner . . . as in [topographical] painting": monumentalized for dramatic effect (the viewer ideally positioned below it), turned obliquely to intensify foreshortening, and set into a backdrop of trees whose "proud heads and large trunks" alternate with inverted triangles of sky and light.[62]

3. *The Arabesque of Walks.* Along the third passage, designed for rituals of strolling and contemplation, the garden takes shape as a sequence of "different scenes" even

more complex and various than that along the entrance drive. Strollers here find themselves now in intimate, penumbral enclosures (copse, ravine, inlet, greenhouse, parterre), now in expansive vistas of brilliant lawn or water; now in polished landscapes and now in pastoral or "wild and comparatively neglected" landscapes.

The Art of the Private Landscape Garden: Montgomery Place

That there is an art to this arrangement, too, Downing's verbal sketch of Montgomery Place in Dutchess County (now open to the public) demonstrates emphatically.[63]

A homologue of Thomas Cole's *View Near Catskill* and *View on the Catskill, Early Autumn* (Color Plates XII and XIII), the vista from the house at Montgomery Place frames the same part of the Catskill escarpment, including High Peak, Round Top, and South Mountain, and from the same angle as Cole, but farther east, of course, from Catskill Creek (Figs. 84 and 85). The foreground at Montgomery Place, a long, undulant lawn "varied with fine groups" and "margined with rich belts of foliage," slopes down from the house, on the crest of a ridge, to a Hudson River that here broadens into a slow-moving "sheet of water," lakelike in its repose and jeweled with "emerald" islands.

Distance transforms the Catskills, the vista's "crowning glory," into a bluish glow that deepens over the course of the morning and, at sunset, a "magical" glow that fills the eye "with wonder at the various dyes that bathe the receding hills. . . . Azure, purple, violet, pale grayish-lilac, and the dim hazy hue of the most distant cloud-rift, are all seen distinct, yet blending magically into each other in these receding hills[,] . . . soft and dreamy as one of the mystical airs of a German maestro."

The Morning Walk, "favorite morning ramble of guests" (not the least for its dramatic backlighting at this time of day), follows the curves of an increasingly wild shorescape. Here, overhanging cliffs crested with pines frown darkly down on the water; there thick tufts of fern and mossy rocks border the path, a long hall through the edge of a dark forest. Through windowlike "frame[s]" in the thick leaves and branches burst vistas of sunlit water, like those at Thoreau's Walden, from a variety of perspectives, now plunging from a height to its surface, now leading the eye across water "sprinkled with white sails" to the blue mountains. Sheltered benches allow the viewer to study these framed scenes at length (Fig. 86). A rustic seat under a huge tree halfway along the walk presents a riverscape "sprinkled with white sails" between forested foreground and mountainous distance. The view from a rustic pavilion on a point offers a panorama from a "lower and wider view," and a boat moored there makes it possible for the spectator to "reverse the scenery, and behold the leafy banks from the water."

From here, the wilderness zone of the garden ascends a narrow wooded valley from the river to the crest of the ridge on which the house sits a few hundred yards to the south. The walk up the valley is a sequence of darkly toned close scenes of rock walls, a plunging river, and thickets of laurel, furnished with benches in the sylvan style. The most dramatic effects occur in the approach designed for "The Cataract," which first appears, suddenly, in a *coup d'oeil* that intensifies its effect. At the top of the steps leading down to it, the view is "spirited and picturesque" (Fig. 87): the lip of the falls juts up into blue sky, and the stroller is able to look down, in a "plunging

Fig. 84 *View from the House at Montgomery Place, vic. Tarrytown, New York.* From A. J. Downing, *Theory and Practice of Landscape Gardening,* figs. 1 and 3.

Fig. 85 View from the Terrace at Montgomery Place.

Fig. 86 A. J. Davis, *View from the Shore Seat West to Hudson River and the Catskills.* Franklin D. Roosevelt Library, Hyde Park, New York.

Fig. 87
The Cataract, looking
upstream.

view" of forty feet, at runnels of water moving over rock, gouts of foam, sun-starred pools. From the bottom of the stairs, the pools are foregrounded, and one sees the art of the Italian workmen, who cut channels into the rock, so that the water ramifies, treelike, into branches and sprays, with the falls above a monumentalized rush of "wild foam and confusion."

At the crest of the ridge above the cataract, the stroller encounters the wild repose of "The Lake" (Fig. 88). Mirrorlike, reflective, its surface turns loveliest in evening or moonlight, and around "a rude sofa" hewn from the living rock a complexly varied scene takes shape. Two sides of the lake are deeply shaded by "bowery thickets" of the forest. To the west opens a vista of the distant blue Catskills opens. To the north is a peninsula "fringed" with willow, carpeted with cedar needles, and furnished with a rustic temple. The cedars themselves make the place "dusky" even at noon. A "foaming, noisy little waterfall," prelude to the Cataract below, falls off on one side of the peninsula; on the other ("a perfect opposite to this") the peace of the lake spreads like a benediction. In moonlight, says Downing, one can drift through the lake's "striking" contrasts of light and shadow in a phantasmagorical boat not unlike the one in Poe's "Domain of Arnheim," its prow decorated with a giant butterfly that "looks so mysteriously down into the depths below as to impress you with a belief that it is the metempsychosis of the spirit of the place."

The fifth and final scenic sequence at Montgomery Place opens from the forest path meandering south along the crest of the lake (the "tour" taking the literal form of a circle completing itself). The forest screen thins and then parts, and across an expanse of brilliant light and exotic foliage (singly planted for the most part), "gay" and "smiling," appears the architectural scenery around the house (Fig. 89). A glass conservatory materializes, crowded with orange and lemon trees, Cape jasmines, eugenias. Beyond, bright and "richly massed" parterres of brilliant flowers "bask in the full daylight." Framed by turf or box, the parterres take on a richly oriental look, like an embroidered rug. The center is dominated by a Warwick vase of the Warwick pattern; the periphery is marked by two "fanciful[,] light" Moorish pavilions; and the garden thus takes on the exotic look of a flowery world of several continents.

"Harmony . . . always supposes *contrasts,*" Downing elsewhere argues, "but neither so strong nor so frequent as to produce discord; [it also supposes] *variety,* but not so great as to destroy a leading expression," to which "the others should be subordinate." The circuit of scenes at Montgomery Place is unified by recurrent, if also varied, effects of a picturesque beauty as evident in the Cataract as it is in the conservatory. What ultimately links the scenes, however, are the joined narratives of a regression to the primitive and a reenactment—like that in landscape painting—of American settlement. The primitive is idealized as a place in which nature and a buoyant spirit intersect. Viewers at the Cataract, Downing declares, undergo a transformation that the whole garden is designed to effect, but nowhere more intensely than here. The water falls. Its music begets "a dreamy revery" and washes, from the viewer's charmed mind, all "memory of the world's toil," "until at last one begins to doubt the existence of towns and cities . . . and to fancy the true happiness of life lies in a more simple existence, where man, the dreamy silence of thick forests, the lulling tones of babbling brooks, and the whole heart of nature make one sensation, full

Fig. 88 *The Lake at Montgomery Place.* From A. J. Downing, *Theory and Practice of Landscape Gardening,* fig. 5.

Fig. 89 *The Conservatory and Flower Garden at Montgomery Place (from the West).* From A. J. Downing, *Theory and Practice of Landscape Gardening,* fig. 73.

of quiet harmony and joy."[64] The walk from the Cataract, with its signs of pre-agricultural civilization, past the lake to the lawn, ritualizes and spatializes the terms in which human enterprise (the house and garden), rightly inspired, both embraces and transforms nature. This and other versions of the sequence stir American painters and poets profoundly—picturesque art inspiring picturesque art. But more significantly, they restore to their senses people "engaged in a feverish pursuit of [the world's] gold and its glitter." The stroller emerges from the garden restored to a state of repose "fatal to the energies of . . . speculation" and to "campaigns of conquest." In the leafy asylum of picturesque landscape gardens, as in the rural house, Americans are offered the experience of a transformation from hustlers into dreamers and thinkers; are charmed into a desire to contemplate the world rather than to colonize it, to see in it the music of more (energetically) pacific selves, and thus to redefine American culture as a collaboration of nature, mind, and culture.

These are deep desires in antebellum America. "[T]he taste for elegant rural improvement is advancing now so rapidly," writes Downing in his inventory of private American landscape gardens, that one can venture a prediction that by the end of the century "there will exist a greater number of beautiful villas and country seats of moderate extent, in the Atlantic States, than in any country in Europe, England alone excepted." At present, he observes in 1841, they are concentrated, along the Schuylkill and Hudson Rivers and in the suburbs west of Boston, and he singles out as exemplars of this transformation the Woodlands near Philadelphia, Montgomery Place and Blithewood (next door), and Waltham House in Brookline. Sargent's "Supplements" to this survey, the first in the 1859 edition of the book (Downing having died in 1852), trace the diffusion of the picturesque landscape garden throughout the Northeastern and Middle Atlantic states and then to the West. Across the continent, Sargent echoes in 1879, with the population well on its way to becoming officially urban, these magic fusions of art and nature offer the chief hope for converting America's restless and material-minded citizenry to a liberating love of place.[65]

Suburbs of the Dead: Mount Auburn and the Rural Cemetery

Privately owned gardens like Montgomery Place, however, constitute only a single chapter in the history of the picturesque landscape in the United States. The "next great step," as Sargent declares, is the construction of spaces that respond to a more inclusively democratic imperative: "Public Parks, for the enjoyment of [all] the People of our Cities and Larger Towns."[66] That step begins in the early 1830s with the construction of Mount Auburn Cemetery. Mount Auburn is both first and representative prototype of the picturesque cemetery—another ubiquitous feature of nineteenth-century American town- and cityscapes: a suburban landscape of the dead.

The rural cemetery expresses a fundamental change in Americans' very idea of death. At Mount Auburn, declares Horace Bigelow (one of its planners), the "revolting ideas" engendered by traditional repositories of the dead—"dreary, desolate and ruinous" crypts and ossuaries in which the dead lie "indecently crowded together"—are replaced by an arrangement in which the graves have "space enough for . . . decent and respectful ornament" and are set in a green space designed to

surround mourners with any of a number of different landscapes "that can fill the heart with tender and respectful emotions"—"the shade of a venerable tree" and "the slope of the verdant lawn"; "the seclusion of the forest." The "discordant scenes of life," dying, death, and the decay of the corpse, are effectively concealed from sight and mind.[67]

From the outset, the planners of Mount Auburn imagined a picturesque design. On the site they chose in Cambridge, notes the anonymous author of *The Picturesque Pocket Companion and Visitor's Guide through Mount Auburn,* picturesque nature had already accomplished "almost all that is required for a painting in three dimensions." The wilderness zone—"a number of bold eminences" with "steep acclivities" (including Mount Auburn itself), and "deep shadowy valleys"—was already there. On the slopes of Mount Auburn, a thick, towering forest of century-old oaks, pines, beeches, walnuts, and other "venerable monarchs," still endowed with "the vigor of their luxuriant progeny" and honeycombed with dark interior vistas "of the most picturesque character"—"many an . . . 'alley green' and 'many a bosky bourn'"—constituted a wholly congruent mise-en-scène for "enduring monuments of marble and granite" (Fig. 90).[68]

This Cambridge landscape also offered the requisite visual path of a "magnificent and unbroken panorama" radiating out from the summit of Mount Auburn. To the east rose the city of Boston, "in full view" and "connected at its extremities with Charlestown and Roxbury." A serpentine Charles River could be seen flowing from Boston to the Blue Hills of Milton, through a pastoral landscape of "cultivated hills and fields," with "[c]ountry seats and cottages seen in various directions, and especially those on the elevated land at Watertown, add[ing] much to the picturesque effect of the scene." Nearer, "about a mile to the eastward," lay the village of Cambridge, dominated by the "venerable edifices of Harvard University." To the west, the pastoral landscape ended in the forested upswoop of Mount Wachusett—a visual rhyme with Mount Auburn itself.[69]

To the north of the mount (Fig. 91), the prospect offered "different vistas" across the cemetery landscape. "At a very small distance" appeared Fresh Pond, "a handsome sheet of water, finely diversified by its woody and irregular shores" and a part of the cemetery's pastoral zone—an Elysian Fields that made the signs of human struggle in the outer landscape seem (for the moment) remote, vain, foolish.

"[B]eautifully undulating in its surface" and crossed by "a long watercourse," the pastoral zone needed only finishing, and for that, too, the picturesque "method pursued in England" provided a blueprint. Roads and paths, wrote General Dearborn, another of the planners, were designed "to follow the natural features of the land" and to wind "gradually and gracefully through the vales and obliquely over the hills" so that they could be kept, like rivers "as nearly level as possible." Nearing the wilderness scenery of Mount Auburn and its forest, they were transformed, appropriately, into footpaths, "smoothly graveled and planted on both sides with flowers and ornamental shrubs."[70]

"A remarkable natural ridge with a level surface," a stretch of pastoral meadow (Wyeth's Meadow), and a stream in the pastoral zone required more extensive reconstruction. In the streambed, workmen excavated Garden and Meadow Pond,

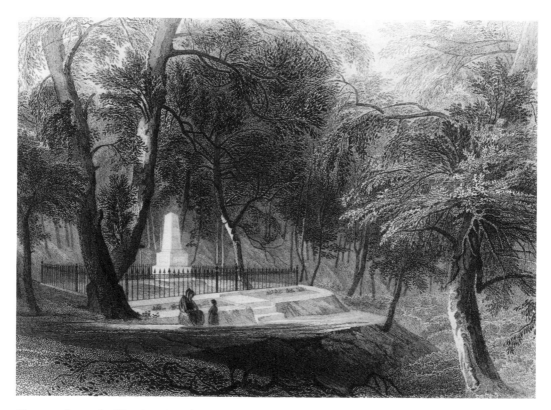

Fig. 90 James Smillie, *Interior View, Mount Auburn Cemetery*, 1847. Engraving. Private collection.

Fig. 91 James Smillie, *Vista from Mount Auburn, looking north to the Chapel and Fresh Pond*, 1847. Engraving. Private collection.

lining the banks of the latter with grass and fieldstones, cutting a path around its upper half and a carriage road that crossed the other end of the pond on a low bridge. Wyeth's Meadow became The Lawn. A bright and spacious sward for those desiring settings of greater elegance and monuments of greater visibility than what the forest offered, the green brilliance of The Lawn was the middle ground of yet another interior vista, designed to terminate at one end in the monumental form of a chapel and at the other in Garden Pond and the muted verticality of a treeline beyond.

Serving the role of the house in the private landscape garden, the chapel was built, eventually, in an elaborate Gothic style and was flanked by a "deep and abrupt hollow" given over to a more conventional, churchyard, form of burial. Close to the chapel, an Egyptian Revival gate of Bigelow's design (based on French drawings of the temples at Karnak and Thebes) framed the entrance to the cemetery (see Fig. 93). Part architecture, part sculpture, the gate introduces one of the cemetery's major sources of a new and eclectic funerary symbolism designed to engender in visitors "agreeable recollections of the past." "Two obelisks are connected with the two lodges by a curved, iron fence," Bigelow explains. Ornamentation on the gate between the obelisks introduces Egyptian motifs of a banded cylinder, foliage (on the cornice), and a winged globe on which a lotus flower conceals "the head of the fabulous animal with which the ancient examples are usually defaced." The symbolism, the size of the stones, and the solidity of the gate are all designed to suggest that the structures within, though engraved with new semiotics, will have "a stability of a thousand years."[71]

That is a promise kept in the principal structures in the cemetery, the funerary monuments. Neither tombs nor charnel houses, they are an eclectic amalgam of sculpture, architectural fragments, and literary texts engraved in stone, all designed to impart to the lives of the dead a visible "substance" more memorable (as Justice Story argued in his Commemoration Address) than words alone.[72] The iconographies of Catholicism, Anglicanism, and even Calvinism are banished: no skeletons, death's heads, or angels of death; no (or few) signs of the cross, that "ignominious engine used for the destruction" of Christ. Their ornaments, their forms, and their meanings derive from an eclectic mixture of pre-Christian and secular codes laid out in French and English symbol-books—Arnaud's *Recueil de tombeaux des quatres cimetières* (1824), Jolimont's *Les Mausolées français* (1821), readings of the sculpture at Stowe and other English gardens—and interpreted repeatedly and at length in magazines, newspapers, sentimental poetry, pattern books, and guidebooks such as *Picturesque Pocket Companion to Mount Auburn*. For most of the early monuments, white marble is the stone of choice because it stands out, glowing, against the green foliage and its dark shadows and because, like the walls of the New Jerusalem, its beauties are not defaced by time. Like freestanding sculpture, the forms exist independently of the grave, "above the surface of the earth,—not under it," for part of the "stability" they express is the promise that they will be read and remembered.[73]

In a pastoral landscape meant to rhyme deeply with that of Rome's Appian Way and in a city that regarded itself as the Athens of America, classical forms are the first and principal signifiers—164 monuments by 1841 (and after that a deluge) running to Athenian grave markers, urns (as in "Ode on a Grecian Urn"), cenotaphs,

sarcophagi, lopped columns: all recoded with contemporary meanings. Even the Egyptian obelisks are there by virtue of having been used in Rome and then in England. Symbols there of military victory, they are now infused with hierophanic and Christian codes that reconstrue them as celebrations of victory over death, and they are festooned, in low relief that complicates their surfaces picturesquely, by such nineteenth-century staples of floral symbolism as olive branches, that associate death with the peace that passes understanding.

Like everything else about these constructions, the classical symbolism serves an ultimately biographical end. With hereditary status in decline in the United States, words carved like tracery into the marble surfaces are designed to reinforce this status, especially where family history leads back along "the Pilgrim way" to New England's founders.[74] Recurrently, the inscriptions also include verbal character sketches celebrating the virtues of the dead in the emerging conventions of sensibility promoted by women and ministers.[75] Especially significant in these sketches are the humanistic virtues prized by Bostonians—learning and other forms of self-improvement, magnanimity, eloquence, rectitude—and, increasingly, the virtues associated with the sentimental tradition, including taste, piety, sweetness and benevolence of temperament, patient long-suffering. The monument to John Hooker Ashmun on Harvard Hill, raised by his students, reads:

> He went behind precedents to principles; and books were his helpers, never his masters. There was the beauty of accuracy in his understanding, and the beauty of uprightness in his character. Through the slow progress of the disease which consumed his life, he kept unimpaired his kindness of temper and superiority of intellect. He did more sick than others in health. He was fit to teach at an age when common men are beginning to learn, and his few years bore the fruit of long life. A lover of truth, an obeyer of duty, a sincere friend, and a wise instructor.

Visual symbolism is also appropriated to biographical ends. The grave of the fugitive slave Peter Byus (corner of Citron Path and Magnolia Avenue) is decorated with a low relief, copied from Wedgwood's "Am I Not a Slave and A Brother," of a fugitive slave breaking his chains: the defining event, for the monument-makers, of Byus's life. The grave of Margaret Fuller Ossoli (Fig. 92), between Pyrola and Belwort paths, takes the form of a Gothic window (framing a view past death's shores) that is topped by a cross and decorated with low reliefs of oak and laurel, symbols of her strength and accomplishment. A verbal biography eulogizes some of the defining events in *her* life, in a sequence suggesting that, like John Adams and Cincinnatus, she put down her books when revolution called:

> By birth a child of New England, by adoption a citizen of Rome, by Genius belonging to the World. In youth an insatiate student, seeking the highest culture. In riper years Teacher, Writer, Critic of Literature and Art. In maturer age, companion and helper of many earnest reformers in America and Europe [including Ossoli, who] . . . gave up rank, station, and home for the

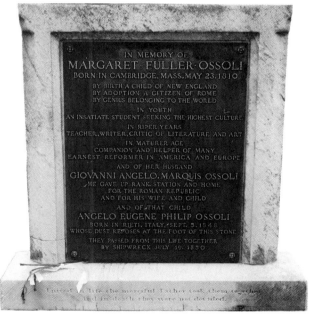

IN MEMORY OF
MARGARET FULLER OSSOLI
BORN IN CAMBRIDGE, MASS., MAY 23, 1810

BY BIRTH A CHILD OF NEW ENGLAND
BY ADOPTION A CITIZEN OF ROME
BY GENIUS BELONGING TO THE WORLD

IN YOUTH
AN INSATIATE STUDENT SEEKING THE HIGHEST CULTURE

IN RIPER YEARS
TEACHER, WRITER, CRITIC OF LITERATURE AND ART

IN MATURER AGE
COMPANION AND HELPER OF MANY
EARNEST REFORMER IN AMERICA AND EUROPE

AND OF HER HUSBAND
GIOVANNI ANGELO, MARQUIS OSSOLI
HE GAVE UP RANK, STATION AND HOME
FOR THE ROMAN REPUBLIC
AND FOR HIS WIFE AND CHILD

AND OF THAT CHILD
ANGELO EUGENE PHILIP OSSOLI
BORN IN RIETI, ITALY, SEPT. 5, 1848
WHOSE DUST REPOSES AT THE FOOT OF THIS STONE

THEY PASSED FROM THIS LIFE TOGETHER
BY SHIPWRECK JULY 19, 1850

Fig. 92 Margaret Fuller Ossoli Monument.

Fig. 93 Bowditch Monument, Mount Auburn Cemetery (1997).

Roman Republic, and for his wife and child. . . . United in life by mutual love, labors, and trials, the Merciful Father took them together, and in death they are not divided.

Visual symbols situated within the window frame amplify these definitive events. A book (sign of her literary career), a star (her signature on her writings), and a sword (sign of the revolution in Rome in 1848 that she and her husband served) float like planets around a portrait medallion of Fuller herself.

Some lives of the illustrious dead are also reconstructed by mise-en-scène. Given a particularly dramatic location in the garden, a life-size statue of the astronomer Nathaniel Bowditch (Fig. 93), for example, erected, at the corner of Central and Cyprus Avenues, by merchants whose international trade profited from his perfection of navigational instruments and methods, sits out under the sky on a thronelike chair, its eyes focused on a vista that culminates in the cemetery's Egyptian gate. (From the gate, the statue dominates the climax of the vista up the slope of Central Avenue.) Emil Spurzheim's sarcophagus, in imitation of the Roman tomb of Scipio Africanus, is also situated atop a hill on Central Avenue, at a site meant to be associated with the place of sepulture described in Virgil's Ninth Eclogue.[76]

By 1850, however, the Mount Auburn landscape had become too crowded with monuments to offer such expansive sets—so crowded, indeed, that this rural cemetery had now become "a *City* of the Dead."[77] In tacit recognition of this, the whole layout of the landscape becomes suburbanized. Before 1850, the monuments had been situated wherever the purchasers chose, "without regard to the economy of the land, or to the size and shape of the intermediate spaces." The new design arranges

the graves into gridded lots designed to make "both the paths and the lots more parallel to each other, with as little space between them as is consistent with their good appearance."[78]

The forest, too, is formalized. So "dense" and "impenetrable" that it concealed most of the monuments from view; its trees bearing the unseemly marks of struggle, deformation, and death ("dead limbs or unseemly knots," trees deformed by the close proximity of other trees), it is redesigned after the example of the newly transformed Boston Common. Its trees are planted apart from each other, to encourage their "free growth and ultimate good appearance," and reduced to half their original number, to create "broad vistas" and parklike "open spaces." Rows of trees now line the major avenues, and the smaller roads are edged by grass, flowers, and low shrubs, "with a few trees left only in unobjectionable places," like those in residential backyards. Lot-borders are planted (also like yards) with roses, laurels, and rhododendrons. To smooth out the terrain, hollows and ponds are graded in with gravel drawn from knolls in the wilderness zone.

Not surprisingly, these gridded and embellished plots are treated recurrently as architectural sets. The monument to Samuel Appleton (between Woodbine and Hawthorne paths) is a miniature Greek temple, encircled by a rise of three steps and crowned by (nonfunctional, symbolic) sepulchral lamps. "Low-relief Corinthian columns appear to support the entablature. Symbolic elements—a serpent coiled in a circle with spread wings over it representing eternity and evergreen wreaths indicating perpetual remembrance—decorate its sides. The whiteness of the marble stands out against the backdrop of a dense grove of evergreens, creating an almost theatrical composition."[79] As Gothic and Italian Revival styles make their inroads into conservative Boston, these styles, too, appear among Mount Auburn's sets.

As the architecture becomes domestic, stone steps, doors, and even windows appear, and iron railings ("jealous markers," Ann Douglas calls them) and grass complete the transformation of lots into tiny yards. The banks of Hazel Dell, not far from the chapel, are lined with crypts designed like village houses: ornamented doors and gables, pots of flowers set on sculpted, but glassless, windowsills. Grass, acanthus, an Empress tree, and a scarlet oak make the middle of the dell a village common. Popular prints complete the picture by peopling such spaces with living women in black, who sit waiting on the steps or picnic on the grass; children playing or gathering wildflowers, in *memento mori*—while, inside the house, the meek sleep until the resurrection.[80]

The domestication of death is not an idiosyncrasy of Boston. By 1849, Downing notes in *The Horticulturist*, there is scarcely a city of note in the United States without its picturesque necropolis.[81]

Urban Pleasures and "The Special Charms of Rural Life": The Picturesque Suburb

Meanwhile, picturesque suburbs, "neighborhood parks," for the living become equally ubiquitous in nineteenth-century landscape—signs, in Frederick Law Olmsted's view, of the "counter-tide" of American migration away from the city and of Americans' desire to combine urban pleasures and conveniences "with the special charms . . . of rural . . . life."

1. *Olmsted's Suburban Designs.* Olmsted most fully defines the picturesque suburb in his designs for Berkeley, California (1866; not built), and Riverside, Illinois (1868; built without the parkway that would have linked it to downtown Chicago). For Olmsted, the pleasures of the rural suburb, too, are largely scenic. Ideally, it is built upon a hill, its roads "gracefully curved" around the higher elevations, so that they offer not only "satisfactory out-goings . . . for walking, riding, [and] . . . pleasure-driving," but also "satisfactory vistas into the surrounding landscape" and, at intervals, close scenes "with suggestions of refined domestic life, secluded, but not far removed from the life of the community." This picturesque scenery, "calculated to draw women out of their houses and private grounds," is designed to motivate active exercise and invigorations of fresh air and sunlight. The visual reward for this "out-going" is a kinematic experience of landscapes now intimate, now distant, now natural, now "artificial"—a Montgomery Place designed for a group of owners.[82]

To the same ends, a communal park becomes another desirable feature of the picturesque suburb. Like the meadowy lawn at Montgomery Place, it is a broad stretch of green, offering "in its fair, sloping surfaces, dressed with fine, close herbage, its ready alternatives of shade with sunny spaces, and its still waters of easy approach, attractive promises in every direction."[83]

For Olmsted, the picturesque suburb and the lives of its inhabitants both oscillate ideally between "range" (the distances, light, and air of vistas) and "seclusion," between outdoor recreation and domestic repose. The promises of new scenes to be encountered and traversed motivate movement along its paths, but benches allow more sedentary viewing and contemplation. The houses are "secluded" but abound with "invitations to movement on all sides." Yards are walled off by foliage from neighboring houses, but the foliage, like the house windows, frames a view worth contemplation: a "well-defined, suitably proportioned, salient, elegant and finished" yard in the foreground, a middle ground that situates house and yard in a neighborhood, and a background that mixes the "natural and tranquil" with "something of human interest"—in short, a rural landscape that is both visual climax and origin, the suburb and the suburban house taking shape as the visible consequences of a history of transformations in the rural landscape. Nearby, when the contemplation of nature and artifice pale, a railroad line stands ready to whisk the suburbanite to the picturesque city.[84]

2. *Llewellyn Park.* Olmsted's ideas accord so well with the design of the first planned suburb, Llewellyn Park (1863–69), that they might be said to constitute a kind of blueprint after the fact, and much the same may be said of other picturesque suburbs subsequently built into the American landscape, including A. T. Stewart's Garden City, Long Island; Pierre Lorillard's Tuxedo Park; Olmsted's own Riverside, Illinois; and the expansion, by many hands between 1850 and 1900, of Newport, Rhode Island.[85] Llewellyn Haskell—head of a chemical company, Perfectionist, friend of Andrew Jackson Downing, and developer of two estates on the Passaic—conceived Llewellyn Park as a social experiment. With the help of two landscape gardeners, Eugene A. Baumann and Howard Daniels, he designed the landscape, and Alexander

Jackson Davis, one of the leading architects of the picturesque style, designed the fifty villas.

Situated on 350 acres of the eastern slope of Orange Mountain, Llewellyn Park is an inclined plane ascending a mile from the village of Orange to a cliff called Eagle Rock. Built on the upper elevations of the slope, on sites of three to ten acres each, the villas are situated and landscaped in such a manner as to make this landscape, too, "seem like one large estate."[86] Its "general effect" is perpetuated by a covenant between the owners: each house to be laid out "with mutual references" to the houses around it; no "inferior class of buildings"; no fences or other visual "nuisances"; no grid. Not surprisingly, Gothic and Italian Revival architecture dominate this antebellum suburb.[87] One of the few surviving houses by Davis is a scaled-down version of Downing's Tudor cottage, a more rustic version of Davis's Rotch House (see Figs. 72 and 74). A study in Downingesque adaptation to its environment, it still settles quietly, William Pierson observes, into the seclusion of "a sunlit clearing surrounded by the deep oak forest of the inner park." "Here, its soaring pointed outlines, tall chimney stacks, and sheltered veranda all gesture sympathetically toward the towering limbs and shadowed verdure of the enveloping forest. The vertical threads of the board-and-batten siding lift its tapered shapes toward the treetops; they also paint on the surface of the buff-colored walls a fragile linear pattern which sharpens and retreats as the shifting shadows of the foliage swing and turn with the wind."[88]

Foliage shades the park's Ramble as well, a communal park of fifty acres or so, centrally situated along the ravine that climbs the slope from the gate lodge to Eagle Rock. A brook in the ravine feeds ornamental water forms and cascades. Walks amble up the slope to the cliff "and to other interesting parts of the grounds," and along them, Sargent notes, the furniture of kiosks, seats, and bridges is constructed in rustic styles, "in keeping with natural character of the surrounding forests." An entrance road (Fig. 94) runs along the edge of the park, providing for travelers (as Olmsted would subsequently suggest) a moving panorama of park, forest, and the periodic embayments of yard and houses.

Like Mount Auburn, moreover, Eagle Rock is designed to provide a visual climax to the climb up the hill. A landscape panorama provides the range for meditation, though its general effect is different than Mount Auburn's. This view takes in "a peep of the ocean through the Narrows, on the east; the Highlands of the Hudson on the north [epicenter of the picturesque aesthetic]; . . . the receding blue of the New Jersey plains in the south; [and] . . . intervening cities, villages, forests, and farms." The urban amenities of Fifth Avenue and Central Park lie a dozen miles to the east.[89]

3. *Frank Scott's Suburban Yardscapes.* The politics of Llewellyn Park and of Olmsted's picturesque suburbs are oligarchic: by rigorous covenant, each house and yard is constructed and maintained as part of the composition and the general effect. In the more speculative versions of the picturesque suburb that emerge in the 1860s and 1870s, covenants become informal or disappear, and the composition takes on a

Fig. 94 *Entrance to Llewellyn Park, Orange, New Jersey.* Etching. From A. J. Downing, *The Theory and Practice of Landscaping,* fig. 105.

looser, more eclectic, character. This is ground defined by Frank J. Scott in *The Art of Beautifying Suburban Home Grounds* (1870).

For Scott, privately owned suburbs are impractical because of "the transient nature of family wealth, in a republic where both the laws and the industrial customs favor rapid divisions and new distributions." One of his alternatives is a rural township "dotted" with new suburban homes—a landscape of "streets, and roads, and streams" (Fig. 95). Working "farm-fields, pastures, woodlands, and bounding hills or boundless prairies" give this complex landscape its rural look, and "schoolhouse towers and gleaming spires" offer the visual coherence of the well-established town; but it is a town transformed by suburbanites. Main Street now offers the amenities of a small city, including "lecture, concert . . . dancing-halls, and ice-cream resorts."[90]

The only new residence in this space is the suburban house with its small yard of half an acre or so, and it is to such a yard that Scott applies a scaled-down version of picturesque landscape architecture. Parks and rural cemeteries are "on a grand scale," Scott argues, but suburban landscape architecture must be gardenesque[91]—compressed, like Randolph's parlors or Poe's short stories. "Some of the most prized pictures of great landscape painters," he declares, "are scenes that lie close to the eye; which derive little of their beauty from breadth of view, or variety of objects; and yet may be marvels of lovely or picturesque beauty."

Like these, Scott's picturesque yardscapes become an art of foregrounds. The terrain being, at most, "billowy" and for the most part devoid of water forms, the lawn becomes the canvas on which foliage constitutes "the art of picture-making." Like paint, foliage adds color and creates shadows that "play with the sunlight and

moonlight on the grass." It frames a private, intimate scenery: "a verdant gate-way arch [turning] the common walk into a picture view"; trees framing both the house and (if possible) the views from it. It also creates the scenery so framed, as in a single "delicate-foliaged tree" planted before a bank of foliage, glowing with the light of the afternoon sun, or "with airy undulations trembling against the twilight sky, till it seems neither of the earth or the sky, but a spirit of life wavering between earth and heaven." Shrub- and flower-lined walks provide "the embellishments and finishing touches" of such "pictures."[92]

The scenic possibilities of picturesque yardscapes, Scott argues, are as various as the houses that constitute "the central interest of [the] picture." As in rural cemeteries like Mount Auburn and in the commercial business districts of cities, complexity and contrast are pushed to their limits here by the spirit of self-assertion. De-

sign becomes as improvisational as a costume parade and is limited only by the small scale and the requirement of congruence with the architecture of the house. As in postbellum architecture, historical periods and styles are freely appropriated and eclectically combined or juxtaposed against each other. The yard of a Gothic or Italian Revival house might be given the scenic shape of a forest glade, "a tree-flecked meadow, a copse-belted lawn." The formalities of Second Empire, Queen Anne, and Colonial Revival architecture require the more formalized "architectural" gardens of Renaissance and "old French" design—a tendency very much evident, for example, in the yardscapes of picturesque Newport. The decidedly "artificial" grammar, Scott demonstrates at length, includes topiary in "fanciful forms"; arcades walled by rectangular, conic, concave, or pyramidal foliate screens; and canopied or parasoled bowers and domed mosques (formed, with varying effects, by evergreens, hawthornes, sassafras, dogwood, or weeping elms) for "cool summer resort."[93]

As Scott sees it, there are only two possible ways of harmonizing the improvisational clangor and jangle of such competing styles. One is by purely neighborly impulses to harmonize new yards with those already constructed. Between one yard in "the old village style, with big cherry trees, maples, lilacs, spruce trees, roses, and annuals" and another constructed as a forest grove of "noble old trees," a new yard could be designed as, say, an open lawn with beds of bright flowers and a parterre lined with vases (rustic or classic, as the architecture dictates) of bright flowers, with more vases situated, out in the yard. The easy formality of this arrangement creates "charming combinations" with the neighboring scenery of old village and forest grove. Each is an appropriate "back-ground" to it, and each, in turn, provides a "charming outlook" on it.[94]

At its most inclusive, Scott's voluntary arrangement of yardscapes might take on the coherence of a composite bio-region, like those in Frederic Church's vistas, the neighborhood exhibiting "almost every kind of vegetable beauty that the climate admits of." To such an end, some yards might feature single or paired species—birch and pine, maple, oak, elm—in "all the varieties that are pleasing to the eye"; others, the spiry-topped forms of spruce or hemlock or the broad, low forms of apple trees, mulberries, catalpas; and others still, the most beautiful displays of spring and summer blooms or fall colors, in dogwood, liquid amber, tupelo, sassafras, sugar and scarlet maples, and scarlet oaks. To other composite arrangements, Scott offers a historical as well as a geographical logic. One yard might display "the classic formalities of the old French style," another the modern style defined by Downing, with its gracefully curved trees (the "weeping varieties") and serpentine walks; and another might add to these Euro-American spaces a tropical scenery of magnolias, catalpas, mulberries, ailanthus. Plantings of street trees of the same species at wide intervals frame these arrangements into a sequence of scenes to be viewed from the common road.

The harmony of such ensembles emerges, if at all, from open (and changeful) dialogue between "individual fancies" and "a general plan." The degree of harmony in the whole—however tentative and complex—is a sign of the community's commitment to a shared spirit of commonality, with minimal loss to individual freedoms.

The individual in an ensemble: this is the paradox that obsesses Whitman, too. His America is a society of "full develop'd and enclosing individuals," complete in themselves and related only as a loose confederation of co-equals. That is, at its best, the semiotics of Scott's suburbs, and it is what gives the picturesque designs of public spaces in the United States their most distinctive traits.

[Prose narrative] should surpass nature herself in its combination of events with character—rejecting all that is not itself dramatically picturesque or in full consonance with the effect or impression.

[In literature] of less extent . . . the pleasure is unique in the proper acceptation of that term—the understanding is employed, without difficulty, in the contemplation of the picture *as a whole*—and thus its effect will depend, in a very great degree, upon the perfection of its finish, upon the nice adaptation of its constituent parts, and especially upon what is rightly termed . . . "the unity or totality of interest."

—Edgar Allan Poe, *Works*

∞

Nineteenth-century American literature, too, adapts the picturesque aesthetic. Descriptive imagery employs an eclectic grammar of images with layered effects, which are subject, in prose narratives (and in poems), to the principle of congruity: every image, every word, declares Edgar Allan Poe, the most articulate theorist of picturesque literature, must contribute to the expression of "a certain unique or single effect."[1] Narrative becomes "dramatically picturesque" when it is focused, in a sequence of portraits, sketches, and scenes, on characters that constitute its subjects. The dominant effect governs this sequence; it governs the selection of "incidents" that constitute the plot; it governs representations of settings that must be congruent with the events taking place in them. Every element of the narrative is pictorialized and every element made part of "the one pre-established design."[2]

Poe's view of picturesque literature is shared, to some degree, by critics as various as Samuel Morse and Ralph Waldo Emerson, although the aesthetic is appropriated to very different ideological ends. At the same time, it constitutes a virtual gloss on American literature between 1820 and 1880: on popular travel narratives; the canonical fiction of James Fenimore Cooper and Washington Irving, Nathaniel Hawthorne, Herman Melville, Henry David Thoreau, and Edgar Allan Poe; and on the more recently canonized fiction of Harriet Beecher

Comparing the Picturesque Arts

LITERATURE AS PAINTING

Stowe, Elizabeth Stuart Phelps, Rebecca Harding Davis, and other women writers; and even (though I can only suggest this in what follows) on the poetry of William Cullen Bryant, Ralph Waldo Emerson, Emily Dickinson, and Walt Whitman. The most evident and significant exceptions to its influence, as I wish to show, are those of African-American writers, including Harriet Wilson and Charles Chesnutt, who challenge its dominion by deconstructing it—though this, too, is an implied recognition of its literary importance.

DISCOURSE AS AN ART OF THE IMAGE

In literary painting as Poe defines it, the most generative agency of effect in narrative discourse is the richly various imagery created by "a fine eye for the picturesque": an imagery that includes the beautiful (flowing curves, smooth textures, soft, cool colors, and cool light), the sublime (heaving or shattered or indistinct lines, erupting surfaces, and brilliant or lurid chiaroscuros), and eclectic blendings and sequencings of these effects. Both poetry and prose fiction demonstrate the full possibilities of this discourse, but travel narratives, product of picturesque excursions, are its first and chief experimental laboratory. The effect of the "bold" and "beautiful" Hudson River at West Point, as Nathaniel Willis sketches it in *American Scenery,* is a case in point:

> The powerful river writhes through the highlands in abrupt curves, reminding one, when the tide runs strongly down, of Laocoön in the enlacing folds of the serpent. The different spurs of mountain ranges which meet here, abut upon the river in bold precipices from five to fifteen hundred feet from the water's edge; the foliage hangs to them, from base to summit, with the tenacity and bright verdure of moss, and the stream below, deprived of the slant lights which brighten its depths elsewhere, flows on with a sombre and dark green shadow in its bosom as if frowning at the narrow gorge into which its broad-breasted waters are driven.[3]

The power of such an elaborate picture, Poe would argue, derives from an impressionistic focus on "some one vivid and intensely characteristic point or touch"—a kind of visual synecdoche. The subject's least expressive details can be muted or omitted to give greater force and presence to its most expressive details, which are capable of presenting in themselves "*the idea of the object*" as well as its shape and color—so that both "start boldly out" to the careful reader.[4] That is the effect of Willis's dark, writhing serpent of a river and of a significant image, later in the sketch (sublime succeeded by beautiful imagery) of the sails of pleasure sloops scudding over it, forming "one of the prettiest moving dioramas conceivable":

> [N]othing is more beautiful than the little fleets of from six to a dozen [sloops], all tacking or scudding together, like so many white sea-birds on the wing. Up they come, with a dashing breeze, under Saint Anthony's Nose, and the Sugar-Loaf, and giving the rocky toe of West Point a wide berth, all

down helm and round into the bay; when—just as the peak of Crow Nest slides its shadow over the mainsail—slap comes the wind aback, and the whole fleet is in a flutter. The channel is narrow and serpentine, the wind baffling, and small room to beat; but the little craft are worked merrily and well; and dodging about, as if to escape some invisible imp, they . . . get the Donderbarrak behind them, and fall once more into the regular current of the wind.

But "[s]imple description," Poe argues, is not enough. For maximum effect, intense tones must make the imagery "poetic."[5] Visual tones, expressed in an imagery of light and color, relate images "by congruity to the passion [the artist] wishes to raise." Tones of voice, on the other hand, are evoked by lyrical discourse. In Willis's sketch, the discordant rhythms when the wind is introduced, the onomatopoeic rhyming of "slap" and "aback," "scudding" and "flutter," and the alliterated "f's" that reiterate the sounds of the fluttering sails all charge the sketch with "the sentiments with which the narrator regards them."

Tonalities in turn give picturesque imagery its reverberant "under currents, however indefinite, of meaning"—its symbolic effects.[6] Willis's imagery in the first of the two sketches quoted above links the Hudson's Narrows with markers, at West Point, of the revolution. The past is evoked chiefly in terms of the sublimities of human violence (the French and Indian War, the Revolution), a recurrent theme of *American Scenery*. Here a "bright finger" of marble pointing to the sky marks the tomb of General Kosciusko, hero of the American Revolution; nearby waves a flag with "blood-bright stripes." The sketch also links human to natural violence. The Culprit Fay, Willis observes, is capped by what local tradition defines as a crow's nest—the place from which sailors on warships watch for their enemies; and as another mountain, Donderbarrak, "heaves its round shoulder," a cliff across the river leans back as if in recoil. The "writhing" Hudson reminds the narrator of Laocoön "in the enlacing folds of the serpent."

In the sketch's present, by contrast, both landscape and human activity have become pacific, pleasant, beautiful. An "emerald island" now decorates the Hudson's "bosom" like a necklace, and its edges are lined upriver with the white buildings of the town of Newburgh, from which, evidently, the white pleasure sloops have sailed. In concert, a battalion of cadets is seen "cutting its trice-line" (that is, sailing) across the green drill-field at West Point. Everywhere, signs of struggle have given way to playful sport, dark sublimities to irradiated and animated beauties.

Sublime and Beautiful Styles

In the lyric strata of picturesque discourse, every effect, sublime or beautiful, and every change of effect can be intensified by congruent rhythms and sounds. With its imagery of powerful energies and massive scale, sublime discourse is telegraphic: fast, suggestive rather than definitive, a "comparatively transient" sequence of impressions. Vowels, like sentences, may shorten. Consonants may turn percussive (b's, d's, g's; p's, t's, k's) and rhythms "sharp, broken, irregular." Unexpected pauses—dash-filled sentences—exclamations!—fragmented sentences: these produce staccato

rhythms congruent with the anxiety, irritation, or terror. The sketch evokes as it pictures.[7] In "The Tenth of January," Elizabeth Stuart Phelps visualizes a mill that has collapsed as a "gallery of tragedy" whose images are as terrifyingly discontinuous as the ruins and as horribly fragmented as the workers' bodies it describes. The bodies are objects of the verbs ascribed to fire as well as to implosion.

> A network twenty feet high, of rods and girders, of beams, pillars, stairways, gearing, roofing, ceiling, walling; wrecks of looms, shafts, twisters, pulleys, bobbins, mules, locked and interwoven; wrecks of human creatures wedged in; a face that you know turned up at you from some pit . . . ; a mass of long, fair hair visible here, a foot there, three fingers of a hand over there; the snow bright-red under foot; charred limbs and headless trunks tossed about; . . . the little yellow jet that flared up and died in the smoke, and flared again, leaped out, licked the cotton-bales, tasted the oiled machinery, crunched the netted wood, danced on the heaped-up stone, threw its cruel arms high into the night, roared for joy at helpless firemen, and swallowed wreck, death, and life together out of your sight.[8]

Beautiful discourse, by contrast, is congruently slow and easeful. A music of long vowels and sonorous liquids and nasals (r's, l's, m's, n's), which are to the ear as "green is to the eye," produces lulling sounds and rhythms and a slow, even pace. In the generative logic of paratactic syntax (picturesque composition *in petto*),[9] phrase builds complexly upon phrase, sentence upon sentence. Since beauty has "a property . . . of increasing," images may recur as leitmotifs. In any case, they proliferate. Descriptions of the beautiful tend to be (relatively) detailed and of some duration. "[S]oft sensible transitions" between images, as if the eye were caressing them, can make them fuse erotically into one another. A hillside in Poe's "Domain of Arnheim," for example, is "clothed from base to summit . . . in a drapery of the most gorgeous flower-blossoms; scarcely a green leaf being visible among the sea of odoriferous and fluctuating color."

> [S]o transparent was the water that the bottom, which seemed to consist of a thick mass of small round alabaster pebbles, was distinctly visible by glimpses . . . whenever the eye could permit itself not to see, far down in the inverted heaven, the duplicate blooming of the hills. On these later there were no trees or shrubs of any size. . . . As the eye traced upward the myriad-tinted slope, from its sharp junction with the water to its vague termination amid the folds of overhanging cloud, it became, indeed, difficult not to fancy a panoramic cataract of rubies, sapphires, opals, and golden onyxes rolling silently out of the sky.[10]

Literary Mise-en-scène

The literary version of mise-en-scène is the product of an imagery gathered into a picture: a sketch, a pictorial scene. By definition, it conceptualizes the images by sit-

uating them in a scene as local expressions of a general effect. As in painting, images present not forms themselves but the look of forms as they appear to the eye, static or moving, when lit, framed, and viewed from a particular perspective. Willis's Narrows are inundated by "a sombre and dark green shadow," so that they seem to be frowning, and the mountains above them both receive and cast shadow as deep as a cavern's. Crow Nest's shadow "slides" over the sails of the sloops in the river below. By contrast, a softer slanting light kindles Kosciusko's tomb, the tents on the drill-field, and the reach of the Hudson at Newburgh beyond the darkness of the Narrows. To similar effect, the reds and whites of the parade-ground flag, the whites of Newburgh's buildings, and the whites of the sails make their bright assertions against the dark greens of shadowy water and foliage.

These alternately illuminated and shadowy images, moreover, take their place within the frame of a vista into deep space. Verbally constructed, the vista is not simply a static frame; it is also a means of plotting the movement of the gaze kinematically. Leaping at times from near to far, far to near, Willis's images do not so much assemble themselves successively into a foreground, a middle ground, and a background (though these distinctions are evident in the sketch) as construct a visual path that juxtaposes sublime against beautiful, natural against human, past against present. Willis first focuses the reader's gaze on the dark middle ground of the Narrows, where it shuttles between the river and its mountainous highlands. Then he directs it to the sunlit drill-field in the foreground; then to the sunlit Newburgh in the background, terminus of the Narrows, and then the deep background of the Catskill Mountains. When his gaze encounters the sailboats, it follows them on their birdlike passage through the Narrows and out into sunlight again. In the process, "sketch" and (pictorial) "scene" become virtually synonymous.[11] The visual path continually reinforces, at several levels of meaning, the general effect of dark energies broken up by sunlit beauties, a sublimity that has become more playful, like the light, than menacing.

As images in picturesque narratives are situated in the spatial fields of the frame, point of view also takes on visual and affective references. Images are distanced or foregrounded by means of variations in the density and specificity of descriptive detail. As in painting, detailed images by definition foreground their subjects; minimal and generalized images distance them. Bryant's poems, an anonymous critic notes, are particularly notable for their "fine foreground passages," such as the "dim vaults" and "winding aisles" of the clearing in "Forest Hymn," with its "barky trunks" and its "delicate forest flower / With scented breath" astir in a breath of wind.[12] As with Lowell's distant Isles of Shoals, off the coast of Maine, in "Appledore Gallery," "painting distance" requires, by contrast, a spare and indefinite imagery:

> Now pink it blooms, now glimmers grey,
> Now shadows to a filmy blue,
> Tries one, tries all, and will not stay,
> But flits from opal hue to hue,
> And runs through every tenderest range
> Of Change that seems not to be change.

The spaces of literary close scenes and portraits (Irving's Rip Van Winkle and Stowe's Uncle Tom; the houses of Templeton in Cooper's *The Pioneers* and of Lowell in Davis's "Life in the Iron Mills") are defined, like their analogues in painting, by detailed description: deformations of line and texture; richnesses of light, shade, and color; and all the multiplicities of feeling and meaning evoked in dramatic expressions and signifying oppositions. Vistas and panoramas (Mary's Atlantic in *Minister's Wooing* and Ishmael's in *Moby-Dick,* Lowell's Isle of Shoals) distance their subjects, like Lowell's Isles of Shoals, by ignoring lines and textures for color and light. A function of point of view, framing focuses tensions between mimesis and expression, between the "out there" of settings (social as well as physical) and the "in here" of a narrator's, or character's, states of mind. In the generation of Davis and Melville, settings become metonyms of states of mind.[13]

NARRATION IN THE LITERARY SKETCH

Pictorial scenes in literature distinguish themselves from those of the other picturesque arts by their kinematic character. Verbal space is by definition an oxymoron. Evoked in a temporal medium where it takes shape image by image, a phenomenon evoked by a voice rather than delineated by a hand, space becomes what Poe calls a plotted "succession" rather than a field of images to be experienced simultaneously. Synchrony can only suggest (by leitmotifs) the simultaneous character of forms in space, while syntax inevitably temporalizes them, rendering them, diachronically, as motion or change—inherent in the subject, environmental, in the viewer's gaze or mind, or any combination of these. Literary framing is not a cage but a continuous and a continuously changing *process,* a sequencing of visual and psychological incidents even at the most basic level of a series of adjectives modifying a noun. In the climactic sketch of Walt Whitman's "There Was a Child Went Forth," a panorama comes to signify the visual and intellectual compass of a child imbibing the intricacies and then the sheer extent of his place. It begins with a sweeping gaze—a literal panning from left to right, right to left, of the hectic, simultaneous multiplicity of city life; then it moves in a slow recessional across the bay, as the young man in the poem seeks to fathom distances. Lighting on the shore of Brooklyn, the gaze moves more slowly from images of light on the rooftops of a village to a wave-rocked schooner, to the receding flight of a bird as it moves, like an angel, past the town (the child's birthplace) and an adjacent salt marsh, natural locus of life and death, into the mysterious depths of the sunset sky.[14] In the process, though it remains coherent as a panorama, the scene becomes four- or even five-dimensional.

> The village on the highland seen from afar at sunset, the river between,
> Shadows, aureola and mist, the light falling on roofs and gables of white or
> brown two miles off.
> The schooner near by sleepily dropping down the tide, the little boat slack-
> tow'd stern,
> The hurrying tumbling waves, quick-broken crests slapping,

a spew of "smoke, fire, stones, and cinders" from a whale's spout. Climax of a long processional, the scene is "one of the most extraordinary I ever witnessed."

> It is probable a few rays from the sun struggled through this vapour, which was not high above our heads, though it seemed to descend half way down the cone, for the streaks of sulphur looked brighter and more unnatural than afterwards. The yellow tint they cast around them, the unnatural, or rather supernatural effect, coupled with the gaping crater, the rumbling of the volcano, and the occasional explosions, combined to give the spot a resemblance to the entrance of the infernal regions. If I could fancy I was obtaining glimpses in at the glories and calm radiance of heaven, when I looked upon the high Alps, looming above the Niesen and cut off from the lower world by a belt of vapour, I had no difficulty in now fancying that I stood on the threshold of hell. Virgil died about half a century before the volcano resumed its action, or he certainly would never have taxed his imagination to use the Lake Avernus, Mare Morto, and Elysian Fields of the Baian shore as machinery for his epic, when Vesuvius presented objects so much more worthy of the subjects. The Campagna was as good an Elysian Field as heart could wish, and the crater a Tartarus equal to the epic. It is true, there is no Styx; but the monk I saw at the Hermitage would answer every reasonable purpose of a Charon.

As the narrator descends, Vesuvius recedes visually but not conceptually. Its dark, apocalyptic sublimity tinges all of his subsequent sketches of Naples. Although a "little bit of heaven . . . on earth," Naples has "a cauldron beneath it."

After 1830, the processional and the recessional come to constitute the plots of whole fictional narratives. Shifts from distanced to intimate views of things are signifiers of Ishmael's education in *Moby-Dick*. In the beginning dour and suspicious, Ishmael distances what he encounters, both spatially and psychically. Gradually and repeatedly, however, close-ups both affect and manifest his redeeming intimacy with what can be known and loved in his fathomless world. He learns to bring things toward him and so to see them in all of their complex just-so-ness, to sound and embrace what affirms and to fend off only what threatens or reduces life. In this way, he learns about Queequeg; about the ocean; about the crew, the ship and its small-boats (in the sequence of whaling "pictures"); about Ahab (from whom, contrarily, he must distance himself); and, of course (in the cetological portraits), about the whales, as they emerge from the distances of myth and anecdote and swim into the foreground. Much the same may be said of Cooper's *Leather-Stocking Tales,* of Whitman's "Song of Myself," and of short stories as diverse as Poe's "Descent into the Maelstrom," Hawthorne's "Ethan Brand," and Davis's "Life in the Iron Mills." The list seems endlessly expandable.[32]

Scenic Sequencing

In literature as in landscape architecture, the sequencing *of* scenes is as crucial an aspect of meaning as the sequencing *in* scenes. It, too, constitutes a narrative path

along which varying effects can be represented as changes; contrasts, as conflicts; and synchronic repetitions, as duration in the subject of the scenes, in the mind of the narrator or a character, or all three. In a chapter in *Moby-Dick* called "The Grand Armada," for example, a sequence of three scenes narrates both a whale hunt and a transformation in Ishmael's consciousness. Melville first juxtaposes two panoramas that contrast fixities of human consciousness with the fluid immensities of their environment. One panorama, on which the crew's gaze locks, is a "great semicircle of sperm whales" spread across half the level horizon ahead of the Pequod, "a continuous chain of whale-jets . . . up-playing and sparkling in the noon-day air." The other, a mirror image, is a semicircle of pirate ships, their sails looking (at first) like whale-spouts, coming up from behind: stalkers stalking stalkers. Ishmael's gaze toward the "greeny palmy cliffs" of the Straits of Sunda, through which whales and ships are passing is juxtaposed against this procession of stalkers with their fixed gazes. For Ahab, the Edenic Sunda merely a gate through which he is "both chasing and being chased to his deadly end." [33]

When the Pequod catches up to her prey, the scene contracts to a fast, fragmented montage of thrashing flukes and tails, fearfully enlarged by proximity and by only partial and fragmentary visibility, since the rowers pursue with their backs to their prey.

The chapter ends with two more contrasting sketches: The "riotous and disordered" hunt continues, but now at some distance (Ishmael's boat having come to the calm center of the encircled whales), and it is juxtaposed against an emerging picture of a newborn whale in the water below, still uncurling from its fetal position. In the midst of the mayhem, Ishmael's imagination is drawn (not for the first or the last time in the novel) to life. The infant's eyes, he notes, are still full of the spirit-realm from which it has come; it looks up "towards us but not at us, as if we were but a bit of Gulf-weed in their new-born sight." In this rapt and loving portrait, Ishmael learns again how simultaneously to de-center his own ego and to embrace and affirm what he can in his hard, violent world.

THE "DRAMATIC PICTURESQUE"

In "The Grand Armada," the line between scenery and the consciousness of the characters who see and represent it is typically permeable and indistinct. Events take place both "out there," in the Straits of Sunda, and "in here," in Ishmael's mind. The scenes he describes and then reads fit seamlessly into a multiple narrative of whale hunting and of altered consciousness.[34] This is a particularly complex and subtle application of what Poe calls the "dramatic picturesque," the literary analogue of genre painting, except that the painter is himself the subject of a narrative.[35]

Portraiture

Like genre painting, literary characterization after 1820 draws from a richly suggestive picturesque imagery of faces and bodies marked, as in genre painting, by the environment, by biological forces (age, disease), or by "agitation": the dramatic expression of consciousness. Incidents involving the mental energies of will, belief,

memory, conscience, and imagination as well as feeling, American writers discover, can all be visualized in the languages of the body, especially in facial expressions, posture, and gesture. So, too, can that history of mental activities called moral character. "A face in which one reads experiences of suffering and endurance" or outrage or capitulation or, indeed, any ongoing state of mind, as Martin Price observes, "is seen in a moment that is earned by the long processes that have gone into its creation; it is a moment of dramatic resolution, in which we see some counterpoise" of moral character and the accidents of time and place. Typically, characters so defined are versions of the sentimental "man of feeling": visible loci of sensations that give rise to moods and moods that give rise to reflection and the converse. At their most elemental, they are, like Rebecca Harding Davis's Deborah in "Life in the Iron Mills," a raw tissue of nerves responding to stimuli. At their most complex, they are characters in whom, as in Poe's Roderick Usher or Ligeia, there is what T. S. Eliot would later call "a direct sensuous apprehension of thought, or a re-creation of thought into feeling."[36]

These characters need not be altogether noble or powerful or beautiful to become the focal center of a narrative. Flawed or unfulfilled, they need only embody, or entertain in their minds, traces of nobility or beauty. Their lives are made significant by a principle of goodness neither notional (intellectually understood) nor active (accomplished in good works). Blameless victims or accomplices to their own victimization, they are made sympathetic by the emotional intensity with which they experience, and resist, what victimizes them. The face and body of Sene, a mill worker in Phelps's "The Tenth of January," are deformed by a history of violence and an entropic drain of the energies that constitute her only capital. She is "slightly built, and undersized," and what little we see of her face (it is muffled, in public, by a hood) is "pallid," "sickly," "shaded off with purple shadows." The history of domestic dysfunction written into her hunched back and the scar on her face is also related, though less directly, to the mill. Sene's mother's alcoholic violence is the immediate cause of the deformations, but the ultimate cause, the narrative suggests, is a rage induced by the mill's relentless and exhausting appropriation of human energies—of buoyancy, vitality, well-being: fatigue and rage, rage and fatigue. Sene's own exhaustion, the reader is later shown, is complicated by the regimen of home-work added to factory work, since she has assumed the role of woman of the house:

> To be up by half past five o'clock in the chill of all the winter mornings, to build the fire and cook the breakfast and sweep the floor, to hurry away, faint and weak, over the raw, slippery streets, to climb at half past six the endless stairs and stand at the endless loom, and hear the endless wheels go buzzing round, to sicken in the oily smells, and deafen at the remorseless noise, and weary of the rough girl swearing at the other end of the pass; to eat her cold dinner from a little cold tin plate out on the stairs in three-quarters-of-an-hour recess; to come exhausted home at half past six at night, and get the supper, and brush up about the shoemaker's bench [of her father], and be too weak to eat; to sit with aching shoulders and make the button-holes of her best dress, or darn her father's stockings, till nine o'clock; . . . creep into

bed and lie there, trying not to think, and wishing that . . . she might creep into her grave. (332)

Nevertheless, when she is introduced at the end of a day at the mill, her eyes shine, and her mouth and chin retain "a certain wiry nervous strength."

Near the beginning of *Moby-Dick,* Ahab looks, to Ishmael, like a martyr "cut away from the stake, when the fire has over-runningly wasted all the limbs without consuming them, or taking away one particle from their compacted aged robustness." His face is "tawny" and "scorched," and the "slender, rod-like scar runs down his head" like a lightning scar, like a brand. Again he looks like Cellini's Perseus and like Christ, "with a crucifixion in his face." His aspect and carriage (though not his eyes) display "the nameless regal overbearing dignity of some mighty woe."[37]

Character and Environment

Like genre painting and, indeed, like Italian figure painting, character sketches subordinate even setting to characterization. They tend to define settings, typically, as metonyms of the characters' consciousness or as synecdoches of social or spiritual environments, and they represent cause-effect relationships between these settings and the characters in terms of congruent or contrasting effects. The last setting in Hawthorne's "Ethan Brand," for example, is dominated by the animating beauties of a Berkshire sunrise. Gold light pours onto hilltops that "[swell] away gently" toward the horizon. Church spires point upward toward the light, and the eye, too, is invited upward. Townspeople stir, then a stage, its horn's "rich, and varied, and elaborate, harmony" reverberating through the echoing hills. Little Joe's exuberant dance in the foreground is in harmony with all of these incidents of light, movement, and sound. It establishes Hawthorne's idea that the boy is in concert with both nature and rural civilization. Contrasts between this environment and the dark mutterings of Bartram the lime-burner characterize *him,* by contrast, as indrawn, rancorous, still raddled by his encounter with Ethan Brand. While Little Joe dances, Bartram is still acting out the effects of the climactic scene from the night before.[38]

The contrasts between Hawthorne's old apple-dealer and his environment likewise suggest an attitude not of distraction but of resistance. Motion, machinery, and noise dominate the setting. A train roars into the station at which the apple-dealer sells his wares, the engine shrieking like a "steam-fiend." Travelers swarm forth. The way the old man folds his lean arms around his lean body and the way he gives a "quiet sigh" and betrays a "scarcely perceptible shiver" become signs of his resistance to this modernity. He is representative, the narrator concludes, "of that melancholy class . . . doomed never to share in the world's exulting progress. Thus the contrast between mankind and this desolate brother becomes picturesque, and even sublime."[39]

Narrative Voice and Dialogue as Picturesque Representation

Endowed with dramatic discourse—with voices and with active consciousnesses— characters picturesquely conceived transcend the limits of painted figures. Like contemporary acting manuals and like Emerson, picturesque narrative extends picturesque values beyond facial to vocal expression: to the play of the human voice (tone

in the vocal sense) and to its verbal utterances. In first-person narration and even in dialogue, speech modeled after picturesque discourse—a vernacular version (still capable, when required, of the formalities of oration) defined by imagistic inclinations, charged tones, and a lyric syntax—becomes yet another means of characterizing consciousness. The varied motions and responses of the mind, Poe argues in concert with the author of *The Art of Acting,* are as audible in the vocal languages of tone as they are visible in gesture and facial expression; and changes of tone, like changes in the body, characterize changes and conflicts of mind. With this discovery, the art of the scene is radically extended to include its dramatic as well as its pictorial denotations, monologue and dialogue as well as visible expression and movement.[40]

The dramatization of picturesque discourse in turn allows experiments with the multiplication of narrative perspectives, a signature of picturesque narration. One recurrent experiment involves the intertwining of the stories of reflexive first-person narrators with those of their putative subjects. In "The Old Apple-Dealer," Hawthorne dramatizes his narrator's struggle to grasp and to express the incidents he presents even as he presents them.[41] The sketch is as much a dramatic monologue—a vocal portrait of the artist—as it is a visual portrait of the apple-dealer. Failing to be able to read his character in the deformations "written" on the old man's body, he tries to invent a past for the man ("Doubtless, there have been better and brighter days"); then confesses the difficulty of portraying him ("the most delicate pencil is likely to spoil [the portrait] . . . by introducing some too positive tint"). As the train arrives, offering its defining contrasts to the old man, his tone turns exultant ("I have him now"), then reverent at what he sees: the old apple-dealer as a being who, despite his colorlessness and his self-abnegation, reveals to a sympathetic gaze the "soundless depths of [his] . . . soul, and of eternity"—that is, his "moral picturesque[ness]." This behavior makes the narrator a character in his own story. The same can be said of Poe's "Fall of the House of Usher," Davis's "Life in the Iron Mills," Hawthorne's *Blithedale Romance,* Melville's *Moby-Dick,* and many other antebellum narratives.

Dialogue, too, becomes infused with picturesque values. Fusions of vernacular and formal discourse make it possible for speakers in third-person narration to describe and narrate, to contemplate, explain, and argue, as well as to converse. A grammar of dialect and a syntax of fragmentation, stress, and repetition—a poetry of the idiomatic—make it possible to represent a character's "peculiarities" of region, class, occupation, and personal idiosyncrasy.[42] The speech of Sojourner Truth, Stowe observes in a sketch of her, is picturesque in all of these ways. It is imagistic and scenic. It expresses, in "a picturesque way," an eclectic amalgam of biblical and idiomatic dictions in an incantatory rhythm that bespeaks her experience as an African-American preacher and a Southerner. Like Thoreau both a picture-maker and a picture-reader, Truth shifts her discourse repeatedly from description and narration to exposition or meditation as she is moved to explain or to ponder the implications of scenes she evokes.

An' I said, "Oh, somebody, somebody, stand between God an' me, for it burns me!" Then, honey, when I said so, I felt as it were somethin' like an amberill [umbrella] that came between me an' the light, an' I felt it was *some-*

body—somebody that stood between me an' God; an' it felt cool, like a shade; an' says I, "Who's this that stands between me an' God?" . . . An' I said, "I know you! I know you! I know you!"—an' then I said, "I don't know you, I don't know you, I don't know you!" . . . An' finally something spoke out in me an' said, "*This is Jesus!*" an' I spoke out with all my might, an' says I, "*This is Jesus!* Glory be to God!" An' then the whole world grew bright, an' the trees they waved an' waved in glory, an' every little bit o' stone on the ground shone like glass.[43]

Imagistic inventiveness and amalgams of diction and syntax also characterize the speech of characters in *Moby-Dick*. Invested with "the stately dramatic thee and thou of the Quaker idiom," inscribed with "a thousand bold dashes of character" formed by their lives at sea, the speech of the Quaker shipowners, for example, takes on a power similar to Sojourner Truth's for all of the differences of consciousness and history it evokes. In Ahab, the effect is magnified by the "bold and nervous lofty language" of the tragic hero:

Aye! I lost this leg. I now prophesy that I will dismember my dismemberer. Now, then, be the prophet and the fulfiller one. That's more than ye, ye great gods, ever were. I laugh and hoot at it, ye cricket-players, ye pugilists, ye deaf Burkes and blinded Bendigoes! I will not say as schoolboys do to bullies,— Take some one of your own size; don't pommel *me!* No, ye've knocked me down, and I am up again; but *ye* have run and hidden. Come forth from behind your cotton bags![44]

THE SHORT STORY AS PICTURESQUE ART

For Poe, it is the short story that realizes most fully the possibilities of literary painting. Anything shorter (a simple sketch, say) lacks its momentum; anything longer lacks its intensity and coherence; and any other literary medium, including poetry (the most elevated expression of effect), lacks its extraordinary variety.[45]

For Poe, the construction of the short story is an application of picturesque values both macro- and microcosmically—both to discourse and to "story" (the configurations of plot, character, and setting). Discursively, narrative construction begins with the combination of visible incidents and their inherent effects—comic, horrifying, terrifying, mysterious, rapturous (the range is sweeping)—and a narrative voice whose tones intensify these effects, either by harmony or by opposition. In Poe's taxonomy of the short story, Gothic fiction evokes terrible events in congruent tones of "terror, or passion, or horror"; but grotesque fiction takes "ludicrous" incidents seriously, with an eye to their incipient horror; and "ratiocinative" (that is, detective) fiction softens terrible events by means of a cool intellectuality, so that their terror and horror become secondary to an interest in reconstructing the hidden causes, the human perpetrators, of the effects. "Mystical" fiction (a kind of prose poetry such as "Ligeia") is defined by its tonal and visual eclecticism: like other narratives of spiritual insight, it combines terror and beauty and in the process elevates

them, by tones of pathos and "ideality," into signifiers of spirituality. Characters designed to focalize the effects (that is, to embody "the dramatic picturesque"), settings designed as spatial elaborations of the story's principal effects: these are, for Poe, the chief literary means of achieving the alchemies of voice and event. At the level of story, verbal painting is the product of an orchestrated sequence of sketches and scenes.[46]

Narratives so "painted," in Poe's term, take on distinctively picturesque compositional tensions between unity and variety or contrast. In literature no less than in architecture, scale determines the degree of complexity. Large (long) works like *Moby-Dick* may incorporate contrasts so forceful as to fragment narrative structure; but in short stories, the reader should be engaged, "without difficulty, in the contemplation of the picture as a whole." Nevertheless, contrasts and variations remain the chief means of plotting the narration. Effects that change (vary in effect) and conflict (contrast in effect) with each other orchestrate the rising action of the plot and its acceleration toward the climax. The story's dominant effect, however varied or contrasted during the course of the story, is the one that dominates the climax, and all others must, as in painting, be harmonized with it.[47]

Poe practices in his fiction what he preaches in his criticism. He himself reads "Ligeia," for example, as a sequence of sketches and scenes, with effects varyingly beautiful and sublime, that dramatize a plot of transmigration. A series of portraits at the beginning of the story evokes Ligeia's beauty, her sublimely powerful will, and her profound intelligence. In her death scene, as her beauty "surceases," horror and grief become the dominant effects, but then these succeed to the terror and mystery of her (apparent) transmigration into the body of Rowena. With Ligeia's (apparent) reappearance at the climax, the tone of "excited fancy" that characterizes the beginning resurfaces, and "the grief is subdued, chastened, is no longer grief." For Poe, it is this "ultimate" exultation, expressing the narrator's belief in (if not the objective fact of) Ligeia's return, that makes the story mystical and not, say, Gothic or grotesque. The mutations of Ligeia's and then Rowena's body and the terrifying displays of a force not immediately or directly definable become stages in the unfolding of a transcendental mystery—objective or subjective, it does not seem to matter.[48]

Voice, like story, is necessarily eclectic. Varying and contrasting tones of voice—like chiaroscuro, like musical discords—orchestrating the narrator's struggle between manifold perspectives and manifold feelings about the events he witnesses, re-situate the plot, in part at least, in the narrator's complex and shifting states of mind. Tonal complexities, in turn, complicate meaning. Writing as if "firmly impressed with the truth yet astonished at the immensity, of the wonders he relates," Poe observes, Hawthorne recurrently defines events as other (more elevated, more mysterious) than what they seem. At other times, he colors events with "that tranquil and subdued manner we have chosen to denominate repose" but injects a "strong 'undercurrent'" of exaltation, as if the narrator felt, even in quotidian normalcies, the presence of beautiful mysteries.[49]

At the same time, varying kinds of discourse (narrative, contemplative, and expository as well as descriptive) give voice to a narrator's multiple perspectives on a subject (a whale, say, or a pond in Massachusetts or a maelstrom)—rendering it, as

might be expected in the picturesque universe, as inherently, even unfathomably, complex. At the beginning of Poe's "Descent into the Maelstrom," a succession of three different voices, each with its distinctive discourse, evokes the manifold and paradoxically conflicting significances of a maelstrom. The epilogue evokes it in Joseph Glanville's deliberative voice and theological perspective: the maelstrom as a natural type of divine vastness, profundity, and power: "The ways of God in Nature, as in Providence, are not as *our* ways; nor are the models that we frame commensurate to the vastness, profundity, and unsearchableness of His works, *which have a depth in them greater than the well of Democritus.*"

The old sailor, narrator of the story-within-the-story, also evokes it in a deliberative voice, which reveals how his descent into the maelstrom has taken shape as an experience of the infinite, how it has displaced, and continues to displace, normative notions of time, space, and self. This is evoked in a telling contrast between the equanimity of "I-now" and the terror, horror, and awe of "I-then":

> [A]bout three years past, there happened to me an event such as never happened before to mortal man—or at least such as no man ever survived to tell of—and the six hours of deadly terror which I then endured have broken me up body and soul. You suppose me a *very* old man—but I am not. It took less than a single day to change these hairs from a jetty black to white, to weaken my limbs, and to unstring my nerves, so that I tremble at the least exertion, and am frightened at a shadow. Do you know I can scarcely look over this little cliff without getting giddy?

The story's frame narrator reiterates this succession of tones and perspectives in the narrative present. His first response is that of terror:

> The "little" cliff, upon whose edge he had so carelessly thrown himself down to rest that the weightier portion of his body hung over it . . . rose, a sheer unobstructed precipice of black shining rock, some fifteen or sixteen hundred feet from the world of crags beneath us. . . . In truth, so deeply was I excited . . . that I fell at fully length upon the ground, clung to the shrubs around me, and dared not even glance upward at the sky—while I struggled in vain to divest myself of the idea that the very foundations of the mountain were in danger from the fury of the winds. It was long before I could reason myself into sufficient courage to sit and look out in the distance.[50]

Subsequent changes of tone, imagery, and discourse further complicate the character of the maelstrom. Fear and panic at its power and obscurity, as he approaches its edge, make the sailor's maelstrom initially sublime. An increasingly cool empiricism, as he plots the possibilities of survival, gives its interior, as he is pulled into it, the character of a scientific event, a study of centrifugal forces whose laws can be discerned. After he sees the fragilely beautiful bridge of light at the bottom, his description is suffused with rapture.

The sailor's discourse reenacts these perceptual transformations in the story's

present, even as that narrator and the sailor recount them. The narrator's transformation, however, is less complete. Although his initial terror, too, gives way to empiricism (he discusses recent scientific theories of the causes of maelstroms), his empiricism does not give way to rapture. Perhaps it may be argued that reporting the sailor's rapture constitutes a vicarious experience of it, since something has led him to a serious rereading of Joseph Glanville. The maelstrom, in any case, is the sum of all these visual, modal, symbolic, and narrative effects.

For Poe, the "unity of effect" that counterbalances this complexity is to be brought about (as in the other picturesque arts) by the picturesque principles of hierarchization, gradation, and repetition of effect. A single effect must dominate by virtue of its recurrence as well as its appearance, at the climax, as the "ultimate impression." In "Descent into the Maelstrom," the frame narrator's voice's disappearance into that of the sailor's is, like the prologue from Joseph Glanville, a tacit confirmation of his recognition that the maelstrom is, above all, a natural type of "the vastness, profundity, and unsearchableness of [God's] works." The "innumerable" other effects are subordinated and made congruent, or appropriately discordant, to it; and passage from one to another is smoothed by means of the art of narrative transition, literary analogue of gradation.[51]

What Poe terms "keeping" or "adaptation" requires of short narrative that all be done in the story that "should be done" and that nothing be done that "should not be": no excess, no omissions of significant detail.[52] Every word must contribute to "the one pre-established design."[53] Likewise, "all the groupings and fillings in of the painting"—characters, settings, events—must contribute to "the gradually perfecting picture." Every scene and every image in it must tend to anticipate "the catastrophe."[54]

The sequencing of scenes, moreover, must be well-motivated, consequential, and end-defined. Episodic plots, Poe argues, are unacceptable in pictorial narrative because they are badly motivated; their incidents lack "natural connexion." Unrelated strands in a multiple narrative are also unacceptable; the writer has to keep shifting the narrative focus with no other motivation than to "bring up" each strand. Relating "incidents and tones" causally, the consequential plot gives them a cumulative pictorial as well as dramatic intensity, a composition so "dependently constructed, that to change the position of a single brick is to overthrow the entire fabric." When sketches and scenes are constructed with the end "constantly in view," the sequence takes on an "indispensable air of consequence, or causation." That affects even beginnings, which must have the character of an "electric bell," designed to summon the reader's attention, and again a "telegraph," conveying radically condensed messages about the effects to be unfolded in the story. "During the whole of a dull, dark and soundless day in the autumn of the year": even these initial phrases in "Fall of the House of Usher," with their alliterated plosives, telegraph what eventuates: "there was a long tumultuous shouting sound like the voice of a thousand waters—and the deep and dark tarn at my feet closed sullenly and silently over the fragments of the 'House of Usher.'"[55]

It is in this consequential relation of parts that nineteenth-century pictorial narration most artfully transmutes its subjects into painting.

THE NOVEL AS PICTURESQUE ART

Poe's well-known animus against long narratives notwithstanding, the American canon of picturesque literature in the United States includes major novels—*The Leather-Stocking Tales, The Scarlet Letter, Walden, Moby-Dick*—as well as the short fiction of Poe and Hawthorne. The scale of the long narrative allows the principles of variety and contrast more complex and radical play than is possible in short or small forms.

Intensive Narration: James Fenimore Cooper's *Last of the Mohicans*

Novels intensively constructed apply the conventions of the "dramatic picturesque"—portraiture and scenes with figures—to fictional histories of a single character, juxtaposed, perhaps, against the subordinated stories of a few minor characters. In the *Bildungsroman* particularly, a popular form of the confession (witness the number of novels named for their central characters), the visual syntaxes of speech, gesture, facial expression, costume, and setting can all be represented as dramatic expressions of interior states of consciousness. In sequences of verbal sketches, as in paintings and in parks like Montgomery Place, variations of effect can be read as changes, contrasts as conflicts, repetitions as duration, and eclectic fusions of effect as resolutions in a plot of intellectual and spiritual growth.[56]

In *The Last of the Mohicans,* Cooper, whose knowledge of picturesque conventions has been well documented,[57] endows Deerslayer, in a sequence of portraits, with the cultural identity of a person living on a social margin. Everything about him is eclectic. His hunting shirt, a picturesquely fringed and faded concoction of deer skin, is dyed green, like the shirts of American infantrymen, "with a view to concealment"; his moccasins are "ornamented after the gay fashion of the Indians." Muscular but "rather attenuated than full," his body, like his rifle (also decorated Indian-fashion), is a hieroglyph of his calling as hunter, itself defined multiculturally.[58]

His demeanor expresses yet another kind of double-consciousness. To the British Major Heyward, an observer of most of the novel's major events, Deerslayer's "blunt" speech, his passionate "antipathies," and his comrades Uncas and Chingachcook all excite anxiety and even distrust. Nevertheless, Natty's conduct is, at the same time, "above reproach"—that of a gentleman. Natty's gestures, too, are eclectic: he affects "the cold and inartificial manner . . . of Anglo-Americans"; but when excited he uses "all the arts of [Mohican] eloquence": his hands picture what his speech evokes. Although his eyes are in constant motion, sign of the "habitual suspicion" that keeps him alive in hostile situations, his face is usually cast in an expression of guileless repose—except when the threat of violence necessitates a stoic mask designed to camouflage stress. When violence occurs, he tries to paralyze combatants with a battle scream simulating rage, aggression, and triumph (how many screams, shrieks, and yells in the novel are calculated for this effect!). His mask of repose is also capable, like Chingachcook's, of being dissolved by tears.[59]

Intentionally or no, everyone and everything in the novel deceives, some considerably more calculatingly than Natty. Deceptions and the misperceptions and misreadings that follow from them constitute the novel's deep plot. Congruently, the

novel's brilliantly evoked wilderness settings oscillate, like the characters, between repose and an energy capable of bursting into a violence magnified by its suddenness. These are also the effects of the forest warfare that gives even such innocent phenomena as foliage and night the ominous character of camouflage.

The most reposeful wilderness settings in the novel are, like the bodies and gazes of Natty, Uncas, and Chingachcook, always astir with latent energies. The July afternoon in which they first appear, deep in the forest of northeastern New York State, is a silence brimming with soft sounds, natural and human alike. The three men's whispered conversation, reduced by the narrator's distance to unintelligible whispers, is shot through with a breeze that sounds like breathing, a low "swelling on the ear" from a distant Glens Falls, and "the discordant cry of some gaudy jay." Later (his speech more intelligible), Natty reads Glens Falls as the moral equivalent of the human inhabitants of this innately peaceful but unstable and always potentially contentious world. Above the falls, "the water runs smoothly, as if meaning to go down the descent as things were ordered." Suddenly, turning away from its course "as if unwilling to leave the wilderness, to mingle with the salt," its "whole design" becomes "disconcerted," and "all sorts of images" appear on its surface, masking its character, "as if, having broke loose from order, it would try its hand at everything." But after being "suffered to have its will for a time," like the French and Indian War and the Revolution, "it is gathered together by the hand that made it," and resumes its course to the sea, "as was foreordained from the first foundation of the 'arth!"[60]

The characters experience an analogous sequence of effects. When human violence erupts shortly afterward, Cooper evokes, repeatedly, the agitated bodies of Chingachcook, Deerslayer, Major Edwards and his party, and the Hurons, as they break loose, repeatedly, from order and are gathered again. Making both violence and peace "natural," the wilderness environment is both partial cause and justification of their behavior. So, too, is Cooper's version of history, which juxtaposes eighteenth-century discords against the pacific and "civilized" nineteenth century in which the story is told.

The discourse, too, is picturesque. The narrative's omniscient voice complicates all of its subjects, characters and settings alike, by shuttling continuously from narration (which defines them as events) to description (which defines them as forms and spaces) to exposition (which explains and argues their motives) to contemplative discourse (which situates them in ideological contexts).

Deerslayer's discourse is similarly various. He is allowed to speak (often not a little garrulously) of many subjects and in many tones.[61] He is by turns explicator of Indian cultures, philosophical idealist, student of natural scenery, cultural comparativist, friend, critic, and orator. Like Emerson's poet, he is a picture-maker; and he learns, as the novel unfolds, to become a speaker like Stowe's Sojourner Truth in whose diction the formal fuses with the idiomatic.[62] In two of the Bildungsroman's climactic scenes, he becomes as eloquent in oratory as Chingachcook, Magua, and Tanemund.

Like the short story, the intensively constructed picturesque novel accommodates not only different discourses but also multiple points of view. *Mohicans* repeatedly foregrounds the perspectives of Heyward and the Munro sisters as well as those

of Natty, Uncas, and Chingachcook. All offer readings of the novel's significant events, and these and their visible responses, as in Woodville's *Sailor's Wedding* (see Fig. 44) or Bingham's *Stump Speaking* (see Fig. 47), multiply and complicate the meanings of these events. Heyward's and the Munros' responses dramatize the perspectives of uncomprehending neophytes. Obscure, filled with opaque masks, deceptions, and discomforting surprises, their forest and the warfare in it is subject to continual misreadings. The only thing the characters have, at the beginning, is knowledge of what Cooper considers the universal languages of the body, in whose lines and surfaces consciousness—even ambiguous or duplicitous consciousness—reveals itself. All else consists of "signs" they must be taught to read, including sounds and "other signs than such as come into the eye."[63]

For these Euro-American newcomers, like the reader of the novel, Natty acts as a kind of reader-in-the-text, continually offering instructions about how to read the texts of landscape and of human presences. At the end, amid the landscapes and rituals of the Hurons and Delawares, Heyward, a warrior as well as a smug Brit, is able to see (like Natty) knowledgeably and sympathetically and (like Cooper) sorrowfully, something of the landscape and cultures he is fighting to erase.[64]

Extensive Narration: Herman Melville's *Moby-Dick*

Extensive narration in nineteenth-century American novels is meant to be more populous and inclusive, to represent "the diverse existence of multitudes of people," each with their different voices, perceptions, and stories.[65] But it, too, as *Moby-Dick* amply demonstrates, is empowered at every level of narration by the picturesque.[66] Intensive when it concentrates on the stories of Ahab and Ishmael (the one a tragic drama, the other a Bildungsroman), *Moby-Dick* also includes the figures and stories of Queequeg, Bulkington, Starbuck, Stubb, Flask, Pip, and Fedallah, as well as Moby-Dick himself. Every passing ship—The Albatross, The Jereboam, The Virgin, The Rose Bud, The Samuel Enderby, The Bachelor, The Rachel—adds its stories as well.

In this narrative web, as Richard Brodhead has observed, Melville makes manifest his commitment to the visual in a strategy of "episodic intensification" that exploits the dramatic possibilities of scenes and sketches and their manifold layerings of picturesque effect to sustain a sense of the world's mystery and multiplicity. In Samuel Morse's apposite words (written about another text), *Moby-Dick* depends for its force upon "affecting incidents" that are "'sometimes dazzling, sometimes touching,' 'now awful and august,' 'now tender and pathetic.'"[67] These are typically presented with skeins of metaphor laid over them and meditations attending them as Ishmael (like Deerslayer) tries to fathom their manifold and elusive meanings. In Brodhead's terms, the novel also depends upon juxtapositions of "the epic and the everyday, the cosmic and the trivial, the physical world of fact and action and the world of spiritual presences." At one moment, the world's hard surfaces seem to be "all . . . there is"; then the surfaces suddenly yawn open "to reveal a spirit, angelic or demonic."[68]

Pictorial description in *Moby-Dick* is subject to all of these dialogical tensions. As in "The Grand Armada," Ishmael's sketches and scenes are spliced into discontinuous narratives with often wildly varying effects. An ongoing sequence of portraits

(multiple portraits for the more important characters) of the crew presents them both in repose and in action during the whaling scenes, literary equivalents of genre painting. The characters are defined not only visibly but also vocally (like Father Mapple early in the novel) by their dialogue and the stories they tell, in typically picturesque discourse; or dramatically (like Pip or Perth the blacksmith or the nameless Captain of The Rachel late in the novel) in roles as subjects of narratives.

"Cetological" portraits of the sperm whale configure not only the "collateral pursuit" of whaling but also Ishmael's attempts to anatomize the sperm whale, to understand it as the sum of its parts, forehead to flukes. Portraits of living whales, in the hunting scenes, are also the occasion of his attempts to divine it more properly by its actions. Contemporaneously, a sequence of seascapes visualizes Ishmael's increasing alertness to the ocean's pacific softnesses as well as its violent energies. The voyage begins on an icy night whose effects Ishmael finds himself having to resist by a conscious act of hope. The night transfigures the Pequod into a troglodytic mammoth:

> It was a short, cold Christmas; and as the short northern day merged into night, we found ourselves almost broad upon the wintry ocean, whose freezing spray cased us in ice, as in polished armor. The long rows of teeth on the bulwarks glistened in the moonlight; and like the white ivory tusks of some huge elephant, vast curving icicles descending from the bows.[69]

But while the outside darkens and freezes in this sketch, Ishmael, inside, influenced by Bildad's typological reading of the ocean as a Jordan to be crossed, dwells in the image of "a pleasant haven" beyond it, with "meads and glades so eternally vernal, that the grass shot up by spring, untrodden, unwilted, remains at midsummer." Toward the end of the sequence of sea sketches, Ishmael shows the adaptability he has learned as Ahab makes manifest the increasing fixity of his obsession. In the sketch called "The Candles," Ishmael balances three perspectives simultaneously. He is terrified but watchful as "sky and sea roared and split with thunder," like an exploding bomb, "and blazed with lightning." In the middle of this apocalypse, he is still able to watch and listen to Starbuck and Stubb as they work to keep the ship afloat while Ahab roars his blasphemous denials of all power but his own. In "The Symphony" a short while later, he balances two conflicting perspectives. Under the sea, he knows, "far sown in the bottomless blue, rushed mighty leviathans, sword-fish, and sharks; and these were the strong, troubled, murderous thinkings of the masculine sea"; but the visible sea-surface, nevertheless, now heaves with "long, strong, lingering swells, as Samson's chest in his sleep." A sky become female, "pure and soft," he notes, even works its seduction on Ahab's body—the "step-mother world, so long cruel," now throwing "affectionate arms round his stubborn neck"—but not, for long, on his mind. Unlike Ishmael's, Ahab's eyes seek the sea's murderous masculine depths. With the air's arms around him, he drops one redemptive tear from a "measureless sobbing that stole out of the centre of the serenity around"—that is, out of the deep, hurting sorrow of his psyche. When he steels himself again, he looks to Ishmael like a blighted fruit tree dropping its "last, cindered apple to the soil." At

the end of the sketch, his glance, Ishmael also sees, fuses with that of the demonic Fedallah in the smooth water—reflection upon reflection.[70]

As this scene/sketch demonstrates, the stories of Ahab and Ishmael are situated in a large and various wilderness as well as in a large and various communal web. Ishmael's consciousness becomes oceanic with the scenes he relates and tries to read. Like Thoreau's and Deerslayer's, his nature is the total of a multiplicity of perspectives and discourses—in his case, those of a sailor involved in the whaling industry; an "advocate," historian, and genre painter of it; a cetologist; an art historian and, of course, an artist of word-pictures; a contemplative philosopher who reads objects, human figures, and events in manifold, changing, elusive, tentative, paradoxical ways. In *his* picturesque universe, meaning is even less certain than in Deerslayer's, not simply because it is deceptive but also because it is boundless, mysterious, God-haunted. Its meanings can never be more than "gleams" and "glimmers" by definition never fully definitive: beyond proof, beyond language; forever mysterious, knowable only by their effects on the mind that attends to them. For Ishmael, representation is approximation and has no closure: there is no ideal place students can situate themselves, for example, to learn the whale—not in autopsies of dead whales, not in hunts of living whales. His reading of the color of whiteness, which expresses his and his culture's unresolvedly ambiguous feelings and ideas about it, ends, typically, in questions. Meanwhile Ahab's darknesses and fixities only deepen as everything in his world contracts to his ego and its enemies.

If knowledge is elusive and problematic, however, learning is a process that Ishmael's discourse dramatizes as an arduous struggle and a slow, cumulative alteration of perspectives. The increasing incidence of beauty in Ishmael's seascapes is a sign of his achievement of an equilibrium in a various and conflicted world. Conversely, the Ahab he portrays early, in "The Quarter-Deck," is not the Ahab he portrays in the three closing chapters called "The Chase." This is not simply because Ahab's universe has shrunk and his discourse reduced to long monologues (an amalgam of Shakespearean, Quaker, and a sailor's discourse) and shouted commands, but also because the Ishmael of the quarter-deck is not the Ishmael of the chase. On his first appearance, Ahab looms monumentalized above Ishmael against a storm-black sky—a man of feeling; a type of Christ (in Ishmael's eyes) or of Cain (in the Manxman's) deeply and repeatedly hurt. But his presence also manifests—as, later, does his speech—a commanding power.

> [F]or the first few moments I hardly noted that not a little of this overbearing grimness was owing to the barbaric white leg upon which he partly stood. It had previously come to me that this ivory leg had at sea been fashioned from the polished bone of the sperm whale's jaw. "Aye, he was dismasted off Japan," and the old Gay-Head Indian once; "but like his dismasted craft, he shipped another mast without coming home for it. He has a quiver of 'em."

Ishmael also sees Ahab's power in his "singular posture," in his eyes, and (as in a genre painting) in its effects on the bodies of the crew:

His bone leg steadied in [an auger] . . . hole; one arm elevated, and holding by a shroud; Captain Ahab stood erect, looking straight out beyond the ship's ever-pitching prow. There was an infinity of firmest fortitude, a determinate, unsurrenderable wilfulness, in the fixed and fearless, forward dedication of that glance. Not a word he spoke; nor did his officers say aught to him; though by all their minutest gestures and expressions, they plainly showed the uneasy, if not painful, consciousness of being under a troubled master-eye. And not only that, but moody stricken Ahab stood before them with a crucifixion in his face; in all the nameless regal overbearing dignity of sonic mighty woe.[71]

The "ultimate" Ahab (to borrow Poe's word) takes a pratfall, and Ishmael's change of mind about him is reflected in changes of mise-en-scène. On the first day of "The Chase," Ishmael now looks down on his captain. A serene sea, a playful Moby-Dick ("the full terrors of his submerged trunk" and "the wrenched hideousness of his jaw" masked by the green water), and a jubilant Ishmael are all in concert. Although the scene is constructed contrapuntally (the whale's actions, Ahab's counteractions) Ishmael can scarcely take his eyes from the whale's cavortings, its "entire dazzling hump . . . sliding along the sea . . . in a revolving ring of finest, fleecy, greenish foam"—a circle within a circle of water so smooth it seems (to Ishmael) to be covered like a floor by a Turkish rug or by "a noon-day meadow."

Before it, far out on the soft Turkish-rugged waters, went the glistening white shadow from his broad, milky forehead, a musical rippling playfully accompanying the shade; and behind, the blue waters interchangeably flowed over into the moving valley of his steady wake; and on either hand bright bubbles arose and danced by his side. But these were broken again by the light toes of hundreds of gay fowl softly feathering the sea, alternate with their fitful flight; and like to some flag-staff rising from the pointed hull of an argosy, the tall but shattered pole of a recent lance projected from the white whale's back; and at intervals one of the cloud of soft-toed fowls hovering, and to and fro skimming like a canopy over the fish, silently perched and rocked on this pole, the long tail feathers streaming like pennons.

A gentle joyousness—a mighty mildness of repose in swiftness, invested the gliding whale. Not the white bull Jupiter swimming away with ravished Europa clinging to his graceful horns; his lovely, leering eyes sideways intent upon the maid; with smooth bewitching fleetness, rippling straight for the nuptial bower in Crete; not Jove, not that great majesty Supreme! did surpass the glorified White Whale as he so divinely swam.

On each soft side—coincident with the parted swell, that but once laving him, then flowed so wide away—on each bright side, the whale shed off enticings. No wonder there had been some among the hunters who namelessly transported and, allured by all this serenity, had ventured to assail it; but had fatally found that quietude but the vesture of tornadoes.

That Moby-Dick dominates the subsequent action is the sign not only of an objective fact but also of a transformation in Ishmael's imagination. After sounding, the whale reappears in an emerging picture under Ahab's boat. The old man is framed by a "scrolled" jaw that keeps growing as it rises until it yawns like "an open-doored marble tomb." When the scrolled jaw closes on the boat six inches from his head, Ahab can still call on his fury to respond, but in contrast to its ponderously graceful movements, which are fully, even hypnotically, evoked, Ahab's become a graceless floundering. He is made the object of the few sentences that picture him. When the boat spills him into the water, he takes an ungainly pratfall "flat-faced upon the sea." "[T]oo much of a cripple to swim," he is "half-smothered" in the foam. When he opens *his* mouth to shout a command, it is filled with wave water. Pulled, finally, into Stubbs's boat, the wrinkles of his skin caked with white brine, his eyes "blood-shot" and "blinded," he lies "all crushed" on its bottom.

Ishmael is moved by Ahab's recovery of his fighting spirit ("Even in their pointless centres," he muses, "those noble natures contain the entire circumferences of inferior souls"), yet the way the scene balances effects of power and powerlessness makes Ahab's assumptions that he is a match for the whale not simply arrogant but ridiculous. As the action unfolds, the eyes and gazes of Ahab and others—Fedallah, the crew in the stove boat and eventually even the crew still on the Pequod—form an expanding circle of witnesses whose center is the old man's impotent head.

Ishmael's metaphors conceptualize both Ahab's comic diminishment and Moby-Dick's power. In the water, Ahab's head bobs like "a tossed bubble which the least chance shock might burst from the boat's fragmentary stem." In Stubbs's boat, he lies "like one trodden under foot of herds of elephants," and "nameless wails" come from deep within him "as desolate sounds from out ravines." Meanwhile

> [r]ipplingly withdrawing from his prey, Moby-Dick now lay at a little distance, vertically thrusting his oblong white head up and down in the billows; and at the same time slowly revolving his whole spindled body; so that when his vast wrinkled forehead rose—some twenty or more feet out of the water—the now rising swells, with all their confluent waves, dazzlingly broke against it; vindictively tossing their shivered spray still higher into the air. So, in a gale, the but half baffled Channel billows only recoil from the base of the Eddystone, triumphantly to overleap its summit with their scud.

By contrast to Ahab's, the movements of sea, whale, and boats (circles within the circle of viewers "on the outer edge of the direful zone") become "planetarily swift."[72]

Thus does the encounter with Moby-Dick complete Ishmael's education to power and his altered view of Ahab. Equivalent transformations with very different conclusions characterize Ishmael's changing perceptions of Queequeg, of whales in general, and of Moby-Dick in particular. Nothing can be known without long, arduous study, close up, as dangerous as proximity might be. It is by this recurrent pattern of revision that (to borrow other words of Samuel Morse) the multiplicities of *Moby-Dick,* "growing up from all parts, are combined into one *whole.*"[73]



Women's Literature and the Reconfiguration of Picturesque Conventions

Nineteenth-century women writers make new and powerful uses of the picturesque. As, say, Margaret Fuller's *Summer on the Lakes* attests, they do not consider themselves bound to the domestic sphere for their settings and subjects. Nor, when they do domesticate their narratives, are they compelled to show their characters content to live within the limits of domesticity. In the fiction of Harriet Beecher Stowe and Elizabeth Phelps, for example, home is not, as separate-sphere ideology defines it, a haven in a heartless world. It is a place affected, even assaulted, by that world. Moreover, like the mindscapes and the bodies of female characters, it is a site of resistances and of liberated consciousnesses. Domesticity, in short, involves plotted conflicts and changing states of mind, and picturesque imagery makes these ramifications both visible and audible.

Women writers dramatize very different relationships between setting and character than their male contemporaries. Stowe's women live in a more durable, densely configured, and authoritative social environment than, say, Natty Bumppo. Not having Natty's alternative of flight to the frontier, they must find ways of seeing past prescribed limits, imagining and then acting out alternatives even as they play the roles the status quo defines for them. Reconfiguring picturesque conventions, Stowe defines the status quo in terms of its visible effects on the house (especially domestic interiors) and the body (dress, gestures, facial expressions) and its audible effects on female voice and discourse. Then she plots the appearance of alternatives from their beginnings as optative images in the spaces of awakening minds through their realization in the speech and the bodies of characters, in the setting, and ultimately in communities of the converted. The domestic interior and the emergent community are both metonyms of the transformed mind and, at the same time, synecdoches of a more liberative democracy.

Mary Scudder's very perception of the "visible world" in *The Minister's Wooing*, for example, is early dominated by an unreflexive Calvinism that Stowe visualizes allegorically and that, internalized but not wholly understood, exacts from Mary "the great battle of duty":

> Self-denial and self-sacrifice had been the daily bread of her life. Every prayer, hymn, and sermon from her childhood, had warned her to distrust her inclinations, and regard her feelings as traitors. In particular she had been brought up to regard the sacredness of a promise with a superstitious tenacity; and in this case the promise involved so deeply the happiness of a friend [the minister of the title] whom she had loved and revered all her life, that she never thought of any way of escape from it. She had been taught that there was no feeling so strong but that it might be immediately repressed at the call of duty.

Her engagement to her minister defines the destiny these duties seem to require of her. So does her mother's house, especially the kitchen, which Stowe defines functionally as the place in which New England women realize the virtues of "faculty"—

"the habit of [producing] the greatest possible results there with the slightest possible discomposure." Faculty manifests itself in the genial effects of domestic labor and in an erasure of the visibility of the labor itself:

> Everything [in the kitchen] seemed always done and never doing. Washing and baking, those formidable disturbers of the composure of families, were all over with in those two or three morning-hours when we are composing ourselves for a last nap. . . . A breakfast arose there as by magic; and in an incredibly short space after, every knife, fork, spoon, and trencher, clean and shining, was looking as innocent and unconscious in its place as if it had never been used.

The fruit of this struggle manifests itself spatially in the "clean, roomy" warmth of the old New England kitchen, with its "snowy" floorboards and its "ancient fireplace . . . in each corner of which a cozy seat might be found, distant enough to enjoy the crackle of a great jolly wood-fire."[74]

The discourse that occurs in this place of sublimated struggle reinforces the Calvinist ethos, but it also manifests, both audibly and visibly, the false constraints in Calvinist culture. As in a chapter titled "Theological Tea," women in stiff dresses discuss in "sharp, hard, didactic" discourse what they have been taught to discuss: the implications of the minister's sermons. The culture proscribes any manifestation of the geniality of the hearth.

Another discontinuity, not doctrinal, is increasingly evident in the spaces of Mary's mind, where her liberation begins. ("Nothing is more striking," Stowe writes of her narrative strategy, "than to compare the inner life and thoughts of elevated and silent natures with the thoughts and plans which those by whom they are surrounded have of and for them.") The imagery that characterizes Mary's awakening mind—in sharp contrast to the cold, "Alpine" sublimities of Calvinist reason—valorizes the kind of imaginative play that produces art. Mary begins to be able both to read pictures of natural scenery (texts anathematized by Puritan culture) and to "think by pictures"—"fancy pictures" (like Thomas Cole's *Voyage of Life*) that give shape and significance to ideals and aspirations not yet made manifest in the New England mind. These Stowe historicizes (her novel being set in the last decade of the eighteenth century) as products of the liberalization of Protestantism and of pre-Romantic European literature, with their picturesque tendencies and their benevolist and sentimental rereadings of nature, the Godhood, and the self.[75]

Under these influences Mary Scudder comes to notice and then to drink in the effects of the Newport landscape and its light, its radiant seas of color at sunrise and sunset. Her linkages of "image and thought and feeling" lead to the idea of a revisionary theology. From "carolling birds" she learns a music less solemn than Calvinist hymns; from the Atlantic (in summer), a less terrifying sense of infinity; and from sunset light, a new sense of "celestial radiance," in the charm of which "[o]ur horizon widens, and blue, and amethyst and gold touch every object." All of these lead to her recognition of a God more loving than angry and to anagogical convictions and a peaceful destiny beyond the "dark valley" of death. These ministries of benevo-

lent nature lead the heart of Mary Scudder, prophet and galvanizer of the change, to color belief with a "warm life-tint." The Calvinist "map of the Infinite" in her mind is displaced by a gallery of sacred—Raphaelesque—pictures in which, theology having "[fallen] away," religious mysteries emerge as picturesque effects: "The sublimity of disinterested benevolence,—the harmony and order of a system tending in its final results to infinite happiness,—the goodness of God,—the love of a self-sacrificing Redeemer,—were all so many glorious pictures, which she revolved in her mind with small care for their logical relations" (342).

Concurrently, these transformations motivate Mary's growing resistance to Calvinist doctrine, discourse, and church polity. As she gravitates, in the spaces of her mind, toward a new way of seeing and a new credo, she encourages these transformations in the minds of the characters around her. The influences of the new thought spread out from Mary, ripplelike. The theology of Samuel Hopkins, her minister, begins to gravitate toward benevolism. The Byronic darknesses in the mind of her other suitor, James Marvyn, begin to be lit by a kind of dawn when he suddenly envisions Mary as a Madonna of Sorrows, whose image illuminates his whole past as "a subtile flash of lightning" illuminates an expansive landscape, revealing a life "so poor, so meagre, so shallow, by the side of that childlike woman . . . that a sort of awe awoke in him; like the Apostles of old, he 'feared as he entered the cloud.'"[76]

The influence of the new thought also manifests itself in the novel's material spaces—the house (notably women's rooms); the body; the emergent community of the converted. The rigorous, white-painted, Federalist geometries of the New England house are "softened" by ornamental fabrics, color, and other appeals to the eye. Mary, the reader early discovers, has decorated her room in picturesque fashion—its effects very much like those Stowe introduces in *The American Woman's Home*. Fringed drapery complicates the lines of the bed and window; a mirror is "curiously wreathed with corals and foreign shells, so disposed as to indicate an artistic eye and skilful hand"; and some "curious Chinese paintings of birds and flowers [add] rather a piquant and foreign air to the otherwise homely neatness of the apartment." A copy of *Sir Charles Grandison*—a literary "raid of the romantic"—lies on a table. The curtain-framed window frames a romantic—indeed, a transcendental—Newport vista, looking out through the arched boughs of apple trees, "now all in a blush with blossoms and pink-tipped buds," to hyper-real manifestations of light and sound. The light comes "golden-green, strained through flickering leaves," and the sounds are a simultaneous multiplicity of subtle motions—the "rustle and whirr of branches and blossoms, a chitter of birds, and an indefinite whispering motion, as the long heads of orchard-grass nodded and bowed to each other under the trees"—that paradoxically give Mary's room "the quiet hush of some little side-chapel in a cathedral."[77]

Toward the end of the novel, these stirrings exercise a visible influence on the social community of Newport as well, especially the community of women. There is a noticeable increase of warmth, vitality, and candor in the body language and the speech of the female characters and, eventually, in the behavior of male characters toward them. That speech is propelled increasingly by strong feeling and by images,

an expression of the characters' felt need to give voice to feelings suppressed by Calvinism.

In similar ways, women's fiction calibrates other massive social changes—slavery, industrialization, urbanization—by means of their expanding effects on mind, body, house, and communal discourse. Uncle Tom's cabin is comparable in virtually every way with the Scudder kitchen. Its (at first invisible) problem is that it and the family are "owned" and thus economically and legally dependent on their "owner's" good intentions. But the owner's intentions are in fact governed by self-interest. When economic need supersedes benevolism, the cabin is abandoned, the family sold and separated. Like Simon Legree's plantation, Uncle Tom's cabin is a synecdoche of the emotional, moral, and legal corruptions of a slaveholding society.

In similar ways, Phelps's "The Tenth of January" (like Davis's "Life in the Iron Mills") visualizes the assaults of northern industrialization on the minds, bodies, and houses of factory workers. Sene's house indicates (as does the story's extraordinary opening paragraph) that the site of the city of Lawrence, Massachusetts, serves the mill at the cost of the workers' energies and their well-being. The house sits on a riverbank under the falls that power the mill, on "a damp, unwholesome" dirt road that is "cut short by a broken fence" and so filled with children that it "tipped now and then, like an overfull soup plate, and spilled out two or three through the break in the fence." Treeless (like all of Lawrence's streets), it lays open Sene's house to constant buffeting by tornadolike winds and blowing sand. But deformed (like Sene's face), by environmental forces, the house also shows signs of Sene's faculty: broken windowpanes are "well mended"; a nasturtium "crawls" in the sandy garden; and a front gate has been cleverly "extemporized," as in the suburban yards of Frank Scott, from a wild grapevine. The house is thus the site of both environmental assault and resistance.[78]

Where the mill has deformed Sene's body and drained its energies, the culture hurts her psychically (Phelps's feminism, too, finding expression in picturesque terms) with its relentless ideal of female beauty. Since the scar across her otherwise "womanly, pleasant mouth" attracts more attention than either the womanliness or the pleasantness, her social life has been reduced to her friend Del and her lover Richard Cross. But the lover is eventually drawn, with some encouragement, toward Del, who is unscarred, buxom, and blonde. Sene's social life suddenly implodes.[79]

Nature, too, is the victim of the mills. The bank of the Merrimack, Sene's place for reflection, has become (like the river in "Life in the Iron Mills") "a moody place." Phelps's description approaches expressionism (that, say, of Charles Burchfield) in its juxtaposition of a river entropically drained of its natural colors and its energies, so that it "skulks" like a beaten animal, against the monstrously swollen energies of the mill.

The bank sloped steeply; a fringe of stunted aspens and willows sprang from the frozen sand; it was a sickening, airless place in summer,—it was damp and desolate now. There was a sluggish wash of water under foot, and a stretch of dreary flats behind. Belated locomotives shrieked to each other across the river, and the wind bore down the current the roar and rage of the dam.

Shadows were beginning to skulk under the huge brown bridge. The silent mills stared up and down over the streams with a blank, unvarying stare. An oriflamme of scarlet burned in the west, flickered dully in the dirty, curdling water, flared against the windows of Pemberton, which quivered and dripped, Asenath thought, as if with blood.

Mill fires dominate even the forest landscape beyond the edge of the city. On Sene's last walk, they "[glare"] from the snow in open spaces and "[blaze]" across the night sky like a type of the apocalypse.[80]

The ultimate industrial assault on Sene's body and consciousness occurs, of course, with the advent of that apocalypse: the mill's collapse. Trapped and knocked unconscious, Sene discovers, when she comes to, that her body and the ruined mill have become literally fused. Debris lies across her two hands, and one of her fingers has been lopped off; her feet are tangled (like Charlie Chaplin in *Modern Times,* but more literally) in gearing and buried in brick; a beam lying across her forehead is coated with her blood. In concert, her shocked mind hallucinates but also delivers her a final grace. When the fire breaks out, her world contracts to a blood-red pillar of holocaustal smoke in which appears a super-real champion "who stood beside her, in the furnace," an angel to her Shadrach, her deliverer to a more hopeful world.[81]

African-American Literature and the Subversion of Picturesque Conventions

Nineteenth-century African-American writing displays a more conflictive relationship to the picturesque aesthetic. Slave narratives employ picturesque strategies, but there is the possibility (in need of exploration) that these were suggested by Northern editors to give drama, force, and immediacy, for an Anglo-European readership, to life under the peculiar institution. *The Narrative of the Life of Frederick Douglass* (1845) quite typically evokes the "bloody scenes" and horrible "exhibitions" of slavery's calculated brutalities, to which Douglass acts as participant, eyewitness, and reader of actions and their often invisible consequences. "Actions" is the operative term, for Douglass concentrates recurrently, in his bloody scenes, on the visualization of violent energies. His verbs depict them, and his nouns yoke them to the actors (subjects) and the black victims (objects) on which they act—the syntax of a system both murderous and obscene. Repetition and rhythms magnify the power of the verbs. With no, or few, adjectives, description takes on the abstract force of allegory or parable, as it must to avoid pornography and to give the scene its character of typicality. In the scene of the torture of Douglass's aunt, "the first of a long series of such outrages" by "a miserable drunkard, a profane swearer, and a savage monster," Douglass accentuates the reductiveness of the violence. The verb "whip" falls five times, and the nouns "blood" and "shrieks" (or some variation) rise four times. The violence seems intended both to exact and to punish feeling. The whip is meant to make the unnamed victim react and then sublimate her reactions while her body is painfully deformed. Douglass resituates this assault in an ongoing present:

> I have often been awakened at the dawn of day by the heart-rending shrieks
> of an own aunt of mine, whom he used to tie up to a joist, and whip upon

her naked back till she was literally covered with blood. No words, no tears, no prayers, from his gory victim, seemed to move his iron heart from its bloody purpose. The louder she screamed, the harder he whipped, and where the blood ran fastest, he whipped longest. He would whip to make her scream, and whip to make her hush; and not until overcome by fatigue would he cease to swing the blood-clotted cowskin.[82]

The motive, the reader learns later, is sexual jealousy. The aunt is "a woman of noble form, and of graceful proportions," and a young African-American man has been "paying attention to her."

Douglass then rehearses the scene in greater detail, as if himself caught up in a flashback, concentrating now on the meaning of his aunt's subjugation and on his own complicated responses as a child witnessing it. The latter take the typically picturesque form of a struggle to define "the feelings with which I beheld [the scene]," feelings that, the narrator (I-now) recognizes, constitute in themselves the true condition of slavery. Striking "with awful force," the scene becomes "the blood-stained gate" to "the hell of slavery, through which I was about to pass." It is thus a "terrible" as well as a horrible spectacle. Shortly Douglass adds, revealing his profound identification with his aunt (his own passage through the gate), that the child (I-then) hid himself in a closet, expecting "my turn would be next."[83]

Portraiture in Douglass's narrative serves to depict the effects of psychological violence on the bodies of actors and victims, slaveholders and slaves alike. Slaves are relentlessly brainwashed to wear a mask of exaggerated submissiveness in "look, word, [and] motion": eyes averted, face empty of feeling or engraved with a smile, tones of voice always and only mollifying, the body held like that of a grateful child or supplicant. All other expressions—what *The Art of Acting* calls the imperious and the sublime emotions especially: anger, horror—are violently suppressed. "Does a slave look dissatisfied? It is said, he has the devil in him, and it must be whipped out. Does he speak loudly when spoken to by his master? Then he is getting high-minded, and should be taken down. . . . Does he forget to pull off his hat at the approach of a white person? Then he is wanting in reverence, and should be whipped for it. Does he ever venture to vindicate his conduct, when censured for it? Then he is guilty of impudence,—one of the greatest crimes of which a slave can be guilty."

The bodies of slaveholders, too, Douglass shows, are deformed by slavery. In her first verbal portrait, Sophia Auld, new to the role of "mistress" by virtue of her marriage to a slaveholder, is still "all she appeared . . . a woman of the kindest heart and finest feelings. . . . The meanest slave was put fully at ease in her presence, and none left without feeling better for having seen her. Her face was made of heavenly smiles, and her voice of tranquil music." In a pendant portrait, she is shown corrupted by "[t]he fatal poison of irresponsible power." She has an eye "red with rage," and her "angelic" face has become demonic. Even her tones of voice—vocal expressions of feeling—have been changed: she speaks in a tone of "harsh and horrid discord."[84]

Douglass's use of picturesque values notwithstanding, African-American fiction

seems more typically critical of picturesque values. Not only does it criticize the aesthetic for the disorders it masks, it also suggests the aesthetic's limitations as an ideal of place. It offers, instead, a more inclusive and a more modern sense of place that is still in need of rigorous definition, though Melvin Dixon, Houston Baker, and others have pointed the way.[85]

In Harriet Wilson's *Our Nig,* for example, picturesquely beautiful "home scenes" are shown to be both formulaic and deceitful. Bellmont homestead, in Massachusetts, Wilson's narrator observes, is "a large, old-fashioned, two-story white house, environed by fruitful acres, and embellished by shrubbery and shade trees." Like its beauty and its natural abundance, its sentimental history seems to sacralize it. "Years ago a youthful couple consecrated it as home; and after many little feet had worn paths to favorite fruit trees, and over its green hills, and mingled at last with brother man in the race which belongs neither to the swift or strong, the sire became grey-haired and decrepid, and went to his last repose. His aged consort soon followed him."[86]

But the psychological and social realities of this house are colder than this. Through irony, the novel dramatizes the ongoing deprivations and brutalities suffered by Frado—"a beautiful mulatto, with long, curly black hair, and handsome, roguish eyes, sparkling with an exuberance of spirit almost beyond restraint"—in Bellmont's only outwardly beautiful environment. A foundling made into an indentured servant, Frado comes of age in an atmosphere as violent and disorienting as Douglass's. For Wilson as for Douglass, setting constitutes a social as well as a material environment, and society (in the person of Mrs. Bellmont) is a relentless antagonist—initiator of all the conflicts played out in the spaces of the house and of Frado's mind. Unlike Phelps's "Tenth of August," this home is the locus of dysfunctions evident only in the behavior of its owners. In it, race is a more potent signifier than family.

Charles Chesnutt's "The Goophered Grapevine" pits a more complexly layered African-American sense of place against picturesque values, which it equates with "proprietary" and empirical perspectives. Chesnutt's characterization of John, the white Midwesterner and narrator of the frame stories, is as powerful a deconstruction of the picturesque aesthetic in its decline as there is in late nineteenth-century literature.

John views the postwar, Jim Crow South chiefly from an entrepreneur's perspective. His interest in the aesthetics of the Southern landscape is secondary (a diversion for moments of leisure), formulaic, and superficial. His sketches of Patesville, North Carolina, the county seat, and of the old plantation he buys are inventories of "the opportunities open to Northern capital in the development of Southern industries." Its crops (notably a vineyard of sweet scuppernong grapes) have suffered "utter neglect," he notices (an observation that bespeaks his ignorance of slavery, the Civil War, and Reconstruction), but the vines—"here partly supported by decayed and broken-down trellises, there twining themselves among the branches of the slender saplings which had sprung up among them"—grow in "wild and unpruned luxuriance." With the effort of restoration, John envisions a vineyard as profitable as that

of his slaveholding predecessor, Dugal McAdoo, a parallel between slaveholder and capitalist that Chesnutt elaborates throughout the book.[87]

Since John does not connect his entrepreneurial and his aesthetic appreciation of the landscape, the latter is as superficial as that of a tourist in search of the picturesque. The piedmont, moreover, is not picturesque enough (in his view) to divert him for long. When it becomes "monotonous" and his days "dull" (133, 103), he turns for diversion to the African-American art of Julius McAdoo, narrator of the stories-within-the-stories, with their attention to the "dark" currents of life under calm surfaces: "the shadow, never absent, of slavery and of ignorance; the sadness, always, of life as seen by the fading light of an old man's memory." But John does not begin to fathom this, or McAdoo's reconfiguration of the landscape, until the end of the book, and how much he will come to see remains problematic. His conversion is by no means complete by the end of the story.[88]

Although connected both economically and spiritually to the land, Julius McAdoo's African-American perspective is emphatically not picturesque. It is "predial"—bound to the land but not in possession of it, historical, and cosmological. The power of his words is the capital enabling him to live in a place owned by others, and his stories thus serve a gatherer's economics. That is all John sees in the stories at first. Places the stories hex turn out to be places in which McAdoo and his community are exercising their predial rights: the scuppernong vines and a honey tree, supplements to a meager diet; an abandoned schoolhouse used by his church.

But McAdoo's motives as a narrator are never only self-interested, and so the meaning of place is multilayered. The stories "re-member" the social environment as it took its particular shape in this landscape, a peculiar institution run by men whose treatment of people is motivated (like John's) by money and protected by a system that concedes no rights and no checks and balances, not even those of conscience, on their power. Crops are off-limits as food for the people who tend them. The "patterole" hunts not only escapees but also people wandering at night in search of food or love, using energies the slave owners want put into labor. People are forbidden, by the same calculus, to sing, dance, or play the banjo—forbidden courting, "Junesying," marriage. Only crops are to be raised on the plantation, and the pressure to increase the yield is so relentless that there are no allowances for sickness or "'trouble in de min.'" Violators are sold off, complaints about this physically punished.

In Julius McAdoo's native's memory of this place, hard work is rewarded by more work or by the risk of being sold off as a valuable commodity. A plantation owner rewards an especially hard-working man named Sandy by "lending" him out to other plantations and selling his wife in his absence. Another rewards the good work of Sis' Becky by selling first her husband (to pay off racing debts), then herself (for a better racehorse), leaving their baby to wither and sicken. John's wife Annie, a better listener, early catches the drift of Julius's slave narratives: "What a system it was . . . under which such things were possible." John calls them "tragic incidents of the dark side of slavery"—not typical, that is to say—and feels compelled to add his conjecture that they are calculated for "the sympathetic ear of a

Northern-bred woman."[89] Small wonder that McAdoo is not drawn to sunsets or to pastoral ideals!

Nature, in McAdoo's narratives, is a cosmos filled with animistic presences, spirits, and spells. At once pre- and postmodern, it is a chaotic field of supernatural energies and intelligences endowed with "a power of transformation that causes definitions of 'form' as fixed and comprehensible 'thing' to dissolve." It is also ecological. Conjurers like Aunt Peggy use the links between it and the life energies of the beings who live in it to invigorate (with charms) their patrons and to debilitate (with goophers) their enemies. Substances are defined by how they heal (hair, certain barks and roots) or poison the human body (a snake's tooth, a speckled hen's gallbladder, hairs from a black cat's tail), not by how they look. There is some poetic justice in this cosmology, but it is not always or even essentially moral. Witches ride even innocent victims over rough ground, galling them with spurs and whips, robbing them of rest for the day's remorseless labors. Good people are sapped by spells, as they are by incessant work. Even the power conferred by metamorphosis can be undercut. Turned into an oak to avoid capture, Sandy undergoes the excruciating torture of being cut down.[90]

Conjurers recognize all forms of life as kindred, learn the languages they speak, learn means of assuming other life forms in order to assume their powers: to see in the dark, to run like wind, to become invisible, to be armed (when circumstances require) with tooth and claw; to be rooted in a world where rootlessness is a condition of being. In this ecological universe, the language of animals shares a common root with human language. Mose, transformed by Aunt Peggy into a hummingbird so that he can fly to his mother, Sis' Becky (who has been sold off) sounds to her, immediately, though she sees only the bird, like the Mose who crooned on her breast. Mose as mockingbird also croons, lights on her shoulder, eats from the bread in her hand. The flutter of his wings on her cheek makes her feel like her son is kissing her cheek. Speaking as well as understanding the languages of being, Aunt Peggy, the conjure woman, asks a hornet to sting the racehorse her master has traded Sis' Becky for and then asks a sparrow to lay a root spell at Sis' Becky's cabin door to make her sick. The idea is that the sick woman will be traded back for the sick horse and thus allowed to rejoin a son who has been conjured back into human form.[91]

For those who are not conjurers, the power in this place is the power of words. Even in John's mind, ultimately, McAdoo's words come to have the power of appropriating nature for the historicizing and spiritualizing work of his stories. As McAdoo evokes the "harrowing" image of Mahaly's ghost communing with a lover who has been locked into the form of a gray wolf, the air (John notices) darkens. Wind whistles through the eaves, slams window shutters, and drives the rain "in fiercer gusts into the piazza," and then bursts into "a long, wailing" wolf howl— "the epitome, as it were, of remorse and helplessness." For the reader, too, McAdoo's words have the power of conjure. The picturesque landscape of rural North Carolina is revealed as a deceit by images of its cruel human history and by a cosmos in which material shapes have no fixity, in which human, plant, and animal are all interrelated. The narrator's wife Annie begins to hear this new music of place

halfway through the book. John does not, yet, because he is compelled to hold onto his sense of "Uncle Julius" as merely a creature of black minstrelsy (clever as he might be), to be tolerated patronizingly for the diversions he offers, but not to be heard. That, the reader is shown emphatically, makes him an obtuse fool.[92]

In some such ways as this, at the end of its century of dominion, the picturesque aesthetic succumbs to overuse and gives way to more diverse and more powerful senses of place.

[M]an's dwelling, in its most complete form, may be regarded as the type of his whole private life. . . . Every material object that becomes the type of the spiritual, moral, or intellectual nature of man, becomes at once beautiful, because it is suggestive of the beautiful in human nature.

—Andrew Jackson Downing, *The Architecture of Country Houses*

[T]he aesthetic element must be subordinate to the requirements of physical existence, and, as a matter of expense, should be held of inferior consequence to means of higher moral growth: . . . yet [it] . . . contributes much to the education of the entire household in refinement, intellectual development, and moral sensibility.

—Catherine Beecher and Harriet Beecher Stowe, *The American Woman's Home*

The Gendered American Dream House

∾

Like postmodernism, the picturesque aesthetic makes the house a visible projection of the lives being lived within. For Andrew Jackson Downing, its windows, cornices, and doors express— like eyes, brows, lips—its moral as well as its aesthetic character: "system or disorder," a spirit of kind hospitality or "miserly care," "peace or discord," garishness or beauty. Even intentions to deceive cannot deceive. Garishness, "intended only to dazzle and impress others," is a corruption of the beautiful. Mean rooms hidden behind "a large and conspicuous facade" are the very image of hypocrisy. The question for Downing is how to make the house the expression of a self at once idealized and authentic. By contrast, for Catherine Beecher and Harriet Beecher Stowe, designers of an American Woman's home, it is the interior alone that expresses the spirit of the house: a spirit that exemplifies the interrelated virtues of justice, efficiency, and health as well as picturesque beauty.[1] For all three of these popular architectural theorists together, the house becomes a text capable of accommodating two fictions of personal transformation, one male and one female, and even perhaps of reconciling them.[2] Both fictions involve the maturation of "modern" selves, complex and various in their mental activities and in their spatial requirements: at once rational and imaginative, profoundly private and profoundly social.

If the complexities of the gender gap write themselves into

the picturesque house, so too do the gaps between nineteenth-century ideals and so-cial actualities. Downing's antebellum and the Beecher sisters' Victorian designs are avowedly democratic, but their explications of the designs are riddled with ambigu-ities about race and class as well as gender. Their designs are avowedly rural, prod-ucts of an unmanipulative relation between art and nature, but the subtext is urban, product of an assumption that nature is an order separable from, and finally subor-dinate to, human art.[3]

ANDREW JACKSON DOWNING: RURAL ARCHITECTURE AND THE REFORMATION OF ISHMAEL

The narrative of personal transformation that serves as blueprint for Downing's pic-turesque cottages is a variation of Timothy Dwight's. Like Dwight's, Downing's houses are both metonyms of the Anglo-American male mentality and synecdoches of an ideal of civilization. Assuming the proximity of towns and cities, Downing's narrative in turn anticipates Frederick Law Olmsted's.[4]

Downing's version of the log cabin, a figurative nomad's tent, is the projection of a mind in a state of desperate and potentially dangerous incompleteness. The Anglo-American male, he argues, is a son of Ishmael, driven by the powerful ener-gies that drove his pioneer fathers. Unchanneled, the energies produce a "spirit of unrest" that tyrannizes and goads him, robbing him of repose and contentment. He can savor nothing. Indifferent to place, a victim of hyper-mobility, he "emigrates, he 'squats,' he 'locates'"—but then, succumbing to the spirit of unrest, he is on the road again, no more rooted than "the cords which confine his habitation to the sandy floor of the desert."[5]

As John Ward has shown, Downing celebrates some products of this energy: its commitment to "liberty and progress, its freedom from old prejudices." "[T]he SPIRIT OF UNREST . . . is the grand energetic element which leads us to clear vast forests, and settle new States, with a rapidity unparalleled in the world's history; the spirit, possessed with which, our yet comparatively scanty people do not find elbow-room enough in a territory already in their possession, and vast enough to hold the greatest of ancient empires." But unmediated energy is destructive to the culture as well as to the self. "The *spirit of unrest* followed into the bosom of society, makes of man a feverish being, in whose Tantalus' cup repose is the unattainable drop. Unable to take root anywhere, he leads, socially and physically, the uncertain life of a tree transplanted from place to place, and shifted to different soil every season."[6]

The farmhouse and the role of freeholder also fail to mediate Ishmaelian ener-gies. With its utilitarian emphasis on practicality, the farmhouse is as drab and joy-less as a factory:

> Here father sits with his hat and in his shirt-sleeves. . . . The boys are busy
> shelling corn for samp; the hired men are scraping whip-stocks and whittling
> bow-pins, throwing every now and then a sheep's eye and a jest at the girls,
> who, with their mother, are *doing-up* the house-work. . . . Not a book is to
> be seen, though the winter school has commenced. Privacy is a word of un-

known meaning . . . ; and if a son or daughter should borrow a book, it would be almost impossible to read it in that room, and on no occasion is the front [of the] house opened except when "company come to spend the afternoon," or when things are brushed and dusted, and "set to rights."

Rigidly utilitarian in its vision of landscape, too, Downing argues, the Ishmaelian mentality has deformed whole rural regions west of New England.[7] The fields may be neat, fruitful, prosperous, but disorder dominates the spaces abutting them. Roadsides are ruinous with garbage and weeds; garden fences, heaped with "unsightly thickets" of sumac and chokecherry; and the gardens, with nettles. Farmyards have been scraped to bare earth by foot traffic. And rural towns, the "especial theme of our lamentation," reveal a "scale and degree of . . . disorder . . . unprecedented in the New World." Treeless streets roast in the summer heat. Civic architecture is makeshift at best or grotesquely dilapidated. Houses, naked and sterile, are as "glaring and ghastly" in their painted whiteness as "a pyramid of bones" in the desert, and inside, "every blind is shut closed as a miser's fist," the inmates cut off from any redeeming contact with the natural environment—cut off from all but work-driven contact with each other.[8]

If the problems are evident, solutions are elusive. How to reawaken in the Ishmaelian spirit "certain virtues that will keep it within due bounds"; how to enrich it with the love of beauty and the repose that will turn it toward a rooted and deliberate life "without checking due energy of character"?[9]

Change the environment, change the man. To achieve this psychological reformation, Downing advocates the reformation of the rural landscape—the roadsides, farmyards, and towns at the peripheries of the fields. The spirit that would achieve this reformation is precisely what Downing wishes for the new American male: a spirit that "transforms what is only a tame meadow and a bleak aspect, into an Eden of interest and delights. It makes all the difference between 'Araby the blest,' and a pinebarren. It gives a bit of soil too insignificant to find a place in the geography of the earth's surface, such an importance in the eyes of its possessor, that he finds it more attractive than countless acres of unknown and unexplored 'territory.'" The reformed landscape in turn participates in the reformation of Ishmael. Because it contains "the mind and soul" of the mature man, "materialized in many of the fairest and richest forms of nature," the reformed landscape is the most powerful "*philtre*" yet devised by civilization to induce a love of place.[10]

The picturesque country house completes this reciprocal reformation of space and mentality. It both articulates and initiates formative dialogues, in the latter, between energy and repose. The classical beauties of the houses's structure (balance, proportion, symmetry) bespeak a spirit of reason "obeying the universal laws of perfect existence . . . easily, freely, harmoniously, and without the *display* of power"; and its classical lines express the "infinity, . . . grace, and willing obedience" of the spirit infusing them. Its picturesque beauties, "strongly or irregularly expressed," are metonyms of Ishmael's ongoing struggle to achieve this spirit. In both the struggle and the house that gives it form, consciousness reaches a state in which "the soul, the intellect, and the heart, are all awake . . . all educated." Energy checked by the love

of place, the harmony of reason, and the repose of beauty; repose invigorated and intellectualized by energy: that, for Downing, is the state of equanimity that the picturesque house and rural landscape would restore to the mind of Ishmael.[11]

The Rural Cottage and the Limits of Individualism

Downing's scenario is complicated by his distinctions between the cottage and the villa.[12] The cottage, smallest and most affordable form of the picturesque country house, plays a formative role in the education of the American male, who is confronted with the fact of manifold limits to his desires; he must learn to balance the demands of self-fulfillment and self-control. The first condition of cottage design is the recognition of economic limits.[13] People should not live beyond their means—and need not if they can control their appetites for wealth and status. Aesthetic economy imposes yet another limit: the "comparatively simple habits of cottage life" require "tasteful simplicity," not "cockney" self-promotion or "gingerbread" fussiness.[14] Above all, cottages are expressions of a self paradoxically liberated by social bonds—bonds that express (and induce) a recognition of other beings and forms of being: family, community, nation, nature, God—and by accepting the discipline of study as the means of maturation. Like Emerson's, Downing's American scholar has as texts, nature, his own life, and books.

1. *Arrangements of Interior Space.* Like Thoreau's, Downing's cottage is constructed from the inside out. It is an accommodation of the cottage's limited interior space to a multiplicity of family needs. The size of the family determines the scale and situation of the bedrooms, loci of the house's private space. The size of the kitchen, locus of the work that sustains its life, likewise depends upon the size of the family. In Downing's Romantic scenario, however, the practical work of the house—canning, weaving, cooking, washing, and so on—no longer as labor-intensive as it was, must be superseded by a new priority: the education of the family's "wants and . . . tastes." Although its scale is contingent upon the need for survival and the limits of the yeoman's income, the parlor (place of parlance) displaces the kitchen as the center of family life, just as leisure (the cultivation of the mind) displaces work.[15] Modern consciousness being, like "modern life," by definition manifold and various, Downing's parlor is designed (like the Beecher sisters') for multiple use. Over the course of a day, it is by turns, a "common apartment," dining room, family room, place for receiving company, and reading room.[16]

Since space in the picturesque house is by definition changeable and expandable and since the yeoman in a booming economy can be assumed to be increasing his income, more specialized arrangements for the parlor can be accommodated as the character of family life clarifies itself. For a family contemplatively disposed, it might be made over into an intimate reading nook like that in the *Symmetrical Cottage* (Fig. 96), with its divan and soft chairs surrounded by an octagon of books. Alternatively (or additionally), the family's social relations becoming paramount, it can be transformed into a place of "simple"—republican—elegance. For this, the parlor of the *Regular Bracketed Cottage* (Fig. 97) is given floor-length windows at the front

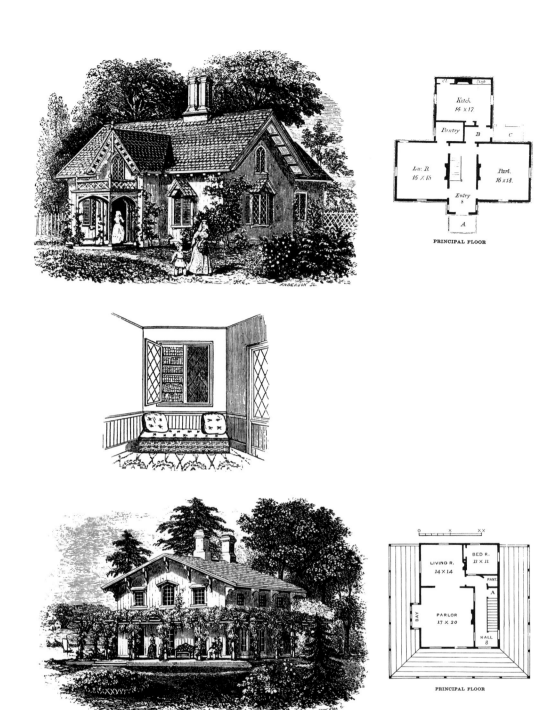

Fig. 96 (top) *Symmetrical Cottage. The Parlor Furnished as Octagon.* From A. J. Downing, *Architecture of Country Houses.* Design VII: 104 and 107.

Fig. 97 (bottom) *Regular Bracketed Cottage.* From A. J. Downing, *Architecture of Country Houses.* Design IX: 112.

and a bay window opposite a mantled fireplace, with sufficient space for a separate family room designed as an extension of the parlor when the sliding doors between the two are opened.[17]

The cultural work of the parlor, Downing assumes with his generation, is largely the office of the woman of the house, and unwilling to trespass in "the female province[s]," he leaves it, like the kitchen, largely *terra incognita*—its possibilities to be explored and its appointments realized by women such as the Beecher sisters:

> [I]t is [*woman*] who holds all the power in this sphere; it is she, who really, but silently directs, controls, leads and governs the whole social machine; and if will but study to raise the character of the farmer's social life, the whole matter is accomplished. . . . [L]et her teach her daughters that, fascinating and brilliant as many other positions appear outwardly, there is none so with so much intrinsic satisfaction as the life of a really intelligent proprietor of the soil, and above all, let her show by the spirit of intelligence, order, neatness, taste and that *beauty of propriety,* which is the highest beauty in *her home,* that she really knows, understands, and enjoys her position as a wife and mother of a farmer's family.

2. *Exteriors as Public Masks.* The presence of the reformed American male is most intensely visualized in the exterior: an idealized public mask for an emerging public self with a multilayered identity. Like Bingham's farmers and Mount's boatmen, the exteriors of picturesque cottages have "the freedom and play of feeling of every-day life." Informal in design (like "familiar conversation" rather than "public declamation"), they have a certain sprawling freedom, like a tree that expands to its fullest growth in the uncrowded, "unrestrained liberty of the open meadow."[18]

Exteriors also idealize the proprietor's new mentality in terms of a balanced opposition between classical and modern values. Proportion and symmetry profess a commitment to "ideas of perfection . . . universal in their application," "divine in their origin," a triumph of idea over material.[19] The playful assertions and surprises of picturesque design, on the other hand, express not the achievement of, but the desire for, these values. The vertical assertions of roofs, gables, and chimneys (Fig. 98) declare an "ambition and energy" characteristic of the spiritually aspirant or upwardly mobile, a straining against the limits of the present. Asymmetries express imaginations characterized, like the speech of Melville's sailors, by "originality, boldness, energy, and variety of character."

The structural unity of the cottage exterior, nevertheless, professes "an agreement made . . . by some one feeling which . . . brings all the varied parts into an agreeable relation with each other."[20]

3. *Ornament as Professions of Domestic and Social Commitments.* Reposeful but not boring, interesting but not frenetic, Downing's picturesque cottages powerfully assert in their "beauty of expression" the dominion of ideal over material beauty; in this they are manifold expressions of "the spirit that lives within."[21] The ideal that Gothic Revival expresses most "directly to the eye," Downing professes, is a love of

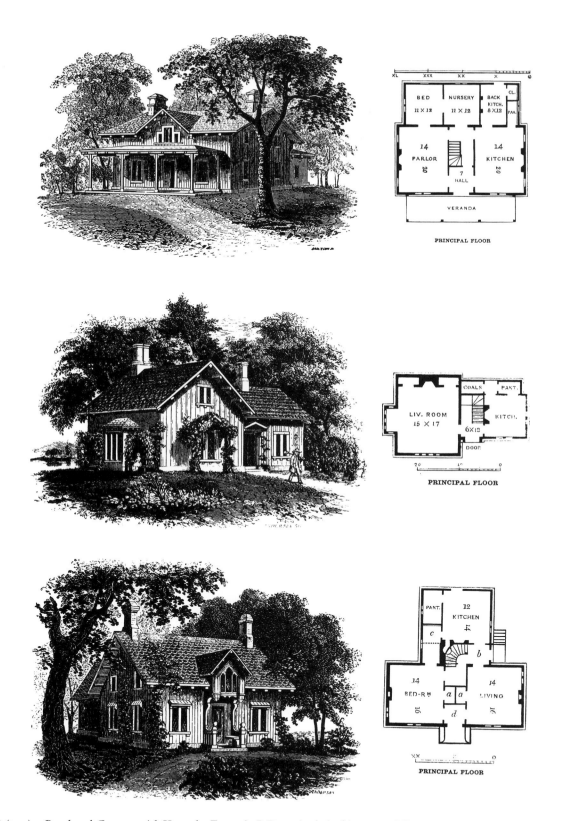

Fig. 98 (top) *Bracketed Cottage with Veranda.* From A. J. Downing, *Architecture of Country Houses.* Design X: 120.

Fig. 99 (middle) *Small Bracketed Cottage.* From A. J. Downing, *Architecture of Country Houses.* Design II: 78.

Fig. 100 (bottom) *Symmetrical Bracketed Cottage.* From A. J. Downing, *Architecture of Country Houses.* Design III: 83.

domestic order. In the high-pitched overhanging eaves of Hudson River Gothic, standing out from the shadows they cast, "broad and deep," on the cottage walls, ornament underscores the ideal of a protection that does not crush, that nurtures aspiration. Exposed rafters and brackets under the eaves express the related ideal of strength and support (Fig. 99). Chimneys treated as columns with base, shaft, and cap all decorated, like doors and windows, with tracery, celebrate the sanctity as well as the warmth of the hearth. Dressings on the front door frame and on hoods or roofs add "force and picturesqueness" to the family's articulations of retirement from or welcome to neighbors. Porches solemnize desires for the rituals of arrival and departure; benches turn them into spaces of contemplation.[22] A wing committed to private space and a small porch and gable around the front door bespeak a predominantly private self (Fig. 100). An arbor is designed for only three sides of a cottage (see Fig. 97); adding to asymmetry the complication of the organic forms of its vines, it bespeaks a self committed to the natural but not wholly bound by it.[23]

4. *Exteriors as Recognitions of the Ministries of Nature.* Gothic Revivalism also expresses the cottagers' recognition of the ministries of nature. Like Thoreau's purposefully unfinished cabin, the porch (see Fig. 100), the veranda—an extended porch (see Fig. 98), and the arbor—a viny porch (see Fig. 97), are all roofed against rain and the heat of the sun but left open to sound (bird song, wind sough, rain), smell (the sweetnesses of honeysuckle, clematis, and of flowering gardens), and touch ("the fresh breath of morning or evening hours"), for the leisure hours before and after work. Above all, they are (like rural windows) transparent walls shot through with moving pictures of wind, light, and seasons (see Figs. 82 and 83). For Downing's as for Emerson's American scholar, the meanings of natural scenes framed by the rural porch (and windows) constitute one of the chief texts for the mind's awakening: "[In] our beautiful woodland slopes, with their undulating outlines, our broad river meadows studded with single trees and groups allowed to grow and expand in a state of free and graceful development, our steep hills, sprinkled with picturesque pines and firs, and our deep valleys, dark with hemlocks and cedars, . . . the real lessons in the beautiful and the picturesque are to be taken, which will lead us to the appreciation of the finest elements of beauty in the embellishment of our country places." A kindred experience, as Thoreau's late essays also attest, is to be had in most New England villages, ornamented as they are by the "sylvan charms" of trees. "Their architecture is simple and unpretending—often, indeed, meagre and unworthy of notice. The houses are surrounded by inclosures full of trees and shrubs with space enough to afford comfort, and ornament enough to denote taste. But the main street of the village is an avenue of elms, positively delightful to behold. Always wide, the overarching boughs form an aisle more grand and beautiful than that of any old Gothic cathedral."[24]

Antebellum writing is shot through with just such house-centered immersions in rural beauty, albeit not all from cottage porches. Sighting Cassiopeia's Chair in the night sky from his doorway, Thoreau discovers that his house is situated in "a withdrawn, but forever new and unprofaned, part of the universe." Hearing the wind and seeing the light in the apple trees outside the window of her vernacular house leads

Fig. 101
*Seat of George Sheaff,
near Philadelphia.* From
A. J. Downing, *Theory
and Practice of Landscape
Gardening,* fig. 10:42.

Stowe's Mary Scudder eventually to a liberalized Protestant theology. And the "angle of a landscape" presents to Emily Dickinson in the window of her large Federal house in Amherst, over the course of seasons, a juxtaposition of living beauty, which blooms and dies, against the durable but chill beauties of ice and snow, natural types of the New Jerusalem.[25]

Adaptations of the house to the landscape are perhaps the most powerful expressions of the rural cottage-dweller's relation to the natural environment. Picturesque design makes the cottage a geometric analogue of the landscape's color and "wealth of flowing lines." Embowered by vines, shrubs, a grove of trees, it dissolves (only visually and from a distance) into a sea of natural effects: haze melting it; earth colors blending it with earth; trees atomizing it—a window, a gable among leaves; the sun (especially at morning and evening) transfiguring it into fragments of light and shadow (Fig. 101), making it possible to contemplate human beings and their artifacts as parts of the natural order.[26]

The Villa as Sign of Self-Fulfillment

Although Downing's cottages are not Ishmaelian tents, they do figure as relatively temporary settings in his narrative of male transformation. In an expanding economy, the industry of the new man will be rewarded by "more than the means of subsistence"; his ambition will propel him to grow intellectually and to ascend socially; and he will be able to afford, eventually, a house that expands both his and his family's social and his psychological boundaries. That means a villa, whose various rooms are scenic manifestations of his "moral, social, and intellectual" maturity.

But the villa, too, requires, from Downing's antebellum perspective, a recognition of social and psychological limits. It, too, is a fitting expression of humanity and republicanism. An emphatic rejection of primogeniture, it should be built of wood, brick, friable stone—materials designed not to last (as dynasties wish to) forever. Neither a palace nor (as it would come to be after the Civil War) a mansion, it should not be opulent. It is an artful house affordable to a burgeoning middle class: comfortable, informal, and roomy enough to house the populous Victorian family and

to give place to the variousness of its social and intellectual being.[27] It completes the reformation of the sons of Ishmael. Inscriptions of the energies pushing and pulling at them from within, Downing's dream house is also a plot of the refinement of these energies: "a little world" in which "that feverish unrest and want of balance between the desire and the fulfillment of life" is "calmed and adjusted."

It is also a text of private lives with enormous public implications. A good house (meaning a "fitting, tasteful, and significant" house), Downing declares, quoting Timothy Dwight, is "a powerful means," as well as a powerful expression, "of civilization." Its sphere of influence extends beyond the family to "the public sensibility and the public taste." Like Olmsted's Central Park Mall, its moral and intellectual character imbues the new man with a desire to struggle for that character. Its beauty induces in citizens "that refinement of manners which distinguishes a civilized from a coarse and brutal people."[28]

SPATIAL AND SOCIAL SEGREGATION IN NINETEENTH-CENTURY DOMESTIC ARCHITECTURE

Nevertheless, Downing's acceptance of the culture's tendency toward spatial and social segregation ultimately compromises both the rural character and the avowedly democratic tenor of his dream house. For all his mistrust of cities,[29] he becomes, in the last decade of his life, a reluctant urbanist. He is attracted after 1840 to Italian Revival architecture because it is a style that expresses "not wholly the spirit of country life nor of town life, but something between both, and which is a mingling of both." In its presence, even the landscape must be formalized into configurations of open-air rooms and ruglike lawns.[30]

Accepting urbanism, Downing also accepts a culture-wide drift toward segregation that sunders urban from natural, work from leisure, private from public, middle from working class, masculine from feminine, and Euro-Saxon from Other spaces. In commercial cities, men's work concenters increasingly in specialized industrial and commercial zones of towns and cities, where making is segregated from selling products, and the spaces of leisure and consumption from the spaces of work. Residential zones separate themselves from both work and communal play. For Downing (as for his contemporaries), the same scenario occurs in the microcosm of the picturesque house. Men's work moves out of it; women's work is relegated to kitchens situated, like factories in the city, out of sight of visitors: at the rear of the house. In villas especially, rooms, too, become specialized zones. Those on the "principal floor" in the front are reconceived and decorated as spaces of social discourse: "family rooms" or "formal parlors." Boudoirs and studies become spaces for reading and meditation: the work of the mind. Outside (as Downing shows in *Cottage Architecture*), the utilitarian spaces of stable and vegetable garden are also pushed to the rear, out of sight from the road. The front yard becomes a space for a gardenesque "picture," framed with fences and furnished, scenically, with lawns and foliage.[31]

Downing also accepts class and ethnic segregation. He leaves to postwar reformers the application of picturesque values to working-class row houses, tenements, and brownstones.[32] Even his workingmen's cottages, assuming an urban industrial zone

at a commutable distance, require from the massive supply of Irish and German immigrants there "the assistance of one or two servants"—the perquisites of an aspirant middle class. Maids and laborers, apparently, need not apply for ownership.[33]

Neither need non-Anglo-Saxon immigrants. With the culture, Downing assumes, innocently (as we say), that "Irish" and "problem," like "American" and "Anglo-American," are synonymous. The pig-littered streets of "our hard-working emigrants from the Emerald Isle" are the very image of the unredeemed rural townscape. Even in these streets, moreover, African Americans are an absent presence.[34]

Downing accepts, though with some qualms, the segregation of genders as well, supposing "the world" to be the space of masculine struggle and destiny and "the home" to be the female's.[35] But the actualities are more complicated than separate-sphere ideology allows. Economically and legally, the house is governed by men. Unlike work in the world, domestic work is uncompensated, and women are therefore excluded from scenarios of the American dream. No wealth and celebrity accrue from it; no recognition of a mastery equivalent to, say, the frontiersman's mastery of skills required of life in the western mountains or the farmer's mastery of farming. It is work as marginalized as it is idealized.[36] "The man," declares one anonymous writer, "bears rule over his wife's person and conduct. She bears rule over his inclinations" by the mild authority of her own ladylike feelings. "The empire of the woman is the empire of softness . . . her commands are caresses, her menaces are tears." For this, as Harriet Martineau trenchantly observes, she receives only the recompense of "indulgence."[37]

The nineteenth-century house, including Downing's designs of it, is a map of gendered functions and territories almost as surreal as those of slavery and Jim Crow. Men are ceded the design of yard or landscape garden; women, the flower gardens and other ornamental spaces nearest the house. A male architect or carpenter designs the house's exterior as a largely male physiognomy. Excepting such relative anomalies as bachelors' digs (Thoreau's cabin, the apartment in Poe's "Philosophy of Furniture"), the interior is "the province of feminine taste." Nevertheless, to make "the same general spirit of composition pervade *all* the lines and forms" of the house, men not only design the floor plan but also preside over the architectural details of the interior on the grounds that moldings, wainscoting, door and window frames, and furnishings must be congruent with the style of the exterior.[38] Ceded what is left—the furniture, textures, and colors of the interior, the woman is charged with helping to enforce separate-spheres dicta, making some rooms masculine and some feminine in their effects. Downing invents none of this, of course, but his assent to it clearly compromises his democratic principles. Fortunately, the designs are more plastic and adaptable than their apologist.[39]

THE BEECHER SISTERS: SUBURBAN ARCHITECTURE AND THE ELEVATION OF THE AMERICAN WOMAN

Downing values the picturesque house most for the part it plays in the reformation of the American male. The Beecher sisters value it most for the part it plays in the reformation of the American female, both intellectually and politically. Published in

1869, when Beecher was sixty-nine and Stowe fifty-eight, *American Woman's Home* is a reprise of both sisters' work on the house and the home, including Beecher's *Treatise on Domestic Economy* (printed fifteen times between 1841 and 1856) and Stowe's *House and Home Papers* (1865–67), especially its chapters on aesthetic design.

Compared to Elizabeth Cady Stanton's and Susan B. Anthony's, the sisters' feminism is an elusive mix of the conservative and the progressive. Accepting separate-spheres ideology, they seek to reconfigure it, as Booker T. Washington seeks to reconfigure a related form of segregation, on the principle of "separate but equal." Bound to the work of westward expansion, industrialization, and urbanization, American males have a manifest destiny to "till the earth, dig the mines, toil in the foundries, traverse the ocean, transport merchandise, labor in manufactories, construct houses, conduct civil, municipal, and state affairs, and all the heavy work." But society, Beecher declares in her *Treatise,* "is moving and changing." "Many thousands" of Civil War widows have taken jobs in cities for their self-support, and middle-class women in urban spaces ranging from boulevards and parks to restaurants, theaters, department stores on the Ladies' Mile (Broadway from Fourteenth to Twenty-fourth Streets) are at the same time extending the notion of woman's place beyond the precincts of home.[40]

For the sisters, this confusion of boundaries between the world and the home is not unmitigatedly good. At a time when the culture expects more from the domestic sphere than ever before, horizontal mobility is removing married couples from their sources of familial instruction. Upward mobility compounds the problem. "Persons in poverty," Stowe declares, "are rising to opulence, and persons of wealth, are sinking to poverty. . . . [E]ven in the more stationary portions of the community, there is a mingling of all grades of wealth, intellect, and education." After 1850, domestic servants are a condition of liberation for middle-class women, but why should working-class women accept the doubly marginal status of servants when they can be doing salaried work elsewhere? For the Beecher sisters, the need to hire "foreigners" (Irish, African American) is at best a poor alternative to the workforce of Yankee farm women drawn to more lucrative kinds of work.[41]

In other ways, however, the sisters believe that change has not gone far enough. The dicta that woman is "an intelligent, immortal being, whose interests and rights are *every way* equal in value to that of the other sex" and that she has "an equal interest in all social and civil concerns" undergird a female bill of rights that, though grounded in biblical hermeneutics, has been ignored by the nation. The first of these is the right of every woman to do any work she chooses outside the home—or at least any work to which, "by her natural organization and talent, she is peculiarly adapted." Talent qualifies any woman who has it for "the professions requiring natural genius": writing, painting, sculpture, and such "subordinate arts" as photography. Experience in running a home qualifies women for teaching ("profitable in its higher branches," though currently overcrowded in the lower); landscape gardening and architecture; medicine (nursing, chiefly); business and, at the lower social levels, millinery work, typesetting, and textile work like that done by the "girls" at Lowell.[42] Equal pay "for work which she does equally well" as a man follows as a logical corollary.

The right of a woman to own property, including her own home, is another "neglected truth" in need of national recognition. Propertylessness consigns women "in many respects, [to a situation] precisely similar to that of the negro slave."[43] Already in effect in several states, Stowe argues, property rights ensure the stability of the home in case of "the imbecility or improvidence of the natural head of the family," but they also ensure legal as well as economic independence, for property-holding brings with it the right of suffrage. Women, Stowe declares, "should be represented in the State by their votes."[44]

For both sisters, recognition of women's rights remains the great issue of the Reconstruction era. "[W]ith the downfall of Slavery," "the only obstacle to the success of our great domestic experiment is overthrown, and there seems no limit to the possibilities which it may open before the human race. . . . We need to know and feel, all of us, that, from the moment of the death of Slavery, we parted finally from the regime and control of all the old ideas forced under the old oppressive systems of society, and came upon a new plane of life."[45]

On this new plane of life, women will need neither marriage nor motherhood to lead fulfilling lives, even fulfilling domestic lives that do not require the "distinctive duties of obedience to man." Single women earning their own income may "institute the family-state" by adopting children; a small resident community of women can run a rural or suburban school or even (the most prophetic paradigm) an urban settlement house, offering to "orphans, the aged, the sick, and the sinful" among the urban poor the "temporal and spiritual elevation" of a home.[46]

As the Beechers see it, however, these are solutions for a minority of women. For the majority, who will continue to define their lives by their commitments to marriage and a family, *the real wrongs of woman* are that this profession has been devalued and dishonored. Typically, the American woman drawn to domestic life is recompensed with little of the " honor and advantage that stimulate the other sex." That must change.[47]

The Home as Synecdoche of the Nation

The American home, the sisters insist, must be reconceived not as a refuge from the world but as a model of what the world could be: the home as the synecdoche of a nation redefined by the democratic principles and the social arrangements of an industrial society. As in the marketplace, domestic labor is specialized and increasingly requires, like the professions, specialized knowledge. Women must also have the skills and virtues of statecraft. "No statesman, at the head of a nation's affairs," Beecher declares, has "more frequent calls for wisdom, firmness, tact, discrimination, prudence, and versatility of talent than a married woman's duties require."

> She has a husband, whose peculiar tastes and habits she must accommodate. . . . She has constantly changing domestics . . . ; she is required to regulate the finances of the domestic state, and constantly to adapt expenditures to the means and to the relative claims of each department. She has the direction of the kitchen . . . [so] that the various operations shall each start at the right time, and be all in completeness at the same given hour. She has the

claims of society to meet, calls to receive and return, and the duties of hospitality to sustain. She has the poor to relieve; benevolent societies to aid; the schools of her children to inquire and decide about; the care of the sick; the nursing of infancy; and the endless miscellany of odd items constantly recurring in a large family.[48]

Above all, she is the mother of children "whose health she must guard, whose physical constitution she must steady and develop, whose temper and habits she must regulate, whose principles she must form, whose pursuits she must direct." Race does not gainsay these obligations; neither does class. The most populous of female professions needs to be reestimated as a profession rather than as labor.[49]

The ethic of self-sacrificing maternal work, moreover, needs to be understood as both an exemplar of Christian ethics and of democratic government *in petto*. The Christ of the Atonement, the sisters argue, links power to submission, influence to self-abnegation—a lesson exactly opposite to the self-centered values of the modern world. Paradoxically, Christ's power consists "in taking a low place in order to raise others to a higher." To teach the centrality of self-sacrifice, Christ "humbled himself from the highest to the lowest place," choosing for his birthplace "the most despised village; for his parents, the lowest in rank; for his trade, to labor as a carpenter," a sign of His covenant "to labor with his hands" and to teach that "the great duty of man" is by that labor "to provide for and train weak and ignorant creatures." Paradoxically, Christ's power consists in "taking a low place in order to raise others to a higher."[50]

Just so, the sisters argue, self-sacrifice elevates wives and mothers to the status of types and ministers of Christ and could redefine the family in terms of a communism like that which governed the early church. Women are called to teach their husbands and children that the power of family life is the "self-sacrificing labor of the stronger and wiser members to raise the weaker and more ignorant to equal advantages." If the new man works to sustain the domestic economy; the new woman works, like Christ, to establish in her microcosm "a kingdom exactly opposite to that of the world." She would please God, not men, when she humbles herself to elevate others. Like men, however, she should receive "honor and remuneration" for her elevated work.[51]

The House as Metonym of Women's Mind and Work

The Beechers' picturesque house proceeds from a very different conception of houses as well as a very different domestic polity than Downing's. In Downing's view, typical of nineteenth-century males, the house is foremost a sedentary space of cultivated leisure and a work of visual art designed both to express and induce that cultivation. In design, it is chiefly an exterior. For the Beechers, the house is foremost a space for maternal profession, an interior whose aesthetics must embody the principles of justice, health, and the moral and intellectual growth of the family, including that of the husband and father. Except for a single illustration (Fig. 102), the exterior of their house is invisible and irrelevant. The design of the interior, moreover, expresses at several levels its redefinition as a maternal environment. Here

Fig. 102 House, Landscape, Home Scenes. Catherine Beecher and Harriet Beecher Stowe, *The American Woman's Home*.

women's most elevated work is "training . . . God's children" both for "their eternal home" and for their place in the new republic by "guiding them to intelligence, virtue and true happiness."[52]

1. *Minimizing the "Hard Labor" of Housework*. Accordingly, the first function of cottage design is to minimize the domestic labors of housework, which is the sisters' cardinal reason for making the American woman's home a cottage. "Double the size of the house," Beecher had earlier argued, "and you double the labor of taking care of it, and . . . vice versa." Few of the comforts and refinements of large houses need be given up, they argue, if the rooms are designed for multiple use and clutter kept to a minimum with ample storage space (see Fig. 102).[53]

Domestic work sites are redesigned, like industrial production lines, for maximum efficiency. Baseboards and cornices are to be made of oiled woodwork—easier to clean than painted wood. Beds are set into "bedpresses," out of sight and out of the way except when needed. Radically compressed and situated (like Downing's) at the back of the house, the kitchen is organized like a ship's galley so that the cook can reach everything in "one or two steps." Food, utensils, and even scouring powder are stored on built-in shelves or in drawers within easy reach of the moulding board, the focal point of meal preparations; and that is set, in turn, within easy reach of stove and the sink. Two windows provide adjustable light and ventilation, and glazed sliding doors mask the sight, heat, and smells of the kitchen from the rest of the house. The same principles govern the redesign of the laundry, which is shifted to the basement. To obviate the "heavy labor" of toting water in the laundry, washtubs are fitted with running water (hot and cold) and with drain pipes. Laundry lines are strung an arm's length away, on a frame equipped with wheels so that it can be pulled outside. To carry off spillage, the floor is sloped down to a drain, and to keep this work, too, invisible, the laundry is shifted to the basement.

As in Downing's cottages, the chief work of the house is given place and visibility in the family room at the front. A screen on wheels (Fig. 103), with built-in closet, serves to subdivide it, multiplying its uses. The space on one side might function, variously, as breakfast nook, sewing room, and bedroom; the space on the other side defines the family room proper. At its center, altarlike, stands a table designed not only for dining but also for the maternal ministries of education.

2. *Women as Domestic Engineers*. An efficient environment, the sisters argue, is a just environment, because it gives the new woman time and energy to follow her higher calling. A healthy environment serves that calling by providing the optimum conditions for mental and physical growth. To that end, the new woman becomes a domestic engineer committed to dispel from the house—as Frederick Law Olmsted's Central Park and Jacob Riis's new tenements are designed to dispel from the city—the disorders of darkness, overcrowding, and airlessness, replacing them with the natural tonics of sunlight, a sense of spatial amplitude, and fresh air.

In houses no less than in bodies and cities, stasis is poison. As it breathes (so their Victorian biology assumes), the human body gives off carbonic acid, product of decaying matter and other "impurities" in the blood. Inhaled, carbonic acid produces

Fig. 103
Movable Screen with
Landscape Pictures
for the Family Parlor.
Catherine Beecher and
Harriet Beecher Stowe,
*The American Woman's
Home*, fig. 4.

the symptoms Riis ascribes to overcrowded tenements and Olmsted to overcrowded city streets. Families poison themselves by their own respirations. The symptoms begin with emotional depression—a loss of vitality, a deadening of the sensibilities—and, intensifying over time, progress to states of moral insanity. Sooner or later, even the dutiful child wakes up, "hair bristling with crassness, strikes at his nurse, and declares that he . . . don't want to be good." Eventually, emotional disorders degenerate into criminal behavior. Physical illnesses are yet another symptom of carbonic acid: scrofula (from the touch of the poisonous air), diseases of the joints, eyes and ears, tuberculosis, consumption. The only antidote to these disorders—physical, psychological, and moral—is the flow of fresh air and sunlight.[54]

These Victorian medical fictions produce both real improvements in the environment of the house and a real elevation of the power of women as home-builder. Unlike any designed by nineteenth-century male architects, including Downing, the Beechers' house incorporates the best and latest of technological designs. The new woman oversees a house-wide flow technology that includes a ventilation system, central heating from a furnace with ducts, running water, and flush toilets. The self-purifying environment, Beecher argues, nurtures the naturally buoyant energies of children and makes them wholly and enthusiastically receptive to their education.

3. *Art of the Interior.* Picturesque beauty is not only "subordinate" to the requirements of justice, efficiency, and health; it also serves their ends. Yet it, too, is a crucial feature of the American woman's home. "[H]e who prepares a home with no eye to beauty," Stowe's persona Christopher Crowfield argues in *House and Home Papers,* "neglects the example of the great Father who has filled our earth home with such elaborate ornaments." Beauty, moreover, can be made to serve both efficiency and economy; since "there is nothing so economical as beauty" properly understood, Stowe restricts the budget for the beautification of the interior to less than eighty dollars.[55]

Aesthetic simplicity is as important a virtue as economy. Like the modernists who

follow her, Stowe would banish the overstuffed Second Empire parlor, with its velvet wallpaper and gold moldings; its Axminster carpets "with flowery convolutions and medallion centres, as if the flower gardens of the tropics were whirling in waltzes, with graceful lines of arabesque,—roses, callas, lilies, knotted, wreathed, twined, with blue and crimson and golden ribbons, dazzling marvels of color and tracery"; its mantel-mirrors and window curtains of "damask, cord, tassels, shades, laces and cornices" that curtain the windows and make the rooms "close and sombre as the grave"; its overpopulation of sofas, lounges, etageres, center-tables, screens, chairs "of every pattern and device." Not only is it too difficult as housework and too expensive (three thousand dollars for a front and back parlor, she calculates), but it allows "no unity of effect." The only impression it produces is that its owner is able to buy "good, handsome things, such as all other rich people get." Likewise with the Gothic "curlywurlies" and "whigmaliries" on the rooflines outside: they make the house "neither prettier nor more comfortable," and a "very ugly, narrow, awkward porch" costs twice as much as, say, five chromolithographs that could adorn the walls inside.[56]

The artist of the American woman's interior is properly the new woman herself, and her chief work in this is to produce the setting for two related narratives of personal transformation: her own self-development, as well as her elevation to the status of professional and citizen in full; and the education of the children, and the husband, to aesthetic "refinement, intellectual development, and moral sensibility."[57] Picturesque effect is both an expression and a means of her desire to make the home "happy and attractive." Like its designer, it works subtly, indirectly, a power that empowers without imperatives, toward a development of the visual intelligence. As in all picturesque art, its general effects are reiterated and intensified in every element of the design: furniture, fabrics, color, pictures on the wall (scenes-within-a-scene), and "poetic" arrangements of natural forms—visual stimulation with emotional and intellectual effects.

The picturesque interior, moreover, is a process as well as a composition. Meaning inheres not simply in arrangements of space and form, but in the ways these arrangements are produced and the uses to which they are put as maternal teachings. Both text and enactment of these teachings, the family room is the product of family labor for the common good; the family is educated not simply to understanding beauty but to creating it. Constructed by the man, the room's mostly homemade furniture, a mix of homemade vernacular and rustic, is finished and integrated into the emergent composition of the room by the women and children. The man builds the table, for example, so that it is "generous-topped" enough to allow the whole family to sit and work, or read, or write around it; the woman and children cover it with a cloth chosen, like all of the fabrics, with an eye to softening its hard lines and surfaces and integrating it into the room's color field. The finishing of the windows is particularly important to the room's "grace and elegance." Curtains of white muslin, covered by lambrequins cut in any of a variety of shapes, fringed and tasseled (complicated, that is, by picturesque lineation), soften the hard lines of the window frame, complicating its geometry with the curves of the drapery. Alternatively, potted plants on the sill and vines trained around the frame, repeating the effect, also in-

tensify the semiotics of the room. The window becomes a simulacrum of the natural scenery it frames. So does the moving screen that divides the room (see Fig. 103), when landscapes are hung on it. Constructions of the mother and children, the picture frames on the wall are, like the other furniture, rustic. Irregular branches or pine-cones or wood mosses or seashells can be glued on a flat underframe and "garnished" at the corners with acorns or the like. Vases are fashioned from wood bowls ornamented with "[d]ifferent colored twigs and sprays" found by the children on walks and glued into "fanciful network[s]."

The room's highest manifestation of beauty, the Beechers declare, is a "*harmony of color*" produced, as in all picturesque compositions, by repetition. On a color ground established by a warm, "sunshiny" straw rug and extended by buff walls, the brown-yellows of stained picture frames, the gold tones of chromolithographs, and the oiled wood of door and window frames, as on a picturesque landscape, the scenarist introduces whatever primary color (green, blue, crimson) best serves the effect she desires. The green mattress cover on the daybed, figured with a foliate motif, rhymes with green pillows, green border on the wallpaper, green window curtains, green drapery on the parlor table—which may be figured, for variation's sake, with grapes and a border of black grape leaves. The effect produced by this concertation of form and color is of a grace and beauty "far beyond what . . . expensive cabinet furniture could" achieve.

Pictures on the wall are not just part of the composition; they are chosen for their semiotic values as well. In *House and Home Papers,* Stowe is particularly interested in painting and sculpture that idealizes the *domus* and the domesticated landscape, that represents nature (including human nature), and that epitomizes the history of Western art. Near the mantel in her ideal parlor hang sculpted copies of the Venus de Milo and "the lovely Clytie" and chromolithographs of the Bay of Naples (behind the Venus) and Lake Como (behind the Clytie). Over the parlor door, lithographs of angel heads copied from Raphael's *Madonna del Sisto* are hung "to watch our goings and comings"; and a "great German lithograph" of the Madonna is hung on the wall opposite the Venus, the juxtaposition demonstrating "how Greek and Christian unite in giving the noblest type to womanhood." The room's *chef d'oeuvre* is an American landscape by a French painter, which, like nature itself, rewards study "at all hours of the day." The inhabitants of this idealized place have seen how the picture looked "when the morning sun came aslant the scarlet maples and made a golden shimmer over the blue mountains, how it looked toned down in the cool shadows of afternoon, and how it warmed up in the sunset and died off mysteriously into the twilight." Their "tower of strength" and "rallying-point of their hopes," landscape art replaces the landscape itself.[58]

In the parlor of *American Woman's Home,* too, art subsumes nature. Affordable chromolithographs and engravings from Prang, reproducing "much of the real spirit and beauty of the celebrated pictures of the world," Stowe argues, provide a particularly powerful, and inexpensive, education to visual literacy even if they do diminish art's aura. Landscapes (Bierstadt's *Sunset in the Yosemite Valley*), still lifes (Newman's *Blue Fringed Gentians*), and genre paintings (Eastman Johnson's *Barefoot Boy,* Miss Oakley's *Little Scrap-Book Maker*) supply the family with exemplars

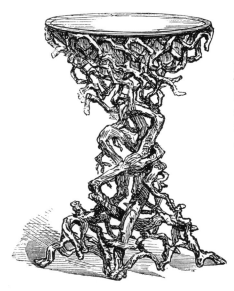

Fig. 104
Table Stand made of Tree
Roots. Catherine Beecher
and Harriet Beecher Stowe,
*The American Woman's
Home,* fig. 46.

of picturesquely beautiful scenes and incidents conducive to "eager and intelligent inquiry" and a gradual "refinement of thought."[59] In this, they reiterate the effects of the room itself.

Nature, too, adds its beauties to the architecture of the American woman's interior—but not before being transfigured, by family labor, into art. Nearby forests yield "beautiful ferns and mosses" and "tremulous grasses"; forest floors provide wind-fallen tree roots for furniture—a plant stand, say (Fig. 104)—and "colored twigs and sprays of trees, such as the bright scarlet of the dogwood, the yellow of the willow, the black of the birch, and the silvery gray of the poplar" for weavings of "fanciful net-work." Throwaways from an industrial culture may also be pressed into service, for the more eclectic combinations of forms the better. An ox-muzzle planted with plumes of fern and a border of swamp grasses becomes a coat of arms.

For Stowe, these transfigurations charge the room with magic. Ivy trained to form living window-frames, cornices, and curtains give the room the look of a leafy bower (Fig. 105). Trained to grow from behind pictures on the wall, a living beauty sprouting from a work of art, ivy makes the room a "fairyland." Planted in the sealed environment of a Ward's case, trailing arbutus or mayflower bloom unseasonably early, and "magical" fern grottoes or grottoes of shell, edged with the watery surfaces of mirrors, materialize. With mirrors at the back, these miniature landscapes extend into apparently distant chimera and are juxtaposed, perhaps, against reflected images of the viewer's face. The effects of such Ovidian metamorphoses is to establish in the minds of the children, as well as the adults, the power and mystery of artistic process, its power to make even the familiar and the domestic strange as "a nymph's cave." Teaching and at the same time stirring an active imagination, they are a part "the great design for which the family is instituted."

CODA

Although we cannot paint over the abyss of gender created by separate-sphere ideology, the picturesque cottages of Downing and the Beecher sisters seem, like Victo-

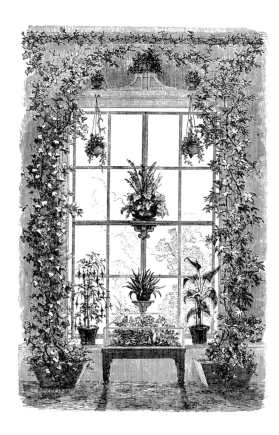

Fig. 105
Foliate Treatment of a
Window. Catherine Beecher
and Harriet Beecher Stowe,
*The American Woman's
Home,* fig. 45.

rian wives and husbands, reconcilable despite enormous and in some cases intractable differences. Superimposed on each other, they compose an outside and an inside that articulate the family as a daunting, anxious, dialogic, but also a needed and a possible arrangement between male and female that does not require the subjugation of one to the other. In each of their scenarios, the spouse contributes to the fiction of personal transformation. In each, marriage is the product of a division, but a complementary division of fictions of self-fulfillment. Both, moreover, are songs of socialized (if also socially constructed) selves: in each, the domestic interior is a metonym for the conscious and unconscious mind as it struggles to reconcile desire for self-fulfillment with an unbreachable commitment to assist other selves in this mutual struggle. Downing's new man must recognize, and through his house profess, that self-fulfillment depends upon a recognition of the dialectic between a rich interior life and a rich family life and between these and the need to act in the world. The Beechers' new woman likewise commits herself to ego-limiting labor, not in a spirit of bondage but in a celebration of the paradox taught by the Atonement: that the self discovers itself in giving itself to others—assuming it is not used up in the process, that it is voluntary, and that the others, too, are committed (or can be taught to commit themselves) to the same covenant. For all three writers, the picturesque house is a place in which "that feverish unrest and want of balance between the desire and the fulfillment of life" is "calmed and adjusted" without loss of vitality; in which both spouses, and the children with them, learn to "contribute to the entire household in refinement, intellectual development, and moral sensibility."[60] Outwardly manifested, these commitments exert an influence on "the public sensibility

and the public taste" as well as on the family. A good house, Downing argues, is a powerful means as well as a powerful expression of civilization. The Beechers could not agree more.

Disturbingly, both narratives of personal transformation assume a massive segregation by gender and ethnicity.[61] But as their appropriations by Irish mill workers and architects of tenements and of three-decker housing would indicate, the designs turn out to be more hospitable—less exclusive—than their expositors.

And disturbingly, though the ideal is rural, the product of a harmonious and unmanipulative relation between nature and art, the reality is a set of increasingly powerful urbanist assumptions. The home of "mechanics," Downing's Victorian cottage is situated in a suburbanized landscape, a world of strangers, and threatens to become a mere facade, a segmented social performance. For all its connections to the work of the nation, the postbellum house the Beechers build, also suburban, threatens to seal off the family, like a Ward's case, from social and natural environment alike. The American woman's garden is only a place for teaching children the virtues of labor for the common good, and the two piazzas included in the floor plan remain unexplored white spaces. The windows, vine-framed or curtained, occlude, as if extraneous, views of the landscapes beyond them: the reader is invited to look at but not through them. The parlor declares that art replaces as it transfigures nature. What Ellen Frank so excellently says of William Morris's Blackwell is equally true of the Beechers' American woman's home: it makes an illusion of the belief that "individuals participate [in nature] rather than view [it]." Inside, "one is as outside as one can or need be, since there is nothing more outside than the structures and renderings—the decorative projections—of one's own imagination."[62] Segregated from wilderness, the Beechers' nature is also segregated from the sanctuary of the home.

Lasting impressions [such as may be experienced in rural and small town life] . . .
consume, so to speak, less mental energy than the rapid telescoping of changing
images, pronounced differences within what is grasped at a single glance, and the
unexpectedness of violent stimuli. To the extent that the metropolis creates these
psychological conditions . . . it creates in the sensory foundations of mental life,
and in the degree of awareness . . . , a deep contrast with the slower, more habit-
ual, more smoothly flowing rhythm of the sensory-mental phase of small town and
rural existence. Thereby the essentially intellectualistic character of the mental life
of the metropolis becomes intelligible.

—Georg Simmel, "The Metropolis and Mental Life"

The Picturesque City

Urban versions of the picturesque aesthetic articulate both the subjective experience and the objective design of the American city, with New York as chief case in point. Adapting picturesque conventions, urbanites learn to read the bodies of strangers as expressions of feeling, thought, and moral character. Meanwhile, as the city itself expands northward and its suburbs onward from there, a picturesque urban architecture—with its oppositions between symmetry and asymmetry, flat and sculpted surfaces, straight line and curve—is designed to ameliorate the hard, monotonous geometries of the grid's unbending streets and rectangular lots.[1] Civic, residential, and commercial architecture all go through a succession of picturesque revival styles that parallels the succession in rural architecture: first Gothic and Italianate (with their various substyles); then Second Empire, from Haussmann's Paris, by the 1860s; by the 1880s, Queen Anne; and by the 1890s, Richardsonian Romanesque. Challenged by Beaux-Arts classicism (itself arguably shaped by picturesque values) and then by modernism, picturesque architecture participates in the vertical as well as the horizontal expansion of the city, appearing in the ornamentation of New York skyscraper architecture throughout the 1920s.[2]

THE DRAMATIZATION OF URBAN LIFE

Versions of the subjective New York emerge, as early as 1820, as subjects of literary excursions "in pursuit of the picturesque":

portraits, "pictures of society," and "incidents" of figures. The inescapable metaphor for these is that of a theater crowded with players acting out an improvised theater of the streets. The impression is intensified by verbal sketches of the streets themselves, with a growing emphasis, as in urban genre painting, on the business and entertainment zones migrating north, with the expanding city, from lower Broadway to Union and Madison Squares and then to upper Fifth Avenue.

The City as Set

As the century unfolds, the picturesque city takes shape in this literature as a fantasmagoria of monumental castles, cathedrals, campanili, given "strange, new, bizarre proportions" by gaslight and then by electricity. Fire-signs transform Broadway into the Great White Way and Coney Island's Luna Park into an incandescent dreamscape. "[C]hariots of fire" begin to streak along the el tracks, the motion of the train itself turning the city into exhilarating Whitmanesque montages. "It was better than the theater," writes William Dean Howells of a couple viewing the city from the el, "to see those people through their windows":

> . . . a family party of workfolk at a late tea, some of the men in their shirt-sleeves; a woman sewing by a lamp; a mother laying her child in its cradle; a man with his head fallen on his hands upon a table; a girl and her lover leaning over the windowsill together. What suggestion! What drama! What infinite interest! At the Forty-second Street station they stopped a minute on the bridge that crosses the track to the branch road for the Central Depot, and looked up and down the long stretch of the elevated; . . . the track that found and lost itself a thousand times in the flare and tremor of the innumerable lights; the architectural shapes of houses and churches and towers, rescued by the obscurity from all that was ignoble in them. . . . They often talked afterward of the superb spectacle, which in a city full of painters nightly works its unrecorded miracles.[3]

"Speculative Modeling": The Body as Performance

Figures in this fantasmagorical city of strangers seem equally strange and exotic. From a distance, an observer notes, they meld into the apparently uncontained energy of crowds: an "uneasy mass of black dots" that "seem to eddy, to rise and fall in constant commotion." Closer up, on "the fashionable promenade and *bon ton*" of Broadway, they present themselves, in brief and anonymous encounters, as "pictures of society . . . in all variations and degrees": "the slouching 'loafer,'" "the 'Broadway swell,'" "the successful miner, just arrived from the California diggings," "the wealthiest and most handsomely dressed lady in New York . . . out for her walk," and innumerable, unfathomable others. At night, observes the anonymous writer of "Life on Broadway" in 1878, gaslight transforms the "snug little alcove window" of a Broadway bar or restaurant into "the private box of a theatre, . . . from which the Vanity Fair outside is like a grand performance prepared for our own particular amusement."[4]

The theater he describes is intensely erotic. The Broadway *flâneur* experiences "a confliction of ecstasies" in contemplating the varieties of female beauty: "all that is dark and sensuously melting in woman flits by in a compact brunette, to be succeeded by all that is fair and heavenly in a *spirituelle* blonde. . . . Perfection seduces us one moment in the petite, and the next moment embodies herself in a voluptuous amplitude of rosy flesh," and all exude the perfume of the flowers they buy from the street stands that sell them. Their clothes, too, add the beauty of "vivid color without a suggestion of gaudiness."

But the theater is also commercial. "Most of the commodities visible," like the dresses and the flowers on the bodies of women, are also visibly displayed in store windows, which evolve, over the late nineteenth century and the early twentieth, into elaborately decorated sets designed to seduce the eye. In this strangely metonymic, vividly lit, and relentlessly superficial world, commodities seem to take on lives of their own:

> Here is a little oyster saloon with two windows. One window is filled with moist dark green moss, upon which a stock of live frogs have flattened themselves underneath the sign of "fried frogs' legs," and just inside the shop a glowing range and frying-pan are ready to finish the business for the captives. In the other window several groups of lobsters have been made by a few touches of paint to resemble card and dinner parties with such verisimilitude that we wonder why so simple and available a disguise is not used oftener in this lying world.
>
> Around another window a crowd are watching a bulbous-headed child who is demonstrating the action of a patent swing called the "Baby Walker," which has a diabolical tendency to produce some brain disease in any infant sacrificed to it. . . . Here a toy-shop window has been converted into a miniature lake, upon which tiny steamboats are puffing about, and there a pretty girl is fingering a piano-like machine which obviates the use of a pen in writing.

"The dramas which reproduce Broadway scenes," the writer concludes, "are always successful, however destitute they may be of intrinsic merit," because "the exhilaration of the reality [diffuses] itself into the pasteboard mimicry."

Dramas on the streets, including those of sidewalk vendors, are similarly charged with "the exhilaration of . . . reality."

> The eloquence of the vagabond whose commodity is small tablets of grease-erasers, and of his twin brother in humbug, the man with the dentifrice, brings a laugh to the most serious face. . . .
>
> A few years ago a precocious youngster attracted large audiences by his drawings on the sidewalk. His materials were a few bits of chalk hoarded in a torn trouser pocket, and with these he rapidly drew political and legendary characters on the flag-stones. No policeman being near, he fell earnestly to his work on his knees, and a life-sized figure soon appeared in plethoric

blotches of red, blue, and yellow. An amused crowd gathered and silently watched the swift motions of the little vagabond's hand. Whose portrait would it be? In the earlier stages of its progress every body thought he could detect Captain Kidd, but an unforeseen touch quickly dissipated that notion; then it seemed to be bold Ben Butler, and then the late Mr. Eddy as Ingomar the Barbarian. Thus exciting the curiosity of his critics, and holding a dozen faces spellbound, the artist completed his subject, working several more blotches of yellow into the legs and mixing a little brown with white over the face. It was only "a Turk," indisputably crude; but was there no zeal and cunning in its execution? We fancied that we could see both, to say nothing of the brighter light in the none-too-clean face of the artist as he rubbed the colors on the flags.

Reading the figures and performances of people in the crowd—what Charles Sanders Peirce calls "speculative modeling"—becomes a natural extension of this dramatic syntax. Peirce himself conceives of it as a kind of impromptu portrait painting: the street as atelier. On a street car,

> I see a woman of forty. Her countenance is so sinister as scarcely to be matched among a thousand, almost to the border of insanity, yet with a grimace of amiability that few even of her sex are sufficiently trained to command:—along with it, those two ugly lines, right and left of the compressed lips, chronicling years of severe discipline. An expression of servility and hypocrisy there is, too abject for a domestic; while a certain low, yet not quite vulgar, kind of education is evinced, together with a taste in dress neither gross nor meretricious, but still by no means elevated, bespeak companionship with something superior, beyond any mere contact as of a maid with her mistress. The whole combination, although not striking at first glance, is seen upon close inspection to be a very unusual one.

The woman, he concludes, straight-faced, is a former nun![5]

Meretricious as it may be, Peirce's reading is typical in the way it marginalizes exemplary types of character and behavior, such as Emerson's generation had internalized, and introduces new psychological and social types whose significance is that they are not exemplary but are massively representative of urban life and work. Walt Whitman's poem "Faces" evokes a variety of such types in its version of speculative modeling.

> The face of the singing of music, the grand faces of natural lawyers and judges
> broad at the back-top,
> The faces of hunters and fishers bulged at the brows, the shaved blanch'd
> faces of orthodox citizens,
> The pure, extravagant, yearning, questioning artist's face,
> The ugly face of some beautiful soul, the handsome detested or despised
> face,

The sacred faces of infants, the illuminated face of the mother of many
 children,
The face of an amour, the face of veneration. . . .

Characteristically of a generation in transit, Whitman's typology has verticality as
well as breadth. Figures descend from ideal paradigms to social norms to the moral
darknesses and physical grotesqueries of the lower depths:

This now is too lamentable a face for a man,
Some abject louse asking leave to be, cringing for it,
Some milk-nosed maggot blessing what lets it wrig to its hole. . . .

This face is an epilepsy, its wordless tongue gives out the unearthly cry,
Its veins down the neck distend, its eyes roll till they show nothing but their
 whites,
Its teeth grit, the palms of the hands are cut by the turn'd-in nails,
The man falls struggling and foaming to the ground, while he speculates
 well.

Where dramatic vignettes are lacking, the impulse to narratize these encounters
leads to speculative histories. In the absence of known histories, urban narrators de-
duce their own or, like the Hawthorne of "The Old Apple-Dealer," make narratives
of their search for narrative coherence. Just such a lamentable face as Whitman de-
scribes draws the narrator of Poe's "Man of the Crowd" from his comfortable, win-
dow-framed, "abstract and generalizing" view of a crowd on a busy street into an at-
tempt to piece together the secret moral history of a man whose "idiosyncra[tic] . . .
expression" evokes in him "ideas of vast mental power, of caution, of penuriousness,
of avarice, of coolness, of malice, of blood-thirstiness, of triumph, of merriment, of
excessive terror, of intense—of supreme despair." Eventually, Poe's narrator experi-
ences a recognition of his own part in the dark mysteries of urban identity, for at
its base speculative modeling like all picturesque figuration, is the expression of an
urge to go beneath surfaces ("Everything is external, and I remember my hat and
coat, and all my other surfaces and nothing else," writes Emerson in New York), be-
yond the yawning differences of class and circumstance, to discover some sense of
shared communality and shared destiny, some grounds for a social compact, in the
lives of others even if they remain strangers.[6]

Slums as Street Theater

Broadway and upper Fifth Avenue are the center stages for these improvisations, but
there are other stages as well. Both nineteenth-century urban journalists and travel
writers exhibit a marked, if also ambiguous, interest in slums and other loci of the
new immigrants, because, overcrowded and lacking sufficient commercial and private
space inside the buildings lining them, their streets are a combination of *agora* and
parlor. Offering a transparent wall through which even the familial intimacies of
strangers can be viewed, they bring out the ambiguities of Anglo-American *flâneurs,*

who are curious, but also not a little offended by confusions of public and private, foreign and familiar. The Friday market on Hester Street, for example, presents the theater of "a genuine Jewish ghetto": an *omnium gatherum* of strangely exotic figures, costumes, rituals, and vignettes.

> Here is a cart laden with grapes and pears, and the fruit merchant, a short, dark-complexioned, bearded fellow, clad as to outer garments in an old cap, a dark-blue sweater, and a nondescript pair of dirty-hued trousers, is shrieking at the top of his voice: "Gutes frucht! Gutes frucht! Metziehs! Drei pennies die whole lot.". . . Such a vendor's call is fairly indicative of the sort of jargon that passes current as the common language of the ghetto.

The writer of this sketch, a typical practitioner of what John Ruskin calls "the surface picturesque," reveals an ambiguous delight in ruin (the "dirty-hued" clothes, the linguistic ruin of "jargon") stained by racism. Unable to read beneath the surfaces, he assumes of his subject a comic ineptitude, like that in minstrel shows, for civilized decorums, including language.[7] That is one of the many signs of detachment that mark the influence of the metropolis on mental life.

In literary and pictorial slum tours, the convention of dramatic expression tends to suggest that ruin and corruption, in their various manifestations, are inherent in the subjects, a consequence of moral or intellectual inadequacies. The literature of urban reform shares this assumption, but not completely. From the *Report of the Committee on Internal Health on the Asiatic Cholera* (Boston, 1849) through such explorations as Matthew Hale Smith's *Sunshine and Shadow in New York* (1868), this literature reads disorders and deformations as caused, at least in part, by environmental disorders. Pulled out of the shadows and spotlighted (a metaphor drawn from picturesque as well as theatrical conventions of lighting), it is assumed, they will move indignant or embarrassed readers to change the conditions. A topographical sketch in Jacob Riis's *How the Other Half Lives* (a series of picturesque tours, punctuated with anecdotes, case histories, and statistics, of the Lower East Side) sketches a vista down Cherry Street in which two contrasting social orders are juxtaposed: the Brooklyn Bridge and the slums on the winding slope of the street itself. The bridge is alive with light, motion, and grace; the street has become overshadowed and ruinously overcrowded. In the descriptions of the houses, whose still-legible touches of elegance identify them as the ruins of Knickerbocker New York, present poverty is also juxtaposed against a genteel past. Brownstone steps are worn and broken; doorways and cornices rotten. In the old back gardens, a remembered repose— "arched gateway[s]," "a shady bower on the banks of the rushing stream"—is juxtaposed against the disorders of "a dark and nameless alley," a "dripping hydrant," "a horde of dirty children," and an allegorical wolf knocking, loudly, "in the troubled dreams that come to this alley." Sorrow, depression, torpor, intermittent terror: the reader is introduced to the pathologies besetting the overcrowded inhabitants of Cherry Street before a single human figure is introduced.[8] The causes Riis ascribes to these deformations—the absence of light and air, the "promiscuity" of people liv-

ing too close to each other—make his Lower East Side a macrocosmic version of the Beecher sisters' unventilated house.

Reading the slums—reading any cityscape, reform literature assumes—requires a fundamental revision of the relationship between the author and the reader of picturesque effects. Since the author of nature is God, natural landscapes are to be read for the most part the way Emerson teaches in *Nature:* acceptantly, praisefully, exegetically—as scripture. Since the authors of cities are human, cityscapes must be read above all critically, for (like Riis's Cherry Street) they can be expected to be unjust, assaultive, unhealthy, and unharmonious. Caused by humans, however, these disorders can be corrected by humans. That is as much a premise of Central Park and the picturesque brownstone as it is of *How the Other Half Lives.*

But what exactly is to be done? Enlisted into the service of reform, the urban picturesque takes on the ambiguities of American reform thinking about where the responsibilities for reform lie.[9] Ideas about the causes of urban suffering oscillate between a sense of the need for reform of the victims and that for the reform of oppressive material and social environments, between espousals of laissez-faire individualism and espousals of some form of social contract. As urban genre painting suggests, the problem can get even more complicated. Individual responsibility, limited by environmental forces, is at the same time empowered by ideologies of self-creation and success. Social criticism of the owners of slums is therefore tinged with the assumption that the victims (particularly when they are not, like Horatio Alger, Anglo-Saxon) are accomplices to their own victimization. They will do better—so goes the assumption—when they feel the pull of the American dream.

Performing Selves

That identities can be constructed not only for others, by observers, but also discovered within the self as a moral core to which the public self should be consistent is a premise of the picturesque city in its early stages of evolution. That goodness must be camouflaged is a premise of its middle stages. That to achieve visibility (to become known), selves must be self-constructed—flaunted even—in moral public performances is a premise of its late stages, after, say, 1880. In a world of strangers, as Philip Fisher shows, identity is measured increasingly by visibility, and that is achieved by braggadocio performance, outlandish, speeded-up, larger than life—like the persona of Mark Twain as William Dean Howells describes it. Dense, teased hair pulls dreamlike against the symmetries of Twain's public face: a red "crest" crowns it; a "flaming mustache" makes a "wide sweep" across it. Twain habitually wears a sealskin coat, shaggy fur-side conspicuously out, so that it seems to take on a life of its own: a walking metonym. It (not Twain) "sent the cold chills through me," Howells confesses, "when I once accompanied it down Broadway, and shared the immense publicity it won him." Twain's "relish for personal effect," he adds, also announces itself "in the white suit of complete serge which he wore in his last years, and in the Oxford gown which he put on for every possible occasion and said he would like to wear all the time." "We might describe the years between 1890 and 1910," as Fisher so appositely and understatedly adds, "as a series of experiments of

a highly visible structure of identity under the new circumstances of conspicuous performance."[10]

Conspicuous performance does not encourage spectators; it requires them. "No role exists," Fisher observes, "unless it is honored like paper money in the eyes of others who must, in order to validate my role, not simply approve or permit, but enact a complementary role. They must become co-performers. . . . Without the co-performers no one is anything at all." Hence the public setting of the street, with its adjacent network of windowed interiors that are themselves display.

In the performances they witness, moreover, spectators are not only entertained, but also educated to the performances required for entrance into the desired social worlds of the city. Every action, every ritual, of the insiders is to be absorbed. Dreiser says of Drouet in *Sister Carrie,* Fisher observes, that he "fairly shone in the matter of serving" dinner in his fashionable saloon—a public demonstration of a private ritual:

> He appeared to great advantage behind the white napery and silver platters of the table and displaying his arms with a knife and fork. As he cut the meat his rings almost spoke. His new suit creaked as he stretched to reach the plates, break the bread and pour the coffee. He helped Carrie to a rousing plateful and contributed the warmth of his spirit to her body until she was a new girl.

The public performances of the street and its adjuncts reflect and even foster, Fisher concludes, a self "preoccupied with what it is not," or not yet—a self whose actions have been reduced to mannerisms. The performing self "is not a sham, but rather a form of practice," a self-fulfilling prophecy of the self the actor wishes to become. Beneath these studied surfaces, moral character, if it still exists at all, turns opaque.[11]

AN ARCHITECTURE OF URBAN REFORM

After 1840, the construction of the picturesque city unfolds coterminously with the construction of urban identity, and it, too, is moved in part by a spirit of reform.[12] For Frederick Law Olmsted, one of the most audible and articulate advocates of the picturesque city, the grid is doing to New York as a whole what overcrowding is doing to Riis's Lower East Side. Its uniform 25- by 100-foot lots, designed to facilitate the "intense intellectual activity" of the libraries, workshops, and counting-rooms of the commercial city and the paths between them, reduce architecture to ungainly oblongs, narrow, high, deep, and devoid of "pleasing or dignified proportions." The residential city also suffers. Badly ventilated in the absence of side windows and back doors, the urban town house is permeated by smells of garbage and of water closets, fetid and dark. The resultant "irritation and waste" of vitality, Olmsted argues (like Riis and the Beecher sisters), "very seriously affect the mind and the moral strength."[13]

For another thing, gigantic leaps in the scale of commerce, concurrent with the population increase, have made the streets outside too congested even to serve their

utilitarian purpose. The streets are famously choked with heavy traffic; curbstones impede the efficient transfer of goods from vehicles to warehouses; and sidewalks—even when widened by the removal of trees and other street furniture—are still too narrow for the flood of pedestrian traffic. The traffic pollutes, the pollution hangs in the narrow streets, and here, too, as in their ill-ventilated brownstones, city dwellers breathe in "highly corrupt and irritating matters" that "vitiate all our sources of vigor."

For Olmsted, the psychological effects of this constricted and unventilated space are as critical as its effects on health. Overcrowded, New York's streets not only sap strength but also harden feelings. The experience of encounter gives way to "street contact," where "merely to avoid collision . . . we have constantly to watch, to foresee, and to guard against [the] . . . movements" of strangers. Minds are "brought into close dealings with other minds without any friendly flowing toward them." On the streets of working-class neighborhoods, young men lounge, spectators in an unspectacular world, rudely obstructing the sidewalks for people they do not know and for whom they have no respect. Nothing in their demeanor speaks of delicacy, manliness, or tenderness. Presently they descend to the merely "physical comfort" of a dark basement saloon.[14]

The hardness of the streets is mirrored and intensified by the social environment of the commercial zone, with its "excessive materialism[,] . . . loss of faith and lowness of spirit." Compounding the effects of badly designed homes, the marketplace and its ethos produce "vital exhaustion, nervous irritation and constitutional depression." The middle class, Olmsted declares, is "wearing itself out with constant labor, study, and business anxieties." But anomie is not the only problem. Obstructing citizens' rights to the pursuit of happiness, "the selfishness of individuals or combinations of individuals" fills urbanites with an Ishmaelian spirit of unrest. The lower classes are angry, and the middle class is in flight to other cities or to emergent suburbs. Between 1861 and 1862, Olmsted notes, about 30 percent of the "more substantial class" of merchants and tradesmen and 60 percent of small dealers disappeared from the directory of San Francisco. The interest of this class in permanent improvements to the city, he argues, echoing Downing, "differs but little from that of strangers or mere sojourners." Nothing in American cities encourages or nurtures roots.[15]

What is to be done? That is the question for which several versions of the picturesque city provide partial answers.

"Diversities of Ecclesiastical Architecture"

For the civic architecture of the picturesque city, the answer is to supply a monumentality lacking elsewhere in the city until after the war. Gothic Revival emerges as a style adaptable to jails, college buildings, art galleries, museums, railroad stations, and bridges like Brooklyn Bridge as well as to the rural cottage and villa. Above all, it is appropriate for urban churches, the centers of parishes and neighborhoods. To the restrained classicism of American church architecture, Gothic towers, spires, arches, and buttresses add a sense of "the numinous, of soaring verticality, of mystery." The style's allusions to post-Reformation England as well as to Catholic

Fig. 106 Richard Upjohn, Church of the Holy Communion, New York (1844–45). From Robert Dale Owen, *Hints on Public Architecture.*

Europe, moreover, make it the perfect visible expression of a social environment amenable to "every inward type of Christian character and experience."[16]

In typically picturesque fashion, Upjohn's Church of the Holy Communion, 1844–45 (Fig. 106), derived from Pugin's designs, invigorates its expression of Episcopalian theology with an orchestration of opposing visual forces that invigorates the cityscape as well. Its shape is a bold cruciform; its high-pitched, sharp-angled gables, a dramatic departure from the low profiles of Congregationalist churches, are anchored by a landscaped churchyard that give it the look of a rural interlude in the business life of the city. Its transept, an "aggressive" variation on the traditional porch, Pierson observes, is complicated by a round (rather than pointed) window over the door, but the window has the effect of softening the vertical thrust of a thin tower.[17]

As St. Patrick's Cathedral attests (Fig. 107), the "Catholic Gothic" style of German- and Irish-American parishes after the war, a design also indebted to Pugin, distinguishes itself by a soaring verticality that pulls against the horizontal amplitude of Broadway. Typically, it is built of brick or stone to signify the rock on which it is founded. Inside, its massive naves declare (and accommodate) populous congregations. Gothic ornament, color, dramatic lighting, iconography (statues, stained-glass windows, the stations of the cross), and a raised altar with a monumental reredos are all designed to intensify the dramaturgy of the mass.

The interiors of "Presbyterian Gothic," by contrast, accommodate a liturgy of the Word. Pulpit, communion table, and organ are set on an oval platform from which curving banks of pews rise upward as they recede. Placing the minister below his congregation and its presbyters, this composition also situates readings and interpretations of scripture at the center of the service. An ornamentation more abstract than that of St. Patrick's—stained-glass Gothic windows in nonfigural patterns; pointed

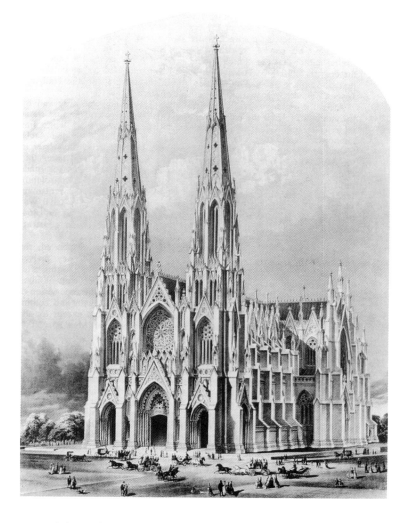

Fig. 107
Ames Renwick,
St. Patrick's Cathedral,
New York, c. 1877.
Lithograph. From
Jay Stiner, *The New
Cathedral.*

roundels with traceries on the pews—confirms the iconoclasm of Presbyterianism's post-Reformation English past.

Residential Facades

The picturesque designs that Samuel Sloan and other architects of urban houses offer in their pattern books are likewise designed to ameliorate, though less monumentally than churches, the city's monotonous and interminable lines of residential boxes with their enjambed facades. Like the rural cottage, the town house passes through a succession of picturesque styles, but its situation precludes the three-dimensional approach to complexity worked out in rural architecture. On the exterior, picturesque treatment is limited to the facade alone—and an incongruously narrow facade at that, as the Runyon W. Martin House demonstrates (Fig. 108). Standing alone, it looks like it has been squeezed into a blocky oblong by a vice. Only in the block-long and thus freestanding mansions of Fifth Avenue can visual complexities be multiplied three-dimensionally to the point of risking "confusion or disagreement." Only in the facades of middle-class houses—unlike many row houses, where simplicity rules because it is cost-effective—is the decorative impulse indulged,

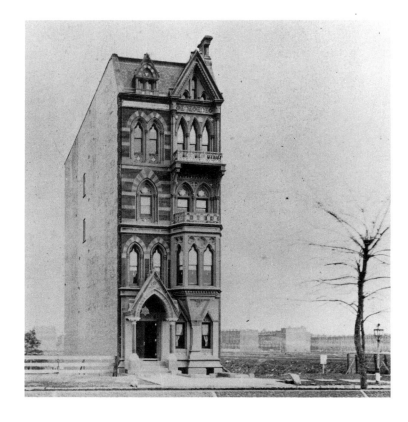

Fig. 108
Runyon W. Martin
House, Fifth Avenue
and Sixty-third Street,
New York, c. 1869.
Jacob Wrey Mould,
Architect. The New-York
Historical Society.

and here the artifices of urban life allow a freer play. The ornamental effects of the single urban townhouse are amplified by block-long enjambments that, like Scott's picturesque suburbs, sometimes assume a purposeful harmony but more often display, like the crowds on Broadway, the unruly energies of eclecticism. "The variety of architecture," observes the writer of "Life on Broadway" in 1878, is both "brilliant and ragged."

> Every material has been used in every style—brick, iron, glass, marble, granite, brown stone, yellow stone, wood, and stucco. Small, modest dwellings of a much earlier period, with old-fashioned dormer-windows projecting from the upper story, and modern plate-glass show windows inserted in the lower story, are threatened with suffocation by buildings twice or three times their height.
>
> The Sierras are not more serrated than the cornice lines of Broadway, and the effect is not at all satisfactory to an artistic eye. Sign-boards hang out and flag-staffs rise from nearly every building.[18]

1. *Gothic and Italianate Revivals.* Even in the early styles of picturesque revival, the materials and the pull of urban formality encourage a sculptural approach to the ornamentation. As the Martin House demonstrates (Fig. 108), the roof, however narrow, might still be broken by an attenuated Gothic dormer. Eaves (where used) can be stoutly buttressed for dramatic effect. Major incidents on the facade, windows (frequently bayed or bowed) are carved with dressings and even flanked by columns slightly flattened, like bas-relief. The doorway, chief incident in the composition, is

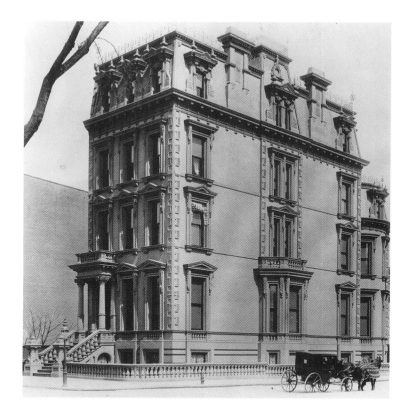

Fig. 109
J. A. Bostwick House,
Fifth Avenue and Sixty-
first Street, New York
(before 1895). Museum
of the City of New York.

given a hooded porch or even (increasingly) an elaborate sweep of stairs railed with balusters and newel posts to formalize the rituals of entrance and departure. The more popular Italianate styles, emphasizing Tuscan and Venetian over Roman variations, celebrate what Sloan calls the Italian "partiality for fenestration" with huge glassed-in arches crowned by graceful curves and, perhaps, triangular chevrons that repeat the shape of the roof. Like the Gothic, Sloan observes, Florentine architecture has a "strong, massive, gloomy" effect—congruent with that of the black business suit—and even the windows are masked.

2. *Second Empire*. The tall windows of the Second Empire style and the top-hat shape of its mansard roof give it an inherently urbane formality (Fig. 109). When domestic architecture balloons, after the war, into the freestanding form of the apartment building, that, too (like its commercial counterpart, the department store), is inspired by Haussmann's Paris. Massive in height and volume, this construction gives such full play to the effects of energy that it recalls its baroque progenitors. On all four sides, asymmetrical bays and other bold projections worry the proportions of the central mass. Classically framed doors and windows bristle with columns and pediments in bas-relief. Facades erupt with pilasters and columns or, in smaller buildings, with arabesques of cast-iron grillwork like those of Haussmann's apartments, and powerful assertions of bracketed cornices at the top of the walls introduce the climactic upswooping curve of the mansard.[19]

3. *Queen Anne*. In the right hands, the Queen Anne style of the 1870s and 1880s restores to urban, as it does to suburban, architecture the play of form, space, and light

that characterizes American picturesque architecture structurally. But in its unbridled relish for effect, it tends toward excess and incongruity: a "fortuitous aggregation of unrelated parts": a *briccolage* of "domes and mansards, pilasters and pinnacles, urns, balconies, and balustrades appropriated (in Montgomery Schuyler's words) "from the slums of the Rococo"; and at its most extreme, a hodgepodge (as Gowans adds) of Renaissance Italy, Gothic Flanders, Elizabethan England, and the Near East. Rooflines are festooned with manic, cast-iron gingerbread; windows and doors, with jigsawed equivalents (Fig. 110). Color runs riot. Gray stonework is juxtaposed against polished red brick; green and purple roof tiles against fern green shingles that leap into shades of "chocolate, mahogany, and rust." [20]

This revival of Queen Anne's revival of early Britain, as Jackson Lears has shown, is not as innocent as it seems. Fantasies of a return to the spare coherences of Anglo-American beginnings—a medieval landscape untroubled by modernity, a post-Reformation England untroubled by Catholicism—they betray the anxieties of the Anglo-American ascendancy in the face of an immigration now transforming nineteenth-century American cities and their culture. Paradoxically, however, Queen Anne also presents itself, like its urban inhabitants, as a quintessential urban performance. Like Twain's sealskin coat and flaming mustache, its lines and surfaces shout their clamorous, competing appeals to the stranger's eye.

Fig. 111
Samuel Bayne House,
Riverside Drive and
108th Street. From
*A History of Real
Estate, Building and
Architecture in New York
City* (1898).

4. *Richardsonian Romanesque.* After such excess, the only possible direction lies in the direction of restraint. In Henry Hobson Richardson's revival of the Romanesque style, the final stage of picturesque domestic architecture, the house becomes solid again. Richardson radically limits the multiplication of masses for visual effect, recalling Upjohn's strategies in the King Villa (see Fig. 76), and in the process thus restores unity of effect. The house is anchored firmly by stone foundations and given its massive monumentality by means of a *porte cochère*, long verandas, deep archways (patterned after Louis Sullivan), and square towers that echo the form of the campanile. In his fierce impulse to simplify, Richardson limits ornament chiefly to texture and color; so do his followers, as Frank Freeman's Richardsonian house on Riverside Drive (Fig. 111) suggests. Rustication makes the stone walls undulate, and colors (a black-tiled roof, yellow brick walls relieved by red sandstone moldings and casements) make it vibrate, but formal ornamentation is limited to a simple floral motif running along the edges.[21]

But the semiotics of Richardson's architecture, too, are also blurred by nostalgia and compromised (in hindsight) by their appeal to the early stages of yet another empire, the Roman. To modernists like Lewis Mumford, this makes them shockingly anachronistic. The "doses of exotic architecture which Richardson and his school sought to inject into the American city," Mumford would declare in 1922, a long way from that perfect congruence with contemporary habits and modes of thought which was recorded in buildings like Independence Hall. They "were anodynes rather than specifics": escapes "from industrialism into a culture which . . . has the misfortune to be dead." For Mumford, it is precisely the functional geometries of industrial buildings that modernist architecture should emulate.

Almost down to the last decade the best buildings of the industrial period have been anonymous, and scarcely ever recognized for their beauty. A grain elevator here, a warehouse there, an office building, a garage—there has been the promise of a stripped, athletic, classical style of architecture in these buildings which shall embody all that is good in the Machine Age: its precision, its cleanliness, its hard illuminations, its unflinching logic.[22]

Ironically, the restoration to architecture of a richer play of symbolism gets left, after half a century of modernist "cleanliness," to postmodernism's rediscovery of the picturesque.

Interiors

Nineteenth-century domestic interiors are also designed as compensations for monotonous streets. Time was, Cornelia Randolph writes, "when a few favored individuals possessed what was called a garden in the interior city," but because row houses make that impossible ("the flower, vanquished, retreats before the building stone"), the only possibility left is "a little gardening in your room." In Randolph's rooms, real flowers produce imagined landscapes in a "succession of effects" that make them homologues of the picturesque landscape garden. All of the garden's scenic zones can be reproduced, in miniature, in the parlor. A miniature Claudian vista emerges on a ground of passion flowers, mandevillea, and wood pink, say; its center, violets flanked by yellow flowers arranged on a trellis, with a sidescreen of tree-shaped mignonettes. Pimelias on a bed of cape heath form its foreground, and an elegant camellia its middle ground. Flower-stand gardens mirror the architectural formalities of the parterre. And that most picturesque of surfaces in nature, the riverbank, takes shape, on a mantelpiece or *étagère,* for example, in a bank of crocuses (white, violet, white with violet stripes) and jonquils in "the brightest shades of blue, red, and yellow," some planted in hidden pots, others afloat in water, and interspersed, perhaps, with yellow-bordered red tulips.[23]

Geographical variety can also be represented florally, making the room an epitome of the whole natural world. Profuse masses of myrtle, orange, rose laurel, and pomegranate, interspersed with chrysanthemums, reproduce a tropical landscape; aquatic plants around pool-like pieces of mirror in an aquarium, an Amazonian landscape. Cactus surrounded by stapelias (star-shaped and rough-haired, with thick, fleshy flowers), stonecrop (with its tilted stalks, golden star-shaped flowers, and little green "ecrescences elegantly set into one another"), and ice plants reproduce desert scenery.[24]

Like these floral arrangements, Queen Anne interiors are fashioned aggressively, not a little outlandishly, and with a busyness that worries every line and texture. As in David Belasco's anxious cocoon of a den (Fig. 112), every antimacassar, every tablecloth and wall-hanging, gets fringed. Bric-a-brac swims the wallpaper's bilious seas. Colors and shapes run riot. Colored light may be made to stream through stained-glass Pre-Raphaelitisms—from pageantries to pale lilies—and splash across parti-colored Oriental rugs.[25] Even interiors end up as extravagant sets for extrava-

Fig. 112 Joseph Byron, The Den of David Belasco, 247 West Seventieth Street, 1894. The Museum of the City of New York.

gant performances or fantasies, as if there were no longer any self of all the other selves to find a place for.

Presenting the Contents of Interiors:
Commercial Architecture as an Art of Display

In commercial business districts, meanwhile, the picturesque irregularity of Gothic, Norman, and Italian revivals provides an early solution to the needs of a modern commercial architecture. "The flexibility which the Norman and Gothic manners possess," Robert Dale Owens declares in *Hints on Public Architecture* (1849), "the facility with which they assume whatever external forms may be suggested by interior purpose; the easy freedom with which they lend themselves, as occasion requires, to amendment or addition; all these are essential conditions, in an Architecture that is . . . to attain, in our utilitarian age and in our matter-of-fact country, to the character of national."[26]

But it is Italian Revival styles that dominate commercial architecture before 1860, because of the solutions they offer to a distinctively American set of commercial design problems. To draw eyes to the interior, the urban store has to draw to itself the eyes of strollers. To make their functions intelligible in a world of strangers, Sloan declares in his *City and Suburban Architecture* (1859), storefronts must (like ruins) "display the contents of the interior." But the grid imposes on stores, as on houses,

Fig. 113 (left) Italian Revival storefront. From Samuel Sloan, *City and Suburban Architecture.* Design XVIII. Fig. 114 (right) Second Empire storefront. From Samuel Sloan, *City and Suburban Architecture.* Design XXIII.

a boxy sameness. The building's narrowness, moreover, "precludes all possibility" of drawing attention with disturbances of its "general outline"—that is, with wings, bays, and other picturesque projections—and its enjambment against other stores precludes the attractions of landscaped grounds. Like urban personae, the store's "whole attraction" depends on the ornamentation and color of its facade.[27]

What makes Italian Revival style especially suitable for exposing interiors to the street, Sloan argues, is precisely its "partiality for fenestration." It accommodates groupings of arched windows that progress like a colonnade across "almost the entire facade," opening the interior to the public gaze and at the same time furnishing the facade's "principal external ornamentation" (Fig. 113). As store designers discover between 1850 and 1910, interiors can then be arranged, like geometric gardens, into a succession of vistas (aisles) and intimate close scenes (window dressings, counters, screened boccages) in which artfully packaged products become their own advertisements: buyable props in a elaborate commercial scenery.[28]

The reduction of window columns to "a mere means of decoration" is made structurally possible by the new technique of balloon-frame construction. No longer weight-bearing, the arch and column can now be used exclusively for the visual force they add to the facade. Ornamentation gives the facade "as much . . . lively warmth and gayety of expression as is admissible in a structure devoted to the purposes of traffic." The columns present their sculpted surfaces "successively" and with "changeful aspect[s]" to strollers who, drawn to these, are then drawn to the goods

presenting themselves in the glass interstices. On the upper floors, the piers gradually widen "as the necessity for extended openings diminishes," and this vertical succession climaxes in a bracketed cornice that bespeaks the strength of the walls as the style itself bespeaks the power and glory of the merchant-princes of Renaissance Italy.[29]

But exponential increases in the scale of commercial architecture after 1860, requiring more potent visual gestures, soon render Italianate subtleties incongruous. On the block-long cast-iron facade of A. T. Stewart's second department store (1862), a contemporary observes, stately Italianate ornamentation comes off as too light and too mild to mask the building's aggressive functionalism.

> It bears all over it an evidence of cheapness, especially when we observe it is of iron . . . a cheapness which comes from the desire to save pattern-making, in all probability, not more than six patterns were required to cast the several thousand tons which are put in this great iron wall.
>
> There is nothing inside of this store except iron columns, all cast from one pattern and no end of plaster-corniced girders, save the great cast-iron well-hole over the glove counter with its bull's eye skylight above. This is a perfect mine of wasted iron.[30]

Italianate architecture retains some of its attractiveness even in the vertical city. Indeed, the campanile becomes a prototype for the New York skyscraper. In the Metropolitan Life Tower (1909), for example, references to St. Mark's in Venice not only make the tall building possible but declare in the process, as Goldberger observes, the company's stability, as if the virtues of the past have "somehow been passed along to it"; as if this modern corporation were "not merely a guardian of culture," but a "possessor"—even, as its scale implies, a controller—of it.[31]

But for most urban Americans after 1850, the allusions of the Second Empire style to Louis Napoleon's Paris give it a more contemporary semiotics of power (Fig. 114). Its strong classical assertions are meant to suggest the inherent rationality, and the monumentality, of the commercial enterprise; and its upscaled colonnades, pediments, niches, its elaborately sculpted entrances and show windows, add the kind of performative energy required for visibility. On the more modestly scaled McCreery store, on Broadway between Eleventh and Twelfth Streets (Fig. 115), the ornamentation—and the performance—is less strident. Three-quarter sculpted columns and arches give the facade a weight and a three-dimensionality lacking in A. T. Stewart's store, and a mansard picturesquely complicated by dormers and lacy ironwork characteristic of Baron Haussmann provides a striking top hat.

By the 1880s, even moderately-scaled Second Empire commercial architecture is complicated by more ebullient eclecticisms: various, contrastive, exotic, clamorous, filled with movement and with the apparently random coherences of the *assemblage*—just like the commercial district in which they are located. On Hugh O'Neill's store (built in 1875 on Sixth Avenue near Twenty-first Street), rounded five-story towers at each corner, Boyer observes, are capped with "bulbous Byzantine domes," and a center pavilion is capped by "a sculpted pediment supported by a great bracketed

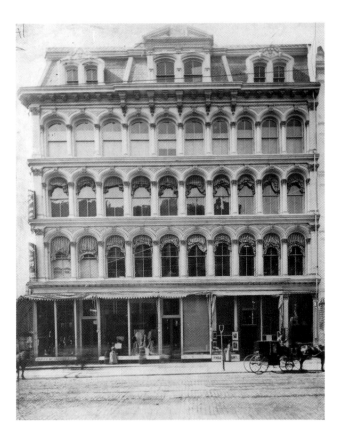

Fig. 115
The James McCreery and
Company Store, Broadway
between Eleventh and
Twelfth Streets. Photograph
c. 1890. The New-York
Historical Society.

cornice." The dramatic effect of the skyline is intensified, a contemporary observes, by a "striking" novelty "in color": "a coating of yellow with black lines and brown trimmings." "It is something to have any relief from the browns and stone or red brick of New York City," the observer adds, but the commercial logic of the color is also clear to him: "yellow can be seen farthest." [32]

CENTRAL PARK AS PICTURESQUE ART

> The work of design necessarily supposes a gallery of mental pictures, and in all parts of [Central Park] I have constantly before me, more or less distinctly . . . a picture which as Superintendent I am constantly laboring to realize.
>
> —Frederick Law Olmsted, Letter of 1861

For Olmsted, the picturesque park is yet another amelioration of the hard monotonies of the commercial city. Unlike Samuel Sloan's, Olmsted's picturesque city does not seek to reclaim the civic or commercial zones. So far as he is concerned, work spaces for laborer and businessman alike are unredeemably utilitarian. Built (like kitchens in the picturesque house) as solutions to problems of production, they are situated, for the sake of convenience, near their sources of capital, supply, and transportation—"a bank . . . the Corn Exchange . . . shipping, . . . shops or manufactories"—and are well served by the grid, which acts to "make all parts [of the city] . . .

equally convenient for all uses," though usage and coherence require a central Great White Way like Ladies' Mile.[33]

What one might call Olmsted's book of the picturesque city consists of plans for transforming Brooklyn, Staten Island, and Queens into middle-class residential neighborhoods like upper Manhattan—a city defined (like Downing's houses) by leisure, not by work. Residential zones require wholly different kinds of space and architecture.[34] Neighborhoods, Olmsted argues, take shape around churches and other establishments in the picturesque city that "minister to their social and other wants," and the chief of these wants, the chief source of well-being, so far as Olmsted is concerned, is just that "free air, space and abundant vegetation" obviated by the grid.[35]

Olmsted celebrates the emergence of a picturesque domestic architecture such as Sloan presents. "Let your buildings be as picturesque as your artists can make them," he declares. "This is the beauty of the town." He also celebrates the enlargements of Broadway and Fifth Avenue into boulevards offering, like those of Baron Haussmann's Paris, spaces "open to the sun-light and fresh air" and filled with a variety of engaging urban scenes—now the vista of the street, with its traffic, its sidewalk theater, and its intermittent islands of foliage and sculpture (Union Square, Madison Square); now the close scenes framed by the store windows of Ladies' Mile and of upper Fifth Avenue. But the chief source of light and air and "the one thing you cannot get in buildings"—even in picturesque buildings or even, sufficiently, in boulevards alone—is openness. What he would add to the picturesque city is "the beauty of the fields, the meadow, the prairie, of the green pastures, and the still waters." Central Park and other urban parks become at once the veranda, the promenade, and the "lungs" of Olmsted's residential city.[36]

An enlarged version of Cornelia Randolph's foliage-filled urban apartment, Olmsted's Central Park is also thoroughly picturesque in its design. It applies the values of complexity, variety, and contrast to the design of all of its constituent forms and scenes, and to their "poetic"—which is to say, symbolic and narrative—effects.[37] Each of the park's multitude of scenes is scrupulously designed, like a theatrical set but without "undignified tricks of disguise," to achieve the effects of openness by means of terrain, water, foliage and architecture, and congruent "modes of arrangement"—that is, mise-en-scène.[38]

Pastoral, Picturesque Sylvan, and Architectural Scenery

Like Montgomery Place, the park is divided into what Olmsted calls "pastoral," "picturesque sylvan," and (by inference) architectural scenery—a zoning strategy well suited to the "heterogeneous character" of the terrain in the park's lower half, on which I wish to concentrate (Fig. 116).[39] This landscape features an "irregular tableland" in its central and western parts with a series of meadows on which "the light falls early and the shadows are broad," and trees have "plenty of room to stretch out their limbs." By contrast, the terrain of the upper central and eastern parts of the Lower Park is relatively flat and even; and that at the upper end, contiguous to Fifty-ninth Street, is "much broken," with "picturesque rock defiles," "several rocky

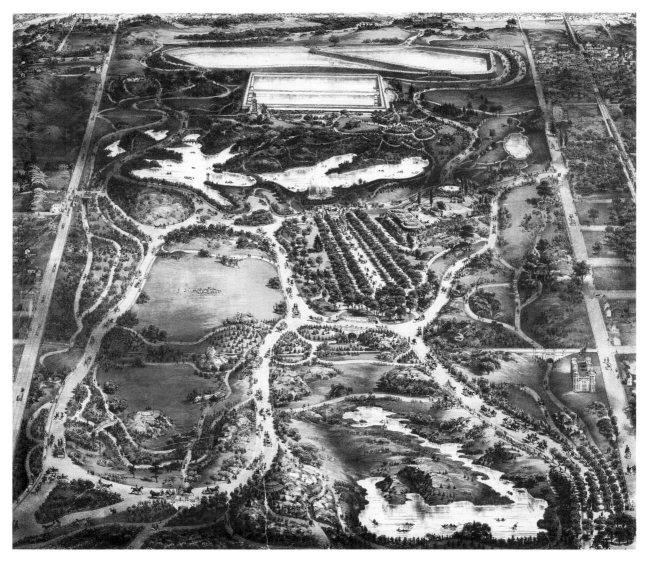

Fig. 116 John Bachmann, *Central Park,* 1863. Lithograph. Map Division, The New York Public Library. Astor, Lenox and Tilden Foundations.

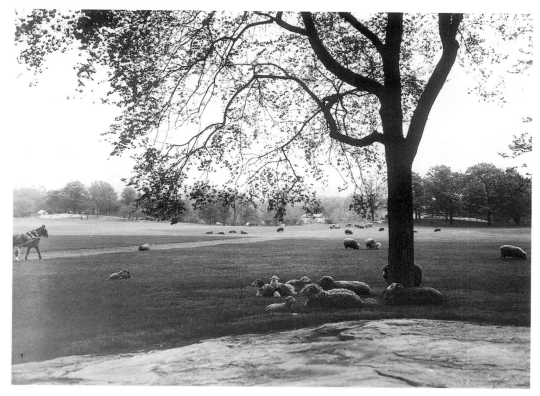

Fig. 117 Anonymous, *Sheep in Central Park*. Photograph. Library of Congress, Prints and Photographs Division, Washington, D.C.

bluffs," a ridgeline, and thickly planted foliage all "bent and mingled together" in "a profusion of lines and colors and lights and shades."[40]

Meadows become the centerpieces of the lower park's pastoral zone (Figs. 117 and 118). Here Olmsted seeks to induce effects of "tranquillity and rest" by appropriating "the three grand elements of *pastural landscape*": hills planted with trees, a lake constructed to vary the effects (Fig. 119), and open meadow or "greensward" that includes the Ballground and the Parade Ground (subsequently the Kinderberg and Sheep's Meadow), with trees "standing singly or in groups, and casting their shadows over broad stretches of turf, or repeating their beauty by reflection upon the calm surface of pools."[41]

The effect of tranquillity, Olmsted argues, depends as much on "the manner" in which the meadowscape is laid out and presented to the stroller's eye as on the furniture of foliage and water. He attaches particular importance to framing the pastoral scenery into vistas whose expansiveness creates the "*sense of enlarged freedom*" that attends the feeling of tranquillity. Trees planted in small groups and screens in the meadowy middle ground expand the visual illusion of distance (and thus the feeling of freedom) and at the same time produce a "haze of shadows" that softens and blends distant forms with a "pleasing uncertainty and delicate, mysterious tone." Claude Lorrain's solution for the background of the vista was a rough mountain terminus, an amphitheatral enclosure to the scene; Olmsted's is the hill named Vista Rock, but the effect is the same. It, too, walls off the world beyond, leading the

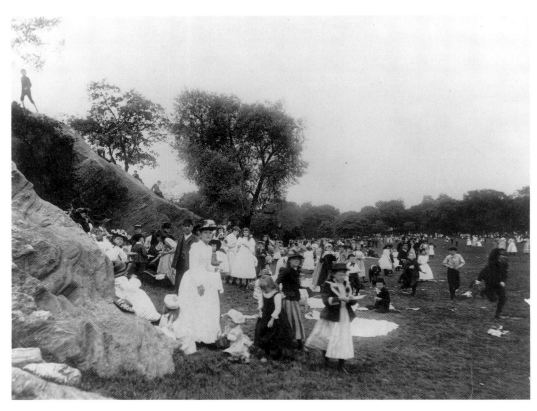

Fig. 118 J. S. Johnston (?), *May Parties in Central Park*, c. 1894. Photograph. The New-York Historical Society.

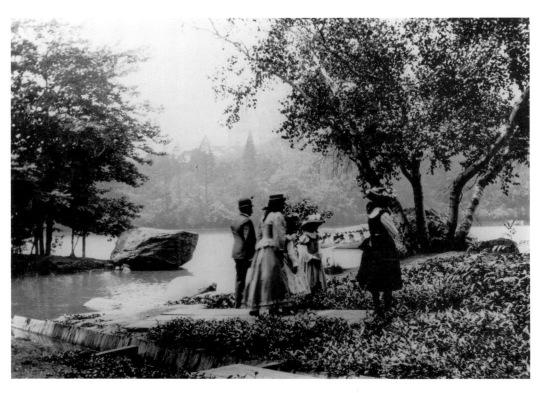

Fig. 119 Anonymous, *The Lake at Central Park*. The New-York Historical Society.

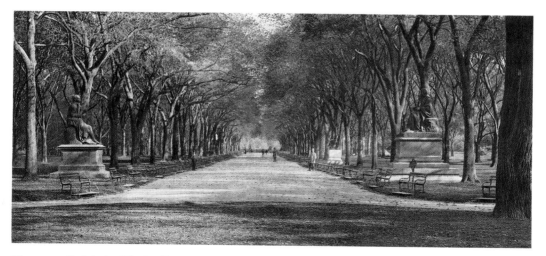

Fig. 120 G. Schulz, *The Mall, Central Park* (n.d.). Photo-engraving. The New-York Historical Society.

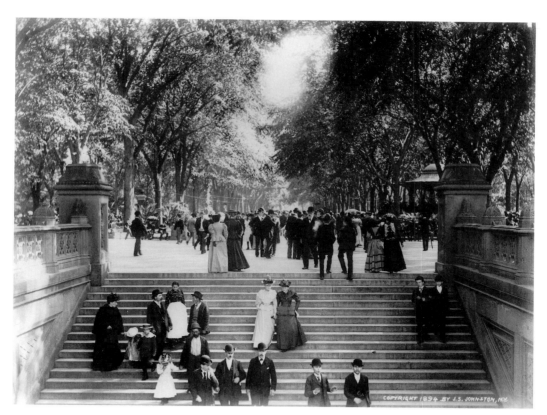

Fig. 121 J. S. Johnston, *The Mall, Central Park, Looking South from the Staircase*, 1894. The New-York Historical Society.

viewer into the depths of the blue sky. In its "soft, commingling lights and shadows and fading tints of color," the imagination is encouraged to extend the vista's pastoral arrangements "indefinitely" into a repose without apparent end.[42]

The rest of the lower park, given over to "contrast and variety of scene," is nevertheless "confluent to . . . the constant suggestion to the imagination of an unlimited range of rural conditions." On the flattest terrain, Olmsted builds the scenery of an architectural zone that replicates the scenery around a rural villa without the villa itself. Effects here run to polish, "grandeur and magnificence"—though on a limited scale "commensurate with the size of the park." Lined by double rows of elms planted with classical symmetry, the Mall (Fig. 120) serves the scenic function of a "hall of audience" to the imaginary villa, and around it various other scenic spaces are configured like "rooms, corridors and passages": a "driving room, riding room, walking room, sitting room, skating, sailing and playing room," a music room, even a dining room (in the form of the Ladies' Restaurant)—all (except the restaurant) constructed with foliate walls, ruglike parterres, fountains, and other architectural furnishings.[43]

Here as elsewhere in the picturesque city, the scenery is designed to affect not only a softening of feelings, but also (out of these feelings) more civil forms of urban behavior. Architectural scenery, Olmsted argues, has the social functions of a "dressing ground," or promenade, offering, as on upper Broadway and Fifth Avenue, the "human theatre" of strolling crowds in which "the position and movements of each person" become parts of the spectacle (Fig. 121). Therefore "[i]t is desirable that there should be a continuous movement of all engaged [to facilitate social encounters and to create] . . . the enjoyments which are special to the promenade. The more the movement of each person is regulated with reference to the enjoyment of all by fixed conditions, and the less by the constant effort of his individual judgment; the more the vision of each over the promenade before him is unobstructed, and the more complete and extended his command of the spectacle, the greater will be the enjoyment of all."[44]

The broken ground north of the Mall becomes the Ramble, a forest scenery in "*strong contrast*" to the Mall's architectural niceties. Accommodating, as its name suggests, the movements and rituals of the contemplative stroller—the *penseroso*, dreamer of green thoughts in green shades—it is constructed with a sylvan "furniture" of running streams, waterfalls, defiles through broken walls of rock, trees in complex groupings, and a "wild intricacy of low growing foliage, especially on broken and rock-strewn surfaces" (Fig. 122). Paths, unpaved and narrow, seem to wander aimlessly through a continuously shifting sequence of forest scenery as they follow the climbs and dips of the ridgy terrain (Fig. 123). Forks in the paths disperse the strollers, and turns screened by foliage erase them from each other's view.[45]

The scenery continuously invites the viewer to sit as well as stroll. The most typical frame in the Ramble is the close scene—a glade of fine turf, a copse, a bower, a rocky dell, a cave, a rustic shelter (Figs. 124 and 125)—framed by "trees disposed in irregular clusters," their lower branches mingling here and there with bushy underwoods, "sweeping the turf or bending over rocks." The density of plantation creates a cool, umbrageous darkness spattered or split by chiaroscuros of sunlight. Benches

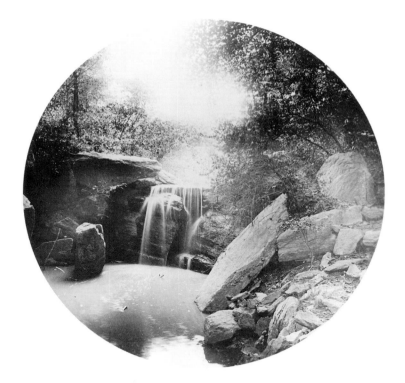

Fig. 122
August Hepp, *Waterfall in Central Park*, c. 1855. Museum of the City of New York.

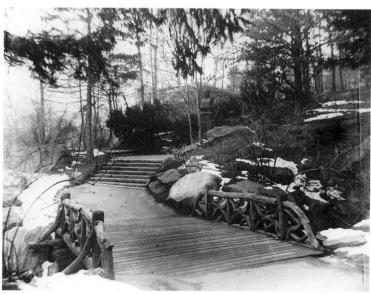

Fig. 123
H. P. Beach, *Rustic Bridge in Central Park* (n.d.). Museum of the City of New York.

and other artifacts constructed in a properly sylvan style impart the comfortable familiarity of a primitive room.

The Unity of the Park

Central Park is thus the self-conscious orchestration of a variety of effects, manifested in a variety of forms and scenic arrangements. But Olmsted is as insistent as Poe on the need for a unity of effect. "The Park," he declares, "THE PARK . . . IS A SINGLE WORK OF ART, AND AS SUCH, SUBJECT TO THE PRIMARY LAW OF EVERY WORK OF

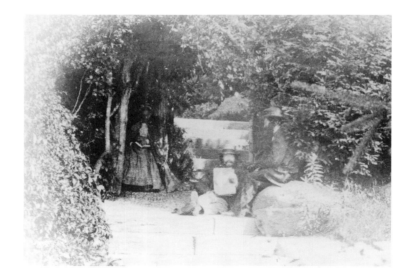

Fig. 124
Anonymous, *Small Group of People Sitting Under Trees, Central Park* (n.d.). The New-York Historical Society.

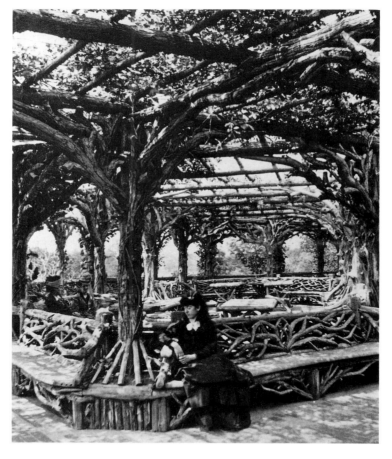

Fig. 125
Anonymous, *Interior, Rustic Shelter* (n.d.). Stereograph published by J. W. and J. S. Moulton. The New-York Historical Society.

ART. NAMELY THAT IT SHALL BE FRAMED UPON A SINGLE, NOBLE MOTIVE [theme], TO WHICH THE DESIGN OF ALL ITS PARTS, IN SOME MORE OR LESS SUBTLE WAY, SHALL BE CONFLUENT AND HELPFUL."[46]

Like that of Montgomery Place and Mount Auburn—like any picturesque art, Central Park's unity of effect is achieved by means of the principles of hierarchiza-tion, gradation, and repetition. Since it is a "natural" as distinguished from an "ar-

chitectural garden," pastoral effects dominate by virtue of their being repeated with variations, like musical chords. To keep the Mall "confessedly subservient to the main idea," Olmsted screens it with thickly planted trees from the pastoral scenery to the west and south, so that what visibility it retains from the outside is muted by shadow and reduced to visual fragments. From inside, the Mall is a shadowy and muted visual passage, punctuated by windowlike breaks in the foliage that frame brilliant pastoral vistas: to the east, "a half-mile . . . of lawn and trees" stretching from about Fifty-ninth Street to Seventy-second Street; to the west, stretches of the "natural, tranquilizing and poetic" Sheep's Meadow. The Mall terminates, moreover, at Bethesda Terrace whose uninsistent horizontalities are masked by its position on a slope down to the lake. A point of view as well as a place, the Terrace is the elaborate foreground of a wooded vista to the north.[47]

Olmsted limits the visibility of the Ramble as well. For one thing, he situates it in the backgrounds of the vistas from Merchant's Gate and from the terrace, where distance softens its effects and harmonizes it, as the Apennines are harmonized in Claude, with a pastoral middle ground. Although "the eye nowhere penetrates far," this effect, too, conveys the impression "of freedom, and of interest beyond the objects which at any moment meet the eye"; and it adds to the experience of the mind being led "to an indefinite distance from the objects associated with the streets and walls of the city." Inside, the Ramble's foliate screens are punctuated (like the Mall's) with windowlike openings into pastoral vistas toward the ridge, dominated by the aptly named Vista Rock.[48]

This dynamic of subordination and gradation informs the semiotics as well as the structure of the park. Its "main object and justification," Olmsted argues, "is simply to produce a certain influence"—that is, an orchestration of picturesque effects—"in the minds of people and through this to make life in the city healthier and happier." For feelings hardened by commerce and the hard monotonies of the street, the park's bright, expansive scenery and the spectacle of other people at ease in it are designed to produce an "emotional and physical recuperation": an "*unbending*." Distances are meant to draw the mind out of itself and into the organic repose of the landscape. Because of the sheer number of scenic changes along the paths, subjective time slows and expands to congruent effect. In a few hours, Olmsted claims, the park offers, "inexpensively," the equivalent of "a month or two in the White Mountains or the Adirondacks . . . to those in easier circumstances."[49]

This expansion of feeling has its intellectual effects as well. Like the scenery of Emerson's Concord, that of Central Park has the capability of educating its visitors to a fuller, healthier life of the mind; of teaching them "to acquire habits of living healthily and happy from day to day." Intellectual unrest is to be allayed by the park's inducements to the education of "refinement and taste." In Olmsted's hopeful view, the park should become a kind of open-air university of the liberal arts, offering music (in the bandstand), natural science (in the zoo) and, eventually, painting (in the Metropolitan Museum) for the education of the contemplative mind. It is to be an "educator of the popular taste" as well, designed to instill in all New Yorkers, middle and working class alike, an ideal of picturesque beauty they might well wish to apply to the city as a whole, including their own homes.[50]

In the Mall, this education takes on a distinctly social character. Here, among

crowds of promenaders (see Fig. 121), a state of mind susceptible to the "charm" of natural scenery begins to accommodate a state of mind susceptible to the charm of benevolent human nature. The Mall is designed to create a quiet contagion of good feeling communicated by facial expression and gesture. Among "poor and rich, young and old, Jew and Gentile," Olmsted observes after its completion, "I have looked studiously but vainly . . . for a single face completely unsympathetic with the prevailing expression of good nature and light-heartedness."[51]

For Olmsted, the image of these ethnically diverse citizens beaming at each other becomes a metonym of the city as the state of mind and way of life it could and should be. Good feeling, once stirred, can cross all social divides, melt all the accumulated hardnesses of life in the commercial city. The experience of a benevolent form of community and the presence of role models for scenarios of upward mobility will allay working-class unrest; the experience of working-class people enjoying the decorums of the promenade will allay middle-class anxieties. In this way, the Mall offers a democratic "opportunity for people to come together . . . unembarrassed by the limitations with which they are surrounded at home, or in the pursuit of their daily avocations."[52]

THE PARK AS NARRATIVE

The most inclusive effect of Central Park, however, is its elusive and discontinuous narrative. As at Montgomery Place and in Mount Auburn Cemetery, path is plot, making scenes pictures whose aspect and meaning constantly change "with the movement of the observer."[53]

Benches offer the possibility of more fixed views, narratized, as in painting, by visual paths laid out recessionally—into the depths of the framed space, so that, as in a dream, the present is foregrounded and the future backgrounded—or processionally (out toward the viewer), an event moving toward a foregrounded future. As in all picturesque art, variations in these sequences imply change, the temporal equivalent of variety; contrasts imply conflict; and leitmotifs of form or color, the landscape architect's equivalent of metaphor, imply continuity, duration. Leading from one scene to another, moreover, paths give the park the narrative character of a kinematic succession.

Entrance Vistas as Pastoral Enchantments

Produced by the stroller's visual and physical movements, Central Park's narrative takes, appropriately, a pastoral form. The pastoral ideal, as Leo Marx has shown, takes the shape of an enclosed garden in which the inhabitant enjoys a balance of "the sophisticated order of art and the simple spontaneity of nature." The pastoral design, however, takes the narrative shape, at the beginning, of a retreat (sometimes only in dreams) from "a larger, more complicated order of experience" and, at the end, of a disruption caused when that order breaks the spell of the pastoral ideal. The pastoral design is thus only an interlude from the complexities of quotidian life.[54]

Central Park enacts this design precisely. Its Chapter 1, set into the park's entrances, is that of a pastoral retreat. At the Merchant's Gate, near Columbus Circle,

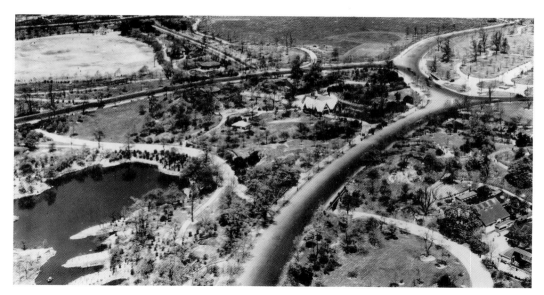

Fig. 126 Anonymous, *Central Park Looking Northwest*, July 1, 1931. Museum of the City of New York.

for example, strollers are confronted with a foliate screen, through which appear, gradually, like a cinematic fade-in, the emerging scenery of the Cricket Ground.

> The observer . . . cannot but hope for still greater space than is obvious before him, and this hope is encouraged, first, by the fact that, though bodies of rock and foliage to the right and left obstruct his direct vision, no limit is seen to the extension of the meadow in a lateral direction; while beyond . . . an undefined border [of low shrubs] in front, there are no . . . impediments to vision for a distance of half a mile or more.[55]

As the stroller approaches the end of the screen, "the imagination . . . is led instinctively to form the idea that a broad expanse is opening"; and the effect is "strengthened, and the hope which springs from it in a considerable degree satisfied" by "a view of those parts of the Cricket Ground which lie to the right and left of his previous field of vision." When the screen ends, the vista sweeps unimpeded to its dramatic terminus: the wooded knoll of Vista Rock. The green repose of the turf, lit perhaps by golden sunlight, leads the eye and the mind away into leafy fastnesses and blue sky.

Other vistas in the Lower Park from or near gates have similar narrative effects. The main drive from Fifth Avenue at Fifty-ninth Street, for example, replicates for carriage-owners the entrance drive of the country villa. And by the early 1870s, the landscape of the Dairy (Fig. 126)—situated at "the *precise point in the Park which could be reached with the fewest steps* . . . by visitors [arriving] on seven different lines of railway"—is designed as "a visit to the country" for the mothers of the Lower East Side and their infants, whose death rates double in July and August in the stifling tenements. Fresh milk is to be available for the infants and for the mothers the physical relief of a porchlike gallery "constructed for coolness and . . . open to the South

Breeze." Rocking chairs furnish the porch to ease the "fatigue, anxiety and various slight embarrassments" of carrying children.[56]

Emotional relief is provided by a sequence of three pastoral scenes that can be entered merely by shifts of the mother's gaze as she sits with the infants on the cool porch, experiencing the view as from a rural cottage. These scenes, too, enact a return first to the rural and then to the primitive landscape. A view to the west and south of the porch provides a vista across the Cricket Ground. Converted in 1872 into a "ball-ground" joined, to the east, by the Kinderberg, it is designed to accommodate the robust "tastes and [play] habits" of older children from the Lower East Side, who are no longer confined to the paths.[57] As Olmsted envisions it, the women can direct upon this pastoral space peopled with their children a maternal as well as a contemplative gaze.

To the south, the middle of the triptych, a carefully framed and circumscribed vista mediated by a rural foreground ("a cow or two, a ewe with lambs, and a few broods of chickens . . . for the amusement of the children") recedes across turf, rocks, and coppices to a particularly dramatic view, across a bay of the Lower Lake (just north of Fifty-ninth Street, the left foreground of Figure 126), of a "bold dark shore" rising to a hill crest "crowned with firs."

The third scene in the triptych lies to the southeast. Framed as a "wild and secluded" close scene dominated by two masses of rock, it is the setting of a domestic life that might have been lived by pioneers in a forest. The effect of embowerment produced by the positioning of the viewer on the porch and by the frame is repeated in the form of an arbor atop one of the rocks that is walled by trellised vines "so placed as to cover with verdure the larger part of a broad, flat, [and otherwise] uninteresting mass of rock." Around this accessible bower, "thickening and extending" the sylvan effect, grow "loose thickets of sassafras, dogwoods, sumachs, bitter-sweet, and their common rock-edge associates," planted as if they had sprung up naturally, in wild and exuberant profusion, along the borders and clefts of the rock.

With a turn of the mother's gaze, the pastoral scene on the right thus shifts to a scene with a pastoral foreground and a sylvan background, and then (on the left) to a sylvan foreground.

The "Finest View" in the Park

It is the vista from Bethesda Terrace and its mirror opposite from Belvedere, however, that constitutes the park's "finest [view]," "the most important feature," and the climax and the resolution of the lower park's pastoral narrative.[58]

With its central staircase and entrance hall; its graceful fountain (Fig. 127); its flanking staircases and ramps (this, too, is a set designed for entrances); its elegant balustrade and masts adorned with pennants—flashes of color and motion; its tapestried formal plantings; and its boat dock serving a fleet of rentable Venetian gondolas, Bethesda Terrace is designed to combine rural with aristocratic and cosmopolitan forms for the urban stroller, "who, in the best sense, is the true owner." From it, as from park-level above and behind the Terrace (Fig. 128), the vista recedes to the Ramble, which here takes the shape of a rough ridge broken by bold bluffs and covered with the "density, obscurity, and wild intricacy of low . . . foliage" growing from

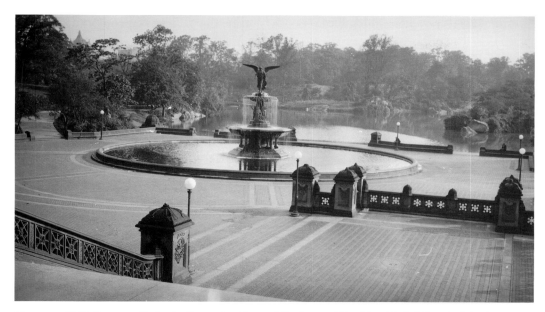

Fig. 127 T. F. Connor, *Bethesda Fountain, Central Park,* 1921. The New-York Historical Society.

Fig. 128 *Vista from Western Half of Bethesda Terrace from the Music Stand, Belvedere in the Background.* From Clarence C. Cook, *A Description of the New York Central Park.*

"broken and rock-strewn surfaces." Distance, the "ornamental sheet" of the lake in the middle ground, and the thick screen of foliage constructed along the far shore soften the outlines and textures of this wilderness, giving it the look of a leafy rural retreat.

Olmsted complicates the effects of the screen by weaving into it forms and scenic fragments designed to represent "the superabundant creative power, infinite resource,

and liberality[,] . . . the childish playfulness and profuse careless utterance" of tropical jungle as well as deciduous forest. It is no small irony, and no coincidence, that his ideas about jungle landscapes derive from a tour to Panama, though constructed with North American flora. Ailanthus and aralia perform as distant palm trees "as a landscape painter would depict them." Holly-leaved barberry, sweet flag, and tiger lily festooned with vines compose the illusion of a tropical riverbank. "[L]arge spreading trees like the Chestnut or Sycamore," densely leaved, festooned with clematis vines, and planted on a steep hillside, suggest a rain forest, with its "cavernous depths" of green, light-stippled shade. Subsequently, bits of desert scenery, too, would be added to this amalgam.[59] The wilderness is furnished with artifacts, from bridges to huts and shelters in the sylvan style (see Figs. 123–25).

The Ramble's edge thus becomes a radical extension of Frederic Church's landscapes—a composite not of regional but of continental New World wildernesses. The vista from Bethesda Terrace offers not only a spatial but also a temporal retreat from the urban present: a supranational version of that narrative of New World civilization told by liberal Protestant preachers and Brahmin historians, by travelers such as Timothy Dwight, painters such as Thomas Cole, and architects such as Andrew Jackson Downing—but reversed, so that it takes shape as a regression from the elegant comforts of the nineteenth century to the pioneer stage of Euro-American civilization. The stages of the narrative are elaborated by contrasts between the elegant, urbane architectural furniture of the terrace and the primitive furniture of the Ramble. History becomes (as later in Disneyland) an effortless, specular daydream.

Fort Belvedere, on the skyline of the Ramble, is the visual climax of the vista from Bethesda Terrace. Its Italianate style and forested site extend the narrative of pastoral retreat back to its historical and geographical limits in medieval Italy, with its landscape of hills crowned by feudal castles run by lords who acted like highwaymen, levying customs duties or plundering merchant caravans, like the ogres in fairy tales.[60] It is a narrative particularly familiar to Victorian Americans, whose interest in medievalism is also evident in the architecture of the Gothic and Queen Anne Revivals. The sight of a fortified castle in a scenery of mountainous landscapes and wild passes, Andrew Jackson Downing suggests, "affects us agreeably, because we know that baronial castles were generally built in similar spots, and because the battlements, towers, and other bold features, combine well with the rugged and spirited character of the surrounding objects." It has the same fascination, in short, as the old wars of the Europeans, waged in terrain much like that of the Ramble.[61]

The violence of war, however, is softened by both distance and nostalgia. Like the medievalism of Queen Anne houses, it is the stuff neither of nightmare nor of historical actualities but of heroic fantasy. Belvedere's scale, as Clarence Cook observes in his *Description of Central Park*, confirms this. Feudal Italy becomes in the Belvedere a stagelike floor of several levels (battlements, ramparts, a tower) designed not for battle but as if for courtly spectacles of pomp and ceremony. It is actually designed for "shelter and outlook": *Bel-vedere,* beautiful sight, beautiful view.[62]

The vista from Bethesda Terrace is the climax of the park's pastoral retreat; that from the Belvedere, a reversal of this vista, is its resolution: an awakening from the pastoral dream. As John Bachmann's view dramatizes, situating the viewer above the

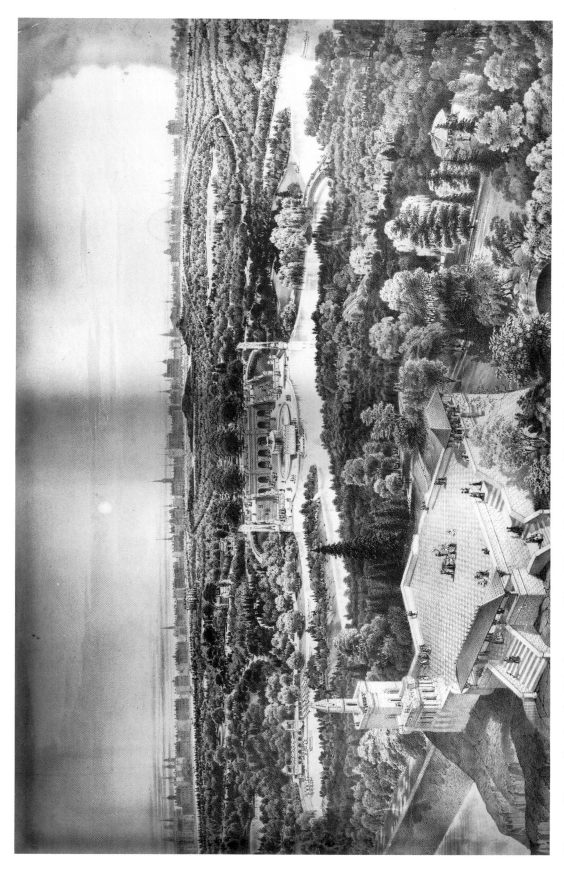

Fig. 129 Herman Bencke, after John Bachmann, *View of Central Park*, c. 1875. Tinted lithograph. I. N. Phelps Stokes Collection, Miriam and Ira D. Wallach Division of Art, Prints and Photographs, The New York Public Library. Astor, Lenox and Tilden Foundations.

Belvedere at bird's-eye height (Fig. 129), it, too, is an epitome of the park's scenic zones (it includes, indeed, most of the lower park, south of the reservoir), setting into the context of an urban present all of the territory traversed by the viewer and the nation.

In this vista, the exotic but (to American eyes) unenlightened wilderness of medieval Europe is displaced first by the Ramble's democratized conditions of life in the New World wilderness, then by the rural and democratic civilities of Bethesda Terrace. The Italian Revival style of the terrace proclaims its kinships with premodern Italy, but reconfigures it as the icon of a Protestant, post-Enlightenment civilization. The heraldic granfalons of the Belvedere, repeated in the furnishing of Bethesda Terrace (see Fig. 128), are emblazoned with the symbols of the city and the state. By means of such leitmotifs, the pageantry, color, vigor, and beauty of the courtly past are appropriated by nineteenth-century New York and its history of political and ecclesiastical violence erased.[63]

In situ, this space dedicated to the city's body politic is defined as the climax of the reformation of the rural landscape that Downing and others had called for, conferring its order pictorially, aesthetically, and ideologically upon the extensive lawns to its left (or west) and the rural meadows to its right. It strikes a dreamlike balance between art and New World nature, between the wild and the urban—intense, powerful, easeful, magical, tantalizingly possible.

But as in traditional pastoral designs, the dream is brief. The order that it symbolizes and the narrative of historical progress in which it participates are both completed by the forms of the distant city (the Mall pointing like an arrow toward it), the terminus of the vista. Bethesda Terrace is to be read in *this* context as a middle ground and passage between wilderness and urban civilization. Its ideals of domesticity and of rural informality are completed in the city that extends and fulfills its design—a literalization of Olmsted's own hopeful view of the city. In Bachmann's congruent view (a vista of a vista), the hard, geometric mineralities of gridded streets and narrow lots are largely screened from sight by trees. New York is defined chiefly by the aspirant verticals of its monumental architecture—in short, by expressions of those civic and religious ideals set into stone in the picturesque city.

The view from Belvedere is a visual and conceptual path that the feet must now, meanderingly but also ineluctably, follow. The art of the pastoral does not simply yield to, but becomes, in more than one way, an art of the picturesque city.

Holding a white pine needle in my hand, and turning it in a favorable light . . . , I perceive that each of its three edges is notched or serrated with minute forward-pointing bristles. So much does Nature avoid an unbroken line. . . . Fine and smooth as it is, [the needle] is serrated after all. This is its concealed wildness, by which it connects itself to the wilder oaks.

[William Gilpin writes in "The Art of Sketching Landscape"] that "there is a . . . *higher character* in landscapes than what arises from the *uniformity of objects*—and that is the power of furnishing images *analogous to the various feelings and sensations of the mind*." Can good landscape have any lower aim?

—Thoreau, *The Journals*

∞

TOWARD A LITERATURE OF THE LOCAL

As in the increasingly remote wilderness, so in local landscapes: The impulses of preservation and reformation play out in counterpoint to each other. In the Northeast, the reformers include the architects of the transformation from rural to suburban landscapes, including Andrew Jackson Downing, whose architecture and landscape architecture have their roots in the Hudson River Valley, and Frank Scott, who proposes to do for backyards what Downing does for rural estates.[1] The preservers include Henry David Thoreau and Fitz Hugh Lane, George Perkins Marsh, and such writers of early regionalist fiction as Nathaniel Hawthorne, Harriet Beecher Stowe, Rose Terry Cooke, Mary Wilkins Freeman, and Sarah Orne Jewett. The picturesque provides both constituencies a common vocabulary.

Postmodernists are strengthening the argument that indigenous ideas of place may well be, in some ways, more inclusive than those of the nation. Where the aesthetic exploration of wilderness in the nineteenth century is dominantly a masculine pursuit, the study of local landscapes, by definition home-centered, includes both masculine and feminine territories. The sentimental tradition makes them a "picture-like" icon of "*home feeling*," "dear to taste, to imagination, to heart, and to memory." Transcendentalism makes them a seat in the universe.[2]

In narrative representations of the local, the lines between

Walden as Picturesque Narrative

setting and character become elastic, breachable. Including both natural and built spaces, place is by definition both a bio-region that can be evoked in landscapes and a social environment that can be evoked in sketches of topography and domestic space, in sketches of manners and morals, even in dialogue. The Newport of Stowe's *The Minister's Wooing,* for example, is defined not only by its coastline and its light but also by its intricate, layered, and changing social ecology. The configurations of plot, as well as character and setting, are also transformed in representations of the local. The narrative of Bryant's *Picturesque America,* a tour book of the nation, is episodic. Stowe's *The Pearl of Orr's Island,* by contrast, typically pairs the plot of the *Bildungsroman* (the coming of age of the characters of Mara and Moses) with an ecological narrative of social change over time. In it, nature, society, self, and history are all interwoven.[3]

Localist ideology, moreover, is poles apart from that of nationalism. Stowe's social imagination is fired by a vision of community as a kind of extended neighborhood, and so too is Thoreau's. It is a vision potentially more catholic than that of nationalism in its apprehension of the Other, for it tends to be more inclusive of class and even, to a point, of race, and it is particularly empowering, as Jane Tompkins and others have shown, to women. Yet another feature of the local imagination is its ongoing embrace of religious cosmology. As in Stowe's *The Minister's Wooing,* "[t]wo worlds . . . mingle—the great and the little, the solemn and the trivial, wreathing in and out, like the grotesque carvings on a Gothic shrine."[4]

Walden's, too, is an art of the local. "He who is only a traveller," Thoreau declares, "learns things at second-hand and by the halves, and is poor authority." In *Walden,* as in Lane's Gloucester, the traveler's movement across manifold landscapes is displaced by the patient observer's sense of subtler and more elusive motions and changes in a single place over time. That changes the very definition of the picturesque landscape. Unlike the spectacular forms of the English Lake District, Walden Pond is of "a humble scale," and its environing landscapes, though "smooth but still varied" (and therefore picturesque), look largely mundane to the cursory glance. No islands break up and vary its water surface as they do in the Lake District and in that American exemplar, Lake George. The landscape has no "striking objects" like the Catskills or the Palisades. It "cannot much concern one," therefore, "who has not long frequented it or lived by its shores."[5]

Walden is not one book but three, interwoven. It is an autobiographical confession; a series of secular sermons preaching the reform of American culture and mind; and most important, a sketchbook, fruit of Thoreau's frequenting of the Concord landscape and living by the shores of Walden Pond. This discursive multiplicity is itself a sign of the book's commitment to picturesque principles of construction, but it is the sketchbook, and particularly the sequence of sketches of Walden Pond, that constitutes (with Melville's *Moby-Dick*) the *summa* of American picturesque art in prose narrative.

THOREAU'S EDUCATION TO THE PICTURESQUE

Where the luminists' knowledge of the aesthetic must largely be inferred from their artistic uses of it, Thoreau's is fully documented in the journals. He is a knowledge-

able critic of picturesque architecture. Picturesque ornamentation of the house has its place, he argues Downingesquely in *Walden,* but it must emanate from "a core of truth, a necessity," in the lives of its inhabitants. As things stand, our houses are "cluttered and defiled," reifications of the desire for social status; let them accommodate and express the inner lives of the lives they house. Thoreau is also a knowledgeable student of landscape architecture. His advocacy of forest preserves as picturesque town parks, their pathlike "aisles" connecting varieties of forest scenes, for the tonic of wildness they add to lives makes him a forerunner to both Frederick Law Olmsted and John Muir.[6]

Toward the picturesque canon of paintings, however, Thoreau is, like Emerson, New Englandly cool. The highest offices of painters such as Guido Reni and Titian, he argues in his journal, is that they confirm the aesthetic superiority of nature (including human nature) over painting:

> The true art is not merely a sublime consolation and holiday labor . . . but . . . a human life, wherein you might hope to discover more than the freshness of Guido's Aurora, or the mild light of Titian's landscapes; not a bald imitation or rival of nature, but the restored original of which she is the reflection. For such a work as this, whole galleries of Greece and Italy are a mere mixing of the colors and preparatory quarrying of marble.[7]

Thoreau's typically American paradigm of the picturesque is not art but nature — a conviction justified not only by Emerson's argument in *Nature,* but also by William Gilpin, whose books constitute the armature of Thoreau's education to the aesthetic.[8] Gilpin defines the picturesque as the kind of beauty "capable of being illustrated by painting," and his books are filled with descriptions of canonical paintings he studied at English estates he visited. But his writings are dominated by the actual landscapes of Wales, Scotland, the Lake District, and above all (in *Forest Scenery*) his native New Forest. For Gilpin, actual landscapes constitute the chief part of the picturesque canon because they embody aesthetic values that painting seeks to represent. Let the landscape be the means of judging the success of that representation, Gilpin argues, and not the obverse. Just so, the Concord landscape, Thoreau's "lake country."[9]

For a period of more than six years, Thoreau studied Gilpin, as Walter Harding and Michael Meyer observe, "at greater length . . . than any other non-contemporary figure." Language, Gilpin teaches him, is as fit a medium as paint for representing picturesque forms and landscapes, and so it is Gilpin who presides over the conversion of Thoreau's journals from commonplace books to verbal sketchbooks. Long after Thoreau begins to question his ideas, Gilpin remains a fecund source of imagery for his sketches. Gilpin's *Forest Scenery*—"a pleasing book, so moderate, temperate, graceful, roomy like a gladed wood"—becomes a word-hoard for leaf shapes, bark textures, and ramifications from trunk to spray in a wide variety of forest trees (oak, maple, hemlock, and pine being particular favorites of both) and for forest "groupings," from copse to glade to natural screens, with their undulant, polytonal walls and skylines.[10]

Gilpin's imagery of picturesque light is equally germinal. The rising sun, he observes, turns "the upper parts of objects" gradually ruddy as it sinks their lower parts into deepening shadows. The color of sunset has a different warmth, he notes in a passage that Thoreau copies into his journal, and "the shadows of the evening are much less opaque, than those of the morning." Mist has a "transcendent" effect on forms lit by sunrise, when the light "[sets] on fire, as it were, their upper parts; while their lower skirts are lost in a dark mass of varied confusion." "Gilpin says well that the object of a light mist is a 'nearer distance,'" Thoreau observes on April 1, 1852, and during five days of rain that week sketches repeatedly this effect of mist and the play of its cool light on natural forms.[11]

For much of the 1850s, indeed, Thoreau copies, annotates, and modifies what Gilpin has to teach him mornings and in the afternoons, equipped with a homemade Claude glass and a notebook,[12] tests it in detailed readings of his neighborhood. Ridges, hummocks, bays, and points on the riverbanks, swamps, meadows, woods, wildflowers from Estabrook to Fairhaven all take congruent form as variations of the picturesque line of beauty. Even Thoreau's gravitation toward the symbolism of transcendence in picturesque phenomena, inspired certainly by Emerson, has its sometime confirmation in Gilpin as well. "We are most delighted," Gilpin declares,

> when some grand scene . . . rising before the eye, strikes us beyond the power of thought—when the *vox faucibus haeret;* and every mental operation is suspended. In this pause of intellect; this *deliquium* of the soul, . . . [t]he general idea of the scene makes an impression, before any appeal is made to the judgement. We rather feel than survey it.[13]

Thoreau's eye, however, is drawn less to the "grand scene" than to ordinary landscapes and to the mysteries of detail viewed closely: the irregular textures, for example, of pine needles, lichen, rock, bird feathers, that shimmer with meaning as they are inundated with light, so that it is difficult to tell where light ends and idea begins. A "bluish sheeny light" emanates in June from "the under sides of leaves (fresh and white) turned up by the wind" or from bent blades of meadow grass. In July, the awns in a grainfield reflect a "solid mass" of brilliant light. A "downy light" appears after sunset on the undersides of high-pillared clouds. Sweet fern gives off a "halo" of silvery light in November and snow crystals a silvery glow.[14]

For the primary forms of the Concord landscape, especially the ponds, *Observations on Cumberland and Westmorland,* Gilpin's narrative of his journey through the English Lake District has a similar resonance. Gilpin's notion of forms "of the mixed kind" suggests that classical and picturesque beauty and the sublime can all coexist in natural forms, simultaneously or in sequence. The sky, Thoreau reads, is a "great regulator" of effects that continually change the character of forms over time. If the golds and reds of sunrise and sunset imbue a lake, say, with the quality of magnificence, and "'a brooding storm'" (Gilpin resuscitating Virgil's *inhorruit unda tenebris*) imbues it with sublimities of energy and darkness, then we call the lake—or any other form of the mixed kind—"sublime, or beautiful, only as the ideas of sublimity, or . . . beauty prevail" at a given moment. Gilpin's hypothetical lake is—as

Walden will become—now a "marmoreum aequor, pure, limpid, smooth, as the polished mirror"; now a sublime obscurity under darkness or ice; now a mirror visually "broken by shades of various kinds; or by reflections from all the rough objects in its neighborhood"; now a surface raddled by the inflow from a hidden rill, or the "breath of air which nothing else can feel," or the impact of "the merest trifle, a striking fly, a falling leaf . . . a sound"—so that it seems (Gilpin echoing Ovid as he anticipates Thoreau) "'tremblingly alive.'"[15]

WALDEN AS SKETCHBOOK

Clearly an exemplary response to Gilpin's call for a picturesque art of the literary sketch, Thoreau's journals nevertheless articulate an increasingly different sense of the aesthetic from Gilpin, and so does the book he composes from them.[16] In Gilpin's prose, images are Augustanly, untroublingly, contained within the limits of their visual and conceptual frames. Thoreau's prose explodes the static image, both resorts to and resists scenic contextuations of the image, resorts to and resists the very limits of the verbal sketch. Gilpin hints at relations between matter and consciousness; Thoreau makes them part of a continuous transaction. Gilpin looks at picturesque landscape in the expectation chiefly of pleasure; Thoreau, in a search for its (Emersonian) ministries to the mind; the plot of his book is a consent and a homage to the ones he encounters.

The *Walden* sketchbook also takes a radically new interest in picturesque principles of mise-en-scène, discourse, and scenic sequencing. Synchronically, the sketches evoke a New England landscape at the end of the golden age: village, farms (many of them already abandoned), meadow and forest, field and pond—above all, the pond, for despite the extent of the landscape he evokes and despite the promise in the subtitle of a book on "Life in the Woods," the pond is by far the dominant subject of the book. It appears first in the four brief sketches in "Where I Lived and What I Lived For"; then in the sequence of eight sketches, with pendant expositions and meditations, in "The Ponds"; in a sketch in "House Warming" and three sketches in "The Pond in Winter"; and finally in the four climactic sketches of "Spring."

Diachronically, however, the sketches have a very different logic. Like paintings at an exhibition, they seem to have "only such connection and series as is attainable in the galleries." They both reflect and invite a "sauntering of the eye," shifting montage-like, often without apparent transition, from one aspect of the pond to another, one effect to another; now focusing on narrative effects, now on the pond as the "raw material of tropes." Like the metaphysical poets, Thoreau sometimes makes these tropes explicit but more frequently leaves them implicit, as wordless as the world from which they are drawn and the order they intimate. Metaphor becomes the superimposition, as Ezra Pound would later conceive it, of one image over another. Other images (and sketches) are juxtaposed against each other: present against past (things seen and things remembered); present against future (things seen and things anticipated); outward against inward (things seen and things imagined); the truths of fact against the truths of fable.[17]

Although Gilpin advocates the "close scene" for forest interiors, he declares the Claudian vista—with its "rich" foreground, its reflective lake in the middle ground, its background of mountain and sky, and its "sidescreen" of trees or valley slopes—the most picturesque of frames. For reasons of terrain and ideology both, Thoreau early comes to view the vista as an outworn convention: "all side screens and fore screens and near distances and broken grounds." The sketches of Walden dispense with the Claudian foreground: water alone, Thoreau declares, "makes the best foreground."[18] They dispense with sidescreens, space stretching laterally without containment. They dispense with or compress the backgrounded mountains of the Claudian vista: the Apennines become New England ridges (Emerson's Cliff the highest at 150 feet) more horizontal than they are vertical. As in luminist painting, vista becomes panorama.[19]

Borrowing from conventions of horticulture and natural history,[20] Thoreau revises the conventions of the close-up as well, adding to Gilpin's "close-scene" a portraiture almost microscopic in detail. In *Walden* (as in *Moby-Dick* and later in *Mountains of California*), the art of the literary close-up reaches its apogee.[21] Visual fixities are dissolved by a narrative dynamic that subsumes form to event and process: hawks in hawkflight; ice filling with bubbles; green fire in spring grass; the flow from the railroad cut. Perspective is mobilized to the point of becoming kinematic. Portraits emerge from accumulations of discontinuous detail; panoramas become pans, moving the reader's mind's eye laterally—or, alternatively, from the proximate to the distant or the converse.

This is not mere technical bravura. In *Walden,* mise-en-scène is as manifold, fluid, and shifting as the world it evokes. Both matter and its images are plastic and ultimately immaterial. As the catalogue of Walden's colors (that small miracle of patient observation) early makes clear, appearances change with changes in perspective as well as weather. Seen from a distance, the water is blue under a clear sky, dark slate under storm clouds; close up, its colors are more complex and have more complex causes. A refraction of the sandy bottom gives shallow water a yellowish tint that in some lights turns a vivid green: refractions and reflections of the yellow sand, the sky's "prevailing blue," and a clear New England light.[22]

As framing and spectator-positioning vary in the sketches, so the pond's very identities multiply. Depending upon the degree of tilt, the close-ups evoke either the transparency of the surface, which may at any moment disappear into superimpositions of reflected clouds and the "rich bronze" bodies of fish, or its mysterious, opaque animatenesses, its "continually receiving new life and motion from above" and below. The final sketch of "The Ponds," a series of close-ups arranged like a kind of zoom in film and viewed from a boat in the water, focalizes picturesque "imperfections" in the water surface on a windless October afternoon. Seen from this perspective, the surface shines with calligraphic ripples of light and motion, signs of its sensitivity even to the invisible "spirit in the air." Skater insects make waves of "the finest imaginable sparkle"; water-bugs, "a conspicuous ripple bounded by two di-

verging lines." The wake of the boat gives a "ribbed appearance to . . . reflections" of the landscape, as if they too were boats or ships. Like grace, an otherwise invisible wind manifests itself in "streaks or flakes of light." The inherent character of the pond also makes itself visible. A leaping fish leaves "one bright flash where it emerges, and another where it strikes the water" the two flashes joined, if the eye is quick enough to see, by a "silvery arc." Dimples appear where fish dart at thistle-down. The subtlest disturbance of all, and the climactic one in the sketch, is the "faint glimmer," where Walden's source, a spring, the seme of its innermost being, wells upward and outward like joy.[23]

In the panoramas, by contrast, Walden is defined chiefly by its relations to the environment: the pond as mirror of earth, sky, and light; or as Transcendental medium able to float the landscape, to give itself up to the airy mist and ascend. The five preludic sketches in "Where I Lived," all panoramic, establish the full range of relationships between distance, light, and Transcendentalist ideology. The first two evoke the water's different characters under different lights and atmospheres. One is an "emerging picture" of the pond as a dark mountain caldron from which rises morning mist, a ghostly presence: Walden as seat of supernatural presences. The other pictures the visual (and picturesque) anomaly of a calm surface filled in August with dark, reflected storm clouds so precisely imaged as to make it "a lower heaven": Walden as anagogical emblem of last things and as the projection of a mind so in balance that it is untroubled even by the specter of apocalypse. In the third—which positions the viewer further away, on a cleared hilltop (Heywood's Peak?)—the water seems subtly to expand to oceanic proportions, to float the landscape: Walden as Transcendentalist epitome of the fluidity and buoyancy of matter. A wide "indentation" in the backgrounded hills suggests "a stream flowing out in that direction"; more distant hills are "tinged," like the water, with blue; and the most distant mountains have melted into blue ideas. From its elevated point of view, the fourth sketch evokes a Walden in spring flood that creates a "mirage" in the Sudbury meadows beyond, elevating them "like a coin in a basin" and transfiguring the more distant parts of the landscape into a "thin crust" afloat between sky-water and sky. The fifth and final sketch evokes the pond as a place made sacred by its acting as window on worlds beyond worlds. Walden takes its place in a recessional from the distant ("the prairies of the West and the steppes of Tartary," landscape of scriptures) to the truly remote (Cassiopeia's Chair) "delectable" paradises, new, unprofaned, and unreachable—except as visible "*sedes,* a seat," to the locally rooted imagination.[24]

Thoreau's Poetry of Light

Changing lights, atmospheres, and seasons transfigure the pond with similar symbolic effects. Night erases it, as do the pellucid stillnesses of October and November afternoons. Snow turns it into a whiteness-in-whiteness, and spring, into a darkness stippled with sparks of gold or silver. Wind ruffles create the most complex palette, seeming to mix sky, shadow, and light, so that the tilted planes of the waves radiate, under some conditions, "a darker blue than the sky itself." Under others "a matchless and indescribable light blue" the color of watered silk or sword blades ap-

pears on one side of the waves while the other turns "a muddy vitreous greenish blue, like those patches of winter sky seen through cloud vistas in the west before sundown." [25]

Language cannot picture light with the subtlety and complexity of paint; but it allows a more precise and explicit symbolization of light, by means of metaphor, pendant meditation, and a strategy of narratization that dramatizes its ministries. For Thoreau, as for Emerson and Lane, light is "almost moral," guiding the mind "to the first rudiments of life," like grace sweeping the motes from vision. It suffuses even quotidian forms with sacred mysteries. It quickens things, like a descent of Spirit. Its golden warmth and softness, especially at dawn and sunset, gives forms the ruddiness of flesh and even makes them seem to breathe in the still air. Haze and distance melt things together: a visible type of the anagogic prophecy implied in the word "universe": a going toward oneness. On still water, reflections transfigure forms, so that, loosed from earth, aglow, they drift, their very buoyancy a sign of their impulse to ascend. Like them, meaning appears to be "floated up to the surface . . . by a source of light that wells up from within." [26]

The narrative effects of light are equally profuse and various. The most recurrent poetry of light in Walden is the *trompe l'oeil*—a "trick of the eye," or "mirage." For Thoreau, this seems to be a species of metaphor (or metaphor a species of *trompe l'oeil*) hinting at elusive and ultimately unsayable meanings, but also a form of rhetorical assertion always potentially comic in its exaggerations: mystery and play in continuous tension with each other. The first of the two climactic sketches in "The Ponds" is narratized by an incident of *trompe l'oeil;* the surface plane of the preternaturally still water appears, at water level, as "a thread of finest gossamer stretched across the valley, and gleaming against the distant pine woods, separating one stratum of the atmosphere from another"; and on this, as if on "an invisible cobweb," rests "a yet darker and smoother water . . . boom of the water-nymphs." From above, the stillness and purity of Walden water make a reflection of sky so perfect that the surface becomes, suddenly, sky-water. A second sun, equally bright, appears, and the narrator imagines himself able to walk (like his inverted reflection) dry across the pond—though he does not take this as literally as the birds who "sometimes dive below the line, as it were by mistake, and are undeceived." [27]

As in baroque art, the *trompe l'oeil* in *Walden* is also capable of reflecting a world in which objects suddenly take on multiple, unfamiliar, and elusive identities. Recurrently, light is seen to sunder vision from matter and to reveal behaviors that are visible but independent of material laws. Matter becomes fantasmagorical; fantasmagoria take on apparent substance; and obliquely, briefly, intimations of divine realities emerge from the shadowy reflections of this dematerialized world.

That is what happens, for example, in the cryptic and elusive opening sketch of "The Ponds." Almost immediately after the narrator situates himself in his boat on the pond at night, natural laws begin to be suspended. The water appears to disappear. Perch seem to hover beneath the boat, above a moon seen traveling over "wrecks of the forest" that are strewed, like shipwrecks, across the pond bottom. There is a material basis to this: a reflection of the moon is superimposed, on the water's limpid surface, against the drowned trees on the pond bottom, its apparent

motion caused by the motion of the boat. But for the moment, the visual experience detaches itself from the material reality. Up and down become confused, reflections materialize, and matter dematerializes. Plastic to the eye, the moment becomes plastic to the imagination. Metaphors (products of another kind of reflection) intensify the surreal effects of strangeness and mystery in the sketch, evoking other metamorphoses. The narrator is "serenaded" by owls and foxes. An unknown bird makes not a song but a "creaking" noise. The hovering fish are seen to be connected by a "long flaxen line"—moonlight? a reflection of fishing line? a line of thought?—to "mysterious nocturnal fishes which had their dwelling forty feet below."

Then the picture shifts, as by a filmic jump cut—a transition that intensifies the scene's sublimities. Drifting above the moon in the night breeze, trailing sixty feet of line, his thoughts having "wandered to vast and cosmogonal themes in other spheres," the narrator is summoned by vibrations in the line. A horned pout, source of the message, rises "squeaking" like the birds into the upper air above the moon, where we have been hovering. Cast yet further "upward into the air," could not his hook fish out something from the heavens as from the earth? It is not facts but glimmerings and prophecies that visual appearances manifest to the open-eyed perceiver.

A Multiplication of Perspectives

Perspectives of Walden Pond are multiplied by a variety of discourses. Discursively, "perspective" connotes as much a conceptual as a visual orientation, various discourses relating various ideas and even various shapes to a given subject. In *Walden* as in *Moby-Dick* and "Descent into the Maelstrom," natural forms are the manifold products of manifold discourses. "The scientific differs from the poetic or lively description," Thoreau writes in his journal, and both of these, and other, discourses complicate the character of *Walden*. Thoreau continuously extends the discursive limits of the sketch, mixing into its dominantly descriptive discourse, in varying degrees and to various ends, scientific, philosophical, contemplative, expository, and especially narrative discourses. Poetic description shades into scientific description (glaciation, the pond's depth): Walden as both picture and natural process. Description shades into contemplative discourse elaborated by metaphors that are both product of and incitement to contemplation or, alternatively, into argument directed toward the book's readership: Walden as mysteries to be sounded or lessons to be taught. In the climactic montage in "Spring," with its sketches of a landscape filled with awakening energies, a mood of jubilation establishes the tonal coloration of the incidents Thoreau sketches. Spring is both an emerging picture and an emergent state of emotional rejuvenation. Then, without warning, Thoreau interpolates an argument for preserving forests as picturesque town parks in which citizens might savor "the tonic of wilderness." Implicitly but emphatically, this converts the sketches into an argument for the creation of a public landscape in which all citizens could experience the facts and ministries of spring.

The most recurrent discourse, not surprisingly, is narrative: Walden as a concatenation of incidents and processes both in the landscape and in the consciousness of its witness. Time constitutes a fourth dimension of the Walden landscape.[28]

1. *Narratives of Natural Ecology.* Some narrative strands define the pond as the product of a natural ecology: so the narratives of a shore "shorn" by the rise and fall of the pond's water level, of the cycle of condensation and evaporation in which the water participates, of seasonal change. Like Lane, Thoreau is fascinated with the interchanges between earth and weather. The sketchbook takes shape, in part, as a time-lapse study of Walden as it is transformed first by the lights and color of summer and fall, then by the white rigidities of winter, and then by the explosion of spring lights, color, and motion.[29]

In "Housewarming" and again in "Spring," the narrator evokes with particular care the interrelation between sunlight and ice, which is as sensitive as water. As in Emerson's *Nature*, nature naturally tends toward a picturesque beauty at every stage of change. Air bubbles are trapped beneath the hard, dark transparency of the first ice. In early winter, under the sun's heat, these turn into "narrow oblong perpendicular bubbles" that rise into the ice from its underside, turning it "opaque and whitish or gray," obscuring its textural beauty—or rather introducing minute new formal beauties. In late winter, bubbles in the shape of "sharp cones with the apex upward" appear, multiply, and overlap each other, "like silvery coins poured from a bag."[30]

Like water, Walden ice is not static but ecologically dynamic, constantly changing. Under a slight wind, strata of scientific discourse demonstrate, it undulates like water. Snowmelt on it drains, in apparent defiance of hydrodynamics, into holes cut in it. When holes in the ice refreeze at night, a "fresh smooth ice" appears that is "beautifully mottled . . . by dark figures, shaped somewhat like a spider's web, what you may call ice rosettes." The sun both encapsulates and suffuses the whole icefield. Filled with spring sunlight, the ice bubbles burst with energy, like "papillae." Reflecting off sand in the shallows to its undersurface, it melts the upper surface by direct radiation, turning the bubbles into "burning glasses," sun and darkness expanding and contracting the entire sheet of ice until it booms, morning and evening, like thunder.[31]

2. *Narratives of Social Ecology.* A shorter narrative strand defines aspects of Walden as products of a social ecology.[32] Here the purity of the pond water is set off against deformations in the landscape around it caused by human presence. A picturesquely irregular path, "alternately rising and falling, approaching and receding from the water's edge," is the first of many signs of human uses and misuses that have scarred and aged the landscape. More destructive changes by Euro-Americans are evident in the absent presences of ducks and eagles; the destruction of vine-covered "bowers," "aisles," and "occasional vistas" through the trees and of amphitheaters of "sylvan spectacle." Nineteenth-century modernity imprints itself in the appearance of the railroad, the "sties" of its Irish laborers, and, in winter, the Irish ice-cutters.[33]

Another social ecology, more sympathetically treated, is that of myth—a product not of economic enterprise but of cultural imaginings in which Thoreau himself participates. He constructs a pastoral myth, in which the pond becomes situated as a stone-lined well of sweet water. He tries to resuscitate the mythical connotations of Walden's name. He uses the Edenic myth to sacralize Walden's purity: unlike the landscape around it and the figures who show up in its precincts, it is prelapsarian.

More critically, however, since he considers Walden the product of a feminized creator rather than a wrathful judge,[34] he is at pains to deconstruct the local legend that makes the pond, in its depth, a gate to hell.[35]

3. *Autobiographical Narrative.* Narratives of natural and social ecology, in turn, gradate into autobiographical confession: narrative (as Thoreau says of his journal) of the "experiences and growth" of a self defined by what it feels, sees, thinks, and believes rather than by how it acts. Like, say, Augustine's *Confessions, Walden* evokes in all of its complex and mysterious intensity the progress of this self from a state of "desperate incompleteness" to a state in which the consciousness is fully awake, fully in harmony with both itself and the world in which it finds itself.[36] That is the narrative of Thoreau's "second experiment" at Walden: his attempt to live judiciously, by long looking and clear thinking.[37] "I went to the woods," he confesses just before introducing his first sketch-sequence of the pond, "because I wished to live deliberately"—deliberatingly—so that if life were sublime "I . . . [would] know it by experience, and be able to give a true account of it." The sketchbook is Thoreau's corroboration of the sublimity of life. The story of Walden water is its continual regeneration; the story of its narrator is the discovery of a kindred capacity in himself. *Walden* takes its most inclusive coherence as a personal transformation culminating in the praise-song of "Spring" in which the spirits of the narrator rise, with the Concord landscape, in a jubilant awakening.[38]

Walden and the Art of Montage

Structurally, the scenes of Walden Pond that flesh out these various narratives are as variable as reflections in wind-rippled water: now they are flooded with sunlight, now with night or snow; now they sweep panoramically across an arc of space; now they freeze on the iridescent scales of a pickerel or the flight of a hawk; now description shades into narration, exposition, contemplation. The logic of the sequence resembles nothing so much as a cinematic montage so complex that its strands, too, must be given coherence by picturesque means—that is, by hierarchization, gradation, and repetition.

As in a montage, leitmotifs establish a principal effect—the "general quality," as Sergei Eisenstein puts it, in which each detail participates. The general quality of Walden is its eclectic fusion of a beauty and sublimity made manifest in variations of the irregular curve, in the purity and the animation of its water, and in its remarkable but not unusual depth. In the "particular description" of "The Ponds," Thoreau defines Walden's unspectacular shoreline as picturesquely "irregular enough not to be monotonous"—a gradated sequence of curves. The southern shore is "beautifully scalloped" with "successive capes" and coves; the western, "indented with deep bays"; the northern (site of the cabin) "bolder." Seen from the water, the shoreline has the radical simplicity of a luminist painting.[39] The eye rises "by just gradations": first to the "shorn" shore, relieved by "a belt of smooth rounded white stones" and by two short sand beaches; then to banks picturesquely varied by intricate masses of "fibrous red roots" (willows, alders, and maples); then to the curve upward from "the low shrubs of the shore to the highest trees" to low hills and sky,

whose reflection in the water completes an Emersonian circuit of forms. Walden's subtle colors and surface textures are also part of its visual syntax. The "pure white sand" in the shallows is a surface almost preternaturally clean and smooth (and therefore classically beautiful), Thoreau notes, yet it is still varied enough to be picturesquely interesting. It turns yellow and then green as the water deepens and is subtly varied and broken by the "circular heaps" of chivin's nests, by patches of sediment and—invisible to the casual bather—by bright green "heart-leaves and potamogetons, and perhaps a water-target or two."[40]

These "humble" beauties are eclectically suffused with softened sublimities of depth, duration, and obscurity (that of its source and its bottom) and by sublimities of relation to a sky vastly and mysteriously deep and an atmosphere of pervasive silence, stillness, and repose. Perceived symbolically as an incarnation of higher laws, Walden is imbued with metaphysical beauties and sublimities as well. Its highest beauty is as a "[Lake] of Light"—vessel of a luminous, reposeful, reflective, tender, and enduring (though not a fixed) harmony. Its highest sublimity is its power continually to receive, in its repose, "new life and motion" from the universe and, in return, to express, through the sympathetic viewer, "joy and happiness to itself and its Maker."[41]

Each of the three chapters of the sketchbook (not counting the preludic sketches of "Where I Lived") finds its own unity by focalizing on a single dominant effect.

I. *Imaging Purity in "The Ponds."* "The Ponds" is an elaboration on the manifold character of the water's purity. The theme is complicated by the opening sketch, which evokes the sublime effects of darkness, and by sketches of the deformations in the pond's environing landscape—another sort of darkness; yet even these notes are linked by leitmotif to the dominant effect. The *trompe l'oeil* effects in the chapter's first sketch, as well as its last, are results of the water's transparent purity.

Like Fitz Hugh Lane's *Norman's Woe* (Color Plate xx), Walden emerges here as a luminous center environed by margins and veins of darkness. Thoreau's shore world elicits an elegiac sense of the inevitability of organic ruin in the landscape, but unlike Lane, Thoreau is outraged by Euro-American predation. Tones of outrage surface with particular force in a stratum of Gothic imagery of strident sounds, monsters, and demons, including a "devilish Iron Horse." A symbolic undercurrent connects these images to a theme of social disorder Thoreau elsewhere addresses more explicitly and to an ongoing narrative of American alienation from nature. Nevertheless, the vestigial beauties of the landscape still relate it to the beauties of the pond and are the measure of its losses.[42]

By contrast, Walden's purity, first and chief of its beauties, reveals itself in manifold ways: in its sweet incorruptibility; in the cleanliness of its shore and bottom; in its preternatural transparency; in the related qualities of buoyant elasticity and animate stillness (sign of its inherent calm and sensitivity even to invisible influences); and in the clarity of its reflections. Even its colors turn out to be manifestations of its purity, for like Melville in "The Whiteness of the Whale," Thoreau views them as immaterial qualities of light rather than as material properties.[43]

Thoreau's "religious exercise" of bathing in the pond, moreover, links material purity with spiritual purification and, by extension, with the themes of heightened

perception and spiritual renewal that constitute the confessional element of *Walden*. As in the faces of enlightened people, the pond's outward aspects of clarity and repose are signs and ramifications of its purity. The still, clear water is thus transformed into an allegorical type of transcendental awareness. Like the New Jerusalem and the clear mind both, it is "transparent, so that the 'light of higher laws shines through it'": that is the drift of its recurrent transfiguration into a "lower heaven." By extension, the pure water, "unchanged" by the Fall and therefore by time, is "perennially young." A remnant of the original creation, it has not acquired "one permanent wrinkle." Before the path worn along the shore by "successive nations" beginning with aboriginal hunters; before even the fall of Adam and Eve, Walden's character derived from its distillations of "celestial dew." Like Melville's sperm whales, it is immortal. It is as "pellucid" and animate as ever. It is inherently "untroubled" even when troubled. Stirred, it becomes "elastic and vigorous," as "full of life and motion" as the world around it and the purified consciousness that greets it as kin. Left to itself, it returns to a mirrorlike stillness, "ever fresh." "The reflections of surrounding objects," as Thomas Cole observes, "are the most perfect in the clearest water, and the most perfect is the most beautiful." Thoreau agrees. It is the purity of Walden water that gives it its hyper-real clarity, its nearly palpable reflections.[44]

And it is these qualities, in turn, that make Walden a minister, a paradigm, of artistic representation. Like the art Thoreau practices, indeed like all picturesque art, the reflection is a type of mimesis, but it is also expressive: "never a true copy or repetition of its substance but a new composition." Like a Michelangelo, Walden commingles reflections or refractions of sand, foliage, and sky into a palette both more intense and subtler than earthly color. Like a Michelangelo, it enlarges, distends, and abstracts what it reflects, so that the body of a (white) bather appears "of an alabaster whiteness," its limbs baroquely "magnified and distorted." Life in this light-struck medium is also intensified. Walden's pickerel have a Titianesquely "dazzling and transcendent beauty" of color. One specimen brought to the surface is "steel-colored"; another, bright gold "with greenish reflections"; a third, gold peppered with dark brown, black, and "blood-red" spots.[45]

2. *Imaging Depth in "The Pond in Winter."* The sketch sequence of "The Pond in Winter" elaborates another quality, its "unusual" depth, which Thoreau juxtaposes against a concerted reading of its frozen surface. The disorientation produced by the veil of snow, like that produced by the veil of sleep, is followed by the discovery that the "liquid and trembling surface" of the pond has become as solid as the landscape and seems "not to be distinguished from any level field." Linked to the narrative of social ecology, the notes of discordance and disorientation continue throughout the chapter. The field that is not a field is "plowed" by farmers who are not farmers. This overlay of pastoral images gives ironic voice to Thoreau's anger at the destructive intrusion of the Irish ice-cutters with their "ungainly" tools. They look like farmers, but they act like soldiers, armed with pike-staffs designed not to plant the icefield, but to rip out and cart off its "virgin mould"—another lay of the land. The ice they stack in piles on the shore tellingly resembles "the base of an obelisk"—a monument of martial triumph—and again like "a vast blue fort or Valhalla," home of dead warriors, it takes on the look of a mossy ruin when its chinks are stuffed with straw.[46]

These superficial events, however, are subordinated to the chapter's principal focus on Walden's depth, which becomes measurable through other holes Thoreau himself cuts into the ice: the pond's interior purity and repose juxtaposed against its violated surfaces. One hole acts as a window to the "quiet parlor" of the fishes, filling it with a softened light as through ground glass. Through holes cut by ice fishermen come pickerel: "animalized . . . crystals" of Walden water with a "dazzling and transcendent beauty."[47]

This imagery softens the pond's sublimity of depth, and so do Thoreau's soundings. In contrast to the local "fancy picture" of a pond that is bottomless, or riddled with "vast holes," or "an entrance into the Infernal Regions," Thoreau's plumbline — a case study of how the habit of mensuration, as Barbara Novak calls it, tempers the sublime imagination after 1835 — establishes its greatest depth as a "remarkable" but hardly infinite 102 feet. In contrast to Gilpin's Burkean topography of Loch Fyne in Scotland ("a horrid chasm" formed by a "convulsion of nature . . . before the waters gushed in"), Thoreau's topography locates the pond bottom in a more Lyellian picture of geological change. Walden is "only like a shallow plate" of New England bottomland, as beautiful as other undulations in its environing landscape, though filled with water rather than with cornfields. Its congruence with the neighboring hills is "so perfect that a distant promontory betrayed itself in the soundings quite across the pond, and its direction could be determined by observing the opposite shore. Cape becomes bar, and plain shoal, and valley and gorge deep water and channel."[48]

The ice, too, ultimately softens Walden's sublimities. Portraits of the ice forming in early winter, being harvested in winter, and being melted in spring complicate its obdurate obscurities with picturesque beauties. At its most solid, Walden ice is clearly Walden water, reflecting a similar spectrum of colors: seen close up, it is green (for Thoreau, unaccountably so since there is no green in the landscape for it to reflect); seen at a distance, it is blue. Like the moted mirror the water becomes in October, the ice in March becomes a thing of globes and circles as air bubbles undergo their protean transformations to spheres and hemispheres as thickly gathered, eventually, as the cells of honeycombs.[49]

3. *The Resurrections of "Spring."* In "Spring," the third and climactic sketch sequence plots the reanimation of the pond, first in the melting ice and then in a Whitmanesque montage of the "tender signs of the infant earth" being born again. The melting landscape is epitomized in a close-up of sand and water flowing from the bank of a railroad cut. As the wave of energies liberated by light and warmth spreads, withered plants begin to assume a "stately beauty," red squirrels to play "mad pranks." The landscape is filled with the music of water trickling its way to the Atlantic. Songbirds add "carols and glees" to the "circling groping clangor" of Canada geese. As if in another descent of Spirit, greens glow, grass flames on hillsides "like a spring fire," yellow pollen showers from pitch-pines, and blooming trees brighten "like sunshine."[50]

4. *Circles.* In the intricate dance of theme and effect that composes the Walden sketchbook, recurrent images of circles, flowings, and ascents bind into Thoreau's

Transcendentalism even the most disparate details. The very reiteration of these leit-motifs gives them symbolic weight and density. Nature becomes a divinely mandated, pervasive, gradually emergent harmony introducing itself, quietly and repeatedly, into the world's flux.

As in Lane's luminist panoramas, circles, circular arcs, and irregular curves everywhere endow forms with beauty and join them harmonically with other forms, and the accumulating harmonies of the landscape are reiterated in the intensifying harmonies of the book. In the circle of vision, the landscape itself undulates, under its globed foliage, with rounded hills and ridges. So do the pond's bottom, its circular chivin's nests, its globular plants. The shoreline is a concertation of indented, scalloped, and rising curves in three dimensions. With a dusting of snow, the path around the pond becomes a white circle "alternately rising and falling, approaching and receding from the water's edge." [51]

Time, too, is a circle. The patterned variations of the seasons unfold in the same sequence from year to year. In spring, days repeat the seasonal cycle "on a small scale": evening a kind of fall, night a kind of winter, and morning a kind of spring. [52] The sketchbook itself begins in spring and ends in spring, begins with morning and ends with morning, the imagery of its last sketch mirroring that of its first.

5. *Flow.* Like the skeins of narrative and the montagelike sequencing of the sketches, the imagery evokes a world full of movement that is also cyclical. Tidelike, the water rises and falls, laving the shore, shearing its foliage. Even the ice undulates with wind. All nature, Thoreau exults in *A Week on the Concord and Merrimack,* is an outspreading ripple—a circle that propagates circles; and this holds for Walden Pond as well. Stirred even by "the spirit that is in the air," the water turns all contact—all disturbances from storms to insects—into "trembling," "dimpling," "circling dimples," spreading in "lines of beauty" across the water: "the beautiful types," in Transcendentalist iconography, "of all influence." The same is true, in slower motion, of the ice bubbles and the ice floes as they melt. "[G]reat sweeping curves in the edge of the ice" appear in spring, "answering somewhat to those of the shore, but more regular," and the surface of the ice is "all watered or waved like a palace floor"—doubtless the Doge's palace in Venice. Under the radiations of the sun, water and sand flow down the bank of a railroad cut into curves and circles that form grotesque abstracts and epitomes of all organic life. [53] Natural forms, the body, art: all become manifestations of the sun's ripples. Protean, they take the cylindrical forms, as they descend, now of stalactites in a cave, now of "sappy leaves or vines, making heaps of pulpy sprays a foot or more in depth," which resemble lichen, coral, leopard's feet, birds' feet, brains, bowels, excrement and (with their bronze colors and their forms "more ancient and typical" than any leafy product of nature) art. Nature is the art of God, making the earth utter its character in this flowing language of beautiful forms. At the bottom of the bank, flattening from semicylinders into strands still bearing the faint impress of vegetable forms, the flowing sand again re-enacts Creation, exfoliating almost simultaneously (such are the effects of interweaving in Thoreau's catalogue) into a delta landscape, a leaf with all of its correspondent forms, animal and human, internal (lobe and thus liver, lungs, and fat; "the ova of

insects in their axils") and external (feathers, bird wings, trees, rivers, towns and cities, language).[54]

6. *Ascents.* What stirs aspires. Movement in *Walden* is ultimately upward: a sign of the impulse inherent in all creation to transcend. Mist rises in the first sketch like a conventicle of witches and in the last like incense. The pickerel, animate spirits of the pond, "give up their watery ghosts" when caught, "like a mortal translated before his time to the thin air of heaven." The eye of the narrator keeps being drawn upward even when it glances down into the water: heaven is both above and below. The mood of the sketches keeps rising, falling, rising again. And these impulses spread, in "Spring," to the whole landscape. Grass flares up. Music rises from meltwater, from birds. The hawk alternately soars like a ripple, then plummets earthward, "mounting again and again," then repeating "its free and beautiful fall, turning over and over like a kite, and then recovering from its lofty tumbling" to soar again.[55]

The impulse to ascend is evident as well in the stratum of metaphors that articulates Walden's sentience. Throughout the sketchbook, the pond takes on intermittent and shifting resemblances to a human face, whose youth, freshness, and innocence are ethical homologues of the water's purity. Sometimes the pond is a mouth, licking its beardless lips (the "shorn" shore) or again, uttering mist that ascends like prayer to "float as clouds . . . and be reflected in its bosom still." Most often—now explicitly, now implicitly—Walden becomes an eye: its brow, Emerson's cliff; its eyelashes, the fringe of forest trees; and its iris, the dark green in the middle. Thoreau is particularly drawn to the eyelike sensitivity that makes the pond "the landscape's most beautiful and expressive feature": the eye marked by an Emersonian ascent up the ladder of awarenesses. Like the eyes of artists and saints, Walden's is by nature calm and reposeful, supremely reflective, transparent,[56] sensitive to the subtlest influences from its environs, turned toward light. Like Michelangelo's, it magnifies and at the same time dematerializes the world it reflects. From its inner life, wild impulses might surface, like the piscine murders, but the dominant and most constant impulses are the "upwellings" from its hidden springs: kinetic expressions of elation, expansion, joy. Despite the changes caused by human exploitation of its surrounding forest, these virtues bespeak an unchangeable—a divine—constancy in the world's flux and tumult: "the same thought is welling up to its surface that was then; it is the same liquid joy . . . to itself and its Maker, ay, and it may be to me. It is the work of a brave man surely, in whom there is no guile! He rounded this water with his hand, deepened and clarified it in his thought. . . . One proposes that it be called 'God's Drop.'"[57]

In winter, the correspondences shifting again, Walden ice becomes skinlike. Then, its eye clouded and then shut, as in a state of hibernation or death, it becomes a type of the mind again. Now in the fullness of its interior life, it sounds "the difference between the affections and the intellect." Like thought, the ice remains "sweet forever." Like the intellect, it is supremely, if abstractly, reflective. Sky-blue from a distance and earth-green (emerald, in fact) close up, it crystallizes as it generalizes the world with its signifying images. Healing readily after the wounds delivered by the ice-cutters, stretching in spring, it turns into a skin again, alive and "cov-

ered with papillae"—with bubbles that, like nipples, are fed by the expansive and nurturing warmth of the sun.[58]

The climactic image of Walden as sentient being—and of the sketchbook—is that of a New England saint paradoxically both resurrected into the heavens and reincarnated into an earthly life. In his final panorama, Thoreau concentrates on the widening "canal" of open water where the spring ice has begun to melt. The liberated water is transfigured by light and metaphor in concert. First "a ribbon . . . sparkling in the sun," it becomes "a bare face," its sparkling texture an expression of "glee and youth"; then it is a silvery gleam and then a shiner or sunfish, quickened by light.[59] William Ellery Channing caught the biblical undertone in this latter image, noting in the margin of his copy of *Walden,* "Luke XV, 24": the passage in which a father celebrates the return of his prodigal son. Confirms Thoreau: "Walden was dead and is alive again." In this picturesque book, that characterizes the pond, of course. But reflexively it also characterizes the pond's rapt, rejuvenated witness.

I give Thoreau's book of a pond (a book-within-a-book) the climactic position because, a summa of the picturesque in nineteenth-century American art, it constitutes an ultimate test of the reader's knowledge of the aesthetic. Such is the logic of my reconstruction of the theory and practice of American versions of the picturesque, a prolegomenon to the work of historicization. On the same grounds, I have bypassed the earliest stages of its career in the United States—the periods of its transmission from England, c. 1790–1820, and of its first flowering in the generation of Irving, Cooper, and Cole—a period well reconnoitered by Donald Ringe and, more recently, by Bryan Wolf—in order to concentrate on its high period, from 1835 to 1870, which followed the emergence of eclecticism, changes in the psychology of effect, and the intertwining of narration and mise-en-scène. Its high period, as I have come to see, itself consists of two stages. The first of these is antebellum: Emerson's *Nature;* the genre painting of William Sidney Mount and George Caleb Bingham and their contemporaries; the Hudson River School and early luminist painting; Andrew Jackson Downing's writings on rural architecture and landscape architecture; *Moby-Dick* and *Walden.* The second stage is Victorian: genre painting after 1850, including the portraits of urban street children; actual urban vistas; the Beecher sisters' American woman's home, Olmsted's Central Park, and other elements of the picturesque city; Harriet Beecher Stowe's *The Minister's Wooing* and Elizabeth Stuart Phelps's "The Tenth of January," Harriet Wilson's *Our Nig* and Charles Chesnutt's *Conjure Woman.*

One way of getting at the differences between these two epochs proceeds from the recognition of a massive shift in the relationship between natural and built, rural and urban, environments after 1850. Victorian versions of the picturesque, as Thomas Bender has demonstrated, assume a radical discontinuity between natural and urban orders. Cityscapes and natural landscapes, art and nature, might be contiguous, but they are clearly demarcated and the city clearly privileged. The ideal of a national pastoral landscape gives way to a discontinuous mosaic of landscapes and cityscapes. This is the visible expression of an American assent, on the one hand, to the emergent reality of urbanization, and to a powerful desire, on the other hand, to preserve natural retreats. The very notion of a mosaic suggests impulses that cannot be unified, though, like other contrasts, they can be harmonized by picturesque values. The mosaic, moreover, is itself subject to change, as cities play an increasingly dominant role in it, assuming the character of centers that define both their rural peripheries and the future of the nation. That characterization applies very clearly to Central Park (whose site was by no means central when it was chosen), to Phelps's "The Tenth of January," and to the Beecher sisters' American woman's home, from which the husband commutes by train to a job in the city.

When and under what conditions did the American picturesque come to an end? That exceedingly difficult question is also in need of further study. One arguable scenario is that of a gradual devolution (or is it, after all, an evolution?) as first realism and then modernism bring their changes to American art, though this argument is complicated by the reemergence of picturesque values in postmodernist theory and practice. What *is* clear is that there is not a sudden or even a complete ending.

The devolution, if it is that, begins with an epistemological shift. Accommodated after 1870 by realism, picturesque values gradually enter the universe of empiricism. Scenes and images, still constructed in picturesque terms, are imbued with increasingly different codes of signification.

The process is well illustrated by developments in American painting. In the emergent modernity of New York City, painters, like writers, are drawn to the subjects of the city both as an arrangement of new spaces and as an emergent way of life. The focus of the figure-crowded canvases of the Ashcan School (1890–c. 1915) is on the new conditions of urban identity-as-performance in the private and public spaces (tenement apartments, hallways, rooftops; tenements, saloons, Chinese restaurants, circuses, vaudeville and movies, boxing rings; and above all, the streets) of the Tenderloin and the Lower East Side. From Manet, the Ashcan painters learn how to critique the forms and values of the urban environment and, in the process, to tell new (often darker) kinds of stories. Nevertheless, they continue to rely on the representational art of picturesque mise-en-scène. In John Sloan's *Hairdresser's Window* (Fig. 130), a close-up view of a brownstone in the process of becoming commercialized, variations and contrasts are still the chief sites of meaning and leitmotifs the chief means of constituting a unity of effect. Change is represented by variations: the first floor has already been commercialized; on the second, house windows are still in the process of being changed into show windows by a decorative accretion of advertising signs loudly superimposed on the building's spare, functionalist shape, as new colors are superimposed on its muddy yellows, somber browns, and blacks. The improvisational character of Mrs. Malcomb's presentation of her hairdressing establishment, moreover, suggests its marginality even in this working-class mirror of the Ladies' Mile. A smaller and less polished display than its exemplars on Broadway, it also betrays the domestic origins of the service now being commercialized. Its location on the second floor, moreover, points to its marginality even in its local context. So does Mme. Malcomb's name, and so does the character of the advertising. Like the sign for the Chinese restaurant, the five signs around the hairdresser's window are crudely—not (like those on the sidewalk level) professionally—lettered. There is no logo. This is a culture in which giving a business a family name still constitutes an assurance of honesty.

Nevertheless there is already some evidence of the mastery of advertising gimmickry. "Mme." is an appropriation of the panache of Parisian art and worldliness. The misspelled "Curline," which suggests the provisional character of the business, is also, ironically, a mnemonic device, like the misspellings ("lite" and so on) invented by professional advertisers to grab the attention and stick in the mind. Like those of professionals, moreover, the signs, like the performance in the window, advertise the process more than the product. Like the building, the figures are defined almost

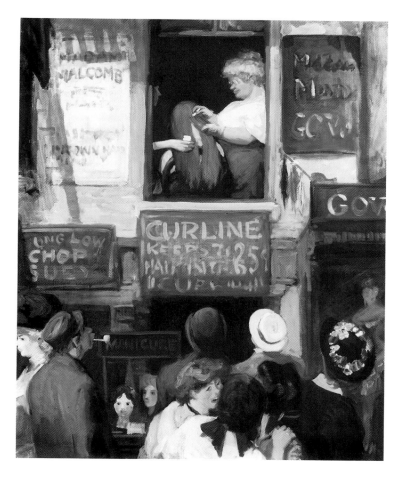

Fig. 130
John Sloan, *Hairdresser's Window*, 1907. Oil on canvas, 26 × 31⅞ inches. Wadsworth Atheneum, Hartford, Connecticut. The Ella Gallup Sumner and Mary Catlin Sumner Collection Fund.

wholly by their performances (the congruence of setting and figures being another feature of picturesque representation). Mrs. Malcomb's performance of a domestic ritual has now become itself an advertisement whose layered messages can be read in the varying responses of the crowd on the sidewalk. In painting such as this, as in earlier paintings of street children, material environments and figures alike become synecdoches of urbanism as a way of life. The values that constitute this way of life are pragmatic, but the means of representing them are not.

It remains for the early modernist painters to discover, in Postimpressionist and Expressionist color and in Cubist and Futurist forms and spaces, images and scenes as progressively constructed as the city itself. The painting of Stuart Davis is a case in point. Before the Armory Show of 1913, Davis is an Ashcan painter; after it, he begins to gravitate toward the "objective order" of Cubist space, defined by its subjective juxtaposition of planes. Color, too, begins to play increasingly important roles not only in the semiotics of the painting but also in the organization of pictorial space. Color plus drawing equals "color-space."

As far as the term "color-space" goes, it is simply a phrase I invented for myself in the observation and thought that every time you use a color you create a space relationship. It is impossible to put two colors together, even at random, without setting up a number of other events. Both colors have a

relative size; either they are the same size or not. And they are either the same shape or not the same shape. They also have, always and automatically, a positional relationship to some necessary, basic, coordinative referent. So the notion of thinking of color as a thing by itself seemed inadequate. For my own personal use I simply called the things that happen when you use two colors, and the process of drawing and painting, a color-space event.

Perspectival space, and with it the picturesque art of mise-en-scène, disappears or is at the very least subject to massive modification. So, too, avowedly, does narrative, which Davis calls "sentimental," though he includes it in a distinctively modernist (and cinematic) form in some of his finest paintings, including *Abstract Vision of New York, Trope de Teens,* and *Ana.* In this new pictorial space, Davis's search for a way of representing the simultaneous multiplicity and "plural significance" of urban space propels him toward the visual syntax of synthetic Cubism, with its expansion of the notion of what constitutes an image, its elaboration of the possibilities of juxtaposition, and its Einsteinian universe. The city of *Hot Stillscape,* for example, is visualized as an eclectic multiplicity of abstracted natural forms and urban artifacts juxtaposed against "invented" shapes in a now-familiar modernist discontinuity. Some of the images are synaesthesic metaphors for audial events; some are reflexive (images of paintings); some, signifiers of personal memories; some, abstractions of evident invisibilities (not speeding forms, for example, but "fast speed" itself). "The subject matter of this picture," Davis declares, though (like modernist literature) not simply a representation of visual experience, is still "well within the experience of any modern city dweller"—"Fruit and flowers; kitchen utensils; fall skies; horizons, taxi cabs; radio; art exhibitions and reproductions; fast travel; Americana; movies; electric signs; dynamics of city sights and sounds"—and its syntax is synthetic "in that it recombines these selections of color and shape into a new unity, which never existed in nature but is a new part of nature." "The best work of the last seventy-five years is great," Davis declares elsewhere, "because it is real contemporary art which expresses in the materials of art the new lights, speeds, and spaces of our epoch. Modern chemistry, physics, electricity . . . have produced a world in which all the conceptions of time and space have been enormously expanded and modern and abstract art both reflect and are an active agent in that expansion. . . . Abstract art . . . is the actual progressive force in the art of our epoch."[1]

It is into this kind of art—abstract in its imagery, relativist in its view of time/space—that picturesque values seem finally to disappear. Davis's city is and requires, before all else, a transformation of consciousness. Yet what do the recurrent resurgences of realism—that of Edward Hopper, Charles Burchfield, and other painters of the 1920s; the Regionalists and the documentary photographers of the 1930s, the New Realists after 1960—have to do, if anything, with picturesque values? Does realism transform them, or does its hospitality to picturesque principles of composition simply stop after 1915?

A parallel but more reflexive scenario of aesthetic transformation is evident in late nineteenth-century prose narrative. By the 1890s (before that in the case of Henry

James), writers had begun to critique the picturesque both explicitly and implicitly, by means of irony. Yet, like the painters, they seem to subordinate and refocus elements of picturesque imagery and mise-en-scène rather than abandoning them. As in Stephen Crane's "The Open Boat," the criticism is sometimes explicit. Crane writes of four men in a boat on a high sea: "Viewed from a balcony, the whole thing would doubtless have been weirdly picturesque. But the men in the boat had no time to see it, and if they had had leisure there were other things to occupy their minds." Despite his change of perspective, however, Crane's omniscient narrator concentrates on the varying effects of the ocean environment on the four men in the boat. Periodically, he resorts to sketching the energy and vastness of the ocean (and the attendant effects of the shark, the line of breakers, and the obscurity of night). But all of this is focused, as cause to effect, on the psychological effects it produces on the bodies and the speech of the men immersed in it, as, in relentless succession, wave after wall-like wave looms over the boat, lifts it into its jagged, mawlike crest, then plunges it down into the deep trough of its passing. In an accumulaton of feelings and sensations reminiscent (to a point) of Poe's "Descent into the Maelstrom," Crane's crew suffers fear (at the forces arrayed against them), fatigue, depression, and anger, all complicated by various strategies of disconnection and denial and punctuated by brief but recurrent seasons of hope. Crane dramatizes these feelings in the dialogue, but also in a sequence of verbal sketches that focus, like figure painting, on varieties and contrasts of body language: the cook gazes eastward (at the sun) and exclaims, as if surprised, at each thump of a wave crest; the injured captain's mind is "buried" in dejection and indifference at the loss of his ship and three crewmen; the correspondent takes it all in and broods on it as he can; and only the oiler seems impervious, wholly focused on his task, as the environment intensifies its influences upon character. The cyclical rhythm of the waves gives a cyclical rhythm to the men's perspectives on the situation and to their feelings. On the up side of the cycle, as they move toward the crests and their view of the ocean expands, their hopes are buoyed: they can see the sky (and the gulls—signs of hope); they can see the horizon line (on which land will appear). On the down side as the wave-walls close in, their height magnified by perspective, space contracts claustrophobically, their hopes sink, and fear or depression intensifies. Much the same effect is caused by the cycle of night and day.

But perhaps only the epistemology differentiates this from such a picturesque narrative as "Descent into the Maelstrom." The "ultimate" effect (in Poe's terms) of "Descent" is a transcendental vision; that of "The Open Boat" is more emphatically pragmatic: a new, compassionate social contract (like that among veterans) based on shared hazards, a shared sense of human vulnerability, and an adamant resistance to the order that assaults them—in Crane's case, a mindlessly violent nature.

What is true of Crane's pragmatism in "The Open Boat" seems true of regionalist narrative as well: it adapts picturesque structures to different epistemological ends. "It was not vital and instinct with the experience and observation of the average American," Bret Harte says of antebellum fiction in "The Development of the Short Story" (1899): "[I]t made no attempt to follow his reasoning or to understand

his peculiar form of expression—which it was apt to consider vulgar; it had no sympathy with those dramatic contrasts and surprises which are the wonders of American civilisation; it took no account of the modifications of environment and of geographical limitations; indeed, it knew little of American geography." Harte retains a sense of the picturesque in his representation of "American civilization" and human character, including speech, but character is now a synecdoche of geography and of history. It is "the treatment of characteristic American life, with absolute knowledge of its peculiarities and sympathy with its methods; with no fastidious ignoring of its habitual expression, or the inchoate poetry that may be found even hidden in its slang; with no moral determination except that which may be the legitimate outcome of the story itself." Harte's own subjects and characters are "distinctly Californian," part of the massive occupation of the Pacific slope, in northern California, by Anglo-American gold miners: a "heterogeneous and remarkable population," mostly young adventurers "consequently free from the trammels of precedent or tradition in arranging their lives and making their rude homes" and of a "Utopian simplicity." The California landscape is "magnificent," "unique," "marvelous in its proportions and spontaneity of growth"; and this picturesque environment is given its "strongest relief," and its "dramatic possibilities," by "its setting among the crumbling ruins of early Spanish possession—whose monuments still existed in Mission and Presidio, and whose legitimate Castilian descendants still lived and moved in picturesque and dignified contrast to their energetic invaders."

In *Country of the Pointed Firs,* Sarah Orne Jewett dramatizes her deep interest in the culture of maritime Maine as, in part, an evolution of aesthetic authority from picturesque idealism to realist pragmatism. Like Charles Chesnutt's John, Jewett's narrator begins as a student of the picturesque—a luminist and latent Transcendentalist—in her attraction to coastal panoramas and the ministries of light and water. But she is converted into more positivistic and more socialized ways of seeing space. She early becomes aware of the landscape's Darwinian element. In a sketch that frames the rest of her narrative, she pictures a funeral procession walking along the shore road, her impressionism reducing the physical landscape to an arrangement of simple primary forms not unlike, say, John Frederick Kensett's "Cliffs of Newport": bay-sheltered islands, a great sea, a clear, high sky, and the shoulder of a slope that runs from her vantage point down to the water. But the indifference of a naturalistic universe is made manifest, first, by the incongruously joyful music of song sparrows, then by her recognition that its marchers are "futile and helpless on the rocky shore," unconsciously enacting, without knowing it, their own imminent disappearance when they disappear beyond a hill "as if . . . into a great cave."

A sketch the narrator presents after the funeral begins as another luminist painting. Dark shadow dominates the foreground, but a sunray makes the outer islands shine out "clear in the light," as if, she muses, "a sudden revelation of the world beyond this." But in her companion's response to this view, she is induced to reread the landscape in terms profoundly social. As in *Walden,* landscape becomes place: a material arrangement but also familial (and later cultural) memory. "That's where mother lives," says Mrs. Todd, student of wild herbs and healer, matriarch of an emergent feminist community, of an island kindled by the light. "Can't we see it

plain. I was brought up out there . . . I know every rock and bush on it." For much of the rest of the story, Mrs. Todd and other natives reread for the narrator other landmarks and tell stories of seafaring times past as well, articulating in the process a pragmatic view of nature (source of food and income, source of healing plants). The collective history, the culture, and the strength of spirit they display in the process become increasingly coherent and at the same time increasingly fragile counter-balances to the "army of . . . pointed firs" marching across abandoned farms toward a port increasingly used for the traffic of tourists.

Like synaesthesia in modernist painting, literary realism also complicates visual spectacle with the play of the other senses. Jack London evokes the Alaskan landscape in "To Build a Fire," for example, minimally and infrequently (in perhaps five sentences all told), as a white field marked by an occasional treeline, subtle signs of a streambed, and even subtler signs of thin ice under the snow. His Alaskan environment is defined chiefly by the sensations and emotions its invisible coldness causes as it invades the body of the protagonist. The natural environment is an "environment" in the literal sense of the term, since it wraps itself around the characters inhabiting or traversing it. As in "The Open Boat" and *The Country of the Pointed Firs,* it is, at the same time, at least in part, an active antagonist.

Nevertheless, the pictorializing impulse persists in realism as it does in modernism, though both epistemological and aesthetic changes mask its picturesque structure. For one thing, the sublime emerges from its decidedly subordinate status in Victorian versions of the picturesque to the point where even beauty is subordinated to it. In the process, empiricism changes the idea of sublimity from a sign of divine presences to a manifestation of the forces (thermodynamics, quantum energy) defined by physics, chemistry, and evolutionary biology as the paradigm of effect is redefined by the emerging social sciences, including psychology and sociology. Lines lose much of their pictorial importance; colors gain importance as signifiers of energy. As things are defined as fields of force in motion—as events with human consequences—verbs and adverbial modifications displace nouns and nominal modifications: "These waves were of the hue of slate, save for the tops, which were of foaming white, and all of the men knew the colors of the sea. The horizon narrowed and widened, and dipped and rose, and at all times its edge was jagged with waves that seemed thrust up in points like rocks."

In keeping with an empirical view of the relation between environment and the body, moreover, realism telescopes the physical and psychological distances that determine the difference between sublime and life-threatening forces: the difference, for example, between a stormy Atlantic seen from a balcony and experienced in a fragile boat. Like Dreiser's Sister Carrie, characters and readers are waifs immersed and typically assaulted by environmental forces. In prose narrative, the experience of immersion and assault is intensified by first-person narration or (as in "To Build a Fire" and "The Open Boat") by an omniscience limited, for the most part, to the perspective of the victims. In all of the stories I have mentioned here, the assault of the environment becomes foregrounded as the plot.

Much the same can be said of naturalism in painting as well. In Winslow Homer's *Northeaster* (and in other seascapes of the 1890s), viewers are offered only an unstable

triangle of rock at bottom left for a sense of purchase—another open boat—in the face of an incoming wave that is caught moving toward them, lifting and curling, its collapse imminent, its slope beginning to be transfigured into the mawlike curl of a breaker. The cause of the awkwardly arrested motion of two beautifully articulated ducks in flight in *Right and Left* is a visual riddle until the viewer picks out two tiny orange cylinders on the stormy coastline below: blasts from a shotgun. The discovery radically redefines the narrative subject and the viewer's relation to it. Both are in a target zone—immersed in "the destructive element." Like Conrad's spears in *Heart of Darkness,* the shotgun has already done its damage before the viewer can construe what is happening to the lovely bodies of the ducks.

A parallel universe of forces manifests itself in the sudden, massive, and disruptive emergence of modern urban-industrial society. Its representation complicates the very notion of setting, which now tends to become (as it is in *Country of the Pointed Firs* and *The Conjure Woman*) a social as well as a natural environment. Urban modernity is not only spatialized in material settings (cityscapes, for example) after 1880; it is also recurrently personified and dramatized, in characterology, as a personification of the impact of the modern city on consciousness. In literature as in Ashcan painting, this personification places heavy emphasis on the human figure and therefore on genre painting. Figuration and characterization not only dominate setting, they become setting. Even body language may be a signifier of social place, as may a character's view of the world. Dreiser is perhaps the chief observer, in the generation of the 1890s, of the city as social environment, but urbanism, as Jay Martin has observed, hovers along the periphery of regionalist fiction as well: the farmscapes and small towns drying up, like Jewett's Dunnet's Landing, in a kind of national backwater or succumbing to the inroads of the new social order. Chesnutt's white narrator John is an emissary of modern consciousness; so, too, from a less critical perspective, is Crane's correspondent, the central consciousness of "The Open Boat." In both of these manifestations, social environments, like their natural homologues, are active agents of plot, even to the point of becoming antagonists.

Epistemological changes engender a discursive change as well. Like the waves in Crane's description above, detail is radically pared down, simplified, and in this sense abstracted. The block descriptions of antebellum narrative are replaced by the quick, impressionistic sketch, the speed of the discourse reiterating the speed at which events unfold in a universe of forces. The process of abstraction culminates (and in another sense begins) in Ezra Pound's Imagist, and not coincidentally urban, sketch of a Paris metro station—

> The apparition of these faces in the crowd:
> Petals on a wet, black bough—

a visual strategy that, like Davis's *Hot Stillscape for Six Colors—Seventh Avenue Style* (Fig. 131), juxtaposes representational with abstract imagery. The petals are not literal; they are imagined, not material, images of the apparitional faces; and at the same time they are signifiers of the poem-speaker's epiphany: in them, things "outward

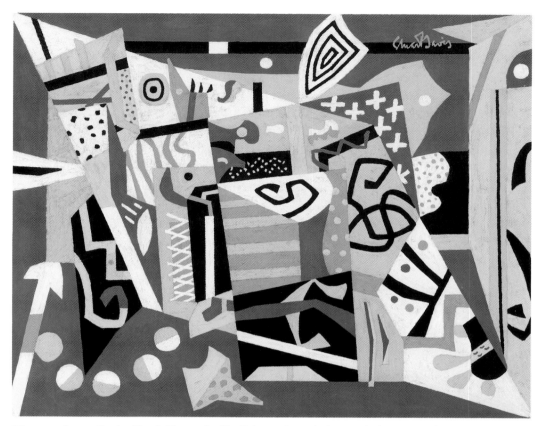

Fig. 131 Stuart Davis, *Hot Stillscape for Six Colors—Seventh Avenue Style*, 1940. Oil on canvas, 36 × 45 inches. Museum of Fine Arts, Boston. Gift of the William H. Lane Foundation and the M. and M. Karolik Collection, by exchange.

and objective" become "inward and subjective." This is a strategy carried into the lyricized discourse of modernist narrative as well, so that it too is able to engender an imagery equal to the task of representing the new urban ontology. Jean Toomer's sketch of Washington's "Seventh Street," the literary equivalent of Davis's *Hot Stillscape,* defines a moment of social and cultural succession in the history of its urban environment by means of images both mimetic and abstract: images, chiefly of burning (a radiating energy); of a (black) wedge driving itself into (white and white-washed) wood; and of blood flowing, an animate and invigorating life-force, like D. H. Lawrence's "blood-consciousness":

> Money burns the pocket, pocket hurts,
> Bootleggers in silken shirts,
> Ballooned, zooming Cadillacs,
> Whizzing, whizzing down the street-car tracks.

Seventh Street is a bastard of Prohibition and the War. A crude-boned, soft-skinned wedge of nigger life breathing its loafer air, jazz songs and love, thrusting unconscious rhythms, black reddish blood into the white and

whitewashed wood of Washington. Stale soggy wood of Washington. Wedges rust in soggy wood. . . . Split it! In two! Again! Shred it! . . the sun. Wedges are brilliant in the sun; ribbons of wet wood dry and blow away. Black reddish blood. Pouring for crude-boned soft-skinned life, who set you flowing? Blood suckers of the War would spin in a frenzy of dizziness if they drank your blood. Prohibition would put a stop to it. Who set you flowing? White and whitewash disappear in blood. Who set you flowing? Flowing down the smooth asphalt of Seventh Street, in shanties, brick office buildings, theaters, drug stores, restaurants, and cabarets? Eddying on the comers? Swirling like a blood-red smoke up where the buzzards fly in heaven? God would not dare to suck black red blood. A Nigger God! He would duck his head in shame and call for the Judgment Day. Who set you flowing?

> Money burns the pocket, pocket hurts,
> Bootleggers in silken shirts,
> Ballooned, zooming Cadillacs,
> Whizzing, whizzing down the street-car tracks.

In architecture, the scenario of stylistic succession for the most part parallels that in painting and literature. The radical simplification of picturesque intricacies begins in the work of Henry Hobson Richardson and culminates in the early modernism of Frank Lloyd Wright. Wright, too, is critical of picturesque values. In his essays "Building the New House" (in *The Natural House*) and "Prairie Architecture" (in *Writings and Buildings*), modernist architecture emerges directly from a deconstruction of the picturesque house—for Wright, a "bedeviled box" with an interior like a honeycomb, a "fussy lid," and outer walls riddled with holes made to let in light and air and with "an especially ugly hole to go in and come out of." The multiplication of rooms in the interior, Wright argues, creates a "cellular sequestration": of "boxes beside boxes or inside boxes" all situated within "a complicated outside boxing. Each domestic function was properly box to box."

In the prairie house, by contrast, the interior walls come down, and the whole ground floor becomes "one room," only the kitchen and the "sleeping boxes" remaining sequestered. The prairie house, Wright declares, is a polliwog whose body is the living room and whose tail can be expanded or contracted as the family expands and contracts—"one bedroom, two bedrooms, three, four, five, six bedrooms long; provision between each two rooms for a convenient bathroom"—and separated from the body "with a loggia—for quiet, etc.; especially grace." The hearth too—an affair of mantel and marble frame set "slam up against the plastered, papered wall," for "a few coals in a grate"—is simplified and integrated into the wall.

Wright's modernism begins, he believes, with his redefinition of the wall as "no longer the side of a box," but at once an "enclosure of space affording protection against storm or heat only when needed" and "a means of opening up space . . . without affecting the soundness of the structure"; a window admitting light into the house "as the plant admits light into its interior." That is accomplished by plate glass

and by a streamlining that erases picturesque form. The "useless heights" of the picturesque house are compressed: the attic disappears, and so does the "unwholesome basement." The roof is radically simplified, streamlined: its slope made more oblique, in keeping with the horizontality of the space it protects; its surface swept free of dormers, wings, and other such deformations; its ornamented chimney clusters reduced to one "broad, generous" mass sitting low on the roof. The projecting roof, a Downingesque feature Wright keeps (as he keeps the principle of adaptation), now serves as a visual compression of the walls. With low walls made lower by the mask of the eaves, the house becomes a "broad shelter in the open, related to vista, vista without and vista within."

Space becomes the basic element in architectural design. Like prairie plants, organic architecture rises "from the ground up" (but not far up) "into the light." And like plants, its form is plastic, streamlined, and above all continuous. The "noble room" inside is the cause of the shape of "the architecture outside." The outside of the house becomes like "the expressive flesh covering of the skeleton," or again like the skin of a hand: an expression of "the . . . spiritual idea that form and function are one."

For Wright, the notion of continuity liberates architects from picturesque space and ushers them into "the space of Einstein" (*House,* 20). The plasticity of the new materials of construction (glass, concrete, steel) allows the wall to become a "folded plane" in which floor, walls, and ceiling all merge into "the expressive flow of continuous surface" while still "reacting upon each other." Ceilings are merged into walls by means of broad, curved bands of plaster; walls and floors are made continuous by similar means. Corners are erased, so that the flow becomes horizontal as well as vertical. Where possible, even furniture is built into the walls and therefore made "a minor part of the building itself." In yet a fourth dimension, outside flows (visually) into inside: "Open reaches of the ground may enter as the building may reach out and associate with these vistas of the ground. Ground and building will thus become more and more obvious as directly related to each other in openness and intimacy, not only as environment but also as a good pattern for the good life lived in the building." And conversely, like the crown of a tree, patios extend the ground floor out into the environment and cantilevers do the same for upper floors.[2]

This transformation is not merely physical. Wright's innovations, Philip Fisher observes in "Appearing and Disappearing in Public," redefine the very notion of domestic architecture as private space.

The very feature of a house that announces in capital letters the wealth and importance of the family within, the entrance, often posed on its pedestal of unnecessary steps and flanked by pillars as pompous and grand as funds permit, is absent in the new Wright homes. It is often difficult to see where to enter these homes, as though they did not wish to invite strangers at all. The facade, that upright, decorative statement facing the street, disappears in favor of a three-dimensional form, equally rich and interesting on all sides. The houses hug the ground almost in disdain of the visibility that the vertical di-

mension commands. In an age of skyscrapers, Wright reclaimed the symbolically "low" territory for its advantages for privacy. His houses protect inner life and they renew it. The Robie House, to take only the most famous example, could be said, in traditional terms, to have not only no facade but not even a front. It refuses to address the street, to announce the family within, to be their social face or at least the outer face of their prestige and wealth. It is nearly impossible at first glance to see how to approach the house or to enter it, both normal and conspicuous features of the facade.

Epistemological change; critique; marginalization; and eventual abandonment: This seems the most plausible scenario of the decline of the picturesque aesthetic at the end of the nineteenth century. Still, it does not account for the amazing continuities. Although it is fruitless to call Stuart Davis's *Hot Stillscape,* Jean Toomer's "Seventh Street," and Frank Lloyd Wright's prairie house picturesque, it is not true to say that they are not manifestations of visual complexity, variety, and contrast or that they do not continue the cultural project of visual narration begun with the picturesque aesthetic. It is increasingly difficult to endorse modernism's own declaration of a radical discontinuity between itself and its nineteenth-century predecessors. The organism is radically evolved, but the kinships between species seems still recognizable. If so, the scenario of modernization in the American arts that disclaims any connection to nineteenth-century art is also deeply in need of revision.

Meanwhile, postmodernism's revival of the picturesque complicates (to say the least) visions of the end of the picturesque aesthetic. "Modern architects," Robert Venturi declares in *Complexity and Contradiction in Architecture,* "with few exceptions eschewed ambiguity." "Frank Lloyd Wright wrote: 'Visions of simplicity so broad and far-reaching would open to me and such building harmonies appear that . . . would change and deepen the thinking and culture of the modern world. So I believed.' And Le Corbusier, co-founder of Purism, spoke of the 'great primary forms' which, he proclaimed, were 'distinct . . . and without ambiguity.'" "But now," he adds, "our position is different." "At the same time that the problems increase in quantity, complexity, and difficulty they also change faster than before, and require an attitude more like that described by August Heckscher: 'The movement from a view of life as essentially simple and orderly to a view of life as complex and ironic is what every individual passes through in becoming mature.'" Focusing on space as they did, modernist architects "abandoned a tradition of iconology in which painting, sculpture, and graphics were combined with architecture" and "shunned symbolism of form as an expression or reinforcement of content." Postmodernism recovers both architectural form and its semiotic resonances. "It is now time," Robert Venturi declares, "to reevaluate the once-horrifying statement of John Ruskin that architecture is the decoration of construction, but we should append the warning of Pugin: It is all right to decorate construction but never construct decoration."

That is where the picturesque and its baroque predecessors reenter the picture. Venturi identifies as "false picturesqueness" a decorative strategy that is not "part of the program and structure of the whole rather than a device justified only by the de-

sire for expression." The complexities of ornamentation and symbolism must be "interdependent" with architectural function; and both must be based on "the richness and ambiguity of modern experience, including that experience which is inherent in art." The best picturesque architecture, he declares in *Learning from Las Vegas*, evokes "romantic allusions to the past to convey literary, ecclesiastical, national, or programmatic symbolism. . . . The overlapping of disciplines may have diluted the architecture, but it enriched the meaning."

The stylistic eclecticism of the nineteenth century was essentially a symbolism of function, although sometimes a symbolism of nationalism—Henri IV Renaissance in France, Tudor in England, for example. But quite consistently styles correspond to building types. Banks were Classical basilicas to suggest civic responsibility and tradition; commercial buildings looked like burghers' houses; universities copied Gothic rather than Classical colleges at Oxford and Cambridge to make symbols of "embattled learning," as George Howe put it, "tending the torch of humanism through the dark ages of economic determinism," and a choice between Perpendicular and Decorated for mid-century English churches reflected theological differences between the Oxford and Cambridge Movements.

Although its end is "commercial persuasion rather than theological refinement," the hamburger-shaped hamburger stand, Venturi concludes, is only a recent manifestation of the need to express architectural function symbolically. Like its baroque and picturesque predecessors, the highway strip, that paradigm of postmodernity, is difficult, complex, and eclectic not only because of its ambiguities but also because of its desire for inclusiveness: "[T]he order of the Strip *includes* . . . includes at all levels, from the mixture of seemingly incongruous land uses to the mixture of seemingly incongruous advertising media plus a system of neo-Organic or neo-Wrightian restaurant motifs in Walnut Formica. It is *not* an order dominated by the expert and made easy for the eye. The moving eye in the moving body must work to pick out and interpret a variety of changing, juxtaposed orders, like the shifting configurations of a Victor Vasarely painting"—or of a novel such as Cristina Garcia's *Aguero Sisters,* which juxtaposes present and past, the worlds of tropical nature and of cities, postmodern Cuba and the United States, commercial and *mestiza* consciousness. Like that of the King Villa, Central Park, and *Walden,* the unity of the strip and that of Garcia's novel is the unity that "maintains, but only just maintains, a control over the clashing elements which compose it. Chaos is very near; its nearness, but its avoidance, gives . . . force."

Chapter 1. The Picturesque Aesthetic: An Introduction

1. DeVoto 136–38.
2. Cole, *Sketches*, 130–32.
3. Kenner 93–98.
4. Martin Price 277–78.
5. For foregrounded forms, the principal subjects of the picture, picturesque theory allows "a separate style of outline" and a touch "expressive of its character" (Bowen 9).
6. Chapman 300. Uvedale Price 115–22. Morse 130, 131.
7. Tuckerman 374–75.
8. Cole, "Essay," 10–11, 6.
9. Bryant I:iii. Italics mine.
10. See, for example, Huth, *Nature and the American;* Nash, *Wilderness and the American Mind;* Marx, *The Machine in the Garden;* and in art history, Novak, *Nature.*
11. See, for example, Boime, *The Magisterial Gaze;* Prown et al., *Discovered Lands, Invented Pasts;* Angela Miller, *Empire of the Eye;* David Miller, ed., *American Iconology;* Shapiro et al., *George Caleb Bingham;* and Truettner and Wallach, eds., *Thomas Cole: Landscape into History.*
12. Burton 312–14.
13. Buell, *The Environmental Imagination.*
14. Burton 312.
15. Downing, *Cottage Residences,* viii.
16. For a more complete survey, see Schimmelman, *Checklist of European Treatises on Art and Essays on Aesthetics Available in America Through 1815.*
17. See Marzio, *The Art Crusade.*
18. *The Crayon,* 1:10 (March 7, 1855) and 1:25 (June 21, 1855).
19. See, for example, *The Crayon,* 1:5 (January 31, 1855).
20. See the bibliography of etiquette manuals in Haltunnen, *Confidence Men and Painted Women.*
21. Bloch 43–47. I follow Novak's catalogue of these visual influences in *American Painting,* 158.
22. Chapman 12–13, 178, 175. Rimmer, 7, 5. For a suggestive study of this subject, see Lynes, *The Taste-Makers.*
23. Downing, *Rural Essays,* 110–18. Chapman 22–23.
24. Jarves, *Art Idea,* 316.

Chapter 2. Eclecticism and the Multiplication of Feelings in Forms

1. This is ground covered more extensively in Walter Hipple, *The Beautiful, The Sublime, and the Picturesque;* Christopher Hussey, *The Picturesque;* and Malcolm Andrews, *The Search for the Picturesque.*
2. Burke 92–96.
3. Uvedale Price I:125–26.
4. Burke 50–73.
5. Uvedale Price I:115–25.
6. Gilpin, *Essays,* 11–12.
7. Morse 81–82.
8. Poe, *Complete Works,* XII: 36–40; II:311–12; III:33; I: 22. Downing, *Theory,* 117–20.
9. Poe, *Works,* II:412. Tuckerman 383–84. Cole, "Essay," 5–10. Encyclopedic demonstrations of the eclectic diversity of the American landscape are popular throughout the century. As its subtitle indicates, *Picturesque America* (1874), for example, applies the eclectic concept, in writing and in visual illustrations, to *The Mountains, Rivers, Lakes, Forests, Waterfalls, Shores, Can[y]ons, Valleys, Cities and Other Picturesque Features of Our Country, from New York to California, Maine to Florida.*
10. The picturesque canon is still in need of definition. Hussey, *The Picturesque,* is a good starting point for the painting, the poetry, the architecture and the landscape architecture of the canon through about 1800, but it is not exhaustive and does not recognize the additions made to it in the nineteenth-century history.
11. For most American artists and serious amateurs before 1870, study of painting in the museums along the European Grand Tour remains a necessity. Reproductions supplement but do not displace firsthand study of canonical texts.
12. *The Crayon,* I:55, 252; I:252. Cooper, *Italy,* 242.
13. Jarves here quotes from Anna Jameson, *Legends of the Madonna* (*Art Hints* 354).
14. Jarves, *Art Studies,* 461, 455; quoted in *Art Hints,* 355.
15. Jarves, *Art Studies,* 461, 455; quoted in Jarves, *Art Hints,* 355. Uvedale Price 125–27, 130–31. Jarves, *Art Hints,* 383, 296–97. Morse 105.
16. *The Crayon,* I:262, III:228.
17. Martin Price 271.
18. Morse 62–70. Like much of the English theory from which they draw (see Watkin, *The English Vision*), Morse's lectures do not use the term "picturesque" explicitly. Nevertheless, his ideas of both nature and art include picturesque principles of motion, change, novelty, and contrast, and his notion of compositional unity is based on the picturesque principles of connection and

congruity (unity of effect); variety and uniformity; contrast and gradation.

19. On eclecticism in architecture, see Downing, *Theory and Practice of Landscape Gardening* (Section IX) and *The Architecture of Country Houses.* On eclecticism in English picturesque landscape architecture, see Carter et al., *Humphry Repton, Landscape Gardener, 1752– 1818,* and Watkin, *The English Vision.*

20. Poe, *Collected Works,* III: 862–63.

21. Morse 130.

22. Poe, *Collected Works,* III:312–13; 157–58.

23. Quoted in McKinsey 43.

24. Cooper, *Italy,* 109, 132; *Switzerland,* 138. Fuller 11–13. Hawthorne agrees with Fuller. See "My Visit to Niagara" (Weber, Lueck, and Berthold 55–61).

25. See Adamson 51–57.

26. King 78–79, 89.

27. This phenomenon of cultural adaptation needs to be studied more closely and more systematically. Most work, as Novak, *Nature,* demonstrates, has tended to concentrate exclusively on the adaptation of European ideas to the deciduous forest landscapes of the American Northeast of this work. What we need now are studies of the representation of other regional landscapes by means of conventions identifiable as picturesque.

28. See Kolodny, *Lay of the Land.*

29. Catlin II:130. Novak, *Nature,* 38. Catlin makes another point here as well: that "a small part of the great 'Far West'" has become tamed enough so that "ladies"—that is, women of cultivation—"can have access"; that their "femininity" and decorum will not be undermined; that the scenery has become harmless spectacle. The itinerary he outlines, a kind of Midwestern version of the American Grand Tour, begins with a trip to St. Louis; then by steamer to Rock Island, Galena, Dubuque, Prairie du Chien, Lake Pepin, St. Peters, the Fall of St. Anthony, and back to Prairie du Chien; and from there to Fort Winnebago, Green Bay, Mackinaw, Sault Ste. Marie, Detroit, Buffalo, and Niagara Falls.

30. Novak, *Nature,* 34–44.

31. Work needs to be done on pictorial representation in these narratives, following the cues given by Kolodny in *The Land Before Her* and Baym in "Melodramas of Beset Manhood" (in Showalter).

32. Novak, *Nature,* 38. See, for example, Boime, *The Magisterial Gaze;* Cronon, "Telling Tales on Canvas: Landscapes of Frontier Change" (in Prown); Franklin Kelly, *Frederic Edwin Church and the National Landscape;* Angela Miller, *The Empire of the Eye;* David Miller, ed., *American Iconology;* and Truettner, ed., *The West as America.*

33. For a detailed reading of urban sublimity in the nineteenth century, see Trachtenberg 101–39;

for an analysis of picturesque sublimity in skyscrapers, see Domosh.

34. See, for example, the discussions of Italianate Revival style in urban architecture in Owen, *Hints on Public Architecture;* Sloan, *City and Suburban Architecture;* and Tuthill, *History of Architecture.*

35. See Chapter 11. Poe's "Man of the Crowd" is a particularly powerful conception of the urban street as stage and the figures on it as actors in a kind of improvisational theater of incidents and vignettes, and Byer, "Mysteries of the City" (in Bercovitch) is a brilliant reading of it in this light. Two other recent essays are also particularly generative: Fisher, "Appearing and Disappearing in Public: Social Space in Late Nineteenth-Century Literature and Culture," and Vidler, "The Scenes of the Street." Although Fisher concentrates on late nineteenth-century American cities and Vidler on eighteenth- and nineteenth-century Paris, they offer rich possibilities for a reading of the nineteenth-century city as theatrical scene.

36. Wilton is the most adept contemporary navigator of this taxonomy. See his *Turner and the Sublime.*

37. The exploration has been hampered by the fact that, during the reign of modernism, eclecticism had mostly negative connotations, particularly in architecture, where it was used to characterize the late stages of picturesque architecture, when coherence had been lost (see Chapter 8). The term implied the absence not only of structural unity but also of any coherent relation between ornamental (symbolic) motifs and structural function. See, for example, Geoffrey Scott's modernist deconstruction of eclecticism in *The Architecture of Humanism.* Postmodernists such as Robert Venturi, in *Complexity and Contradiction in Architecture,* have been more hospitable both to the picturesque and to the eclectic spirit.

38. See Novak's treatment of this development in "Sound and Silence: Changing Concepts of the Sublime," *Nature,* 34–44.

39. See Schiller, "On the Sublime."

40. Cooper, *Italy,* 109, 84, 94. Cooper's sketch of Lago Maggiore (*Switzerland,* 290–93) is a glossary of the visual characteristics that make the Italian landscape for him so distinctively picturesque. The sheer "multiplicity of . . . objects" offers one kind of visual complexity; the "irregular" curve of the shoreline and the "bold" vertical curves of hills leading up from the beach to a "noble background" of mountains offer another. The western coast of Italy is configured this way; so are the Campagna, the Apennines, the Bay of Naples, and the mountainous architectural forms of Rome, dominated by the peak of Saint Peter's.

41. Cooper, *Italy,* 111–12.

42. Cooper, *Italy,* 131–32.

43. Thoreau, *Maine Woods*, 60–65; *Cape-Cod*, 180–89. Downing, *Theory*, 56–57. On Cole's *Sunset in the Catskills*, see Novak, *Nature*, 38–40. In *The Grand and the Fair: Poe's Landscape Aesthetics and Pictorial Techniques*, Ljungquist argues persuasively that Poe formulates a Schillerian version of sublimity during the 1830s. By the 1840s, it is possible to see in his work "a general turn away from the sublime." Landscape description "The Elk" is typical: "*'beauty* is, indeed, its sole character. It has little, or rather nothing, of the sublime'" (Ljungquist 72ff., 82).

44. For a detailed elaboration, see my "Fitz Hugh Lane and the American Picturesque."

45. Downing makes a similar argument about American picturesque landscape architecture in *Theory*, 56–57.

46. *The Crayon*, June 1866. Jarves, *Art Studies*, 30–32.

47. Emerson, *Works*, I:15.

48. Hawthorne, *Works*, VIII:59. More complex examples of Hawthorne's moral picturesque are the "three worthies" (the stage-agent, the doctor, and Lawyer Giles) in "Ethan Brand" and the central figure in "The Old Apple-Dealer." For an analysis of the former, see my "Industrial Sublime: Assailant Landscapes and the Man of Feeling," 36–38; for the latter, see Baym, *The Shape of Hawthorne's Career*, 104ff.

49. Emerson, *Works*, I:15.

50. Ruskin, *Works*, IV:15–32.

51. Novak, *Nature*, 39–44. Prose narratives foreground and narratize the subject of the concentrated gaze; so, too, do paintings.

52. Novak, *Nature*, 39. Cole, "Essay," 7.

53. See Buell's elegant and convincing assessment of Stowe as fictional historian of New England in *The New England Literary Culture*, 261–80.

54. Stowe, *Wooing*, 334–42.

55. Stowe, *Wooing*, 486.

Chapter 3. Reading Forms: Symbolism in Picturesque Effect

1. Emerson, *Works*, I:14.

2. Like biblical language, natural forms can be seen to be capable of expressing typological, allegorical, even anagogical significances. On the relation of biblical exegesis and literary symbolism, see Gura, *The Wisdom of Words*; Bercovitch, *Typology and Early American Literature*; Brumm, *American Thought and Religious Typology*; Buell, *Literary Transcendentalism: Style and Vision in the American Renaissance*; and Lowance, *The Language of Canaan*. The relation of biblical exegesis and pictorial symbolism in nineteenth-century American culture is yet to be explored.

3. Emerson, *Works*, I:14.

4. Downing, *Theory*, 53.

5. Downing, *Theory*, 54–55.

6. Willis, *American Scenery*, 24–25.

7. Chapman 19. Sheldon 177–78.

8. Downing, *Architecture*, 10–19.

9. Stowe, *Wooing*, 28–29.

10. Hussey reminds us that, in the late eighteenth century, the picturesque was connected with the cult of ruin (Hussey 77, 179, 194). However, the notion of picturesque deformation transcends by including a sense of the manifold significances of ruin.

11. Price II:239ff.

12. Gilpin, *Cumberland*, II:123–25.

13. Willis, *American Scenery*, 230.

14. Quoted in Willis 104.

15. McElroy 14, 19, 41. Quoted in Tuckerman 468. The subject of political ideology and pictorial representation in genre painting is treated suggestively in Hills, *The Painters' America*; McElroy, *Facing History*; Menkes, *Of Time and Place*; Taylor, *America as Art*; Williams, *Mirror to the American Past*; and Johns, *American Genre Painting*.

16. Marsh 36, 38–39, 40, 42.

17. Downing, *Theory*, 320–21.

18. Durand 146.

19. Emerson, *Works*, I:39.

20. See Chapman 36–90, 182–93. Exceptions include Whitman and Poe, though even their representations of sexuality are typically covert. For Dickinson and Whitman, see Gilbert, "The American Sexual Poetics of Walt Whitman and Emily Dickinson" (in Bercovitch, ed., *Reconstructing American Literary History*, 123–54). For Poe, see Davidson, *Poe: A Critical Study*. The kind of concealed eroticism that Davison notes in Poe, Hills notes as well in genre painting (*Painters' America*, 75). In a chapter entitled "The Erotic Imagination," Reynolds sets a bold context for future study of visual strategies in the expression of "sexual tensions and perversions" in antebellum America (*Beneath the American Renaissance*, 211–24).

21. Emerson, *Works*, I:30.

22. For another version of the transcendental picturesque, see Horace Bushnell's *God in Christ* (1849) and Gura's fine analysis of it in *The Wisdom of Words*, 51–71. Gura concentrates on Bushnell's ideas about language but in the process also touches upon Bushnell's idea of nature as a divine picture-language.

23. *Works* I:10; *Journals*, V:212.

24. *Journals*, II:306; *Works*, I:12–14.

25. *Works*, I:12.

26. *Works*, I:13.

27. *Works*, I:10, 13.

28. This paradox is at the heart of Emerson's epistemology as well. Where does meaning reside? Emerson argues that finally it does not matter whether it is in nature or the consciousness: "In my utter impotence to test the authenticity of my senses, to know whether the Impressions they make on me correspond with outlying objects,

what difference does it make, whether Orion is up there in the heaven, or some god paints the image in the firmament of the soul. . . . Whether nature enjoys a substantial existence without, or is only in the apocalypse of the mind, it is alike useful and alike venerable to me. Be it what it may, it is ideal to me, so long as I cannot try the accuracy of my senses" (*Works*, 1:29). He also argues, however, that it does matter, that idealism, if it "leaves God out of me" as the source of meaning, the cause of effects, "leaves me in the splendid labyrinth of my perceptions to wander without end" (*Works*, 1:37).

29. *Works*, 1:30.
30. Packer 69.
31. *Works*, 1:25–26. Emerson defines the operations of the conscience on the visible world more fully in the "Divinity School Address."
32. *Works*, 1:15–16, 28.
33. *Works*, 1:16, 31–32, 36.
34. *Works*, 1:19–23.
35. *Works*, 1:23, 9, 17, 39–40.
36. Packer 47. *Works*, 1:37–38. JMN, v:187. Variations on this theme appear as a leitmotif in *Nature*.
37. *Works*, 1:44–45.
38. *Works* (Boston: Houghton Mifflin, 1883), III:22. This is Barbara Packer's lovely phrase (Packer 77).

Chapter 4. Reading the Human Body: The Dramatization of Picturesque Effect

1. Feeling also constricts the breath in ways that allow it to be heard as intonation. For American theorists, vocal tone is the analogue of painterly tone in that it "colors" vocal discourse. See Chapter 7 for an elaboration.
2. By extension, picturesque forms, too, become dramatically expressive when their deformations are perceived as gestural. The earth is a body, and so is the sky, Spurzheim declares. Consequently, there is "a physiognomy of the heavens: some forms and characters of clouds portend wind, certain others rain, others thunder, others fine weather, etc." (Spurzheim 11). For American artists, there is a physiognomy of the earth and its forms as well. The Niagara River as it flows toward the falls thus displays a sequence of changes in its surface that suggests the emotions arising in the face of death. Above the rapids, in Nathaniel Willis's version of the trope, the river has an ingenuously "confiding tranquility" (*American Scenery*, 49). But in the rapids, with the shock of its impact on broken rocks, an agony comparable to Laocoön's begins: the water "seems tossed . . . into the very sky"; then "racked at every step by sharper rocks and increased rapidity, its . . . choked waves fly back" and are pushed forward again by the current. Near the lip of the falls, the water is "convulsed with supernatural horror." At the lip, agitation suddenly ceases: "the foam and resistance sub-

side into a transparent stillness,—and slowly and solemnly the vexed and tormented sufferer drops into the abyss." William Gilpin treats agitation as an expressive element of the human body as well as the face (*Three Essays*, 10–13).
3. Henry 51. Anon., *Art of Acting*, 5, 12.
4. Spurzheim 22. Spurzheim's work had a massive impact on nineteenth-century American intellectual life. Spurzheim himself took a triumphal tour of the States in 1832 and after his death was accorded the honor of a monument in Mount Auburn Cemetery. In the interim, *The American Phrenological Journal* announced a commitment to "PHRENOLOGIZE OUR NATION." Between 1825 and 1855, as Russell Nye observes in *Society and Culture in America*, seventy-two books were published on the subject of phrenology alone, and a number of societies, schools, and journals were formed to promulgate the subject. Some attention has been paid to its impact on artists. For a brief treatment of phrenology in Poe and Whitman, see Reynolds, *Beneath the American Renaissance* (224–27 and 325–29). For George Caleb Bingham, see E. Maurice Bloch, *George Caleb Bingham: The Evolution of an Artist*.
5. *Our Manners*, 87–88. Osmun 58. Young 22. Many of the passages quoted here are drawn from quotations in John Kasson, *Rudeness and Civility*, in chapters entitled "Reading the City: The Semiotics of Everyday Life" (70–111) and "Venturing Forth: Bodily Management in Public" (112–46). See also Haltunnen, *Confidence Men and Painted Ladies*.
6. "Toilet," *Godey's Ladies' Book*, 62 (May 1861), 460–61. Quoted by Haltunnen 83.
7. Greenough 321–22.
8. Haltunnen 76, 79.
9. Todd 122 (quoted in Haltunnen 76, 79). Smith 375–76.
10. Anon., *Art of Acting*, 6.
11. Haltunnen 92–123.
12. Haltunnen 161. Kasson 118, 121, 124, quote on 124. Dayton 119–20. Young 145–56.
13. Greenough 321–22. Moore xv. Kasson 118–21.
14. Anon., *Art of Acting*, 1–6. Henry 1:4.
15. See also Cott, *Bonds of Womanhood*.
16. Anon., *Art of Acting*, 16–20. Douglass 118.
17. Anon., *Art of Acting*, 9, 16, 21.
18. The masks of the blacks of minstrelsy, Houston Baker shows, are partly linguistic; they involve the contortion of language and syntax by "*misspeakers*" who were taken by white audiences to be "bereft of humanity." These minstrels also act out a "comic wild excess" in "intricate, grotesque" dances that make them look (again to white audiences) like "carefree devils strumming and strumming all day" or like "violent devils fit for a lynching" (Baker 17–24).
19. See Allen, *Horrible Prettiness*.
20. Johns, *American Genre Painting*, Huntington,

Art and the Excited Spirit, and Marzio, "The Not-So-Simple Observation of Daily Life in America" (Menkes 178–91) all treat in suggestive ways the subject of nineteenth-century ethnic and racial pictorial stereotypes based on physiognomy as well as emotional exaggeration. Two monumental studies of visual representations of black Americans offer more systematic analyses of the subject: Hugh Honour, *The Image of the Black in Western Art* (vol. 4), and McElroy, *Facing History.* Work is needed on visual representations of Asian and Native Americans. On the latter, James Flexner remains astute and provocative (Flexner 66–86). See also Cronon, "Telling Tales on Canvas" (in David Miller, ed.).

21. Anon., *Art of Acting,* 10, 12 et. seq. Douglass 118.
22. Flexner 189. Tuckerman 475.
23. Gilpin, *Essays,* 10.
24. Johns (162–76), however, shows how in her painting Spencer complicates and subverts separate-sphere ideology.
25. Gilpin 12. American acting manuals gloss the tragic passions as sublime energies that make the body seem ready to explode with movement. Fear, for example, causes mouth and eyes to gape, giving the face "an air of wildness." The hands lift palm forward, shieldlike, toward the object of fear, as if to ward it off, while one foot draws back behind the other—the body "shrinking" away from it and poised for flight. Grief lifts the gaze heavenward, like joy, but also lifts fisted hands to the head, and rocks the body crablike, without purpose, backwards and forward.
26. Rimmer 39.
27. Eliot 246.
28. See McElroy. Catlin I:2. These are all effects evident in literature as well: for example, in Frederick Douglass's portrait of Sophia Auld, Melville's portraits of Queequeg, and Poe's "Mask of the Red Death."
29. Frankenstein 197–98.
30. Hills 75.
31. Huntington 5.
32. Groseclose 75. Quoted in Hassrick 92.
33. Groseclose 75, 78. Huntington 5.

Chapter 5. An Art of the Scene

1. Lucas II:31–32, 55.
2. Morse 92.
3. Lucas II:16.
4. Morse 66, 106. Whittock 153.
5. Thomas Cole, Fitz Hugh Lane, and George Caleb Bingham, for example, all read art-instruction books, in which these arguments were made. For Cole's knowledge of picturesque theory, see Baigell, *Thomas Cole,* and Powell, *Thomas Cole* (especially chapter 2: "Thomas Cole and the Picturesque") and "Thomas Cole and the American Landscape Tradition: The

Picturesque." Lisa Andrus has demonstrated Lane's, and Maurice Bloch, Bingham's, relations to American art-instruction books.
6. Burton 241–42.
7. Published in England, Whittock's book went through multiple editions in the United States. Thus, like Gilpin and Ruskin, Whittock, though not American, is a germinal theorist for American readers.
8. Whittock 157–68.
9. Lucas 40, 29–30. Emerson, *Works,* I:9.
10. Whittock 155. *Crayon,* II:XIII, 191. *Forest Scenery,* 247.
11. Lucas 43. *Forest Scenery,* II:233–39.
12. Donald Ringe lists a dozen narratives by Irving and Cooper that employ images of firelight in significant ways. The next generation seems equally fascinated. As, for example, "Night Sketches," "Earth's Holocaust," "Young Goodman Brown," "My Kinsman, Major Molineux," and "Ethan Brand" attest, firelight is a signature image of Hawthorne's (as it is of Poe's) sketches and stories. "Ethan Brand" is the first of the industrial infernos in antebellum literature, which include Melville's tryworks and the mills in Whitman's "Crossing Brooklyn Ferry," Davis's "Life in the Iron Mills," and Elizabeth Stuart Phelps's "The Tenth of January."
13. Hawthorne, *Works,* XI:304–5.
14. Quoted in Poe, *Works,* IX:31.
15. Gilpin, *Forest Scenery,* II:233–39.
16. Lucas 30. Gilpin, *Forest Scenery,* II:234–35. Hawthorne, *Works,* I:35–36. Emerson I:13.
17. Quoted in Noble 39.
18. Gilpin, *Forest Scenery,* II:239–41.
19. *Crayon,* II:XIII:191.
20. Otis n.p. Price 122–23, 126. Morse 12In.
21. See Chapman 126.
22. Burton 245. Rimmer 7.
23. Andrus (Wilmerding 32).
24. Perspective creates what Gerard Gennette calls "focalization": a determining of both what and how things come to mean in a work of art (*Narrative Discourse,* 189–94). Gennette's notion of "external focalization" seems particularly germinal for further study of mise-en-scène in painting.
25. Otis n.p.
26. Lucas II:62.
27. Anselm Strauss, *Images of the American City* (especially chapter 1, "The City as a Whole"), brings this aspect of perspective to an analysis of late nineteenth- and early twentieth-century urban imagery.
28. Williams 8. Lucas III:5.
29. Chapman 132. Nineteenth-century literature also has its examples of this elevation of the viewer, as it does every other aspect of picturesque mise-en-scène. Consider, for example, Coverdale's arboreal viewing platform in Hawthorne's *The Blithedale Romance* (chapter XII);

Ishmael's masthead (*Moby-Dick,* chapter XXXV); and Emily Dickinson's bedroom window in "The Angle of a Landscape" (#397), "By My Window Have I for Scenery" (#797), and other poems.

30. The instruction books warn against extreme foregrounding, however, because it distorts forms too radically. "Care must be taken," Nathaniel Whittock quotes Edward Dayer, an English draftsman, "not to get too near an object, as, by having a short point of sight, it will be made to appear under so great a point of distance as to look quite distorted" (Whittock 152). The typical solution is "never to be nearer" the foregrounded subject than twice its elevation or length, "which will bring the object within an angle of forty-five degrees." The same holds true of the distance the viewer is advised to take from the painting.

31. Williams 6.

32. Gilpin, *Cumberland* 85.

33. Otis n.p. Whittock 155–56.

34. Hills 26, 53. Johns 121–31.

35. Bowen 11–12. Chapman 291.

36. Andrews 29–31.

37. Andrus 31–40.

38. Gilpin, *Cumberland,* 81–126.

39. For an elaboration of this argument, see my "Fitz Hugh Lane and the American Picturesque," *Revue Française d'Etudes Americaines,* 1986.

40. Novak, *Painting,* 92–135; *Nature,* 41–44. Andrus (in Wilmerding 46–55).

41. Novak, *Nature,* 237. Chapman 172, 175–76. Clay 164.

42. See Cantor's excellent essay on topographical painting.

43. Gilpin, *Forest Scenery,* 1:214.

44. Quoted in Douglas 130. M. Davis 132–33.

45. Novak, *Painting,* 87–90; *Nature,* 239–41. Durand 1:145–46.

46. See Johns 137–75.

47. Adamson (*Niagara,* 11–81) and McKinsey (*Niagara Falls*) have demonstrated, without using the term, how changes in mise-en-scène define the history of nineteenth-century paintings of Niagara Falls.

48. Noble 276–99.

Chapter 6. The Body as Narrative in American Genre Painting

1. Jarves, *Art-Hints,* 105. In Gennette's definition, anachrony is any introduction of a before or an after to a narrative present (*Narrative Discourse,* 33–79). Cutbacks, flashbacks, and foreshadowing are all kinds of anachrony.

2. Jarves, *Studies,* 292–306, 360–61, 380–84; *Hints,* 360–61.

3. Morse 93. On this point, the writers of art-instruction books concur. Nathaniel Whittock argues that the "principal feature" of a painting is defined "by bringing the greatest power of light on it, . . . so that it may be distinctly seen at the first glance (Whittock 156). Foregrounding and lighting, Fielding Lucas declares, are the chief means of signifying the "sentiment, form, and importance of the picture's principal forms and incidents" (Lucas II:11–12).

4. Jarves, *Art Studies,* 29. Morse 67, 78, 86. "Keeping," in its strictest definition, is the use of color and tone to create a coherent illusion of depth, in which "everything shall appear in its proper place, and at its due distance . . . [I]f any colour be too glaring, the object [that it represents] will be brought too forward, and be out of *keeping*" (Lucas II:64).

5. Morse attributes it mistakenly to Albert Dürer.

6. Morse 109.

7. Morse 106–7. *Incongruity,* by contrast, is the inclusion of a form or incident out of keeping with the primary effect. It can have a legitimate function as "the basis of the ridiculous," if that is the effect intended. "Much of [visual] wit depends upon it, and it lies at the foundation of caricature."

8. Poussin's plot, it may be added, also manifests what Poe calls *adaptation:* a logical consequentiality between incidents that relates them to each other by cause and effect. In merely episodic plots, incidents are not so related. In well-adapted plots such as that of *Landscape with Pyramus and Thisbe,* they form a probable, well-motivated, and end-defined whole.

9. Morse 78.

10. On pace in prose narrative, see Gennette, *Narrative Discourse,* chapter 2.

11. Morse 66.

12. Morse 105–6n, 121n. Gradation, Morse demonstrates, is also a vocal principle: "Sound on a stringed instrument, or in the human voice, is capable of the most perfect gradation from the highest to the lowest note, or on almost every instrument from the gentlest breath of sound to the loudest, or from the softest to the shrillest" (Morse 66).

13. Noble 163.

14. Jarves, *Art Studies,* 394–97.

15. Jarves, *Art Studies,* 374–75.

16. The corpus of American genre painting to which I refer is that defined chiefly in Johns, *American Genre Painting;* Hills, *The Painters' America;* McElroy, *Facing History;* Menkes, *Of Time and Place;* Taylor, *America as Art;* and Williams, *Mirror to the American Past,* as well as in monographs on individual genre painters.

17. Chapman 183. The same focalizing strategy is evident in the plotting of picturesque narratives, particularly short stories. In Poe's "Fall of the House of Usher," for example, the effects on both of Usher's houses begin to be pictured in the story's opening paragraph; their cause is backgrounded in an ambiguous "undercurrent" of ambiguous implication; and the story evokes a sequence of verbal sketches and dramatic

scenes that position the reader closer and closer to their intensifying effects.

18. Flexner 21.
19. Frankenstein 340, 361, 247, 271, 173, 271.
20. Huntington 5–6.
21. Quoted in Tuckerman 500.
22. See Johns 26–59.
23. Tuckerman 410.
24. This is Hawthorne's characterization of *The Scarlet Letter* in a letter he wrote to his publisher James Fields, January 20, 1850 (quoted in Mellow, 310).
25. Douglas 184, 195.
26. Quoted in Frankenstein 75–76.
27. Quoted in Bloch 158–59; Groseclose (Shapiro 74–75).
28. Tuckerman 462.
29. Haltunnen 74–86.
30. Anon., *Art of Acting*, 6.

Chapter 7. Space as a Verb: Frame and Narration in Landscapes and Interiors

1. Anonymous, "Some Remarks on the Landscape Art," *Bulletin of the American Art-Union* 2 (December 1849), 18. Quoted in Angela Miller 83.
2. Henry Bellows, "Moral Perspectives," *The Crayon* (February 1857), 34. Quoted in Miller 84.
3. Recent studies of Washington Allston indicate that narratization in American painting is evident at least as early as 1806. See Wolf, *Romantic Re-Vision*, 3–77, and Gerdts, "The Paintings of Washington Allston," in Gerdts and Stebbins, 9–174. Angela Miller demonstrates the narrative character of some Cole landscapes (26–55), but I believe that pictorial narration after 1825 is a tendency more widespread than she suggests. It is certainly as much an element of Cole's "home scenes" (representations of actual landscapes) as it is of such allegorical "fancy landscapes" as *The Voyage of Life* (see chapter 5).
4. "Some Remarks on the Landscape Art," 18.
5. Dwight II:321–29.
6. Harvey n.p.
7. Marsh 36 and 53ff. Succession, as Marsh points out, is also a plot Thoreau lays out in his late essay "The Succession of Forest Trees."
8. Tuckerman 375. Novak, *Nature*, 47. Cole, *Essays*, 136.
9. Emerson I:18. Cott 84–98.
10. Cole 15.
11. Novak, *Nature*, 157, 181–82, 166. And see Marx and Danly.
12. It is Cole, Novak argues convincingly, who first incorporates into the landscape vista "that style of formal declamation which is appropriate . . . for public utterance" (*Nature*, 18–33). Church and Bierstadt bring this tendency to its stupendous climax.
13. Cole 5–6. For Downing's ideas about the adaptation of the picturesque house to the picturesque landscape around it, see Chapter 8.

Buell (*New England Literary Culture*, chap. 13) and Wood ("'Build, Therefore, Your Own World'") offer particularly resonant analyses of the iconization of the picturesque New England village.

14. Noble 63.
15. Tuckerman 377, 380. See James Jackson Jarves for a dissenting view of Bierstadt's and Church's composite vistas: "With singular inconsistency of mind they idealize in composition and materialize in execution, so that, though the details of the scenery are substantially correct, the scene as a whole is often false" (*The Art-Idea*, 233ff.). Many of the details, as Tuckerman himself suggests, are revised for dramatic purposes or presented as pictorial formulas (Flexner 243–44).
16. Tuckerman 383.
17. Durand VII:274. Cropsey 79. Marsh defines these cycles at length in *Man and Nature* (113–280). For a more elaborate treatment of aerial studies, see Novak, *Nature*, 78–100.
18. Andrus 4. Quoted in Howat 230. Howat 229.
19. Quoted in Adamson 53. Andrus 40. Adamson 25, 51–57.
20. Quoted in Downing, *Essays*, xxxiii.
21. Cole 13.
22. Bryant, *Picturesque America*, II:468–70. And see Bender 79–80.
23. Bender 79–93.
24. For the literature of urban picturesque architecture, see, for example, Owen, *Hints on Public Architecture* (1849); Sloan, *City and Suburban Architecture* (1859); and Tuthill, *History of Architecture* (1848). For an authoritative recent history of urban picturesque architecture in the United States, see Pierson, *American Buildings and Their Architects: Technology and the Picturesque, the Corporate and the Early Gothic Styles* (1980).
25. On this subject, see also Chapter 11. See also Boyer's treatment of the Ladies' Mile on New York's Broadway in *Manhattan Manners*, chapter 3.
26. After the turn of the century, as Leach has shown (*Land of Desire*, 39–90), the art of the shop window and the art of the store within come to mimic in three dimensions the scenography of painting.
27. The process of agriculturation in New England reached its peak in the 1850s; then, with New England farms in decline, the forest began to reclaim the landscape. This is a process described in Hugh M. Raup, "The View from John Sanderson's Farm," and powerfully evoked in Sarah Orne Jewett's *Country of the Pointed Firs* and in Robert Frost's poetry.
28. As Barbara Novak has argued, Cole's gravitation after 1835 to fictionalized "fancy landscapes" is a sign of his ambiguities about both social change and about the nature of art (*American Painting*, 61–79). For a more recent and elaborate treatment of Cole's gravitation toward fancy

landscapes, see Stansell and Wilentz, "Thomas Cole: Landscape and the Course of American Empire" (in Truettner and Wallach).

29. Bushman considers the effects of the ethos of refinement in telling detail in *The Refinement of America*, 207–447. In *Rudeness and Civility* (chapter 3), John Kasson considers its effects on self-presentation in city streets.

30. Johns 141.

31. Johns 142–43, 151–57. On the work of Lilly Martin Spencer, see Johns 160–75; and Lubin, "Lilly Martin Spencer's Domestic Genre Painting in Antebellum America" (in David Miller, ed.).

32. Schama 389–91.

33. Frank traces a similar process in five cottages built, over the course of the nineteenth century, in the English Lake District (Knoepflmacher, ed.).

34. Wolfflin 24; quoted in Sheldon 69.

35. Flexner 174–86.

36. Stebbins, ed., *New World*, 285–86.

37. See, for example, Frankenstein 361.

38. Stebbins 278–79.

39. Chambers 42.

40. In Wilmerding 25.

41. This is a theme in Thoreau's *Cape Cod* as well. See the ending of his chapter 1.

42. In Wilmerding 25–26.

43. *Walden*, 86. Thoreau, *Journals*, V:253–54.

44. *Journal*, X:97. *Walden*, 177.

45. Emerson I:17. *A Week*, 331.

46. Emerson, I:17.

Chapter 8. Comparing the Picturesque Arts: Architecture and Landscape Architecture as Painting

1. Frankenstein 340. Olmsted 248. Poe, *Works*, XI:108, VIII:125–36.

2. Downing, *Architecture*, 14, 114, 17.

3. See Pierson 270–431. Both terms, Pierson shows, are plastic to the point of instability, connoting neither a particular shape nor a particular style. The instability is liberating to Downing's generation, but after the war it becomes the cause of enormous confusion: witness the construction of massive Victorian "cottages" in Newport, Rhode Island, beginning in the 1880s, including one called the Marble Palace.

4. *Architecture*, 17.

5. *Architecture*, 46.

6. *Treatise*, 349. "[I]n highly picturesque situations, such as a mountain valley, or a wooded glen," greater complexities are allowable because they would be congruent with the complexities of the landscape (*Architecture*, 46).

7. *Treatise*, 60, 344–46.

8. *Architecture*, 14–15.

9. *Architecture*, 345, 295.

10. *Architecture*, 17, 280.

11. Quoted in *Treatise*, 334.

12. There are literary analogues to Italianate de-

sign as well. See my "Thoreau's Luminist Landscapes."

13. The quotation in this sentence I excerpt from Downing's quotation, in another context, from J. C. Loudon, *Architecture*.

14. *Cottage Residences*, 144. *Treatise*, 333–36. *Architecture*, 286, 380.

15. *Architecture*, 372, 403.

16. To make "the same general spirit of composition pervade all the lines and forms" of the villa, Downing notes, there are Italianate interiors and furnishings for Italianate Revival architecture and Gothic interiors and furnishings for Gothic Revival architecture (*Architecture*, 380–82, 412–40; 382–88, 440–48).

17. *Architecture*, 403–4.

18. Poe, *Collected Works*, I:499, 503.

19. Morris, *Lecture*, 30–31.

20. Downing, *Architecture*, 376–77, 262–63, 71, 26, 388; *Treatise*, 364.

21. *Treatise*, 320; *Cottage Residences*, 67.

22. White houses, Downing argues, standing "harshly apart from all the soft shades of the scene," destroy the "breadth of tone" achieved when "broad masses of colors . . . harmonize and blend agreeably together" (*Architecture*, 201–4). Downing makes an exception for New England villages, whose houses are "surrounded by foliage, and set in a wide landscape." Here white houses give pleasure to the eye as con-trasts to the dominant notes of green foliage and blue sky.

23. Downing, *Architecture*, 43–44 201–4, 34, 206–12. *Treatise*, 11. Downing echoes in this last passage William Wordsworth's description of English Lake District cottages (*Guide to the Lakes*, 62).

24. *Architecture*, 263.

25. *Architecture*, 263, 343–45. Cooper, *Deerslayer*, 452–53.

26. *Treatise*, 333, 336n; *Architecture*, 286. It is also possible to foresee an evolution, in the 1890s, from the graceful horizontalities of Italianate Revival architecture to such twentieth-century designs as Frank Lloyd Wright's "natural house," the earth-hugging California bungalow, and the Spanish Colonial ranch house.

27. *Treatise*, 363–65, 90; *Cottage Residences*, 148.

28. Clark 51–52. For more detailed treatments of this subject, see Clark, chapters 7–11, and Bushman, chapters 7–11. Clark draws from three local studies of nineteenth-century architecture: Weeks, *The Building of Westminster in Maryland;* Schmitt and Karab, *Kalamazoo: Nineteenth-Century Homes in a Midwestern Village;* and Johnson, *The Building of Galena* (Illinois). He also provides a selective bibliography of other local studies, including, notably, Downing and Scully, *The Architectural Heritage of Newport, Rhode Island* (247 n. 8).

29. A more extensive array of architectural scales characterizes picturesque architecture as a whole, with the Newport "cottages" of the Vanderbilts

(see Downing and Scully, ibid.) at one end of the spectrum and, at the other, working-class architecture (see Dannell, *The Christian Home in Victorian America;* Gowans, *Styles and Types of North American Architecture;* and Wright, *Building the Dream*).

30. Clark 62.
31. Clark 57. Gowans, *Styles,* 172.
32. For a catalogue of antebellum styles, see Downing, *Treatise,* 328–52.
33. Downing and Scully 142.
34. See Downing and Scully 144–60; Gowans, *Styles and Types,* 197–201; and Rybczynski, *Home,* 176–79.
35. Downing and Scully 166.
36. Downing and Scully 148–49. Rybczynski 179. The interior of the High Picturesque house is the balloon frame, which replaced mortise-and-tenon construction in the 1860s. This revolutionized the construction not only of wooden country houses but also (built with cast-iron and later steel) of urban architecture in a variety of materials.
37. These interiors are described by Frederick in some detail in *Household Engineering.*
38. Gowans, *Styles,* 199. Downing and Scully 160.
39. Quoted in Rybczynski 147.
40. Downing, *Treatise,* 103, 66, 85, 76, 113–14n.
41. Morse 81–82.
42. *Treatise,* 115–16.
43. *Treatise,* 85–88.
44. *Treatise,* 56–57.
45. On unity in cottages, see the beginning of this chapter; on unity in short stories, see Chapter 9. "In some of the finest smaller compositions of Raphael, or some of the Landscapes of Claude," Downing adds, "every object, however small," also "seems to be instinct with the same expression" (*Treatise,* 56).
46. See Downing's elaborate taxonomy of the beautiful and the picturesque in trees and vines in *Treatise,* 117–286.
47. *Treatise,* 61–63.
48. *Treatise,* 86–91.
49. *Treatise,* 90. Repton quotation in Carter et al., *Humphry Repton,* 60.
50. For Repton's gravitation toward the formalities of the architectural garden, which he situated next to the house itself, see Carter, 58–61, and Watkin, 81–84. The growing American attraction (after 1850) to these formalities is evident in Henry Winthrop Sargent, "The Italian Garden," an essay included in posthumous editions of Downing's *Treatise.*
51. See, for example, Sargent's "Suggestions Concerning Italian Gardens" and his description of the Italian gardens at Wellesley (in Downing, *Victorian Cottage Residences,* 243–45, and *Treatise,* 442–47).
52. For some American theorists, the *garden* is an adjunct to the country house; the *park* is public property and has no house, but it does have an architectural zone defined by terrace, garden, and lawn scenery. Downing early concentrates on private landscape gardens, but by 1850 he begins to concern himself with the possibilities of town parks, then, before his death in 1852, of a "Central Park" for New York City—a project carried out by Olmsted. "National parks," when they appear toward the end of the century, constitute a kind of found picturesque landscape architecture.
53. *Cottage Residences,* 102–13.
54. *Treatise,* 90.
55. Where not found, a lake can be made—or its functions served by an extension of the lawn. Lawns, too, concentrate sunlight and can be punctuated with small groups of trees in such a way as to add, like islands in a pond, "a charming variety in the scene" (*Treatise,* 87–88).
56. *Treatise,* 303, 299–303.
57. *Treatise,* 313.
58. *Treatise,* 82–83.
59. Cast-iron or concrete replications of logs, park designers discover, produce the same scenic effects and are more durable than wood.
60. *Treatise,* 397.
61. Downing, *Treatise,* 364–65. Olmsted and Kimball 408. Price 1:22, 335–36. I reverse here the logic of Uvedale Price, who compares the writer to a landscape gardener. "[P]artial and uncertain concealment," Price repeatedly argues, "excites and nourishes curiosity." Like the landscape gardener, the "judicious author" must conceal his art and even his presence. Thus Homer "scarcely ever appears in his own person." The reader/viewer is engaged by "the most interesting and striking scenes, and . . . carried on," as in the picturesque landscape garden, from one scene to another "in such a manner, as to be totally unconscious of the consummate skill with which [the] route has been prepared."

Like the picturesque garden, literary discourse should be "full of unexpected turns, of flashes of light," and even familiar objects should be "placed . . . in . . . singular, yet natural points of view." Writer and landscape architect alike should "[strike] out such unthought-of agreements and contrasts; such combinations, so little obvious, yet never forced nor affected, that the attention cannot flag." Readers of both, moreover, appreciate the freedoms accorded by this arrangement: "There is in our nature a repugnance to despotism even in trifles, and we are never so heartily pleased as when we appear to have made every discovery ourselves" (Price 1:22, 335–36).

Transitions between scenes are also analogous. As landscape architects must attend to "the small connecting ties and bonds of scenery," writers must attend carefully to "all the connecting particles of language": "our pages would be a good deal like our places" if "all the conjunctions, prepositions, &c. were cleared

away, and the nouns and verbs clumped by themselves" (Price, 1:341–42, 240–41).

62. Downing, *Rural Essays,* 195.

63. *Rural Essays,* 192–202.

64. *Treatise,* 65–67.

65. *Treatise,* 23, 25–31, 558.

66. *Treatise,* 561. Jacob Bigelow, "On the Burial of the Dead, and Mount Auburn Cemetery" (*Modern Inquiries,* 135–36).

67. *Guide,* 47, 12. Bigelow 138–39. Letter from General Dearborn, January 18, 1842. Printed in "Constitution, Reports, Addresses and Other Publications in Relation to the Massachusetts Horticultural Society and the Cemetery at Mount Auburn from 1829 to 1887."

68. Bigelow 15. George Chadwick, "The American Park Movement" (*The Park and the Town,* chapter 9), remains an excellent brief introduction to public parks in the United States.

69. Bigelow 15, 61.

70. Bigelow 172, 17–18. Letter from Dearborn, January 18, 1842, ibid.

71. Bigelow 136–37, 26.

72. Bigelow makes the same argument when he declares his hope that the chapel would become a gallery of "busts, statues, and other sepulchral monuments" commemorating the city's, and the nation's, "men of high intellect, indomitable courage, and unquestioned patriotism,—such qualities as civilized nations, in all ages, have been prompt to recognize and commemorate in lasting memorials" (Bigelow 42, 64–65). That idea was not fully realized in the chapel, but it seems to have influenced the ornamentation of the graves.

73. Quoted in Linden-Ward 223. Linden-Ward 218. Bigelow 128.

74. Bigelow, "On the Limits of Education" (*Modern Inquiries,* 32).

75. Douglas 211.

76. Linden-Ward 234.

77. Buckingham, *America: Historical, Statistic, and Descriptive,* III:391–92. Quoted in Linden-Ward, 261. The population of Mount Auburn is now upward of 99,000 souls.

78. Bigelow 118–29.

79. Linden-Ward 243.

80. Changing rituals of waking and mourning, Douglas observes, also reflect a powerful desire to perceive death as peaceful sleep. Sylvester Judd thus left instructions to be laid out after his death for viewing "in apparent comfort upon his couch, as if in quiet and natural slumber." Alternatively, as if death were a journey, children's coffins were made to look like (among other things) trunks, with a lock and key in place of "remorseless screws and screwdrivers" (Douglas, 209).

81. Downing, *Rural Essays,* 154.

82. Sutton 293–95, 299–300, 297, 276, 299, 273.

83. Sutton 302–3.

84. Sutton 303, 294, 277–78.

85. See Tunnard 196–203. Olmsted's design for Newport's Easton's Beach (1887) is a case in point.

86. Downing, *Treatise,* 570. Downing died in 1852, a year before Llewellyn Park began; Henry Winthrop Sargent provided the description of the park and other developments in picturesque landscape architecture in a supplement included in editions of Downing's *Treatise* after 1859.

87. Sargent includes in his supplement a house design "in the Tuscan manner," its grounds laid out in "the natural style" by Eugene Baumann (*Treatise,* 571; figs. 107 and 108).

88. Downing, *Treatise,* 570, 571. Pierson 429.

89. Downing, *Treatise,* 569.

90. Scott 27–31.

91. The British theorist J. C. Loudon introduced the gardenesque scale, "calculated for displaying the art of the gardener," to picturesque landscape architecture in such books as *Suburban Gardener and Villa Companion* (1838). Scott's notion of the garden is more explicitly related to the picturesque ideal.

92. Scott 92, 14–19, 72.

93. Scott 18, 16, 121–30.

94. Scott 60–69.

Chapter 9. Comparing the Picturesque Arts: Literature as Painting

1. See Ljungquist, *The Grand and the Fair,* for a detailed analysis of Poe's theory of picturesque literature.

2. Poe, *Complete Works,* XI:108; XIII:113; XI:60n.

3. Poe, *Complete Works,* XI:108; VIII:216. Willis 8–10.

4. Poe, *Complete Works,* XI:272; VIII:215–16; VIII:215; XI:272.

5. "Tone" and "mood" appear to be synonymous in picturesque theory. Tone is a term used to denote not, as in present definitions, the emotional stance of the narrator toward the reader, but—like mood—the emotional relationship between narrator and subject defined by the voice.

6. Morse 72, 78. Poe, *Complete Works,* XIV:182–83, 207.

7. Morse 18, 132. Uvedale Price I:116.

8. Phelps 346–47. As this passage demonstrates, the most radical disjunctions of sublime style approach an art of montage. Images may be drawn from different contexts (images perceived, remembered, imagined; images conceptualized into metaphors) and juxtaposed against each other; or, drawn from a single scenic context, they may be purposely jumbled in order to intensify the effects of disorder, shock, and disorientation associated with sublimity. In "the juxtaposition of . . . separate shots by splicing them together," Sergei Eisenstein writes of cinematic montage: "each montage piece exists no longer

as something unrelated, but as a given *particular representation* of the general theme that in equal measure penetrates *all* the shot pieces [read: images]. The juxtaposition of these partial details in a given montage construction calls to life . . . that *general* quality in which each detail has participated and which binds together all the details into a *whole,* namely, into that generalized *image,* wherein the creator, followed by the spectator, experiences the theme" (Eisenstein 11).

9. F. O. Mathiessen noticed Whitman's use of paratactic syntax long ago. Buell (*Literary Transcendentalism,* chapter 6) and Smith ("Emerson and the Luminist Painters") indicate its pervasive presence in nineteenth-century American prose as well.

10. Uvedale Price I:116, 294–96; II:98. Poe, *Collected Works,* III:128.

11. Ringe 90–122. *Crayon,* I:3, 179. In this, Americans are influenced by Sir Walter Scott, Charles Dickens, and other British writers. See McLuhan, *The Interior Landscape,* 51–53, 56–67 et passim, and Fisher, *Hard Facts,* 14–86.

12. These are the observations of G. M. James in an article titled "The Landscape Element in American Poetry."

13. Ringe 17, 24–25, 27.

14. For other examples of the panorama, see Whitman's "Crossing Brooklyn Ferry" (Part III), the buffalo hunting scene in Parkman's *Oregon Trail* (chapter 7), and the long concluding sketch of "The Ponds" in *Walden.* I analyze the panoramas of *Walden* at some length in Chapter 12.

15. For one typical definition of "the poetry of motion" and of other such classifications I treat here—"the poetry of atmosphere," "the poetry of light"—see Burton, *Scenery-Showing.* Gilpin, *Scotland,* 1:183.

16. Burton 274. Muir, *Yosemite,* 20–21.

17. Hawthorne, *Works,* XIV:68–69.

18. Catlin II:125.

19. Burton 274–76.

20. The narrator of Poe's "Landor's Cottage," for example, describes as a vanishing picture the gradual emergence of a landscape "piece by piece, here a tree, there a glimpse of water, and here again the summit of a chimney," through dispersing fog (*Collected Works,* III:13, 30–31).

21. Cooper, *Switzerland,* 39.

22. Quoted in Lossing 158.

23. Burton 243.

24. Melville, *Typee,* 47.

25. *Walden,* 186–89.

26. Poe, *Collected Works,* III:1331.

27. Burton 244.

28. Cooper, *Switzerland,* 112.

29. Burton 279, 283.

30. In film, the zoom and the pan are moving, as distinguished from fixed, frames. See Bordwell and Thompson, *Film Art,* 163–87.

31. Cooper, *Italy,* 90–95, 151–52. See my analysis of Cooper's narrative of *Italy* as a self-consciously "picturesque book" (Cooper, *Gleanings from Europe: Italy,* xxx–xli).

32. Consider, for example, the sequence of identities and effects that Hawthorne evokes in the lime kiln in "Ethan Brand." Hawthorne first emphasizes its power (it is a "rude, round tower," a solid New World fortress and church, with hellish "smoke and jets of flame issuing from the chinks and crevices of its door") and then its eventual dissolution. Abandoned mills, the narrator observes, are transformed by nature despite their "great solidity": weeds take root in the chinks and even in the furnace, and lichen eventually sprout on the stones (*Works,* III:478). By contrast, the kiln presented in the story appears at night and at distances calculated to accentuate the terrible, mesmerizing power of its fire. But the fire, too, is variable in its effects. At a middle distance, as when other characters arrive, its light is "ruddy," even "cheerful." Up close, its flames are increasingly violent, infernal, imbued with the power to transfigure not only marble but the meditative men who tend them. The varying intensity of the flames caused by the opening or closing of its door, as well as by distance from them, also calibrates the emotional characters of the men who gather around it, with their various mixtures of grotesqueness, power, and beauty. At the end, Hawthorne juxtaposes the dead kiln against the dawn-gilded town at the bottom of the mountain. For a more detailed analysis of the kiln, see my "Industrial Sublime." For an analysis of Davis's representations of a steel mill, see my "Assailant Landscapes and the Man of Feeling."

33. *Moby-Dick,* 87:380–90.

34. Poe, *Complete Works,* XIII:113.

35. Martin Price 280.

36. Eliot 246.

37. *Moby-Dick,* 28:123–24.

38. Hawthorne, *Works,* XI:100–102.

39. Hawthorne, *Works,* X:445–46.

40. Poe, *Complete Works,* XI:60n.

41. Hawthorne, *Works,* X:439–46. This is also true of poem-speakers, as, say, "Song of Myself" well demonstrates.

42. See Richard Bridgman's excellent analysis of later stages of this process in *The Colloquial Style in America.*

43. Stowe, *Writings,* 14:318.

44. *Moby-Dick,* 16:73–74; 13:168.

45. Poe, *Complete Works,* XI:108. One measure of his saturation in the aesthetic, Ljungquist observes, is that Poe uses the term "picturesque" and related forms ("picturesqueness") no fewer than sixty-seven times in his criticism (Dameron 38). This figure does not include his picturesquely eclectic definitions of beauty and sublimity.

46. Poe, *Letters,* 1:57–58. *Complete Works,* XI:108, XIII:113.

47. Poe, *Complete Works*, VIII:125–26; XI:277–78. Samuel Morse agrees. In the "nodus or intrigue," which dramatizes "the dangers to which the hero is exposed," Morse argues, "the poet must create difficulties for his hero, and make them grow and thicken 'upon us by degrees' until after a season of suspense he winds up the plot in a natural manner." That requires sequences of scenes with variable (conflicting and intensifying) effects. More complex narratives allow the introduction of effects of "*Mystery and Contrast* which . . . so powerfully rou[s]e the curiosity" (Morse 75).

48. Poe, *Complete Works*, XI:83.

49. Poe, *Complete Works*, XIV:205–6; IX:138; XI:102–13; XIII:141–55.

50. Poe, *Collected Works*, II:577–79.

51. Juxtaposing sublime events with very little transition intensifies their mystery and terror, while beautiful events are most effectively joined by gradual transitions so that the transformation from one effect to another is effortless. In either case, Poe adds, "the delicacy and grace of transition is a point which never fails to test the power of the writer" (*Collected Works*, X:38).

52. Andrew Jackson Downing uses the term "adaptation" in ways very similar to Poe (Chapter 8).

53. For Poe, "polish" and "finish" are synonyms for keeping in discourse. Polish is "skill in details"; and finish, a polish so extensive that "every point of the picture fills and satisfies the eye. Everything is attended to, and nothing is out of time or out of place" (*Complete Works*, X:53; XIII:166–67; X:48; X:37) XI:108, XIII:13; IX:47–48, XIII:62, IX:47–48; IX:47–48, XIII:62.

54. Poe, *Complete Works*, VIII:125–26; XVI:22, IX:47–48, XI:108, XIII:13, IX:47–48, XIII:62, IX:47–48; IX:47–48, XIII:62.

55. Poe, *Complete Works*, XI:108, 117; XIV:188, 193; XI:106; XVI:18. *Collected Works*, I:417.

56. Among others, Francis T. Hart defines the confession in "Notes for an Anatomy of Modern Autobiography" (*New Literary History*, I [1970], 485–511). See also Buell, *Literary Transcendentalism*, 263–330.

57. See the introductions, written under the editorship of James Beard, to the MLA Editions of *The Leather-Stocking Tales* and of Cooper's *Gleanings in Europe*.

58. Cooper, *Mohicans*, 29.

59. *Mohicans*, 62, 199, 59.

60. *Mohicans*, 28, 55.

61. Tones, indeed, convey meaning even when the perceiver cannot hear or does not understand the words being spoken.

62. For Stowe's ideas about picturesque speech and speakers, see pages 209–10 above.

63. *Mohicans*, 51. Sounds are very much part of the picturesque grammar of imagery, particularly when they serve (picturesquely) sublime effects. In "The Hollow of the Three Hills," Poe observes, Hawthorne "wonderfully heighten[s] his effect" by using audial images (the perceiver's head being tucked into the cloak of a witch), because sounds are more suggestive than visual images and have "an all-sufficient intelligence" (*Collected Works*, XI:112).

64. The novel's multiplicity of perspectives is perhaps most dramatically illustrated by the various interpretations offered when the Hurons' horses are discovered cowering in the dark. The proximate cause, several characters agree, is the presence of a wolf, but what drew the wolf? Natty's sense is that it has been drawn to "the offals of the deer the savages [have] kill[ed]" (*Mohicans*, 51). Heyward's alternative reading—that it may have been drawn by the scent of the colt or the buck Natty has just killed (to silence the one and eat the other)—gives Natty pause. David Gamut's biblical reading of the colt as prey to "ravenous beasts" makes it a type of the plagues Yahweh visited upon Egypt as a sign to let his people go. Natty's acceptance of both readings suggests that all three readings are possible, manifold and contending as they may be. Gamut's has "the religion of the matter in believing what is to happen will happen." Heyward's is plausible enough to cause him to throw the deer carcass into the river (after he has cut steaks from it) so that it will not draw the wolves, and therefore the Hurons, to them. Ironically, even if the Hurons' (and Heyward's) interpretation of the wolf's presence were wrong, it would lead the Hurons to Natty's party.

65. McLuhan 57.

66. This description also applies, at times, to Whitman's "Song of Myself" (see, for example, Sections 33–36). In "Spatial Form in the Modern Novel" (*The Widening Gyre*), Frank defines some of the strategies of juxtaposition this structure entails.

67. Morse 75. Morse seems to have in mind the episodic narrative, the epic poem and perhaps, by extension, the ode, with its strophic plotting. Nevertheless, his observation clearly anticipates later kinds of narrative discontinuity as well.

68. Brodhead 121, 130, 144–45. Melville argues that Hawthorne's *House of the Seven Gables* evokes an "intense feeling of the visable [*sic*] truth" and defines this as "the apprehension of the absolute condition of present things as they strike the eye of the man who fears them not, though they do their worst to him" (*Letters*, 124–25). Brodhead quotes the phrase "episodic intensification" from W. J. Harvey's *Character and the Novel*, where Harvey applies it to Dickens. I quote these quotations here to suggest their applicability to other picturesque novels as well as *Moby-Dick*.

69. *Moby-Dick*, 104.

70. *Moby-Dick*, 503–8, 542–45.

71. *Moby-Dick*, 122–24.

72. *Moby-Dick*, 548–52.

73. Morse 75.
74. *Minister's Wooing*, 508, 511, 2, 16–17.
75. *Minister's Wooing*, 41–66, 375, 271–72.
76. *Minister's Wooing*, 315, 127, 351–54, 342, 36–37.
77. *Minister's Wooing*, 28–29.
78. Phelps 309–10.
79. Phelps 307, 332.
80. Phelps 314, 334.
81. Phelps 349–51.
82. Douglass 50–52.
83. See Wallace's detailed reading of this scene in "Constructing the Black Masculine" (Moon and Davidson, eds., *Subjects and Citizens*).
84. Douglass 118–19, 77–78.
85. See Melvin Dixon's underread book, *Ride Out the Wilderness*, and Houston Baker, "On Knowing Our Place" (*Workings of the Spirit*).
86. Wilson 17.
87. Chesnutt 3–6, 34.
88. Chesnutt 133, 103, 4, 168.
89. Chesnutt 60, 40–41.
90. Baker 46.
91. Chesnutt 89, 183, 46, 32, 146–61.
92. Chesnutt 192–93.

Chapter 10. The Gendered American Dream House

1. Downing, *Architecture*, 25, 204, 260.
2. See Cott, *Bonds of Womanhood*.
3. See Bender 73–93 on the split between nature and the city in American thought after 1850.
4. Downing's cottages are meant to house "industrious mechanics" and craftsmen; the villas, businessmen and professionals. Some of the villas in *Architecture of Country Houses*—the Rotch House of New Bedford, Massachusetts (296–98), the King Villa of Newport, Rhode Island (317–21)—are situated in urban enclaves.
5. *Essays*, 13–15.
6. Ward 277.
7. Downing, *Essays*, 399–403. In New England, Downing believes, a millennium has already begun. Wood considers at length the New England town as paradigm of the picturesque ideal. For a more detailed treatment of Downing's campaign for the reformation of the rural landscape, see my "American Dream Houses of Andrew Jackson Downing."
8. Downing, *Essays*, 237, 304–5, 266, 261, 400. See Nylander, *Our Own Snug Fireside*, on the functionalism of nineteenth-century houses.
9. *Essays*, 15, 205.
10. *Essays*, 16.
11. *Treatise*, 29, 13, 53; *Architecture*, 28–29, 40–43; *Essays*, 210.
12. See Pierson 270–431 on nineteenth-century American distinctions between the cottage and the villa.
13. For Thoreau's ideas of cottage architecture, see *Walden*, 27–69.

14. *Architecture*, 71, 43–47. For Downing as for Thoreau, moral economy is not wholly contingent upon income, but it is in part. For those who can afford it, the villa makes possible the achievement of a more complex balance between self-fulfillment and self-control.
15. *Architecture*, 96.
16. *Architecture*, 40–41. See Nylander, chapter 10, and Bushman, chapter 4.
17. *Architecture*, 97, 105–8, 115–16; *Rural Essays*, 398–99. For a recent and especially relevant redefinition of the relation of the American woman to the yeoman as depicted in painting, see Johns 12–16 and 24–59.
18. *Architecture*, 20–23, 28, 270, 373, 407; *Cottage*, 22.
19. Proportion governs "the relation of individual parts to the whole"; symmetry requires the "balance of *opposite* parts" (a wing on one side of the central mass answered by a wing on the other, for example), an arrangement necessary to form "an agreeable whole," even in picturesquely irregular designs.
20. *Architecture*, 10–17.
21. *Architecture*, 20–23, 260, 29. Downing's ideas of the picturesque are departures from English conventions (Chadwick 164), and they are also somewhat unstable. In theory, Downing argues for an emphatic distinction between the beautiful and the picturesque. In practice he melds the two. "Absolute beauty," as he defines it, is by definition picturesque (*Architecture*, 10–20). So, too, are the beauties of decoration and expression (*Architecture*, 260, 29). Since picturesqueness denotes power, "all architecture in which beauty of expression strongly predominates over material beauty, must be more or less picturesque."
22. *Architecture*, 101, 26; *Cottage*, 43; *Architecture*, 113–14, 91; *Essays*, xxxiii. Downing's discourse can be characterized in much the same way: he writes fervently "peaceful books" in relentless pursuit of repose (*Rural Essays*, xviii).
23. *Architecture*, 10, 28–29, 16, 78–79, 83, 122–23, 263; *Treatise*, 53–54.
24. *Rural Essays*, 90, 121. *Architecture*, 120, 84, 79; *Cottage*, 13, 4.
25. Thoreau, *Walden*, 88. Dickinson, *Poems*, 179.
26. *Theory*, 320–21; *Architecture*, 48.
27. *Architecture*, 270, 286.
28. *Architecture*, xx. *Rural Essays*, 210–12.
29. See my "American Dream Houses of Andrew Jackson Downing," 21–23.
30. *Architecture*, 286. And see Chapter 8.
31. For a particularly insightful analysis of spatial segregation, see Johnson's *Shopkeepers' Millennium* (37–61), which considers its evolution in Rochester, New York, in the late 1820s and early 1830s. For a later manifestation in Chicago, see Warner, "The Segregated City" (*The Urban Wilderness*, 85–112).

32. The notion of the gardenesque derives from the work—widely read in the United States (and read especially carefully by Downing and Scott)—of the English landscape architect J. C. Loudon. See Chapter 8.

33. *Architecture,* 257.

34. *Rural Essays,* 238. Downing's advocacy of English Gothic styles of architecture rests in part on the grounds that they are signs of an American claimancy upon English history and English tastes. Part of their attractiveness to Anglo-Saxon Americans, he argues, is their historical and racial associations: they call to mind "the feelings and habits of a refined and cultivated people, whose devotion to country life, and fondness for all its pleasures, are so finely displayed in the beauty of their dwellings, and the exquisite keeping of their buildings and grounds" (*Treatise,* 351–52). Some English Gothic styles provoke memories of "the venerable castles, abbeys, and strongholds of the middle ages"; others, memories of "the dwellings of that bright galaxy" of English writers (Shakespeare's Avon cottage, Pope's Twickenham, and so on). Nevertheless, aspirant working-class Irish Catholics adapted picturesque domestic architecture to their own ends (see McDannell), and there is some evidence in novels such as Frances Harper's *Iola Leroy* that aspirant African Americans living in the North were also drawn to it.

 On the subject of urban working-class architecture, see Wright, *Building the Dream: A Social History of Housing,* and Gowans, *North American Architecture.*

35. For some good analyses of separate-sphere ideology, see Frances Cogan, *All-American Girl,* Cott, *Bonds of Womanhood,* and Johns.

36. Cott 58.

37. Anon., "Matrimony," *Lady's Amaranth,* II (December 1839), 271. Martineau, *Society in America,* 3:106.

38. For similar reasons, Stowe hints, discreetly, that married women should also have the right to a form of sexual autonomy to match that of their husbands: "The common law, while it allows to a husband the free privilege of living apart from his wife, if he does not choose to be with her, allows to the wife neither privacy nor retreat from her husband if he proves disagreeable to her" (Stowe 8:520). As Hedrick observes in *Harriet Beecher Stowe: A Life* (360–73), Stowe's hints are mild ones compared to Angela Heywood's espousal of "voluntary motherhood" and Victoria Woodhull's of free love.

39. *Architecture,* 373, 405, 407.

40. *Home,* 19. Quoted in Boydston 134. Stowe 8:256.

41. Sklar 152. Hedrick 110 et seq. Quoted in Boydston 135.

42. Quoted in Boydston 118.

43. Stowe 8:251–54. In the discussion that follows, however, Stowe seems first to revert to an acceptance of the separation of spheres. The right to vote is limited to female property owners and, even among them, is not a right they would wish actively to exercise, once granted it. Then, with an apparently casual leap of association, she imagines not only women influencing certain legislation with their votes but women holding office. A female mayor, she has her male persona imagine, could even conceivably clean up a city like New York by a synecdochic extension of the idea of housekeeping (8:252–53).

44. For the feminization of religious discourse, see Tompkins, *Sensational Designs,* 138–46; for the feminization of discourse about nature, see Douglas, *The Feminization of American Culture,* 141–51, 161–63, 213–20; and for the feminization of discourse about urban etiquette, see Johns 142–47.

45. Stowe 8:257–60, 250–51.

46. *Home,* 204, 455.

47. Quoted in Boydston 139–40.

48. Sklar 265, 157. Quoted in Boydston 139, 269. *Treatise,* 143–44; *Limits,* 137.

49. *Treatise,* 37–38.

50. The Beechers define marriage as a social phenomenon in complex and problematic ways. They argue that it should be based on an equality achieved by a balance of complementary strengths. Nevertheless, they also accept forms of male hegemony—but the terms of the hegemony are provisional. Since the man's duty is to fund the family's domestic economy and since he has a right to his own earnings, Beecher argues in *The True Remedy for the Wrongs of Women* (1851), his wife "consents to be supported by him" by virtue of the marriage contract and "can not take away this right." "As the general rule, therefore, man must hold the power of *physical strength* and the *power of the purse.* . . . If a woman chooses to put herself into the power of a man by becoming his wife, let her submit to that power" (*Remedy,* 2.24–32; *Limits,* 141). But for Beecher, as Sklar has shown, this is a political expedient "necessary to the maintenance of democracy in America" (136–37, 158).

 More necessary to the democratization of marriage, moreover, is an elevation in status of the roles of wife and mother. The sisters define these roles as callings as well as biological and religious imperatives and refuse to allow them to be consigned to spheres beyond history and society. Women who take them on are to be defined, honored, and remunerated as professionals.

51. *Home,* 17–22. In the paintings of Lilly Martin Spencer, as Johns reads them, and in the novels of Stowe herself, the domestic setting, the plot of self-sacrificing labor, and the characterology of the new woman are all translated, by means of the picturesque aesthetic, into persuasive images and scenes. Even her gendered consciousness is

visualizable. With the help of sentimental conventions, sensibility, grace, tenderness, imagination, compliance, and other such "feminine" qualities of the heart may all be imaged by means of the visible languages of gesture, facial expression, and dress; and, in literature, by means of the nonverbal language of vocal tone as well. Strategies of dishevelment and agitation are capable of defining with particular force an inner life valued for its capacity to register, in visible waves of sensation and feeling, the emotional effects of experience. Mise-en-scène is yet another means of characterization.

52. *Home,* 22, 18.
53. *Home,* 24; *Treatise,* 259.
54. *Home,* 43–58.
55. *Writings,* 8:56.
56. *Writings,* 8:58–60.
57. *Home,* 84–103.
58. Stowe 8:65–66.
59. See Marzio, *Chromolithography,* 70–71 et seq.
60. Beechers, *Home,* 84. Downing, *Architecture,* xx.
61. See Hedrick, 117–21 et passim, on Stowe's attitudes toward Irish Americans and African Americans.
62. Frank 87.

Chapter 11. The Picturesque City

1. The grid was officially imposed on the island of Manhattan in the city's Commissioners' Plan of 1807. See Boyer 3–7.
2. See Domosh, "The Symbolism of the Skyscraper."
3. Corn 60–61. Howells 66. My evocation of New York as spectacle follows Corn closely, including the Howells passage, which she quotes.
4. Anon., "Life on Broadway" (1878), in Oppel 33–43. *The River Hudson,* 44–45.
5. Peirce, *Collected Papers,* 7:115.
6. Poe, *Collected Works,* 11:506–13. Emerson, *Journals,* 6:165.
7. Quoted in Schoener 56.
8. Riis 27–28.
9. Work needs to be done on the role of the picturesque in nativist, temperance, working-class, and abolitionist as well as feminist reform activities, all of which produced powerful pictures to visualize both the disorders they campaigned against and the reforms they envisioned.
10. Fisher 164–65.
11. Fisher, *Hard Facts,* 139–60.
12. For treatments of various elements of the picturesque city, see Pierson, Chadwick, Boyer, and Gowans; Bender, *Toward an Urban Vision* (chapters 4 and 7); and Goldberger, *The Skyscraper.* For the City Beautiful movement, see Tunnard and Reed, *American Skyline* (Part 6), and for the ideal of the White City, which inspired it, see Carr et al., *Revisiting the White City.*
13. Sutton 69, 65.

14. Sutton 78–79.
15. Sutton 107, 65–66, 70, 112–13.
16. Gowans, *Styles,* 143–44, 145, 147–48, 151. Report of the Building Committee of the Congregational Church, 1853, quoted in *Styles,* 155.
17. Pierson 176–77.
18. Oppel 36.
19. Scully 142.
20. Schuyler 558. Gowans 173.
21. Boyer 211. Gowans 173–74.
22. Mumford 11–12.
23. Randolph 3–4, 21. See also Williams, *Window-Gardening.*
24. Randolph 34, 38.
25. Gowans, *Styles,* 173.
26. Owens 66–66.
27. Sloan 83, 19.
28. See Leach 39–75.
29. Sloan 40. Owens 65. Sloan 82, 72–73.
30. Quoted in Boyer 93. The store was built on Broadway between Ninth and Tenth Streets.
31. Goldberger 38–39.
32. Boyer 96; quoted in Boyer 101.
33. Fein 149–50.
34. It is not literally a book, of course, but rather, like Poe's work on picturesque narrative (see Chapter 7), an accumulation—in Olmsted's case, of scholarly papers, articles, lectures, reports to the board of Park Commissioners—that is booklike in its scope, subtlety, and cumulative coherence. Four anthologies represent various "chapters" from Olmsted's hypothetical book of the city. Sutton's Civilizing *American Cities* has the broadest focus, defining Olmsted's ideas about the structure of cities and the roles of the urban park and the suburb. Fein's *Landscape into Cityscape* focuses on Olmsted's ideas for New York as a picturesque city, with such projects as Morningside, Riverside, and Central Parks (a green belt across Manhattan) and the transformation of Brooklyn, Staten Island, and Queens into residential enclaves. Olmsted, Jr., and Theodora Kimball's *Forty Years of Landscape Architecture: Central Park* and Beveridge and Schuyler's *Creating Central Park, 1857–1861* concentrate on Central Park. The picturesque city that Olmsted envisions is also largely hypothetical, since most of it did not get built.
35. Fein 149; Sutton 50; Olmsted and Kimball 239. The grid system, Olmsted argues, also imposes limitations on other urban zones. Because it obviates the experience of monumentality, it diminishes the role of civic architecture in the cityscape. Even monumental architecture is restricted to a length of sixty-six yards, and there is no room for sufficient open space in which to set it: "no place . . . where a stately building can be looked up to from base to turret, none where it can even be seen full in the face and all at once taken in by the eye; none where it can be viewed in advantageous perspective. The few tolerable

sites for noble buildings north of Grace Church and within the built part of the city remain, because Broadway, laid out curvilinearly, in free adaptation to natural circumstances, had already become too important a thoroughfare to be obliterated for the system" (quoted in Sutton 46).

36. Fein 147. Sutton 72, 81.
37. Olmsted and Kimball 356. Parks, Olmsted writes in 1893, must have all the qualities necessary to justify the use of the term "scenery, or of the word landscape in its older and more radical sense, which is much the same as that of scenery" (quoted in Olmsted and Kimball 212).
38. Olmsted and Kimball 268.
39. As Olmsted proposes it, the design of the northern half of Central Park, above the reservoir, manifests a similar dynamic between scenic zones: the Arboretum in the eastern part is to be arranged as a combination of "lawn and woodland landscape"; the central part is left "as open as possible" for pastoral scenery, and Bogardus Hill is to be treated much like Vista Rock (Olmsted and Kimball 230–31).
40. Olmsted and Kimball 215, 250–51.
41. Fein 106.
42. Fein 98. Olmsted and Kimball 250.
43. Olmsted and Kimball 222–23, 238–39, 254–63, 382, 495–96. Fein 102. Kelly 28ff.
44. Olmsted and Kimball 386.
45. Olmsted and Kimball 250–51, 263.
46. Olmsted and Kimball 248.
47. Olmsted and Kimball 222, 258–59, 496, 254–63, 382, 496. Fein 102. Kelly 28ff. Olmsted distinguishes natural from architectural gardens by the type of scenery that predominates: in architectural gardens, "natural features are employed adjunctively" to architectural scenery. In natural gardens, "artificial" (that is, architectural) scenes and forms are employed adjunctively, and natural forms predominate (Olmsted and Kimball 256).
48. Olmsted and Kimball 250–51.
49. Fein 100–101. Olmsted and Kimball 356, 514, 239, 481.
50. Olmsted and Kimball 501–3, 472–73.
51. Quoted in Bender 180. Sutton 75. See also Olmsted and Kimball 24–26. For another, earlier version of this scenario, see Downing, *Rural Essays,* 142–43 and 151.
52. Fein 101. Between 1861 and 1862, Olmsted points out in his proposal for a park in San Francisco, 2,100 out of 5,500 of "the more substantial class" of merchants and tradesmen and 60 percent of "small dealers" had disappeared from the directory—and, perhaps, from San Francisco—an indication that the interests of this class in "the permanent improvement of the city differs but little from that of strangers or mere sojourners." The problem, he suggests, is by no means limited to San Francisco.

53. Olmsted and Kimball 408. The quotation is from one of Central Park's Board of Commissioners.
54. Marx 19–33.
55. Olmsted and Kimball 239–40n. Fein 109.
56. Olmsted and Kimball 242–45.
57. Olmsted had resisted this development for several years because he believed the use of lawns for the kind of active and populous physical play desired by members of the working class ran counter to the requirements of a park designed for visual play. Once he accepted it, he opened the meadows, too, to human use (see Fig. 118).
58. Olmsted and Kimball 215.
59. Olmsted and Kimball 222, 263, 224, 343–49.
60. McCarthy 56–57.
61. Downing, *Treatise,* 343. Olmsted and Kimball 478.
62. Cook 123.
63. Cook 56.

Chapter 12. Walden as Picturesque Narrative

1. See Birch, *Country Seats of the United States . . .* (1809); Davis, *Rural Residences* (1837); Wheeler, *Rural Homes* (1851); Cleaveland and Backus, *Villages and Farm Cottages* (1856); and Scott, *Victorian Gardens,* Part 1: *Suburban Home* (1870).
2. Burton 313.
3. Stowe 205.
4. For an apt definition of the fiction of social ecology, see Gelfant, *The American City Novel* (chapter 1). Gelfant's definition concentrates on local urban ecologies—streets, blocks, apartment buildings, and so on—but it seems readily adaptable to small town and rural ecologies.
5. *Walden,* 211, 197, 175. *Maine Woods,* 155.
6. *Walden,* 36, 46, 317–18.
7. *Journal,* 1:167.
8. The roles of Channing, Margaret Fuller, and other friends in teaching Thoreau the picturesque aesthetic have yet to be examined. That they played such a role is very evident in Channing's *Thoreau, The Poet-Naturalist.*
9. Gilpin, *Essays,* 3. *Walden,* 197.
10. Harding and Meyer 101. *Journal,* III:370.
11. Gilpin, *Forest Scenery,* II:233–46. Thoreau, *Journal* III: 428–44.
12. The Claude glass is a tube with a piece of colored glass at one end used for framing found landscapes. Because it is tinted, the glass also gives (as Thoreau quotes Gilpin) " 'a greater depth to the shadow; by which the effect is shown with more force' " (*Journal,* IV:335–40).
13. *Journal,* V:531. Gilpin, *Essays,* 49.
14. *Journal,* IV:98, 223; XI:331; XIII:112, 114, 383.
15. Gilpin, *Essays,* 42–43; *Cumberland,* 93–102.
16. Thoreau records some aspects of his quarrel with Gilpin in his journals. See, for example, *Journal,* VI:53 and 55–59.
17. *Journal,* 1:423; V:45, 135.

18. Gilpin, *Forest Scenery*, 93–101; *Cumberland*, 81–126. Thoreau, *Journal*, IV:283–84.

19. See especially the sketches in "Where I Lived," at the end of "The Ponds," and in "Spring."

20. See, for example, Thoreau's study of J. C. Loudon's descriptions of plants (*Journal*, VIII.387; IX: 496–97; XI:17n, 41; XII:18, 362; XIV:147, 148, 297, 323). See also Gura's analysis of the influence of John Josselyn's verbal sketches of natural history ("Thoreau and John Josselyn").

21. Frames are evoked in the words of *Walden* by variations in the density and character of descriptive detail. The expansive frame of the vista mixes generalized images of landscapes and waterscapes with images of space and light. The limited frame of the close-up constricts the picture-space to a foreground or even (in the portrait) to a single form, pictured in all of its inherent complexity.

22. *Walden*, 175–77.

23. *Walden*, 188–201.

24. *Walden*, 86–88.

25. *Walden*, 176–77.

26. *Journal*, I:451; *Walden*, 188. Novak, in Wilmerding 25.

27. *Walden*, 186–87.

28. *Walden*, 173–75, 316–19.

29. *Walden*, 181.

30. *Walden*, 246–48.

31. *Walden*, 293, 299–302.

32. See Buell's reading of *Walden* as an anatomy of New England township in *New England Literary Culture*, 321–34.

33. *Walden*, 179–80, 191–92, 294–98.

34. On the feminization of liberal Protestant theology, see Douglas.

35. *Walden*, 285–87.

36. See Hart.

37. The first experiment, of course, is economic: a wage-earner's attempt to discover—his capital being not money but the days of his life—how few days a year must be spent for the necessities of life and how many can therefore be devoted to more "deliberate" activities. The answer to the first question, Thoreau reports, is six weeks (69), though this figure does not take into account the help he got from friends. See Harding, *The Days of Henry Thoreau*.

38. *Journal*, VIII:134; *Walden*, 90–91.

39. For a suggestive treatment of the relations between Walden and luminist painting, see St. Armand, "Luminism in the Work of Henry David Thoreau."

40. *Walden*, 185–86, 178, 175–79.

41. *Walden*, 199, 188, 193.

42. *Walden*, 192.

43. "Colour," writes the author of an article entitled "The Doctrine of Colours," which appeared in 1836, "is merely a property of the light in which [objects] happen to be placed." Material bodies have the capacity to stop "certain rays of white, while they reflect or transmit to the eye the rest of the rays" (*American Magazine*, 2 [May 1836], 375).

44. *Walden*, 193, 179, 186–90. Cole, *Essay*, 9–10.

45. *Journal*, X:97; *Walden*, 177, 184, 284–85.

46. *Walden*, 282, 293–98.

47. *Walden*, 284.

48. *Walden*, 287–89. Gilpin, *Scotland*, II:4, 289.

49. *Walden*, 246–48, 293–302.

50. *Walden*, 309–19.

51. *Walden*, 179–80.

52. *Walden*, 301.

53. *Walden*, 304–9. Emerson 1:18. The first perspective on the thawing bank (*Walden*, 304–5) moves from material ("sand of every degree of fineness and of various colors") to causation (the actions of the sun's heat on the frost and the consequent effects on the bank and at the bottom). The second focalizes a contrast between one bank, in shadow and thus "inert," and another, " twenty to forty feet high," in sunlight and thus melting, and makes explicit the effect of the spectacle on the viewer: "I am affected as if . . . I stood in laboratory of the Artist who made the earth and me" (306–7). The third perspective concentrates more microscopically on the *process* of foliation in the sand, as if it were a kind of graphic writing. A "drop-like point" of water moves down the sandy slope, leaving behind it, like ink from a pen, a line of "silicious matter" (307). In a pendant meditation, the narrator sees the human body as the result of similar deposits. For an excellent reading of this passage, see Gura, *Wisdom of Words*, 131–37.

54. See Gura's analysis of Thoreau's theory of language as this sketch enacts it, a theory derived from Charles Kraitsir (134–36). For Thoreau in this passage, language too is a kind of overflow. "All begins internally (with the gutterals) as a lobe, thick and moist in its womblike position in . . . [the] vocal organs, which then slips and slides outward, delivered finally to the *liquid labials*, and concludes in a leaflike sound, *dry* and *thin* when finally externalized. The liquids press it forward, as they do over the entire globe, but all ends in those dental sounds—the 'symbols of death,' as Kraitsir called them: l-e-a-f, g-l-o-b-e, l-i-f-e." Wordplay in the sketch, Gura shows, continually rehearses this linguistic recapitulation of the natural cycle. "Sand" is transformed into "lava." Streams *interlace*, "a *living* stream or a *live* plant. Sappy leaves and vines appear . . . lichens are evoked, with their lobed, imbricated thalluses. The dominant sounds become the liquid labials, and one sees a living organism that before was dead: leopards' paws, birds' feet."

55. *Walden*, 285, 316–17.

56. In Emerson's *Nature*, the transparent eyeball is an image of the highest state of perception: reflexive and yet in a state of being beyond ego,

supremely alert to the look of things both as they are and as they are seen to be parts of an "uncontained and immortal beauty" (Emerson 1:10).

57. *Walden*, 177, 187–88.
58. *Walden*, 296–97, 302.
59. *Walden*, 311.

Conclusion

1. The three quotations of Davis are from Lowery Stokes Sims, ed. *Stuart Davis: American Painter* (New York: Harry N. Abrams and The Metropolitan Museum of Art, 1991), 71, 28–29, 26.

2. Two quotations are taken from Frank Lloyd Wright, *Writings and Buildings* (New York: Penguin Books, 1960), 313–14, 76–77; the rest are taken from *The Natural House* (New York: Penguin Books, 1970), 14, 34, 165, 32, 33, 47, 32, 28–29, 20, 14, 17–19, 35, 37–38, 167–74, 45, 40, and 41.

English and European Picturesque

Primary Sources

Allison, Archibald. *Essays on the Nature and Principles of Taste.* London, 1790. Reprinted. Hartford, Conn., 1821.

Burke, Edmund. "On the Sublime and the Beautiful." In Charles W. Eliot, ed. *Edmund Burke.* The Harvard Classics. New York: P. F. Collier & Son, 1937.

Gilpin, William. *Observations on the River Wye.* London, 1782. Reprinted. Richmond, Surrey: The Richmond Publishing Co., 1973.

———. *Observations on Cumberland and Westmorland.* London 1786. Reprinted. Richmond, Surrey: The Richmond Publishing Co., 1973.

———. *Observations on the Highlands of Scotland.* London, 1789. Reprinted. Richmond, Surrey: The Richmond Publishing Co., 1973.

———. *Remarks on Forest Scenery.* London, 1791. Reprinted. Richmond, Surrey: The Richmond Publishing Co., 1973.

———. *Three Essays on Picturesque Beauty.* London, 1792.

———. *Observations on the Western Parts of England.* London, 1798. Reprinted. Richmond, Surrey: The Richmond Publishing Co., 1973.

Loudon, J. C. *A Treatise on Forming, Improving and Managing Country Residences.* London, 1806.

———. *Hints on the Formation of Gardens and Pleasure Grounds.* London, 1812.

———. *Encyclopedia of Gardening.* London, 1822.

———. *The Suburban Gardener and Villa Companion.* London, 1838.

Mason, William. *The English Garden.* London, 1772–79.

Price, Uvedale. *Essays on the Picturesque.* London, 1810.

Repton, Humphry. *Sketches and Hints on Landscape Gardening* (1795) and *Theory and Practice of Landscape Gardening* (1803). In J. C. Loudon, ed., *The Landscape Gardening and Landscape Architecture of the Late Humphry Repton, Esq.* London, 1840.

Ruskin, John. "Of the Turnerian Picturesque." In *Modern Painters,* 5:15–32. Boston: Colonial Press Co., n.d.

Schiller, Friedrich von. "On the Sublime." Trans. Julius A. Elias. New York: Frederick Ungar, 1975.

Whately, Thomas. *Observations on Modern Gardening.* Dublin, 1770.

Wordsworth, William. *Guide to the Lakes.* London, 1810. Reprinted. Oxford: Oxford University Press, 1970.

Secondary Sources

Alpers, Svetlana. *The Art of Describing: Dutch Art in the Seventeenth Century.* Chicago: University of Chicago Press, 1983.

Andrews, Michael. *The Search for the Picturesque: Landscape Aesthetics and Tourism in Britain, 1760–1800.* Stanford, Calif.: Stanford University Press, 1989.

Barrell, John. *The Idea of Landscape and the Sense of Place, 1730–1840.* Cambridge: Cambridge University Press, 1972.

Carter, George (Patrick Good and Kedrun Laurie), eds. *Humphry Repton: Landscape Gardener, 1752–1818.* Norwich, England: Sainsbury Centre for the Visual Arts (University of East Anglia, Norwich), 1982.

Chadwick, George F. *The Park and the Town: Public Landscape in the 19th and 20th Centuries.* New York: Praeger Publishers, 1966.

Crane, R. S. "Suggestions Toward a Genealogy of the 'Man of Feeling.'" In Kathleen Williams, ed., *Backgrounds to Eighteenth-Century Literature.* Scranton, Pa.: Chandler Publishing Company, 1971.

Hipple, Walter John, Jr. *The Beautiful, the Sublime, and the Picturesque in Eighteenth-Century British Aesthetic Theory.* Carbondale: Southern Illinois University Press, 1957.

Hunt, John Dixon. *Gardens and the Picturesque: Studies in the History of Architecture.* Cambridge: MIT Press, 1992.

Hussey, Christopher. *The Picturesque: Studies in a Point of View.* 1927. Reprinted. Hamden, Conn.: Shoe String Press, 1967.

Klingender, Francis D. *Art and the Industrial Revolution.* Edited and revised by Arthur

Elton. Hertsford, England: Granada Publishing Limited, 1968.

Knoepflmacher, U. C., and G. B. Tennyson, eds. *Nature and the Victorian Imagination.* Berkeley and Los Angeles: University of California Press, 1977.

McFarland, Thomas. *Romanticism and the Forms of Ruin: Wordsworth, Coleridge, and the Modalities of Fragmentation.* Princeton: Princeton University Press, 1981.

McLuhan, Marshall. "Tennyson and Picturesque Poetry" and "The Aesthetic Moment in Landscape Poetry." In *The Literary Criticism of Marshall McLuhan.* Eugene McNamara, ed. New York: McGraw-Hill, 1971.

Malins, Edward. *English Landscaping and Literature.* London: Oxford University Press, 1966.

Monk, Samuel H. *The Sublime: A Study of Critical Theories in Seventeenth-Century England.* 1935. Reprinted. Ann Arbor: University of Michigan Press, 1960.

Price, Martin. "The Picturesque Moment." In Frederick Hilles and Harold Bloom, eds. *From Sensibility to Romanticism.* New York: Oxford University Press, 1965.

Robinson, Sidney K. *Inquiry into the Picturesque.* Chicago: University of Chicago Press, 1991.

Rosenthal, Michael. *Constable: The Painter and His Landscape.* New Haven: Yale University Press, 1983.

Stechow, Wolfgang. *Dutch Landscape Painting of the Seventeenth Century.* 1966. Reprinted. Ithaca: Cornell University Press, 1981.

Watkin, David. *The English Vision: The Picturesque in Architecture, Landscape, and Garden Design.* New York: Harper & Row, 1982.

Watson, J. R. *Picturesque Landscape and English Romantic Poetry.* London: Hutchinson Educational Limited, 1970.

Wilton, Andrew. *Turner and the Sublime.* Chicago: University of Chicago Press, 1980.

American Picturesque

Primary Sources

Painting and Drawing

Drawing Instruction Books

Anon. *The Art of Drawing, Colouring and Painting Landscapes in Water Colours.* Baltimore, 1815.

Anon. *The Art of Drawing Landscapes.* Baltimore, 1820.

Anon. *Drawing Book of American Landscapes.* New York, n.d.

Anon. *A New Juvenile Drawing Book.* Philadelphia, 1822.

Anon. *The Picturesque Drawing Book.* Philadelphia, 1843.

Anon. *The Theory of Effect.* Philadelphia, 1851.

Anon. *The Youth's New Drawing Book.* New York, 1848.

Bowen, John T. *The United States Drawing Book.* Philadelphia, 1838.

Chapman, John G. *The American Drawing-Book.* New York, 1845.

———. *The American Drawing-Book.* New York, 1847.

Coe, Benjamin H. *Drawing Book of Trees.* Hartford, 1841.

———. *A New Drawing Book of American Scenery.* New York, 1844.

Hill, John. *The Art of Drawing Landscapes.* Baltimore, 1820.

———. *Drawing Book of Landscape Scenery.* New York and Charleston, 1821.

Lucas, Fielding. *Progressive Drawing Book.* Republished. Baltimore, 1826–27.

Otis, Fessenden Nott. *Easy Lessons in Landscape.* New York, 1851.

Peale, Rembrandt. *Graphics: A Manual of Drawing and Writing.* Philadelphia, 1835; rev. ed., 1853.

Rimmer, William. *Elements of Design.* Boston, 1864.

Ruskin, John. *The Elements of Drawing.* Boston, 1828.

———. *The Elements of Perspective . . .* New York, 1860.

Smith, John Rubens. *A Compendium of Picturesque Anatomy.* Boston, 1827.

———. *A Key to the Art of Drawing the Human Figure.* Philadelphia, 1831.

———. *The Juvenile Drawing Book.* Philadelphia, 1845.

Smith, R. S. *A Manual of Topographical Drawing.* New York, 1874.

Turner, Maria. *The Young Ladies' Assistant in Drawing.* Cincinnati, 1833.

Whittock, Nathaniel. *The Oxford Drawing Book.* New York, 1852.

Williams, Henry. *Elements of Drawing.* Boston, 1828.

Picturesque Figuration

Anon. *The Art of Acting; or, Guide to the Stage: in which the Dramatic Passions are Defined, Analyzed, and Made Easy of Acquirement.* In Anon., *Modern Drama,* vol. 9. New York, 1855.

Anon. *Our Manners at Home and Abroad: A Complete Manual on the Manners, Cus-*

toms., and Social Forms of the Best Ameri-
can Society. Harrisburg, Pa., 1883.

Dayton, Abram C. Last Days of Knickerbocker Life
in New York. New York, 1882.

Goodrich, Samuel. What to Do and How to Do It;
or Morals and Manners Taught by Ex-
ample, 28. New York: Sheldon, 1865.

Greenough, Horatio, "The Art of Dress." The
Crayon, 1:21, 321–22.

Lavater, Caspar. Essays on Physiognomy. Boston,
1790.

LeBrun, Charles. Bowles's Passions of the Soul . . .
London, 1800.

———. The Conference of Monsieur LeBrun . . .
London, 1701.

———. Heads Representing the Various Passions
of the Soul . . . Boston, n.d.

———. LeBrun's Expressions of the Passions of the
Soul. London, 17—(?).

———. A Method to Learn to Design the Pas-
sions . . . London, 1734.

———. A Series of Lithographic Drawings Illus-
trative of the Relation Between the Human
Physiognomy and That of the Brute Cre-
ation. London, 1827.

Le Clerc, Sebastian. Caractères de Passions
craves . . . Paris, c. 1700.

Moore, Clara Sophia Jessup. Sensible Etiquette of
the Best Society, Customs, Manners, Morals
and Home Culture. 10th ed. Philadelphia,
1878.

Osmun, Thomas Embley. The Mentor: A Little
Book for the Guidance of Such Men and
Boys as Would Appear to Advantage in the
Society of Persons of the Better Sort. New
York, 1885.

Peirce, Charles Sanders. Collected Papers. Cam-
bridge: Harvard University Press, 1931–58.

Spurzheim, Emil. Outline of Phrenology. Boston,
1832.

———. Phrenology in Connexion with the Study of
Physiognomy. Boston, 1833.

Todd, John. The Young Man: Hints Addressed
to the Young Men of the United States.
Northampton, Mass., 1850.

Young, John H. Our Deportment, or The Man-
ners, Conduct and Dress of the Most Re-
fined Society . . . Rev. ed. Detroit, 1884.

Critical Essays and Histories

Cole, Thomas. "Essay on American Scenery."
The American Monthly Magazine VII
(January 1836), 1–11.

Cropsey, "Up Among the Clouds." The Crayon,
II (August 8, 1855), 79–80.

Dunlap, William. History of the Rise and Progress
of the Arts of Design in the United States.
1834. Reprinted. New York: Dover, 1969.

Durand, Asher, "Letters on Landscape Paint-
ing." Letter I. The Crayon, 1:1 (January 3,
1855), 1–2.

———. Letter II, The Crayon, 1:3 (January 17,
1855), 34–35.

———. Letter III. The Crayon, 1:5 (January 31,
1855), 66–67.

———. Letter IV. The Crayon, 1:7 (February 14,
1855), 97–98.

———. Letter V. The Crayon, 1:10 (March 7,
1855), 145–46.

———. Letter VI. The Crayon, 1:14 (April 4,
1855), 209–11.

———. Letter VII. The Crayon, 1:18 (May 2,
1855), 273–75.

———. Letter VIII. The Crayon, 1:23 (June 6,
1855), 354–55.

———. Letter IX. The Crayon, II:2 (July 11,
1855), 16–17.

Harvey, William. Connected Series of Forty Views
of American Scenery. New York, 1841.

Henry, James. "The Incentives and Aims of Art."
The Crayon, 1:4 (January 24, 1855), 51.

Huntington, Daniel. A General View of Fine Arts.
New York, 1851.

Jarves, James Jackson. Art Hints. New York, 1855.

———. The Art-Idea. New York, 1864. Re-
printed. Benjamin Rowland Jr., ed. Cam-
bridge: Belknap Press of Harvard Univer-
sity Press, 1960.

———. Art Studies: The Old Masters of Italy.
New York, 1861.

———. Art-Thoughts: The Experience and Obser-
vations of an American Amateur in Eu-
rope. New York, 1869.

Noble, Louis L. The Course of Empire, Voyage of
Life, and other Pictures of Thomas Cole,
N.A. with Selections from His Letters and
Miscellaneous Writings: Illustrative of His
Life, Character, and Genius. New York,
1853. Reprinted. Elliot S. Vessell, ed. Cam-
bridge: Harvard University Press, 1964.

———. After Icebergs with a Painter: A Summer
Voyage to Labrador and Around New-
foundland. New York: Appleton and Co.,
1861. Reprinted. New York: Olana Gallery,
1979.

Sheldon, George W. American Painters. New
York, 1879.

Spooner, Shearjashub. Biographical and Critical
Dictionary of Painters . . . New York, 1853.

Tuckerman, Henry T. Book of the Artists. 1867.
Reprinted. New York: James F. Carr, 1966.

**Architecture, Landscape Architecture,
and Urban Design**

Anon. "American Landscape Gardening." Arc-
turus 2 (1841), 36–37.

Anon. *Homes of American Authors.* New York, 1855.

Anon. *Picturesque Pocket Companion and Visitor's Guide Through Mount Auburn.* Boston: Otis Broaders and Company, 1839.

Beecher, Catherine, and Harriet Beecher Stowe. *The American Woman's Home; or, Principles of Domestic Science: A Guide to the Formation and Maintenance of Economical, Healthful, Beautiful, and Christian Homes.* New York, 1869. Reprinted. Hartford, Conn.: Stowe-Day Foundation, 1985.

Beveridge, Charles, and David Schuyler, eds. *Creating Central Park, 1857–1861.* Vol. III of *The Papers of Frederick Law Olmsted.* Charles Capen McLaughlin, ed. Baltimore: Johns Hopkins University Press, 1983.

Bigelow, Jacob. *A History of . . . Mount Auburn.* Boston, 1860.

Birch, Thomas. *Country Seats of the United States . . .* Philadelphia, 1809.

Buckingham, James Silk. *America: Historical, Statistic, and Descriptive.* 3 vols. London, n.d.

Cleaveland, Henry W., and Samuel D. Bachus. *Villages and Farm Cottages: The Requirements of American Village Homes.* New York, 1856.

Cleaveland, Nehemiah. *Green-Wood Illustrated.* Illustrations by James Smillie. New York, 1847.

———. *Hints Concerning Green-Wood, Its Monuments and Improvements.* New York, 1853.

———. *Green-Wood Cemetery: A History of the Institution, from 1838–1864.* New York, 1866.

Cook, Clarence C. *A Description of the New York Central Park.* New York, 1869. Reprinted. New York: Benjamin Blom, 1979.

———. *The House Beautiful: Essays on Beds and Tables, Stools and Candlesticks.* New York, 1877. Reprinted. New York: Dover, 1995.

Davis, Alexander Jackson. *Rural Residences.* New York, 1837. Reprinted. New York: Da Capo Press, 1980.

Downing, Andrew Jackson. *A Treatise on the Theory and Practice of Landscape Gardening, Adapted to North America.* 1841. Ninth ed. (1875). Reprinted. Sakonnet, R.I.: Theophrastus Publishers, 1977.

———. *Cottage Residences; or, A Series of Designs for Rural Cottages and Cottage Villas.* New York: Wiley & Putnam, 1842. Reprinted. New York: Dover, 1981.

———. *The Architecture of Country Houses.* New York: D. Appleton, 1850. Reprinted. New York: Dover, 1969.

———. *Rural Essays.* George William Curtis, ed. New York: George P. Putnam Company,

1853. Reprinted. New York: Da Capo Press, 1974.

Dwyer, Charles. *The Immigrant Builder.* 1859.

Fein, Albert, ed. *Landscape into Cityscape: Frederick Law Olmsted's Plans for a Greater New York City.* New York: Van Nostrand Reinhold, 1981.

Flagg, Wilson. "Landscape and Its Treatment." *North American Review* 84 (1857), 146–82.

Mumford, Lewis. "The City." In Harold E. Stearns, ed., *Civilization in the United States.* New York: Harcourt, Brace, 1922.

Notman, John. *Guide to Laurel Hill Cemetery.* Philadelphia, 1844.

Olmsted, Frederick Law, Jr., and Theodora Kimball, eds. *Forty Years of Landscape Architecture: Central Park.* 1928. Reprinted. Cambridge: MIT Press, 1973.

Owen, Robert Dale. *Hints on Public Architecture.* New York, 1849.

Parmentier, André. "Landscapes and Picturesque Gardens" (1822). Reprinted in Leighton.

Rand, Edward Sprague, Jr. *Flowers for the Parlor and Garden.* New York: Hurd and Houghton, 1876.

Randolph, Cornelia J. *The Parlor Gardener: A Treatise on the House Culture of Ornamental Plants.* Boston: J. E. Tilton & Co., 1861.

Scott, Frank J. *Victorian Gardens.* Part 1: *Suburban Home.* 1870. Reprinted. Watkins Glen, N.Y.: Library of Victorian Culture, American Life Foundation, 1982.

Sheldon, George William, ed. *Artistic Country Seats: Types of Recent Villa and Cottage Architecture.* 1886. Reprinted. New York: Da Capo Press, 1979. 2 vols.

Sloan, Samuel. *The Model Architect: A Series of Original Designs for Cottages, Villas, Suburban Residences, Etc.* Philadelphia, 1852. Reprinted. New York: Da Capo Press, 1975.

———. *City and Suburban Architecture.* Philadelphia, 1859. Reprinted. New York: Da Capo Press, 1976.

Stowe, Harriet Beecher. *The Writings of Harriet Beecher Stowe.* Boston: Houghton Mifflin, 1896. 16 vols. Reprinted. New York: AMS Press, 1967.

Sutton, S. B., ed. *Civilizing American Cities: A Selection of Frederick Law Olmsted's Writings on City Landscape.* Cambridge: MIT Press, 1979.

Tuthill, Louisa C. *History of Architecture.* Philadelphia, 1848.

Van Rensselaer, M. G. "Picturesque New York" (1892). In Frank Oppel, ed. *Gaslight New York Revisited.* Secaucus, N.J.: Castle Books, 1989.

Vaux, Calvert. *Villas and Cottages.* New York:

Harper & Brothers, 1857. Reprinted. New York: Dover, 1970.

Walter, Cornelia. *Rural Cemeteries of America.* New York: R. Martin, 1847.

———. *Mount Auburn Illustrated.* Bound with Nehemiah Cleaveland, *Green-Wood Illustrated.* Illustrations by James Smillie. New York, 1855.

Wheeler, Gervaise. *Rural Homes: Or, Sketches of Houses Suited to American Country Life . . .* New York, 1851.

Williams, Henry T. *Window Gardening.* New York, 1872.

Willis, Nathaniel. *Outdoors at Idlewild.* New York, 1855.

Literature

Anonymous. *The River Hudson, Together with Descriptions and Illustrations of the City of New York.* New York, 1859.

Bryant, William Cullen, et al., eds. *Picturesque America; or The Land We Live In. A Delineation by Pen and Pencil of The Mountains, Rivers, Lakes, Forests, Waterfalls, Shores, Can[y]ons, Valleys, Cities and Other Picturesque Features of Our Country.* New York, 1874. Reprinted. Secaucus, N.J.: Lyle Stuart, 1974.

Burton, The Rev. Warren. *The District School as It Was, Scenery-Showing, and other Writings.* Boston, 1852.

Catlin, George. *Letters and Notes on the Manners, Customs, and Conditions of the North American Indians.* London, 1844. Reprinted. New York: Dover, 1973.

Cole, Thomas. *The Collected Essays and Prose Sketches.* Marshall Tymn, ed. St. Paul: John Colet Press, 1980.

Cooper, James Fenimore. *Gleanings in Europe.* James Beard, Editor-in-Chief. 4 vols. (Italy, Switzerland, The Rhine, and England). Albany: State University of New York Press, 1980–86.

———. *The Last of the Mohicans* (1826). James A. Sappenfield and E. N. Feltskog, eds. Albany: State University of New York Press, 1983.

Davis, Rebecca Harding. *Life in the Iron Mills* (1861). Reprinted. Old Westbury, N.Y.: Feminist Press, 1972.

Dickinson, Emily. *The Complete Poems of Emily Dickinson.* Thomas Johnson, ed. Boston: Little, Brown, 1960.

Dreiser, Theodore. *Sister Carrie.* Donald Pizer, ed. New York: W. W. Norton, 1970.

Dwight, Timothy. *Travels in New England and New York.* New Haven, 1821–22. Reprinted. Cambridge: Belknap Press of Harvard University Press, 1969. Barbara Miller Solomon, ed. 4 vols.

Emerson, Ralph Waldo. *The Journals and Miscellaneous Notebooks of Ralph Waldo Emerson.* William Gillman et al., eds. Cambridge: Harvard University Press, 1960.

———. *Collected Works.* Alfred R. Ferguson, General Editor. Cambridge: Harvard Universtiy Press, 1971.

Fuller, Margaret. *Summer on the Lakes* (1844). Reprinted. Urbana: University of Illinois Press, 1991.

Hawthorne, Nathaniel. *The American Notebooks.* Randall Stewart, ed. New Haven: Yale University Press, 1932.

———. *The Centenary Edition of the Works of Nathaniel Hawthorne.* William Charvat and Roy Harvey Pearce, eds. Ohio State University Press, 1962–.

———. *Hawthorne's American Travel Sketches.* Alfred Weber, Beth L. Lueck, and Dennis Berthold, eds. Hanover, N.H.: University Press of New England, 1989.

Irving, Washington. *The Works of Washington Irving.* 21 vols. New York: G. P. Putnam's Sons, n.d.

King, Clarence. *Mountaineering in the Sierra Nevada.* New York, 1871. Reprinted. New York: W. W. Norton, 1935.

Lewis, Merriwether, and George Clark. *The Journals of Lewis and Clark.* Bernard DeVoto, ed. Boston: Houghton Mifflin, 1953.

Lossing, Benson J. *The Hudson, from the Wilderness to the Sea.* New York, 1866. Reprinted. Port Washington, N.Y.: Kennikat Press, 1972.

Martineau, Harriet. *Society in America.* 3 vols. New York, 1837. Reprinted. New York: AMS Press, 1966.

Melville, Herman. *Typee.* George Woodcock, ed. New York: Penguin Books, 1981.

———. *Moby-Dick.* Vol. 6: *The Writings of Herman Melville.* Chicago: Northwestern University Press and The Newberry Library, 1988.

Milbert, Jacques. *Picturesque Itinerary of the Hudson River* (1828–29). Trans. Constance D. Sherman. Ridgewood, N.J.: Gregg, 1968.

Morse, Samuel F. B. *Lectures on the Affinity of Painting with the Other Fine Arts.* Nicolai Cikovsky, ed. Columbia: University of Missouri Press, 1983.

Muir, John. *Yosemite.* New York, 1912. Reprinted. Garden City, N.Y.: Anchor Books, 1962.

Noble, Louis L. *After Icebergs with a Painter.* New York, 1861. Reprinted. New York: Olana Gallery, 1979.

Oppel, Frank, ed. *Gaslight New York Revisited.* Secaucus, N.J.: Castle Books, 1989.

Parsons, Horatio. *A Guide to Travelers Visiting the Falls of Niagara.* Buffalo, 1834.

Phelps, Elizabeth Stuart. *The Silent Partner.* Old Westbury, N.Y.: Feminist Press, 1983. This edition includes the short story "The Tenth of January."

Poe, Edgar Allan. *The Complete Works of Edgar Allan Poe.* Virginia edition. 17 vols. New York, 1902.

———. *Collected Works of Edgar Allan Poe: Tales and Sketches, 1831–1842.* Thomas Olive Mabbott, ed. Vols. 2 and 3. Cambridge: Belknap Press of Harvard University Press, 1978.

Riis, Jacob. *How the Other Half Lives: Studies Among the Tenements of New York.* New York, 1890. Reprinted. New York: Dover, 1971.

Schoener, Allon, ed. *Portal to America: The Lower East Side, 1870–1925.* New York: Holt, Rinehart and Winston, 1967. See especially "The Street," 53–68.

Smith, Matthew Hale. *Sunshine and Shadow in New York.* Hartford: J. B. Burr, 1868.

Stowe, Harriet Beecher. *Uncle Tom's Cabin.* Boston, 1852. Reprinted. Boston: Houghton Mifflin Company (Riverside edition), n.d.

———. *The Minister's Wooing.* New York, 1859. Reprinted. Hartford, Conn.: The Stowe-Day Foundation, 1988.

———. *The Pearl of Orr's Island.* Boston, 1862. Reprinted. Hartford, Conn.: The Stowe-Day Foundation, 1987.

———. *Writings* (1898). Boston: Houghton Mifflin, 1896. 16 vols. Reprinted. New York: AMS Press, 1967.

Thoreau, Henry David. *Journal.* Bradford Torrey and Francis H. Allen, eds. 14 vols. Boston: Houghton Mifflin, 1906.

———. *Cape Cod.* Dudley C. Lunt, ed. New Haven: College & University Press, 1965.

———. *Huckleberries.* New York: University of Iowa (Windhover Press) and the New York Public Library (Berg Collection), 1970.

———. *Walden.* J. Lyndon Shanley, ed. Princeton: Princeton University Press, 1971.

———. *The Maine Woods.* Joseph J. Moldenhauer, ed. Princeton: Princeton University Press, 1972.

———. *A Week on the Concord and Merrimack Rivers.* Carl F. Hovde, ed. Princeton: Princeton University Press, 1980.

Whitman, Walt. *Leaves of Grass.* Scully Bradley and Harold W. Blodgett, eds. New York: W. W. Norton, 1973.

Willis, Nathaniel. *American Scenery; or, Land, Lake and River Illustrations of Transatlantic Nature.* 2 vols. 1840. Reprinted. Barre, Mass., 1971.

Secondary Sources

Painting and Drawing

Adamson, Jeremy Elwell, et al., eds. *Niagara: Two Centuries of Changing Attitudes, 1697–1901.* Washington, D.C.: Corcoran Gallery of Art, 1985.

Andrus, Lisa Fellows. "Design and Measurement in Luminist Art." In *American Light: The Luminist Movement, 1850–1875.* John Wilmerding, ed. Washington, D.C.: National Gallery, 1980.

Arnheim, Rudolf. *Art and Visual Perception.* Berkeley and Los Angeles: University of California Press, 1974.

Baigell, Matthew. *Thomas Cole.* New York: Watson-Guptill, 1981.

Bloch, E. Maurice. *George Caleb Bingham: The Evolution of an Artist.* 2 vols. Berkeley and Los Angeles: University of California Press, 1967.

Boime, Albert. *The Magisterial Gaze: Manifest Destiny and American Painting, c. 1830–1865.* Washington, D.C.: Smithsonian Institution Press, 1991.

Burns, Sarah. "Barefoot Boys and Other Country Children: Sentiment and Ideology in Nineteenth-Century American Art." *The American Art Journal* 21 (1988), 25–50.

Cantor, Jay E. "The New England Landscape of Change." *Art in America* 64 (January–February 1976), 51–54.

Chambers, Bruce W. *The World of David Gilmour Blythe.* Washington, D.C.: Smithsonian Institution Press for The National Collection of Fine Arts, 1980.

Conron, John. "Fitz Hugh Lane and the American Picturesque." *Revue Française d'Etudes Américaines.* Special Issue: American Landscape, 1986.

Corn, Wanda M. "The New New York." *Art in America* 4 (July–August 1973), 58–65.

Danly, Susan, and Leo Marx, eds. *The Railroad in American Art: Representations of Technological Change.* Cambridge: MIT Press, 1988.

Drepperd, Carl W. *American Drawing Books.* New York: New York Public Library, 1946.

Driscoll, John Paul, and John K. Howat. *John Frederick Kensett.* New York: W. W. Norton, 1985.

Ellis, C. Hamilton. *Railway Art.* Boston: New York Graphic Society, 1977.

Ferber, Linda S., and William H. Gerdts. *The New Path.* New York: Brooklyn Museum and Schocken Books, 1985.

Flexner, James Thomas. *That Wilder Image.* New York: Dover, 1970.

Foshay, Ella M. *Mr. Luman Reed's Picture Gallery.* New York: Harry N. Abrams, 1990.

Gombrich, E. H. *The Image and the Eye.* Ithaca: Cornell University Press, 1982.

Groseclose, Barbara. "The 'Missouri Artist' as Historian." In Michael Shapiro et al., eds. *George Caleb Bingham.* New York: Harry N. Abrams, 1990.

Hassrick, Peter. *The Way West.* New York: Harry N. Abrams, 1983.

Hendricks, Gordon. *Albert Bierstadt.* New York: Harry N. Abrams, 1974.

Hills, Patricia. *The Painters' America: Rural and Urban Life, 1810–1910.* New York: Praeger Publishers, 1974.

Honour, Hugh. *The Image of the Black in Western Art.* Vol. 4: *From the American Revolution to World War I.* Cambridge: Harvard University Press, 1989.

Howat, John K., et al. *American Paradise: The World of the Hudson River School.* New York: The Metropolitan Museum of Art, 1987.

Huntington, David C. *The Landscapes of Frederic Edwin Church: Vision of an American Era.* New York: George Braziller, 1966.

———. *Art and the Excited Spirit.* Ann Arbor: University of Michigan Press, 1972.

Johns, Elizabeth. *American Genre Painting: The Politics of Everyday Life.* New Haven: Yale University Press, 1991.

Kelly, Franklin. *Frederic Edwin Church and the National Landscape.* Washington, D.C.: Smithsonian Institution Press, 1988.

———. *Frederic Edwin Church.* Washington, D.C.: National Gallery of Art, 1989.

McElroy, Guy C. *Facing History: The Black Image in American Art, 1710–1940.* San Francisco: Bedford Arts Publishers, 1990.

Marzio, Peter C. *The Art Crusade: An Analysis of American Drawing Manuals, 1820–1860.* Washington, D.C.: Smithsonian Institution (Smithsonian Studies in History and Technology, no. 34), 1976.

———. *Chromolithograph, 1840–1900: The Democratic Art; Pictures for a Nineteenth-Century America.* Boston: David R. Godine, Publisher, 1979.

Menkes, Diana, ed. *Of Time and Place: American Figurative Art from the Corcoran Gallery.* Washington, D.C.: Smithsonian Institution and Corcoran Gallery of Art, 1981.

Merritt, "A Wild Scene, Genesis of a Painting." In *Studies on Thomas Cole, An American Romanticist.* Annual II. Baltimore: The Baltimore Museum of Art, 1967. See especially Appendix II, "Thomas Cole's List 'Subjects for Pictures,'" 82–101.

Miller, Angela. *Empire of the Eye: Landscape Representation and American Cultural Politics from 1825 to 1875.* Ithaca: Cornell University Press, 1993.

Miller, David, ed. *American Iconology: New Approaches to Nineteenth-Century Art and Literature.* New Haven: Yale University Press, 1993.

Novak, Barbara. *American Painting of the Nineteenth Century.* New York: Praeger Publishers, 1969.

———. *Nature and Culture: American Landscape and Painting, 1825–1875.* New York: Oxford University Press, 1980.

Powell, Earl A., III. "Thomas Cole and the American Landscape Tradition: The Picturesque." *Arts Magazine* 52:7 (March 1978), 110–17.

———. "Thomas Cole and the American Landscape Tradition: Associationism." *Arts Magazine* 52:8 (April 1978), 113–17.

———. *Thomas Cole.* New York: Harry N. Abrams, 1990.

Prown, Jules David, et al., eds. *Discovered Lands, Invented Pasts: Transforming Visions of the American West.* New Haven: Yale University Press, 1992.

Rainey, Sue. *Creating Picturesque America: Monument to the Natural and Cultural Landscape.* Nashville: Vanderbilt University Press, 1994.

Schimmelman, Janice G. *A Checklist of European Treatises on Art and Essays on Aesthetics Available in America Through 1815.* Worcester, Mass.: American Antiquarian Society, 1983.

Schweizer, Paul D. "The Voyage of Life: A Chronology." In Elwood C. Parry III et al. *The Voyage of Life by Thomas Cole.* Utica: Munson-Williams-Proctor Institute, 1985.

Shapiro, Michael Edward, et al., eds. *George Caleb Bingham.* New York: Harry N. Abrams, 1990.

Shearman, John. *Mannerism.* New York: Penguin Books, 1967.

Sims, Lowery Stokes. *Stuart Davis: American Painter.* New York: The Metropolitan Museum of Art and Harry N. Abrams, 1991.

Stebbins, Theodore E., Jr., Carol Troyen, and Trevor Fairbrother, eds. *Close Observation: Selected Oil Sketches by Frederic E. Church.* Washington, D.C.: Smithsonian Institution Press, 1978.

———. *A New World: Masterpieces of American Painting, 1760–1910.* Boston: Museum of Fine Arts, 1983.

Stein, Roger. *John Ruskin and Aesthetic Thought in America, 1840–1900.* Cambridge, Mass.: Harvard University Press, 1967.

———. *Seascape and the American Imagination.* New York: The Whitney Museum of American Art and Crown Publishers, 1975.

Talbot, William S. *Jasper Cropsey, 1823–1900.* Washington, D.C.: National Collection of Fine Arts, 1970.

Taylor, Joshua C., *America as Art.* Washington, D.C.: Smithsonian Institution Press, 1976.

Truettner, William H. *The West as America: Reinterpreting Images of the Frontier, 1820–1920.* Washington, D.C.: Smithsonian Institution Press, 1991.

Truettner, William H., and Alan Wallach, eds. *Thomas Cole: Landscape into History.* New Haven: Yale University Press, 1994.

Williams, Hermann Warner, Jr. *Mirror to the American Past: A Survey of American Genre Painting, 1750–1900.* Greenwich, Conn.: New York Graphic Society, 1973.

Wilmerding, John, ed. *Fitz Hugh Lane.* New York: Praeger Publishers, 1971.

———. *Paintings by Fitz Hugh Lane.* New York: Harry N. Abrams (with The National Gallery of Art), 1988.

———. *American Light: The Luminist Movement, 1850–1875.* Washington, D.C.: The National Gallery of Art, 1980. Reprinted. Princeton: Princeton University Press, 1989.

Culture and Space: Architecture, Landscape Gardening, Urban Design, and Urban Self-Presentation

Allen, Robert C. *Horrible Prettiness: Burlesque and American Culture.* Chapel Hill: University of North Carolina Press, 1991.

Baker, Houston. *Modernism and the Harlem Renaissance.* Chicago: University of Chicago Press, 1987.

Bender, Thomas. *Toward an Urban Vision: Ideas and Institutions in Nineteenth-Century America.* Lexington: University Press of Kentucky, 1975.

Bigelow, Jacob. *Modern Inquiries: Classical, Professional, and Miscellaneous.* Boston, 1867. Jeanne Boydston et al., eds. *The Limits of Sisterhood: The Beecher Sisters on Women's Rights and Woman's Sphere.* Chapel Hill: University of North Carolina Press, 1988.

Boyer, M. Christine. *Manhattan Manners: Architecture and Style, 1850–1900.* New York: Rizzoli, 1985.

Bushman, Richard. *The Refinement of America: Persons, Houses, Cities.* New York: Vintage Books, 1993.

Carr, Carolyn Kinder, et. al. *Revisiting the White City.* Hanover: University Press of New England (for National Museum of American Art and National Portrait Gallery). 1993.

Chadwick, George F. *The Park and the Town: Public Landscape in the Nineteenth and Twentieth Centuries.* New York: Praeger Publishers, 1966. See Chapter 9, "The American Park Movement."

Chase, David B. "The Beginnings of the Landscape Tradition in America." *Historic Preservation* 25:1 (January–March 1973), 35–41.

Clark, Clifford Edward, Jr. *The American Family Home, 1800–1960.* Chapel Hill: University of North Carolina Press, 1986.

Conron, John. "The American Dream Houses of Andrew Jackson Downing." *Canadian Review of American Studies* 18:1 (Spring 1987), 9–40.

Cranz, Galen, *The Politics of Park Design: A History of Urban Parks in America.* Cambridge: MIT Press, 1982.

Darnall, Margaretta J. "The American Cemetery as Picturesque Landscape: Bellefontaine Cemetery, St. Louis." *Winterthur Portfolio* 18:4 (Winter 1983), 249–69.

Domosh, Mona. "The Symbolism of the Skyscraper: Case Studies of New York's First Tall Buildings." *Journal of Urban History* 14:3 (May 1988), 321–45.

Etlin, Richard A. *The Architecture of Death: The Transformation of the Cemetery in Eighteenth-Century Paris.* Cambridge: MIT Press, 1984. See especially "A New Eden: The American Rural Cemeteries," 358–68.

Fein, Albert. *Frederick Law Olmsted and the American Environmental Tradition.* New York: George Braziller, [1968] 1981.

Fisher, Philip. "Appearing and Disappearing in Public: Social Space in Late-Nineteenth-Century Literature and Culture." In Sacvan Bercovitch, ed., *Reconstructing American Literary History.* Cambridge: Harvard University Press, 1986, 155–88.

French, Stanley. "The Cemetery as Cultural Institution: The Establishment of Mount Auburn and the Rural Cemetery Movement." *American Quarterly* 26 (March 1974), 1.

Garland, Joseph E. *Boston's North Shore . . . 1823–1890.* Boston: Little, Brown, 1978.

Gowans, Alan. *Images of American Living: Four Centuries of Architecture and Furniture in the United States.* Philadelphia: J. B. Lippincott, 1964.

———. *The Comfortable House: North American*

Suburban Architecture, 1890–1930. Cambridge: MIT Press, 1986.

———. *Styles and Types of North American Architecture: Social Function and Cultural Expression*. New York: Harper-Collins (Icon Editions), 1992.

Griswold, Mac, and Eleanor Weller. *The Golden Age of American Gardens*. New York: Harry N. Abrams, 1991.

Haley, Jacquetta M., ed. *Pleasure Grounds: Andrew Jackson Downing and Montgomery Place*. Tarrytown, N.Y.: Sleepy Hollow Press, 1988.

Haltunnen, Karen. *Confidence Men and Painted Ladies*. New Haven: Yale University Press, 1982.

Johnson, Carl H., Jr. *The Building of Galena: An Architectural Legacy*. Stevens Point, Wis.: Worzella Publishing Co., 1977.

Johnson, Paul E. *A Shopkeeper's Millennium: Society and Revivals in Rochester, New York, 1815–1837*. New York: Hill & Wang, 1980.

Kasson, John. *Rudeness and Civility: Manners in Nineteenth-Century Urban America*. New York: Hill & Wang, 1990.

Kelly, Bruce, et al., eds. *Art of the Olmsted Landscape*. New York: New York City Landmarks Preservation Commission and the Arts Publisher, 1981.

Koenigsberg, Lisa. *Renderings from Worcester's Past: Nineteenth-Century Architectural Drawings from the American Antiquarian Society*. Worcester, Mass.: American Antiquarian Society, 1987.

Leighton, Ann. *American Gardens of the Nineteenth Century: "For Comfort and Affluence."* Amherst: University of Massachusetts Press, 1987.

Linden-Ward, Blanche. *Silent City on a Hill: Landscapes of Memory and Boston's Mount Auburn Cemetery*. Columbus: Ohio State University Press, 1989.

McDannell, Colleen. *The Christian Home in Victorian America, 1840–1900*. Bloomington: Indiana University Press, 1986.

Pierson, William H., Jr. *American Buildings and Their Architects*. Vol. 2A: *Technology and the Picturesque, the Corporate, and the Early Gothic Styles*. Garden City, N.Y.: Anchor Press (Doubleday), 1980.

Roper, Laura Wood. *FLO: A Biography of Frederick Law Olmsted*. Baltimore: Johns Hopkins University Press, 1973.

Rybczynski, Witold. *Home: A Short History of an Idea*. New York: Viking Penguin, 1986.

Schmitt, Peter J., and Karab Balthazar. *Kalamazoo: Nineteenth-Century Homes in a Midwestern Village*. Kalamazoo, Mich.: Kalamazoo Historical Commission, 1976.

Schuyler, Montgomery. "Recent Building in New York." *Harper's Weekly* 67 (June–November 1883), 557–58.

Scott, Geoffrey. *The Architecture of Humanism*. Garden City, N.Y.: Doubleday Anchor Books, n.d.

Scully, Vincent, and Antoinette Downing. *The Architectural Heritage of Newport, Rhode Island*. Reprinted. New York: American Legacy Press, 1982.

Tatum, George. "The Emergence of an American School of Landscape Design." *Historic Preservation* 25:2 (April–June 1973), 34–41.

Trachtenberg, Alan. *The Incorporation of America: Culture and Society in the Gilded Age*. New York: Hill & Wang, 1982.

Venturi, Robert. *Complexity and Contradiction in Architecture*. New York: The Museum of Modern Art (1966), 1977.

———. *Learning from Las Vegas*. Cambridge: MIT Press, 1991.

Vidler, Anthony. "The Scenes of the Street: Transformations in Ideal and Reality, 1750–1871." In Stanford Anderson, ed., *On Streets*, 29–111. Cambridge: MIT Press, 1986.

Ward, John. "The Politics of Design." In *Red, White, and Blue: Men, Books, and Ideas in American Culture*. New York: Oxford University Press, 1969.

Warner, Sam Bass. *Streetcar Suburbs: The Process of Growth in Boston, 1870–1900*. New York: Atheneum, 1976.

Weeks, Christopher. *The Building of Westminster in Maryland*. Annapolis: Fishergate Publishing Co., 1978.

Wood, Joseph S. "'Build, Therefore, Your Own World': The New England Village as Settlement Ideal." *Annals of the Association of American Geographers* 8:1(1), 1991, 32–50.

Wright, Gwendolyn. *Building the Dream: A Social History of Housing in America*. Cambridge: MIT Press, 1981.

Zaitzevsky, Cynthia. *Frederick Law Olmsted and the Boston Park System*. Cambridge: Belknap Press of Harvard University Press, 1982.

Literature

Baker, Houston A., Jr. *Workings of the Spirit: The Poetics of African-American Writing*. Chicago: University of Chicago Press, 1991.

Bakhtin, M. M. *The Dialogic Imagination*. Trans. Caryl Emerson and Michael Holquist. Austin: University of Texas Press, 1981.

Baym, Nina. *The Shape of Hawthorne's Career*. Ithaca: Cornell University Press, 1976.

———. "The Function of Poe's Pictorialism." *South Atlantic Quarterly* 65 (1966), 46–54.

———. "Melodramas of Beset Manhood: How Theories of American Fiction Exclude Women Authors." Reprinted in Elaine Showalter, ed., *The New Feminist Criticism*. New York: Pantheon Books, 1985. 63–80.

Bercovitch, Sacvan. *Typology and Early American Literature*. Amherst: University of Massachusetts Press, 1972.

Bordwell, David, and Kristin Thompson. *Film Art*. New York: Alfred A. Knopf, 1986.

Bridgman, Richard. *The Colloquial Style in America*. New York: Oxford University Press, 1966.

Brodhead, Richard. *Hawthorne, Melville, and the Novel*. Chicago: University of Chicago Press, 1976.

Brumm, Ursula. *American Thought and Religious Typology*. New Brunswick: Rutgers University Press, 1970.

Buell, Lawrence. *Literary Transcendentalism: Style and Vision in the American Renaissance*. Ithaca: Cornell University Press, 1973.

———. *New England Literary Culture: From Revolution Through Romance*. Cambridge: Cambridge University Press, 1986.

———. *The Environmental Imagination: Thoreau, Nature Writing, and the Formation of American Culture*. Cambridge: Harvard University Press, 1995.

Byer, Robert. "Mysteries of the City." In Sacvan Bercovitch, ed., *Ideology and Classic American Literature*, 221–46. Cambridge: Cambridge University Press, 1986.

Chatman, Seymour. *Story and Discourse: Narrative Structure in Fiction and Film*. Ithaca: Cornell University Press, 1978.

Cogan, Frances B. *All-American Girl: The Ideal of Real Womanhood in Mid-Nineteenth-Century America*. Athens: University of Georgia Press, 1989.

Colacurcio, Michael. *The Province of Piety: Moral History in Hawthorne's Early Tales*. Cambridge: Harvard University Press, 1984.

Conron, John, and Constance Denne. "Historical Introduction" to James Fenimore Cooper, *Gleanings in Europe: Italy*. Albany: State University of New York Press, 1981.

———. "The Industrial Sublime: Assailant Landscapes and the Man of Feeling." *American Examiner* 5:3 (Spring 1978), 26–49.

———. "Assailant Landscapes and the Man of Feeling: Rebecca Harding Davis's 'Life in the Iron Mills.'" *Journal of American Culture* 3:3 (Fall 1980), 487–500.

Dameron, J. Lasley, and Louis Charles Stagg. *An Index to Poe's Critical Vocabulary*. Hartford, Conn.: Transcendental Books, 1966.

Dayan, Joan. "The Road to 'Landor's Cottage': Poe's Landscape of Effect." *University of Mississippi Studies in English* 3 (1982), 136–54.

Douglas, Ann. *The Feminization of American Culture*. New York: Alfred A. Knopf, 1977.

Dixon, Melvin. *Ride Out the Wilderness: Geography and Identity in Afro-American Literature*. Urbana: University of Illinois Press, 1987.

Eisenstein, Sergei. *Film Form and the Film Sense*. Trans. Jay Leyda. New York: Meridian Books, 1957.

Eliot, T. S. *Selected Essays*. New York: Harcourt, Brace & World, 1960.

Fields, James T. *Hawthorne*. Boston, 1876.

Foster, Edward Halsey. *Civilized Nature: Backgrounds to American Romanticism, 1817–1860*. New York: Free Press, 1975.

Furrow, Sharon. "Psyche and Setting: Poe's Picturesque Landscapes." *Criticism* 15 (1973), 16–27.

Gelfant, Blanche. *The American City Novel*. Norman: University of Oklahoma Press, 1954.

Gennette, Gerard. *Narrative Discourse*. Trans. Jane E. Lewin. Ithaca: Cornell University Press, 1980.

———. *Figures of Literary Discourse*. Trans. Alan Sheridan. New York: Columbia University Press, 1982.

Gura, Philip. *The Wisdom of Words: Language, Theology, and Literature in the New England Renaissance*. Middletown, Conn.: Wesleyan University Press, 1981.

———. "Thoreau and John Josselyn." *The New England Quarterly* 48:4 (December 1975), 505–18.

Halliburton, David. *Poe: A Phenomenological View*. Princeton: Princeton University Press, 1973.

Harding, Walter, and Michael Meyer. *The New Thoreau Handbook*. New York: New York University Press, 1980.

Hart, Francis. "Notes for an Anatomy of Modern Autobiography." *New Literary History* 1 (1970), 485–511.

Hartman, Geoffrey. "Romantic Poetry and the Genius Loci." In *Beyond Formalism: Literary Essays, 1958–1970*. New Haven: Yale University Press, 1970, pp. 311–36.

Hess, Jeffrey. "The Sources and Aesthetics of Poe's Landscape Fiction." *American Quarterly* 22 (1970), 177–89.

Huddleston, Eugene L. "Topographical Poetry in the Early National Period." *American Literature* 38 (1966–67), 303–32.

Huth, Hans. *Nature and the American: Three Centuries of Changing Attitudes.* 1957. Reprinted. Lincoln: University of Nebraska Press, 1972.

Jacobs, Robert D. *Poe: Journalist and Critic.* Baton Rouge: University of Louisiana Press, 1969.

Jones, Buford. "'The Man of Adamant' and the Moral Picturesque." *American Transcendental Quarterly* 14 (1972), 22–41.

Kehler, Joel R. "New Light on the Genesis and Progress of Poe's Landscape Fiction." *American Literature* 47 (1975), 173–83.

Kelly, George. "Poe's Theory of Beauty," *American Literature* 27 (1956), 521–36.

Kenner, Hugh. *A Homemade World: American Modernist Writers.* New York: Alfred A. Knopf, 1975.

Kolodny, Annette. *The Lay of the Land: Metaphor as Experience and History in American Life and Letters.* Chapel Hill: University of North Carolina Press, 1975.

———. *The Land Before Her: Fantasy and Experience of the American Frontiers, 1630–1860.* Chapel Hill: University of North Carolina Press, 1984.

Laser, Marvin, "The Growth and Structure of Poe's Concept of Beauty," *ELH* 16 (1948), 69–84.

Lears, T. J. Jackson. *No Place of Grace: Antimodernism and the Transformation of American Culture, 1880–1920.* New York: Pantheon Books, 1981.

Levy, Leo. "Hawthorne and the Sublime." *American Literature* 38 (1966), 391–402.

———. "Picturesque Style in 'The House of the Seven Gables.'" *New England Quarterly* 39 (1966), 147–60.

———. "The Landscape Modes of 'The Scarlet Letter.'" *Nineteenth-Century Fiction* 23 (1969), 377–92.

Ljungquist, Kent. *The Grand and the Fair: Poe's Landscape Aesthetics and Pictorial Techniques.* Potomac, Md.: Scripta Humanitas, 1984.

———. "Howitt's 'Byronian Rambles' and the Picturesque Setting of 'The Fall of the House of Usher.'" *Emerson Society Quarterly,* 33: 4, no. 129 o.s. (Fourth Quarter, 1987), 224–36.

Lowance, Mason. *The Language of Canaan.* Cambridge: Harvard University Press, 1980.

Lubbock, Percy. *The Craft of Fiction.* New York: The Viking Press, 1957.

Lutwack, Leonard. *The Role of Place in Literature.* Syracuse: Syracuse University Press, 1984.

Lynes, Russell. *The Taste-Makers.* New York: Harper & Brothers, 1955.

McKinsey, Elizabeth. *Niagara Falls: Icon of the American Sublime.* Cambridge: Cambridge University Press, 1985.

McLuhan, Marshall. "John Dos Passos: Technique vs. Sensibility." In *The Interior Landscape: The Literary Criticism of Marshall McLuhan.* Ed. Eugene McNamara. New York: McGraw-Hill, 1969.

Martin, Terence. *The Instructed Vision: Scottish Common Sense Philosophy and the Origins of American Fiction.* Bloomington: Indiana University Press, 1961.

Marx, Leo. *The Machine in the Garden: Technology and the Pastoral Ideal in America.* New York: Oxford University Press, 1964.

Matthiessen, F. O. *American Renaissance: Art and Expression in the Age of Emerson and Whitman.* New York: Oxford University Press, 1941.

Mellow, James T. *Nathaniel Hawthorne in His Times.* Boston: Houghton Mifflin, 1980.

Miller, David C. *Dark Eden: The Swamp in Nineteenth-Century American Culture.* Cambridge: Cambridge University Press, 1989.

Nevius, Blake. *Cooper's Landscapes: An Essay on the Picturesque Vision.* Berkeley and Los Angeles: University of California Press, 1976.

Nye, Russell Blaine. *Society and Culture in America, 1830–1860.* New York: Harper & Row, 1974.

Packer, Barbara J. *Emerson's Fall: A New Interpretation of the Essays.* New York: Continuum, 1982.

Peck, H. Daniel. *Thoreau's Morning Work: Memory and Perception in "A Week on the Concord and Merrimack Rivers," the Journal, and "Walden."* New Haven: Yale University Press, 1990.

Phillips, Elizabeth. "The Imagination of a Great Landscape." In *Edgar Allan Poe: An American Imagination: Three Essays.* Port Washington, N.Y.: Kennikat Press, 1979.

Pitcher, Edward W. "The Arnheim Trilogy: Cosmic Landscapes in the Shadow of Poe's Eureka." *Canadian Review of American Studies* 6 (1975), 27–35.

Poenicke, Klaus. "The View from the Piazza: Melville and the Legacy of the European Sublime." *Comparative Literature Studies* 4 (1967), 267–81.

Pollin, Burton. "Poe and the River." In *Discoveries in Poe,* 144–65. Notre Dame, Ind.: Notre Dame University Press, 1970.

Poulet, Georges. "Edgar Poe." In *The Metamorphoses of the Circle,* 182–202. Trans. Carley Dawson and Elliot Coleman. Baltimore: Johns Hopkins University Press, 1966.

Rainey, Sue. *Creating Picturesque America: Monument to the Natural and Cultural Land-*

scape. Nashville: Vanderbilt University Press, 1994.

Reynolds, David. *Beneath the American Renaissance*. New York: Alfred A. Knopf, 1988.

Richardson, Robert D., Jr. *Henry Thoreau: A Life of the Mind*. Berkeley and Los Angeles: University of California Press, 1986.

Ringe, Donald A. *The Pictorial Mode: Space and Time in the Art of Irving, Bryant, and Cooper*. Lexington: University of Kentucky Press, 1971.

Rosenfield, Alvin. "Description in Poe's 'Landor's Cottage.'" *Studies in Short Fiction* 4 (1967), 26–29.

Shi, David. *Facing Facts: Realism in American Thought and Culture, 1850–1920*. New York: Oxford University Press, 1995.

Smith, Gayle L. "Emerson and the Luminist Painters: A Study of Their Styles." *American Quarterly* 37:2 (Summer 1985), 193–215.

St. Armand, Barton Levi. "Poe's Emblematic Raven: A Pictorial Approach." *ESQ* 22 (1976), 190–210.

———. "Poe's Landscape of the Soul: Association Theory and 'The Fall of the House of Usher.'" *Modern Language Studies* 7 (1977), 32–41.

———. "Luminism in the Work of Henry David Thoreau: The Dark and the Light." *Canadian Review of American Studies* 11:1 (Spring 1980).

Stott, William. *Documentary Expression in Thirties America*. New York: Oxford University Press, 1973.

Strauss, Anselm. *Images of the American City*. New York: Free Press of Glencoe, 1961.

Thompson, G. R. *Poe's Fiction: Romantic Irony in the Gothic Tales*. Madison: University of Wisconsin Press, 1973.

Tompkins, Jane. *Sensational Designs: The Cultural Work of American Fiction, 1790–1860*. New York: Oxford University Press, 1985.

Vanderbilt, Kermit. "Art and Nature in 'The Masque of the Red Death.'" *Nineteenth-Century Fiction* 22 (1968), 379–98.

Wallace, Maurice. "Constructing the Black Masculine: Frederick Douglass, Booker T. Washington, and the Sublimits of African American Autobiography." In Michael Moon and Cathy N. Davidson, eds., *Subjects and Citizens: Nation, Race, and Gender from Oroonoko to Anita Hill*. Durham, N. C.: Duke University Press, 1995.

Ward, John. *Andrew Jackson: Symbol for an Age*. New York: Oxford University Press, 1962.

Warren, Austin. *Connections*. Ann Arbor: University of Michigan Press, 1970.

Welter, Barbara. "The Cult of True Womanhood." *American Quarterly* 18: 2 (Summer 1966), 152–74.

Woolley, Mary. "The Development of the Love of Romantic Scenery in America." *American Historical Review* 3:1 (October 1897), 56–66.

Page numbers in *italics* refer to illustrations.

monuments, 184–88, *186*, *187*
picturesque design, 182
Mount, William Sidney
on "conversation pieces," 109
Dance of the Haymakers, 102–3, *103*
disheveled clothing in paintings, 53, 112–13
Farmer Whetting His Scythe, 60, *62*
landscape paintings, 82
The Long Story, 110, *110*
on narrative in painting, 102
The Painter's Triumph, 105–6, *107*
on painting, 155
The Sportsman's Last Visit, 47, 50, 86, 112–14, 139
Mrs. James Donaldson (Inman), 142, *143*, 144
Muir, John, 201, 291
Mumford, Lewis, 267–68

narrative. *See also* literature; novels; travel narratives
autobiographical, 299
central characters, 207–8
ecological, 120–21, 125–26, 128, 298, 302
emerging and vanishing pictures, 202–3
in landscape architecture, 174–76, 282–88
local landscapes, 289–90
mise-en-scène and, 8–9
in modern art, 310
multiple, 6, 94–96
multiple perspectives, 209, 211–12, 215–16, 217–18
in picturesque aesthetic, 6–7
processional and recessional, 6, 204–5
quest plots, 12
in scenes, 10
sequence of scenes, 195, 205–6
settings and characters, 208, 221
space, 200–201
unity in, 155–56
voice, 208–10, 211
in *Walden,* 290, 297–99, 301–2
The Narrative of the Life of Frederick Douglass (Douglass), 225–26
narrative in paintings
anachronic, 91, 101, 116–17
Cole's *Voyage of Life,* 87
comic elements, 103–5, 107, 109
complications, 98–101, 103–9
conflict, 100–101
congruity, 93–98, 103–9
contrast and variation, 98–99, 100–101, 103

domesticated vistas, 121–25, 126–27, 137
in domestic interiors, 116, 138–40
ecological narrative, 125–26, 128, 298, 301
emergence of beauty from violence of nature, 150–52
in genre painting, 101
gradations linking incidents, 97–98
groups of figures, 92, 102
house portraits, 136–38
in landscape paintings, 115–17, 150–52
multiple, 94–96, 98–100, 117
pace, 96–98
principal subject, 92, 94, 117
reflexive, 104–6
settlement, 118–21
Transcendentalist, 152–54
typological, 121, 125
urban growth, 133–35
visual hierarchies, 70
visual path, 92–93, 94, 96, 102, 117, 137
nationalism, 8, 26, 290
naturalism, 34–35
Nature (Emerson), 39–44, 121, 259, 291
nature. *See also* landscape
emotional effects, 41, 43
human presence, 6–7, 298–99, 300, 301–2
idealized, 43
in interiors, 35, 140–41, 162, 249, 250, 252, 268
ministries of, 11, 41–42, 238
multiple meanings in, 40
narrative in landscape paintings, 115–17, 150–52
in narratives by African Americans, 229
narratives of ecology, 120–21, 125–26, 128, 298, 302
picturesque aesthetic and, 3, 8, 20, 155
picturesque effect in, 19
picturesque sublimity of, 20–21, 23
relationship to landscape painting, 155
ruins in, 35
separation from built environment, 307
sublimity, 20–21, 30–31, 292
unity of effect, 44
violence in, 150
Neagle, John, *Pat Lyon at the Forge,* 59, *60*
Newburyport Meadows (Heade), 73
New Jersey, Llewellyn Park, 189–90, *191*
Newport (Rhode Island), 189

"Edgewater," 166–67, *167*
King Villa, *160*, 161, 267
novels set in, 223, 290
Skinner House, 167, *168*
villas and cottages, 166
yardscapes, 193
New York City. *See also* Central Park; cities; urban architecture
Ashcan School, 308–9, 314
Church of the Holy Communion, 262, *262*
commercial architecture, 269–72, 288
elevated trains, 254
overcrowding, 260–61
as picturesque city, 253–54, 288
St. Patrick's Cathedral, 262, *263*
separation of commercial and residential districts, 272–73
skyscrapers, 271
slums, 257–59
street grid, 260, 269–70, 272–73
vistas of, 133, *133*, 135–36, *135*
New York City Hall, Park and Environs (Bachmann), 133, *133*
Niagara Falls, 20–21, 24, 34, 128–29
Norman Revival architecture, 159, 269
Not at Home (Johnson), 86, 140, *140*
Novak, Barbara, 30, 123, 128, 150, 152, 302
novels. *See also* African American writers; literature; women writers
characters, 214, 221
discourse, 215
dramatic picturesque in, 214–16
multiple perspectives, 215–16, 217–18
picturesque aesthetic in, 12, 214

Old Kentucky Home (Life in the South) (Johnson), 36, *37*
Olmsted, Frederick Law, 170, 232, 291. *See also* Central Park
on picturesque architecture, 273
on picturesque parks, 155, 272, 279–80, 281–82
suburban landscape designs, 189
on suburbs, 188
on urbanization, 131
views on cities, 260–61, 272–73, 288
On the Coast of New Jersey (Richards), 76, 82, *83*